RODIN

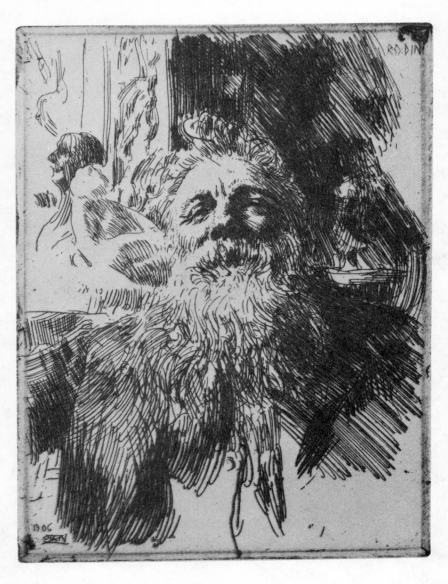

Rodin by Anders Zorn.

ZORNSAMLINGARNA, MORA, SWEDEN

FREDERIC V. GRUNFELD

RODIN

A Biography

HENRY HOLT AND COMPANY NEW YORK

Published by Henry Holt and Company, Inc.,
115 West 18th Street, New York, New York 10011.
Published in Canada by Fitzhenry & Whiteside Limited,
195 Allstate Parkway, Markham, Ontario L3R 4T8.

Library of Congress Cataloging in Publication Data
Grunfeld, Frederic V.
Rodin.
Bibliography: p.
Includes index.
1. Rodin, Auguste, 1840–1917. 2. Sculpture, French.
3. Sculpture, Modern—19th century—France.
4. Sculpture, Modern—20th century—France.
5. Sculptors—France—Biography. I. Title.
NB553.R7G78 1986 730′.92′4 [B] 87-258
ISBN 0-8050-0279-0

Grateful acknowledgment is made to the following for permission
to reproduce the works herein: Musée Rodin, Paris; Bibliothèque
Nationale, Paris; Museu d'Art Modern, Barcelona; SPADEM (Société
des Auteurs des Arts Visuels); Zornsamlingarna, Mora, Sweden.

Grateful acknowledgment is also made for permission to reproduce
Rodin in His Studio by Jean François Raffaëlli. © The Art Institute
of Chicago. All rights reserved.

Designed by Lucy Albanese
Printed in the United States of America
3 5 7 9 10 8 6 4 2

ISBN 0-8050-0279-0

To the memory of Edgar Varèse

CONTENTS

*Illustrations follow
pages 146, 306, and 466.*

PREFACE

To write the way Rodin sculpts.

—JULES RENARD
Journal, 1891

Some years ago, while writing a *Horizon* essay on Rodin's *Balzac*, I tried to find a biography that would reflect something of the literary aura that surrounded the life and times of the most famous artist of an age teeming with notable writers on art—Goncourt, Zola, Maupassant, Mirbeau, Mallarmé, Renard, Gide, Apollinaire, Rilke, Simmel, Brandes, Henley, Stevenson, Bernard Shaw and so on, all of whom had interesting things to say about Rodin. But the available Rodin literature consisted mainly of monographs, picture books, catalogues and other works of exegesis. Since the book I envisaged didn't exist I decided to write it myself, and this is the result.

Since the last real Rodin biography based on original research—Judith Cladel's *Rodin, Sa vie glorieuse, sa vie inconnue*—appeared in 1936, it was, in any case, high time to take a fresh and unbiased look at the record. Cladel's study, long out of print in both French and English, was written from a highly personal point of view. Though she had known Rodin from her earliest childhood and had worked for many years as one of his public relations assistants, she was unfamiliar with most of the documents of his early years and with much of the Rodin literature written in languages other than French.

The Rodin monographs published since then have relied chiefly on Cladel for biographical information and have rarely gone very deeply into other sources. A rather special case was Victor Frisch's 1939 biography—still quoted by unsuspecting scholars—which was a total fabrication, as fraudulent in its testimony as the "Rodin drawings" produced by the notorious forger Ernst Durig.

Having spent most of my life among artists, I was certain that the real Rodin could not have been the philosopher-aesthetician he is made out to be in art history treatises, nor could his story have entailed quite as much sweetness and light as Cladel suggests in her *vie glorieuse* (which fails to mention Camille Claudel by name, for example, and omits Gwen John altogether). My first principle in writing this biography, therefore, has been to let the documentary record speak for itself and to avoid the temptations of making it glorious. The result, I hope, is a portrait of "a man with all of his inborn contradictions," as Goethe put it. It seems to me that such an uncensored portrait makes Rodin's work far more comprehensible than the standard effusions about the *grand maître* that also tried the patience of Bernard Shaw, who held that "all the stuff written about him is such ludicrous cackle and piffle."

Of course the phenomenon of Rodin's life in art—at the very center of the European stage during the years when modernism was born, and as one of the catalysts and *points de rencontre* of French culture—is inseparable from the nineteenth-century idealism that shaped his thinking as well as his sculpture. I have tried to convey the tone and temper of the times by quoting frequently and at length from Rodin's contemporaries, with all of their enthusiasms and prejudices. But I have refrained from dwelling on that interminable topic, the aesthetics of his "genius" (a worn-out word that occurs hereafter only when someone else is being quoted). Taking my cue from Walter Benjamin I have done my best to reconstruct Rodin's life in "nonconceptual details, in concrete moments," by assembling a mosaic of documentary evidence. Much of it, fortunately, concerns the neglected practical aspects of a sculptor's life—how much he was paid and what percentage of that was profit; who cut his marbles, and how the patina was put on his bronzes. By the same token I have written this book as much as possible "without interpretation," not only because Rodin exegesis is a well-covered field, but because I share

the sculptor's distrust of writers presuming to analyze the "meaning" of his work.

I have dedicated this book to the memory of Edgar Varèse, my own mentor and maître, who provided the original impulse for it many years ago. Varèse, who had once been Rodin's protégé, gave me a sweeping view of the whole epoch: when he was seventy and I was twenty-five he used to invite me for osso buco in Greenwich Village and tell me what Debussy had told him about Mallarmé's Tuesdays. Perhaps this book should also be dedicated to the memory of Truman H. Bartlett, the forgotten American sculptor whose 1889 essay on Rodin remains the most valuable single source of information about the first half of the artist's life. Though Bartlett was an admirer of Rodin, he was not overawed by him, as was almost everyone else. He conducted his interviews, moreover, with an intuitive Yankee concern for hard fact—at a time when Rodin still remembered his early years in vivid detail. Afterward he reported what Rodin had told him without the cloying sentiment and fanciful elaboration that prompted later biographers to turn the Father Eymard episode, for example, into a kind of pious idyll. Only slightly less essential to the pragmatic biographer are the two Rodin books—both equally scarce— which the English expatriate Frederick Lawton wrote just after the turn of the century.

Altogether I consulted more than 1,500 sources during my research in France, Britain, the United States, Germany and Spain, and originally I hoped to include all of them in the bibliography, but it would have made the book impossibly bulky and expensive. I have cut the list down to just those sources from which I have actually quoted, and a selection of other significant works of reference.

In the matter of illustrations I have followed Rodin's maxim that "drawings are always more intelligent than photographic reproductions." He was very conscious of the problem of depicting three-dimensional sculpture on a two-dimensional page, and although he was not averse to using photographs to publicize his work, he much preferred to see it reproduced by means of line drawings, wood engravings, etc. Accordingly I have used prints and reproductions that appeared, usually with Rodin's sanction, in books and magazines during his lifetime. To emphasize the fact that this is a biography and not a monograph, and to convey the atmosphere of the epoch, I

have also included a good deal of illustrative material that is not by Rodin, but representative of his artistic environment.

The sources of quotations will be found starting on page 637, where all citations are identified by page and line number. The acknowledgments begin on page 705, and it is no exaggeration to say that without the help of the people listed there, especially those in the first paragraph, this book could not have been written. Hence they, too, have a share in the dedication.

<div style="text-align: right">Deyá, Mallorca, July 1987</div>

RODIN

1
THE NEED TO TOUCH

La sculpture est le besoin de toucher.

—PAUL CLAUDEL
Positions et Propositions

E ighteen-forty is notable as a vintage year in the French arts, since it produced not only Rodin and Redon but also Monet, Daudet and Emile Zola. Though each of them was to make his name in Paris, "the capital of the nineteenth century," only Monet and Rodin were born there and only the latter actually grew up in the city. With a population of nearly one million, Paris was then the largest city on the Continent, though still only half the size of London. The majority of its inhabitants were not native-born Parisians but had, like Rodin's parents, come from the provinces in search of a living. These migrants had helped swell the city's population from 546,856 in the census year 1801 to 935,361 in 1841.

There was work to be found and money to be made in Paris, but by the same token it could be a ruthless and unforgiving environment for newcomers whose only assets were their hands and bodies. Paris was far more brutal than anything described by Balzac, whose tragedies were bourgeois rather than proletarian. At mid-century, as in Rousseau's time, Paris was "perhaps the city in the world where fortunes are most unequal, and where flaunting wealth and the most appalling penury dwell together." One of the more revealing statistics

about the Paris of 1840 is the illegitimacy rate: of the 30,312 babies born that year, nearly one-third, or 9,213, were illegitimate.

"Among every three Parisians one meets one is likely to see one bastard," calculated the journalist André Cuchot in the *Revue des deux mondes*, adding that in the charity hospitals—the well-to-do had their babies at home—nine out of ten of the newborn were illegitimate; "their birth is a punishment for error." Some 4,000 foundlings were abandoned in the city's streets every year, and three-quarters of these promptly died in hospitals or in the homes of municipally employed wet nurses.

The relentless exactitude of these statistics reflects the diligence of the small army of clerks charged with recording everything of significance that happened in the city, in particular the hard-working *fonctionnaires* of the Paris police, among whom was the sculptor's father, Jean-Baptiste Rodin. Writing things down in detailed reports and keeping them on file had already become something of an obsession with the authorities; the local *commissaires* who watched over every street in the city were better at generating reports than at apprehending criminals. Yet these methods proved quite effective as a means of imposing some measure of control on even the most crowded and troublesome slum districts.

In addition to their conventional duties of suppressing crime and mendicancy, the police functioned as a "half-political and half-sanitary hydra" with dozens of secondary responsibilities. They supervised the cleaning and lighting of the streets, the conduct of brokers, peddlers, porters and hackney drivers, the unloading of boats on the Seine. They fixed the price of bread and verified weights and measures in shops and markets; tasted wine before it could be put on sale; kept a register of licensed prostitutes; inspected schools, hospitals and hotels; recorded the monthly receipts of all places of amusement; and maintained lists of every foreigner in Paris—a category that included English art students like Thackeray and a growing colony of resident expatriates ranging from Belgian laborers and Italian stonemasons to the Polish piano teacher Frédéric Chopin and the German writer Heinrich Heine. Their strictest surveillance was reserved for political agitators among the Parisians themselves. When Marc Caussidière, one of the Socialist Louis Blanc's associates, became prefect of the Paris police after the revolution of 1848, he sent for the dossier

of secret police reports on his own activities and was startled to find that they contained "not only my actions, but my intimate thoughts!"

Jean-Baptiste Rodin had joined the Paris police at the age of twenty-five, in April 1828, in the depths of an economic depression that was to last another four years. Born on February 18, 1803—"the 29th of Pluviose, Year Eleven of the Republic," as his birth certificate has it—he had come to the capital from Yvetot, a town in Normandy, north of Rouen, where evidently there was no work for him. Indeed, unemployment was general throughout the north of France: in 1828, in the department of the Nord alone, out of 224,000 workers, 163,000 were forced to subsist on charity. Jean-Baptiste, who had spent some time as a lay brother in a monastery, must have considered himself fortunate to have gained a foothold on even the lowest rung of the bureaucratic ladder.

His name first appears on the police payroll, with an annual salary of 800 francs (equivalent to a manual worker's) as an attendant, or *garçon de service*, at the Dépôt de Mendicité de Saint-Denis. Situated at what is now the Place Victor Hugo, the Dépôt was an immense baroque hospital that had been turned into a prison during the Revolution and now served as a *maison de répression*—a workhouse for 1,200 convicted beggars, vagabonds and ex-convicts. (Any workman apprehended without a *livret*, a work permit endorsed by the police, was automatically arrested as a vagabond, and anyone employing him was subject to a heavy fine.) It was, by all accounts, a dreadful place of detention, where a prisoner's chances of survival were hardly better than in a foundling home: fully half the inmates died of cholera and other diseases thought to emanate from the open sewer that ran beneath the building.

After a year with the mendicants, Jean-Baptiste moved on to become a warden (*surveillant*) at the Conciergerie, the medieval prison that formed part of the Palais de Justice of the Ile de la Cité. Conditions here were more tolerable, since most of the occupants were defendants awaiting trial. The upper stories contained privileged prisoners who could afford to pay for a bed, and in addition to a promenade for inmates there was a *parloir* where, for an hour at a time, they were permitted to talk to visitors through iron bars.

At the time of his son's birth Jean-Baptiste appears to have been assigned to duty in the Halles quarter, but the police records fail to

mention another transfer or promotion until after the February Revolution of 1848 and the reorganization of the force under Caussidière, when Jean-Baptiste became an *inspecteur sédentaire* of the Administration Centrale at the Préfecture, on the quai des Orfèvres. The fact that after twenty years his salary was only 1,200 francs indicates that despite the title of *inspecteur* his functions were those of a very minor official. He was assigned to the Cinquième Bureau of the First Division, a department which, according to the archives of the Paris police, concerned itself with such matters as suicide and the suppression of unlicensed prostitution.

Jean-Baptiste must have known as well as anyone the dark and desperate sides of Parisian life which Emile Zola was to explore in his novels. It was estimated that for every registered prostitute (*fille soumise*) there were at least ten clandestine ones, a total of about 50,000 in a city of one million.* The unregistered women, *filles insoumises*, were frequently used as pawns in a game of blackmail that the police themselves played with the city's pimps—as the sculptor David d'Angers discovered when he tried to intercede with the Préfecture on behalf of one of his models, Clémentine, who had fallen on illegal ways. A detective, Monsieur Canler, afterward the chief detective of Paris, told the surprised sculptor how it was that Clémentine had already been released, and permitted to return to her *souteneur*:

However great an artist you may be, Monsieur David, you could not produce a statue without the outlay for the marble, or for the casting of it in bronze. You, moreover, want to pay your *praticien*, who does the rough work for you. Our *praticiens* are the informers. . . . The *souteneur*, the most abject of them all,

*In 1831, A. J. B. Parent-Duchâtelet conducted a survey among 5,183 prostitutes of Paris in order to learn something about this problematic métier: 1,441 women gave "absolute destitution" as their reason for taking up the profession, 1,244 cited "loss of parents and expulsion from home," 1,425 were "mistresses abandoned by their lovers, and having no other resources," 464 had been "brought to Paris, seduced and abandoned," and 289 were "domestics seduced by their masters and sent off." The remaining 320 gave a variety of other reasons for their prostitution. See Parent-Duchâtelet, *De la prostitution dans la ville de Paris* (Paris, 1857).

is, perhaps, the most valuable. Though he lives in comparative comfort from what his mistress gives him, he rarely makes a big haul. His mistress gone, the pot ceases to boil; in fact, he calls her his *marmite*. . . . [If she is arrested] he repairs to the Préfecture, and obtains her liberation in exchange for the address of a burglar or even a murderer who is wanted.

Very little is known about Jean-Baptiste Rodin's attitude toward the legion of miscreants who provided his professional raison d'être. In later years Auguste Rodin rarely mentioned his father, and early biographers, working with information supplied by Rodin himself, referred to him merely as a man "in very humble circumstances" or a "modest employee," or again, still rather misleadingly, as "a clerk in the offices of the Préfecture of the Seine." Rodin's reluctance to identify his father as a police inspector stemmed, certainly, from the abhorrence in which that organization was held by most people: "The word police is repulsive to Paris," declared the editor of the *Charivari* in 1835.* "Rodin was a son of the people," wrote his biographer Judith Cladel. But the reality was something else and more complex: to be a son of the people is not the same as being the son of a police *fonctionnaire* whose job is to suppress the vices of the people.

As one of the three hundred clerks and inspectors who ran the central administration, Jean-Baptiste was also, by definition, a member of the educated class—an important distinction at a time when, according to the 1842 police statistics, out of every 1,000 men called up for conscription, only twenty-eight could actually read and write; of the rest, 815 could read a little but not write, 150 were wholly illiterate, and the remainder somehow escaped classification. Literacy was not, for that matter, regarded as a prerequisite for a useful life.

*Still, it was no mean accomplishment to have become an inspector, and Auguste Rodin never forgot it. Anatole France once talked to him about having seen *"deux mouchards"*— a very uncomplimentary slang word for detectives. "What *mouchards*?" Rodin interrupted irritably. "The two *mouchards* who . . ." "What *mouchards*?" Rodin repeated in a voice trembling with rage. The novelist wondered what was the matter. "Ah, you see," explained the sculptor's helpmeet, Rose Beuret, "it's just that Monsieur Rodin's father was an *inspecteur de la Sûreté!*"

As the gentleman painter Edgar Degas wrote later in the century: "Weren't people much happier without all this useless education they receive at school?"

In terms of Rodin's development as an artist, the fact that his father belonged to the literate bureaucracy was far more significant than the supposed "peasant" ancestry that led one biographer, Anita Leslie, to call her book *Rodin: Immortal Peasant*. In fact, both his father's and his mother's male ancestors were weavers, not farmers. On Jean-Baptiste's birth certificate the profession of his father, Jean-Claude Rodin, is given as *marchand de coton*—a term that may conjure up visions of a merchant surrounded by bales of cotton, though in this case it refers to a petty trader in cotton cloth. An earlier document lists him simply as a *toilier*, a weaver of linen. Jean-Claude, in turn, was the son of another weaver, Claude Rodin, who appears in the records as a *compagnon tisserand* (journeyman weaver) and as the husband of a woman whose maiden name was Louise Regotat. They lived in Troyes, in the department of Aube, when Jean-Claude was born in 1764. The Rodin family thus came from the province of Champagne and not from Normandy: it has often been suggested that Auguste might be descended from the stonemasons who built the cathedral of Rouen, but he might more easily have had ancestors among the sixteenth-century sculptors who furnished the churches of Troyes with some of the well-known limestone *retables* whose flamboyance of detail prefigures Rodin's *Gates of Hell*.

The earlier history of this weaving family is obscured by the sheer profusion of Rodins in the town records of Troyes, some of whom spelled their name "Raudin." The surname is a medieval one, derived from the Teutonic word for red, and originally spelled Chrodin, or Hrodin. (By coincidence, Auguste was to have chestnut-red hair and a beard the color of a ginger cat.) Jean-Claude signed himself "Rodin" on most surviving documents, but also used "Raudin" on occasion. He moved from Troyes to Yvetot, which was developing into a flourishing textile center where 2,500 weavers exercised their trade, and in 1799 married Marie Clotilde Renault, daughter of a local shoemaker named Nicolas Renault and his wife, née Marie Clotilde Dufée. Within a year they had their first child, Nicolas Stanislas, who was followed by five other boys and two girls; Jean-Baptiste was the fourth in this sequence.* He married twice. By his first wife, Gabrielle

Cateneau, he had a daughter named Clotilde who is said to have been exceptionally pretty and who, by a Zolaesque turn of events, became a fallen woman and got into trouble with the police. Thereafter the family never mentioned her name.

In 1836 Jean-Baptiste married a second time. His bride, Marie Cheffer, had been born on May 20, 1807, in Landroff, a tiny hamlet in the vast open plain east of the Moselle, but her family actually lived in Gorze, a much more substantial little town, nestled in the hills on the western bank of the Moselle. Gorze was famous for its Benedictine monastery, founded by Saint Chrodegang, bishop of Metz in the eighth century. Marie's father Claude Cheffer (occasionally spelled Cheffert) was a weaver in Gorze, though a native of Metz; her mother, née Catherine Chéry, or Cherry, came from Marly, near Valenciennes. Claude, who had served in the Napoleonic Wars, was the son of Mathias Chéfer, alias Mathieu Cheffer, a weaver from Metz, many of whose male relatives appear in the Metz records as "master weavers"—indeed, weaving was a valuable craft that was passed on from fathers to sons throughout the eighteenth century. Although much has been written, mainly by Germans, about Rodin's supposed German antecedents on his mother's side, Landroff was not a German-speaking village (it is often confused with Launstroff, which does lie on the German-speaking frontier) and, in any case the Cheffers came from French-speaking Metz (though their name derived from the German *Schäfer*, shepherd). The first German connection in the family tree was Marie Palezen, wife of Mathias's father Jean Cheffer, who had been born in Bavaria but emigrated to Lorraine early in the eighteenth century.

Claude and Catherine Cheffer had five daughters. Two stayed behind in Metz, to marry a restaurateur and a hairdresser, respectively, while three went to Paris. One became housekeeper to the composer François Aubert, director of the Paris Conservatory for nearly thirty years; one married Monsieur Rodin; and the youngest, Thérèse, kept house for the painter Michel-Martin Drölling. Before marrying a man named Eugène Dubois, Thérèse had three sons who

*The third, Jean-Hippolyte-César Rodin, born in 1802, became a teacher and botanist; he founded a boys' school in nearby Beauvais that was to play an important role in Auguste's education.

[7]

were born out of wedlock—Auguste, Emile and Henri Cheffer. If artistic talent is, in fact, an inherited rather than an acquired characteristic, then presumably it ran in the Cheffer family, for these three cousins of Rodin all became master craftsmen in artistic occupations: engraving, commercial design and typography. The art of sculpture, too, requires constant effort and unceasing attention to detail—and perhaps it is not a coincidence that these are also characteristics of a master weaver.

In 1838, when Jean-Baptiste was thirty-five and Marie Rodin thirty-one, they had their first child, a girl they christened Marie-Louise but called Maria to distinguish her from Marie. Their son, François Auguste René Rodin, was born at noon on the 12th of November, 1840.* The christening did not take place until two months later, on January 24, 1841, at the nearby parish church of Saint-Médard. Since both parents were devout Catholics, the delay probably meant that the mother was ill during the intervening months. The boy's godparents were Auguste Lévis, a shop clerk, and Françoise Adam, a chambermaid.

Rodin used to tell friends and journalists that the house in which he was born had been torn down. In fact it is still standing, though it was subsequently renumbered and is now No. 7, rue de l'Arbalète (Crossbow Street). No plaque identifies the house as the birthplace of one of the great artists of France; it is an old and quietly shabby building on a narrow, cobbled street that threads through the hilly part of the old Latin Quarter known as the *quartier de la Mouffe* because its main thoroughfare is the rue Mouffetard. The district had been quite splendid during the Middle Ages but had become one of the poorest and most overcrowded districts of working-class Paris. The rue Mouffetard, just up the street, was lined with tenements and small shops; footpads and petty criminals made it unhealthy for honest folk to walk there at night. The *Charivari* published a caricature of two Mouffetard provisioners about to sell a skinned cat as wild hare— out of season.

*Jean-Baptiste waited for two days before presenting the infant at the Mairie of what was then the Twelfth and is now the Fifth arrondissement. His witnesses were an architect who lived at the same address as the Rodins, No. 3, rue de l'Arbalète, and a baker who lived around the corner.

"My childhood was quite arduous, comparable to that of a worker's son," Rodin remembered afterward. But his parents, with the certitude of 800, then 1,200 francs a year, were able to live a far more relaxed existence than the slum dwellers who inhabit some of Zola's novels, the *gens sans feu et sans aveu*—people without hearth or faith—whom Karl Marx dubbed the *Lumpenproletariat*. Jean-Baptiste had already taken the first step along the road that was to lead his son out of the working class into *la grande Bohème*, the world of successful artists and writers. The important thing was not to have to perform backbreaking labor. When J. K. Huysmans, later in the century, wrote about the armpit of Paris, he described the very point of distinction between a police clerk and a drayman who might be living side by side in the same sunless courtyard.

There are some smells which are as suspicious and equivocal as a cry in a dark street. They are exuded by certain working-class districts of Paris, in the summertime, if you pass near a group of people in the street. Negligence, and the weariness of arms that have toiled at backbreaking tasks, account for the sharp, goat-like odor that comes from their sleeves.

The old Twelfth arrondissement was among the most pungent of what were then the twelve districts of Paris: nearly one in six of its inhabitants was legally registered as a pauper. But the Rodins moved out of their fifth-floor tenement flat into the greener periphery of the Latin Quarter soon after Auguste was born. Marie Rodin was a determined and hard-working woman. She laid in a small stock of rosaries, scapulars, religious medals and *images de piété* and sold them to her neighbors—not only to help make ends meet but because she was serious about religion. Every Sunday she took her two children to mass, first to Saint-Médard, later to other nearby churches, including Sainte-Geneviève (the once and future Panthéon) and, when they were living in the rue du Faubourg-Saint-Jacques, to the church of Saint-Etienne-du-Mont, architecturally and sculpturally one of the most fascinating churches in the whole of Paris.

Auguste received his first schooling from the monks of a teaching order, the Frères de la Doctrine Chrétienne, who ran a primary school just a few steps away from his birthplace, at Val-de-Grâce. Although

he attended this school until he was nine, and the frères had an excellent reputation as educators, Rodin is said to have learned "almost nothing" during these years. Modern writers have placed him, retroactively, among the great dyslexics; at the time he seemed merely slow in learning to read and write. But he had already become interested in things that were not taught in school. Later he retained two distinct memories of his earliest childhood, and both had to do with his first remembered pleasures in the realm of art.

"When I was very young," he told his friend Dujardin-Beaumetz, "as far back as I can remember, I made drawings. A grocer patronized by my mother used to wrap his prunes in paper bags made of pages torn from illustrated books, or even prints. I copied them; they were my first models." Truman Bartlett, Rodin's first biographer, recorded his earliest recollections of sculpture:

> When he was five years of age, his mother was one day frying some cakes, the dough of which was first rolled thin, like pie crust, and then cut up into various fantastic forms, before it was dropped into the boiling fat. These fanciful forms attracted the boy's attention, and he asked his mother to let him make some *men*, to fry. She assented, and he immediately made them so large that there was not dough enough to make many of them, or room enough in the kettle to fry them, and his mother hastened to cut short the ambitious career of the dough sculptor. Strange as it may appear, the incident was not without its amusement and significance, for, when the men were fried, the dough had been tortured by the fat into such curious and striking positions that it made both the mother and child laugh heartily, besides indelibly impressing upon the latter's memory his first sight of the extraordinary movements that even a dough man could be made to go through.

A psychoanalyst would recognize both of these as "screen memories"—seemingly innocuous memories retained in adult life that conceal suppressed or forgotten experiences that were crucial in the child's development. In Rodin's case, his earliest memories confirm the classic psychoanalytic conception of the "born sculptor" as a

child whose "very early and characteristic urge to knead or model things with the hands" began in the anal stage of infancy. There are many instances of children who became sculptors by transferring their infantile interest in excrement to dirt, earth, clay and stone.* Rodin remembered the childhood pleasure of kneading dough figures because it was an activity that both satisfied his own needs and won him the approval of his "extremely neat" mother—the first in a long series of women whom he was able to charm by the exercise of his talent for kneading and modeling.

The psychoanalyst Felix Deutsch wrote an essay on Rodin's "creative passion" in which he focused on the sculptor's lifelong habit of rolling pellets out of bread or clay and leaving them lying around. There was, he suggests, a physiological basis for this constant activity of the hands and fingers—it was a form of compensation for the myopia from which Rodin suffered even as a child. If the eyes fail to serve the young ego as they should, another sensory faculty is brought into play to aid or replace them; thus hands and skin played a decisive role in the sculptor's development. "The sense of touch will be the mediator for the discovery of objects outside the individual's own body," and for the rest of his life Rodin's creative passion remained indissolubly tied to his large, sensitive hands. Many of those who knew him as an adult noticed that his hands were never still—he was always "manipulating pieces of clay with his fingers, just like an inveterate smoker constantly rolling cigarettes," as one critic observed. This habit of kneading, fidgeting, feeling the substance of things was central to his being, Deutsch noted. "When he was modeling, his eyes were fixed on the model while his hands shaped the clay which no more demanded his eyes. His hands had the vision."

*In the *Zeitschrift für Psychoanalytische Pädagogik* (Volume III, 1928–1929), Dr. Eduard Hitschmann described the case of a small boy who "used to shake himself energetically in order to let the faeces drop from his trousers to the ground, and then begin to knead them energetically, as well as smearing them on his own body and other objects. The intelligent parents had the good idea of providing the child with a plastic material, plasticine. . . . The boy now ceased his perverse behavior and soon displayed great interest and skill in modeling plasticine imitations of the things he saw, especially animals."

The poet Paul Claudel, who had reason to regret having known Rodin, once described the genesis of a sculptor in almost the same terms: "*La sculpture est le besoin de toucher.* Sculpture is the need to touch. Even before it can see, the child waves its small, groping, swarming hands. There is an almost maternal joy in having the plastic earth in its hands, in modelling, in holding these round forms between its ten fingers . . . it's the first desire that appears." Claudel's sister Camille became a sculptress, and then fell, literally, into Rodin's hands. That was why Claudel could never forgive Rodin for the extraordinary power he derived from his elemental need to touch:

> Rodin was very nearsighted. He worked literally with his nose in the sculpture, his enormous boar's snout. His clay and his model; he had his nose in them. His sculpture was made for the touch rather than the eye. Hence the theme of the large creative hands that he employed so frequently. Hence the wrinkled, kneaded, beaten quality of his sculpture.

But the development of an artist depends on more than the sum of his gifts and idiosyncrasies. It also involves the child's recognition that art is a kind of strategy with which it can communicate with an audience—beginning with the exigent mother who can be made to laugh if one manipulates a little pastry dough. The rest depends on the reaction of relatives, teachers, friends; on the social matrix of techniques and traditions imposed by schools and apprenticeships.

In Rodin's childhood it was his sister Maria who tipped the balance in his favor by providing the moral support he needed to become an artist. His parents hardly knew what to make of the boy; she believed in him implicitly from the very beginning. She played the same role as that which Camille Claudel was to assume in the education of Paul Claudel—the older sister as stimulus, protectress and example. Frederick Lawton, the English biographer who talked to Rodin about his childhood half a century later, described her as the boy's tutelary genius: "Proud of her brother, anxious for his future, she strove to encourage and stimulate him by praise—if need be, by gentle reproof, and was always at his elbow to help."

Maria was lively and gifted: on Sundays when the Rodins and

Thérèse Cheffer and her sons went together to the Jardin des Plantes, it was Maria's banter with Jean-Baptiste that kept them all amused. On such occasions the *inspecteur*, "though not very clever, was original, well-tempered and gay," according to Judith Cladel, who heard the story from the Cheffers. Auguste was quieter and more thoughtful: while the others played games "he would stay close to his mother, whom her husband would sometimes tease for being peevish." Yet Jean-Baptiste got along well with his wife, and both were immensely proud of Maria, who "had the same gentle heart as her mother; she adored her parents."

>✠<

In 1848 the Panthéon quarter of Paris was one of those seized by the revolutionaries of the June uprising that inspired *Les Misérables*. The Panthéon itself served as headquarters for the insurgents, and barricades were thrown up along the full length of the rue Saint-Jacques and the rue Mouffetard. Rodin, who was seven and a half, heard the guns and caught glimpses of the fighting without knowing what it meant. After the change of government, and Jean-Baptiste's promotion, the new *inspecteur* was all the more anxious that Auguste receive an education befitting the son of a government official. Consequently, before his tenth birthday, he was packed off to Beauvais to attend the boarding school run by his uncle, Jean-Hippolyte-César Rodin.* Though Jean-Baptiste could barely afford the tuition fees, he was willing enough to pay them if a change of venue would improve the boy's educational prospects. Evidently there were reasons for his difficulties which no one had suspected. "I could not see the figures on the blackboard," Rodin remembered afterwards. "I have always been nearsighted. As a child I did not know what was the matter and I hated mathematics because I could not see."

Hippolyte's "institute," the Pension Rodin, was situated near the heart of medieval Beauvais, in a large, square house facing on three

*Other biographers, borrowing from Cladel, refer to this schoolmaster uncle as Alexandre Rodin, but he was another of Jean-Baptiste's brothers. Several records, including the *Liste nominative des habitants de Beauvais* for 1851, are quite unequivocal on this point: the school belonged to Hippolyte Rodin.

streets—the rue du Tournebroche, the rue de l'Ecole du Chant and the rue Saint-Nicolas. The great unfinished Cathedral of St. Pierre loomed over the rooftops less than 150 yards from the courtyard of the school. Hippolyte, who turned fifty in 1852, had achieved some local distinction as an intellectual, having served as the municipal librarian of Beauvais, and as teacher in the public boys' school before setting up a *pensionnat* of his own. He was a dedicated naturalist who served as secretary of the Beauvais horticultural society and wrote occasional books and pamphlets on such subjects as the flora of the Oise. "As head of a boys' school for twenty years and a passionate lover of botany," he declared, "I have always tried, in my teaching, to instill a taste for botany, my favorite science."

Auguste spent four years at the Pension Rodin and became an outstanding student in several subjects.* Yet what he remembered in later years were the petty brutalities of life in a boarding school, for which a shy, nearsighted redhead is a ready-made target. He told Bartlett that neither the school nor the curriculum had appealed to him, and that he had spent most of his time "drawing fanciful designs, telling stories and reciting imaginary descriptions to his comrades." What he liked best were the classes in French composition, in which Hippolyte would assign short themes on selected topics. Once Auguste was told to write on "The Miser." He had already decided that his uncle was a tightwad, and as Bartlett reports, "the *sou*-loving pedagogue was served up by his young relative with all the picturesqueness of which he was capable."

Hippolyte read the essay to the class without recognizing himself in it and "complimented its author upon the excellent manner in which he had acquitted himself"—much to the amusement of Auguste's fellow students, who had understood the joke all along.

Yet Rodin in later years often spoke well of this uncle who had, after all, attained a *certaine culture* and who had impressed him with his "love of the poets and the old French authors." Under his tutelage Rodin developed an undeniable gift for expressing himself in words;

*Botany was not among them, yet Hippolyte's efforts in this area were not entirely wasted. Long afterwards, in a conversation wih Rainer Maria Rilke concerning his studies of human anatomy, Rodin said, "I would rather have learned botany than anatomy"— since "the nature of plants" interested him more than that of people and animals.

for a time he even dreamed of becoming an orator. "During the class breaks he sneaks into the empty schoolroom, steps up to the lectern and delivers a speech to the empty rows of benches," Cladel reported. "He only feels ridiculous if someone comes in unexpectedly and interrupts his passionate oratory."

Ironically, it was not Auguste but his cousin Armand Rodin who won first prize for recitation at the Pension Rodin. On the other hand, Auguste won two consecutive first prizes in 1853 and 1854—for his work in French history and in *Cosmographie et Géographie*. Surprisingly, in view of his later disregard of the finer points of spelling, he also won a prize in orthography.

The years at Beauvais laid the foundations for his love of Gothic art and architecture. Long afterwards, in one of his sketchbooks, he wrote that "the child with its imagination catches a glimpse of marvelous things—it is that which the Gothic has accomplished, with its order and structure, in transmitting the magic of nature." From the windows of the school he himself had caught glimpses of one of the most daring and curious monuments of French architecture, a truncated cathedral that had remained unfinished because part of its roof collapsed in 1284, its 150-foot vaults having exceeded the limits imposed by Gothic technology. (No structure as tall as this was attempted again.) But the transept, choir and apse that remain are no less imposing for being *non finito*: the lesson one could learn from this fragmentary cathedral was that an unfinished work can have a grandeur and power of suggestion—"looking like a living giant"—greater than that of a finished work of art.

When Rodin returned to Beauvais as a grown man he wondered why there was not a crowd of people here on their knees, worshiping this Gothic miracle as "pilgrims of the beautiful." The cathedral's late-Gothic façade left him with a distinctly visceral impression. The writer Michel Georges-Michel ran into him one day when he was an old man, eating a dinner of bouillon and tripes à la mode de Caen in a very modest Saint-Germain restaurant. "These are the dishes of my childhood," Rodin explained, adjusting the napkin that was tied around his neck. And when the tripe was served he became quite lyrical. "Doesn't this remind you of stone, of cathedral stone? The cathedral of Beauvais, for instance? Few people know it. Still, it is the most sublime in France, in the world. . . . This tripe, with its

warm tones, its crinkles and crevices, makes me think of the cathedral of Beauvais!"*

><

In 1854 his parents could no longer afford to keep him in Beauvais, and Rodin returned to Paris. He had shaken off the lethargy of his primary-school years and had learned most of what Hippolyte wanted to teach him—except Latin, then a prerequisite to any academic or professional career. "The pupils studied Latin," Rodin recalled. "I don't know why, but I didn't like Latin, and I have often regretted it; perhaps my life would have been different. I was poor; perhaps I would have become a teacher."

As it was he came home without any clear idea of what to do next. Fourteen, he once told his secretary René Chéruy, "is the age when a poor boy begins to learn a trade":

I had no idea and they had none either. So I was left alone for a while. I loved to read and I spent a lot of my time at the public library near the Panthéon [the Bibliothèque Sainte-Geneviève]. One day I found a big book on the table. It was a book of engraved prints after the works of Michelangelo. They were like a revelation to me. The next day I asked for the book again. And soon I was overcome by a desire to model works like those I saw. I had found my calling!

According to Chéruy's version—quoting Rodin in his sixties—Jean-Baptiste offered no objection when Auguste broached his plans. "To him a sculptor was a sort of high-class stonemason. He learned

*The association of cathedrals with primary matters like food or (in *les Cathédrales*) with women like his mother is not as fortuitous or farfetched as it might seem. The English writer Adrian Stokes has shown that the cathedral, with its "ideographs of immense ramification," is a surrogate for the provident mother, and that its forms satisfy emotions originally aroused during the process of eating and being fed. Stokes first arrived at this insight in Italy (where Ruskin had been tempted to "eat up" St. Mark's cathedral), among the "cylinders of *maccheroni* and *spaghetti*, the pilasters of *tagliatelli*, the lucent golden drums of *gnocchi alla romana*. . . ." Rodin came to see this resemblance, in time, from his own viewpoint, or rather from his customary series of shifting perspectives: "A church from the outside is shaped like a woman on her knees."

that they received a good salary, and I began my studies. I went to the 'Petite Ecole de Dessin.'" But there are other variants of the story. According to another of his later secretaries, Anthony Ludovici, Rodin's father objected to the idea because, as he said, *"C'est des fainéants et des propres à rien"*—artists are idlers and good-for-nothings. At all events it was to learn drawing, rather than with the idea of studying sculpture, that Rodin entered art school. The Petite Ecole, where tuition was free, gave him a remarkably solid foundation of technique and tradition. It was, he later realized, "the germinating period of my life, where my own nature planted itself on firm ground without let or hindrance; where the seeds of my subsequent development were sown. . . ."

From now on he was irrevocably committed to the artist's way of life, "half academic, half Bohemian," that suited him so much better than the more respectable alternatives his father would have preferred. The Imperial School of Drawing and Mathematics in the rue de l'Ecole-de-Médecine was called the Petite Ecole to distinguish it from the "Grande" Ecole des Beaux-Arts, nearer the Seine, whose essential function was to turn out the "fine" artists whose works would dominate the official Salons. The Petite Ecole was a less ambitious establishment, a trade school founded in 1767, under Louis XV, for the express purpose of training artisans and craftsmen for the applied arts, including decorative sculptors and specialists in ornamentation.

Despite the class distinctions implicit in this division of labor, the Petite Ecole had long since exceeded its mandate by educating many of the finest painters and "fine-arts" sculptors of nineteenth-century France; among its notable students were Guillaume, Frémiet, Chapu, Dalou, Aubé, Legros, the Régameys, Fantin-Latour, Lhermitte and Carrier-Belleuse. The Grande Ecole, moreover, had begun to look on the Petite as a kind of training ground, and recruited many of its best students from among those who were still in mid-course in the smaller school, much to the faculty's annoyance.

During Rodin's student days the director of the Petite Ecole was Jean-Hilaire Belloc, a friend of Géricault and a painter of some distinction. (It was his grandson, the English writer Hilaire Belloc, who was to write *The Bad Child's Book of Beasts*.) Although classes were held only in the morning—from eight to twelve during the winter;

a half-hour earlier in the summer, six days a week—the curriculum covered a wide range of subjects, from geometry and mathematics to architectural design, sculpture, stonecutting, ornamental composition, animal and flower drawing, drawing from memory, modeling *d'après l'antique* and so on. There was one singular omission: since they were supposed to become artisans rather than "fine" artists, they drew plants *d'après la plante vivante* but not living people; human forms were drawn and modeled only from plaster casts. There was no life class; or rather it was not introduced into the curriculum until 1858.

"This school still retained something of the esprit that animated the eighteenth century," Rodin remembered in a brief memoir he wrote for the critic Gaston Schéfer, "and around 1855 its teachings were very different from those of the Ecole des Beaux-Arts, which ended by imposing its heavy style on all its students."

During his first year Rodin encountered Jean-Baptiste Carpeaux, then a twenty-seven-year-old instructor in the sculpture department, and destined to become the most elegant sculptor of the Second Empire. "When I saw him for the first time," he told Dujardin-Beaumetz, "they had given him the job of classroom supervisor. Yet— I don't know why, for we were too young to understand him—he attracted our instinctive admiration; it seemed that we could sense the great man in him, and even the most unruly among us had enormous respect for him. Perhaps he impressed us with some particularly enlightening comments and corrections; I don't know. Later, after having seen his work, I had eyes only for him."

Carpeaux, himself a former student at the Petite Ecole, had just won the coveted Prix de Rome at the Beaux-Arts, and he was off to Italy for his obligatory period of residence at the Villa Medici before he could exercise any significant influence on the young Rodin. Far more important, in terms of Rodin's development, was the influence of Horace Lecoq de Boisbaudran, professor of drawing and afterwards, briefly, Belloc's successor as director of the school. Born in 1802, he had been teaching at the Petite Ecole since 1841 (his salary as titular professor, 1,200 francs per year, was exactly the same as that of an *inspecteur sédentaire* of the police); in the afternoons he taught private classes on the quai des Grands-Augustins which were attended by such pupils as Fantin-Latour, Legros, Cazin and Tissot.

"Père Lecoq"—he lived to be ninety-five—was one of those remarkable teachers whose influence derives from their ideas rather than their own work. "He kept an atelier like those of the eighteenth century," Rodin recalled half a century later, paying him the highest compliment of which he was capable. "We did not fully appreciate at the time, Legros and I, and the other youngsters, what luck we had in falling in with such a teacher. Most of what he taught me is assuredly in me still."

Lecoq had devised an elaborate system of memory training that proceeded step by step from the most basic procedures—drawing a line from A to B—to the most complex exercises in observation. Students were taught to observe and retain an image in their mind's eye for hours and days before committing it to paper. In time they became so practiced in observation that they could reproduce entire paintings from memory. "Lecoq's methods of teaching were his own, and their effect may be seen in the work of all his pupils," Alphonse Legros noted. "He made us use our powers of observation to the utmost, by accustoming us to seize upon *the essential points of everything*. Often he sent us to Nature, but still more frequently to the Louvre, where we had to make drawings, which in turn had to be reproduced from memory at the school." Legros never forgot the proud moment when, after a visit to the Louvre where he had refrained from making any drawings, he sat down at his drawing board in the school and—with Lecoq looking on—proceeded to make an accurate copy of Holbein's *Erasmus*.

Rodin learned from Lecoq how to look at an object, fix its image in his mind and then draw it without further reference to the model. The result was something he retained all his life, "a rational manner of observing nature," as Julius Meier-Graefe called it. In his early years, as he told Bartlett, he would visit the Louvre and then go home and paint the pictures he had most admired. Twenty years later, on his first trip to Italy, he did the same thing with the Medici tomb figures: "After looking at these figures long and well, I returned to my room at the hotel and began making sketches to test the depth of my own capacity for composition and of the impression I had received."

At the Petite Ecole, his initiation into the art of drawing consisted of an exhaustive course of studies and exercises in which students

first learned to draw "from the flat," i.e., from drawings and engravings, and then "from the cast," using such traditional techniques as stomping and cross-hatching. During his first year in the school's rotunda drawing atelier he was put to work copying eighteenth-century prints and red-chalk drawings by Boucher, Bachelier (the school's founder) and Carle Van Loo; it was the professor of plant drawing, Amédée Faure, who was the first to notice and encourage the boy. Later he won a first prize with the back view of a man drawn in Lecoq's class—an *académie* in charcoal crayon.

Meanwhile, he had realized for the first time that there was something wrong with his vision. While learning to draw from plaster-cast ornaments, he "drew only the more prominent portions," as Bartlett learned, "and, thinking that there ought to be some details to full up the spaces, thus giving completer interest to the work, he put in such additional forms as he thought best." The instructor wondered if the boy were daydreaming and discovered that he was nearsighted, "a fact which no one had previously found out, though Auguste had often wondered why he did not see things as other boys did." From now on he was obliged to wear glasses, and the world must suddenly have looked very different—myopic people often complain that glasses are spoilsports and that everything looks far more beautiful when they cannot see the details.

Rodin's introduction to sculpture came later, though the drawing classes had prepared him for it: as Donatello put it, "Pupils, I give you the whole art of sculpture when I tell you to draw." For the fifteen-year-old Rodin, moving on to clay seemed like a homecoming. "After a year of studying drawing I see *l'antique* for the first time in a higher class," he wrote in one of his autobiographical sketches:

I am filled with admiration on seeing that one can draw from a distance without copying a drawing, admiration on realizing that there are young men who can make antique figures out of clay. I already know how to draw, and I am quick to understand what an older student tells me about the way to lend emphasis to a figure by means of contrapposto [*faire porter une figure sur ses oppositions*]! After a week I understand it, and the rest is only a question of development; of course I also work at it.

When he modeled his first sculptures, Lawton records, "the clay figures which his hands shaped gave him a pleasure he had not experienced in his drawing"—indeed, happiness is the fulfillment of a childhood wish. In his conversations with Dujardin-Beaumetz he remembered the excitement of that first tactile encounter with clay: "I thought I was in heaven. I made separate pieces; arms, heads, feet, then attacked the entire figure. I understood the ensemble at one blow; I modeled it with as much ease as I do today. I was in ecstasy."

Classes at the Petite Ecole were small; in sculpture they consisted of only six or seven students, and Rodin was grateful for the fact that the uncrowded classroom left him sufficient space to walk around the plaster model and observe it from all angles. Normally, each student works only from the side of the model that he sees from where he is. But even at that point, as he was to tell Arthur Symons, he already sensed intuitively what was to become one of his guiding principles— that a work of sculpture should be seen to advantage from all points of view (and not merely *de profil*, like an equestrian statue, or *de face*, like most full-length portraits).

"He had been drawing the model from different points of view, as the pivot turned, presenting now this and now that profile," Symons noted. "It occurred to him to apply this principle to the clay, in which, by a swift, almost simultaneous series of studies after nature, a single figure might be built up which would seem to be wholly alive, to move throughout its entire surface." In time he became accustomed to take "one profile after another, each separately and all together, turning his work in all directions," looking up at it and down onto it from above, until there was "no need of even a final point of view."

Rodin's passion for sculpture did not diminish his curiosity about other areas of art, particularly those which were not covered by the curriculum of the Petite Ecole. His genius for assembling bits and pieces, which was to become another of his hallmarks as a sculptor, also served him well in his search for a more comprehensive education. Mid-century Paris offered several free courses in art, and there were a number of institutions that enabled penniless students to improve their minds at public expense. Rodin took whatever suited

his needs and worked out a program that included part-time courses in literature and history at the Collège de France, visits to galleries and libraries, anatomy lectures at the Dupuytren medical museum, some private lessons, "night school" at the Gobelins tapestry factory and, finally, years of practical experience as an assistant in other sculptors' studios.

After attending the Petite Ecole in the mornings he would walk to the Louvre at noon, "lunching on rolls and a bar of chocolate as he went" to give him more time to make drawings from the classical sculptures on the ground floor. "In the Louvre of those days, like saints to a monk in his cloister, the Olympian gods told me everything a young man could usefully hear."

Rodin also wanted to study painting, a subject that was not taught at the Petite Ecole. "An old painter with whom I became acquainted taught me a little about painting," he told Chéruy. The painter in question, Pierre Lauset, had not yet turned sixty; he specialized in painting animals, and had exhibited at the Salon. "He thought I was a little overenthusiastic, for several times I rang his bell at five in the morning, before going to school."*

Napoleon III, who had made himself emperor in 1851, advertised the merits of his Second Empire with the Universal Exhibition of 1855, for which even Queen Victoria came to Paris. Like everyone else, Rodin was seized by the "general fever and excitement of the first Universal Exhibition," as Lawton reports: in the Arts section he saw Delacroix's *Médée furieuse*, which afterwards inspired him to make an attempt at a three-dimensional version.

The year after the exhibition Rodin began to pay regular visits to the print room of the Bibliothèque Nationale, where he made copies of prints and book illustrations. (Users of the print room, as distinct from readers of books, had to obtain a card of admission from the *conservateur*, and the record shows that Rodin received his in 1856.†)

*He told Gustave Coquiot, however, that he had studied with Lauset "in the morning hours before going to earn my bread at an ornamental sculptor's"—i.e., after leaving the Petite Ecole.

†Rodin, who celebrated his sixteenth birthday in November 1856, was one of the youngest ever to be admitted. Delacroix had begun using the print room at eighteen, Géricault at nineteen, Doré at seventeen, Degas at nineteen; Renoir was to obtain permission at twenty and Manet at twenty-seven. Only two of Lecoq's pupils were younger when they

The Cabinet des Estampes was usually crowded with young artists making sketches from prints of well-known paintings. For Rodin it was a window on the world beyond the Louvre, notably the works of Raphael and Michelangelo, and a place to read illustrated books such as Bernard de Montfaucon's classic, *les Monuments de la monarchie françoise.* Apparently the librarians were reluctant to issue him some of these rare books because he was shabbily dressed and looked insignificant. Sometimes he had to leave "without having received what he asked for"—an experience not unknown to present-day users of the Bibliothèque—having had to content himself with other people's leftovers: "I looked at the books left on the tables by more highly regarded visitors; because I was so eager to learn, every bit helped."

Copying from prints and illustrated books, he would make quick sketches, "producing more than a dozen drawings at a single sitting," and then devote his evenings to copying them out with care, adding remembered details. So much time went into these studies that he became accustomed to "working even at table, even while eating," as Cladel noted, "without worrying about the gastritis that was soon to torment him."

Paris was full of stimulating locations for an art student with a perceptive eye. "For a long time I frequented the horse market," Rodin wrote in one of his brief memoirs; "I am a great admirer of horses." The horse market was held in what is now the boulevard Saint-Marcel, and there "I drew everything I saw. How I was pushed and stepped on!" Most of the surviving drawings of his boyhood, however, are of human figures: thumbnail sketches of pictures in the Louvre, such as Andrea del Sarto's *la Charité* (one of Delacroix's sources for the *Médée furieuse*), some very bold, swift pen-and-ink studies of classical and baroque subjects; drawings of embracing lovers—the first tentative statements of what was to become a dominant theme—and conventional male nudes in studio poses, the so-called *académies.*

Only a few of these early drawings reveal something of his own

first obtained the privilege—Fantin-Latour was thirteen and Jules Dalou twelve. Curiously, Rodin's first permit to copy a picture in the Louvre was not issued until September 2, 1862: presumably his earlier Louvre copies were done from memory and did not entail setting up an easel in the galleries, for which a permit was required.

life at the time. The Musée Rodin owns his rough sketch of a fellow *rapin* (art student) with a drawing board on his lap; evidently it was made during a class. And there is a much more studied pencil self-portrait (now lost) of Rodin when he was about eighteen—a slender, almost Chopinesque figure without a beard, in a soft shirt and knotted scarf. At the time he was "sickly and very pale, with a poor boy's pallor," as he later recalled. As yet this frail, blue-eyed boy showed no sign of what he was to become; a short, powerfully built man with a massive head and huge hands. His self-portrait also failed to show his big feet, which were preternaturally large. Once, in later years, when he was invited to visit a coal mine, it was discovered that not even the largest pair of miner's boots would fit him, and he had to make the descent in his street shoes.

To his infinite regret most of the sketchbooks which he filled with his early drawings were later lost. Gsell reports that he mourned their loss as though they had been boyhood friends: "My fine albums, how much I would like to leaf through them today!" They contained the evidence of his increasing mastery, and of his insatiable curiosity in matters of art. He wanted a book on the anatomy of the horse and, being too poor to buy one, he copied it piece by piece. Altogether it was a thoroughly practical and far-ranging education, though he realized that there were limits to what he could learn from his haphazard collection of free courses and chance encounters in galleries and libraries. The taste of the epoch was stiff and neoclassical, and although his instincts were closer to Delacroix's romantic passion, "for a long time I was banal and cold," as he told a friend thirty years later. "Though I did not receive a conventional education at school, it still got through to my mind via my eyes."

The conventions by which he felt seduced and oppressed were those of the Beaux-Arts ideal of beauty, which students were taught to apply to every work of art as a kind of fixed, insipid smile. It had begun as a neo-Grecian aesthetic and ended by masking the realities of life as it was actually lived during the modern industrial revolution, helping to turn the nineteenth century into the age of the euphemism par excellence.

Artistic tendencies that ran counter to the Beaux-Arts ideal were dimly perceived as a threat to the social order. The unruly Carpeaux, having produced a Neapolitan fisher boy as his *envoi* from Rome, was

told that he must "try to elevate his style by working on noble sub-jects." Monet, studying with the Salon painter Charles Gleyre, tried to paint the model as he saw him and was instantly corrected: "You've a dumpy little man there, and that's how you've gone and painted him! . . . It's very ugly, that sort of thing. Remember . . . when you do a figure study, always have the antique in mind."

Yet the antiques they used as models were those that conformed most closely to the Beaux-Arts ideal rather than those that might have led students to question it. "When I was a student," Rodin later told his disciple Bourdelle, "they gave us such bad antiques to study, though there are such beautiful works. Oh, the absence of real maîtres, what a curse!" He was sure that, had he been able to see and study some of the really important Greek sculptures, "I would be a different sculptor!" Only gradually, during the next decade, did he develop his own sure instinct and judgment about what was important in this art. Set apart from the others, he learned to distinguish his own feelings from received opinion. "Where did I learn to understand sculpture? In the woods by looking at the trees, along roads by observing the formation of clouds, in the studio by studying the model; everywhere except in schools."

2

THE BUST IN THE ATTIC

He was himself, and himself alone.

—RODIN on Barye

I f Rodin was essentially self-taught it was not for lack of alternatives: the choice was largely of his own making. When he was about fifteen he was given a chance to study with the man he later recognized as the greatest sculptor of his time, Antoine-Louis Barye, but he was too young to grasp Barye's significance and to avail himself of the opportunity. "Imagine," he said ruefully to the Dutch critic Willem Byvanck in 1891. "When I was a young boy, no higher than *that*, I worked in the atelier of Barye; I could have become his pupil, but I left him, because the man didn't impress me very much [*ne me semblait pas grand'chose*]. He was so unpretentious in his speech and manner; he never thought about fame; he was always searching, searching; I thought I could never learn anything from him." And in Rodin's conversations with the Belgian writer Gustave Fuss-Amoré he remembered:

At that time the eminent animal sculptor was a small, elderly man, always very badly dressed and unkempt, and my fellow students had acquired the bad habit of making fun of him for this. I was too stupid to understand Barye's genius, and to be

influenced by it. Only much later did I accord him the place
he occupies among our great sculptors.

The lessons with Barye took place about 1855. Emile Cheffer,
who also attended the Petite Ecole and who was to become a com-
mercial designer, had made friends with Barye's sons and often played
with them in a deserted monastery near their home in the rue de
Pontoise. Rodin was too "serious and even retiring" to take part in
these games, but he became acquainted with Barye's oldest son, and
joined him and several other boys in attending a course in animal
anatomy given by Barye at the Jardin des Plantes, where the sculptor
had been appointed professor of zoological drawing and sculpture in
1854.

The job had been created to keep Barye from starving; he had
accepted it with distaste. But at least he had been assigned to the
right place: here, in the zoo attached to the gardens, he was able to
make regular and detailed observations of the wild animals he mod-
eled with greater verve and skill than any other sculptor of modern
times. He worked from life at the cages and dissected the cadavers
of animals that had died, measuring their bones and calculating
anatomical relationships. Like Rodin in later years he taught his
students that nature is the great teacher: "To observe nature and align
oneself with it; what more could one teach?"

When Rodin entered Barye's class, he and his young friends felt
uncomfortable in the bourgeois environment of the museum. "We
were ill at ease among amateurs and women, and were intimidated,
I think, by the waxed parquet floors of the library where the class
was held." They found a more congenial place in which to work, "a
sort of cellar whose walls oozed dampness, and there we installed
ourselves delightedly."

A post stuck in the ground held up a board that served us as
a stand; it didn't turn, but we turned around our stands and
around our work.

They were kind enough to put up with us, and to let us take
pieces of animals from the museum; lion's paws, etc. We worked
like furies there; we were like wild beasts.

The great Barye came to see us.

[27]

He looked at what we had done and went away again, most of the time without saying anything, yet even so it was from him that I learned the most. Perhaps we were not strong enough to interest him. . . . In any case we were too young to understand him.

He was a very simple man. His shabby suit gave him the seedy air of a poor tutor. . . . I have never known so sad a man, with so much power. . . . This poor, great man inspired in us unfeeling urchins [*gamins*] a sense of defiance mingled with fear.

There were few things that Rodin regretted later in life; this missed opportunity was one of them. Bourdelle often heard him speak of it; in time Rodin had come to understand "the disdain, the solitude with which the great Barye was surrounded; the wounded pride of this misunderstood master, his silences," which had misled and discouraged Barye's young students. They had drifted away, one by one. "Rodin ended by leaving him, too, as all his comrades had done."

Barye, at the time, was described by his admirers as "the pleasantest, most kindly, most courteous of men," but also as stubborn and melancholy: "Barye observes you and waits, listens to you with singular patience and penetrates your character without fail." Rodin worked under his supervision "in the afternoon, for nearly a year," as Lawton reports about these sessions in the cellar:

Here, after the lecture, he and his fellow-students did their modelling at their ease; but first they had, like Mahomet going to the mountain, to visit the animals in the cages. When once sketch-book and memory were sufficiently garnished, they repaired to their blocks and endeavoured to transfer their designs to the clay; sometimes they did the same with the skeletons in the museum, fashioning the anatomical structure of the model, and then filling in the solid parts of the body.

No one, at the time, had any conception of Barye's importance to sculpture. Besides teaching animal anatomy he kept a dingy and unprofitable shop on the quai des Célestins where he sold bronze

conversation pieces and animal art of his own manufacture: anything from a small rabbit or turtle for two or three francs to a hippogriff for 700. Born in 1796, Barye had been apprenticed to a metal engraver at thirteen, had been conscripted into Napoléon's topographic service and had attended the Ecole des Beaux-Arts before going to work for a goldsmith. Then the zoo at the Jardin des Plantes had suggested his true vocation: he began modeling the astonishing wild animals that are the very antithesis of the bland, tame sculptures of the official Salon. In 1866 the critic Henri Rochefort wrote that Barye had "put more life and truth into the legs of a goat or the head of a lion than had the whole of the Institute with all its sculptures put together."

Rodin did not become consciously aware of Barye's stature until twenty years after he had attended his classes. One day, "in a shop window, I noticed two greyhounds in bronze," he told Byvanck. "They ran. They were here, they were there; not for an instant did they remain in one spot. I saw them running: they were signed Barye. An idea came to me suddenly and enlightened me; this is art, this is the revelation of the great mystery; how to express movement in something that is at rest. Ancient sculpture knew the secret; we can only stammer. But Barye had found the secret; he is the great man of our century."

Bartlett, too, heard from Rodin that although he had received little actual instruction from Barye, "he felt later on the result of what he had instinctively acquired." In the 1880s Rodin vented his feelings about Barye in a long, glowing eulogy of which Bartlett made a verbatim transcript that has been preserved among his papers at the Library of Congress:

> He clung to nature like a god, and he thus dominated everything. He was beyond all and outside of all art influences, save nature and the antique. He was one of, if not the most, isolated artists that ever lived. Emphatically original, and the first in the world in that kind of originality. He was himself, and himself alone. I think of him and the Assyrians together, but I don't know whether he knew anything about them, because everything he did was Barye. They don't like him in France, he is too strong. He is so great that his contemporaries can't stand him.

In later life Rodin never spoke about Barye except with feelings of remorse. Yet at the same time he understood that this missed opportunity had been part of the price he had paid for his fiercely defended independence. "Apart from this childhood fault against Barye," he told Bourdelle, "apart from this grievous error of my youth, I did well to escape all teaching—I mean of the official sort."

His course at the Petite Ecole came to an end in 1857. Even before then Rodin had to begin thinking about earning a living. In 1855, according to the archives of the Paris police, Jean-Baptiste had retired after twenty-seven years of service, seven of them in the Cinquième Bureau. His eyesight was failing, and his pension of 600 francs was barely enough to support the family. When Rodin announced his intention of becoming a sculptor, Jean-Baptiste tried to dissuade him, and Marie Rodin, too, expressed misgivings. For one thing, it was a disturbingly messy métier. "When are you going to take away all those lumps of plaster?" she asked her son, who had been cluttering up the house with pieces brought home from school. "You're filling up the corners; they're even under the bed."

More worrisome for people in their circumstances was the fact that further schooling would cost money. Her words, and his, as recorded by Bartlett, have an unmistakable ring of authenticity: "If you wish to be an artist, you must have not only money to pay your teachers through a long course of study, but to help along afterwards, for art, my son, rarely brings generous returns to its followers."

"I don't want any professors. I can work through it alone."

Since Jean-Baptiste wanted to be assured that his son was not wasting his time, they arranged for an interview with Hippolyte Maindron, a neoclassic sculptor whose works had been winning Salon medals for twenty years. Maindron looked at Rodin's drawings and expressed enthusiastic approval.* Rodin always remained grateful for these timely words of encouragement, which reassured his parents and allowed him to entertain hopes of moving from the Petite Ecole

*One wonders whether he added some words of caution concerning the hardships of the sculptor's métier. Delacroix, after a visit to Maindron in 1847, noted that the sculptor's garden "is populated by unfortunate statues which the unhappy artist doesn't know what to do with. The atelier is cold and damp." Rodin remained loyal to Maindron's memory: thirty years after the interview he attended the wedding of Maindron's son Maurice and the eldest daughter of the poet José María de Heredia.

to the Beaux-Arts. Yet he had already turned his back on the stylized neoclassicism of Maindron's generation—"the sculpture of Louis Philippe's epoch; the quintessence of ugliness," as he later referred to it.

The entrance examinations for the Grande Ecole were highly competitive since there were many more applicants than places and a Beaux-Arts education was virtually a prerequisite for a Salon career. The examination took six consecutive days. Candidates in painting and sculpture came for two hours each day and painted, or modeled in clay, from the male model posing in the center of the atelier. The painters set up their easels in a semicircle at the front while the sculptors worked at their stands behind them. Each candidate thus had twelve hours in which to produce a trial piece by which he would be judged.

Rodin, who competed for the first time at seventeen, failed to gain admission—not once but three times within eighteen months. The humiliation of these rebuffs was scarcely lessened by the fact that the examiners acknowledged his gift for drawing but rejected his sculptures. Afterwards he remembered these trial pieces as "well constructed, perhaps a little dry, but the bones were there." While he was working on them, in fact, the other candidates crowded around to watch him, "envying him the touch that his fingers imprinted," as Lawton says. Perhaps, after all, the time spent at these examinations was not entirely wasted: for the first time in his life he realized that "his drawing and modeling were different from that of other pupils," as Bartlett learned, "and they watched him and his work with much curiosity and attention."

His failure to gain admission was largely a matter of academic politics. Candidates who came armed with recommendations from influential teachers were not so easily turned away. That was the reason why Rodin once told the writer Jean-Bernard that he had been excluded from the Beaux-Arts for having refused to choose a maître.

Eventually he was to see this rejection as a blessing in disguise. "I was refused by the Ecole des Beaux-Arts," he writes in one of his self-sketches. "Great good luck." The sculptor Jules Dalou, who had succeeded in gaining admission but dropped out after repeatedly failing to win the Prix de Rome, told him that he was fortunate to have escaped indoctrination—"It would have killed you." Dalou blamed the Beaux-Arts for every kind of stylistic sin. "Whenever I do anything

in my statuary that is bad, I attribute it to what I learned there."

In any case there was no time to brood over his failure, since he had already gone to work turning out ornamental masonry at five francs a day. "Studies interrupted by life's struggles," he remembered in his curriculum vitae. "Work every day . . . combined, in free time, with continued studies. Hard work of the sort that poor young people know." Later in his career he often made it seem as though these deprivations were somehow due to his unwillingness to compromise with the prevailing taste. Yet even if he had succeeded in attending the Beaux-Arts and carrying off one of its prizes he would hardly have been better off financially. Sculpture, on the whole, was (and is) an unprofitable and often heartbreaking occupation.

Young sculptors, even those who had won major academic prizes, were known to take any sort of menial job just to stay alive. Barye had begun his career with a *médailleur* who had put him to work designing uniform badges and buttons; Carpeaux modeled bibelots and chimney pieces before being taken up by the fashionable world; Chapu sculptured in lard for a pork butcher when he found himself insolvent after returning from his Rome-prize years in Italy. Frémiet, who began as an apprentice lithographer earning five francs a month, became a makeup man of cadavers for the embalmer, Dr. Suquet.

It was not particularly unusual, then, for Rodin to support himself by going to work as an *ornemaniste* for a master mason named Blanche. For the next six years he was employed by a succession of ornament makers, mixing plaster, preparing casts, cutting the mold marks from castings and so on.

Twentieth-century functionalism has put the ornemanistes out of business; they were essential to the nineteenth century, which abhorred plain surfaces without *adjonctions*. Fortunately this rage for decoration—floral and animal, Grecian and neo-Gothic—provided work for otherwise unemployable sculptors. It was the one practical point of contact, other than the Salon, between contemporary sculpture and the emerging bourgeois society of Paris. Wages in the industry were higher than the norm: Rodin's five francs a day was two francs more than the going rate for an ordinary mason. When Zola, in 1859, wrote to Cézanne, in Aix-en-Provence, suggesting he come to Paris, he drew up a budget that included lunch for eighteen *sous* and dinner for twenty-two—a total of two francs per day for food—plus twenty

francs a month for rent and twenty-five more for laundry, light, tobacco and incidentals: altogether it came to less than what Rodin was earning at the time.

Life in an ornemaniste's studio was less arduous than in a shoe factory or textile mill, yet as Rodin told Bartlett, he "hated his work and his employers, and they returned his sentiments by hating him and finding fault with everything that he did." Later he looked back on this apprenticeship with mixed feelings, regretting its hardships while recognizing that it had given him his astonishing facility in clay and plaster.

For years Rodin had to lead a double life, working as a craftsman by day and as an artist by night and on Sundays. He would get up early in the morning in order to have time to do some drawing or modeling before beginning the day's work at eight o'clock; at noon he would gulp down his lunch in order to save half an hour for drawing and at dusk he began studies that often lasted into the small hours. "I was always wild about working," he remembered. And although he was not very strong physically, "an intense nervous excitement drove me to work without respite. I never took up smoking—I think because I wanted to avoid being distracted for so much as a minute."

For a time he combined working as an ornamental sculptor with attending the free drawing class at the Manufacture des Gobelins, the government-owned tapestry factory on the banks of the Bièvre (a small tributary of the Seine that has since disappeared beneath the sidewalks). It was within easy walking distance of the rue des Fossés-Saint-Jacques, where the Rodins were then living on the third floor of an old house whose windows overlooked a convent of repentant *filles*. Classes in art, tapestry weaving, dyeing, etc. were regularly given at the Gobelins for employees and their children but were also open to outsiders. The class that Rodin attended from 5:00 to 8:00 P.M., six days a week, consisted of drawing, *étude de l'antique* and a life class for about sixty pupils, held in what had been the dining room of the painter Charles Lebrun, director of the Gobelins under Louis XIV. It was here that Rodin had his first opportunity to work regularly from the nude model instead of a plaster cast of the human figure; indeed he considered it a special advantage that the model regularly held his pose for three whole hours.

The course was given by Abel Lucas, a painter and *artiste-tapissier*

who had held the professorship at the Gobelins since 1848; as Rodin gratefully recalled, he "taught without preconceived notions, a thing very rare at that time." Once again he had stumbled on an institution where, as he put it, "they had remained faithful to the traditions of the eighteenth century; the drawings were closely related to the *ronde bosse* technique [of sculpture in the round]." In later years he liked to say, "I'm a pupil of the eighteenth century."

>‡<

Now for the first time he also had a friend of comparable talent with whom he could exchange ideas on art, the sculptor Jules Dalou. They met while both were working as assistants to the ornemaniste Auguste Roubaud. Dalou was two years older than Rodin; he too disliked the official style of sculpture and he was no less poor, ambitious and hard-working. At the Beaux-Arts, fellow students had said of him, "Dalou dines on ten centimes' worth of cheese and a page of Plutarch."

"My first friend was Dalou," Rodin later told Gustave Coquiot. "He was a fine artist in the great tradition of the eighteenth-century masters, a born decorator. We met when we were very young in the studio of an ornemaniste who often forgot to pay us, so that we were obliged to separate, Dalou and I; he to go to work for a taxidermist and I for another *patron* who paid more punctually than the first."

In Dalou he had recognized a virtuoso very like himself, and both were to become renowned for the speed with which they worked in clay. Years later Rodin could still boast of having *une main d'une prodigieuse vitesse*—prodigiously fast hands, "like Dalou and Carrier-Belleuse." As a studio assistant he was, in fact, obliged to work more quickly than he liked, and on every conceivable kind of sculpture. Sometimes he had to pay attention to meaningless details that went "against the grain and *à contre-sens*," yet there was always something to be learned from even the most commonplace ornament: "It produces alert hands."

The chance encounters in this apprenticeship taught him more than he could have learned at the Beaux-Arts. His work for the church-art firm of Biais, for example—"I made the human figures interspersed among the ornaments"—gave him his first inkling of the real as opposed to the neo-Gothic. "Before I was twenty my eyes had

been opened while I was working for a sculptor named Biais, who had a good deal to do with the 'restoring' of Notre-Dame. It was to him that Viollet-le-Duc [who supervised the restoration] once said, 'Forget all you know and you will execute something Gothic!' "

Unfortunately Biais seemed unable to learn anything, in turn, from Rodin. The young sculptor never pleased Biais, as Bartlett records, since the *patron* "could not see anything in his workman but a willful maker of strange ornaments he could not use." Rodin's fellow workmen were more perceptive. They admired the drawings he was always making on the side, especially on cold winter mornings when he would draw fantastic figures on the frosty window panes—"images that excited their wildest astonishment, and extended his reputation with them, as a being they could not understand."

One of the ateliers in which he worked opened onto a neglected garden where he found models both for floral ornaments and for his own studies of flowers and shrubs. "He drew them without pause," reports Paul Gsell. "He filled books with them." One day as he was modeling a capital ornamented with foliage one of his fellow workers, an older sculptor named Constant Simon, gave him some words of advice which he took so much to heart that he could still quote them verbatim thirty years later: "Rodin, you're doing it the wrong way. All your leaves look flat; that's why they don't seem real. Turn up the edges so that their tips point toward you, and so that in looking at them one has the sensation of depth."

Rodin followed his instructions and was surprised at how lifelike the leaves looked. Simon was only one of the countless *plâtriers* from the provinces who earned an anonymous living as an *ornemaniste*, yet he had learned from experience the difference between bas-relief and sculpture that had escaped so many better-known artists: "Remember well what I am going to tell you," he said to Rodin. "From now on when you carve, never see the form in length but always in thickness. Never consider a surface as anything but the extremity of a volume; as the point, more or less large, which it directs toward you. That way you will acquire the *science of modeling*."

Later it seemed to Rodin that Simon's explanation had altered his whole way of looking at sculpture: "For me this principle proved astoundingly fruitful. I applied it to the human figure. Instead of envisaging the different parts of the body as more or less flat surfaces,

I perceived them as projections of interior volumes. In each swelling of the torso or the limbs I attempted to suggest the outward thrust of a muscle or a bone that lay deep beneath the skin."

He also received advice and encouragement from Jules Klagmann, a sculptor whose work had figured prominently in the Universal Exhibition and whose *Sainte Clotilde* stood in the Luxembourg Gardens. Yet the commercial sculptors who hired Rodin seemed determined not to recognize his gifts. He encountered the same lack of comprehension when he went to work for the brothers Auguste and Joseph Fannière, who were among the leading gold- and silversmiths of the Second Empire. Although Rodin supplied them with wax models of earrings and buckles "made with all the skill and exactness that he was able to put upon them," as Bartlett heard, they failed to please the Beaux-Arts taste of the Fannières. Still, Rodin recalled having created brooches and tiepins that others admired—"one of the designs was bought by an archduke."

At last he did find an appreciative employer, Michel-Victor Cruchet, who had an atelier in Montmartre that supplied the imperial household with carved woodwork, marble mantelpieces and *carton-pierre* ceiling ornamentation. Cruchet liked Rodin's work and treated him as a friend, whereupon the grateful young sculptor did a terra cotta bust of the young, attractive Madame Cruchet—a portrait in which he lavished his trompe-l'oeil skills on such details as the ruffled lace collar of her dress.

It was a very different matter when he did the portrait of his own father. *Jean-Baptiste Rodin* is as austere as the busts of the Roman emperors in the Louvre; they were his point of departure, at any rate, for this quasi-antique portrait of a man whose features so closely resembled his own—the long nose and receding forehead, intense gaze and stubborn chin. As Rodin recalled, "Papa was not happy because I refused to do his mutton-chop beard, which he wore like a magistrate. He could not see that, in treating the bust as an antique, I was bound to leave it out."*

*When a son elevates a father to the status of a stone emperor, it is not only the ancient Romans who gaze over his shoulder but also the Greek parricide Oedipus Rex. To deprive a man of his beard (or even to pluck a symbolic hair from the sleeping giant's beard) is, in the oldest fairy tales, a metaphor for depriving him of his manhood. The

Several other portraits accumulated in the Rodin household during the early 1860s. Auguste himself painted portraits in oils of both parents: a somber image of his father, this time as he looked to the rest of the world, in the patriarchal fullness of his beard, and a very frank, informal painting of his mother—"with her tormented face, a little demented," as Judith Cladel noted. He had painted her with an elaborate bow at the neck, and she protested at this suggestion of an expensive dress: "Leave me in my everyday dress, your poor bonne femme of a mother!" "But Maman," came the answer, "you are the most beautiful of all women; I see your soul!"

There was also an unsmiling portrait of Maria Rodin by Auguste's friend Arthur Barnouvin, a fellow student at the Petite Ecole who was romantically interested in the girl and painted portraits of both brother and sister. He must have noticed the striking resemblance between them, for both were obviously children of Jean-Baptiste, with the same long nose, wide mouth and prominent chin. While painting Maria's picture Barnouvin may have decided that she was insufficiently pretty, or at any rate too troubled and intense for his liking— these qualities seem to dominate the portrait. She, on the other hand, had fallen in love with him, and when he married someone else shortly afterward she was deeply hurt.*

In such cases it was not unusual for the jilted woman to take the veil. Evidently it was Madame Rodin, "always inclined toward re-

dutiful son whose first important sculpture is a portrait of his father may combine filial duty with an ingenious way of working off his Oedipal resentments by removing the beard of authority (and sexual dominance) from the paternal chin. Indeed, it would be surprising if the inspector had not felt vaguely threatened by this omission which had shorn him of his secret pride.

*In later years, far from bearing him a grudge, Rodin tried to help his erstwhile friend, whose full name was Jean-Baptiste-Pierre-Arthur Barnouvin. A pupil of Lecoq de Boisbaudran and Hippolyte Flandrin, Barnouvin specialized in copies of well-known paintings: at the Salons of 1869 and 1870 he exhibited watercolors based on Delacroix, Cabanel and Baudry. As Rodin told Lawton at the turn of the century, Barnouvin "possessed great poetic insight, but without the power to become an original painter. He made copies of great pictures which were almost if not quite equal to the pictures themselves. I lost sight of him for a long time, then met him somewhat down at the heels, gave him a lift up, and again heard no more of him for years, myself preoccupied by the hard exigencies of life. More recently I came across him once more; he was worn out, a wreck, all marks of his former self lost. I did what I could, but from what I found out subsequently, I fear the aid was useless. He had sunk too low."

ligious things," who persuaded her daughter to enter a convent. Maria was to serve a two-year novitiate as Sister Saint-Euthyme, but after five or six months she fell ill and came home to die, of peritonitis. Her death certificate states that she died at three o'clock on the morning of December 9, 1862, aged twenty-four, in the home of her parents at No. 91, rue de la Tombe-Issoire; in making his declaration to the police Jean-Baptiste was accompanied by his brother-in-law Stanislas Coltat, a jeweler who lived in the rue d'Enfer.

His sister's death plunged Rodin into the first great crisis of his life. She had meant everything to him: in 1860, when she and Maman had gone to visit Tante Annette Hildiger, he had asked her to "write me every day, if possible, in many lines close together; a distant sister is doubly loved." It was clear from everything he wrote to her, and later said about her, that he was indeed Maria's well-loved brother, *ton frère bien aimé*. Judith Cladel heard that "Auguste's grief was so profound that one feared for his reason." Lawton, too, reports that Rodin felt her loss "to the extent, indeed, of his mind being almost unhinged." A priest who had befriended Madame Rodin tried to help him, but Auguste seemed inconsolable. Then, at the priest's urging, he entered a religious institution that had just been established in the rue du Faubourg Saint-Jacques, the Congrégation du Très-Saint-Sacrement, whose founder and director was Father Pierre-Julien Eymard, a remarkable priest who was to be canonized in 1962.

A hundred years earlier, at Christmas 1862, Rodin's parents witnessed their son, now "Frère Augustin" and wearing a surplice, assisting Father Eymard at mass in the community's chapel. But the Society of the Blessed Sacrament was far from a conventional religious retreat; it had been created in direct response to the poverty and ignorance of working-class Paris. Though trained in the Oblates of Mary, Father Eymard had founded a new order especially to honor the Eucharist, but it was not until May 1863, just as Rodin left the community, that it received the official approval of Pope Pius IX.

Father Eymard's guiding principle was that "to save society we must revive the spirit of sacrifice," and to this end he preached a highly personal doctrine of suffering and self-abnegation. "You have not been admitted into this society to become good and virtuous men, nor even to increase the amount of your merits, or to obtain greater glory in heaven," he told his novices. "You are here solely to immolate

yourselves, body and soul, to the service of your Eucharistic King."
He spoke to them about social injustice, that the world "seeks for
nothing but its own interests and doesn't care a farthing for you.
Provided you do your day's work, that's all it cares about." His
remedy, however, was acquiescence rather than revolt: "It is my duty
to be gentle and meek." He tried to follow this precept in running
the community. "Let others be fathers," he told his novices. "As for
me, I only aspire to be your mother."

Father Eymard had brought together several gifted young men to
enlist their talents in the service of the Church, and Rodin was to
join them. There was a shed in the community's garden which was
set aside for his work in clay so that, as Lawton relates, he could
combine "secular and theological studies." Father Eymard agreed to
sit for his portrait. Rodin remembered that the priest fascinated him
because "his head and face gave no indication of its owner's age"—
he was fifty-two—and that it had "a character that the sculptor liked
to study." The first photograph of Rodin together with one of his
sculptures shows him at work on the bust—a work that manages to
suggest the sitter's Savonarola-like intensity.

But Father Eymard was the first in the long line of Rodin's sitters
who disliked what the sculptor made of their faces. Bartlett reports
that the priest "took the sudden fancy that the masses on the sides
and top of his bust suggested the 'horns of the devil,' and he would
not accept it unless these troublesome reminders were reduced to a
more human appearance. This the inflexible young sculptor would
not do."

Rodin had cause to remember that Father Eymard had "summed
up the experiences of his life and observation in the expression,
which he enjoyed repeating, that 'life was an organized lie' "—yet
now, ironically, the priest was asking him to produce a dishonest
image. It was impossible for him to acquiesce. The upshot of their
disagreement was that Father Eymard refused to pay for the bust or
for the reduced-size duplicates that had already been made of it, at
Rodin's expense. "So much did Rodin need the money at this time,"
Bartlett noted, "that the amount he had paid for reducing and du-
plicating this bust was a matter of serious importance to him, and
caused him considerable subsequent privation."

Father Eymard was so displeased with the bust that when Rodin

later gave a copy to the women's branch of the Society, in Angers, the priest "told the nuns to keep this work, which he found abominable, stored well out of sight"—a task that was done so thoroughly that people forgot it was there until 1925. At that point, according to Father Ullens of the Society, "having got wind of the matter, I had the Servantes du Saint-Sacrement conduct a search which resulted in the rediscovery in an attic after more than half a century of the poor bust blacklisted by Father Eymard."

Aside from this contretemps, Rodin's membership in Father Eymard's community had certainly served its original purpose. During his stay "the poignancy of his grief abated," as Lawton relates. "Sooner, perhaps, than if he had not changed his course of living, he recovered his equanimity, and with it the consciousness that he had no vocation for the ecclesiastical estate." This realization came when, after several months as a probationer, he was invited to pronounce the definite vows: Rodin "refused, withdrew from the institution and returned to his former trade."

At least these months of training and therapy had restored his will to live, and he was now more determined than ever to follow his own inclinations. But the experience had left him with decidedly ambiguous feelings toward the Church. In later years Rodin sometimes expressed a vague nostalgia for the monastic life: "I wish I could live in such peace." By then, however, he had become a confirmed pantheist. "If you mean by religious the man who follows certain practices, who bows before certain dogmas, evidently I am not religious." He had also become intensely suspicious of the Church and its motives: the grudge he bore Father Eymard may well have been the reason for the anticlericalism of his later years. "When a religion falls it is the priests who brought it down," he jotted into one of his notebooks. Ambroise Vollard recalled asking him in 1915 whether he had made any arrangements for a place in which to be buried. Rodin's answer was blunt and to the point: "I've always been a simple man. I just want a hole in my garden . . . and above everything [here he made a gesture with his hand as though he were cutting off somebody's head] no priests! Otherwise I wouldn't be a true heir of the French Revolution, a child of the twentieth century . . . I am not afraid of the devil: *Je n'ai pas peur du Diable, moi!*"

3

A HIGHER CLASS OF EMPLOYER

*He has worked for me for ten years, and I
have not been able to print myself upon him!*

—CARRIER-BELLEUSE on Rodin

odin did not rejoin his parents when he left Father Ey-
mard's community; instead he moved into his first studio,
in a stable at the juncture of the rue de la Reine Blanche
and the rue Lebrun—"I shall never forget it. I had some
hard times there." The rent was only ten francs a month, but it was
hardly worth more: "The air filtered in everywhere, through badly
fitted windows and a warped door, and since the slates on the roof
were worn or had shifted in the wind, there was a constant draft. It
was ice cold; a well had been dug in one corner and the water stood
almost at the curb, so that it was penetratingly damp at all seasons
of the year."

Still, some of the best-known sculptors of Paris worked in barnlike
buildings with cement floors; in this respect his studio was no ex-
ception. He was happy to have found something he could afford, and
here he completed the work he regarded as his first important piece
of sculpture, *l'Homme au nez cassé*—The Man with the Broken Nose.
Later in life it always gave him pleasure to talk about the genesis of
this almost classical head, and the details of his ugly-duckling story
varied with each telling. "It was made from a poor old man who
picked up a precarious living in the neighborhood by doing odd jobs

for anyone who would employ him, and who went by the name of 'Bébé,' " Bartlett reports. Actually the model was called Bibi*; according to one account, he earned a living at the horse market holding the bridles of horses that were to go on sale. "I did not go out to look for that fellow," Rodin told the young American Agnes Meyer:

> I was desperately poor as a young man and could not afford to pay the usual rate for a good model. The only person I saw was a terribly hideous man with a broken nose who used to come in two or three times a week to clean out my atelier. Finally I had to have somebody to model and I made this fellow sit for me. At first I could hardly bear to do it, he seemed so dreadful to me. But while I was working, I discovered that his head really had a wonderful shape, that in his own way he was beautiful. . . . That man taught me many things.

Rodin felt that the face was "stamped with a nobleness of expression that looked so much the more striking for its contrast with the ruin to which it was attached." Lawton heard that he had first met Bibi at the workshop of a master ornemaniste to whom the odd-job man was delivering a box: "He had seen better days, but had sunk to the position he then occupied through misfortune and drink." Rodin thought he might be of Italian origin, since his face resembled those of Greek and Roman busts. For that matter, his portrait of Bibi also bore a distinct resemblance to a well-known seventeenth-century work, Pierre Puget's imaginary portrait of Homer; whether by coincidence or design Rodin emphasized the resemblance in a later version by adding a fillet to the head in precisely the way Puget had tied it around Homer's. L'Homme au nez cassé, he said twenty years later, had "determined all my future work":

> It is the first good piece of modeling I ever did. From that time I sought to look all around my work, to draw it well in every respect. I have kept that mask before my mind in everything I have done.

*Bibi was a common nickname, rather like "Mac," or "Buddy," among working-class Parisians. The undertaker's name in Zola's l'Assommoir is Bibi-la-Gaieté. It was also a term of endearment for a bibulous friend with whom one gets pleasantly soused.

It took him about eighteen months to finish the bust, since at the same time he was working for Biais, whose workshop was located at No. 20, rue de la Reine Blanche. The work was begun before he joined Father Eymard's community but completed after he left it. In the end it was the cold winter of 1863–64 that decided the form in which the work was to be presented to the public. The temperature dropped below the freezing point; Rodin was too poor to keep his stove going at night. *"The Man with the Broken Nose* froze. The back of his head split off and fell down. I could save only the mask. . . ."

It has been suggested that this story is apocryphal, but Rodin himself vouched for it—evidently it was not merely derived from a far more tragic incident that took place at the same time in another sculptor's studio. The artist Louis Brian (1805–1864), who had just completed a clay figure of Mercury, made the supreme sacrifice for his work: in the icy weather he wrapped the statue in his only blanket to keep it from freezing, and froze to death himself. The Salon jury of 1864 awarded Brian its medal of honor posthumously. For once, Rodin did not object to the choice. When he studied this *Mercury* at the exhibition, "I saw that it was one of the best things in the world," as he told Bartlett. "I have always loved that statue . . . it's the best medal of honor that was ever given in Paris. . . . It has force and beauty."

Winter was always a difficult time for the poor artists of Paris: Whistler has a drawing of Fantin-Latour in bed with all his clothes on, working at a drawing and "pursuing his studies with difficulty— 14° [C.] cold," in December 1859. But cold weather was particularly hard on sculptors, since unfired clay is a highly frangible substance. As yet Rodin lacked the money to have plaster molds and casts made of his works as a kind of sculptural life insurance. His first studios, according to Bartlett, were always cluttered with "numberless sketches in various degrees of execution"—among them his first free-standing figures. Since he was rather negligent, however, and "without means either to care for or preserve these sketches and finished models in plaster, they dried up, fell to pieces, and went into the clay-tub, continually to appear again in other forms, and to follow the same round of resurrected destruction."

Rodin looked back on these misadventures as a waste of good sculpture, but also with a certain pride in his profligacy. "My life

has been like a great fire," he once told Léonce Bénédite. "I was for a long time too poor to afford to have molds made of many of my works and thus a large number have been lost." To prevent all of his pieces from drying up, Rodin had to spend some of his precious time each day "covering my clay sculptures with wet cloths, but in spite of that I had accidents at every turn, owing to the freezing cold or the heat; whole blocks would split—heads, arms, knees, chunks of torsos would fall off. I found them in pieces on the tiles that covered the floor. Sometimes I managed to collect some of the fragments."

It was not long, however, before he had found a young woman who would keep his sculptures covered in wet cloths and, what was more important, agreed to pose for him in the drafty studio. Marie Rose Beuret was a seamstress of nineteen when they met in 1864; she was working for a *confectionneuse* named Madame Paul, and he was busy producing decorative sculpture in the foyer of the Théâtre de la Gaîté, one of the many new theatres going up all over Paris.* Like the Cheffer sisters thirty years earlier, Rose Beuret had come to Paris from eastern France in search of work; for a time, according to Jacques-Emile Blanche, she delivered bread in the Auteuil district. Born on June 10, 1844, she came from Vecqueville in the Champagne, where her father, Etienne, and her mother, Scholastique, were wine-growing peasants. She was the eldest of their six daughters and two sons. At Madame Paul's she had been sewing clothes and making artificial flowers and feather decorations for hats. "She had come to pose for Rodin," wrote his pupil Malvina Hoffman, who heard the story from Rose. "They fell in love and she moved in with him."

Until then he had been timid and uncertain with women. "At twenty I had contempt for women," he remembered later. "I looked down on them because I was shy." It was Rose who awakened the dormant, belated sensuality of this young man who had just escaped the restraining influence of parents and priests. Years later he would look back on this time in far less romantic terms than it is usually depicted. It seemed to him that Rose had been the aggressive one in their relationship. "She has attached herself to me like an animal,"

*Years later Rodin told Marcelle Tirel that he had met Rose while working on the Théâtre des Gobelins, but his memory was playing tricks: construction on the Gobelins did not begin until 1869.

he remarked in his conversations with Victoria Sackville-West: *"Elle s'est attachée à moi comme une bête."* Yet he was fascinated by her beauty, and he was to model some of his most striking sculptures on the face and body of this woman who, as he said, "did not have the grace of city women but all the physical vigor and the firm flesh of the peasant girl, and the lovely, frank, decisive, masculine charm which enhances the beauty of a woman's body."

Significantly it was as a Bacchante that he chose to sculpt her— though he may have been only dimly aware that the mythological Bacchantes were not just girls in vine leaves but, as maenads, capable of tearing their victims apart. She was used to being the dominant older sister, and it was not surprising that she had a mind of her own: "I come from Joan of Arc country!" she liked to say.

Rodin later recalled that his *Bacchante* took him about two years to bring to completion, and that it was his most important work of the 1860s:

> The pose was commonplace; it mattered very little to me.* For one thing I didn't want to tire my *amie* by placing her in a pose which she wouldn't be able to hold for a long time, and also I was convinced that to work really well I had to work from real life. . . . I settled on a simple pose to which the model could easily return after a few minutes' rest, allowing me to make the comparisons that are indispensable if one wants to model from nature really well. To produce this figure I struggled with nature for nearly two years. I was twenty-four, already a good sculptor; I saw and executed the direct radiance of a form just as I do now; I was absolutely scrupulous and deliberate in drawing the contours. . . . I did them ten times, fifteen times, if necessary; I was never satisfied with one that was merely close.

Since he was busy earning a living he had only a few hours a day to spend on the *Bacchante*: in the early morning, from the moment the light entered his studio until it was time to go to work, and then

*Rose herself remembered having "posed standing up, one hand on her head as if to hold up her hair, the other as if she had just put down her mirror." But a "Young Woman at Her Toilette" hardly qualifies as a *Bacchante*. Perhaps Rodin modeled two large free-standing figures on Rose Beuret during the 1860s.

again after his return in the late afternoon, until there was no more natural light to work by. Sunday was his only free day. After an intensive modeling session in the morning they would go for a stroll in the fields that then extended to the very gates of Paris. But the *Bacchante* was always uppermost in his mind: "What discouragement when something didn't want to happen; what happiness when at last I found the contour I was searching for! When the failing light interrupted my work and the gathering shadows crept across the studio, I saw my statue stripped of its details, retaining only its planes and silhouette; then its mass alone appeared."

He was fortunate to have found such a patient and untiring model. "She says she posed for hours . . . and got so cold," Victoria Sackville-West noted in her diaries. Rodin could not afford a professional model; for two hours' posing they earned as much—five or six francs—as he did for a day's work. Nor would it have occurred to him, despite his superbly trained visual memory, to work without a model. It was an unchallenged convention that artists worked from models, though they would adjust reality to suit their own vision. As one critic expressed it, a model was to the artist "what a character in real life is to the author—a substratum on which to fashion the creature of his imagination."

Rose Beuret posed for Rodin in all kinds of roles, not only as a Bacchante but also as an ingenue, for a terra cotta bust in which she wears a straw hat decked out with what might have been her own artificial flowers. For Rodin, though, it was the *Bacchante* that really mattered: "in style of modeling it was like The Broken Nose," he recalled. "Very firmly modeled—possibly a little cold." When it was done he was convinced he had achieved "a good piece of work," and the next stage would have been to make a plaster cast, but he lacked the money to pay a *mouleur* for the molds. "I waited impatiently for the moment when I could afford to have the figure cast, but I waited for a long time," he told his friend Dujardin-Beaumetz many years later. "I thought of nothing but my figure; I was simple—I never suspected my own talent." The day came when he wanted to move to another studio; by then his stable was cluttered with heavy sculptures including, apparently, replicas of the *Venus de Milo* and *The Dying Gladiator*. "At the end of the day we were extremely tired; without consulting me the two movers took hold of the *Bacchante*,

one by the head, the other by the feet; they took a few steps; the armature swayed and whipped; the clay fell off at one blow. Hearing the crash I sprang forward; my poor *Bacchante* was dead."

A half-size version of the figure evidently existed as well, but it "dried up and perished like the other one" before a mold could be made. Afterward Rodin always spoke of the *Bacchante* "with a feeling of deep regret," as Bartlett noted; he never forgot "the long hours of patient suffering labor that the figure cost him."

On the whole the 1860s were a decade in which he had little to show for his efforts, and he was hardly better off at thirty than he had been at twenty. But he liked to say that *"la patience est encore de l'action"*—"patience is also a form of action." Once, in 1863, he seemed on the verge of launching a career in the world of "fine arts," but again nothing came of it, for reasons unconnected with his own abilities. A private arts club known by the rather grandiose name of Société Nationale des Beaux-Arts offered him, for the first time, an opportunity to meet established artists and writers. The Société had been founded by the most original art dealer in Paris, Louis Martinet, who had opened a gallery on the fashionable boulevard des Italiens. Martinet exhibited such well-known painters as Ingres and Delacroix side by side with the still unknown Manet and several artists in their twenties, such as Legros, Fantin-Latour and Carolus-Duran, who were just two or three years older than Rodin. "Hearing that Martinet was very friendly to young artists and much disposed to give them a word of encouragement or do them a kindness," Bartlett reports, "Rodin went to him to see if he could be made a member of the club. The director put the young aspirant through a kind of examination, and came to the conclusion that he was eligible."

Martinet's club was supposed to promote private exhibitions and bring together artists and patrons (it had only its name in common with the far more important Société Nationale des Beaux-Arts founded in 1889 by Rodin and other Salon dissidents). From time to time its members showed their work at an exhibition preceded by a banquet: Rodin took advantage of one such occasion to exhibit his bust of Father Eymard, which was much admired by other members of the Société. As Bartlett writes, Rodin "felt, for the first time in his life, that there was a ray of light not unwilling to fall upon his head." In his curriculum vitae it figured as his one modest success of the Sixties:

"He becomes a member of the Société Nationale des Beaux-Arts at 26 boulevard des Italiens and exhibits there."

Théophile Gautier served as the Société's president, and Puvis de Chavannes, Paul Baudry and Carrier-Belleuse were members of the executive committee. Rodin remembered having met Alexandre Dumas *père* and other prominent personalities, including Gautier. "I met him once at a banquet," he recalled, "and with the confidence begotten of a glass of champagne, I tackled him in conversation. But I fear I said some stupid things, and he did not pay much attention to my youth."

The fellow member who interested him most was his former teacher, Jean-Baptiste Carpeaux, recently returned from his Rome-Prize years in Italy and now embarked on his brief, brilliant career as one of the fashionable sculptors of the Second Empire. Carpeaux's figure of *Ugolino*—the imprisoned Count who dies of starvation together with his sons, in Dante's *Inferno*—had been shown at the Ecole des Beaux-Arts in 1862 and won first prize for sculpture at the Salon of 1863. The intensely tactile and lifelike quality of his modeling had made a powerful impression on the young sculptors of Paris. As Jules Dalou said afterward, "It was Carpeaux who liberated us."

Rodin realized that Carpeaux's work represented a frontal attack on the then-fashionable sculpture that resembled "polished pieces of ivory, cold and weak." He felt that "Carpeaux was the first man in our day to get out of this narrow way of looking at sculpture"—and he wanted to do likewise. As he wrote to Bourdelle years later,

> Carpeaux had a sense of composition; had made the happy discovery of lightness and of grandeur; had rediscovered the allure of the eighteenth century while he was studying the Italians in Rome and elsewhere. . . . I realized that this gave Carpeaux a strength and direction of which he took advantage, but I also recognize in him a structural principle [*règle*] that I made use of, and he as well—namely the principle embodied in the structural planes of the Italians.

In 1863 Carpeaux had just been commissioned to decorate the new Pavillon de Flore of the Louvre for Napoléon III, but he was far from well-to-do. "A little ugly man, almost deformed, with a wild

head and beard," recalled one of his sitters, Helene von Racowitza,* in her memoirs; "he lived in his hideous atelier, and in a little room beneath it, in dreadful dirt and disorder." Rodin, however, wanted nothing more than to work in Carpeaux's atelier: at one of the meetings of the Société he asked the older sculptor if that might be possible. The reply was a cordial, "Certainly! Come when you please," but when Rodin went to see him, as Bartlett reports, "to his sad astonishment, Carpeaux received him coldly, almost brutally, and he left without any disposition to return at a more propitious moment."

Carpeaux may not have been feeling well that day—he was intermittently ill during this period—or he may merely have been in a bad temper. The upshot, at all events, was that Rodin never received any encouragement from an artist of his own stature; during these formative years, as he told Bartlett, he never came into "close and constructive contact with any master, never thought of asking one to see and criticize his work." He still had hopes that after his success with the bust of Father Eymard he could exhibit *The Man with the Broken Nose* at the Société's next banquet, "but before that patiently awaited event was to take place the club was dissolved."

He tried once more to gain recognition for *le Nez cassé* by submitting it to the Salon of 1864. He had every expectation of a favorable reception since the method of choosing the judges had just been liberalized, following the public outcry that had led to the creation of a *Salon des refusés* in 1863. But the jury returned the work, and this further disappointment dealt such a blow to his pride that he gave up trying to enter the Salon. Another eight years were to elapse before he submitted his work to another exhibition of "fine arts," and he did not compete for the Salon again until 1875.

Yet admission to the Salon was an ineluctable rite of passage for any artist hoping to make a career in painting or sculpture. It served as both the proving ground and marketplace of French art; any professional so unfortunate as to be excluded was automatically written off as a nonentity. In some cases the jury's approval became literally a matter of life and death. In 1866 the painter Jules Holzappel com-

*Helene von Racowitza, née von Dönniges, enjoyed a brief fling as one of the belles of the Second Empire. It was on her account that the headstrong German Socialist leader Ferdinand Lassalle was killed in a duel in 1864.

mitted suicide after being rejected; it was, everyone agreed, a painful case, and there were predictable recriminations in the newspapers. But Henri Rochefort, the prince of Paris journalists, pointed out in *le Figaro* that the jury "cannot be expected to ask, before forming a judgment: 'Do you believe that if we refuse this painting, the artist will blow out his brains?' "

Rodin was never in any danger on this account; psychologically he was invulnerable to the 400 blows which the world of official art held in store for him. If there was no place for him in the Salon he would go on as an artisan, or what he called a *maçon d'art*, only a step removed from a stonemason. Among Bartlett's notes there is a scrap of paper on which he jotted Rodin's answer to one of his questions: "No—I never felt slighted or frustrated, because I never thought much of attaining a high position. I am content with the chances as they have come." Only toward the end of his life, when he felt time running out, did he become bitterly resentful of the fact that he had spent half his working years as a hired hand. "The worst of it is," he told Frank Harris, "that in those years I was full of ideas, pregnant with a thousand conceptions which never saw the light."

He had found a new employer, the gifted and energetic Albert-Ernest Carrier-Belleuse, who was one of the most successful sculptors of the day. When Rodin went to work for him he signed himself simply A. Carrier—the ancestral Belleuse, inherited from a Count Carrier de Belleuse, was added to his signature after 1868. Rodin was evidently introduced to him by the pioneer photographer Charles Aubry, whose atelier was situated in the same street as Rodin's studio, and who had taken photographs of Carrier's favorite sculpture. He also took the earliest photographs of Rodin at work and came to the conclusion that the young sculptor "might possibly get something to do for a higher class of employer than those he had been working for." They went together to see Carrier, who returned the visit, looked over Rodin's work, especially the *Nez cassé*, and agreed to employ him.

After six years as a decorative sculptor Rodin was delighted with this change of métiers "because it took me away from an ornament maker to one that made figures. I began to work for him in 1863, and remained until the breaking out of the Franco-German War; although, at first, I only worked in the afternoons, continuing with Fannière in the mornings." Carrier was quick to recognize Rodin's

talent as a maker of figures, a so-called *figuriste*, but before the young sculptor had reconciled himself to the idea of a long stay with one employer he twice left Paris to try his hand working for other sculptors.

The first of these, Léon Fourquet, was a young acquaintance who had studied in Paris but moved to Marseille to work as a subcontractor of ornamental sculpture for the Palais de Longchamp, an immense museum complex dedicated to natural history and fine arts. The work was directed by a distinguished sculptor, Jules Cavelier, and Fourquet needed help with his commissions: Rodin was happy to accept an invitation to Marseille. En route he stopped off to see the churches and palaces of Arles, Vienne and Nîmes. He was "glad enough to get out of Paris" and set off with great enthusiasm, looking forward to earning his bread under the sun of the Midi, but once again he was doomed to disappointment. Fourquet was "less disposed than Carrier-Belleuse to trust to the initiative of his assistant," as Lawton learned, and Rodin "cut off too much in some places, and left too much on in others. In fact, he was not the kind of workman that his employer wanted, and so he was discharged."

Unwilling to return to Paris immediately, he found work with a local ornament maker, but soon there were the inevitable differences of opinion. Rodin "would not swerve a hair to please anyone in his work," for he had become accustomed to doing the sort of modeling that was too robust for the petty requirements of ornemanistes and commercial sculptors. After another two or three weeks in Marseille he packed his bundle and returned to Paris.

Not long afterward he received another offer, this time from an Alsatian friend, the sculptor Eugène Dock, who had studied in Paris and then returned to Strasbourg to become a specialist in church sculpture and decoration. During the three months Rodin worked in Strasbourg he discovered that there were still tricks to be learned in this trade. "He did his best," Lawton writes, "which, however, was not quite like what his companion could do." Dock, who was thirteen years older than Rodin, had developed a knack for Gothic and Romanesque effects. "He would take one of the figures Rodin had fashioned, add a touch here, another there with his chisel; and it assumed the exact likeness of the old carving of the Middle Ages which the Parisian sculptor loved and admired without as yet possessing its equivalent perfection."

Rodin wrote to Rose a few days after his arrival to say that he was having a wonderful time and that his old friend "is very nice to me."*

I'm quite happy; the city is enjoyable but just think, I no longer know how to spend the night alone, I find it too long so I get up at four in the morning; anyway since Wednesday when I arrived in Strasbourg I have been working ardently. I'm staying in a pension, in this funny country you're not free to choose your mealtimes; I pay thirty *sous* [1.50 francs] per day and I'm supremely well fed. What a difference between here and Marseille! My room rent is 13 francs.

And you my little angel what are you doing? I can see you already getting angry but please note that I think you're working as hard as I am; I think this is the time when both of us are going to save money—if you manage to save some don't go on a binge with it. Ah, my little Rose I wish a good fairy would waft you through the air and bring you to me, I would very much like to . . . oh, but I was going to say silly things; anyway I kiss you with all my heart,

<div align="right">your friend Auguste Rodin</div>

In a postscript he expressed his amazement at "how expansive I become when I'm far away from you," and indeed he loved writing to her about his Strasbourg adventures: he had already paid his first visit to a foreign country by crossing the Rhine to drink beer and eat cakes in Kehl, on the German side of the river. In his next letter he mentioned that he had written her three more letters but was sending just one—"to show how much pleasure I have with you, or rather the thought of you."

But you don't do the same for me; you don't fill up your paper, it seems you're afraid to spend a little more time at your desk,

*This and the following letter, which bear no date, were mistakenly dated 1879 by Judith Cladel, who then had to invent an extra visit to Strasbourg to account for them. This error has been copied by everyone else, even in the Musée Rodin's 1985 edition of the Rodin *Correspondance*. But the second letter contains the phrase, "I have written to my parents," which indicates that Rodin's mother was still alive when he wrote it. She died in 1871, the year Strasbourg surrendered and became a German city: Rodin did not see it again until 1907.

you've unlearned how to write, you spell less well than a year ago; I can see little Rose that I'll have to make you do correspondence for at least a year. But, *ma petite amie*, Strasbourg is a paradise of delights; I feel good here even though I'm rather ill, my stay is so pleasant that I couldn't get enough of living here; Ah, Rosette, I'll definitely stay here forever and if you want to see me again the only way is to save money so you can come here and join me—but enough of my awful jokes, I can't tell you when I'll be back, but it will be soon so don't worry, wait patiently, don't go crazy, you wouldn't recognize me when I return. . . . I see that your despair is too dreadful. Go for walks now and then, take some fresh air for when I return. Tell me what you eat, drink, tell me when you sleep, at what time. Tell me what you do with your money—don't get mad, I'll come back soon, or send you some.

During this Strasbourg interlude he modeled a small bust that he called *The Little Alsatian Girl*. As he told Bartlett, during a church festival one day, "when thousands of fair women and young girls were filling the streets with their beauty and pretty costumes, he saw a little head which pleased him so much that he went to his room and modeled in an hour or two *la Petite Alsacienne*"—a feat that would have been impossible without the benefit of Lecoq de Boisbaudran's methods of memory training. He was quite proud of this bust, but he must have felt uncomfortable spending his time on pseudo-Gothic sculpture that had to be knocked into shape by someone else's hammer, and before long he "grew homesick" and returned to Paris, this time to remain with Carrier-Belleuse.

Perhaps it was inevitable that two artists working together so closely as *patron* and employee should have underestimated each other. Carrier's remark, "Oh, he is a good workman, but he copies anything and everything he happens to see," sums up his attitude toward an assistant he regarded rather grudgingly as gifted but hopelessly unmanageable. The depth of his incomprehension is conveyed by another comment reported by Bartlett, dating from the years when Rodin was setting out on his own: "*Sacré nom de Rodin*, he has worked for me for ten years, and I have not been able to print myself upon him! He will never be able to model as I want him to." Yet the visual

evidence suggests otherwise; Rodin, in fact, adjusted his daytime style to the point where his modeling became indistinguishable from his employer's. It galled him to work under these conditions, but as he told Bartlett, it seemed to suit his purposes for the moment:

> Though I was making poor sculpture for Carrier-Belleuse I was always thinking to myself about the composition of figures, and this helped me later on. I carried to the work I did for him the result of my study at home. He occasionally praised me, though not much or often, and rarely, if ever, criticized. I knew he liked what I did. He was too much of a businessman to praise much, for he did not wish to raise my wages. He was no common man, was very intelligent, understood his own kind of work, and was lucky to have me for the price he paid. I think, in sentiment, Carrier-Belleuse was an artist. He had good ideas of arrangement, a pretty correct eye, and composed well, though he had never been able to study. He would make a sketch that no one could finish as well as myself, and he did not always know this. He was a man of his day in sculpture. Nothing I ever did for him interested me.

If the last sentence is true, it is a terrible indictment of their relationship. But in his conversations with Bartlett—in 1887, the year of Carrier-Belleuse's death—he was still too close to the experience, and his remarks were tinged with the residual animosity of the disgruntled ex-employee. The years he had spent with Carrier, he decided, had been of "great injury" to him as an artist because he had been obliged to "please the uncultivated, often vulgar fancy of the commercial world." Carrier rarely worked from the living model— "haste took the place of thought and observation, a bad style of modeling was practiced, and a manner of finishing equally reprehensible."

In later years Rodin became far more objective in his assessment of Carrier-Belleuse. When he was in his early sixties he told Gustave Fuss-Amoré that Carrier had been "the maître to whom I owe the most," and although he had been a "paltry" artist, he had also been a marvelous craftsman. "I owe him the power to do whatever I want to do with hands; that's how one should begin." The painter J. E. S. Jeanès, who knew Rodin for many years, wrote in his memoirs that

the sculptor "never regretted" the years spent with Carrier, and that "he never spoke of his maître except with respect and even a little admiration" for having been gifted in his métier and sensitive toward nature. Only Carrier's lack of feeling for structure had prevented him from becoming an artist of the first rank.

Carrier himself had risen through the ranks as an apprentice and studio assistant. Coming from a family of impoverished aristocrats— his father had disappeared when he was a child—he knew very well what it was like to be a penniless sculptor in Paris. Like Barye he had worked for the goldsmith Fauconnier for several years and had then gone on to study sculpture—at the Petite Ecole, with David d'Angers and, briefly, at the Ecole des Beaux-Arts, where his fellow students named him *grosse-tête* (swelled head). He fell in love with an orphan girl who earned her living painting fans, and whom he married after their fourth child; later there were to be four more, with the result that he was usually hard-pressed for money.

The *Gazette des Beaux-Arts* placed Carrier "among the most distinguished of the pictorial sculptors," yet he was never elected to the Academy—his modeling was considered "too natural, too alive." Charles Baudelaire, in his review of the 1859 Salon, congratulated Carrier on the three busts he had on view but sensed the lack of an organizing principle:

> Like his favorite masters he has energy and spirit. A slight excess of décolleté and disarray in costume, may, unfortunately contrast with the rigorous and patient finish of his faces. I do not think it is a fault to crumple a shirt or a cravat, or to give a pleasant twist to a lapel; I refer to a lack of harmony with respect to the total idea . . . [Still,] M. Carrier's busts have given me such keen pleasure as to make me forget this fleeting impression.

This penchant for marble imitating lace and crumpled fabrics became one of the hallmarks of Carrier's style. Rodin said afterward that modeling so much folded cloth for Carrier had "spoiled draperies" for him; hence "I prefer the nude." Nevertheless there was a great deal to be learned in the day-to-day operation of Carrier's studio at No. 15, rue de la Tour-d'Auvergne, in Montmartre. Rodin realized later that he had acquired his art step by step and solved the principal

problems only after solving many minor ones of the sort that kept him busy at Carrier's. As the *patron*'s favorite *figuriste* he was constantly at work on a variety of projects. Official portrait busts formed part of the atelier's thriving business with the government: it was Rodin who put the finishing touches on the medals and epaulettes that proclaimed the subject's importance in the world.

In times of prosperity Carrier's atelier employed as many as fifty workmen who produced everything from commercial lamp bases to ornamental moldings and *bustes de fantaisie* of pretty girls with flowers in their hair. Someone described the maître as "almost a sculpture-machine . . . but a machine with *verve*," churning out busts, ornaments, statues, statuettes, candelabra, caryatids, etc. in bronze, marble, plaster, alabaster. Rodin added finishing touches to an important share of everything that was produced by the studio during these journeyman years, and he himself "lost count of how many of these elegant statuettes he had produced"; as Coquiot reported, "he modeled them in a matter of hours, and never, he himself assured us, did he perform *la pratique*, that is, the carving of a marble replica." He did, as a *modeleur*, assist Carrier in executing the stucco decorations for the Grande Galerie of the Louvre, and there is said to be "a little from his hand" in the Church of Saint-Vincent-de-Paul, which acquired several of Carrier's figures. Apparently Rodin also worked on the hands and feet of Carrier's best-known Salon sculpture, *Hebe Asleep*.

"Today it is no longer possible to invent anything new," Carrier liked to say, and by the same token he became something of a specialist in transformations and recombinations. He would juxtapose plaster casts of existing works so as to produce new groups with relatively little effort—a method that Rodin adopted in his later work to produce such assemblages as the *Three Shades*.*

Rodin became particularly expert at touching up Carrier's maquettes, the small models that precede the finished sculpture. Carrier made delightful sketches, but in Rodin's opinion, he was incapable

*Ultimately he was to carry Carrier's technique to its aleatory conclusion. "Rodin delights in making tiny models of men and women, placing them in a case together and then shaking the case up," reported one visitor to his studio after the turn of the century. "They assume all sorts of queer postures, and Rodin leaves them this way. They give him ideas for groups, he says."

of "furnishing the slow, patient, continuous toil necessary for the attainment of the best results." In developing these sketches Rodin had to imitate his employer's style very closely, since the finished pieces had to bear the master's signature. Carrier always exercised very strict control over even the most gifted of his assistants. The writer Léon Maillard is quite precise about what he heard from Rodin on this point: "His task was merely to follow, quite strictly, the dispositions and motifs of Carrier-Belleuse." But at the same time he was free to add anything he wanted provided it did not contradict Carrier's style.

Most of the groups on which he worked (in sculpture, a combination of even two figures is a "group") were allegorical nudes in more or less stylized attitudes of *volupté féminine*. Rodin did his best to inject some anatomical truth into the genre—and in recognition of his special talents as a *figuriste* he was the only one of the studio assistants whom Carrier authorized to work from a nude model.

Both at work and at home Rodin was thus compelled to take an active interest in women's faces and bodies. At Carrier's there were the *fantaisie* women with their elongated torsos and windblown draperies; in his own studio he had Rose Beuret, his uncomplaining model at dawn and dusk, with her strong country face and the splendid full-breasted body that appears repeatedly in his early sculptures and drawings. While he went out to work she continued to earn money as a seamstress in dressmakers' workrooms or at home, sewing garments at piece rates. Rodin used to help her by sewing on the buttons and she, in turn, became expert at keeping his sculptures covered with damp cloths.

Often they were too poor to buy drawing paper, and many of his early drawings were made on menus, billheads and laundry lists: "Rose would collect these old bills and bring them home to me." Even when they had reached the point of being able to afford a separate room in which to live they were sometimes too poor to make the most of it. Leaving the studio at night, Rose recalled, they "walkéd home and went straight to bed without lighting the stove and without food." Rodin afterward remembered times when he was always hungry: "It was incredible the amount of food I could eat when someone invited me."

For a long time he kept Rose's existence a secret from his parents.

Yet such ménages of artists and models were an accepted feature of the vie de bohème that no one made any fuss over, and most such couples led lives of irreproachable domesticity. The young women who moved in with the artists were usually "modest in demeanor and quiet in dress," as Somerset Maugham observed later in the century. "They were model housewives who had preserved their self-respect notwithstanding a difficult position and did not look upon their relation with less seriousness because they had not muttered a few words before Monsieur le Maire."

Rodin finally introduced Rose to his family at one of the regular Sunday gatherings in the rue de la Tombe-Issoire, when his mother would "put on a pot-au-feu, Thérèse brought a cake, and they all dined together." Aunt Thérèse had become his confidante following Maria's death, and apparently she was the first to learn that Rose had given birth to a son on January 22, 1866. The boy was named Auguste-Eugène Beuret; he was born at the home of a midwife in the rue Port-Royal, and his birth certificate calls him "the natural son of an unknown father." Rodin's biographers have speculated about his reasons for not acknowledging his son or marrying Rose: perhaps he was waiting for his financial prospects to improve. More probably he preferred a docile mistress to a legal wife. "I like obedient women," was his way of putting it in later years. It was not that he overlooked the matter: he knew perfectly well what marriage was—"It's the ancient custom and your union should be consecrated," he once advised Jelka Rosen and Frederick Delius. If he failed to solemnize his own union with Rose it was because he considered her unsuitable as a wife. He lived with her, as he told Rilke in 1902, for the simple reason that a man "needs a woman"—*il faut avoir une femme*—though it would really be preferable to remain alone.

Rose always made a point of her loyalty to him, but Rodin perceived this loyalty as a form of dependency and an attempt to manipulate him. He resisted it by deliberately ignoring her needs. Often he would go off for days without telling her where he was. She never forgot the day he came home penitent after one of his long disappearances and asked her to prepare a special meal that evening: "Rose, you must cook a nice little dinner for tonight, at seven o'clock—seven o'clock sharp. After dinner I'll take you out somewhere." She went off to prepare a feast, singing with happiness at

the return of the prodigal—but it was three weeks before she saw him again.

Sometimes there were violent scenes. "Do you remember," she reminded him long afterward, "when you used to beat me and say yield, you dirty slut, yield!" Eventually she yielded to the point of becoming his housekeeper, or rather she "served the Master like a servant and mother in one for half a century," as Frank Harris wrote. Rodin thrived on her peasant cooking; her home remedies soothed his upset stomachs. Yet only the infirmities of old age would ultimately persuade him to marry her. He knew instinctively that "a married man is a reactionary in art," as Courbet said, and he intended to remain unencumbered. Sometimes even living with a mistress struck him as a trap: after reading Maeterlinck's *Life of the Bee* in 1901 it occurred to him that he, too, had been victimized by a queen bee. "In human life the man sacrifices himself for the woman and is ruined by her," he decided, "and woman sacrifices herself for the child."

Yet he was far too upright a man to desert Rose, as Carpeaux had abandoned the peasant girl he used as the model for *la Palombella*, and who is said to have died of grief as a result. Rodin knew only too well the destiny of "mistresses abandoned by their lovers, and having no other resources." Hence he kept her with him but without reciprocating her "eternal devotion." The novelist Octave Mirbeau was not exaggerating when he told Edmond de Goncourt in 1889 that Rodin's mistress was "a little *blanchisseuse* [laundress] who has not the slightest communication with him, and is kept in complete ignorance of what he does." It was not the romantic relationship his biographers would have preferred, but it suited his requirements.

The birth of their child complicated their lives, though at first Rodin did not regard the boy merely as a nuisance and intruder. One of his statuettes of the 1860s shows Rose with her splendid mane of hair, her hips swathed in drapery à la Carrier-Belleuse, holding her infant to her breast—a startling image of the young mother not as the provident Madonna but as a continuing object of sexual desire. When the boy grew older he came to resemble his father: "with his sloping forehead and prominent nose he resembled Rodin," Cladel noted, "but his eyes were like his mother's." Early in life Auguste Beuret lost the battle with his father over priority of access to his mother's attention. As he himself recalled in middle age, "We were

very poor when I was born, so no one was happy about my arrival, only my grandfather. But he was blind, and couldn't help a great deal." The boy realized that he was being pushed aside by his father: "Mother loved him very much and always did what he liked. So no one bothered about me."

They had moved across the river to the slopes of Montmartre, then a quiet garden suburb that had recently been incorporated into Paris as the city's Eighteenth arrondissement. Many artists and writers moved to Montmartre in the 1860s because, as the novelist Champfleury (Jules Husson) pointed out, it was like a small provincial town at the gates of Paris: "no traffic, no police, no people in the quiet streets, small houses set in gardens, little shops that smell of the country." Rodin and Rose settled first in the rue Hermel, near the porte de Clignancourt, and then in the rue des Saules on the Butte Montmartre, which was closer to Carrier's studio. As before, after a day at Carrier's atelier he would work in his own studio for as long as the light lasted. "I knocked off my fourteen hours a day and rested only on Sundays. On that day my femme and I would go to some little *guinguette* [garden restaurant] and eat a 'huge' meal that came to three francs for the two of us; that was our only treat for the week."

He was searching for ways of perfecting his sculpture. "At my work I was never sad," he told Bartlett. "I always had pleasure in it. My ardor was immense. I was always studying. Study embraces it all. Those who saw my things pronounced them bad. I never knew what a word of encouragement was. The little terra cotta heads and figures that I exposed in shop windows never sold." He visited the Salon and admired the work of Perraud and other established sculptors whom he considered important artists, though "in their sketches I saw that they were not strong."

In looking at the hands they made, I thought them so fine that I should never be able to equal them. I was all this time working from nature, but could not make my hands as good as theirs, and I could not understand why. But when I got my hands all right from life, I then saw that theirs were not well made, nor were they true. I know that those sculptors worked from plaster casts taken from nature. Then I knew nothing about casting from nature; I only thought of copying my model. I don't believe

those sculptors knew what was good modeling and what was not, or could get out of nature all there was in it.

Hands, for Rodin, expressed the essence of a body; they were the fragment that stood for the whole. To have "got them right" meant that he now felt confident of his power to do better than the official sculptors of the day. At that moment other dissatisfied artists were searching for ways to break the stranglehold of the Salon and the Academy. The 1860s had begun with the scandal of Manet's *le Déjeuner sur l'herbe* at the Salon of 1861 and were to end with the emergence of Impressionism—Monet and Renoir painting the effects of sunlight side by side on the banks of the Seine at Argenteuil in 1869.

Most of the avant-garde painters were no better off financially than Rodin. "Renoir brings us bread from his own home or we should die of hunger," Monet wrote to Bazille in the summer of 1869. "For a week now we have been without bread, without fuel to cook by, and without light." But at least they were actually painting the pictures that would eventually bring them to public notice, and they were convinced that the time would come when, as Cézanne told Zola, "a bunch of carrots truthfully and powerfully painted would create a revolution in art." Among the major artists of the generation born around 1840—Cézanne, Monet, Renoir, Berthe Morisot, Sisley, Redon—only Rodin was still wholly unexhibited by 1870 and had produced virtually none of his important work. The others had a history; Rodin remained shrouded in obscurity. Even Redon, the most reclusive artist of this generation, had exhibited prints in the Salon of 1867. When Fantin-Latour, in 1869, painted his group portrait of the young innovators of French painting, he included Manet, Zola, Renoir, Monet—people whose stars were clearly rising. Rodin, meanwhile, was busy putting the finishing touches on Carrier's confections for the *fabricants de bronze*. Had he been killed in the Franco-Prussian War—as were Bazille, Regnault and several other artists—he would have been merely one of the innumerable forgotten sculptors of the century.

Conditions in the French art world tended to favor avant-garde painters rather than sculptors. Paris during the 1860s was in the throes of a vast transformation requiring the services of stonecutters rather than visionaries. Under the impatient direction of Baron Hauss-

mann the city was effacing its past to make room for the present. The old crooked streets gave way to boulevards and railway lines; department stores and factories were going up; new bridges spanned the Seine; theatres were being demolished and constructed. The population had more than doubled since Rodin's birth: in 1866 there were 2,150,916 inhabitants. They required new hospitals, asylums, schools; new market and exhibition halls; a new prison, new stables for the emperor's horses, new docks on the river and new *mairies* for the arrondissements, a new morgue; even whole new districts like the Quartier de Chaillot.

Just across the way from the old Palais de Justice, where Jean-Baptiste had once guarded prisoners, the government was erecting a monument to a new kind of justice, the Tribunal de Commerce, where industrial and economic conflicts could be resolved. One of the sculptors called in to celebrate the spirit of commerce in stone and stucco was Carrier-Belleuse, who furnished the twenty-four caryatids that supported the skylight of the glassed-in courtyard. (Subsequent alterations have trapped them behind partitions, so that they now do their work unseen and unnoticed, like the underpaid assistants who carried the whole edifice of bourgeois France on their backs.)

But the quintessential building of the Second Empire was the Paris Opéra, a temple to music and affluence in which the epoch's genius for conspicuous consumption found its proudest expression. Carrier-Belleuse and his *équipe* produced several important sculptures for it: he would have been a logical supplier even if he and the architect, Charles Garnier, had not been old friends. It was nearly four times the size of its nearest rival, the Munich Opera House, and took more than a decade to build. Some of the best-known sculptors of France had been commissioned to provide the allegorical groups for its façade, including Chapu (*la Cantate*), Falguière (*le Drame*), Perraud (*le Drame lyrique*), Guillaume (*la Musique*) and Carpeaux (*la Danse*).

Carrier's first contribution consisted of a pair of caryatids, *la Comédie* (with mask) and *la Danse* (with tambourine) for the east chimney of the grand foyer. Rodin may well have worked on these outsize figures in "galvano-plastic" (an electrolytic substitute for bronze). But Carrier's most spectacular sculptures at the Opéra, the torch-bearing nymphs that illuminate the grand staircase, were executed in the 1870s, after Rodin had left his atelier.

For Rodin the most important piece of sculpture at the Opéra was not by Carrier but by Carpeaux. "When they unveiled *la Danse* [July 27, 1869] I was working at Carrier-Belleuse's studio," he recalled. "We were eager to see the end of our day's work, my comrade and I, so that we could go to the steps of the Opéra to proclaim our admiration for this masterpiece at the tops of our voices; but in the other camp, what outrage and cries of indignation, real or pretended!"

The guardians of public morals denounced Carpeaux's nude dancers as an outrage against public decency, and a midnight vandal splashed a bottle of ink over it. Rodin, profoundly moved by the group, admired it all the more because it dealt "a body blow to the formulas of the Academy." The three groups flanking it, by Guillaume, Jouffroy and Perraud, seemed "deathly cold" by comparison. "Nothing in its movements, its bearing or its gestures was provocative or excessive," Rodin recalled, "but Carpeaux had committed the then-unpardonable crime of imparting life to stone through the vibration of the flesh; he modeled with suppleness and passion; the others modeled with a dead hand. They avenged themselves by accusing him of indecency."*

Carrier-Belleuse and his assistants had meanwhile been working on another of the landmarks of the age, the Hôtel de Païva in the Champs-Elysées (now the Travellers' Club). The age of Napoléon III has been called "the epoch of the parvenus ruled by a parvenu," but of all the obscure people who had risen to fortune in that glittering society, none had come further or faster than the Marquise de Païva, née Thérèse, or rather Esther, Lachmann in a Russian ghetto, whence the pianist Henri Herz had brought her to Paris. Abandoned by her lover, and having no other resources, she did not wait to be arrested

*They might have been even more outraged had they known that Carpeaux had placed a woman's head on a male body (a device that Rodin was also to employ) in order to create a sexually composite *génie de la danse*. The head was that of the femme fatale Helene von Racowitza, the body that of a young carpenter, Sébastien Visat. According to Guillaume Apollinaire, when the result was placed on view, Carpeaux received a letter from a lady asking the model's name and address, since "he represented perfectly her masculine ideal, which she had never had the good fortune to meet in real life." Henry James was also struck by *la Danse*: he told his readers in the New York *Tribune* that "those who have seen it have not forgotten the magnificent tipsy laugh of the figures in the dancing group on the front of the Opéra; you seem to hear it, as you pass, above the uproar of the street."

as a *fille insoumise* but borrowed the money to buy a wardrobe in the latest fashion, was duly taken up by English lords and French dukes, and acquired a title of her own by marrying an impoverished, Oxford-educated Portuguese man-about-town, the Marquis Araujo de Païva. After his suicide she became the mistress—later the wife—of an immensely rich German mine owner, Count Guido Henckel von Donnersmarck, ten years her junior. He bought her the Château de Pontchartrain outside Paris and then, for eight million francs, built her the most sumptuous Renaissance-style mansion in Paris.

Carrier-Belleuse was only one of many artists commissioned to work for La Païva, but he was among the busiest of her suppliers, and as usual Rodin assisted him. The extent of his involvement in any one piece is unknown, but he retained fond memories of the ornamental sculpture he had produced for the house. Emile Bergerat writes in his memoirs of the 1880s that "Rodin himself showed me, at the Hôtel de Païva, beneath the roof, several ornamental motifs which he had produced at piece rates for Carrier-Belleuse."

Carrier's atelier also furnished the bronze ladies supporting the green malachite panels of the fireplace in the Marquise's bedroom, and the *Fountain of Venus and Cupid* that decorated her private apartments. Rodin may well have put the finishing touches on these, as well as the *Surtout d'Ariane,* an elaborate silver table decoration that Carrier delivered to La Païva in May 1867.

When Jules and Edmond de Goncourt were invited to view this work they thought it hopelessly vulgar and noted in their diary that "the banal sculptor of the thing, Carrier-Belleuse, this junk dealer in second-hand eighteenth-century notions . . . hasn't done anything in this *surtout* except copy Clodion."

That year Carrier won the medal of honor at the Salon and was finally made a chevalier of the Legion of Honor. The studio assistants who executed his sketches were not so much as mentioned in the newspapers, but in his own way Rodin was moving up in the world of sculpture: he was no longer working for a daily wage but had become a pieceworker and an independent contractor of sorts. Afterward he took a certain wry satisfaction in remembering the one hundred francs he received for his largest work of the decade, the giant figures that adorn the façade of the Théâtre des Gobelins, one of the theatres erected during the building boom of the late 1860s.

"I was very proud of having been so well paid," he told a friend many years later. At the time, any Impressionist would have been happy to sell a picture for thirty or forty francs.

The Théâtre des Gobelins still stands at No. 73, avenue des Gobelins, but it has been converted into a film theatre, and no one seems to notice the two large figures in relief surmounting the loggia on the upper floors. The two figures, both with arms outstretched, lean toward each other across the arch of the loggia: they represent the lighter and darker sides of the theatre usually symbolized by the masks of comedy and tragedy. The smiling female figure holds a jester's staff and a pair of castanets (or rather, the classic Greek krótala); the long-haired male *furioso* flourishes a torch and a sword. Both faces bear a much closer resemblance to real faces than most allegorical sculptures of the day. Even here, three stories above the street, Rodin insisted on a naturalism that was closer to Carpeaux's *la Danse* than Carrier's *Hebe Asleep.*

The Théâtre des Gobelins opened its doors in September 1869, the last year of peace under Napoléon III and a very busy one for ornamental sculptors. That year Carrier received the Order of Leopold from the King of the Belgians, as well as a commission to provide sculptures for the new stock exchange then being built in Brussels. During the autumn and winter of 1869, with Rodin's help, he produced 20,000 francs' worth of sculptured ceilings for the Grande Galerie of the Louvre, but war was to intervene before they could be installed.

The Second Empire, in the plenitude of its prosperity, was being maneuvered into confrontation with its arch-rival, Prussia, over, of all things, the old dynastic question of the Spanish succession. War broke out during the summer of 1870. In Paris the mobs were shouting *"A Berlin, à Berlin!"*; in Berlin the cry was *"Zum Rhein, zum Rhein!"* On the 2nd of September the ailing Napoléon III and his army were caught in a giant trap at Sedan and forced to surrender. Two days later, at a dinner for twenty guests from the world of letters and politics given by the Marquise de Païva, Emile de Girardin announced that the revolutionaries were already out in the streets. "Yes," said the canny Marquise—her words are quoted in Arsène Houssaye's *Confessions*—"one day the whole structure finally cracks all over. It's like an earthquake."

Next day the Empress fled and the "tragedy of an arriviste who

arrived" was at an end. A decree issued by the provisional government on September 12 conscripted the able-bodied men of Paris into the Garde Nationale. Auguste Rodin, *sculpteur*, was drafted into the 8th Company of the 158th Battalion of the National Guard, whose muster roll gives his domicile as No. 175, rue Marcadet, in Montmartre. Serving with him, in képis and voluminous trousers, and carrying chassepot rifles, was a cross section of Paris—blacksmiths, shopkeepers, shoemakers, tailors, carpenters, office and restaurant employees, and the occasional journalist, painter and sculptor. Their mission was to resist the Prussian siege of Paris, which began on September 19 and was to last 132 days. Rodin became a corporal, perhaps in view of his superior education, and was nicknamed *le grave caporal* because he was rarely seen to smile. When winter came he suffered so severely from cold feet that he was forced to wear wooden shoes (sabots), and the neighbors now dubbed him *le caporal en sabots*. For Rodin it was an inauspicious beginning to what came to be known as *l'année terrible* of French history.

There was little for the National Guard to do but wait for an attack that never came. While they were sitting out the siege, as the *Revue des Deux Mondes* reported, the soldiers found ways of passing the time: "Some play at interminable games of *bouchon*, others, notwithstanding orders to the contrary, turn their attention to *écarté* and piquet; others gossip about the news of the day with the artillerymen, who are mounting guard over their cannon." The artists of Paris did what they could: Ernest Meissonier, the great painter of military pictures, was colonel of an infantry regiment; Dalou was a captain, Manet a lieutenant who, as Berthe Morisot noted, "spent his time during the siege changing his uniform." The sculptor-guardsman Alexandre Falguière, in his late thirties, amused the bored soldiers of his battalion by modeling in snow a colossal figure of a nude perched defiantly on a cannon—a symbol of *la Résistance* which became so famous that he was later obliged to reconstruct his snow woman in wax, clay and bronze.

For Rodin and his household there was even less to eat than usual. "He had no money," Bartlett relates; "food and fuel soon became scarce, and misery, cold, and hunger were almost unendurable. They were at first glad to eat horse meat, and at last a small piece of hardly edible bread was all they had." Fortunately he was asked to make

busts of two officers of his battalion for about thirty francs each. Then he was invalided out of the service on account of his myopia: the eyes with which he was to create the best-known images of France during the next forty years of peace were considered too feeble to serve the nation in time of war.

At the end of January 1871, the exhausted city capitulated to the Germans and the first food shipments reached the starving population. Rodin left Paris early in February, as soon as the roads reopened. Originally he intended to go to London to find work. But Carrier-Belleuse had gone to Brussels at the beginning of the war to establish a workshop there: he managed to obtain a *laissez-passer* for his quondam assistant, who set out for Belgium "thinking he might be again employed."

A passport he received from the French Embassy after his arrival in Brussels provides a detailed description of the young sculptor as he appeared at that uncertain moment of his life: it lists his height as 1.63 meters (5'4"), his eyes as blue, hair as chestnut, beard as reddish chestnut, forehead as high, nose as long, face as oval and complexion as *ordinaire*. He had left Rose behind to care for the five-year-old Auguste and a studio full of his plaster and clay sculptures. But France, at that moment, was clearly no place for an artist who wanted to make his way in the world. "I departed for Belgium," he recalled, "with great plans for the future and without a *sou*."

4

MY SAVAGE MUSE

Ce séjour à Bruxelles est pour moi
le point culminant de ma vie.

—RODIN
Autobiographical Notes

After his return to France Rodin described the six years he spent in Brussels as "the high point of my life" because they had ushered in his "manhood" as a sculptor and taught him to see art and nature in a new light. "It was there that I came to understand the power of nature," he wrote in his autobiographical notes of 1906. "It was the Walloon, but above all the Flemish landscape that brought it home to me; a land I loved as if it were my outdoor atelier."

His first months in Brussels were harder than he liked to remember. He arrived in February 1871, at a time when the Belgian capital was swarming with French refugees: the war had created thousands of displaced person who were learning, as Rodin did, to *se débrouiller*; to shift for themselves. Fortunately Carrier-Belleuse had work for him at a journeyman's wages of 1.50 francs an hour, for the war in France had done nothing to diminish the building boom in Brussels, a city of 160,000 just coming into its own as a modern commercial center. While Prussian shells were falling on Paris it was business as usual in Brussels. Carrier was engaged in creating a long, complicated frieze for the Bourse du Commerce, an imposing stock-exchange

building that was to be adorned with sculptures by various hands illustrating the onward march of mercantile prosperity.

The neo-Renaissance Bourse had been designed by a prominent Belgian architect, Léon Suys, whose work was even more ornate than Garnier's Paris Opéra. At the architect's invitation, Carrier had installed his Brussels atelier in a building belonging to Suys in the suburb of Ixelles, at No. 80, rue Montoyer. In addition to the frieze for the rear and sides of the Bourse, he was to sculpt the figures of Prudence, Vigilance, Jurisprudence and Order—excellent virtues to be embodied in stone at a time when Belgium was trembling at the news of the disorder and imprudence of the Paris Commune. But Carrier was also turning out commercial sculpture for the local *bronzes d'art* market—"new terra cottas and casts of his earlier ones," according to Maurice Dreyfous, a friend (and later biographer) of Dalou who was among the French refugees in Brussels.

Dreyfous had known Carrier in Paris: in his memoirs he recalled that in these new surroundings the sculptor "employed a whole *équipe* of young men whom he paid by the hour. Among them was Rodin, who had not yet finished growing the beard that was to be his later glory. He was obliged to subordinate the natural vigor of his talent to the demands of the job, which called for him to imitate Carrier's supple, elegant style. Often he only half succeeded, and then, onto some rather facile work of Carrier's he would manage to graft a wonderfully energetic morceau of his own that would nevertheless harmonize with the rest. I don't recall ever hearing him complain about having to perform these chores at what were certainly modest enough wages."

As before, Rodin was earning about twice as much as a stonemason, enough to enable him to save the small sums he intended to send to Rose and pay the rent on his Paris studio. But political events intervened: on March 27 the Commune was proclaimed by the radical leaders of Paris, many of them Rodin's former neighbors in Montmartre. A few days later the city was besieged a second time—by a French army loyal to the right-wing National Assembly, which had established its headquarters at Versailles.

Rodin heard the news with mounting anxiety, but for two months there was no way he could communicate with Rose or his parents. It

was a traumatic period for the Parisian refugees in Brussels, whether their sympathies lay with the left or the right. Cut off from news of their families, they read daily reports of artillery barrages and of atrocities committed by both sides. "Every dispatch brought us news of some fresh act of vandalism," Dreyfous recalled. "Once there was a report that the Tuileries had been set on fire—which led me to commit a terrible gaffe. I happened to meet Carrier-Belleuse; by way of greeting I rushed up to him and shouted, 'Have Carpeaux's sculptures been damaged?' He assured me that happily they were intact. At that moment, be it said to his credit, he had completely forgotten that a fronton of his own adjoined Carpeaux's masterpieces on the Pavillon de Flore."

When Rodin joined it, Carrier's Brussels *équipe* was headed by three Belgian sculptors: Antoine-Joseph Van Rasbourgh, Norbert Mewis and Juliaan Dillens. Van Rasbourgh, the senior assistant, had worked for Carrier in Paris for five or six years before returning to the land of his birth; according to Rodin he was a craftsman of limited attainments "who had some talent for making figures of infants." Mewis, by his own admission, was only "a modest sculptor-workman." Even so, he was placed in charge of one of the most important Stock Exchange commissions: "On behalf of M. Carrier-Belleuse I executed all the bas-reliefs that decorate the three façades of the Bourse," as one of his letters testifies. Dillens, a gifted sculptor who was only twenty-one at the time, also worked on "a large part" of the frieze. Rodin's part in this project seems to have been minimal, since most of it was finished by the time he arrived. It was, in any case, a faintly ridiculous affair—a series of chubby infants, or *amorini*, engaged in activities representing agriculture, coal mining, beer brewing and so on.

While working in Carrier's studio Rodin rented a room near the center of the city, above a workingman's café at No. 36, rue du Pont-Neuf. At Carrier's atelier he became particularly friendly with the youngest member of the staff, who never forgot the impression that Rodin made on him. "I was a *modeleur*," Dillens recalled. "Rodin scraped away at the plaster; his pockets were full of books and he used to smack his lips in anticipation of the large slice of bread and butter with *plattekeis* (white cheese) which he was going to consume that evening. . . ." The other studio assistants often came to Rodin

for advice. When they asked him why he had not yet produced a masterpiece that would show the world what he could really do, he told them that there was no need to hurry; an artist always had time to make a beginning once he was sure of his subject—"an artist can establish his reputation with a single piece of sculpture."

But Rodin was beginning to resent the conditions of servitude in Carrier's workshop, and inevitably he quarreled with his employer. "After he had been at work for a few months," Bartlett writes,

Carrier-Belleuse made an exhibition of his things, and Rodin, also, put some of his own terra-cotta heads and figures in a shop window in the same street where those of Carrier were, but without the slightest idea of competing with him. He soon learned, however, of the danger of even a similitude of competition with a business sculptor. When the next payday came round, Carrier parentally suggested to Rodin that it would be a good idea for him to rest awhile. Although no reference was made by Carrier to the two exhibitions, Rodin saw the point. It was a discharge, and the workman accepted it, though he was considerably surprised.

Carrier, in any case, was anxious to resume his practice in Paris. He returned to France on May 16, 1871, five days before the army of Versailles commenced its final assault on the last bastion of the Commune. Rodin, meanwhile, had no other prospects for employment and nothing to live on except fifty francs which he had received from Antwerp in payment of some terra cottas. Prudently he invested most of this in a supply of iron rations, including a large ham. There were days when he would dine on "ten centimes' worth of mussels and ten of fried potatoes," as he told Rose afterward; "that was another siege."

Yet just as he was carving the last slices from his ham he managed to make a new set of working arrangements with Van Rasbourgh, who was to take Carrier's place as one of the principal sculpture contractors of the Brussels Bourse. Van Rasbourgh, nine years older than Rodin, was well aware that he would need his colleague's assistance in executing the commissions that were due to come his way. Rodin agreed to go into partnership with him—later there was to be

a formal contract—but several more weeks elapsed before he was again gainfully employed. "Fortunately there is a pharmacist here, and one of my colleagues, who have helped me; without them I don't know what I would have done."

The civil war in France came to an end with a terrible bloodletting at the end of May. In the last days of the Commune, radical extremists executed sixty-four hostages, including the archbishop of Paris. In retaliation the victorious army of Versailles shot 6,000 left-wing prisoners; altogether some 25,000 people paid with their lives to expiate the sins of the Commune.

Jules Dalou, who had played a minor role in the Fine Arts administration of the Commune, was among those who had to flee for their lives; he was to find refuge in England (later he was tried in absentia and sentenced to life imprisonment at hard labor). But during these terrible weeks Rodin's first thought was for Rose and his parents. On June 3, as soon as the mail could get through, he sent Rose a letter whose urgency was underscored by its headlong rush of almost unpunctuated sentences:

My darling angel with a heavy heart I write you my poor Rose where are you? Write me right away I write to my parents too what has become of them.

Write me right away how you are as for me I had hopes my affairs would go well but I am indifferent to everything. Write quickly I will be able to send you a little money.

If I could press you to my heart again, Rose. Wholly yours,

A. Rodin
rue du Pont-Neuf 36

Her reply reassured him that they had all survived the second siege. Living alone in Montmartre she had dutifully continued to keep his clay sculptures wrapped in damp cloths, and had supported herself and their son by sewing shirts for the Communard Army at twenty-five *sous* (1.25 francs) per day. With little Auguste on her shoulders she had stood in the long queues outside the butcher shops to obtain their meager meat ration. But her letter said little about all this, and Rodin was anxious to know more. A letter he sent in mid-June pressing

for further details went astray; after waiting for four weeks for a reply he wrote another, asking the same questions and giving her an inkling of his own difficulties in making ends meet:

> My little angel I am happy that you are safe and sound except that I am eager for news and your answers are not long enough you don't reply to all the questions I put to you give me details so that I'll know what you were doing during these dark days I can console you in advance by telling you that I'll be sending you some money in a few days because I'll be getting some soon I think things are going to work out, let us keep hoping my angel and if I stay in Brussels I shall send for you because I am lonely for you [*je m'ennuie après toi*].

He wondered whether she had been in touch with Monsieur Garnier, the brick manufacturer whose portrait bust, and that of his wife, he had modeled in 1870, and with Monsieur Bernard the marble cutter, "to whom I shall send money; soon you will go to see him and also to the atelier; nothing is broken I hope?" There had been unforeseen problems in Brussels: "Just think my little Rose, I have had a lot of trouble, it is almost three months that I haven't worked you can imagine how hard it's been we are angry with Monsieur Carrier but even so it will all work out you'll have to wait a little longer Rose, I don't have a *sou* for the moment. . . ."

He had, by then, begun working with Van Rasbourgh in the studio they had rented, also in Ixelles, at No. 111, rue Sans-Souci. For the time being, though they had obtained several commissions, they were still on short rations. Bartlett reports that "the prices they received were very moderate, and though Rodin worked very fast he could succeed in gaining merely ordinary wages." Nonetheless, the immediate effect of this arrangement was that he was able to send Rose twenty francs for herself—"spend them carefully"—and thirty for his mother: "My poor Rose how I'd like to kiss you but I can't send for you yet I still have almost nothing to spend."

Rose's replies have not been preserved, but they must have been long enough to satisfy him, since his next letter brims over with high spirits:

. . . I was in the country I felt fine I enjoyed the pure air of a beautiful day . . . it seemed to me that I could hear you saying sweet things and that you were happy. And all this sequence of thoughts about Rose was the effect of a song you used to sing that came back into my mind:

Soldats qui m'écoutez
Ne le dites pas à ma mère,
Mais dites-lui plutôt
Que je suis à Breslau
Pris par les Polonais
*Qu'elle me r'verra jamais**

He wrote her that he was astonished at having had such an attack of tenderness: "I am so mobile, so changeable that sometimes I am even visited by affectionate little feelings." Still, toward the end of the letter he returned to more practical concerns: "When you moisten my clay figure don't make it too wet or the legs will become too soft. I'm glad you're still looking after my plasters and clay sculptures." Enclosed were five francs for herself, "to spend on completing your wardrobe," and thirty francs for his parents.

By October Rodin had made enough money to repay the rest of his Paris debts and to ask Rose to join him—but these developments were overshadowed by the news that his mother had died, one of the tens of thousands who had succumbed to malnutrition and disease in the aftermath of *l'année terrible.*† At the same time Jean-Baptiste's health was giving serious cause for concern: "Write me, *ma chère amie*, go to see Papa and tell me how he's feeling," he wrote to Rose

*A ballad of the Napoleonic Wars that Rose had evidently learned in childhood. The narrator is a soldier who has killed his captain in a duel and is now to be executed for murder. Yves Montand has made a recording of the classic *Chanson du Capitaine* in a slightly different form, substituting Bordeaux and the English for Breslau and the Poles (Parlophone PMC 1063): "Take my heart, wrap it in a white cloth and send it to my beloved. Tell my mother, not that I am dead but that I am in Bordeaux, a prisoner of the English; this will be my end."

†Apparently she was buried in a pauper's grave along with other delayed victims of the two sieges. There were so many deaths at the time that the police registers could not keep up with them, and the Service des Recherches of the city of Paris has been unable to locate a death certificate for Marie Rodin.

on October 1, 1871. This time he enclosed one hundred francs: "sixty-five for Monsieur Tyrode [their landlord in the rue Marcadet] and the rest for your moving expenses." He added instructions and sketches to help her sort out which of his sculptures were to be left behind, in his studio in the rue Hermel. "Leave the *Gladiateur* which is too heavy you should also leave the little torso of the *amour* which is cut in the belly and cumbersome." The whole prospect of moving his best pieces to Brussels was very worrisome. "Leave the mold of Père Aymart [sic] but on the other hand take good care of the mold of Bibi, and the little virgin in clay (the sketch). . . . Take good care of the casts *ma petite*, wrap each one in newspaper, handkerchiefs or anything, especially the cast of *l'Alsacienne*."

The boy, Auguste-Eugène, was also to be left behind—in the care of the generous Aunt Thérèse, the widowed Madame Dubois. She lived at No. 22, rue Dauphine, where her hard-working son Auguste Cheffer ran a commercial engraving shop that specialized in stationery, cards and medals. He had married Anna, the daughter of Jean-Baptiste's younger brother Jacques-Alexandre Rodin, and had begun to raise a family of his own; in addition, one of the remaining Cheffer sisters had moved in with them, so there was no lack of willing hands to run the household.

When Rose arrived in Brussels she found Rodin already installed in a lodging more suitable for a couple than the tavern near the Pont Neuf; he had found a room in a garden suburb, at No. 346, chaussée de Wavre at Etterbeek, not far from his new atelier and close to the fields and forests where he liked to spend his Sundays. She brought him firsthand reports of the family—Jean-Baptiste was now wholly blind, and his wife's death had left a spate of unresolved problems. On October 20 Auguste Cheffer wrote his cousin a thoughtful, dignified letter explaining that Jean-Baptiste was becoming difficult and rather senile, unwilling to be left alone and incapable of looking after himself. Rodin had evidently wanted his father to join him in Brussels, but Cheffer felt that the retired inspector would not want to leave Paris and would be better off if he, too, lived with them in the rue Dauphine.

Rodin agreed, as he wrote to his cousin, that his suggestion "fulfills all the necessary conditions for a lasting solution. Especially since he'll have the same people around him and won't be living with

strangers. . . . I am immensely grateful to you, both for doing my errands and for offering me a way to solve my problems. As for me, all is well. We're working on a seven-meter group in stone but have to wait awhile for our money. The weather is rotten in this wretched country, and I think this is no place to regain one's health."

Cheffer had sent Rodin a list of the handful of valuables that had belonged to his mother, but Rodin wanted his cousin to have them. "I have no need of them, as you have been so kind as to act as the son of the house, I'm happy to leave them to your discretion." He enclosed twenty francs which were "especially earmarked for a house-warming dinner" to celebrate Jean-Baptiste's arrival in the Cheffer household. "The money should be used only for that; as soon as there's more I'll send some to Papa."

Rodin was relieved that both his father and son were now in safekeeping. But later there were complaints from the Cheffers that the boy was turning out to be a problem—"*C'est un vrai diable*," as Auguste Cheffer wrote. At school in the rue Vaugirard the little *bonhomme* had an annoying way of playing the buffoon—"*Il fait une vie de polichinelle.*" The boy had, in fact, suffered some brain damage when he fell out of a second-story window onto an awning below while trying to retrieve a little girl's balloon.

Rodin invited his cousin to visit them in Brussels but the engraver had to decline: there was too much work at the shop—"I don't have chains on my legs; only an engraver's stool *au derrière*." In August 1873, Aunt Thérèse herself wrote in an almost illegible scrawl to complain about little Auguste, and her son confirmed that he was causing them a lot of trouble with "*ses vilains défauts.*" Jean-Baptiste, the only one who genuinely cared for the boy, was becoming increasingly feeble and subject to fits of depression; sometimes he would spend whole days sitting silently in his chair. When Cheffer's patience finally wore thin he wrote to Rodin that the boy needed discipline; for his own good he would have to be sent to a boarding school.

By then Rodin had so much to do in Brussels that he could scarcely stop to concern himself with what was happening in Paris. His part-nership with Van Rasbourgh was proving more than moderately suc-cessful and he was beginning to feel a sense of accomplishment. They had delivered their first large stone group to the Bourse and had gone

on to produce a second, also to be mounted on the building's lateral façade, along the rue Henri Maus. The city of Brussels paid them the not inconsiderable sum of 14,900 francs for the two groups, which represented *l'Asie* and *l'Afrique* in the geography of world trade: on the opposite side there were complementary groups by two now-forgotten sculptors, *l'Europe* by Charles Van Oemberg and *l'Amérique* by Louis Samain.

Both *Asia* and *Africa* bear Van Rasbourgh's signature but reveal the hand and eye of his silent partner. Asia is personified by an Oriental queen flanked by a Chinese child and the male custodian of a coffer of fecundity. Africa, a woman with Egyptian features, holds a cornucopia on her knee; a muscular tribesman is seated on her left, gazing out over the city, and a naked child stands at her right—it may well embody Van Rasbourgh's "talent for making figures of infants."

However they may have divided the design and execution of these two groups, Van Rasbourgh was bound to take the credit, since Belgian opinion had become militantly chauvinistic in matters of public art.

Van Rasbourgh was thus trading on his nationality rather than his reputation in dealing with the city of Brussels, which employed ten local sculptors on Bourse commissions toward the end of 1872. Rodin was well aware that the prevailing xenophobia obliged him to keep out of sight: he had been anonymous in Carrier's studio; now he was Van Rasbourgh's ghost sculptor. As a result the first criticism of a Rodin work ever published ascribed it to someone else. Jean Rousseau, a prominent Belgian art critic and educator, wrote a detailed appraisal of the new Bourse after its inauguration in December 1873: his article in *l'Art Universel* has a good deal to say about *l'Asie* and *l'Afrique*, "two strong and recognizable subjects" crowning one of the façades:

> There are two things about this sculpture that please us enormously. First the choice of types and attributes is well suited to the subject. Asia is instantly recognizable by her oblique Chinese eyes and the silk drapery falling over her knees, as well as by the elegant Hindu who offers her perfumes on bended

knee. Africa is equally recognizable by her clearly delineated
Egyptian beauty, with her sheaf of corn recalling the proverbial
fertility of the banks of the Nile. And secondly, this lithe and
lively sculpture owes nothing to vulgar convention; in its feeling
for nature and directness of approach it accords very well with
the traditions of our historic Flemish school of sculpture.

The interior of the Bourse contained other works by "Van Ras-
bourgh" not mentioned in Rousseau's article. On the far wall of the
Grand-Salle there is a large pair of double caryatids representing *le
Commerce* and *l'Industrie*, flanked by two untitled winged figures that
may be intended to symbolize *la Gloire* and *la Chance*, both useful
elements in trading on the Stock Exchange. The caryatids support a
large marble relief of cupids, or so-called *génies enfants*, carrying
the globe—a theme which was to become the subject of Rodin's first
drypoint engraving nearly ten years later.

While working on these five major commissions the two sculptors
had legalized their partnership in a contract of association dated
February 12, 1873, which was intended to run for twenty years. Each
had an equal share in the enterprise, and the contract indicates that
they trusted each other implicitly, since both were empowered to sell
the firm's property, or buy materials for it, without the other's coun-
tersignature, and no limit was placed on the amount that each partner
could draw from their joint account. Van Rasbourgh was to make
sketches, direct the work and sign all sculptures intended for sale
in Belgium; Rodin was to do the same for work sold in France; both
names were to be signed for works entered in exhibitions. These
clauses were merely face-saving devices: Rodin seems to have been
responsible for virtually all the sculptures signed by Van Rasbourgh
under this arrangement—except for portions of certain groups, and
a bas-relief at the Palais des Académies whose banality has led to
suggestions that in this one instance the sculptor was Van Rasbourgh
himself.

Inevitably the burden of this partnership fell on Rodin's sturdy
shoulders: not only did he turn out most of the work but he was also
responsible for the firm's accounts and administration. Lawton, re-
porting what Rodin told him about Van Rasbourgh, writes that the

latter was simply "not fitted" for the major commissions they received. "He was a man of timid temperament, whose timidity extended to all he did. His aptitude for sculpture was chiefly in the modeling of baby figures." But Rodin was even more outspoken in his comments to Bartlett, who came away with the impression that Van Rasbourgh "was a good-for-nothing drunkard, as well as a worse-than-useless assistant in the studio," with the result that Rodin "dispensed with his services, kept him out of the studio as much as possible, and did all the work himself."

As usual, however, there are some glaring discrepancies among the various accounts. Rilke, in a letter to his wife, maintains that Rodin told him the very opposite; that Van Rasbourgh "took pride in doing things himself, and drove him from the studio, so Rodin had a lot more free time." Perhaps each tried to push the other out of the studio, but all things considered, Lawton's statement that "Van Rasbourgh was a man he could get on with" seems closest to the mark. Rodin himself, when he went off to Italy in 1875, wrote to Rose, "It's a pity that Joseph didn't come": if his partner was indeed a drunkard, at least Rodin did not bear him a grudge on that account.*

Certainly it was an unequal partnership, yet despite its ludicrous and vexing aspects Rodin was more than satisfied for the time being, since it brought him his independence as a sculptor. Working with the weak-willed Van Rasbourgh meant that he could be his own master, as Bartlett pointed out, "engaged upon work that suited his

*Later writers have often treated Van Rasbourgh as the villain of the piece. The Belgian critic Sander Pierron, who interviewed many of the people who had known both partners in Brussels, concluded that "Rodin, standing in the other's shadow, was the inventor, artist and idealist; Van Rasbourgh was the sneaky assistant, the hack worker, craftsman and profiteer." If so, then Rodin showed surprising kindness in his subsequent dealings with the man. When he returned to Paris in 1877, it was Madame Van Rasbourgh who looked after his effects for eighteen months. Later the Belgian sculptor's career took a predictable turn for the worse, and ultimately there was no more work for him in Brussels. In 1892 his wife wrote a desperate appeal to "Rosette" Beuret, reminding her of the old days and explaining their plight. Rodin promptly helped the Van Rasbourghs move to Paris; he was a witness at their daughter's wedding in 1897, employed their son Edmund as a studio assistant for several years and became the godfather and benefactor of their granddaughter, Zézette-Rosette, who often stayed with Rodin at Meudon. Van Rasbourgh himself died at Clichy in 1902, aged 74.

temperament, large compositions of many figures. From the first to the last he had his own way." At the same time he was at last earning enough to lead a relatively comfortable existence: in Brussels, as Rilke heard thirty years later, "he had the best years of his life."

Rose's fondest memories were also of the years they spent in Belgium—"*Ah! Oui, c'était le bon temps,*" as she told Gustave Fuss-Amoré at the turn of the century. After more than a year of hunger and anxiety they were able to resume their domestic life where it had left off, and with it their old division of labor. Rodin worked at home on his own when he was not busy at the studio in the rue Sans-Souci; Rose did the housework and the shopping, sewed his clothes, posed for him on occasion and kept his clay sculptures covered in wet cloths—she was proud to call herself his *garçon d'atelier.*

At first they lived at Etterbeek; then, after several months at No. 72, rue du Trône, only a few steps from the studio in Ixelles, they moved further south, to a one-room cottage at No. 15, rue du Bourg-mestre, on the northern fringe of the Forêt de Soignes, an immense forest that still covers most of the region south of Brussels. Their cottage, a stone's throw from a salient of the forest known as the Bois de la Cambre, was rented from a horticulturist whose gardens sur-rounded the house: the yearly rent was only 110 francs. Their own garden plot was twice the size of the cottage and contained one tree, "under which in summer they ate their meals, drank French wine, reposed themselves and rejoiced in sylvan happiness," as Bartlett relates. "For company they had a dog, a goat, a cat, and some rabbits." Rose cultivated the garden while Rodin "lay on the grass and gazed at the merciless firmament above him."

The forest of Soignes had been left almost untouched by the in-dustrialization of Belgium. Just beyond their cottage there were ponds, open fields and vast areas of forest traversed by good roads: since "both were fond of walking they made long journeys of many miles, without regard to where they were going, or when or how they would return." Rodin took up landscape painting and also did sketches in sanguine of the rolling countryside around Boitsford, Watermael and Auderghem. "I would spend whole days there," he recalled years later in his conversations with his secretary, Mario Meunier. "I did a little painting in those days. The light is wonderful in that country.

The interplay of sun and rain is so delicate, so varied and evanescent that I tried in vain to capture it in my paintings. . . . But in Belgium it rains a great deal. Rose carried an umbrella. I carried only my box of paints. When I saw a landscape I wanted to paint, or an effect of light that struck me as capable of being transferred to canvas, I would take my brushes, and while Rose protected me with her umbrella against the rain and the wind, I would quickly try to put this fairy tale sky on canvas. But the sun painted more quickly than I could. Ah, what beautiful days and thoughts and silences I spent in that forest of Soignes! It was Belgium that taught me about light."

The whole region of South Brabant provided him with subjects—the Grand-Etang of the priory of Rouge-Cloître, for example, as seen from the chaussée de Wavre; a tree-lined road near the old church of Boitsford, and the drève du Comte near the monastery of La Patte d'Oie in Groenendael.* "In the evening he would end up at the table of a country inn," as Pierron heard, "drinking the local beer and consuming with great gusto slabs of bread topped with white cheese, which he liked for its cool, tangy taste." Rodin came to think of these excursions as a turning point in his evolution as an artist. "The lovely forest of Groenendael!" he remembered long afterward. "It's there, perhaps, that I discovered my savage muse!"

But the sky and the forest were not his only teachers: living amid the Flemish treasure trove of painting and sculpture, Rodin lost no opportunity to expand his knowledge of other people's art. He went to see most of the great art centers of Belgium: Antwerp, Bruges, Ghent, Liège and Malines, as well as Audenaerde and Ypres. When Rodin and Rose stayed in Antwerp in 1874, Bartlett reports, "there was neither nook, corner nor object of interest that they did not see or explore. Rodin saw all the art there was to be seen. With Rubens he was in love, and copied, from memory, in his room many of the great painter's pictures." Rodin told Coquiot that to accomplish this tour de force he would travel back and forth between his lodgings and the museum, continually adding remembered details to his canvas

*At one time the Musée Rodin owned twenty-four of his small Corot-like landscape studies, but ten of them disappeared during the upheavals of World War II, when the museum evacuated its holdings to two châteaux in Sologne.

until he had arrived at a result that satisfied him. His copies of Rubens's *Coup de lance* and portrait of *Adrienne Perez, femme de Nicolas Rockox* seem to have been painted in this fashion.

Something in Rubens's work acted as a catalyst in the transformation that was taking place in Rodin's attitudes: later he said that it was Rubens's example that had helped him find his freedom. "I spent six years in Belgium and had time to love Rubens," he explained in a letter to the writer Lucien Solvay, one of the first Belgians to buy his work. "During my first year I was still under the influence of the prevailing Beaux-Arts taste, though the school itself had refused me admission. The great Rubens had not possessed the purity demanded by the Beaux-Arts; he was full of life and that was all— which is what the Beaux-Arts schools still think of him. Hence Rubens, like his fellow genius Puget, was passed over in silence. Little by little I realized that men of genius were resented. . . . I hewed close to Rubens, this *grand dramatique*, just as Delacroix had, and this helped me a great deal, and I had the courage to assert my manhood [*de me servir de mon sexe*] and to become a man at last."

>✠<

For Rodin this coming of age was a time of discoveries in literature as well as in art: intellectually, too, he was bent on lifting himself out of the ranks of the common *ouvriers-sculpteurs*. His Belgian friends remembered him as a young man with an obsessive interest in books. "His pockets were always crammed with books," Pierron writes. "On his way home in the evening, if light permitted, he would stroll down the middle of the sidewalk, his nose in a book, bumping into people and quite unaware of anything going on in the outer world. He would arrive home without even having heard the angry reproaches of the people whom he had almost knocked over."

His compulsive reading included Dante, Victor Hugo and the dialogues of Plato. Long afterward, when he described these literary adventures to Rilke, the poet decided that they marked another milestone in Rodin's life:

Hidden behind the work that he did for a living was his own growing work, biding its time. He read a great deal. People

were accustomed to seeing him in the streets of Brussels always with a book in his hand, but perhaps this book was only a pretext for his absorption in himself, in the immense task that lay ahead. . . . There was much in the books to encourage him. He read Dante's *Divine Comedy* for the first time; it was a revelation.

Rodin read the *Inferno* in Antoine de Rivarol's eighteenth-century translation, in an edition that cost him twenty-five centimes—"and I have always carried it in my pocket," he told Bartlett. "Other translations have been recommended to me as better than his, more learned, but I have never seen them." He began to think of it as a possible subject for sculpture, and to discuss it with his artist friends. Perhaps he also showed them a small *Ugolino*—his first interpretation of a character from Dante—which he produced in 1875. Dante, in any case, became "his" subject to the point where one of his Belgian friends, the engraver Gustave Biot, could write to him after his return to Paris in 1877: "Are you working on your subject of the *Divine Comedy*? Courage, *mon cher*, this is the moment to do something remarkable." It was the beginning of a lifelong preoccupation with a poet he admired as a "literary sculptor" who spoke "in gestures as well as words . . . in the movement of the body."*

Later the *Inferno* was to be followed by a second great literary affinity. "From Dante he came to Baudelaire," Rilke reports, as though this were the most natural sequence in the world. "He sensed in Baudelaire an artist who had preceded him, who had not allowed himself to be deluded by faces but had looked for bodies, in which life was more intense, more cruel and restless." Baudelaire was to become another of his special subjects—a sensualist who was the first to put faces and feet on many of the erotic ideas to which Rodin gave visual expression. In this constellation of influences—Rubens,

*Rodin's interest in Dante became something like the "friendship with a dead poet" that Jean-Paul Sartre discovered in Baudelaire's relationship to Edgar Allan Poe. But not everyone was to be equally impressed by the sculptor's affinity for the poet. "Rodin allows himself to be swallowed up by the old-fogey antiques of literature," wrote Edmond de Goncourt in his journal of 1889. "In his uneducated workman's brain this Dante becomes a narrow and stupid religion, a fanaticism. . . ."

Dante, Baudelaire—it was the French poet whose profoundly sub-versive "spleen" exercised the greatest fascination.

Baudelaire had, indeed, preceded Rodin—even to Brussels, where he had spent most of his last years, 1864–67, slowly drinking himself to death and complaining about *"ma tristesse en Belgique."* Rodin, on the other hand, had every reason to remember the Bruxellois with gratitude and affection for having given him "the most beautiful and happy days of our lives."

The Belgian artists and writers with whom he came into contact were the first to recognize his gifts: among them were the painter-sculptor Constantin Meunier, the sculptor Paul De Vigne and his cousin, the painter Lieven De Winne; the *animalier* Paul Bouré, Biot the engraver, Rousseau the critic, the sculptor Louis Dubois, Léon Gauchez, editor of the magazine *l'Art*, and his "affectionate comrade" Juliaan Dillens, who worked for a time as an assistant in the Van Rasbourgh studio.

Belgian salon juries were the first to accept Rodin's work for public exhibition. As early as 1871 he showed a *Jeune Alsacienne* (a portrait of Rose) and an unidentified terra cotta at the Salon Triennal of Ghent and the following year *The Man with the Broken Nose*, in plaster and entitled *Portrait de Monsieur B . . .* , made its formal debut at the Cercle Artistique of Brussels, the same society of art lovers to which Baudelaire had lectured on Delacroix in 1864. Though it went un-noticed in the press, Rodin "received, for the first time, words of commendation for it," as Bartlett learned. They came from Biot and Bouré: "The mask was generally admired and helped to make him friends. Among them was M. Jules Petit, a French singer, whose bust Rodin made in terra cotta." Petit had been a fellow pupil at the Petite Ecole before becoming a singer; the bust, which has since disap-peared, earned Rodin his first mention in the press. On November 10, 1875, *l'Art Universel*, which had already reviewed his "Van Ras-bourgh" sculptures, singled him out for praise under his own name in its review of the triennial Brussels Salon: "From Monsieur Rodin, a bust of M. Jules Petit, nobly expressed and compact in its modeling, with an emotional intimacy that makes the man come to life."

At the same Salon Rodin exhibited his bust of the pharmacist Alexandre Van Berckelaer, whose timely help had kept him from starving during the hungry days after his rupture with Carrier-Belleuse

(this bust's present whereabouts are also unknown). Rodin remembered it as a remarkable piece "that I enjoyed making, and one of the best I ever executed. . . . I made it in marble, though I was not paid for it. He had a remarkable head, of pure Flemish type, with a slight touch of Greek in it."

There was another occasion when Rodin repaid a kindness by sculpting one of his increasingly splendid portrait busts. One day he developed a hernia while moving a block of stone in his studio: Rose "ran for the nearest physician, who proved to be lame," as Bartlett relates. "He came, examined his patient, performed an operation, and made a number of successive visits." When Rodin asked him for his bill the doctor, seeing they were not rich, said very timidly that a sum variously reported as six or twelve francs "would not be too much." Rodin, it seems, had been singularly fortunate in his choice of neighbors. Dr. Jules Thiriar, six years younger than his patient, had only recently returned from Vienna, where he had completed his studies under Brahms's famous friend Theodor Billroth. Hernia surgery happened to be one of his specialties. Rodin was so impressed with this young surgeon that "I went soon after to see him and told him that I should be happy to make his bust as an acknowledgment of my appreciation of his kindness. He hesitated at first, but soon afterward, consented, and I made it in terra cotta. I learned, later on, that he consulted some of his friends and made some inquiries in regard to my capacity."

Word of Rodin's competence as a portraitist had begun to spread among the cognoscenti. He did a bust of the astute collector Joseph-Benoît Willems—the uncle of Gauchez of *l'Art*—whose collection of pictures and sculptures would one day form the nucleus of the Musée d'Ixelles. Rodin also did a portrait of De Vigne, three years his junior but already half bald, with something of the almond eyes and brooding forehead of a Debussy. De Vigne had become one of his staunchest supporters, and he was to be an influential member of the Ghent jury that awarded him his first medal, in 1880—an important gesture of encouragement at a time when an artist's standing was measured by the medals he displayed on his walls.

"I worked very hard over there" was Rodin's way of summing up his Belgian years. He was turning out sculpture at a rate that would have done credit to Carrier-Belleuse. No less than eleven pieces

attributed jointly to Rodin and Van Rasbourgh were in the 1873 International Exhibition held in London and Vienna. But much of this production consisted of commercial pieces which he later felt obliged to disown. He sold two small fantasy busts, known as *Suzon* and *Dosia*, to the Compagnie des Bronzes, a Brussels firm with its own showrooms and foundry, which advertised a complete range of "art and furniture bronzes, lighting fixtures and *bronze monumental*." One of them evidently began as a Rodin marble which he called *la Petite Manon*, and which he sold to the Compagnie for 500 francs, plus another hundred francs for the reproduction rights.

"Thinking they had a mine in Rodin which they could work for their exclusive profit," Bartlett says, "they wished to buy more of his things, but his suspicions were aroused at their readiness to purchase at a low price, and feeling that they had taken advantage of him in the first transaction, he would not let them have anything else." The Compagnie turned out Rodin's busts in several sizes and sold hundreds of copies of them until the 1920s. *Dosia*'s pert, pretty face was just what was wanted for the bibelot market: she sold as a stock item for many years and in occasional new guises—with grapes in her hair she became *la Vendangeuse*, The Grape Harvester; with ears of grain she was sold as *l'Eté*, Summer.

There were other pieces of this sort, intended as mantelpiece figurines, with such titles as *Vénus et l'amour*, *la Source* and *Tendresse maternelle*—"I was well punished because I didn't manage to sell them"—as well as a more substantial exercise in Carrier's mannerist vein, two embracing infants later christened *l'Idylle d'Ixelles*. A similar *enfant génie* appears, vastly enlarged, in one of the "trophies" with which the Rodin–Van Rasbourgh partnership decorated the wall surrounding the Brussels Palais des Académies in the spring of 1874: the cupid-geographer measuring the globe with his compass represents *la Science*. Surmounting the other portal farther down the rue Ducale are the attributes of *les Arts*—an almost literal copy of the *Apollo Belvedere* in the Vatican Museum* (of which there must have been a plaster cast in the Musée des Moulages), together with the lute of music and the laurel leaves of poetry. Though they were signed

*A copy of the *Apollo Belvedere*, cast in bronze and signed by Rodin, has recently come to light in America.

by Van Rasbourgh, Rodin afterward acknowledged the paternity of these two large sculptures: the torso, significantly, is the first of his partial figures, and established something of a precedent for the *non finito* sculptures with which he would one day illustrate Puvis de Chavannes's maxim: "More beautiful than a beautiful thing are the ruins of a beautiful thing." He told Lawton that he considered his work for the Palais, along with that on the Bourse, the best he had done in Brussels.

Apart from a bas-relief for the royal palace the partners received only one other major commission in the capital—a 4,400-franc contract to produce two caryatids, two *génies* and a bust of Beethoven for the façade of the main courtyard of the newly remodeled Royal Conservatory of Music. Both the caryatids and the bust were singled out for praise in the official reports of 1874: "Only one bust, that of Beethoven by M. Van Rasbourgh, seems to have been carried out in a completely satisfactory manner. . . ."

Rodin had already demonstrated his special gift for caryatids during the summer of 1872, when he had produced a superb set for two five-story houses on the boulevard Anspach, Nos. 33–35 and 37–39, at the corner of the rue Grétry. Each building received two atlantes (male) and a caryatid (female), which supported a balcony-like window on the second floor—and, in one case, the word CIGARES in a sign advertising Don José and Quo Vadis cigars for the tobacconist's shop on the ground floor. Working under his own name, Rodin had received only 250 francs for each of these caryatids, which were of painted plaster rather than stone: having created three Puget-like figures for one building, he then cast an identical set for the other. Three years later he was commissioned to do two caryatids and two atlantes to separate the bay windows in the ground floor of another building on the bustling boulevard Anspach, this time at No. 106, at the corner of the rue des Pierres.*

Meanwhile, Van Rasbourgh had negotiated a commission that took

*Only one set of the plaster and two of the stone caryatids escaped destruction during the modernization of Brussels: at the last minute the sculptor Jeff Lambeaux managed to save them from the wrecker's hammer. They were housed in an art school in the suburb of Saint-Gilles for a time before being sent to the Musée Rodin in 1927; hence they became known, misleadingly, as the *Caryatids of Saint-Gilles.*

them both to Antwerp for several months, to work on a monument to the city's popular burgomaster, Jean-François Loos, who had died in 1871. Loos had been mayor of Antwerp a decade earlier, when the city's old fortifications were torn down and its port opened to world trade, after the Dutch had ceded their right to levy toll on its shipping: moreover, as the *Journal des Beaux-Arts* pointed out, "his name was inseparably linked to the literary and artistic movement that has distinguished Antwerp." The Loos monument was financed by private subscription and the commission awarded to Jules Pécher, a local shipowner who was also an amateur painter and sculptor; or rather, as Rodin put it, he "had the ambition to pose as a sculptor." Pécher's maquette called for a central figure on a plinth, Antwerpia, encircled by four seated figures representing Commerce, Industry, Shipping and the Arts, who keep watch over a small bust of the burgomaster.

Pécher actually sculpted a sort of Statue of Liberty for the centerpiece of the monument, but for the rest he thought it advisable to call in Van Rasbourgh, and Rodin thus became a ghost sculptor to a ghost sculptor. He created the figure of Commerce with Mercury's caduceus, Industry with a sledge hammer and Shipping as a sailor with an anchor, while Van Rasbourgh worked on the corpulent nude symbolizing Art. "Thinking it a good opportunity, for the credit of all concerned, to do some extra fine statues," Bartlett writes, Rodin "decided to make them full size, or nine feet. Unfortunately he was throwing pearls before swine, and received the reward often meted out in payment for generous actions, for the contractor would only pay fourteen of the twenty hundred dollars [10,000 francs] promised; though he was very willing to put his name on the monument, as its author."

Rodin remembered that the plaster models for his three figures cost him a good deal of effort and aggravation, but they were also the prelude to the next step in his development as an artist: "I made the figures as I pleased, as I did everything I ever made, but our employer did not like them. He wanted them in the Rubens style of sculpture, and he would come to the studio when I was absent—he did not dare to come when I was there—and oblige Van Rasbourgh to alter them, to their great injury. I left them hardy and vigorous, but Van Rasbourgh's changes, and the wretched way that they were

executed in stone, have made them round, heavy, and lifeless. I was so disgusted with this that I lost all interest in the figures, and never went near them while they were being cut.

"Although I was in feeble health, a severe cough making my nights wretched, I worked on those figures with the greatest ardor . . . and it was while making the figure of the sailor that I was struck with its resemblance to the statues of Michelangelo, though I had not had him in my mind. The impression astonished me, and I wondered what should cause it. . . . My interest and curiosity were greatly awakened, and to satisfy my mind of the reality of this resemblance . . . I made a lot of sketches to see if I could get the same character, but without success."

Although the finished figures disappointed Rodin, others saw past their deficiencies and realized that here was something more than the work of a local amateur. In his description of the monument in an 1885 guide to Antwerp, the Belgian writer Camille Lemonnier was the first to use the fateful word "tormented," soon to become a cliché in connection with Rodin's work; "in tormented marble . . . massive, muscular figures whole fulsome nudity and jutting athletic profiles . . . recall the old Flemish sculpture and reflect the current Antwerp taste for robust opulence and magnificent forms."

The Loos monument turned out to be the partners' last joint venture. They ceased working together early in 1875, though their partnership was not legally dissolved until two years later. Later, Rodin remembered 1875 as "the year in which we had no work," but it did bring him the first sign that he was no longer wholly cut off from the official world of art. The sculpture jury of the Paris Salon accepted two of his works—the five-year-old terra cotta *Portrait of M. Garnier* and, more important, his *Man with the Broken Nose*, rejected by the jury eleven years earlier. This time it was submitted not in plaster but in marble. The carving had been executed by Rodin's praticien, Bernard, who did the work in Paris while he was occupied in Belgium.

The Salon opened on the 1st of May, 1875, and Rodin must have gone to Paris to see the exhibition at the Palais des Champs-Elysées. But he no longer had his old studio in the rue Hermel, in which he had stored "a large number of previous sketches, a quantity of valuable plaster casts and a clay figure, upon which he had worked for

two years." While he was living in Brussels the owner of the building, M. Robinet, had decided that he wanted the house for himself and had sold its contents at auction. No one had thought to inform Rodin and when he returned to the city, as Bartlett reports, "instead of finding his studio safe and sound, ready for his occupancy, he discovered that his possessions were scattered to the four winds, and his clay figure broken to pieces for the purpose of getting the iron that supported it, to sell to a junk dealer. It was truly, as he mournfully says, one of the cruelest events of his life."

Lacking a Paris address of his own, he gave Fourquet's address for his first listing in a Salon catalogue—their Marseille disagreement had been conveniently forgotten:

RODIN (Auguste), né à Paris, élève de MM. Barye et Carrier-Belleuse. A Bruxelles, rue du Bourgmestre, 15; et, à Paris, chez M. Fourquet, rue des Fourneaux, 36.

Though his belated debut went unnoticed by the critics, it represented a significant milestone in his career: in the eyes of the French public only those who had exhibited at the Salon could lay claim to being bona fide artists.

After returning to Brussels Rodin began working on a free-standing figure which, for once, had not been commissioned by anyone. It was to be his next Salon entry, large enough to be noticed in a crowd of statues, and as yet unnamed. By exercising "the greatest economy" he had saved enough money to support himself while the work was in progress—June 1875 to December 1876—and to meet the heavy expenses such a figure entailed. Though he had some notions as to a possible subject, his principal motive was "to make a study of the nude, a good figure, correct in design, concise in style, and firm in modeling—to make a good piece of sculpture."

To find a suitable model he asked an acquaintance, Captain Malevé, who commanded a signal company in the Belgian army, to send him nine of the strongest men in his unit. "From among them, Rodin chose me," remembered the Flemish *télégraphiste* Auguste Neyt nearly fifty years later. He had been twenty-two at the time, "a fine, noble-hearted boy, full of fire and valor," in Rodin's words. He was sent to Rodin's studio in the rue Sans-Souci, where "in lieu of doing

military drill I was supposed to pose for him"—sometimes as early as 5:00 A.M., sometimes at six in the evening.

Neyt was "a plain simple fellow, but of a certain native refinement," as Lawton learned, "well-featured, and with just sufficient instruction to respect things beyond his understanding." At first Rodin had the problem of placing him in the right pose, and they experimented with many different positions. "It was not at all easy," Neyt recalled. "Rodin did not want to strain the muscles; he had a horror of academic 'poses.' He wanted the model to assume a lifelike, natural stance. I managed to train myself to do this, and would pose for him two, three and even four hours at a stretch, up to the point when fatigue would destroy the truthfulness of my pose: 'a little longer, a little longer!' he would say—he himself never seemed to get tired."

He had told his friends that "an artist can establish his reputation with a single piece of sculpture," and it was clear that the nude figure which became *l'Age d'airain* was intended to perform this feat on his behalf. A dozen years later it seemed to Rodin that this figure was the great watershed; until then he had been misled by "the narrow way of looking at sculpture" into producing "an effect of a figure, not the fact."

> I lived until I was thirty-five years of age before I dared quit this false way of working as a sculptor, and I never made any progress until I did get out of it. I was always desirous of making strong and powerful things, but in spite of all I could do they look little and lifeless. I knew it but could not help it. They were as distasteful to me as were the works of other sculptors. And though I kept on working in that way, I felt it was not the right way.

In his new figure he wanted to apply the principles he had derived from experience and observation: "I was a realist, that is . . . I was trying to make good sculpture." But before he could finish it there were certain difficulties to overcome. "When I was making *l'Age d'airain* I was in the deepest darkness, thought it a failure," he told Bartlett. In conversation with another critic he remembered having spent three months on one leg of this figure, until "I had at last

absolutely mastered it." Still he was not satisfied with the way things were going. "The sailor at Antwerp lay uneasy on his mind," Bartlett noted. "The studies of the past eighteen years were demanding some definite order and classification, some tangible point of departure."

He thought that by consulting Michelangelo in situ he might be able to sort out these problems. Hence, as the year 1875 drew to a close, Rodin set out on his first journey to Italy, alone, but no longer a journeyman: at thirty-five he was a young master in search of his roots. His arrival in Florence happened to coincide with that city's celebration of the 400th anniversary of Michelangelo's birth.

5

A LION IN
THE SHEEPFOLD

*Il est certain qu'il n'était pas à sa place,
lui, lion dans la bergerie.**

—ANTOINE BOURDELLE
La Sculpture et Rodin

odin traveled to the Italian Renaissance by way of the
French Gothic. He stopped off first at the citadel town of
Dinant, on the Meuse, to see the church of Notre Dame,
one of the finest examples of High Gothic in the whole of
Belgium. Then the railway took him to Reims, whose cathedral he
was afterward to describe as the "immense figure of a woman kneeling
in prayer." It was the beginning of a new phase in his lifelong fas-
cination with the great cathedrals of France. "Dinant is picturesque,"
he wrote to Rose a week after his arrival in Florence, "but Reims,
its cathedral, is of a beauty I have not yet encountered in Italy."

He was traveling "just as I do at home, eating and drinking at the
prices I want to pay, and so I have become intrepid, like all travelers,
and get on very well." At Pontarlier, last stop before the Swiss border,
the ground was covered with two feet of snow, and Rodin thought it
prudent to buy a sausage as an alimentary precaution. "The view of
the Alps on the way to Lausanne was admirable all the way to Ge-
neva—a beautiful city. Then the railway enters Savoie, a wretched

*"It is certain he was not in his proper place, this lion in the sheepfold."

[93]

country, whose finest chalets are the ones the Savoyards have built on the outskirts of Paris. In Savoie itself there is nothing but mountains—horrible all the way to St.-Jean-de-Maurienne. Hemmed in by these awful walls human beings soon become cretins." On the Italian side of the Alps the landscape "is not only very beautiful but more human, and just as grandiose as Savoie." Then came Turin in the rain: "it has modern sculpture in all the public squares, very ugly, including the Marochetti, an equestrian figure sheathing his sword."*

In Genoa he feasted on artichokes and peas: "very pretty women, Rosette. Pugets very like Michelangelo in detail, but somehow less Puget than the ones I know. The train takes me on to Pisa, more than a hundred tunnels, all very small, just like the Alps. . . . From Pisa to Florence wonderful weather, an earthly paradise, with mountains that are green, purple, blue. In Florence the weather has been foggy, with a little rain, for the last six days."

He was still carrying the Pontarlier sausage; "it begins to embarrass me, I thought it would be impossible to eat in Italy, and this was to be my iron ration. But I eat well and drink to your health quite well too. I've just poured myself a glass from a bottle like a Marie-Jeanne; I've had it brought to my room to give me strength for the hard life I'm leading."

His letter to Rose included the usual urgent instructions about studio maintenance: "Take good care of my figure, don't wet it too much; I prefer it to remain rather firm. Attend to this yourself and don't let the clumsy little Paul [Frisch, his *apprenti*†] touch it when he is alone." But the important thing, as he told Rose, was that he had accomplished what he set out to do—study the great Michelangelo sculptures at first hand. "All that I have seen of photographs and plaster casts cannot begin to give an idea of the Sacristy of San Lorenzo. One must see the tombs in profile, from a three-quarter view. I have spent five days in Florence; not until today did I see the Sacristy—so for five days I've been cold. Up to now three things

*The monument to Emmanuel Philibert, Duke of Savoy, by Charles Marochetti (1801–1868) in the Piazza San Carlo.
†And no relation to Victor Frisch, a sculptor who worked for him briefly in later years and wrote a bogus biography of Rodin.

have made a deep and lasting impression on me: Reims, the ramparts of the Alps and the Sacristy.

"Seeing them for the first time it is impossible to make a rational analysis. You won't be surprised if I tell you that, from my first hour in Florence, I have been studying Michelangelo, and I believe that the great magician is letting me in on some of his secrets. . . . I have made sketches in the evening, in my room, not directly of his works but of their structure [*les échafaudages*, the scaffolding]; the system I'm building in my imagination in order to understand him. Well enough; I think that I've succeeded, in my own fashion, in giving them that élan, that indefinable something, which he alone knew how to produce."

He began by making drawings from memory of some of the figures in the Medici Chapel, and went on to fill his notebook with tiny sketches of other works that caught his eye—a *Pietà*, a *Diane et Actéon*, a Roman sarcophagus, a Centaur, a Medea-like group that bears the scribbled comment, "work interrupted; good-bye to school," and numerous paraphrases of Michelangelo, including one that transforms a male nude into a clothed woman with child. As usual he was interested in surfaces as well as structures. "He told me," recorded his pupil Malvina Hoffman, "that he had spent many hours studying Michelangelo's sculpture in Florence and identifying the strokes of certain tools, and just what effects they were capable of giving."

The whole journey to Italy was one of the great formative experiences of his life. He had come to Florence "with my head full of the Greek models which I studied so passionately at the Louvre," only to find himself "disconcerted" by the Michelangelos. At every point, he told Paul Gsell, "they contradicated all those truths which I had regarded as definitive. 'Hold on!' I said to myself, 'why this incurving of the body? Why this hip raised, this shoulder lowered?' I was very perplexed. . . . And yet Michelangelo could not have been mistaken! I had to understand him; I went on trying and I succeeded."

Thirty years later Rodin explained to Bourdelle that "It was Michelangelo who liberated me from academicism, and from whom I learned, by observation, rules that were diametrically opposed to the ones I had been taught (in the school of Ingres). . . . I repeat, it was

he who reached out his powerful hand to me. It was by this bridge that I crossed from one school to the other. He was the mighty Geryon who carried me; it was to this opportunity to go to Italy in 1875, *to study him*, that I owe my liberty."

Yet these recollections belong to Rodin's later years. While the experience was still fresh in his mind he expressed himself far more ambivalently about this pilgrimage to Michelangelo. Talking to Bartlett in 1887 he conceded that the Medici tombs had touched him more profoundly than anything he had ever seen—but only "as a matter of impression." As usual he was looking at everything with a quizzical eye: "For Michelangelo, great as he is, is weak in modeling in comparison with the antique. I like his works because they are living and I could find in them what I wanted. After looking at these figures long and well, I returned to my room at the hotel and began making sketches, to test the depth of my own capacity of composition and of the impressions I had received; and I found that I could do nothing like my sailor, unless I copied Michelangelo.

"I made no end of sketches, always with the same result. During my journey to Rome, Naples, Siena, and Venice, I continued drawing, in the hope of discovering the principles upon which the compositions of Michelangelo's figures were founded.* I was, at the same time, struck with the idea that these principles were not original with him, but the result of discoveries made by those who had preceded him. I also had my doubts about his being conscious of these principles, or that he was the consummate artist and man that many think he is. He seems to me to have worked little from nature; that he had one figure, or type, that he reproduced everywhere and constantly, and that he took entire figures from Donatello. . . ."

Still, it was the question of Michelangelo's "secret," rather than Donatello's, that preoccupied him on his accelerated grand tour—a week in Florence and less than two weeks, all told, in Rome, Naples,

*Lawton reports that Rodin learned that in Michelangelo's statues "there was a simplification of the Greek rhythm of four lines, four volumes, and four planes made by a man when standing in a position of equilibrium, one sloping out from the shoulders, another coming back through the hips, a third sloping down and out again through the knees, and a fourth returning in a direction opposite the first and toward the feet. The Italian sculptor reduced the four-lined zigzag \gtrless to a two-lined one $>$, obtaining broader surfaces, and consequently a stronger play of light and shade."

Siena, Padua, and Venice. In Rome he seems to have begun working on the idea of an *Ugolino*, the Dantean subject which Carpeaux had chosen as his major *envoi* from Rome nearly twenty years earlier.*

In Naples there was another memorable discovery at the National Museum, with its magnificent collection of Greek and Roman sculptures. At home Rodin had just spent three months on the leg of his steadfast soldier; now, at the Museo Nazionale, he noticed an antique "whose leg was in exactly the same pose as my figure. . . . I studied it, and realized that though on the surface everything seemed to be done at a stroke, in reality all the muscles were properly built up and the details could be distinguished one by one."† It struck him that this figure embodied the results of "all his study and research," and that he had arrived intuitively at the same conception as the ancient Greeks—"because the ancients studied everything in its successive profiles, because in any figure and every part of a figure no profile is like another; when each has been studied separately the whole appears simple and alive."

Although he was in a hurry to return to Brussels Rodin stopped off in Paris for two days to visit his father and nine-year-old son; in a postscript from Italy, Rose had been reminded to "finish Auguste's little overcoat in time for that." Later, in his studio at Ixelles, he went back to his figure while continuing his studies of the elusive Michelangelo problem. For six months, as he recalled, he "did quantities of sketches for which he arranged his models in Michelangelesque poses," hoping that they might help him discover the secret.

Only then did he arrive at a solution that seemed to satisfy him: Michelangelo, he decided, had depicted natural human attitudes

*Carpeaux, too, when he first arrived in Italy in 1856, proceeded "to discover in Michelangelo methods of construction of which I was ignorant." As a Rome-prize winner he came to the conclusion that "when an artist feels pale and cold, he runs to Michelangelo to warm himself in the rays of his sun."

†Rodin remembered this sculpture as "an Apollo," but it was probably the *Doryphorus* (spear carrier) of Polyclitus, one of the treasures of the Museo Nazionale. Rodin's figure not only stands like the *Doryphorus* but was also, at first, intended to hold a spear. Perhaps the resemblance was only a coincidence, but Rodin may well have seen a plaster cast of this well-known figure before coming to Italy.

rather than artificial poses—"he transcribed from nature the human body's marvelous diversity of action." Afterward Rodin liked to say that he had "gone to search in Rome for that which he could have found in Paris or anywhere else," yet he looked back on this first Italian journey as his great voyage of discovery. It had taught him, he said, that the essence of sculpture was in its intrinsic form and material, *le modelé*, rather than in the pose or "character" of a piece. This view of modeling as important for its own sake had its counterpart in Mallarmé's insistence that "you can't make a poem with ideas. . . . You make it with words."

For the time being, at least, Rodin was still struggling with the problem of a subject for his unnamed figure, which was to take another whole year to complete. "I was in the deepest despair with that figure," he told Bartlett, "and I worked so intensely on it, trying to get what I wanted, that there are at least four figures in it." The difficulties were largely conceptual, since Rodin never did quite decide what the figure was intended to represent: "I had no name for it. This name [*The Age of Bronze*] was given to it by someone—it is the life I search for, life always."

Originally, as he told Coquiot, "I wanted to do a wounded soldier, leaning on a lance." Wounded soldiers were, of course, the sculptural aftermath of the lost war. The medal of honor at the 1874 Salon had been won by the twenty-nine-year-old Antonin Mercié with a Rome-prize *envoi* in plaster entitled *Gloria Victis*—the spirit of *gloire* bearing the naked body of a fallen youth, still clutching a broken sword. It had been exhibited again in bronze a year later, when Rodin must have seen it at the Salon, together with Falguière's much-admired statue of a Swiss girl supporting an exhausted French soldier.

Yet there was another strong current in Salon sculpture that accorded with the prevailing interest in archeology, paleontology and all things primeval. In the same Salon Emmanuel Frémiet won acclaim with his *Stone Age Man*, regarded as a worthy companion piece to his recurring subject, that of a gorilla making off with a native woman. Rodin told Lawton that he had originally thought of his figure in similar terms; during his rambles through the forest he had envisaged a sort of Man of the Woods from Jean-Jacques Rousseau. "His idea was to represent one of the first inhabitants of our world, physically

perfect, but in the infancy of comprehension, and beginning to awake to the world's meaning."

Rodin's figure originally wore a narrow fillet (which left traces of a furrow on the head which he made no effort to remove) and held a shoulder-high spear in the left hand—attributes equally consistent with a warrior stoic in defeat or a *Man of the First Ages*. Later there were to be still other titles, such as *Man Awakening to Nature* and *Primeval Man*. To Bartlett, Rodin conceded that all these titles were rationalizations—the "question of subject" had not concerned him until after he had experimented with his model and placed him in a "harmonious" pose. The resulting figure was "really nothing more nor less than a piece of sculpture—an expression of the character of his model, and of his capacity to reproduce it in clay."

When the figure was first exhibited, in plaster, at the Brussels Cercle Artistique in January 1877, it bore the title *le Vaincu* (The Vanquished). Rodin had already taken off the headband and removed the spear from the left hand "as somewhat interfering with the play of light on that side," leaving the arm poised enigmatically in midair. Despite this omission it "caused a sensation among the artists," as Jean Rousseau reported in *l'Echo du Parlement Belge*—"as a work of art it is very beautiful and above all very original." Still, some of the cognoscenti who flocked to see it asked predictable questions about "this standing figure of a nude young man in an attitude of dejection." It seemed that the young sculptor had been so concerned with matters of style and execution that he had "forgotten only one thing: to baptize his plaster and explain his subject. . . . What is the meaning of these half-closed eyes and that raised hand? Is this the statue of a sleepwalker?"

Rousseau, who must have known all about the genesis of Rodin's figure, did his best to answer these objections. "Let us be reassured: all is clearly and logically explained by the figure's title, *le Vaincu*, and it suffices to add that the raised hand ought to hold two spears."*

*Rodin made a drawing, now lost but reproduced in Maillard's book (1899), of the figure holding one spear; a second would seem wholly superfluous, and Rousseau was probably mistaken. On the other hand he may well have visited Rodin's studio while the work was in progress, and have seen a preliminary version involving two spears.

His unsigned article, however, did not appear until April 11, by which time Rodin and his plaster figure had already left for Paris. Rousseau's defense was really a belated reply to a brief but fatally mixed notice that had appeared in *l'Etoile Belge* on January 29:

> M. Rodin, one of our most gifted sculptors, who has thus far attracted notice at the Salon only with his busts, has exhibited a statue at the Cercle Artistique which is destined to figure in the next Paris Salon. It will certainly not go unnoticed, for it attracts our attention by its originality and retains it by virtue of a quality as precious as it is rare—life. As to what role casting from life may have played in the making of this plaster we shall not examine here.

Rodin had every reason to resent the suggestion that he had used *surmoulage*—casting from the live model—in the making of his figure. Surmoulage was a trick often used by professional sculptors: in an age of wedding-cake figures it speeded up the process of arriving at a reasonable facsimile of the human form. But Rodin had come quite honestly by the realism that impressed everyone about *le Vaincu*: he had worked on it more intensively, and for a longer time, than on any other single figure of his career. The charge of surmoulage was all the more galling because he knew, even if his critics did not, that casting from life produced only the most mediocre results. "It is poor, thin, dead," he told Bartlett. "A poor kind of photographing from nature; the trick of the plaster molder, not real sculpture."*

He wrote an angry letter to *l'Etoile Belge* that was published on February 2. "If any connoisseur will do me the favor of reassuring himself on this point, I shall show him my model and he can judge how far an artistic interpretation must be removed from a slavish copy." The editors, in turn, thought it strange "that he should use our perfectly friendly report as a basis for his reply to doubts that had their origin at the Cercle Artistique."

This was a less than satisfactory apology, and Rodin realized that

*A century later George Segal was to build a wholly respectable career on casting from life, to the delight of critics and collectors. But that was in another country, and besides, the charm of his sculptures is that they look quite dead.

the denial rarely catches up with the accusation. His ultimate vindication would have to come from the Paris Salon. In March he went to Paris to prepare the way for his figure's submission to the jury. Writing to Rose toward the end of the month, he admitted being unusually nervous about the outcome: "I ran so many errands today that I'm very tired. I see that my affairs are going well enough, but I'm still anxious and worried about my statue. What a waste of time. I had to go to the railway station three days in succession hoping to collect it; it arrived safely without anything broken. I went to the exhibition several times, anyway I'm going to work a little while waiting for the jury to decide, which will take place on the 5th and 6th of April; sometimes I get discouraged, today it seemed to me that my statue was not as good as I thought it was; M. Falguière thought it was very fine."

For the time being he had found space in a studio belonging to a friend, the sculptor Victor Tournier, at No. 3, rue de Bretonvilliers on the Ile Saint-Louis. No sooner had his figure arrived in Paris than he began to have impatient thoughts about some of the work left unfinished at Ixelles—notably the study of *Ugolino*, a figure of *Josué* (Joshua) "with lifted hands commanding the sun to stand still" and the maquette for a Byron monument he planned to enter in a British competition. A set of instructions was promptly dispatched to Rose:

I'd like to work on my *Ugolin* and to have it here. Has a cast been made of the Byron monument and assembled? There is one side where the molding is not profiled; it should be properly cut and replaced on that side. Has the *Josué* been cast in plaster? Tell me about all these things in detail and don't be afraid to tell me everything. My father is well and Auguste too.

To his great relief, the Salon jury accepted his figure, still in plaster though now somewhat paradoxically entitled *l'Age d'airain*, the Age of Bronze (*airain* is literally brass, but Lucretius's Age of Bronze is called *l'Age d'airain* in French). Yet already there was talk among members of the jury that its astonishing realism had been achieved by means of surmoulage. Rodin learned that during the jury's deliberations someone had remarked, "If it's a veritable piece

of modeling and not a cast from nature, the man who made it is bigger than we are."

This conditional compliment could only have rubbed salt into his wounds. "I am thoroughly unhappy," he wrote to Rose. "Falguière finds my figure very beautiful but people say it was cast from life. I put my faith in the power of truth. He tells me it's a sort of praise, but it makes him mistrustful." In the days that followed he was mainly concerned with trying to salvage the reputation of *l'Age d'airain*. When the placement committee arranged the sculpture rooms of the Palais des Champs-Elysées, he realized that his figure had been "badly placed in the half-light" of an obscure corner of the Salon because some of the jurymen believed the rumors of surmoulage. There was even talk of removing his figure from the exhibition. "I am quite worried," he confided to Rose on April 13. "Everyone thinks my statue is beautiful but they persist in saying it is cast from the model!"

He wrote to the chairman of the sculpture jury, Eugène Guillaume, asking for an opportunity to clear his name and establish the facts. "Owing to these terrible doubts raised by the jury, I find myself robbed of the fruits of my labors. Contrary to what people think I did not cast my figure from the model but spent a year and a half on it; during that time my model came to the studio almost constantly. Moreover I have spent my savings working on my figure, which I had hoped would be as much of a success in Paris as it was in Belgium since the modeling seems good—it is only the procedure that has been attacked. How painful it is to find that my figure can be of no help to my future; how painful to see it rejected on account of a slanderous suspicion!"

Guillaume, then director of Rodin's bête noire, the Ecole des Beaux-Arts, suggested he submit the references and technical evidence that would enable him to prove his case. The effort cost him both work and money, but at least it gave him the satisfaction of seeing his Belgian friends rise to the occasion. On April 25 Félix Bouré wrote a testimonial expressing his wholehearted support: "I declare and affirm that I saw you model that statue from beginning to end with your fingers and the paring chisel. Don't let yourself be discouraged by these tiresome contretemps; take heart. Your statue is very much out of the ordinary; doubtless that is why you are being treated in this fashion."

On the 26th the engraver and painter Gustave Biot, a near neighbor in Ixelles, sent a formal statement certifying that he had seen the sculptor begin and complete his figure "working entirely *d'après le modèle vivant.*" With it came a warm personal letter reassuring Rodin that every possible string was being pulled on his behalf:

> As soon as I read your letter I went immediately to see Bouré, who promptly sat down to write a declaration which you will receive together with mine. . . . That's not everything; I saw Rousseau this morning, and after we talked about you he sent me on his behalf to the painter Smits, who solemnly promised to write immediately to his friend, the sculptor Paul Dubois. He is also a friend of Falguière. . . . For me the thing that matters is that you have created a work that is truly remarkable.

Rodin had proposed that the Salon jury send for Auguste Neyt, but Guillame advised him to have photographs taken and to make life casts of his model "so that the comparison would be more convincing." Rodin lost no time having this done—as he explained three years later in a summary of the case requested by the incoming Secretary of Fine Arts: "As soon as I had the photographs I sent a complete set to M. Falguière, a member of the jury. I sent my life casts, my photographs and my letters to the Palais des Champs-Elysées; the photos and letters in a sealed envelope. I waited anxiously, hoping to put an end to this suspicion which weighed on me, and at the same time trusting that I would receive some recompense to encourage me for the future and reimburse me for the enormous expense I had incurred in reproducing this figure. All this was to no avail; the jury was probably inadequately informed, for when I went to find out the results of its examination they returned my photographs, and I learned to my despair that everything I had done was completely useless. The seals that closed the envelope containing all the evidence had not even been broken."

Rodin never forgot his frustrations over this affair, but he also remembered the Salon of 1877 as the beginning of a new phase in his career. *L'Age d'airain* had been "condemned by the professors, while the students, connoisseurs and independent spirits loved it,"

he wrote in his curriculum vitae. "From that time on the artist was surrounded by friends."

One member of this newly acquired circle of admirers was the young American painter Will Low, whose memoirs record the precise moment when the independent spirits first became aware of Rodin's existence. Low, a competent portraitist who had a picture in the Salon that year, was eager to see the sculpture section and wanted an unobstructed view before the official opening. He happened to be a friend of Adrien Gaudez, a gifted young artist who was to become one of the better-known sculptors of Paris; even Rodin expressed a liking for his work—"Dalou and I greatly admired his *Nymph Echo*." With Gaudez's help, Low managed to sneak past the guards at the gate in a plaster-bespattered blouse—it was one of the days when sculptors were admitted to make last-minute repairs to their exhibits: "Once within the spacious glass-roofed garden with its snow-white population . . . the circuit was slowly made, our group mingled with others like it, passing before each principal work."

Finally, Gaudez suggested that some of the best work might be hidden in the darker corners of the gallery, and they took a turn around the sculptures placed inconspicuously against the walls. "Here in one of the darkest corners of the 'Morgue,' as this section was pleasantly entitled, we were arrested by the view of a single figure of a man, nude, exceedingly simple in movement and without accessories of any kind. After a moment's inspection murmurs of admiration rose, and these trained sculptors soon realized that they were in the presence of a masterpiece. But whose work was it?" When they read the name of the sculptor—Rodin—no one had heard of him. But then Gaudez remembered: "I have it! And I even know him a little; he is a fellow who works as an assistant for Carrier-Belleuse. . . ." Gaudez and his friends regretted that the figure was placed so close to the wall that no one could see the superb back "with its relaxed muscles and its sense of latent energy." They complained to the guardians, then to the head guardian, whom Gaudez finally persuaded to give *l'Age d'airain* a position closer to the center of the gallery.

Gaudez's reaction to the figure was typical of the younger generation's. "Among the real artists it had a great success," Bartlett learned from an acquaintance whom he identifies merely as "one of

the best of the younger French sculptors"; it may well have been Alfred Boucher. The old school "were down on it to a man," while the younger sculptors "thought that it was the most lifelike piece of sculpture that had been produced in French art since the *Mercury* by Brian, and that it was really entitled to the medal of honor." Technically it was "such an astounding piece of modeling even to the best sculptors that we were all completely taken off our feet."

The art critics, however, focused their attention on that year's medal-winner, Just Becquet's *Ismael*, and other notable pieces in the storytelling vein. Only Charles Tardieu of *l'Art* had a good word for *l'Age d'airain*:

> M. Rodin's work is a study rather than a statue—too servile a portrait of a model without character or beauty; an astonishingly exact portrait of a banal personality. But if M. Rodin appears to care so little about style, he makes up for it with his vivid preoccupation with life, and that is saying a great deal. In this respect his work is most interesting, and it would need only some trifling modifications—a little more nobility in the head, a little less thinness in the lips—to silence the criticisms to which it has been subjected.

Although the Salon would be slow to reflect the change, the pendulum of French art was, at that moment, swinging perceptibly from idealism to realism. In February 1877, Zola's publisher had brought out his new novel *l'Assommoir* (literally the place where one gets smashed, i.e., "The Gin Mill"), with its horrendous exposé of working-class life. Denounced by its critics as a mass of gutter filth and a slander on France, it paved the way for a group of like-minded young writers who called themselves Naturalists—notably Guy de Maupassant, J. K. Huysmans and Octave Mirbeau.

For the next few months the question on everyone's lips was "Have you read *l'Assommoir*?" It broke all existing records by selling 80,000 copies in three years, but as yet there was no comparable market for the new realism in the visual arts. The major scandal of the 1877 Salon had been the rejection, on moral grounds, of Edouard Manet's picture *Nana*, which was exhibited instead in the window of a private gallery on the boulevard des Capucines. Manet had painted a noto-

rious demimondaine at her dressing table—"Half naked and bursting with sexuality" like her namesake, the Nana of *l'Assommoir*, an incipient cocotte who was soon to have an entire book to herself.

Manet's pictures, and those of the Impressionists, alias Intransigeants, were still selling for paltry sums. During the preceding winter Monet had been obliged to borrow from Zola to prevent his landlord from attaching his furniture and throwing him out into the street. Eighteen Impressionists, including Monet, Cézanne, Degas, Pissarro and Renoir, most of whose work would not have passed muster in any case, turned their collective back on the Salon and showed 230 of their works in an empty apartment on the second floor of No. 6, rue le Peletier—the third Impressionist exhibition. It opened on April Fools' Day to hostility and laughter; the public seemed to think that they were "perhaps not devoid of talent and that they might have executed good pictures if they had been willing to paint like the rest of the world." After the show closed, some forty-five of the canvases were sold at auction for an average price of 169 francs. Indeed, as Manet's brother Eugène had written to his wife, Berthe Morisot, a few months before, "The entire clan of painters is in distress. The dealers are overstocked. Edouard speaks of watching his expenses and giving up his studio. Let's hope the buyers will return, but it's true that the moment is not favorable." If this was an inauspicious moment for Rodin's re-entry into the Paris art world, at least he was not alone in his predicament.

It was a practice of the French government to purchase what were deemed the most deserving works of art shown at each Salon. Rodin's formal request to have *l'Age d'airain* bought by the Direction des Beaux-Arts, dated May 22, was answered with a routine letter of refusal. Since there were no private buyers either, he had no choice but to store the plaster in his new studio at No. 36, rue des Fourneaux (now the rue Falguière)—a low workshop building, described as "a mere shed," adjoining the one he had borrowed from Fourquet in 1875. Meanwhile, his preparations for moving to Paris had used up the last of his savings. The *mouleur* who had made a plaster cast of *Ugolino* demanded an exorbitant 150 francs for the job, "which I will not pay." It seemed to him that he now had "worries from all sides. I am happy when I can go to bed and sleep for eight hours, which doesn't happen very often," as he told Rose in his letter of April 13.

"Try to get some money from M. Van Berckelaer. Sell the barrels"—
they had evidently been used as modeling stands.

He still had high hopes for his entry in the competition for a Byron
monument, which offered the chance for an important commission.
A group of eminent Victorians—including Disraeli, Tennyson, Swin-
burne and Longfellow—had sponsored a belated memorial to this
most un-Victorian of nineteenth-century British poets. Rodin envis-
aged the monument as "a high pedestal descending into a fountain,
with Byron seated at the summit and two other figures in the fountain
beside the pedestal"—forerunners of the muses with which he would
one day surround his figure of Victor Hugo.

Since he could not be back in Brussels in time to put the finishing
touches on the maquette, his letters were full of anxious instructions
to Rose and Paul Frisch on how to proceed in his absence. "Paul
has to make a base that he thinks is right. . . . The monument has
to be in London before the 1st of June, you will receive the crate
toward the end of next week. . . . Have Paul put the figure on top
of the pedestal the way I did it before, at about a three-quarters angle,
and let him cut down the corners of the pedestal and adapt it to the
figure's base. . . . Put a square base on it; let Paul's eye and judgment
decide the proper size."

The maquette went off in time but failed to win so much as an
honorable mention. It was the English sculptor Richard Belt who won
out over a field of thirty-six, and whose statue was placed in Hyde
Park three years later. Rodin's maquette was exhibited at the Albert
Hall together with the other entries, but after that it seems to have
vanished and is regarded as one of his lost works.*

In June Rodin returned to Belgium to wind up his affairs: those
of his sculptures and other belongings which were not immediately
needed in Paris were stored with the Van Rasbourghs. On the way
to and from Brussels he indulged his growing passion for Gothic

*There is a mysterious Rodin wax sculpture in the Nelson-Atkins Museum, Kansas City,
which may well have been a sketch for the Byron monument—a brooding figure gazing
into the distance, right arm resting on left knee, as Michelangelo might have posed him;
the poet as a tentative precursor of *The Thinker*. The Nelson Gallery handbook describes
it as a *Study for the Sailor* (of the Loos monument). But all the Loos figures look upward,
toward the Antwerpia looming on the plinth behind them. This figure is seated in a
pensive and perhaps "literary" pose.

cathedrals. Cladel reports that during 1877 he revisited Reims and stopped off at some of the other nearby cathedrals—Soissons, Noyon, and Amiens. Another journey took him to Chartres, south of Paris. He had become an ardent connoisseur of medieval churches and cathedrals, the less restored the better, making countless sketches of such details as moldings, arches and "palpitations of the stone against a murky sky." It was their masonry as much as their sculpture that fascinated him. "And these people of the cathedrals," he once told Camille Mauclair, "these anonymous builders! They did not sign their name to a tower; we put our signatures on paperweights. They sculpted directly onto the churches; they were the real sculptors, and we—we're *modeleurs.*" For the rest of his life he made a habit of wandering off to see one or another of the cathedrals near Paris whenever he was in the mood for a change of scene. Edmond de Goncourt has a brief note in one of his journals: "Rodin the sculptor sometimes disappears from his home for several days and no one knows where he's off to; when he returns and people ask him where he's been he says, 'I've been to see the cathedrals.' "

When Rodin brought Rose back to Paris toward the end of the summer of 1877 they went to live in a small, cheap apartment in the rue Saint-Jacques, at the corner of the rue Royer-Collard—also on the Left Bank but across the Luxembourg gardens from his new studio. He had run into Carrier-Belleuse, and had agreed to work for him again, though this time as "a sort of junior partner" with the prerogative of working in his own studio rather than in Carrier's workshop. Yet the pay was still minimal, and for the next three years he went back to earning a living as an anonymous *figuriste*, turning out pieces that were signed by other hands.

His seventy-four-year-old father and eleven-year-old son had come to live with them and they were cramped for space: before long they moved down the street to No. 268, rue Saint-Jacques, and by 1882 they would move again, to No. 39, rue du Faubourg Saint-Jacques, to a house belonging to the Assistance Publique, which administered the Cochin Hospital next door. All three were poor people's addresses, for Rodin's finances remained in dire straits until the mid-Eighties. The poet Charles Morice speaks of him during these years as "young, timid, sad and suffering." But when his cousin Henri Cheffer, by now a master typographer, ventured to ask him how he proposed to

support himself, Rodin was as obstinate as ever: "It's not money I'm after, it's something else. When I've found it, I'll have money."

The presence of father and son compounded his difficulties. The ex-inspector had become cranky and mentally unbalanced after going blind; there may have been a tendency to senile insanity on his side of the family. Yet Rose faithfully nursed Jean-Baptiste until his death at the age of eighty, on October 26, 1883. He was buried in the Montrouge cemetery, where his son arranged to buy a second plot so that one day he might be buried beside him.*

Rose was understandably delighted to be reunited with her son, but the boy was more unmanageable than ever—his fall from the window had "caused a permanent impairment of his mental faculties," as Cladel learned from the Cheffers. Rodin seems to have been unaware of what was ailing his son and tried to turn him into an artist's apprentice; the boy learned how to sweep out the studio, tend the fire in the stove and prepare the balls of modeling clay. He remembered that his father had taught him how to draw on scraps of paper and old shirt cuffs, "marking off the seven parts of the body— the head, the pectoral muscles, the navel, etc." Auguste seems to have shown occasional flashes of talent but his case was clearly hopeless. In later years he blamed his failure on his father. "I also wanted to be an artist but he didn't want that," he told an interviewer. "Rodin was a peculiar man, a great artist. I also liked to draw but my father didn't like it when I hung around his studio. . . . Now and then my father had a look at what I was doing. He took my work and put it away."

In the 1880s, the writer Octave Mirbeau, who knew both of them intimately, described Rodin's offspring to Edmond de Goncourt: "Yes, he has a son, a strange son with an extraordinary eye and the face of an assassin. He never says a word and spends all his time at army posts drawing *the backs of soldiers*—backs which his father says are sometimes the work of a genius. . . . One never sees this son except when the soup is on the table; afterwards he disappears."

*Instead, Jean-Baptiste's nephew Henri Coltat was eventually buried there. No attempt was made to unite the remains of husband and wife in a joint grave; presumably because they received paupers' funerals, the family records are silent as to the burial places of Marie and Maria Rodin.

6

THE THAW

*La débâcle des glaces a commencé hier matin. . . . * *

P aris Herself Again was the title of a book which the British
correspondent George Augustus Sala wrote about Paris and
the Universal Exhibition of 1878. That year, by general
consent, France ceased to mourn for the dead of 1870 and
resolved to forget the horrors of the Commune. Sala had witnessed
the Prussian siege, when the city had been "barricaded, bombarded,
beleaguered, dragooned and all but sacked"—but now, once again
the cynosure of all eyes, it was "comelier, richer, gayer and more
fascinating than ever."

The exhibition opened on the 1st of May: its halls covered the
Champ-de-Mars and the heights of Chaillot, where the sprawling new
Palais du Trocadéro had been erected on the site of a former stone
quarry overlooking the Seine. The whole city, now with a population
of nearly two million, turned out to celebrate the occasion. There
were dances in the streets and open-air banquets in many neighbor-
hoods; merry-go-rounds in parks and squares; roller skating in the
Bois de Boulogne. At night the city was lit up like a huge torch.

*"The ice began breaking up yesterday morning"—a January 4, 1880, newspaper report
announcing the end of a cold spell in which the Seine had frozen over.

Around the Etoile the first electric street lamps added their glow to the glare of gas lights.

Long parades of students, workers and shopkeepers marched down the boulevards arm in arm, singing songs in praise of peace. A captive balloon hovered above the Tuileries; Victor Hugo lectured on Voltaire, whose centenary was being celebrated; Stanley, the discoverer of Dr. Livingstone, received a rousing reception at the Trocadéro. A quarter of a million people attended this world's fair during the first eight days; in September there were 150,000 in a single day. Altogether, sixteen million visitors came to see it between May and November—and the city's cab drivers raised their rates accordingly.

The postwar French Republic had been designed as a provisional arrangement; it was the Universal Exhibition that made it definitive. The "Peace Festival" of June 30 turned into a huge popular demonstration which even the monarchists were obliged to recognize as the real baptism of the Republic. The exhibition also proved that what had transpired during the postwar years was nothing less than an economic miracle. "Defeated France has risen to its feet," Zola wrote, "and has triumphed in the field of art and industry."

The exhibition halls were filled to overflowing with French and foreign manufactures, including an impressive range of luxury goods. Sala went to see the porcelain on display and told his English readers that the monumental porcelain of Sèvres "beats us hollow." The formerly royal, then imperial, factory, now owned and subsidized by the Republic, was producing vases fifteen feet high decorated with gods and battle scenes—such an establishment, in Sala's eyes, was "one of the national glories of France."

For Rodin the Exposition Universelle had the additional advantage of providing him with a market for his skills. When *l'Age d'airain* failed to find a buyer he had told Rose that life in Paris was going to be hard for them: "The future looks dark, and we can expect only *la misère*." Fortunately the building trades were embarked on a program of feverish activity in preparation for the world's fair. Rodin hired himself out to several ornamental sculptors at piece rates, sometimes earning as much as eighty or one hundred francs a day. "When I was working for the ornemaniste Legrain on the 1878 Exhibition I often modeled a life-size figure in a few hours," he later recalled.

The sculptor Eugène Legrain had found work for Dalou on the Hôtel de Païva before the war and now proved equally helpful to Rodin. Originally the two artists were friends; it was Legrain who had added the floral decorations to the small terra cottas à la Carrier-Belleuse that Rodin turned out for sale to bric-a-brac dealers during his lean years. (Rose would go out heavily laden, in all kinds of weather, to deliver them to a shop in the Passage des Panoramas.) But when Legrain asked Rodin to help him with a series of sculptures for the Trocadéro Palace, the stage was set for another collision of temperaments. Bartlett reports that Legrain was "especially critical" of some large heads that Rodin had made for him, yet "he was willing to sign and exhibit them," and to collect a medal for them. The works that Rodin modeled for Legrain included two large heads that decorated the arches overlooking the fountains beneath the Trocadéro, and a series of grotesque waterspout heads used in the fountains themselves. These *mascarons* were subsequently presented to the Trocadéro Museum of Comparative Sculpture, and Bartlett wrote that they "are now regarded as prized examples, some say masterpieces, of modern French decorative sculpture, though no one knows who really made them."*

The British *Magazine of Art* described these grotesque faces as "among the most amusing examples of the sculptor's art at the exhibition." One of them depicted a river god with tangled locks and a conch shell on his head who evidently disliked too much cold water—he "does not relish the draught and is getting rid of an unpleasant mouthful."

Even if Rodin did not get credit for the waterspouts, his facility with clay soon became the talk of the Paris studios. The sculptor Jules Desbois, eleven years his junior, remembered meeting Rodin for the first time "when I was working in his company for Legrain,

*Legrain's grotesque heads were derived from those of Antoine Coysevox (1640–1720), which were based, in turn, on Greco-Roman models. The fountain *mascarons* have disintegrated and are known only from drawings, all duly attributed to Legrain; the keystone heads are at the Musée Rodin. But the extent of Rodin's contribution remains open to question. Legrain obtained the commission only after submitting small-scale maquettes: were these, too, originally modeled by Rodin, or did he merely add the finishing touches? Legrain's designs include similar heads for other projects, such as the Hôtel de Ville *mascarons*, in which Rodin played no part.

one of the great entrepreneurs of ornamental sculpture. He was singularly skilled, and astonished us all; later he was to surprise us even more." Rodin worked for several employers during this period, not only for Legrain and Carrier-Belleuse but also, briefly, for the Beaux-Arts *statuaire* Louis-Ernest Barrias, the jeweler Fannière, the cabinetmaker Ginsbach (for whom he modeled caryatids and a mask for a walnut cupboard, and two children for a mahogany bed), and the sculptor André Laoust, another successful graduate of the Beaux-Arts.

Since most of them were men of Rodin's generation—Legrain was born in 1837, Barrias in 1841, Laoust in 1843—they might have been expected to have some understanding for Rodin's way of looking at sculpture. Yet, as he told Bartlett, "All these men wanted what is known as 'the sculpture of the school.' " As a consequence—and because too much brilliance in an employee is usually unsettling to the *patron*—they professed to be dissatisfied with his work; some of them discharged him. "Not one of these men treated me like a man," Rodin recalled. Only his fellow studio assistants appreciated his worth. Bartlett heard from one of them, "who worked in the same shop with Rodin," that the latter was "the most learned, skillful and rapid worker in clay that had ever been seen in Paris. There was no one like him. His things were masterpieces, but his employers were ignorant, pretentious and abusive."

This testimony probably came from Alfred Boucher, ten years younger than Rodin but already the winner of a second-class medal at the 1878 Salon, who also worked for Laoust. Rodin remembered that Boucher had watched him one day "when they asked me to do a small fronton containing two children playing together. I took some clay. For two hours I prepared small balls of clay; then I went to lunch. When I returned I started putting the *boules* to work, and the outlines of a figure immediately took shape. In five hours I was finished."

Boucher told his maître Paul Dubois about this breathtaking performance. Dubois, whose *Florentine Singer* was the best-known of nineteenth-century "troubadour" sculptures, had recently been appointed Guillaume's successor as director of the Ecole des Beaux-Arts. Both he and Carrier-Belleuse came to see and admire Rodin's fronton. Their support was to prove vital in Rodin's subsequent appeal for a revision of the Salon's verdict on *l'Age d'airain*, but the im-

mediate result was that another of the Beaux-Arts masters, Henri Chapu, asked Rodin to work for him. Chapu's *la Pensée* for the tomb of "Daniel Stern" (Liszt's inamorata, the Countess d'Agoult) had just won the highest awards available to a French sculptor. "He asked me to make a vase of large dimensions—a work with figures three meters high, commissioned by Baron de Rothschild. I finished it in eight days. But Chapu decided that the figures were not well constructed. He was mistaken on this point. He started all over again by himself."

Although these were lean and difficult years, Rodin was already receiving visits from younger artists who wanted him to know how much they admired his work. One of them, the teenage painter J. E. S. Jeanès, first went to see Rodin in 1878 when the sculptor was "strapping, thickset, bearded, reddish-blond, wearing glasses (his attitude; his very way of listening, betrayed his myopia), dressed like a workman in an old knitted vest and a pair of blue trousers. He wore enormous old worn-out shoes. He spoke hesitantly, but often his words astonished me . . . he had things to say that were different; his point of view was new: 'We must unfreeze sculpture,' he said. 'Life is the thing; everything is in it, and life is movement.' "

Bartlett heard about a group of young artists who went to call on Rodin in the rue des Fourneaux to express their enthusiasm for *l'Age d'airain*—"to our amazement we found him working on the same kind of commercial art that Carrier-Belleuse made by the yard, and in spite of ourselves we voluntarily expressed our feelings in words. To which he modestly remarked, 'Yes, I'm doing this for Carrier-Belleuse—to get my bread.' Our pain was as great as our surprise, to see an artist who had produced such things as *l'Age d'airain* and *The Man with the Broken Nose* obliged to work for such a man as Carrier; to spend his time and murder his sensibilities on the stuff he was then making."

In point of fact Rodin was turning out some splendid sculpture for Carrier, almost incidentally. The *Vase des Titans*, for example—a pottery jardiniere signed by Carrier-Belleuse—began life as four Rodin studies based on figures from the Sistine ceiling; massive, twisted bodies whose roughly modeled bases of half-smoothed *boulettes* betray something of the speed with which he was working.

"But when he showed us the body of the *Ugolin* we were still more

surprised, and hardly knew what to say," Rodin's visitor recalled. "It looked a bit like Michelangelo, it was so large, lifelike, and ample in the character of its planes and modeling." What the students saw was the unfinished torso of a seated *Ugolino*—the massive figure that had followed him from Brussels, together with the equally unfinished *Joshua*. Once arrived in Paris, however, they were both put aside when he resolved to "spend my money on a new attempt" to wring recognition from the Salon jury and he moved on to a new free-standing figure. He was to return to the subject of Ugolino, but with a different model, a few years later. The underlying theme of *Joshua*—a biblical figure seen in mid-movement—was carried over to his new subject, John the Baptist preaching in the desert.

This time it was to be a larger-than-life figure so that there could be no question of its having been molded from the model's body. There are various conflicting accounts of how he arrived at the subject of *Saint Jean-Baptiste prêchant*: Rodin's favorite version suggests that it was the model himself who made him think of Saint John. "One morning there was a knock on the studio door; an Italian entered, accompanied by one of his compatriots, who had already posed for me. It was a peasant from the Abruzzi who had just arrived from his native country, and who came looking for work as a model. I looked at him and was profoundly impressed: this rough, hairy man exuded such an air of violence and physical strength, but also the mystical element of his people. I thought immediately of John the Baptist, which is to say a man who lives amid nature, a visionary, a believer, a precursor who has come to announce the advent of someone greater than himself."

When the peasant, whose name was Pignatelli, removed his clothes and climbed onto the modeling platform Rodin thought his movements so natural that he could hardly be a professional model: "He stood firmly rooted, his head raised, his torso straight, resting on both legs which were open like a pair of calipers." Rodin "resolved immediately to sculpt what I had seen." The result was a gaunt, wild-haired Saint John, very much in the medieval tradition. In later years he described Pignatelli as "a terrifying fellow, capable of cruelty, with the maliciousness of a civilized being and the cunning of a savage; the glint in his eyes was like that of a wild beast at night, and when he smiled he resembled a wolf."

The story that Bartlett heard only a few years after the event was not nearly as dramatic. His interview notes suggest that Rodin had been thinking of a Saint John before he met Pignatelli; in any case, "Rodin liked his model for the *Saint John*, and both model and statue represent a rude, earnest man of the common people whose movement and attitude are natural, unstudied, but very true and forceful, either generally or in the arm, head, hands, feet or back."

Rodin's first sketch was a half-size maquette, and he took an immense amount of trouble with the figure. The preliminary studies include a splendid torso with a surface like that of a terminal moraine, and an unfinished striding figure that was later to be re-edited as *l'Homme qui marche* (The Walking Man). There were several studies of Pignatelli's bearded head, culminating in the bronze-coated plaster bust of *Saint Jean-Baptiste prêchant* which he exhibited in the 1879 Salon (together with his bust of Madame Cruchet). The year before he had shown only a bronze version of *The Man with the Broken Nose*, accepted by the jury at last, but ignored by the press. The *Saint Jean* proved more compelling: it earned Rodin, at thirty-eight, his first formal recognition from the Salon—an honorable mention.

While waiting for better times, Rodin continued to work as a subcontractor for other sculptors but redoubled his efforts to obtain commissions on his own account. On August 16, 1878, the director of fine arts formally rejected his request to have *The Man with the Broken Nose* bought by the state—hardly a surprising decision, in view of the fact that the post was now held by the same Eugène Guillaume whose glacial indifference had helped scuttle *l'Age d'airain*. Guillaume, moreover, had taken an active dislike to the piece. "One day, finding my plaster mask of *l'Homme au nez cassé* in the studio of one of his friends," Rodin remembered, "he insisted it be thrown into the rubbish bin."

Guillaume's influence, however, was destined to be short-lived. French politics took a decisive turn to the left with the senatorial elections of January 1879, when the republicans swept into office, replacing the conservative leaders who had been working toward an eventual restoration of the monarchy. Bastille Day became the national holiday; the *Marseillaise* the national anthem. The Senate and the Chamber of Deputies returned from Versailles to Paris. Jules Ferry, who entered the government as minister of public instruction

in February and later became premier, launched a sweeping program of anticlerical reforms that secularized the public school system and established state control over higher education. Guillaume was replaced by Ferry's right-hand man, Edmond Turquet, whose title became undersecretary of state for fine arts.

Under Turquet's direction, government fine arts policy became flagrantly republican: in lieu of religious paintings the state now commissioned big pictures of the storming of the Bastille and other memorable moments from the Revolution. The Salon was to be made a more democratic institution: the privilege of voting for the members of the jury, formerly restricted to medal winners, was to be accorded to all artists who had exhibited in previous Salons. The artists were to be "given back their freedom," as Turquet put it: management of the Salon was turned over to a ninety-member committee consisting of fifty painters, twenty sculptors, ten architects and ten graphic artists.

These long-awaited changes took months to reach fruition. Rodin had reason to hope that the new regime would lend his appeals for aid a more sympathetic ear, but no immediate assistance was forthcoming. In May 1879, the award of an honorable mention for the bust of *Saint Jean* raised Rodin's hopes once more. This time, when he submitted the customary request for state purchase, it was accompanied by a recommendation from a distinguished academician, Jules Thomas, the sculptor of *le Drame* and *la Musique* at the Opéra, who had found the bust "truly remarkable" and urged the undersecretary to buy it. Early in June, "during the interview I had the honor to have with you, Monsieur le Sous-Secrétaire," Rodin was advised to submit a second request in the form of a petition for state aid: it would be the first time, he noted, that anyone had granted him a favor. This *demande d'Encouragement* was followed by another letter bearing endorsements from the aging but still influential socialist leader Louis Blanc, and from the municipal councillor of Rodin's home district: Rodin was beginning to understand the politics of patronage. Yet all of these efforts were cut short by the curt ministerial annotation: "Acquisitions have been terminated—regrets."

Rodin tried again, also in June, with an application to the Municipal Fine Arts Commission, which had charge of building the new Hôtel de Ville, in place of the one that had been burned down during

the last days of the Commune. Its façades were to shelter the statues of no less than 106 Parisian notables: would the commission entrust one of these to the skilled hands of M. Rodin? "In the absence of a figure, I would be happy to be entrusted with a bas-relief, some decorative heads, mascarons, or any other element of statuary which may be a necessary adjunct to the ornamental motifs."

The letter was neatly arranged in two columns, with Rodin's petition on the right and a note from Carrier-Belleuse on the left, to the effect that he was happy to recommend "my pupil A. Rodin, whose skill and artistic taste are worthy of being encouraged." Significantly there was also a brief endorsement from Turquet's chief assistant, Georges Hecq: "I am personally acquainted with him, and know him to be an artist of talent." Yet this appeal proved to be no more effective than a subsequent letter from Carrier's dealer, Ernest Garnier, to a friend in the Public Works Department "warmly recommending the bearer of this letter, M. Rodin," who was "one of our most sensitive and distinguished talents" but in the unfortunate position of being "in pressing need of work."

These requests for patronage were necessitated by the fact that the private market for serious sculpture hardly existed, and was confined to a handful of millionaires. For most sculptors the main sources of support were state purchases and commissions. Fortunately there was a sudden rush to erect monuments to national heroes—a great wave of *statuomanie*. Before the Franco-Prussian War Paris possessed nine public monuments to kings or famous men; by 1914 a hundred statues had been erected.

Many of these monuments were commissioned on the basis of public competitions—a method of selection that Rodin came to detest, since only the winners were paid for their time and trouble. In 1879, however, with nothing better in the offing, he entered two of these competitions. In April the Préfecture of the Seine announced that it would erect an "allegorical monument to the defense of Paris in 1870" at the rond-point de Courbevoie (now known as la Défense), using an existing granite pedestal on which a statue of Napoléon I had stood before the war. The entrants in this competition included Bartholdi, Carrier-Belleuse, Boucher and Falguière.

Rodin submitted a model of the group now known as *l'Appel aux*

armes (The Call to Arms), in which he took up the familiar theme of the fallen warrior supported by the female Genius of War. His version of the subject was far more explosive than Mercié's *Gloria Victis*: Rodin's winged *génie de la guerre* echoes the shout and open-armed gesture of Rude's *la Marseillaise* on the Arc de Triomphe, but his figure—for which Rose may have posed—is bare-breasted rather than clothed in chain mail, and conveys something of a harpy's fury.

The idea failed to please the jury: it was his ex-employer Barrias who won the prize. "There were a good sixty sculptors in the competition," Rodin told Coquiot, "but in spite of all my efforts, in spite of the life which, I believe, animated my group . . . I was not even among the finalists. And, as an admirer of Delacroix who knows by heart his famous letter about competitions,* I still often ask myself what I was doing there. Of course I couldn't compete with Barrias and Mercié. My group must have seemed too violent, too vibrant. So little progress had been made since Rude's *Marseillaise*—she, too, shouts with all her might."

A few weeks later he entered a competition for a bust of The Republic which was to be installed in the newly built town hall of the Thirteenth arrondissement. Rodin submitted yet another interpretation of Rose's face—this time of Rose in a truculent mood, personifying a pouting, defiant, even bellicose Republic. Rodin claimed that he had captured this expression during one of their not-infrequent domestic quarrels: he ascribed them to her chronic and incurable jealousy. To complicate matters he placed a Greek helmet on the head of this warlike *Bellona* rather than the Phrygian bonnet regarded as the standard headgear of the Republic, and again a more conventional entry won the prize.

These disappointments were all the more galling because Rodin needed the money: during this period he was still so poor that when Rose injured her knee and was laid up for several weeks he worried about being able to pay for the doctor's visits. Secretly he began

*Delacroix wrote a letter to the editor of the leading Romantic journal, *l'Artiste*, in 1831, castigating competitions as the means whereby "a man of inferior capacity can gain the advantage over others whose talents are more natural and passionate." See Delacroix's *Selected Letters* (London, 1971), pp. 166–71.

hoarding five-centime pieces in a drawer, so that when the time came to pay he produced his savings and "there was enough and to spare."

>✷<

One result of the shortage of work in Paris was that Rodin went briefly to Nice to work for Charles Cordier, an artist noted for sculptures of exotic subjects in unusual materials (such as the bust of an Arab with a bronze face in an onyx burnoose). Together they created an elaborately decorated façade for the Villa Neptune, a town house that was being built for a well-connected actress in the fashionable promenade des Anglais. Cordier had done the designs; Rodin is said to have executed them, including a mascaron of Neptune and two ingenious caryatids flanking a loggia which were intended as a sort of visual pun. A passerby on the street could see only two fishtailed children holding tridents, while the viewer within, looking out of the loggia window, was treated to the sight of two voluptuous female bodies.*

Rodin was delighted to be working in Nice, as he wrote to Rose in the summer of 1879: "I'll tell you the weather is very nice here and the heat far more bearable than in Paris. I work just in front of the sea which is obscured by nothing except oleanders, southern trees, cactuses. I'm delighted every time I look at it, the ships that pass seem as indolent as the beautiful sea that carries them; meanwhile I've bathed in the sea, holding on to a rope and turning my back to the waves, which are so strong that they would have carried me out had I not held on tight."

On the way to Nice he had stopped at Vienne, Orange and Arles; at Marseille he had seen a Puget satyr that reminded him of a figure on which he was working. But the arrangement of the Marseille Musée des Beaux-Arts left much to be desired: "Truphème and other sculptors get the honors and this poor Puget is in the corner and too high, and one can't walk around it. Indeed, stupidity is the refrain of our great song about Progress." He wished he had the courage to take a bath in the sea every morning, "but it's a bit cold for someone who can't swim." His thirteen-year-old son was also mentioned in the

*The house is no more, but the sculptured balcony with its Rubens-like ladies, signed by Cordier, is in the garden of the Musée des Beaux-Arts Jules Chéret, in Nice, which regards Rodin's part in them as "highly problematical."

letter: "Tell Auguste that I want him to be a good boy and give him some paper, and put him to work filling fifteen sketchbooks for me, let him draw men on horseback."

It was Carrier-Belleuse who finally solved Rodin's financial problems by offering him a congenial and relatively well paid job at the Manufacture de Sèvres, the state-owned porcelain factory on the outskirts of Paris, of which Carrier had been appointed artistic director in 1876, with a view to improving the factory's aesthetic standards. Rodin was hired to assist Carrier as a sculptor "temporarily attached to the Manufacture," with a monthly retainer of 170 francs and a fee of three francs an hour for work actually performed in the factory's ateliers.

Since its founding in 1756 Sèvres had always been an important employer of sculptors. Clodion had modeled nymphs and fauns for its kilns a hundred years before Rodin, and Boucher, Pigalle and Falconet had all worked for it. Sèvres had earned its international reputation as a producer of royal porcelain for the Bourbons, and had continued to flourish, still heavily subsidized, as the supplier of imperial porcelain to the court of Napoléon III. The government of the Third Republic saw no reason to interfere with this tradition: a supervisory commission headed by the minister of public instruction decreed that Sèvres would go on perfecting its wares "from an artistic point of view" in order to raise the level of public taste and set a standard for private industry.

During his twelve years as artistic director Carrier-Belleuse took these guidelines so much to heart that he created no less than five hundred prototype vessels, chiefly as basic shapes to be decorated by other artists. He designed the "Saïgon," "Pompeii" and "Korean" vase forms, for example, and others named for Houdon, Pigalle and Ledoux, eclectic in nomenclature but chiefly rococo in inspiration.

For Rodin, always conscious of his debt to the eighteenth-century tradition of applied art, going to work at Sèvres was a kind of homecoming. He had attended a school established to train artisans for the royal workshops, had studied figure drawing with the state tapestry apprentices and had modeled animals amid the vestiges of the royal zoo. Hence the assignment at Sèvres was his almost by right of inheritance: it fired his imagination far more than the decorative pieces he had been turning out for the Paris ornemanistes.

One of his fellow artists at Sèvres, Taxile Doat, remembered Rodin's total absorption in the decorative friezes which he applied to Carrier's vase forms. "While he worked Rodin was impervious to everything around him, so that when the lunch hour came I would go to his atelier to remind him that it was time to eat, and to get him to go for a walk with me. Very slowly, with an air of bewilderment, he would raise his wide-eyed gaze from the piece on which he was working, as if he regretted being awakened and torn away from the dream that filled his thoughts, which someone else's presence was bound to dissipate."

At that moment the Sèvres factory was experimenting with new processes and materials as well as vase forms. Its new director, Charles Lauth, was a chemist who specialized in porcelains and glazes; later in his career he was to become director of the School of Physics and Chemistry. The vases and table decorations that Sala had admired at the exhibition entailed complex techniques of slip-casting for very large or thin pieces, painting on biscuit, colored paste, paste-on-paste and transparent enamels in relief. Lauth's predecessor had worked on the development of "soft pastes" that could be modeled with far greater freedom than the traditional hard-paste medium. Lauth himself went on to experiment with still other pastes of *"grande plasticité"* and lower firing temperatures, which would be particularly suitable for casting or modeling "objects of fantasy or luxury."

While Lauth worked on chemical formulas Carrier and his four consulting sculptors explored the artistic possibilities of both the new and the old medium. Rodin began by contributing two groups to a table centerpiece on a hunting theme, *la Chasse*, designed by Carrier-Belleuse. The first of his own pieces to be ready for the kiln, a vase named *les Eléments*, employed a technique known as *pâte rapportée*, a paste-on-paste method of modeling on a pre-molded form—in this case one of Carrier's "Saïgon" vases—with a paste different from the clay in which the vase was made. Taxile Doat remembered its genesis in detail: "Before any decoration was applied the vase was covered with a slip of white paste, diluted in water to the consistency of barbotine. The design was drawn on the unfired paste by removing the white slip with a riffler or simply with the blade of an old pocket knife crudely tied to a handle consisting of a piece of wood. The rose

ground, reapppearing wherever the slip was scratched away, formed the darker areas of the design. The lighter portions were accentuated, as in Limoges enamels or in Prud'hon's black and white drawings, by a second wash of white paste applied with a brush."

Rodin thus achieved effects of highlighting and low relief comparable to those of a classical cameo; his subject matter tended to blend pagan mythology with vaguely Oriental motifs. *Les Eléments* and many of the other vases, bottles, plates and plaquettes he produced for Sèvres were decorated with the cupids and *enfants génies* that Rodin, by now, could draw and sculpt more fluently than any artist since Prud'hon—a painter of whom he always spoke with great admiration because he had known how to paint *enfants*. Rodin felt that none of his contemporaries had the knack: "Nowadays they don't do children; they do small adults."

One of his vases is ringed by a *Bacchic Farandole* danced by horned demons, centaurs and cupids. Another, *l'Enlèvement*, depicts a primal scene: a nude male abducting a nude female while two infants look on. There were others in a similar vein, notably *l'Illusion* with a pair of lovers and a dancing faun, and a superb pair of "Pompeiian" vases, *Day* and *Night*, each encircled by a pantheist frieze in *pâte rapportée* whose nudes and cupids are already embarked on the path leading to art nouveau.

Rodin's employers were incapable of understanding the significance of such pieces—that with sufficient encouragement he might have launched a renaissance in decorative porcelain. Instead he was hindered at every turn by the internal politics of Sèvres, especially the rivalry that had flared up between Lauth and Carrier-Belleuse. That Lauth took a dim view of Carrier's protégé can be read between the lines of the minutes of a Sèvres board meeting that took place on July 1, 1879, just after Rodin completed his first month there, having clocked in a total of sixty-three hours of studio work (for a bonus of 189 francs) on *la Chasse* and several other projects.

LAUTH: What is the actual situation of M. Rodin? This artist earns three francs an hour and was engaged as a sculptor; for what reason, precisely, had M. Carrier-Belleuse put him to work doing sgraffiti?

CARRIER-BELLEUSE: M. Rodin is an artist of great merit and a

very versatile talent; consequently, ways must be found to enable him to employ his talent in new areas. At the moment I would like him to engrave in paste, and since his drawing is well-nigh perfect the day when he finds a practical solution is not far off. With suitable evidence we shall have created a new process; a way of engraving figures on porcelain which will be most interesting in technique and appearance.

When Rodin's first two decorated vases emerged from the kiln in December, as Bartlett reports, the director "declared that they were so poorly executed that he would not accept them. But other persons connected with the factory were so much delighted with them, that he finally accepted one and threw the other away among the objects that had aready been condemned." The surviving vase—*les Eléments*, with its water babies surrounded by vines, tendrils and leaves of grass—was entered in an exhibition of industrial art, attracted a great deal of attention and was bought by the government for the Sèvres museum.

Having condemned the piece, Lauth was naturally annoyed to see it singled out for public praise; he had it placed "in the most out-of-the-way position he could find in the museum." Again Rodin's friends came to the rescue; pressure was brought to bear and Lauth was obliged to accord the vase "a position worthy of its merit." Lauth then tried to maneuver his recalcitrant sculptor into resigning, on the grounds that "Such a disturbing element as Rodin ought not and should not demoralize a great government institution." He wrote to Turquet to the effect that Rodin wanted to leave Sèvres, but the Sous-Secrétaire took the trouble to question the sculptor himself and learned that "he had no intention of leaving but, rather, wished to remain."

Manifestly, Rodin now had a friend at court and could no longer be treated as an anonymous outsider. In Bartlett's interview notes there is an important jotting: "He says that Turquet really created him." Yet for nearly a year Turquet had failed to do anything positive for Rodin, despite the sculptor's repeated appeals to the Subsecretariat of Fine Arts. His efforts to clear his name in the matter of the surmoulage scandal might also have remained in limbo had it not been for Turquet's protégé, the art expert Maurice Haquette, whose influence finally tipped the scales.

Maurice Haquette, who was only twenty-six at the time, was the younger brother of the painter Georges Haquette, whose wife was a sister of Madame Turquet, née Montgomery. He had been made an administrative assistant at Sèvres in February 1879, a few weeks after Turquet became undersecretary. Six months later he was promoted— on merit, one would like to think—to be *secrétaire de l'administration* of the Manufacture Nationale. He and Rodin became close friends, and from now on it was Haquette who managed the campaign to rehabilitate the sculptor of *l'Age d'airain.*

>I<

The winter of 1879–80 was the coldest in living memory. In December the Seine froze over; there was ice skating on the river and public braziers appeared in the streets. It was so cold that the barges were frozen into the canals: "life in Paris was blocked by ice." Then, on January 3, the great thaw set in. The Seine flooded, smashing huge ice floes against the bridges and demolishing the Pont des Invalides.

For Rodin the thawing-out of the government bureaucracy took almost two months longer. It was a fitful and uncertain process that began on January 11 with another interview between him and Turquet, who was convinced of the authenticity of *l'Age d'airain* and wanted to buy a bronze cast of it but was obliged to go through the motions of consulting his department's experts in the matter. On the 13th, Rodin submitted the three-page "summary report" quoted above (page 103), which sets out the whole story of the injustice he had been made to suffer at the Salon of 1877. But it concluded on a hopeful note: "I finish this too-long letter thanking you for the friendly welcome I received from you. I have long waited for the day when a Liberal Minister would come into office and do me justice."

At Haquette's urging an official commission of experts met in Rodin's studio on February 5 in order to examine *l'Age d'airain.* Against all expectation they submitted a report that seemed to confirm everyone's worst suspicions:

This examination has convinced us that even if the statue is not a life cast in the absolute sense of the word, surmoulage plays such a preponderant part in it that it cannot truly pass as a work of art. We do not think, therefore, that there are any

grounds for casting this statue in bronze. Comparison with a clay figure of a Saint-Jean-Baptiste which we saw in the artist's studio confirmed our opinion that without the aid of literal translation provided by surmoulage, M. Rodin is not yet capable of modeling a figure correctly, either as a whole or in its details. . . .

This astonishing document, which might well have written an end to Rodin's career, was signed by the six members of the commission of inquiry, including the inspector of fine arts, Henri d'Escamps, and the critic Paul de Saint-Victor, but it was probably the work of the deputy inspector, Roger Ballu, who signed with a flourish below the others. The son of the principal architect of the new Hôtel de Ville, Ballu was a poetaster, pastellist and teacher at an art school for young women. Guillaume, who happened to be his cousin, had given the twenty-eight-year-old Ballu a job at the ministry when he was director of fine arts, but the change in administration had done nothing to damage the young man's prospects, and he was to succeed d'Escamps as full inspector at the age of thirty-one.*

Rodin was informed of the report on February 9—in this case the wheels ground swiftly—and Turquet added a heartbreaking annotation: "Under the circumstances I regret to inform you that it is impossible for me to accede to your request." Bartlett relates that Rodin was utterly crushed by the news. Having come this far, he now "believed himself lost. There really seemed no hope for him. . . . The help he needed to put him on his feet was government recognition, the sanction of its buying authority."

Fortunately, Rodin and Haquette had already prepared their riposte, and another letter to Turquet was ready on the 23rd of February. The wording was almost certainly Haquette's:

*Edouard Manet ran into Ballu when he tried to persuade the authorities to let him decorate some of the walls of the Hôtel de Ville with scenes from Parisian life. Ballu, Manet said, "received me like a dog that dares to lift his paw against an official wall. To want to paint Paris life in the city's Hôtel de Ville! Away with such mad ideas! Long live Allegory! The wines of France, for instance, with Burgundy represented by a female figure with brown hair, Bordeaux by a woman with chestnut tresses, Champagne by a blonde. . . ."

To the Undersecretary of State for Fine Arts:

Allow us to seek your kind support on behalf of the sculptor M. Auguste Rodin. After a visit to his studio and a thorough examination of his work, we are happy, both in the artist's interest and for the sake of art, to call your attention to the noble tendencies of his talent: thus the figures, grouped or alone, the finished studies or fragmentary sketches, such as the *St. Jean*, the *Création de l'homme* [Adam] and the bust of the Republic, but above all *l'Age d'airain*, furnish proof of an energy and a very rare power of modeling, and even more of great character.

The purpose of our sincere and unanimous appreciation is to refute the accusations of surmoulage, which are completely erroneous. We would be gratified, Monsieur le Sous-Secrétaire, if, taking our wishes into account, you would undertake to encourage this artist, whom we expect to occupy a great place among the sculptors of our time. . . .

[signed] Chapu, Paul Dubois, Alexandre Falguière, J. C. Chaplain, G. J. Thomas, Mathias Moreau, Carrier-Belleuse, Eugène Delaplanche

This remarkable letter from eight of the foremost artists of nineteenth-century France is preserved in the French National Archives. It bears Turquet's scrawled note to his chief assistant, Georges Hecq: "Very important. Add it to the dossier concerning the commissioning of the bronze. Issue the purchase order. Advise the signers of what I have done."

It was these hasty lines that marked the real turning point in Rodin's career, since they lifted him, at a stroke of the pen, from the ranks of the unemployables. The Paris art world interpreted Turquet's decision as an act of political courage, since "he ran the risk of offending all of our art authorities."

As a first step in Rodin's rehabilitation *l'Age d'airain* in plaster was purchased for 2,000 francs, and another 2,200 francs of the ministry's art budget was spent on casting it in bronze. "It was a great event for Rodin," Bartlett noted. "What mattered if he only got a hundred dollars for his eighteen months' work, having paid two

hundred to his model for posing; he had at last received the justice due him."

The bronze cast of *l'Age d'airain* was ready in time for the Salon in May and received belated recognition in the form of a third-class medal. Biot wrote from Ixelles on June 4 to congratulate him: "We have toasted your health with a glass of Château d'Iquem. . . . I suppose you deserved more than a third-class medal, but one is best off content with what one has."

Another Belgian supporter, the novelist Camille Lemonnier, wrote a review of the 1880 Salon for the Brussels newspaper *l'Europe* that pleased Rodin enormously: it was the first wholly favorable review he had ever received, unmitigated by the usual critical quibbles and escape clauses. The first-prize winner was merely workmanlike, Lemonnier wrote; it was the third-class medalist who was "truly remarkable":

It seems that there is something slightly accidental in the figure called *l'Age d'airain*. Indeed it is not impossible that in searching initially for something else, the artist was finally led to this definitive formula, a little vague perhaps and yet very powerful, which might embody a variety of subjects—a Cain seeking to escape the divine curse, a prodigal son weary of wandering, a wounded soldier and so on. This very ambiguity gives us room to conjecture before this great sorrowful figure. It moves on the narrow plinth on which the sculptor has placed it; we sense that these steps have left bloodstains along the way; the toes, cramped with weariness, drag along the ground with the effort to move more quickly.

The *Saint-Jean prêchant* also has a long stride, beneath his erect head and neck and his orator's square chest; his arms stretch out over his audience, the hands open, scattering the words from his lips—he seems to be moving into a crowd. While he speaks his harsh, haughty face turns toward the sky as if he were filled with a vision. The wind from on high stirs the vertebrae of his furrowed back, brutally muscled with the energies of a Donatello. And this fanatical eater of locusts, this tribune of the people grown great through preaching, is suddenly transformed into the very essence of the apostles, sanc-

tified by the utter submission to God that he teaches. I don't
know of any other work in the Salon with a more expressive
stance or a more germane gesture . . . it is perhaps the only
truly great movement of the year.

It was such an unusual experience to be praised that Rodin wrote
a glowing letter to Tardieu, in Brussels, pointing out that thus far
only three writers had helped him—Tardieu, Jean Rousseau and
Lemonnier; all Belgians. Moreover, "during my stay in Belgium I
was treated with the solicitude you would accord one of your good
Belgian artists." Soon there was another sign of goodwill from Bel-
gium. This time it was his former assistant Paul De Vigne (who had
moved to Paris and become a near neighbor) who sent the good news
from Ghent to Paris on August 20: "I write you in haste just to let
you know that you have won a [gold] medal at the Ghent exhibition
[for the bronze *l'Age d'airain*]. Please accept my warmest congratu-
lations. This news makes me all the happier since I was a member
of the jury."

It was Rodin's first gold medal, and he never forgot the old Belgian
gentleman who brought it to Paris—an ex-minister, Rolin-Jaeque-
myns, who had decided to congratulate Rodin in person. "When he
saw how threadbare the artist's living quarters were he had to laugh,"
Rodin recalled, but his visit was "the loveliest thing that ever hap-
pened to me."

>✲<

Now that the ice was broken, things began to move quickly. Plans
were afoot to establish a new Museum of Decorative Art—a Paris
equivalent of what is now the Victoria and Albert Museum in London;
its most active promoter was the journalist and republican député
Antonin Proust, who headed the French Union of Decorative Arts.
Though Proust and Turquet were political rivals, both had been think-
ing of "ordering something" from Rodin, but neither was quite sure
about a suitable subject. Turquet proceeded cautiously, since he was
risking his position if he made a mistake. "Turquet made inquiries
about me just as one makes inquiries about a maid one wishes to
engage," Rodin told Coquiot. "He surrounded himself with opinions
and listened to much advice. What did he risk? What didn't he risk?

I knew about these terrible perplexities; they made me laugh. . . . I decided to help him out of his predicament. He was at a loss for a subject for me? Very well, embarking on an adventure that I myself guessed would be interminable, I proposed, for a derisory sum . . . to model a giant portal, *la Porte de l'Enfer!*"

Turquet was willing enough to listen when the sculptor explained that this project would at least protect the undersecretary's reputation, "since it will never occur to anyone, not even the most stupid of my enemies, to accuse me of having used surmoulage for these hundreds of figures, and then reduced them to the dimensions necessary for fitting them into the ensemble of my door." During their conversation at the ministry, "my eyes never left Turquet's. He listened, reflected and declared himself satisfied."

Turquet was well-meaning, impressionable and ready to oblige: at his home in Neuilly he lived surrounded by artists, poets and musicians "to whom he displayed the hospitality of a Medici." The upshot was that Rodin received a government commission for a portal destined for the future Musée des Arts Décoratifs, "ornamented with bas-reliefs representing the *Divine Comedy* of Dante." (Not until 1917 was it referred to in official documents as *la Porte de l'Enfer*.) The purchase price of 8,000 francs, fixed by official decree on August 16, 1880, was hardly a derisory sum at the time, though it must have appeared that way in retrospect, after Rodin had spent years on the *Gates of Hell* without reaching a conclusion. The allotted fee, moreover, was raised by 10,000 francs in October 1881—again, a far from negligible sum for an artist who was still putting in fifty or sixty hours a month at three francs an hour decorating vases at Sèvres. But Rodin was right in calling this commission the beginning of an interminable adventure. He had relieved Turquet of his perplexities only to take them onto his own shoulders: the Gates were to be both a vital source of ideas and an insoluble problem that dominated his sculpture for many years.

Even before the commission was formally announced, Rodin was assigned one of the government-owned studios in the Dépôt des Marbres at No. 182, rue de l'Université, not far from the Invalides. A "grace and favor" studio in the state marble depot was one of the privileges which the kings of France had bestowed on their court sculptors since Louis XIV, and again the Republic had seen fit to continue the

tradition: anyone thus honored acquired the status of an officially recognized sculptor. Not long after Rodin moved in, the critic Gustave Geffroy described the Dépôt as a place rather like a cross between a farmyard and a stone quarry: "A wide main entrance . . . a huge mossy paved courtyard, its corners overgrown with grass. . . . And everywhere hexahedral and parallelepiped blocks, massive blocks, oblong, upstanding, laid flat—a stonecutter's yard during the day, and at night in the undefined shadows a landscape strewn with blocks."

Opposite this yard full of marble blocks, "this outdoor warehouse where materials pile up," there were the doors of the sculptors' studios, which the government bestowed on some of the most famous artists of Paris. At first Rodin shared Studio M with Joseph Osbach, a pupil of Carpeaux.*

In 1883 Rodin received exclusive use of Studio H, retaining his share in M, and seven years later he was also given Studio J, to which he then moved the *Gates of Hell*. As an additional sign of favor under the new dispensation he also received a commission from the city of Paris—to produce, at long last, a statue of d'Alembert, the *Encyclopédiste*, for one of the niches in the overloaded façade of the Hôtel de Ville.

For the time being it was the Dante commission that consumed his time. There were repeated conferences with the still slightly mystified Turquet. Emile Bergerat, then a young journalist and struggling playwright, recalls in his memoirs having caught his first glimpse of Rodin after one of these interviews. He had been sitting in Turquet's outer office when the undersecretary's door suddenly opened—"and framed a beard, for indeed it was nothing but a beard pierced by two eyes and mounted on feet, which advanced toward me like Birnam Wood in *Macbeth*, disguising a man." Rodin, it seems, had just sketched out his Dante reliefs into one of Turquet's notebooks.

Until then, Bergerat writes, only Turquet "saw in that beard the burning bush of genius." There in the outer office he took the measure of this unknown sculptor of forty: "Visibly athletic, his feet rooted in the earth like those of Antaeus, but with gentle, even timid move-

*Osbach was to die in abject poverty: in 1898 he was "found on his pallet," as Emile Bergerat records, "quite stiff, his teeth clenched, a bullet of clay between thumb and index finger."

ments, his gaze both naive and visionary behind his myopic's glasses; his hands large and well-shaped, the brow of Dante, large and low, creased by a vertical furrow drawn by a ploughshare of thought—he resembled old father Rude, himself the very image of an old Napoleonic guardsman, though Rodin overtook him by a beard's length."

Rodin had known some writers in Brussels but was unacquainted with a single Paris journalist. It was the painter Georges Haquette who now "introduced him to this phenomenon, in my person," as Bergerat recalled. "From the anxiety I inspired in him at first, and which I detected from the undulations of his beard, I realized that he exaggerated our merits and also our self-importance. But a good dinner dispelled these misconceptions, and the capital seafood that Haquette offered us came straight from Dieppe. . . . I seem to remember that the simple 'stonecutter,' or *maçon d'art* as he called himself, did not owe the first article published about him solely to the corrupting influence of these gastronomic delights."

Soon they ate together a second time. Rodin invited Bergerat, an avid art collector and a son-in-law of Théophile Gautier, to join him for lunch at his favorite café-restaurant in the rue de l'Université. "He feasted me on such awful veal and salad that his *Ugolin* himself seemed, after that, to deserve every excuse for his conduct. Oh, the poor veal, the painful salad! Yet, as he proudly admitted, this sort of thing had been his regular fare for the last fifteen or twenty years."

Other writers soon sought him out at the Dépôt des Marbres and there were increasingly good dinners for the "new" sculptor whom people were anxious to meet. "Paris is a funny place, *une drôle de ville*," Bergerat remarked. "As soon as someone gets the merest sleighbell of a reputation, everybody starts to sound the tocsin. . . . Thank heaven Rodin didn't have long to wait for his consecration. A number of notable writers soon harnessed themselves to his chariot."

The intellectual salons of Paris, where reputations were made or broken, opened their doors to him. He was invited to the home of Juliette Adam, at that moment the most famous hostess in Paris, who presided over a salon where the city's political and literary mandarins gathered every Wednesday evening—"the place from which France is governed and administered," as Turgenev observed. Rodin received

a formal invitation asking him to appear at 9:00 P.M. at No. 190, boulevard Malesherbes.

"As the clock struck nine," Bergerat reports, "a man correctly dressed in a black tailcoat and a snowy white shirt appeared at the door, top hat in hand, and found himself all alone in the flower-bedecked rooms whose mirrors reflected his look of dazed incomprehension. He consulted his watch. It was neither too soon nor too late; exactly 9 o'clock. Yet there was not a soul to be seen. Had he come to the wrong address? He turned to a group of footmen who were watching him—

" 'Pardon me, is this where I can find Madame Adam? Is this her home?"

"The servants looked at one another and eyed him quizzically without replying. They have a sense of what is fitting and proper, and they knew that no one invited to this house, even an artist, could possibly wear a beard of such antediluvian foliage. But suddenly one of them slapped his forehead; he had understood. He took one of the trays and handed it to the sculptor: 'Ah, camarade, you're one of the extra waiters?' It was after this soirée that Rodin trimmed his beard a little . . . as a painful concession to the demands of Parisian elegance."

7

PROMETHEUS
UNBOUND

Je suis comme un Prométhée déchaîné. . . .

—RODIN,
in conversation

I t was in the spring of 1881 that the whole of the Paris art
world began talking about Auguste Rodin, represented at
that year's Salon with two freestanding figures, the *Saint
Jean* in bronze and a plaster version of *la Création de
l'homme*, soon to become better known as *Adam*. "Have you seen the
Rodin?" was the universal question.

"You must go to see the Rodin. . . . You haven't seen the Rodin?
But really, what do you think of Rodin?"

Initially there had been some of the usual difficulties about both
figures. The *Saint Jean*, as Rodin wrote two years later, was judged
to have "unfortunate tendencies at least from the vantage point of
those who are all twisted up [*crossed out*]—those who had already
arrived and were to be demolished by it, but it was welcomed by the
young artists who were marching toward expressiveness."

At the same time his "new figure, *la Création*, just missed being
[*crossed out*]—was accepted thanks to a friend on the jury, Captier,
who does much to assist the *artistes libres* [i.e., the nonacademic
sculptors]." Yet when he saw how the Salon had been arranged,
Rodin again had cause to complain that his figure was "badly placed;

still near the doors." This *Création* shocked the conventionalists with its "corkscrew" *contrapposto* and its "hunchback" pose, derived from Michelangelo but rationalized by Lawton as "Adam stretching himself painfully in his endeavour to rise from the clay of the soil out of which he had been fashioned." The critics felt on surer ground with the *Saint Jean*: when it was shown in Brussels later in the year *l'Art Moderne* described it as an achievement of the first order—"one of the most remarkable works of contemporary sculpture." Indeed, for the young sculptors who were watching Rodin's progress with avid interest, the wiry, striding figure of the Baptist was an even more significant development than *l'Age d'airain*, since it proclaimed what was literally a new "movement" in sculpture. One of his admirers told Bartlett that the *Saint Jean* "was the loudest clap of thunder that has been heard in France for a hundred years."*

The summer following the Salon of 1881 seemed a propitious time for Rodin to spread his wings. In August he took advantage of his newfound freedom to pay his first visit to London: it was just over ten years since he had set out on his interrupted journey to England following the armistice with Prussia. This time he had been invited to London by his old friend Alphonse Legros, once one of Lecoq's favorite pupils and now comfortably ensconced as professor of drawing at the Slade School of Art at the University of London. Legros had earned a formidable reputation as one of the great portraitists and printmakers of his generation: his finest works are his meticulous drypoint portraits of such contemporaries as Carlyle, Tennyson, Longfellow and Victor Hugo.

Rodin admired Legros's work but found him crotchety and difficult, living "in an unenviable situation" as a Frenchman marooned in a sea of Englishmen, and given to bitter outbursts about the poverty and neglect that had driven him from France in 1863. To Rodin's annoyance, "he insisted on recalling the terrible struggles" he had undergone as a destitute young artist, though at the moment he had little enough to complain about.

*The *Saint Jean* again prompted accusations that Rodin had used surmoulage. "Would you believe that they've accused me of having cast it from a living model?" he said to his young admirer Jeanès. "Because all the muscles are so clearly delineated. But every one is in action! Just try to cast that in plaster! And yet these are sculptors who dare to say this."

Legros had acquired an English wife, English children and British nationality but had managed to remain staunchly indifferent to the local language. At the Slade he communicated with non-French speakers through a bilingual deputy who accompanied him on his rounds of the class to inspect the students' work. One of his pupils, A. S. Hartrick, remembered that when this assistant translated the words of "the master," he always began respectfully, "the Professor says . . ."

What the Professor said was usually "*pas mal*" or something equally colourless; but in correcting the life-drawing he had one peculiarity; on the smallest opportunity he cut down the size of the genitals, saying, "Michelangelo always made them small."

Despite his eccentricities, gifted pupils found Legros an inspiring teacher of classical drawing and painting in the tradition of Leonardo and Raphael. He taught mainly by example, and "the astonishing demonstrations he gave of heads painted within an hour could be seen by all if not imitated."

For Rodin, too, Legros proved to be an unexpectedly stimulating companion who initiated him into the mysteries of a new métier. During the weeks he lived in Legros's rambling house at 57 Brook Green, Hammersmith, there were days when Rodin was obliged to stay at home while his host was busy teaching. Legros suggested he fill the time by trying his hand "at something that would be fresh to him"—the technique of drypoint etching of which Legros himself was arguably the greatest living master. This kind of printmaking, he explained, was "nothing more than drawing on metal," since it dispenses with etching acids and allows the artist to work directly with a graving tool on the surface of the copper plate.

Rodin made some trial plates and found that the technique suited him perfectly: "I understood it immediately." After twenty-five years of unremitting practice as a draftsman he already possessed the boldness, delicacy and precision that Lawton regarded as the hallmarks of a great drypoint etcher—"boldness, so as to furrow the metal with a sure and well directed hand; delicacy, so that the curves may be

ploughed out neither too deep nor too shallow; precision, so that the whole may be clear as well as flexible."

Drawing on copper was not so very different, for that matter, from graving sgraffiti on porcelain at Sèvres. But ordinary burins cramped his style, and he set about devising a tool better suited to his needs. At Sèvres he had worked with a broken penknife; now he used an ordinary darning needle fitted into a sort of penholder, which produced a more elastic stroke and allowed him to draw almost as freely as with a sharp pencil, "lashing the plate in all directions" even in his first experiments.

He engraved his first drypoint on the back of a copper plate that Legros had already used for the head of a young woman: on Rodin's side the maker's stamp (Hughes and Kimber Ltd., Manufacturers, London) was still visible. The subject was a playful throwback to Rodin's Brussels epoch—"a charming sketch, in drypoint, of a band of *amorini* sporting in space with the great globe itself," as a British critic described it when *les Amours conduisant le monde* was exhibited by the Society of Painters and Etchers in May 1882. Rodin also practiced his needle on one other, abandoned experiment, like a page from a sketchbook: two heads that were evidently related to the Dante project, then very much on his mind. The next attempt was a masterful print of Rose as *Bellona* in her Grecian helmet but without the bust's extravagant pout; it was the first of several plates which he drew, not from the live model, but from one of his own sculptured heads. Later there were to be other drypoints—not more than thirteen altogether, but each a virtuoso performance that demonstrated his matchless ability to draw *prima vista* with a draftsman's sparseness and precision. In Paris he dazzled the professional engravers with the controlled power of his technique, with his bravura variations in thickness of line and gradations of pressure. As one of them admitted, "Rodin showed us a print and put us all to flight."

The only specialist in the field whom he could not eclipse so easily was Legros himself. Not long before Rodin's visit the Slade professor had produced a drypoint self-portrait that shows him at the height of his powers, even more bushily bearded than his old schoolmate, and very much the "belated Old Master" the English considered him to be. Now he undertook to engrave his guest's portrait in profile—a quietly understated study of the rather introverted forty-year-old who

was just on the threshold of becoming the best-known sculptor of his time.*

Legros took Rodin on "wonderful walks through the museums of London" and also mobilized his circle of acquaintances on Rodin's behalf. He introduced the sculptor to the influential art collector Constantine Ionides and to the president of the Royal Academy, Sir Frederick (later Lord) Leighton;† to Robert Browning and to W. E. Henley, author of *Invictus* and one of the leading magazine writers of London. Fortunately Rodin's Parisian reputation had preceded him, for he spoke no English and looked unprepossessing—"a small energetic figure with a wispy beard hurrying about the passages of the Slade," as Hartrick saw him, "very different from the stout grave signor (with scented beard) of the International Society twenty years later."

Both Henley and Ionides offered well-intentioned advice, as Legros remembered, and each in his own way "after praising Rodin's work, made use of the same phrase: 'If you want to succeed in England . . .' " Rodin listened skeptically and ended by saying, in his quiet way, "What you tell me is doubtless right, but *je me contente de la journée d'un ouvrier pour faire ce que je fais*—I'm satisfied with a workman's wages to go on doing what I have been doing."

Henley, who was to become Rodin's foremost British apostle, spoke fluent French and was passionately interested in the sculptor's work, with the result that they were soon on the best of terms. He towered over Rodin—a tall, robust Viking from Gloucester with kindly eyes, a booming voice and a fondness for strong drink. As a boy he had suffered from tuberculosis of the bone, and doctors had amputated one leg just below the knee; later the other leg had been saved by Dr. Lister, in whose Edinburgh clinic he had undergone twenty months of treatment. It was here that he had written the brave lines that every

*Victoria Thorson's *catalogue raisonné* of Rodin graphics gives the date of Legros's drypoint as 1885–90, presumably because it makes Rodin look considerably older than his forty years. There is no question, however, that it was done during Rodin's first visit to London: Legros wrote to him about the first proofs of this print in November 1881, and though he afterward painted Rodin's portrait in oils he did not produce another drypoint of the sculptor.
†Ionides bought Rodin's bust of Legros in 1882; Leighton acquired a cast of *The Man with the Broken Nose.*

English and American schoolboy once had to learn by heart, little realizing that they were a literal statement of Henley's hospital experiences:

> *Out of the night that covers me,*
> *Black as the pit from pole to pole,*
> *I thank whatever gods may be*
> *For my unconquerable soul.*

> *In the fell clutch of circumstance*
> *I have not winced nor cried aloud:*
> *Under the bludgeonings of chance*
> *My head is bloody but unbowed. . . .*

> *It matters not how strait the gate,*
> *How charged with punishments the*
> *scroll;*
> *I am the master of my fate:*
> *I am the captain of my soul.*

After the disease was arrested he had gone to work as editor of *London*, a weekly magazine in which he published some of the earliest work of Stevenson, Kipling, Conrad, Shaw and H. G. Wells. He had contributed to many of the leading literary magazines and had written several plays in collaboration with Robert Louis Stevenson. In 1880 he had suddenly developed an overwhelming enthusiasm for art. "O Colvin, Colvin!" he wrote to his friend Sidney Colvin, then Slade Professor of Fine Art at Cambridge. "Why will you not make an art-critic of me? I am not a bloody fool, for I can feel and see and be religious over great art." In a matter of months he taught himself to be an art critic, and shortly after his first meeting with Rodin he was appointed chief editor of *The Magazine of Art*, a lavishly illustrated review for upper middle-class English readers. Many of them were scandalized when Henley attempted, as Will Low put it, "to cram down the throats of his subscribers some appreciation of the great French sculptor."

After Rodin returned to Paris there were effusive letters from Henley relating the good news of his editorship, as well as the fact

that he had (at least temporarily) stopped drinking. Rodin had given him a plaster copy of *The Man with the Broken Nose*; it served as "a perpetual reminder of you," as he wrote to the sculptor on November 9, 1881:

> *Ça reste d'une éternelle beauté*—the beauty of great art. You have not lacked disappointments, my friend; on the contrary, I know that you have struggled hard, suffered much, and toiled hard. And yet how happy you must be! You work for the centuries to come—you know what you are doing; you do it well.

The friendship with Henley marked the beginning of a special relationship with England that brought Rodin back to London on frequent visits throughout the next three decades. His interest in the English art world was facilitated by the fact that connections between Paris and London had never been easier: the boat train via Boulogne and Folkestone took nine to ten hours; via Calais and Dover the trip took an hour and a half longer; third-class fares—Rodin liked to travel as cheaply as possible—were not much more than forty francs. London art exhibitions usually furnished the pretext, but it was not only the expanding British market for his work that prompted these journeys. Friends testified that "Rodin genuinely enjoys being in London," and that even on his initial visit "he felt the mysterious attraction of the city's immense hum of life and its coloring"—the pea-green and lemon-yellow fogs of coal-burning London that also fascinated Claude Monet. "Nothing can be more beautiful," Rodin decided, "than the rich, dark, and ruddy tones of the London buildings, in the gray and golden haze of the afternoon." Here as in France he was an indefatigable sightseer and museum-goer. Around the corner from the Slade was the British Museum with its Elgin marbles: for Rodin, the *Three Fates* from the pediment of the Parthenon were "the most beautiful thing Greece ever produced."*

It has been suggested that Legros introduced him to the work of

*Legros, too, was a passionate admirer of the Elgin marbles. Once, when a friend suggested that the sculptures should be returned to the Greeks, he burst out: "*Jamais! je prendrais un fusil; je descendrais dans la rue*" ("Not on your life! I'd take a gun and man the barricades").

Blake, Fuseli and Flaxman, three artists then almost unknown in France, and that the Flaxman illustrations for the *Divine Comedy* which found their way into Rodin's library influenced his thinking on the Dante doors. In any case, Rodin's interest was not confined to what he could see in the London museums. During his visits to England he took the trouble to see the Queen's Holbein drawings at Windsor (of which he spoke "with all an artist's love") and made an excursion to Oxford, where he dined at the Fellows' table of Christ's College and admired the conjunction of gardens and Gothic. On the way back to London he traveled by short stages in order to see something of Reading and the banks of the Thames.

Legros, having introduced his guest to an unfamiliar medium, had been repaid in kind when Rodin encouraged his experiments in sculpting portrait medallions. Henley saw these pieces in November 1881, and wrote to Rodin that they had come out very well, particularly the medallion of Charles Darwin that Legros had just completed: "It is partly to you that we owe them, and you have a right to be proud of them." Legros sent the plasters to Paris so that Rodin could supervise their being cast in bronze; he himself was to follow in short order. "I am anticipating the pleasure of having my bust from you," he wrote, "and when I come to Paris I will give you a good many sittings."

When he arrived in December, Rodin dropped everything in order to work on the promised bust. The indispensable Maurice Haquette was asked to convey the necessary excuses to Monsieur l'Administrateur at Sèvres: "He should not be too annoyed that I was unable to come on Wednesday. . . . Legros is in Paris, and during his stay all my days are at his disposal; I'm doing his portrait." The sittings took place in the boulevard Montparnasse studio of Gustav Natorp, a wealthy amateur and former pupil at the Slade who had taken Legros's advice and come to Paris to study with Rodin. The resulting bust was a splendid, sympathetic character study of his friend's almost classical face, with its thinker's forehead and shrewd eyes; the flowing beard rests directly on a circular base in lieu of neck and shoulders.

Legros thought it "admirable and very effective; everyone admires it." Later he reciprocated by painting Rodin's portrait in the studio of their mutual friend and fellow Lecoq pupil Jean-Charles Cazin. This time he depicted his subject in a far more vigorous and assertive pose, producing what is easily the most lifelike of all the portraits of

Rodin, who held it in high esteem as "one of the things I most value."
It follows Legros's standard recipe for minimalist portraits—a canvas
covered with a background wash of umber and turpentine. The black-
bearded, rugged face is built up with solid colors; there is only the
merest hint of what happens beyond the collar. The head is framed
with a texture of almost untouched canvas.

For a time Legros came to Paris almost as often as Rodin went to
London, and his social connections were to prove useful to Rodin on
both sides of the Channel. In sending him Gustav Natorp, Legros
had done both men a favor: on many of Rodin's subsequent visits to
England it was Natorp who provided him with a comfortable place to
stay and looked after his needs.

Natorp was four years older than Rodin and an adoptive American,
having been born in Hamburg but educated in the United States. He
had always wanted to be an artist, but his parents refused to allow
it. Instead he went into business, invested his money in the immensely
profitable arms firm of Vickers & Maxim, and found himself, at forty,
wealthy enough to settle in London and devote himself to art. He
married a young model with a "very voluptuous figure," having first
arranged for her to receive an education suitable for a rich man's
wife. In Paris he befriended John Singer Sargent, who painted his
portrait and dedicated it "*A mon ami Natorp*," but most of the profes-
sional artists refused to accord him more than amateur status.

Natorp was Rodin's first significant paying pupil, and though it
was clearly too late for him to become a great sculptor he proved to
be an unusually attentive *élève* whose perceptions of his teacher were
very different from those of the younger pupils who came after him.
Rodin's teaching, he remembered later, "was absolutely a revelation
to me":

> I do not believe he has his equal in the ability to give his
> inferiors the benefit of his vast insight into the great principles
> of all art by his power of analysis, and by the warmth of his
> admiration for all that is great in art and in nature. While I
> was at the boulevard Montparnasse he came to see me twice a
> week from November 1881 to May 1882; and not the least
> admirable lessons were those when we left the studio after dark,
> and when, talking most delightfully about art, he would take

me to a café, call for pen, ink and paper, and illustrate his views on composition, etc., by his masterly drawings.

Natorp returned to Paris for a second series of private lessons, from October 1882 until June 1883, when he sculpted a two-thirds-life-size statuette of Hercules that was exhibited at the Salon and the Royal Academy. "When I left, Rodin said: 'Now, I have given you a compass, by means of which, with nature for a professor, you can steer yourself.' "

Legros was responsible for sending Rodin several other pupils from London, including Robert and Elizabeth Barrett Browning's artist son, Robert Barrett ("Pen") Browning, and Frank-Smyth Baden-Powell, afterwards a naval and military painter of the "Nelson at Trafalgar" school (one of his best-known canvases shows his brother, Colonel R. S. S. Baden-Powell—later to become founder of the Boy Scouts—commanding the British defenders at the siege of Mafeking in 1899). Both were in their early thirties and had, like Natorp, done far more work in painting than in sculpture. But as Pen Browning explained to a colleague, he had interrupted his career as a painter in order to work in Paris "in the studio of a friend, under Rodin the sculptor & I am going in for a dose of modeling which, I take it, is a surer road to knowledge of the figure than drawing in black and white."

After five months with Rodin, Pen sent his father a bronze statuette, *Dryope Fascinated by Apollo*, as evidence of his progress. The elderly poet thought it a "very clever" figure, and he was pleased to accept Rodin's gift of a plaster *Man with the Broken Nose*. In sending the senior Browning New Year's greetings for 1883 Rodin wrote that he was "honored to be in a position to give some points of advice on sculpture to the son of the *Grand Poète Anglais*." The reply from 19 Warwick Crescent, Paddington, was not long in coming:

My dear Monsieur Rodin,

Nothing could be more flattering than your kind note of yesterday, the expressions of which I reciprocate, begging you to believe that it is for me, as for my son, an inestimable advantage that a sculptor of your rank should allow the latter to profit by the advice and friendship which he appreciates as

they really deserve. Believe me, dear Monsieur Rodin, very
sincerely yours,

Robert Browning

On one of his visits to Paris the poet took Rodin to dinner in a
restaurant on the place de Rennes, and he lived long enough to admire
some of the sculptor's important works of the 1880s: "Like Rembrandt, this man makes misery live, and finds beauty and poetry even
in age-bowed backs."

Pen Browning—"a little apple of a man"—joined Natorp and
Baden-Powell in organizing a series of monthly dinners at which Rodin
was regularly the guest of honor. "We had the most delightful gatherings," Natorp reported: they were attended by Sargent, then in his
twenties; Giuseppe de Nittis; Albert Besnard; Raphaël Collin; Albert
Edelfelt; and Henri Gervex, most of whom were destined to swell the
ranks of the Salon painters.

After years as an outsider Rodin was suddenly caught up in the
busy social life of the Latin Quarter. He often breakfasted at the
restaurant Livenne together with Sargent, the young writer Paul Bourget and the still younger portraitist Paul Helleu, whose pastels Rodin
admired. Bourget, Helleu and Rodin all became regular participants
in the monthly dinners of the Bons Cosaques, founded by Octave
Mirbeau in March 1886, which were frequented by *tout l'art jeune*,
including Maupassant, Jean Richepin, Paul Hervieu, Catulle Mendès,
the Rosny brothers, and many other writers, along with the composer Vincent d'Indy and such artists as Alfred Roll and Félicien
Rops.

At the more rarefied end of the social spectrum there was *le highlife intellectuel* at the soirées of Juliette Adam—this "charming, enthusiastic, generous woman," as Rodin called her, who introduced
him to a whole coterie of influential political figures—Eugène Spuller,
who was to become minister of public instruction and fine arts; Ernest
Waldeck-Rousseau, who served for a time as minister of the interior;
and Jules Castagnary, who impressed Rodin as "a critic intelligently
sensitive to beauty," and who was soon to become director of the
Beaux-Arts. "In general the world of the official artists treated me
rather badly," Rodin remembered, "and the public, corrupted by so
much glorified banality, paid no attention to my works, but it was in

[144]

this milieu that I encountered genuine, effective support for the first time."

Soon he was also a regular guest at the Saturday dinners of the city's other great literary hostess, Madame Liouville, daughter of the eminent Dr. Charcot (who was to teach Freud about hysteria) and wife of Dr. Henri Liouville, a prominent republican member of the French parliament. She herself was an amateur painter, and she had devised a parlor game to which all her artist guests were expected to contribute. "A sort of habit was acquired of making drawings on the reverse side of the dinner plates, which were afterwards sent to be burnt in, and were guarded as souvenirs," Lawton explains, though it meant that Mme Liouville was continually renewing her dinner service. For a time, at least, Rodin was fascinated by this new world of the literary salons. Although Octave Mirbeau could describe him in 1885 as a man who hated cliques "and rarely ventures into society," Lawton was probably closer to the truth when he wrote that "Rodin saw more society during this decade than either before or since."

Yet during most of the 1880s he was still living in very modest circumstances. In 1884 he and Rose moved to No. 71, rue de Bourgogne (only a few steps from the mansion known as the Hôtel Biron, then a girls' school and now the Musée Rodin). On days when he did not go home for lunch he persisted in patronizing the cheap eating house that had appalled Emile Bergerat. At his studio he was still practicing the most stringent economies. The Dépôt des Marbres was also a cemetery of deposed political statues, and Rodin came into possession of "a full-length male statue representing a political personage of mature years," as Lawton relates. After thinking hard and long how to reuse the marble in this unwanted hero of the Second Empire, Rodin "calculated the thing out mathematically, and changed the old gentleman into a Bacchante."

Despite the Dante commission he went on accepting small decorative jobs that brought in extra money. Among the more curious items of Rodiniana is an enormous pseudo-Louis XVI bed with an *enfant génie* perched on each side of the footboard: they were carved in mahogany from plaster figures which Rodin delivered in 1882 to Mathias Ginsbach, a master cabinetmaker who had already produced a walnut sideboard with two Rodin caryatids.

He also continued to work at Sèvres, though only sporadically,

until December 1882, when he handed in his final chit for fifty-six hours devoted to creating "a vase and patterns." Though his name remained on the roster of auxiliary personnel, Rodin "had had enough of criticism from his inferiors," as Bartlett records, and he was no longer in the mood for porcelain. His farewell to the medium, in effect, was a handsome bust of his former maître, Carrier-Belleuse, which was cast in *biscuit de Sèvres* and exhibited at the Salon of 1882. Significantly, it was one of the last Rodin portraits to include a detailed rendering of the sitter's shirtfront and cravat—less as a concession to fashion, probably, than because these were essential attributes of Carrier's persona. Besides Carrier there were other artists at Sèvres who watched the sculptor's departure with a twinge of regret. One of them, Fernand Paillet, drew a Rodin page for an album of Sèvres caricatures that shows him with his beard dragging the ground, staggering under the burden of an enormous door marked "Arts Décoratifs" and ornamented with a tangle of naked bodies.

To the very end of his days at Sèvres Rodin enjoyed the confidence and support of Maurice Haquette, who was expected to wield his influence not only for Rodin's projects but also on behalf of his protégé, Alfred Boucher. "I would be most grateful if you could introduce him to M. Hecq and lend him your support at the ministry," Rodin wrote to him at his office in the *manufacture*. And in another note to Haquette: "Boucher would like to ask you if you could use a little of your energy and activity on his behalf. Has his group been purchased? If we don't see you before then, he'll wait for you at eight o'clock tomorrow morning at the Gare Montparnasse." He was also supposed to put in a good word for the medalist Jules Chaplain, who "asked M. Turquet for an interview fifteen days ago and still hasn't had a reply."

But Haquette was to receive a princely reward for his trouble: "I'll see you Tuesday night for your portrait." It was a superb piece of modeling; a portrait of the connoisseur as a young man, gazing out from beneath a canopy of windblown hair. After Turquet resigned from the ministry, however, the days of his brother-in-law's brother were numbered, and Haquette left his post at Sèvres six months after Rodin had done so, to become a noted art expert and dealer, with a shop in the rue de Clichy specializing in "paintings, curiosa and antique jewelry." Though they lost touch with each other, at the turn

*Rodin as a baby,
in the arms of a nursemaid.*
MUSÉE RODIN

*Self-portrait at
eighteen or nineteen:
a Rodin drawing,
the whereabouts of
which are unknown.*
BULLOZ PHOTO

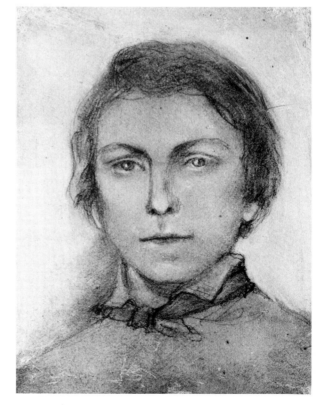

Rodin's portrait of his mother.
BRUNO JARRET AND MUSÉE RODIN BY SPADEM

Rodin's portrait of his father.

Rodin by Barnouvin.
BRUNO JARRET AND
MUSÉE RODIN BY SPADEM

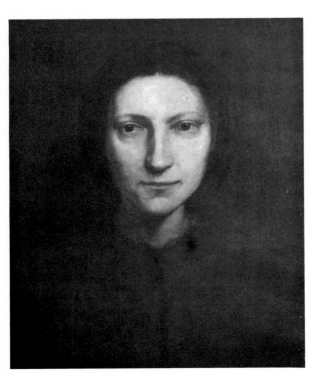

*Marie-Louise Rodin
by Barnouvin.*
BRUNO JARRET AND
MUSÉE RODIN BY SPADEM

*Jean-Baptiste Carpeaux
by Augustin Mongin.*

Antoine-Louis Barye.

*Rodin in his studio
in the early 1860s.*
MUSÉE RODIN

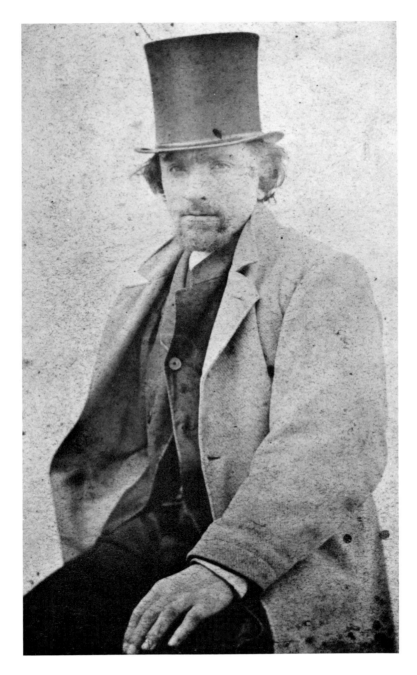

Rodin in his Sunday best,
circa 1864, photographed by Charles Aubry.

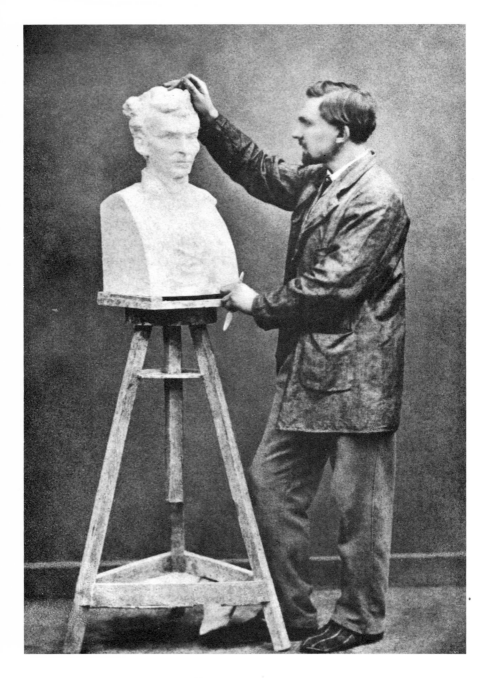

*Rodin at work on
the bust of Father Eymard.*
MUSÉE RODIN

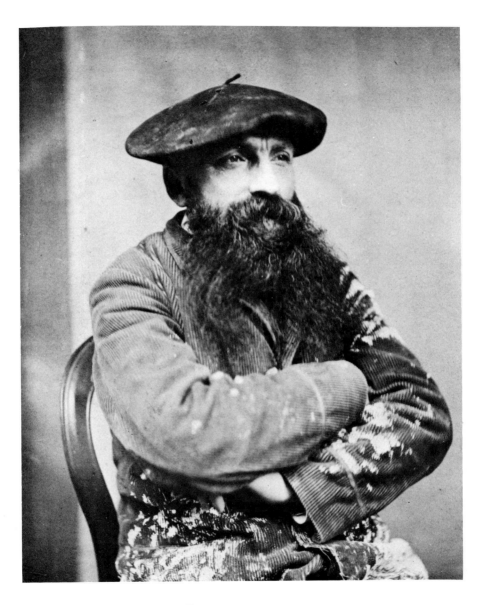

Rodin, in the 1870s,
in a plaster-spattered coat.
MUSÉE RODIN

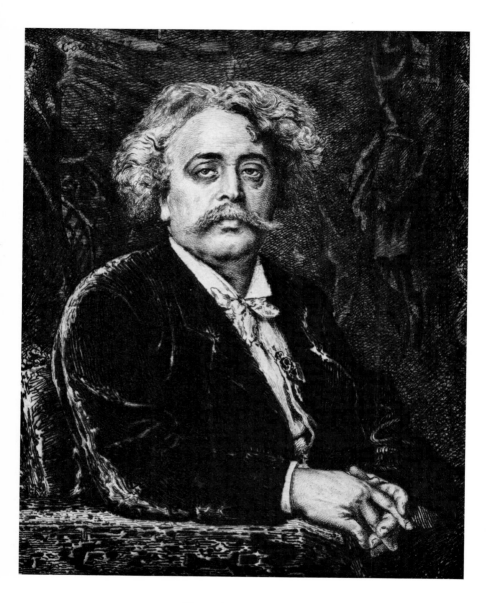

Albert Carrier-Belleuse
by Fernand Cormon.

Rodin's drawing of le Vaincu,
alias l'Age d'airain,
with the spear still in place.

*Rodin's charcoal self-portrait,
circa 1880.*

Legros by Legros: a drypoint self-portrait.

Rodin in London, 1881:
a drypoint by Legros.

Rodin's bust of Legros,
1882, in an engraving by
Auguste Leveillé.

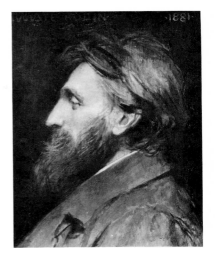

Rodin by François Flameng, 1881.
BULLOZ PHOTO

*Rodin
by Legros:
oil, 1882.*
MUSÉE RODIN

*Jules Dalou
by Alphonse Legros.*

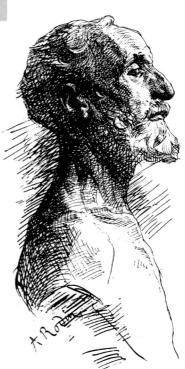

Rodin's drawing of his bust of Dalou.

of the century Rodin still fondly recalled "the time when we used to see each other so often."

>‡<

During these restless years Rodin got into the habit of leaving Paris on the spur of the moment and going off to the provinces without bothering to tell Rose. She had to content herself with receiving his explanations, if any, through the post—curt messages that told her his whereabouts and reiterated his standing orders:

> *Mon ange*, I am at Saint-Gaultier [site of an important Romanesque church] eighty leagues from Paris in the department of the Creuse, I'll be back soon don't worry. My departure was very sudden and impromptu. I'm sending you 5 francs to spend while you wait, take good care of my waxes, wet the clay in the studio.

Such hastily scrawled notes might arrive at any time from any point of the compass: "Write me quai de Hable, Dieppe, care of M. [Georges] Haquette, *artiste-peintre*, you'll be receiving an old piece of furniture, there is nothing to pay here is the receipt. I'll be back Tuesday or Wednesday. Au revoir, Aug. Rodin." Rose still occupied her indispensable place as his housekeeper and guardian of the studios; since their son had turned out to be hopelessly incompetent she was the only person he could trust to carry out his instructions to the letter. Amid the press of business there was less and less time for expressions of tender concern. On June 10, 1882, for example, during his second visit to London, he sent her a list of instructions couched more or less in the style of an army order: "You'll receive a letter from the man who's supposed to do the photography of the bust of *la République*. . . . You'll be at this man's disposal on the day he tells you. Give the address to De Vigne, and if you have expenses do whatever is necessary for yourself or the others. Your devoted friend. . . ."

At home with Rose, however, there were times when he would make an effort to revive the spirit of conjugal entente that had prevailed at Ixelles. On Sundays they still liked to wander through the countryside south of Paris, to the heights of Châtillon and beyond

Vanves, in the direction of the Bois de Meudon and Fontenay-aux-Roses. Sometimes they were accompanied by his "cousin," the journalist Henri Thurat, and his wife, Berthe. Thurat (who liked to style himself a cousin, though he was merely a cousin of Rodin's cousin Hippolyte Coltat) told Lawton that they would usually stop at some country restaurant for lunch, "a favorite menu being soup followed with boiled meat and cabbage. Then came a stroll out on to the hills, and a siesta in the grass, when Rodin would lie back with his hands under his head and discourse in monologue, if dialogue failed, of anything that passed through his mind, and much of Nature's unperceived or neglected delights." But although he often took Rose on family outings, he carefully avoided introducing her to his newly acquired literary friends. She was simply not the sort of mistress one could have brought to a Liouville soirée, or even to a dinner with Browning, Natorp and de Nittis.

Among the new friends from whom he kept her hidden was the prolific writer Léon Cladel, author of a string of naturalistic novels, whose villa at Sèvres was one of the crossroads of artistic and literary Paris. Cladel and his wife had four daughters, a small son, and two spaniels; they kept open house for creative people on Sunday afternoons. He was excitable and articulate, "a revolutionary spirit," as his friend Rosny *aîné* described him, "of medium height with a thin face and keen eyes, his hands constantly in motion." Cladel's dinner parties were not formal affairs, to say the least. At one of them, according to the playwright Catulle Mendès, the host "amused himself by putting his little boy's naked bottom on the soup tureen. It warmed the bottom, made Cladel laugh and gave us an appetite."

Rodin began visiting the Cladels around 1882 at the behest of their mutual friend Jules Dalou, now reestablished in Paris after the general amnesty for Communards. Judith Cladel, one of the novelist's daughters and later Rodin's biographer, mentions some of the other interesting people who used to meet under the lime trees on the terrace of her father's house: Bracquemond the engraver and Henri Cros, then a painter on pottery; the poets Stéphane Mallarmé, Maurice Rollinat, Clovis Hugues and Henri de Régnier; and a clutch of distinguished Belgians including Camille Lemonnier, Emile Verhaeren, Edmond Picard, Théo van Rysselberghe, Constantin Meunier and Georges Rodenbach. There were also a number of critics who became

active Rodin supporters: Léon Maillard, who was to write the first book on Rodin; the journalist Caroline Rémy, who signed her articles "Séverine"; Léon Riotor of the newspaper *la Réforme*; and Arthur d'Echérac, alias "G. Dargenty," who sang the sculptor's praises in *l'Art* and Clemenceau's *la Justice*.

Rodin felt slightly out of place in that garrulous company; "he used to arrive with an air of shyness, of awkwardness, that disguised his determination." Yet Léon Cladel grew very fond of him and nicknamed him *l'illustre ingénu*, the illustrious innocent. To the other Sunday-afternoon literati, he became *le Père Rodin*.

After dinner Cladel and his children would sometimes walk part of the way home with him. "I must go to the Park of Saint-Cloud," he told them one evening. "My wife is waiting there for me." (He had taken to calling Rose his wife when speaking of her to people who were unaware of their real relationship.) Cladel asked why he didn't bring her with him.

"*C'est une sauvage*," Rodin replied with an embarrassed smile. "Then we'll tame her," the novelist suggested. The sculptor "blushed and conveyed his thanks with a look of grateful affection," as Judith Cladel recalled. "But he did not bring his wife to visit us. She always waited for him somewhere, and his friends remained in complete ignorance of his private life."

His professional life, meanwhile, was becoming increasingly interesting to the world's press. The French critics no longer passed him over in silence; in England, Henley described him in the *Magazine of Art* as "M. Auguste Rodin, perhaps the greatest of living sculptors," and thus became the first to apply a superlative that must have galled Dalou and other sculptors capable of reading English. Louis de Fourcaud of *le Gaulois* did not go quite so far but placed Rodin "in the highest rank" of the young sculptors. Paul Leroi advised the readers of *l'Art* to remember Rodin's name—"it will go far." Gustave Geffroy reported in *la Justice* that people were "saying wonderful things about these works in which Rodin seems haunted by the memory of Delacroix's sketches." The cumulative effect of these attentions was not lost on Rodin, who had begun to realize that "the press is a great power," as he once told Michel Georges-Michel. "It's thanks to the Liberal press that I've been able to make a living."

During the winter of 1883–84 when he set down his curriculum

vitae for Gaston Schéfer, editor of the *Galerie contemporaine*, he was delighted to be able to report, without false modesty and in the third person, that the sculptor's light was no longer hidden under a bushel—"his reputation is made." Now for the first time in his life he experienced the sense of creative fulfillment which he was to sum up in the phrase "I am like a Prometheus unbound." He described his state of mind to Schéfer in the third person:

> Overjoyed at the happiness of being able to create sculpture with complete freedom as he had always wanted, Rodin now worked with the same joyful enthusiasm as the artists of former times, needing money chiefly to pay the models he always has at his studio and whom he often allows to move about freely, though he watches them out of the corner of an eye in order to learn from the originality which is in nature.

The public had lately become aware that here was an inportant new exponent of the neglected art of portrait sculpture. Fortunately, his steadily widening circle of acquaintances provided him with a series of interesting and distinguished heads on which to demonstrate his ability to translate character into clay. The autobiographical sketch goes on to point with pride to the fact that

> J. P. Laurens, the great artist, asked Rodin to do his bust, and at the Salon of 1882 one could admire Laurens's masterful portrait of Rodin as well as the sculptor's bust of the maître, which Gonon cast admirably in bronze using the *cire perdue* method.* Laurens also commissioned a bronze cast of a small Rodin sketch which he had in his studio. Next came the bust of Alphonse Legros, the great etcher and French painter who lives in London, and the bust of Danielli.

Rodin had every reason to be proud of the Laurens bust. It was the first time a major artist had asked him to do a portrait and thereby

*The master founder Eugène Gonon had revived and perfected the ancient "lost wax" method of casting, in which a wax original, encased in a mold, is melted away and replaced by molten bronze.

recognized him as a peer. Besides exchanging portraits with him, Laurens went him one better by painting Rodin as a Merovingian warrior into one of the "Sainte Geneviève" frescoes he was then adding to the decorations of the Panthéon. (Thus, less than thirty years after he had attended mass there as a boy, his face was already enshrined on its walls.) Born in 1838, Laurens was a brilliant though rather gloomy history painter in an epoch that doted on narrative pictures. Unlike most of his rivals he combined a superb technique with a profound grasp of history, especially of medieval France.

The critics praised the "Homeric dignity" of Rodin's bust of Laurens, with its heroic expanse of unclothed chest and its patriarchal beard. "With his nude shoulders he is severe, proud, alive and accentuated like a Gothic sculpture," wrote Louis de Fourcaud in *le Gaulois*. Philippe Burty, who specialized in technical details, found that everything was surprising about this bust—"the lines of the temples, the hair, the neck at the onset of the ears, the way the ears are attached to the back of the head." Emile Bergerat, by now an ardent convert, told the readers of *le Voltaire* on May 31, 1882, that the *J. P. Laurens* proved that a bust could be a major masterpiece and "one of the most beautiful sculptures of the year. . . . All the artists spent a long time standing in front of this bronze and admiring it—a piece worthy of Michelangelo which announces the advent of a new master."

Laurens occupied one of the adjoining studios at the Dépôt des Marbres; Rodin told Paul Gsell many years later that it had given him great pleasure to do this bust. "He reproached me good-naturedly for having shown him with his mouth open. I told him that, judging from the shape of his skull, he was probably descended from the ancient Visigoths of Spain, and that this type was characterized by the prominence of the lower jaw."

The Danielli bust was more conventional—a portrait of the helpful young man who had invented a galvanic process of bronze-plating plaster, the "Danielli method," which Rodin used experimentally for one of his *Saint Jean* casts. Danielli, who was also an expert in ceramics and Greek sculpture, founded the firm of "J. Danielli *Jeune*, 108 boulevard St.-Germain," where he sold "malleable marble" and undertook the metallization of plaster casts. For several years he and Rodin were on the best of terms: once, when he invited "M. et Mme

Rodin" to lunch just as the sculptor was on his way to London, Rose was told, "I hope my darling that to please me you'll go on Sunday to have lunch with Monsieur Danielli." It was not often that Rose was sent to deputize for the maître.

But Rodin's powers as a portraitist were soon to be tested on a far more challenging and less cooperative subject. It was the young journalist Edmond Bazire who suggested he do a bust of Victor Hugo, the old literary lion whose lifelong support for democratic causes had made him one of the great popular heroes of the Third Republic. Bazire revered Hugo: as an editor of the newspaper *l'Intransigeant* he had set in motion the extraordinary spectacle of the Victor Hugo Festival held on February 27, 1881, to celebrate the beginning of the poet's ninth decade. It took place on a Sunday, the day after his seventy-ninth birthday, and 600,000 people—more than a quarter of the city's population—marched past Hugo's house at 130, avenue d'Eylau (soon to be renamed avenue Victor Hugo) while the poet stood at an open window, indifferent to the winter weather. It was an unprecedented act of homage to a living writer, and he was duly grateful to Bazire for having given him one of the great moments of his life. (Rodin, irreverently, said that what Bazire had really done was to give Hugo "an exact rehearsal of his funeral" four years later.)

In March 1882, after Bazire—writing as "Edmond Jacques"— had published a favorable review of his *Carrier-Belleuse* at the Exposition des Arts Libéraux, Rodin invited him to visit his studio. "I went to see him in the rue des Fourneaux," Bazire later wrote. "It was not his principal studio but a sort of warehouse and branch office where he stored sketches, studies, projects. . . . He was very gentle, very modest, and quickly showed me the various pieces he had at hand." To get to the main studio they took one of the horse-drawn trolley cars that now traversed the city, "and he told me all about himself on the platform of a tram while we rode to the Dépôt des Marbres in the rue de l'Université.

"On the way he told me about his disappointments, the injustices he had been made to suffer, the hatred he had provoked." When he came to the accusation of surmoulage he told Bazire that there seemed to be no way of scotching this old canard. People were still saying, "Rodin, *peuh! un surmouleur!*"

"Never mind, there's an easy way of changing all that," Bazire told him.

"How?"

"By doing portraits of people whom no one will believe capable of lending themselves to a deception like the one they accuse you of. Victor Hugo, for example, or Henri Rochefort, would never be suspected of having allowed their heads to be cast from life. I can't see either one, his face covered in wet gauze, waiting for you to encase him in wet plaster."

"But I don't know them."

"You will get to know them. And in six months' time, if you like, you'll have finished their busts."

It seemed a simple enough plan but there were unforeseen complications. Bazire obtained Hugo's permission to make the formal introductions, but when Rodin was presented to him—"the host stood by his bookcase and for some time said nothing, being lost in some inner dream"—he refused to pose for the sculptor. "He had been asked to pose for his portrait so many times," Rodin remembered, and to make matters worse, "he had just been martyred by a mediocre sculptor named [Victor] Vilain, who, to make a bad bust, had insisted on thirty-eight sittings." Eventually, "knitting his Olympian brow," Hugo declared his willingness to meet Rodin halfway. According to Bazire he told the sculptor, "No, I can't promise you to 'pose.' But my house is open to you. I'll be happy to have you as my guest; come for lunch, for dinner. You can make sketches as though you were taking notes. You'll see; that will suffice."

Rodin had no choice but to accept these conditions. Hugo was an arbitrary and tyrannical patriarch, more feared than loved by most of the people in his inner circle. According to Bergerat, lesser literati regarded "Victor Hugo as, so to speak, the alpha and omega of literature, the living incarnation of the word." Théodore de Banville saw him as Zeus; Théophile Gautier "seemed to shake with holy terror" at the very mention of his name; Leconte de Lisle had nicknamed him "the monster." For Rodin, a loyal reader of Hugo's books, there was no question but that he was in the presence of a Titan:

The first time I saw Victor Hugo he made a profound impression on me; his eye was magnificent, he struck me as terrifying—

perhaps he was thinking about something that made him angry or truculent, for his natural expression was that of a good man. I thought I was seeing a French Jupiter; when I got to know him better it seemed to me he had more of Hercules than Jupiter.

Before commencing the work, Rodin tried to state his case once more in writing. He hoped to use Hugo's love for his twelve-year-old granddaughter, Jeanne, as the means of improving the conditions under which he was expected to produce the bust:

Dear and illustrious Maître,

I apologize for insisting, but the ambition to be the one who shall have made the Victor Hugo bust of my generation is so natural that you will not reproach me. Moreover, my desire, as I have already told you, is to be ready for Mlle Jeanne's birthday [September 29]. By beginning now I shall manage it. Allow me, therefore, to count on a moment you will grant me from time to time. I shall not abuse your kindness or cause you any fatigue, and the bust will get finished without your perceiving it.

At Bazire's urging, several members of Hugo's household also put in a good word for him—among them Mme Lockroy, Hugo's daughter-in-law, and Juliette Drouet, Hugo's mistress for over half a century and now his acknowledged hostess and companion. But as Rodin recalled, when "Mme Drouet, who knew me, talked to her 'husband' about me, he got angry at the idea of posing and said, 'He can come here and see me as much as he wants; I won't pose, I don't even want to see the pencil.' " The worried sculptor did not feel particularly encouraged when Hugo told him: "You see, long ago David d'Angers sculpted my portrait. After him no artist could do anything that wouldn't be bad by comparison."

The historic encounter between Auguste Rodin and Victor Hugo thus began under somewhat less than auspicious circumstances. On the first day, Bazire reports, Rodin "had his turntable and clay brought to the veranda of the avenue d'Eylau and, at the appointed hour, we sat down at the poet's table." Since Hugo kept open house—he liked

to share his meals with a dozen guests—their presence made little difference to the dinner party, which included Juliette Drouet, Alice Lockroy and the two grandchildren, Jeanne and Georges Hugo. Rodin promptly knocked over his wineglass. After coffee he retired to the veranda-observatory—"not without anxiety," as Bazire noted—"and began all alone to knead his clay." The practice of portraiture had never seemed a more lonely occupation.

From now on he visited Hugo's house almost every day. "He has not what is called 'posed,' " he wrote to Henley in February 1883, "but I have lived with him, lunching or driving or frequenting his soirées for the last four months, with the bust at his house, which allowed me to work there always. Sometimes I was with him whole afternoons, but I did not have him as a model that one places as is most convenient for the purpose." At mealtimes, as Bergerat observed, Rodin would sit silent and absent-minded, eating little and drinking less. He stared at Hugo and made surreptitious drawings on a book of cigarette papers which he kept under his plate, and on which he drew with the stub of a pencil, sketching his subject from every possible angle, even when the poet had his mouth full. Hugo in old age possessed an enviable appetite. Bergerat writes that "he eats like a stonemason, everything, all the time, and drains his bottle to the dregs." The family tried to help Rodin by seating him alternately to Hugo's left or right, occasionally on the opposite side of the table. After dinner he would make more furtive sketches under a lamp before going home. Years later he confided to Anna de Noailles that Hugo had seemed insultingly indifferent to what he was doing: "He would say to me, 'Hello, Monsieur Rodin,' and nothing more. It was extraordinary, his disdain for me. I made my sketches as best I could. And then, after meals, when he was sleeping, I would come up quietly and take my measurements."

Certainly it was the most difficult portrait from life he had ever attempted. "You can imagine how hard my task was," he told Gsell. While observing his subject at table he would "try to stamp his image upon my memory; then suddenly I'd run off to the veranda to fix in clay the memory of what I'd just seen. But often the impression faded in mid-stride, and when I got to my stand I didn't dare touch the clay, and was obliged to return to my model again." He worked for hours on the glassed-in veranda, which was filled with plants and

flowers, and separated from the drawing room only by a glass partition. "Sometimes I saw Victor Hugo cross the salon with a hard, cold expression; sometimes he would go and sit at the far end of the room, absorbed and meditative."

Rodin was more grateful than ever for having learned Lecoq's pictorial-memory method. Despite false starts and fading impressions he gradually arrived at a bust that corresponded perfectly to his perception of the old man as a kind of demigod. It was not a portrait of the puffy-eyed *Père* Hugo as others (and the camera) saw him— to Paul Arène, for example, he "vaguely resembled an old shoe-maker," tottering and melancholy—but of a classical hero. "Hugo had the air of a Hercules; belonged to a great race," Rodin told Bartlett: "Something of a tiger, or an old lion."

He had an immense animal nature. His eyes were especially beautiful, and the most striking thing about him. As a man he was large and agreeable, no personal pride. When he showed pride it was outside of himself. He always had twelve or fourteen guests at his table, and being somewhat deaf he heard little of the conversation, but often in the very midst of it he would break out with some astonishing observation.*

Rodin's reminiscences give no indication of the fact that he had caught Hugo at a very painful and problematic moment. It was hardly surprising that the maître was in no mood to pose: while the sculptor was modeling his bust, Juliette Drouet was dying of cancer. This plucky woman of seventy-five, who had been the wellspring of Hugo's existence since 1833, had taken to her bed in September 1882, and learned in November that she was suffering from an incurable tumor of the digestive tract. Though she continued to appear at some of his dinner parties, she could raise only an empty glass when her deaf

*Léon Daudet told Jules Renard what it was like to have dinner at Hugo's. "Naturally the great poet presided, but he was at one end of the table, in isolation, and little by little the guests drew away from him and toward youth, toward Jeanne and Georges. He was almost deaf and no one spoke to him. He had been practically forgotten when suddenly, at the end of the meal, we heard the voice of the great man with the bristling beard—a deep voice, coming from afar, which said: 'I didn't get any biscuit!' "

lover drank to her health, and could only pretend to eat while in fact she was slowly starving to death.

On January 1, 1883, she composed the last of the 18,000 letters she had written Hugo over the years: "*Cher adoré*, I do not know where I shall be at this time next year, but I am proud and happy to sign my life-certificate for this year with a single phrase, *I love you*. —Juliette." He, in turn, had sent her a poet's greeting in unrhymed verse: "When I say Bless you, I speak of Heaven; when I say Sleep well, I speak of Earth; when I say I love you, I speak of myself."*

Yet as she well knew his devotion was a good deal less than exclusive. For a dozen years he had been leading a busy double life as Juliette's companion and as the lover of her former chambermaid and other interesting young women. His "animal nature" often rebelled against the measures she took to prevent him from exercising the *droit du seigneur* that accrues to distinguished gray poets: apparently Paris was full of beautiful women who would have been only too delighted to have a child by Victor Hugo. She understood the reasons for "this conflict, endlessly renewed, between my poor old love and the young temptations that come your way." But she refused to condone his "depraved and cynical passions," and went on rummaging jealously through his pockets for evidence of his latest infidelities.

Hugo, on the other hand, had decided long ago that "if freedom of conscience has the right to exist anywhere, it must be in matters of love." There was a time in middle age when he believed, almost hopefully, that "the sixties put a man *hors de combat*," but experience had taught him otherwise, and in his seventies he decided that "there is no other limit except this: as long as a man can, as long as a woman wants." Perhaps what Rodin was witnessing was a preview of the later chapters of his own biography. Hugo, too felt irresistibly drawn to women's bodies and wrote ardent poetry about his experiences:

> She said, 'Shall I keep on my shift?'
> And I said, 'Never can woman make a lovelier gift
> Than utter nakedness.'

*Rodin told William Rothenstein that, on arriving at Hugo's early one morning, "he stumbled against someone lying outside the poet's door—it was the faithful Juliette Drouet."

Besides making detailed erotic drawings of the women he slept with, Hugo now kept a curiously meticulous diary of his sex life that included such details as when, and with whom; whether the woman was naked or not; fees paid if she was a servant or prostitute, and where the encounter had taken place—often out of doors. For 1882 the diaries cover only the first nine months—the rest are missing—but during this period he entered thirty of the small crosses (followed by the fee, invariably twenty francs) with which he recorded his sessions with prostitutes: on January 2 there are even four crosses in a row, followed by the confirming total, eighty francs. These diaries were to end only a few weeks before his death in 1885, for even during the last year of his life he was still, understandably, preoccupied with his naughts and crosses. At the avenue d'Eylau, as his biographer Henri Guillemin explains, it was "the discreet and remunerated services of a chambermaid which furnished him the satisfaction which his temperament demanded."

Talking to Dujardin-Beaumetz, Rodin recalled that "Madame Drouet prevailed on him to pose for me for half an hour, but that was all." Yet there are several conflicting accounts of how he obtained this crucial privilege. Bazire writes that he lured Hugo onto the veranda and kept him talking while Rodin used his calipers unobserved. Bergerat, on the other hand, claims to have been the author of a successful ruse: Rodin challenged the proportions of David d'Angers's "definitive" bust, whereupon Hugo supposedly held still and allowed his cranium to be measured against David's marble: "Auguste Rodin still speaks with profound emotion of the three-quarters of an hour in which his hands touched this venerable and colossal head."

But the most credible version, published by Marcelle Adam in *le Figaro*, 1907, holds that neither Mme Drouet nor anyone else could persuade Hugo to pose until Rodin resorted to a brilliant stratagem. "He bribed the maid. This maid took care of the poet and had great influence over him. It was thanks to her intercession that Victor Hugo consented to pose once for Rodin."

The critic Jean Dolent heard further details from Rodin's pupil Niederhäusern-Rodo that stamped the Hugo bust as, among other things, a triumph of sheer presumption. Nothing had been allowed to stand in the way of this project—not even Hugo's insistence that "I can't leave the invalid; let him come here into the bedroom." For

three months Rodin had "arrived punctually every day. Mme Drouet grew worse. Still Rodin came every day. They were appalled when they saw him coming. That was how Rodin did the bust of Hugo."

These circumstances explain the rather embarrassing matter of his leave-taking. Rodin told Lawton that he had continued his studies "until at length an intimation was given that they had lasted long enough." And in the Dujardin-Beaumetz version: "I was given to understand that the bust was finished. I took it away." Hugo, at the time, was "so convinced that I was doing a bad bust that he did not even look at it; his entourage criticized my bust so severely that I became flustered." Some of the maître's intimates decided that he had made their poet look like "*un vieux ciseleur*"—an old bronze worker. But people whose opinion mattered more to him, notably Dalou and Bazire, told him it was a wonderful portrait. Dr. Liouville came to the studio with Danielli, saw a small study for the bust and fell in love with it; he would have liked to buy it on the spot. And Hugo himself must have given his approval after all, for when Rodin wrote his curriculum vitae for Gaston Schéfer later that year he was happy to report:

> The most recent of his busts is that of Victor Hugo. The maître welcomed the artist with great kindness and admitted him to his intimate circle for a time. Though the artist could not employ the normal methods and was often obliged to resort to working from memory—and although *the emotion one feels in being close to this man who is the giant of the century* made him work at it much longer than usual—still, he has produced a bust which will be shown at the next Salon and which has already enjoyed a considerable success in his studio.
>
> The illustrious maître likes it, and Georges and Jeanne find that it resembles him. (When Victor Hugo saw that the bust's head was inclined to one side he had it put back in an upright position, since he wanted it to express not one particular action but rather the whole of his thought.)*

*This last sentence is crossed out in the original manuscript and reads: "*Victor Hugo de penché qu'il était l'a fait remettre droit ne voulant pas qu'il exprime une action particulière mais toute sa pensée.*" The italics in the first paragraph represent Rodin's underscoring.

The bust had cost him an enormous effort, but he rightly regarded it as one of his most important works—superior to *l'Age d'airain* because its planes were more forcefully modeled: *"C'est d'un modelé plus large."* As the writer George Moore once summed up its virtues for Nancy Cunard, "I am sure no greater bust than Hugo has been done since antiquity." Unfortunately Rodin could not leave it at that: the bust led to a series of projects for a Hugo monument in which the question of what body to place under the head was never satisfactorily resolved. There were also personal complications. Toward the end of his labors at the avenue d'Eylau, Dalou asked Rodin to introduce him to the Hugo household, and "I willingly rendered him this service"—with the result that Dalou was often invited to the house while he himself never got invited. Worse yet, when Hugo died the family asked Dalou to make the death mask. Meanwhile, the poet's executor, Paul Meurice, had sent for Rodin to take a cast of the dead man's face: "Rodin went," as Lawton noted, "but met on the threshold Dalou, who had preceded him in the work."

Henley, now firmly in command of the *Magazine of Art*, treated Rodin's latest work as a major news item:

M. Rodin has seen much of his model—has studied him on all possible occasions: at table, in talk, in the act of composition—and the result is an achievement in portraiture. It is the truth, but the truth told by a great artist. Here are the venerable beauty, the rugged majesty, the force, the fire, the victorious energy of one unmatched among contemporary men.

His words had the ring of conviction and the rolling cadence that came naturally to the author of *Invictus*. But when Rodin offered to make Henley a present of a small plaster *Hugo* he was unexpectedly rebuffed. "I think, dear friend, that I should not accept the reduced copy of the bust which you propose to give me," Henley wrote on October 15, 1883. "In the first place you owe me absolutely nothing, and anything I have done and may do in the future I have done and will do because you are a great artist, and because it is my duty as an art critic to praise beautiful things. But besides, I should confess to you I don't love the great poet overmuch; he makes me swear too

much and laugh too much." There were other great subjects Henley
would have preferred, notably himself. "One of these days, if you
want to give me great pleasure, make me a little sketch of my fat
head."

He was to get his wish before long, but first it was Henri Rochefort's
turn to sit for his portrait. Bazire's employer, nine years older than
Rodin, was a successful newspaper publisher with a checkered past
and limitless political ambition. He had been a vaudeville actor,
pamphleteer, agitator and journalist, exiled first by Napoléon III,
then by the Thiers government for his part in the Paris Commune.
His escape by boat from the penal colony in New Caledonia in 1874
had made him a celebrity, and after the 1880 amnesty he had returned
in triumph to launch *l'Intransigeant*, a scandal sheet that soon had
a large and influential readership. He was one of the pioneers of
modern journalism, a "prince of the gutter press," with an editorial
policy that oscillated wildly between left and right. Among fellow
journalists he had the reputation of being "thoroughly unscrupulous,
devoid of convictions, ready to incite riot or outrages, but always
shirking responsibility."

Edouard Manet had been attracted by this *soi-disant* marquis and
had painted not one but two versions of *Rochefort's Escape* before
deciding to paint the formal portrait which he sent to the Salon in
1881: Rochefort with his arms folded, his gray hair flaming upwards
from his pockmarked face—a forehead that struck Alphonse Daudet
as too capacious, "at once a container of migraines and a reservoir
of enthusiasm." Critics praised Manet's picture, but Rochefort, who
fancied himself a connoisseur, refused to accept it even as a gift,
perhaps for the same reason that J. K. Huysmans disliked it—
that his face had the texture of green cheese, "all speckled and
spotted."

He came to his sessions with Rodin, therefore, already biased
against the follies of contemporary art. The sittings took place in a
studio the sculptor had improvised in Rochefort's elegant little man-
sion, full of beautiful furniture and eighteenth-century pictures, in
the Cité Malesherbes, near the Place Pigalle. This time Rodin could
pose his subject exactly as he liked, but "from the very beginning
things did not go very well." The bust took longer than Rochefort

had expected, and as the work progressed he became increasingly dissatisfied and finally refused to cooperate any further,* so that once again it was the sitter rather than the sculptor who decided when to stop. As Rochefort told Bartlett a few years later,

> I went to the studio in the morning, sat down ready for Rodin to begin. Then he would look at me for an hour or two, turn to his work and look at that for the same length of time, put a bullet of clay carefully on it, and by that time we were ready for breakfast. On returning to the studio he would go through the same preliminary operation, and then take off the bullet. The bust will never be done.

Rodin was no less annoyed with his sitter's restlessness: "He couldn't sit still for a minute." Yet the clay bullets, many of them deliberately left unsmoothed, "had told their little story in the production of a great work of characterization," as Bartlett pointed out. Certainly the editors of *l'Intransigeant* thought so; many bought plaster copies of the bust. Eventually their employer had second thoughts and offered to resume the sittings, but Rodin declined; as far as he was concerned the bust was finished. When it was exhibited for the first time, in 1886, and Rochefort saw the critical reaction, he himself joined in the chorus of praises, as Rodin recalled, but "he would never believe that my work had remained exactly as it was when I took it away from his house. 'You've retouched it a lot, haven't you,' he kept saying. In reality I hadn't touched it with so much as my thumbnail."

The very position of the head reproduced a typical Rochefort gesture: "the chin presses into the neck," writes Léon Maillard, "so the head is bent like that of a tall man listening to someone smaller than himself." Rodin had spared none of the tensions reflected in his

*In later life Rodin came to the conclusion that there was nothing quite as thankless as doing portrait busts. "The truer your portrait . . . the less your sitter will appreciate it," was the way Frank Harris summarized his remarks on this point. "Men and women both want to have insignificant, regular features; masterpieces of expression are usually regarded as insults. One has simply to do one's best and pay no attention to the remonstrances of puerile conceit."

face—the hollow cheeks, beak-like nose and weak chin, all subordinated to the vehement skull and violent tufts of hair.

Once the bust had ceased to be a bone of contention, Rodin and Rochefort were reconciled. In later years they were on the best of terms, not least because the sculptor became a regular reader of *l'Intransigeant*. They spent a good deal of time in each other's company, and Rochefort did not hesitate to badger him for further favors. "I remember his asking me to 'rediscover' his portrait by Manet, because Manet had become famous in the meantime. I told him where his portrait was; 20,000 francs was being asked for it. That made him back off. He consoled himself for this misfortune, however, by continuing to despise contemporary art." Rodin was well aware that Rochefort had kept his bust in the attic for many years: "Yet in spite of everything one couldn't hold a grudge against him; he was so fiery, so witty, so entertaining!" In the 1890s the artist Christian Krohg noticed a new, enlarged version of the bust during a visit to Rodin's studio. It struck him that Rochefort's head was bent down as though he were searching darkly for an adversary's most vulnerable spot.

"Rochefort as Mephisto," Krohg suggested.

"Yes, that is the intention," Rodin said with a laugh.

>*<

He did a spate of other busts during the early and mid-Eighties, though mainly of friends and fellow artists who were more conscious of the privilege they were being accorded by the greatest portrait sculptor of the age. He had developed a passion for portraiture—and indeed his busts were to be among his most important works. He had even arrived at a kind of theory of portraiture, though when he tried teaching it to his pupils the secrets of the métier turned out, as usual, to be locked in Rodin's fingertips. It remained for Lawton, at the turn of the century, to set down his instructions on how to proceed when sculpting a portrait:

> I always carefully model by profiles, not from a merely front view. It gives depth and solidity—the volume, in fine—and its location in space. I do this, however, with a line that starts from one's own brain. I mean that I note the deviation of the

head from the oval type. In one, the forehead bulges out over the rest of the face, in another, the lower jaw bulges out in contrast with the receding forehead. With this line of deviation established, I unite all the profiles, and thus get the lifelike form. Those who wish to penetrate into some of the invariable rules nature follows in composing, should observe her opposition of a flat to a round, the one being the foil of the other. They should notice also her gradations and contrasts of light producing color in the real object, and should be careful not to produce effects that are out of accordance with the natural ones. In general, they should avoid blacks, unless these have a purpose, and not put them into the depth of a fold in drapery; the latter should always reflect light. On beginning their work, they should exaggerate characteristic features; the exaggerations will get toned down fast enough later on. In the first instance, the exaggerations are necessary to establish the structural expression. It is only by the graduation of these more characteristic traits that the relative value of all the parts can be determined. In the flesh, there is the spirit that magnifies one or another detail of expression. In the clay or marble, it must be by the positive magnifying of the material part, not especially by size, but by the line, by the direction, the depth, the length of its curve, that the expression is made equivalent.

These complex principles for finding truth in exaggeration are demonstrated with great verve and virtuosity in his bust of the playwright Henri Becque, with its dramatic contrasts between the sitter's bold cheekbones, vaulted forehead and wild shock of hair. Becque was one of the first realists in the French theatre, the founder of what came to be known as *l'Ecole brutale*, forerunner of the theatre of cruelty. He had been very poor for some years, pursued by implacable creditors who kept impounding his furniture: in desperation he had replaced his writing table with a plank of wood nailed to the wall since the bailiffs did not count nailed-down fixtures as "movables." At last, in 1882, the shock effect of *les Corbeaux*—his vitriolic comedy about the "crows" and vultures of the business world—had propelled him into the salons of Mme Adam and Mme Liouville at about the same time as Rodin. To seal their ensuing friendship, the play-

wright sent him a copy of *les Corbeaux* inscribed "To the good and great Rodin, from his friend Henri Becque."

Tall and energetic, Becque moved easily into the world of the literary salons, but real success always eluded him, and he continued to have trouble paying his bills. Women were attracted to him—to his "square skull, everything on it in rebellion, his dark stubble of hair, his stiff little moustache, his glittering eyes," as Freda Strindberg noted. "Becque is reputed to be a genius, though he has not yet 'arrived.' . . ." Rodin worked and reworked his clay bullets to produce an immensely sympathetic image of his resolute head, "fiercely obstinate and stamped with such irascible candor." It was clear that, unlike Rochefort, here was a writer with ideals, not just resentments. "He was a rugged man, incisive and proud of his poverty," Rodin remembered after Becque's death in 1899. "He wore it like a plume. He was certainly full of bitterness, but he saved his gall for the mediocrities of his time." When the bust was finished Rodin paid him the additional compliment of doing a drypoint version of the same portrait—the face of Becque seen from three angles, so that he almost seems engaged in earnest conversation with himself; a not inappropriate image for an inveterate talker and raconteur.

>▣<

Rodin's bust of Jules Dalou was the outcome—and in a sense the culmination—of a much older friendship. Dalou had returned from his ten-year exile in England uncertain of his reception in Paris. The critic Albert Wolff remembered seeing him "prowling about the Salon the first times after his return. He seemed to keep separate and to flee from former comrades" since he was not sure which of them had remained his friends after the uproar over his participation in the Commune. Rodin, however, had never forgotten that "my first friend was Dalou," and was happy to oblige when the latter turned to him for practical information—where did he buy his clay and fire his terra cottas? Their letters of 1880–83 are cordial and intimate, for they saw each other often, went to openings together and brought friends to each other's studios.

Rodin himself was invited to inspect a newly completed Dalou bas-relief on January 3, 1882: "I would be delighted if it were not just our friendship that might cause you to judge my bas-relief with

a favorable eye, since I value your opinion more highly than anyone else's, and indeed I look forward to showing you my work."

It was during this period of mutual trust and admiration that Rodin asked Dalou to sit for his portrait. The resulting bust—originally executed in a transparent green wax that resembled jade—was exhibited at the Salon of 1884 and attracted scarcely less attention than Rodin's other entry, the *Victor Hugo*. To the young critic Roger Marx, still reporting for the provincial magazine *Nancy-Artiste* but soon to emerge as one of the most influential French writers on art, these two portraits were on the same plane as Houdon's busts, "the most remarkable in existence":

Especially admirable is the bust of M. Jules Dalou with its extraordinary boldness in the modeling and composition. Above the plain, naked torso rises the fine head of the great sculptor, gaunt, lean, nervous, energetic; what character in the curve of the lips, the narrowing of the nostrils, the power of his gaze! And the carriage of the head is superb. If you step back ten paces from sculptures close to you they cease to say anything, but this little bust goes on talking. Oh, this rough, unpolished sculptor, M. Rodin!—indeed, little suited for pleasing the ladies or even the gentlemen of the jury whom he frightens like a flock of pigeons with his savage energy.

Beside it, the bust that Dalou himself had made of Dr. Charcot seemed merely "beautiful," which was to say competent and interesting; it was a trifle too glossy for Marx's taste. But Dalou, by then, had impressed the government with his ability to illustrate the French Revolution, both in relief and in the round. His *Mirabeau Answering Dreux-Brézé . . . in 1789* was precisely the kind of historical "showcase" then much in demand. Together with *la Fraternité*, alias *la République* (purchased by the city of Paris for 20,000 francs), it had earned him the Legion of Honor in 1883, just nine years after a French court had sentenced him to life imprisonment.

Soon Dalou was the busiest of public sculptors, filling orders for monuments to such republican heroes as Gambetta, Blanqui and Victor Noir. His colossal *Triumph of the Republic* became the cen-

terpiece of the Place de la Nation and led to successive promotions to *officier* and *commandeur* of the Legion.

There was no open breach, and critics could continue to refer to Dalou as Rodin's "friend and only serious rival," but after 1884 their rivalry gradually extinguished their friendship. As for the splendid bust that Rodin had made of Dalou, "He never took it away, because our relations ceased once I had introduced him to Victor Hugo." Nor did he ever fulfill the demands of simple etiquette and sculpt a bust of Rodin in exchange.

Rodin, undeterred, had spent part of March and April 1884 doing a bust of Antonin Proust, the writer, politician and art collector for whom the Gambetta government had specially created a Ministry of Fine Arts (which disappeared with him). As the prime mover behind the Museum of Decorative Arts for which the Dante gates were commissioned, Proust had already done Rodin several important favors and was in a position to do more. He, too, had already had his portrait painted by Manet, who had, after several discarded attempts, produced a superb picture of his old friend as a man-about-town, in a redingote and top hat—a major canvas that had caused a great deal of discussion at the Salon of 1880. Toward the end of the decade Alfred Roll painted him in much the same costume, this time as the successful director of great public enterprises, inspecting one of the building sites for the 1889 Universal Exhibition, of which he was commissioner-general of fine arts. Rodin chose to portray him without any attributes other than the well-trimmed beard that gave him a certain resemblance to the Prince of Wales; later he did a feathery drypoint engraving of the bust seen in profile. It was a superb likeness, wrote Gustave Larroumet, of "the gentleman who practices diplomacy, art and politics, and imbues his various roles with an attentive elegance." Others, however, saw it as "a calumny in bronze," and Proust himself was not altogether pleased, though he did not make an issue of it: once again a bust had been too sincere for its sitter.

At least the indomitable Henley was wholly delighted with the weatherbeaten image of his Viking face that Rodin sculpted when he visited Paris in May 1884. He had hoped to bring Robert Louis Stevenson with him, and had proposed that Rodin "model the two portraits at the same time." But Stevenson was suffering from tuberculosis and his condition had taken a turn for the worse, forcing

Henley to explain, "I fear we must put off doing his till another moment." In December, when he heard that Sargent had just painted his friend's portrait for the second time, Henley urged Stevenson, in Bournemouth, not to forget his pending appointment in Paris:

> . . . some day we shall get the Rodin bronze. If we don't, I'll have the pick of you there. You'll go down to posterity in Sargent, & I in Rodin, and I know who'll get the credit of the plays [i.e., the plays they wrote together]. You see, there's nothing mean about me. I know this, & I mention it because I know it'll fetch the Bedlamite [Mrs. Stevenson] & set her Rodinizing at once.

For the time being, however, Stevenson was still too weak to travel and Rodin, in any case, had his head full with other affairs. Having produced a dozen busts of eminent men, he had rounded out the series by modeling portraits of three women—his gifted pupil Camille Claudel; Mme Roll, the first wife of the painter Alfred Roll; and Mme Luisa Lynch, wife of the Chilean ambassador to France, Carlos Morla Vicuña.

With Mme Roll's bust, decked out in ribbons and bows, Rodin took a conscious step backward into the world of Carrier-Belleuse, but the bust of Mme Morla* represented a radical departure from the conventional society portrait. Carved in marble, it earned him a long-overdue chorus of praise four years later, at the Salon of 1888, where the critics went into transports of delight over the lady's exquisite face and décolletage. "Those half-closed eyelids, the sweetly raised head" fascinated, among others, the writer Léon Plée: "Her adorably modeled bosom pushes back the gown of fur that oppresses it. Strange creature! One would say that she was escaping from her marble covering like a flower from its verdant envelope." Gustave Geffroy was similarly intrigued by the way "the shoulders and breasts surge from an ample fur." It seemed to him that "by no-one-knows what delicacy of touch, the artist has made manifest the warmth of the breasts, the gentle swelling of the moist lips. . . ."

*Writers unfamiliar with Spanish practice usually refer to it as the bust of Mme Vicuña, but if only one surname is used, the correct form is Mme Morla. At the Salon the bust was labeled only with her initials.

This time no one accused Rodin of having cast his subject from life: instead he had the satisfaction of seeing the press imbue his sculpture, Pygmalion-like, with all the sensuous qualities of a living woman. The painter Benjamin Constant put into words what everyone really felt about this "morsel of femininity" imprisoned in stone: "One wants to touch it amorously, and feel her trembling under one's fingers!"

There was no question but that this bust belonged among the contemporary masterpieces in the Musée du Luxembourg, and Ambassador Morla was prevailed upon to part with it for 5,000 francs in the name of Franco-Chilean friendship. The marble had been carved by Jean Escoula, a prize-winning sculptor in his own right (who had the idea of adding a flower to her corsage), and Rodin felt that it was not a fully satisfactory reproduction of his model, "because it bears too much the impress of the character of the superior marble cutter who executed it."* The better the praticien, indeed, the more he was apt to influence the finished marble with his own interpretation of the plaster model. "And this," Rodin explained, "in spite of the most exacting means of mechanical measurement that he may employ."

>‡<

While he was adding to his long row of portraits *d'après nature* Rodin was kept busy on other fronts: the Dante gates, with which he filled up his atelier at the Dépôt des Marbres, and with sketches for public monuments that never reached fruition. In 1881 he entered a competition for a statue of Lazare Carnot that was to be erected in the general's birthplace, Nolay, in Burgundy, but Rodin's conception of the revolutionary soldier-engineer—standing, with a map draped over one knee—failed to win the prize. Three years later he was no more successful with another dismounted general, Jean-Auguste Margueritte, who had been mortally wounded at Sedan, earning a place as one of the tragic heroes of the lost war.

Later there were to be sketches, at least, for the equestrian statue that Rodin had been longing to make. The figure in the saddle was

*For better or worse, all of Rodin's marbles were carved for him by other sculptors. See pages 566–571.

to represent Luisa Morla's uncle, Admiral Patricio Lynch, a Chilean naval hero who had doubled in brass as an army commander during the war with Peru, 1879–82, and was thus entitled to being depicted as a sailor on horseback. At Carlos Morla's behest Rodin also produced the model of a monument to Benjamin Vicuña Mackenna, the ambassador's maternal grandfather and a more peaceable figure, noted as a writer on Chilean history, for whose statue a fund of 100,000 francs had supposedly been raised. Rodin told the sponsors that his finished monument would cost them 79,900 francs. After at least one false start—"this new maquette [of the Lynch monument] produces an effect far superior to the previous one," Morla assured the sculptor in August 1886—two models were sent to Chile through the embassy. And there, mysteriously, the matter rested. Rodin, who had received only 1,000 francs to defray his expenses, was surprised that after all the fuss nothing more was heard about either project. He had not considered the fact that monuments are essentially political totems: his brave equestrian plan had become entangled in local politics. Chile was on the verge of a civil war that deposed its president, Balmaceda, and diminished the influence of the Vicuña family. The upshot was that Rodin's Chilean statues ended up as two more plaster models gathering dust in one of his storerooms.

Visitors who came to see him during these years were astonished by the sheer quantity of such pieces which he had managed to accumulate in so short a time. In the rue du Faubourg Saint-Jacques he had rented a sort of shed in which to store the sculptures that got in his way elsewhere. New figures were constantly being added. "One could enter the place only with a thousand difficulties," a friend recalled. "It was filled with statues facing the wall, so it was impossible to see what they really looked like. When Rodin was asked about them he would reply with the gesture of a creator who can't be bothered to think about all the things he gives birth to. One could see some wonderful statues there, but what was the meaning of all the other jumbled plasters? No one had a clue."

People wondered how many unfinished ideas were "massacred" amid this prodigious outpouring of sculpture. But Rodin rarely allowed an idea to go to waste, and his method of creation entailed a tremendous proliferation of plaster copies. Léon Maillard mentions a woman's bust that stood in the atelier at the Dépôt des Marbres

and attracted general attention by virtue of the peculiar pose of the head—its forward tilt seemed to free the neck from the shoulders on which it rested. Somehow every visitor was instinctively drawn toward this bust, with its suggestion of an *ondulation féminine* that made it "infinitely lovely to contemplate." Only his studio assistants knew that in order to arrive at this "new and audacious pose," Rodin had first conducted a whole series of studies in the placement of the head, and that in so doing he had created "six or seven versions of the same person, each completely different from the rest, and each constituting a finished work in itself."

Yet by the same token Rodin was becoming more chary of his time: his experiences with public competitions had persuaded him that there was nothing to be gained from that quarter. After the rejection of still another maquette—for a monument to Diderot in the boulevard Saint-Germain—he refused to enter any more open competitions, despite the fact that some of his colleagues were now prepared to rig the juries on his behalf.

The painter Jeanès was visiting Rodin one day at the Dépôt des Marbres when Benjamin Constant came to talk to him about taking part in a forthcoming competition. Constant, as usual, was elegantly turned out—in pince-nez, fur coat and top hat; though five years younger than Rodin he was one of the most successful Salon painters of the day.* Jeanès saw them move to the back of the studio, to a sort of storeroom in which the sculptor used to rest, read or write letters. At first they spoke quietly, but soon voices were raised, enabling Jeanès to overhear what turned into a marathon argument.

"I didn't ask for anything," Rodin was saying. "I'm not a beggar. If anyone wants me he knows where to find me."

"But my dear friend, that's how the affair has been settled—the committee has decided to hold a competition."

"All right . . . a competition! But not for me! I'm not an *élève*. To enter in competition with medal winners, the privileged caste of the Salon; that's their kind of thing, not mine."

*Though he signed himself Benjamin-Constant he was not a lineal descendant of his distinguished namesake, the author of *Adolphe*, but belonged to a distant branch of the Constant family. He had won so many prizes that he was known among his colleagues as Titien-Vaisselle (i.e., in Paris argot, the "medals and ribbons Titian"). His other nickname was Benjamin-*Inconsistant*.

"But you know that the committee has been very well selected. It contains friends of yours who count on you. And you can count on them."

"And the seal of approval, the *estampille?*" Rodin asked.

"What do you mean, the *estampille?*"

"All the people who will show up with their titles, their medals. Pupil of Monsieur So-and-So, member of the Institute or whatnot. Their patrons and protectors, or friends of their patrons, who are members of the committee, of the jury; the teachers at the Ecole des Beaux-Arts. They can't do anything else. It's their clientele. They have the *estampille.* I don't have it, I'll never have it, I don't want to have it!"

"But my dear friend, one can't be against all established institutions—life's like that, and will always be like that. Besides, I'm not the only one who invites you to participate; it's all the maîtres."

Rodin became incensed: "All the maîtres? What masters? You call them the masters? They're not even teachers. They don't even do their job properly when they're in charge of an atelier at the Ecole. Ateliers . . . they're not even ateliers! All they do is give verbal corrections. Me, *I* have an atelier. [Mathias] Schiff is my apprentice; he sees me working, he works with me, for me."

"You know very well that it's impossible to work that way at the Ecole."

"So set fire to the school and abolish the *estampille.*"

"Then the public will no longer know who the best artists are."

"The intelligent public doesn't need it, and who cares about the stupid ones?"

Now it was Constant's turn to be outraged: "Do you want to renounce everything that has accounted for the glory of the French School?"

"The French School? You're not the French School! The real masters never came from your establishment. Neither Millet, nor Corot. You've poisoned painting as well as sculpture. You yourself— you might have been a painter if you hadn't got bogged down by your titles. Once you have the seal of approval you can make money but you can't do anything properly anymore."

"What gives you the right to be so harsh? You pride yourself in a talent which is still highly debatable. I regret having come to you

in this friendly fashion, and you will also regret it; you more than I."

"Aha, and now threats! But I'm not afraid of you because I expect nothing from you!"

Benjamin Constant stalked out of the studio, red-faced and indignant. When the door had closed behind him, Jeanès reports, Rodin began to pace up and down like a caged bear, growling:

"A competition . . . meddling fools . . . all alike! Why did this one have to come and bother me? I know what they want—for me to join the rank and file, and walk behind P—— and S——, nullities, or behind D——,* who rings as false as a counterfeit coin. They want to promote me to corporal and keep me there as long as possible—at the tail end of their queue. I'd rather die. They haven't caught me yet—they can do as they like, I'll do my sculpture. . . . But he's spoiled my afternoon!"

*Jeanès doesn't spell out their names. The P—— is difficult to identify; the others are almost certainly René de Saint-Marceaux and Jules Dalou, both high on the list of Rodin's personal dislikes. Rodin's opinion of Dalou was shared by Edmond de Goncourt, who complained in his journal that there was "nothing frank or open" about this "shriveled, foxy fellow."

8

A SEASON IN HELL

*J'ai seul la clef de cette parade sauvage.**

—RIMBAUD,
Illuminations

L ooming above the rest of Rodin's sculptures of the 1880s, and never far out of mind, were the still-unfinished *Gates of Hell*. His Sèvres colleague Paillet had not been exaggerating when he drew his caricature of the "porter" staggering under the weight of his ornamental *porte*. And Benjamin Constant had spoken for most of the art world when he said that Rodin's talent was still open to question: people wanted to see the finished gates before reaching a final verdict. As early as May 1882, Bergerat had written in *le Voltaire* that Rodin was embarked on "a vast enterprise entailing many years of work," and which would result in "a new Ghiberti door" embodying the whole of Dante's *Inferno*: "Those who have seen the artist's first studies go away declaiming the poet's line, *Nescio quid majus nascitur Iliade*."† Yet toward the end of the decade Bartlett was obliged to explain to American readers that critics were calling Rodin "the greatest living sculptor of *morceaux*" because thus far he had produced heads, figures and groups of not more than two figures, but nothing grand; nothing comparable

*"I alone have the key to this savage parade."
†From the *Elegies* of Propertius: "Make way, you Roman writers, give place, you Greeks; *here comes to birth something greater than the Iliad!*"

to Rude's *Marseillaise*. "Great sonnets he has written in sculpture, but no epic poem, as the door is not complete. . . . 'Wait until the door is done,' they say, 'and we will determine his place and destiny.' "

Initially Rodin had every expectation that this would be an achievable work like any other; all the signs pointed to a successful outcome. Turquet's commission had come at a crucial moment, giving him an opportunity to realize plans that had been quietly hatching for five years. "The idea was already in my head," he told his secretary of the 1900s, René Chéruy. "The conception of the Gate really goes back to my first trip to Italy in 1875. In Florence I saw the doors by Ghiberti, and I studied Michelangelo. When I came home I kept thinking about Florence. . . . And then I read Dante, his *Divina Commedia*. I always had it in my pocket. At every spare moment I read it. In fact, I had started a group of *Ugolino* before I saw M. Turquet. My head was like an egg ready to hatch. M. Turquet broke the shell."

His preliminary studies for the Gates were based on Ghiberti's east door (dated 1425–52): "Rodin says the *Portes* of Ghiberti are as Michelangelo said, the doors of Heaven," Bartlett noted. But Rodin's doors of hell were to be divided into eight, rather than Ghiberti's ten, panels, with four additional panels on the pilasters, all of them apparently to be filled with bas-reliefs illustrating scenes from Dante. Later, when he began making clay models, he changed his mind and discarded the idea of separate panels. Instead, each leaf of the door and the space above it—the tympanum, absent from Ghiberti's doors—were to be covered with bas-reliefs. There were a number of precedents for such doors in France as well as Italy: indeed, he had to go no farther than the Church of the Madeleine, within walking distance of his studio, to find a pair of bronze doors with eight historiated panels (by Henri de Triqueti) surmounted by a huge rectangular tympanum in high relief, centered on a seventeen-foot figure (by Philippe-Henri Lemaire) of *Christ as Judge of the World*. There were other points of contact with the Renaissance tradition of combining bas-reliefs with sculpture in the round—at Rouen, Saint-Denis and elsewhere.

Exceptionally, Turquet's commission had given Rodin carte blanche to decide both the form and content of the doors: "the choice of

subject was left up to me." He began conventionally enough, jotting down ideas concerning the particular episodes he intended to illustrate with his "bas-reliefs representing the *Divine Comedy* of Dante." But the *Inferno* was the only part of the poem Rodin knew or cared about: he was not the first nineteenth-century figure to feel that hell met his "needs as an artist" better than heaven.*

>✠<

As a state commission, the Gates have an administrative history which is much more thoroughly documented than their aesthetic evolution, since every financial and bureaucratic transaction was duly recorded by the scribes of the Subsecretariat of Fine Arts. In practical terms, Rodin's immediate problem vis-à-vis the ministry was to produce a large enough number of preliminary studies to warrant a substantial advance. Within two months of receiving the commission he was able to inform the authorities that he had "made many drawings and sketches which I shall be able to submit for your consideration," and which he hoped would entitle him to a payment covering "initial expenses for armatures, models, etc." Indeed, a first installment of 2,700 francs was forthcoming on October 14, 1880. Yet his original conception of the subject matter was soon to undergo a radical change. "I spent a whole year with Dante, living only for him and with him, drawing the eight circles of his hell," he remembered in 1900. "At the end of a year I realized that though these drawings rendered my vision of Dante, they were not close enough to reality. And I began all over again, *d'après nature*, working with my models. . . . I abandoned my drawings from Dante."

By October 1881, he had already decided to expand the project beyond the simple bronze doors originally envisaged. Thanks to the

*Dante has not, as one might suppose, "always existed" on the European cultural horizon. The Rivarol translation of 1785 from which Rodin worked was actually the earliest French translation of Dante's poem, and contributed its share to the great Dante revival of the Romantic era. The writers, artists and composers of the nineteenth century always preferred the *Inferno* to the *Purgatorio* and the *Paradiso*: it suited their pessimism about the increasingly "satanic" world in which they lived. When Karl Marx described conditions in a typical industrial sweatshop he concluded, "Dante would find in this match factory his cruellest fantasies of hell surpassed."

initial payment he had been able to "lay the groundwork for this great work," as he wrote to Turquet:

> I say great in a physical sense because this door will be at least 4.5 meters high and 3.5 meters wide [they would eventually measure 7.5 by 3.96 meters], and will include, besides the bas-reliefs, many figures almost in the round, in addition to two colossal figures on each side. I apologize, Sir, for going into these details, but they are essential to explain the object of this new request. I shall need at least three years to complete this work. . . . The sum I require will not be a drain on the budget of a single year. . . . This is why I am requesting a sum I leave to your discretion, but which, in my opinion, should not be less than 5,000 francs for each of the figures, namely 10,000 francs.

Rodin had thought of placing *Adam* and *Eve* on a set of steps leading to the Gates, but his studio was not high enough for the frame to be raised about the steps, and his solution was to have the parents of mankind—the first sinners—standing beside the *Porte*. He was prepared to accept any additional fee the government might offer, but warned Turquet that if the amount were less than 10,000 francs he would be obliged to accept commercial assignments "of limited artistic value," resulting in a great waste of his time.

In point of fact the two large figures of *Adam* and *Eve* eventually disappeared from Rodin's grand design, but for the time being they served their purpose by justifying Turquet's decision to raise the sculptor's allocated fee. At first there were political complications: Rodin sent his letter on the eve of a cabinet reshuffle, and for one anxious moment it looked as though his application might not be approved before Turquet's departure. Once again Maurice Haquette was called upon to do his best. "Osbach tells me that M. Turquet may soon hand in his resignation," Rodin wrote to him. "You may find this a useful piece of information. But do me the favor of speaking to M. Turquet if you can (either tonight or tomorrow, though tomorrow I think he'll be in Senlis) about the two figures flanking my door which have not been officially commissioned, nor have the papers

been signed. You see how serious it is for me, and you are the only one who can help."

In fact, Turquet acted quickly, raising Rodin's allocation by 10,000 francs on October 31, 1881—two weeks before resigning his post. But Rodin had worried unnecessarily about what might happen when he lost his friend at court. Turquet's successor proved to be Antonin Proust; only after he resigned—with the fall of the Gambetta cabinet early in 1882—was the post filled with political nonentities. Turquet, moreover, returned for a second term as undersecretary that lasted from April 1885 to December 1886.

Further payments on the Gates, meanwhile, were dependent in large measure on official reports written by the new principal inspector of fine arts, Roger Ballu, whose jaundiced eye had managed to detect surmoulage in *l'Age d'airain*. Fortunately Ballu had made a timely adjustment to the new climate of opinion concerning Rodin, and his report of January 1883, is laced with praises—though he took care to note certain judicious reservations in case the finished work should fail to please his superiors.

I hasten to inform you that the work already completed fully justifies M. Rodin's request, and I think that a sum of 3,000 francs may now be placed at his disposal.

As for my considered judgment of the work as a whole, permit me, Monsieur le Ministre, to express certain reservations. In the artist's studio I was able to see only small isolated groups from which wet cloths were successively removed as I looked at them. I cannot envisage the effect which these compositions, all in high relief, will have on the massive design of the door as a whole. In order for me to give you a fully informed opinion I would have to see all the groups in place. Nonetheless, M. Rodin's work is interesting to the highest degree. This young sculptor possesses an originality and an anguished power of expression which is truly astonishing.

The ministry moved with remarkable speed. Rodin received a second installment of 3,000 francs only four days after Ballu's report was filed. Work on the Gates was, in fact, so far advanced that a larger payment might have been in order. Despite the time it had

cost him to do the Hugo bust, just completed, he had finished most of the principal subjects intended for the doors. Accordingly, after the summer of 1883 Rodin applied for another advance on his contract, and Ballu returned to his studio for a second visit. His report of November 13, 1883, is measurably more enthusiastic than the first: this time there was more to see, and the *Porte* had at last kindled the inspector's rather limited imagination:

> The artist is working on his project with a care and diligence that make it more and more interesting. He models his little figures from nature, piece by piece, and then fits them into the overall ensemble as part of the groups to be placed on the panels of the door.
>
> I believe that the door will have a striking effect. The modeling is carefully detailed, strong and energetic. M. Rodin's personality, already revealed in his previous works, here affirms itself and assumes great power. . . . M. Rodin asks for an advance of 4,000 francs. The work thus far completed justifies his request.

Again Rodin got his money immediately: it was one of the last payments to be made under the aegis of yet another minister of public instruction, the redoubtable Jules Ferry, who had initiated sweeping reforms in French education and was now, on November 20, to take over the Ministry of Foreign Affairs. His replacement was a relative newcomer to cultural politics, Armand Fallières, who administered his department in a more leisurely fashion. Evidently Fallières was not quite certain what to make of this vast and nebulous project which he had inherited from his predecessors. Rodin undertook to reassure him by getting Jules Dalou—newly decorated with the Legion of Honor and not yet an overt rival—to write him a sort of testimonial. The new minister had wanted to base his judgment of the *Porte* on something more substantial than the reports already on file: Dalou's remarkable letter to Fallières of February 25, 1884, goes as far as a conscientious artist can go in recommending the work of a gifted colleague to a government official on whom he himself is dependent for financial support:

Monsieur,

My friend Rodin has told me that you would like to have my opinion of the decorative door which he is creating for the Ministry of Fine Arts.

I find this task more pleasant than easy, because I think so highly of the work he has begun that it would be difficult for me to describe all of its superb qualities without seeming to exaggerate. Suffice it to say that in my eyes—and I say this with the deepest conviction—it will be one of the century's finest works of art, and perhaps the most original.

As for the sum allocated for this work, you know as well as I do that it is really <u>quite low</u> [twice underlined], not only in view of the considerable expenses which it entails, but also as regards the great artistic value of this beautiful sculpture.

If you increase the purchase price you will not only render a service to a great artist by performing an act of justice—you will also pay tribute to art in one of its most beautiful manifestations.

By now the *Porte* seemed to be nearing completion. In June Rodin notified Fallières that he had "arrived at a point where I should come to an understanding with the founder (using the lost-wax process), so that we can alternate our work, enabling us to finish it the sooner." The septuagenarian Eugène Gonon, Rodin's first choice as a lost-wax caster, estimated that the doors would require 8,000 pounds of bronze and cost 40,000 francs; if the government were to furnish the metal the casting would cost 8,000 francs less. As Rodin explained, "Using the lost-wax method for this elaborately hollowed-out surface has the advantage of costing less and conserving all of the sculpture's *chaleur* [i.e., its immediacy and tactile quality]." The ministry, however, was understandably more receptive to a lower bid by one of Gonon's competitors, Pierre Bingen, who offered to cast the *Porte* for only 35,000 francs, bronze included. The work was to be cast in five main sections—the two door panels, the two pilasters, and the cornice with its bas-relief. Bingen stipulated that he would do separate casts of "all the groups of figures which are detachable and which will be mounted in accordance with your instructions."

On the basis of this estimate the ministry set aside 35,000 francs

for Bingen and raised Rodin's personal allocation a further 7,000 francs in August 1884, and 5,000 francs in March 1888, by which time he had actually received eight payments totaling 25,700 francs. But he was not, after all, ready to send the *Porte* to the foundry. He was not yet satisfied with it—though he was happy to live with it in his studio, incomplete and retouchable, as a kind of giant talisman, and as a backdrop to everything else he was doing.

Above all he was not ready to commit himself, especially now that there was no hurry for it to be completed: it had become a hypothetical door to a nonexistent building. The Musée des Arts Décoratifs for which it had been commissioned was unable to raise enough money to erect a new building on the site of the old Cour des Comptes, and the government gradually lost interest in the project.* Instead, a makeshift museum of decorative arts was housed rather ignominiously in a succession of other museums, a cuckoo's egg in alien nests.

>✠<

As far as Rodin was concerned, the *Porte* had long since outgrown whatever practical purposes it had been meant to serve. What had begun as a pair of ornamental doors had gradually taken on the menacing proportions of a chef-d'oeuvre by which he and his life's work were to be judged. Though it was not ready for public exhibition, Rodin took care that the cognoscenti came to see the enormous plaster portal at the Dépôt des Marbres. Most of them liked what they saw, and gave it a good press. Henley, for one, quoted Dalou's generous prophesy that "when the century is out it will remember the *Porte* as its heroic achievement in sculpture." Similarly, the young critic Octave Mirbeau told the readers of *la France* in February 1885 that "one has to go back to Michelangelo to find anything as noble, beautiful and magnificent in art" as this, "the most important work of the century."

*In the end it was the Paris-Orléans railroad that acquired the site, on which Victor Laloux, one of the great architects of the fin-de-siècle, built the Gare d'Orsay in 1900. For nearly forty years the station accommodated 150 to 200 trains a day, until electrification made it obsolete: its platforms proved too short for the longer trains. The derelict station was nearly torn down during the 1960s, but the city fathers thought the better of it and turned it over to the Musée d'Orsay, the world's most sumptuous museum of nineteenth-century art, and the happiest possible realization of Antonin Proust's dream.

These pronouncements constitute the headwaters of the river of ink that has been spilled explaining to the public what the *Gates of Hell* are "about." To Bartlett, who first saw them in November 1887, they were "a perpendicular section of the damned world." But modern critics and scholars have interpreted their symbolism very variously. According to one specialist, the Gates are "about life after death. . . . Rodin's vision of inescapable hell"—in which case Father Eymard's sermons did not fail of their effect. To another scholar, however, the *Porte* exemplifies "Rodin's faith in man capable of thinking the world [sic], in the central figure, which was *The Thinker*." To a third, it represents "the secularization of the Last Judgment." Kenneth Clark, on the other hand, regarded it as "an illustration of a spiritual anguish which he did not feel at all, but took second-hand from his literary friends."

Certainly the *Porte* is "about" hell—but only in the sense that the Finale of Berlioz's *Symphonie Fantastique* might be said to be about hell. Rodin's interpreters have always had a tendency to discover philosophical profundities where he himself was merely following where his fingers led. (Only at a much later date did he begin giving interviews that made him sound like an artist-philosopher, mainly because that was what the journalists expected of him.) After the warm bath of modern academic exegesis, Rodin's own explanation of what he was doing comes as something of a cold shower: there was, for example, the straightforward answer he gave Bartlett in 1887, when asked about the "thoughts and sentiments" that had motivated the *Porte*:

I had no idea of interpreting Dante, though I was glad to accept the *Inferno* as a starting point, because I wished to do something in small, nude figures. I had been accused of using casts from nature in the execution of my work, and I made the *Saint John* to refute this, but it only partially succeeded. To prove completely that I could model from life as well as other sculptors, I determined, simple as I was, to make the sculpture on the door of figures smaller than life. My sole idea is simply one of color and effect. There is no intention of classification or method of subject, no scheme of illustration or intended moral purpose. I followed my imagination, my own sense of arrangement, move-

ment and composition. It has been from the beginning, and will be to the end, simply and solely a matter of personal pleasure.

Dante is more profound and has more fire than I have been able to represent. He is a literary sculptor. He speaks in gestures as well as in words; is precise and comprehensive not only in sentiment and idea, but in the movement of the body. I have always admired Dante, and have read him a great deal, but it is very difficult for me to express in words just what I think of him, or have done on my door. . . .

The salient subjects of the door are the two episodes of Paolo and Francesca da Rimini and Ugolino, but the composition includes three phantoms and Dante. I never so much as thought of Beatrice, though I know it is a beautiful subject. Perhaps I may include it yet, but it will be difficult to treat, because I made only nude figures for the door, and I don't feel like representing her nude. I can't think of her as a nude figure, and for the door she could not be made otherwise. Besides, she is an angel, and I don't see angels as bodies, only as heads. Neither do I represent Virgil.

He had, however, made many drawings of Dante and Virgil before deciding that the latter did not fit into his sculptural scheme of things. Indeed, he had almost exhausted the subject of Dante and Virgil: Dante falling unconscious into Virgil's arms, Dante hurling himself into Virgil's arms, Dante and Virgil on a Pegasus or chimerical horse, Dante kissing and embracing Virgil.

Yet none of these drawings was a conventional "studio" study for the actual figures that appear on the Gates; indeed, of all the known drawings related to the *Porte* in one way or another—the so-called "Dantesque drawings"—only two or three are close enough to the sculptures to be considered "source projects" by art historians. In any case there was rarely a direct causal connection between Rodin's drawings and sculptures. Drawing involved one kind of thought process, sculpture another: his sketches for the latter were executed in clay. What he drew on paper was set down for its own sake rather than as a preliminary to something else. The one significant exception to this rule was the bust of Victor Hugo, which forced him to use

drawing as part of the modeling process. Elsewhere he had no need to make drawing subservient to sculpture, for each existed in its own sphere, with its own raison d'être.

It was hardly surprising that he should have "abandoned" a year's production of Dante drawings when he began modeling his figures in earnest. But the drawings did not abandon him; they had served to concentrate his mind wonderfully while "trying to translate Dante's work into the realm of drawing," as he wrote to Léon Gauchez on May 13, 1883:

Before arriving at the work itself, properly speaking, I had to try to transform myself, and to work within the spirit of this formidable poet; hence there are among these drawings experiments in which I tried to feel my way, to approach the poet's thought closely, and if my drawings are not all suitable for helping me in my work, at least they will have served as preparation for it. I cannot suppose that all my drawings will be modeled into sculpture, since the requirements of the composition as a whole sometimes differ from those of the work I have done from the standpoint of pure expression. Indeed at this moment there are so many of them that they serve, rather, as illustrations of Dante leading up to the point of sculptural expression.

He thus arrived at Dante by a leap of the imagination that took him far beyond mere storytellers like Gustave Doré. Few of the drawings depict recognizable "scenes" from Dante; instead they deal in a disturbing way with father-mother-child mythologies, and with enigmatic relationships among spirits, fauns, centaurs. Some of them evidently originated as Sèvres studies and were enlisted in the *Inferno* only by dint of a Dantean caption scrawled on the margin as an afterthought. Others were pure fantasy, though of an autobiographical kind. He told Gauchez that there was one subject "which I imagine in this fashion":

A sculptor is working on a recumbent figure in marble, wielding his hammer slowly because he is engaged in thinking at the same time; the spirits that have materialized around him are

his thoughts. The palpable image created by his imagination reveals that he is in fact working on another figure—it shows that he is not completely absorbed by the work on which he is engaged.

These studies were apt to be drawn on any scrap of paper that came to hand; pages torn from pads of lined paper, *carnets à deux sous*, pieces of cardboard, odd sheets of stationery. He would draw them with pencil, charcoal crayon or pen and ink, and might then go over them with a brush dipped in sepia or ink, highlighting them on occasion with touches of white gouache or vivid washes of red, purple or blue. Some are delicate calligraphic line drawings, others are roughly sketched wash drawings of compact figures silhouetted against gloomy backgrounds of black ink—Rodin's so-called "black drawings." Later he pasted many of them into a small account book that had been printed for a dealer in flowers and feathers, "J. Maingot et M. Caron, 5 Cité Bergère."

Taken altogether they are as remarkable and eccentric as anything by Blake, Goya or Odilon Redon. Many of them were drawn with a deliberate clumsiness and indifference to conventional beauty: Rodin's disciple Camille Mauclair thought them so bizarre that he was afraid to reproduce them in one of his books for fear they would "injure Rodin with the public at large.* In these violent washes, these pencillings and pen scribbles, the spectator who is not forewarned sees nothing. . . ." Yet Mauclair also recognized their "special and terrible beauty," and had an inkling, at least, that Rodin's sketches represented "a sort of passionate writing. . . . nothing can be less like what is generally known as 'a drawing.' "

They were, of course, what painters like to call "sculptors' drawings"—concerned with mass and outline rather than detail—and some are as schematic as if he were making preliminary sketches for an atlas of anatomy. Yet they also contain the first overt signs of his emergence as an artist-sensualist, whose fascination with sex would

*On the other hand, Rodin's wealthy admirer Maurice Fenaille thought so highly of these drawings that in 1897 he had 142 of them—just as they were, torn notebook pages and all—reproduced in trompe-l'oeil facsimile; they were published by the Maison Goupil, with an introduction by Octave Mirbeau, in an edition limited to 125 copies.

lead, eventually, to a seemingly endless series of *gestes inédits* (as the poet Georges Rodenbach called them). Dante's doomed women and the *femmes damnées* of Baudelaire gave him the pretext for opening a Pandora's box of forbidden sexual images: a "Kiss" étude, for example, far ruder than the later one in marble. Or again, an exquisitely drawn sketch of a centaur returning from a Bacchanale, bearing on his back an exhausted reclining nude of the sort that Félicien Rops liked to depict on banquet tables. There is also Rodin's earliest published drawing of a woman displaying her pudenda—a subject in which he was to take an increasingly obsessive interest as the years wore on. In time his penchant for female nudes doing the split was to become something of a standing joke among his acquaintances: Anatole France was heard to remark that "Rodin depicts hardly anything else but women displaying their you-know-what"— a gross misconception, but one that Rodin himself had done little to dispel.

Sometimes the "black drawings" contain marginal references to the real world. Beneath one pair of embracing lovers he scribbled the exclamation *"Abruzzesi très beau"* in addition to a caption quoted (inexactly) from Baudelaire: "A love as deep as the tombs." Was it Adèle or Anna Abruzzesi who had caught his eye at that moment? Both of the Abruzzesi sisters posed for him, and both were demonstrably beautiful: Adèle, the big-breasted woman who posed for the *Torse d'Adèle*, and several other figures, and Anna, who wrote to him years later that she still dreamed of him, and once sent him "as many kisses as there are roses." Evidently it was with their help that he achieved the high pitch of sensuality that distinguishes this enterprise—"two Italian women, one brown-haired, the other blonde," as he remembered them. "They were sisters, each perfect in her way, but utterly opposite in personality. One was superb in her savage energy. The other had that sovereign beauty which all the poets have described."

>∗<

When he began modeling the Gates in clay the work went very quickly, for much of it was derived from earlier studies and experiments. In 1905 Mauclair estimated that fully three-quarters of Rodin's known sculpture had been anticipated in the work he did during

the decade preceding 1877: "Certain works waited fifteen years to be executed in three months from a previous sketch."

Most of the *Porte*'s main elements, at any rate, were already completed by June 10, 1882, when he authorized Henley's photographer to take pictures of *la Femme accroupie* (the Crouching Woman) and a study for *la Création* (i.e., *Adam*) at his studio in the rue des Fourneaux, and at the rue de l'Université, *le Penseur* (The Thinker), *le groupe de Francesca* (Francesca da Rimini, soon to be retitled The Kiss), a study for *Ugolino*, the *Femme aux bras croisés* (as he then called *Eve*), and *l'Homme renversé* (also known as the Falling Man), which Rose was cautioned to handle with special care: "He's not steady on his base; pay attention."

Many of these figures were to lead double lives, as part of the *Porte* and as independent sculptures; some were incorporated into the Gates more than once, in different contexts. The *Falling Man*, for example, appears upside-down at the top of the left door, clinging to the molding beneath the tympanum as though he were trying to pull himself out of the *Inferno* by main force; his back is seen reversed in the lower portion of the right-hand panel, and still another version of the same figure appears high up on the right pilaster, standing upright with a woman in his arms, his body arched backward toward the viewer. In addition, Rodin executed *l'Homme qui tombe* as a free-standing independent figure and combined it with the *Crouching Woman* to form the remarkable group known as *I Am Beautiful*, of a man who hoists a cowering nude aloft in his arms—"a faunesse contracted with her legs gathered in the astonishing compactness of a frog ready to leap," as Edmond de Goncourt described it.*

The rest of this busy, crowded composition displays the same ingenious duplicity of means. The face of the so-called *Little Martyr*

*In 1885, Rodin used the same *Falling Man* module to create still another variant, this time at the request of the collector Antony Roux, who had asked him for a man with a snake instead of a man with a woman. It was a commission he accepted with misgivings, since the idea had not originated with him. "It is agreed," he wrote to Roux, "but my étude remains as it is and I shall make no modifications for myself. It is for you that I am making changes, and it is in order to enter into the subject [*c'est pour entrer dans le sujet*] 'Man Struggling with a Serpent' that I shall change the arms." The figure as a whole appears in at least one other assemblage, and the torso was enlarged to lead a separate existence as *Marsyas*, or *Torso Louis XIV*. See John Tancock's *The Sculpture of Auguste Rodin*, pp. 163–67.

plays hide-and-seek among the masks on the lintel and appears on some of the figures in the tympanum and the door panels—at least ten times in all. The group called *Fugit Amor* occurs in several variants: the upthrust or outflung arms of the male figure—known separately as the *Prodigal Son*—is one of the *Porte*'s sculptural leit-motifs.

As for the *Crouching Woman*, it was to become the best known of the nudes that Rodin posed in the squatting position: Adèle Abruz-zesi is said to have been the model. The figure appears twice in the Gates; once in the tympanum and again, as a fragment, in the arms of the *Falling Man*. But a closely related figure, the *Fallen Caryatid Carrying Her Stone*, crouches at the top of the left pilaster.

Over the years, as new figures were added and old ones removed, the *Porte* engendered so many additions to Rodin's family of figures that he came to call it "my Noah's Ark." But little is known of the early phases of the Gates' evolution, since there seem to be no extant photographs of the assembled work before the turn of the century. The nearest thing to a description of the *Porte* he expected Gonon or Bingen to cast in bronze comes from the pen of Octave Mirbeau, writing in *la France* of February 18, 1885:

> The portal's two doors are divided into two panels, each sep-arated by a group that forms a sort of doorknocker. On the right-hand door, Ugolin and his sons; on the left, Paolo and Francesca da Rimini. . . . Above the groups, Rodin has placed bas-reliefs from which protrude figures in high relief and scenes in mezzo-relievo that give his work an extraordinary sense of perspective. Each door is surmounted by tragic masks, heads of furies and terrifying, captivating allegories of sinful passion.
>
> Below the groups there are other bas-reliefs from which emerge masks of the face of pain [*masques de la douleur*]. Centaurs gallop along a river of mud, carrying off the bodies of naked women who twist and turn on their upreared cruppers. Other centaurs shoot arrows at the unfortunate ones trying to escape— women, prostitutes, carried away by their swift descent, can be seen falling or throwing themselves head-first into the flaming slough.

The pilasters were covered with still more bas-reliefs; to the right, "lovers doomed to be forever locked in each other's embrace though never to slake their passion," and on the left children (or rather Rodin's *enfants génies*) tumbling head over heels—*dégringolades d'enfants*, in Mirbeau's phrase—and "intermingled with horrifying figures of old women."

Mirbeau's account makes it plain that at this stage the main panels were still centered on two specific "scenes" from the *Inferno*; the tales of Francesca and of Ugolino. Rodin retained these motifs in subsequent versions, but the Paolo and Francesca of 1885 were not the storm-tossed lovers in headlong flight which appear in the "definitive" *Porte*. In the group described by Mirbeau, a seated Francesca has "her arms around her lover's neck, abandoning herself to Paolo's kiss and embrace with a movement at once passionate and chaste." It was, in other words, *The Kiss* that originally formed one of the "doorknockers" of the *Gates of Hell*.

The lines that Rodin had chosen to illustrate were the nineteenth century's favorite Dante episode—the tale of Francesca da Rimini and her husband's younger brother, Paolo Malatesta, and of the fatal passion that sprang up between them when "one day, for our delight, we read of Launcelot, how love constrained him. . . . When we read how that fond smile was kissed by such a lover, he kissed my mouth all trembling. We read no more that day." Unlike Gustave Doré, whose carefully costumed illustration of the text was published in 1861 (and which, in turn, inspired Tchaikovsky's 1876 tone poem, *Francesca da Rimini*), Rodin chose to show his guilty lovers in the nude—which suited his needs as a sculptor but outraged some of the critics when the group was first exhibited separately, as *Françoise de Rimini*: "What, make them naked? It's dreadful." As one reviewer complained at its debut in the 1887 Brussels Salon, "Francesca and Paolo were neither mythological characters nor savages but thirteenth-century Italians; in a pictorial or plastic work they must be shown in the costumes of their time. None of the details of their tragic adventure so minutely described by Dante are shown by Rodin."

Rodin had not, however, dispensed with the one attribute that set this group apart from ordinary sculptured kisses—the erotic storybook of Launcelot and Guinevere, Dante's poem-within-a-poem. Unnoticed by most viewers, Paolo still clasps the fateful book in the hand held

behind Francesca's back. Evidently even Rodin had first approached the subject with a certain diffidence. In his first version of *The Kiss*, he once told Lady Sackville, "the man's hand was not resting on the woman's leg, but about one inch from it. It was more respectful."

The more he worked on it, the more it seemed to him to acquire classical overtones. "When I begin my work it looks like the Renaissance," he told Bartlett, "but if I carry it well along it looks like the antique—the Kiss of '82 looks like an antique."

The centerpiece on the *Porte*'s other panel was hardly less theatrical: Count Ugolino groveling among the bodies of his sons "like a beast benumbed with rage and famine," as Bartlett says. Mirbeau thought there was nothing more terrifying in sculpture than this "synthesis of the horrors of starvation." But as usual there were objections. The same conventionalist critic who disapproved of Francesca's unrealistic nudity found Ugolino too realistic for his taste. Not only was he posed "in a vulgar attitude known in everyday language as crawling on all fours" but—

> The artist seems to have been motivated above all by a desire
> to display his knowledge of anatomy. Ugolino's torso is marked
> by a surfeit of muscular protuberances that remind us of Leo-
> nardo da Vinci's advice to young painters: "Don't draw bodies
> looking like sacks of walnuts."

Rodin had arrived at this group after deciding that he was "not satisfied" with the seated *Ugolino* on which he had been working intermittently since the Italian journey of 1875. It must have occurred to him that this muscular figure bore too many points of resemblance to Carpeaux's *Ugolino*, a group known to the Paris art world as "almost a modern Laocoön." On the way to a different solution Rodin did a whole series of "black drawings" on the theme of Ugolino, including one that seems to be, exceptionally, a preliminary sketch for the subsequent sculpture. In the end he took his cue from two of the concluding lines of the Count's recitation, in Canto 33, of how he and his sons were locked in a tower and left to die of starvation: "I, blind now, groping arms about them threw, and still called on them that were two days dead." As a model for this version of Ugolino he used Pignatelli again, the "wild beast" with the wolf's smile who had

posed for *Saint Jean*; it was no wonder that the finished figure reminded Mirbeau of "a hyena that has dug up some carrion." Its clay was still fresh in June 1882 when Rodin wrote to Rose from the Charing Cross Hotel, London: "Dress up and go on Sunday to the rue de l'Université, see the concierge Baton and ask him to show you my Ugolin; see if he's in good shape. I'll probably be back on Thursday. *Ton ami*, A. Rodin."

Of the original Ugolino group, on which he had spent so much time in Brussels, Rodin "destroyed all save the body of the principal figure"—the powerful torso (with its resemblance to the Belvedere torso that Rodin had placed on the walls of the Brussels Palais des Académies) that had excited the admiration of the young sculptors who saw it in his studio. Significantly, this residual torso was allowed to disappear and is now known only through old photographs. But Rodin was not the one to let such an important étude go to waste. It became a vital link in the evolution of the *Porte*'s dominant figure, originally envisaged as a separate sculpture rather like the Byron monument, and in some respects almost a kind of idealized self-portrait of the sculptor as a poet:

> In front of this *Porte* [Rodin explained to a journalist at the turn of the century], but on a rock, Dante was to be seated in profound meditation, conceiving the plan of his poem. Behind him there was Ugolino, Francesca, Paolo, all the characters of the *Divine Comedy*. But nothing came of this idea. Gaunt, ascetic in his straight robe, my Dante, separated from the ensemble, would have had no meaning. Still inspired by my original idea, I conceived of another Thinker, a naked man crouched on a rock against which his feet are contracted. Fist pressed against his teeth, he sits lost in contemplation. His fertile thoughts slowly unfold in his imagination. He is not a dreamer; he is a creator.

Eventually this figure was placed, not on a separate rock, but at the center of the tympanum overlooking the Gates, as though sitting in judgment over its damned souls. Mirbeau, in his 1885 article, still refers to this personage as Dante—"Dante seated, leaning forward, his right arm resting on his left thigh, which lends his body an

inexpressibly tragic movement." To Mirbeau this Dante had the expression of a vengeful god brooding over the sulphurous vapors of an infernal abyss. Rodin himself, aware of the figure's resemblance to Michelangelo's *il Pensieroso* (Lorenzo de' Medici), had been in the habit of referring to it as *le Penseur*, and the Dante label was quietly dropped: it was as *The Thinker* that it became his best-known sculpture, a nineteenth-century totem as instantly recognizable as the Eiffel Tower or the Statue of Liberty.

When Mirbeau described the Gates, they still lacked one important element. Not until after the article appeared did Rodin add the Three Phantoms, alias the Three Shades, to the very top of the *Porte*. All three are casts of the same Michelangelesque figure—its head bowed toward the left shoulder, the left arm thrust downward. Yet the three are grouped in such a way that the duplication is not noticeable, any more than the fact that each lacks the right hand—"The hands," explained René Chéruy, "have been left in the state of stumps as though eaten by the flames." Looking up at the looming plaster Gates, as Bartlett noted, a visitor to Rodin's studio would see "three sinister left arms, from as many herculean forms, point straight at him, as though in condemnation of his intrusion."

To the critic Félicien Champsaur, who wrote an article on the *Porte* for *le Figaro* in January 1886, the Three Shades seemed to dominate the Gates and "to embody the sentence they point to, written on the pediment: *Lasciate ogni speranza, voi ch'intrate*—Leave hope behind, all ye who enter here." But Rodin then decided to remove the quotation, perhaps because no one would ever enter what had become an unopenable door. For that matter, Dante's words might not have been the most suitable message of welcome to the visitors of a museum of applied art.

The male figure which became the Shade was a close relative of the "corkscrew" *Adam*, whose beginnings were traceable to Rodin's early experiments with Michelangelo poses. In Paris he reworked these sketches, using as his model a carnival strongman named Caillou who could lift 100-kilo weights with his teeth and was known as "the man with the iron jaw." But while the major male figures of the *Porte* were the product of a long gestation period, the female figures tended to spring from chance encounters with interesting models.

The *Eve* which he intended as a counterweight to *Adam* may have owed something of her pose to a figure on the Sistine ceiling, but as Rodin told Dujardin-Beaumetz, it was in the model that he discovered "all the strength and splendor of muscular beauty, the equilibrium and simplicity that make the great gesture." The model in question was one of the Abruzzesi sisters: the story of how this fascinating brunette with "the suppleness and grace of a panther" prevented him from completing his figure was to become one of the sculptor's favorite anecdotes:

> I was working on my statue *Eve*, I saw my model changing without knowing the cause; I modified my profiles, naively following the successive transformation of forms that were growing steadily more ample. One day I learned that she was pregnant; then I understood everything. The contours of the belly had changed in a way that was hardly noticeable, but one can see with what sincerity I copied nature when one looks at the muscles of the loins and sides.

Far from being annoyed, he felt that her pregnancy was "singularly fortuitous" to his characterization of the mother of mankind: "A happy accident had brought her to me. . . ." But soon there was the problem of maternity leave. "My model became more sensitive and found the studio too cold; her visits became less frequent and then ceased altogether. That's why my *Eve* is unfinished." The matter must have been more complicated than that: a friend reported that one day the model simply disappeared—she was said to have gone off to Italy with her Russian lover—and "Rodin didn't touch his statue anymore." Edmond de Goncourt heard a confirmation of this account in 1886, when Rodin showed him the unfinished *Eve*—"a robust sketch of a nude woman, an Italian, a compact, elastic creature; a panther, to use his expression. He says with regret that he cannot finish it because one of his pupils, a Russian, fell in love with her and married her."

Goncourt also heard from Octave Mirbeau how Rodin came to include an old woman in his cast of characters on the left pilaster— again, a figure not to be found in Dante's text:

One day he came on Rodin modeling an admirable work, with an 82-year-old woman as his model. . . . Some days later, when Mirbeau asked him how it was getting on, the sculptor told him that he had demolished it. Later, he felt remorse about having destroyed the work praised by Mirbeau and made the two old women which were exhibited [as *Sources taries*—"Dried-up Springs"]. Incidentally, the story of the 82-year-old model is quite peculiar. She was the mother of an Italian male model and she came from down there on foot to see him once more before she died, and the son told her, "Mama, I'll throw you out if you don't pose." And he suggested her to Rodin without telling him she was his mother.

Besides finding a place for her on the *Porte*, Rodin exhibited this figure as a group made from two identical casts facing each other as though in intimate conversation—these were the "Dried-up Springs." (Among other things, this *mouleur*'s trick forced gallery-goers to look at the figure's splendidly modeled back—an aspect they usually neglected.) Later it was shown as a single figure under various names—*Old Woman, Winter, The Old Courtesan*—until Rodin finally settled on a long literary title, *Celle qui fut la Belle Heaulmière*. "She Who Was the Helmet-Maker's Beautiful Wife" is the heroine of a ballad by François Villon in which a quondam beauty laments the ravages of old age: "And when I see myself naked and changed, poor, used up, gaunt and shriveled, I almost go mad. . . . The breasts, you ask? All dried up, the hips and paps alike. . . ."

The allusion seemed so appropriate that the critics began to write of it as a fait accompli: here was "the whole drama of a body's ruin," as Mauclair has it, drawn "from Villon's poem." Yet the title, as usual, had merely been an afterthought. The Viennese critic Ludwig Hevesi once asked Rodin about the genesis of this unlikely subject. "Oh," was the blunt reply, "I just happened to have such an old woman to hand, and the form intrigued me."

Still there was an implicit moral to be drawn from this figure which Rodin never tired of expounding. When Gsell reminded him that many people found it ugly—"I have often noticed women covering their eyes with their hands to avoid seeing it"—the sculptor explained

that it embodied an important principle: "There is nothing ugly in art except that which is without character . . . only the false, the artificial, is ugly in art."

>✛<

The Belgian artist-sensualist Félicien Rops, "the man who gentrified the devil," wanted to meet Rodin and see the Gates. "Having heard that I knew him," Emile Bergerat recalled, "he asked me to introduce him to the artist, then still completely unknown except to a circle of zealous supporters." One morning in 1884 Bergerat picked up Rops at his rabbit warren of an apartment in the attic of the Crédit Lyonnais on the boulevard des Italiens and took him to a "certain wine-shop near the Trocadéro where I knew that Rodin ate every day, dressed in a smock like a carter"—though as Bergerat hastened to point out, like "a carter (*carrier*) without a trace of Belleuse." Several other artists also came for lunch; Rodin was the last to arrive, "with a flowing patriarchal beard spread across a workman's blouse, his two eyes like a sleepwalker's." Over lunch they had an animated conversation—monopolized by Rops—about art and nature. Then Rodin invited them over to the Dépôt des Marbres and showed them the *Porte*. "At the sight, we visitors were gripped by a profound emotion, and deep silence reigned. Then Rops turned away—Rops the ferocious cynic and pitiless critic—leaned his head against the wall and wept tears of joy. He had found his ideal of beauty; it was here before his eyes, on earth, in France."

It was easy to see why this wall full of voluptuous nudes should have appealed to Rops, who had spent half a lifetime drawing pictures of vampire women engaged in sinful pleasures and unspeakable practices—all of which had suddenly become immensely fashionable in poetry, the novel and the visual arts. By a happy chance, the years in which Rodin was busy on the Gates coincided with the emergence of a great Decadent literature that specialized in *idées érotiques* of every imaginable kind. Zola's rather brutal naturalism had already given way to the refinements of a more selective and Byzantine sexuality. Eighteen eighty-three was the year of Maurice Rollinat's book of poems, *Névroses*, with its convulsive litanies of sadism and lust; 1884 saw the publication of Huysmans's *A rebours* (Against Nature),

a sort of sybarite's handbook that prompted the painter J. F. Raffaëlli to pay him the highest compliment of which he was capable: "My dear Huysmans, your book has made me literally ill and I hasten to tell you that you have achieved something remarkable which will earn you the greatest literary esteem."

It was Huysmans who summed up the morality of the Eighties when he announced, in speaking of Rops, that "only the chaste are truly obscene." Compared to such prophets of Decadence as Joséphin Peladan and Catulle Mendès, Rodin's sexuality was relatively tame and straightforward, rooted in Michelangelo rather than the Marquis de Sade. Yet what was common enough in literature was still new to sculpture: no other artist had devised such an impressive framework for his *idées érotiques*. By an ingenious process of psychological transference his decorative doors for a museum of arts and crafts had become a giant plaster screen on which to project his sexual fantasies: "It was what he saw when he closed his eyes," as Léon Daudet reports in his memoirs. The sculptor had "often confessed to his friends, quite superfluously, that he was obsessed by the lines of the female body. He looked for them again and again unceasingly"—and the results were incorporated into the *Porte*. "Without a doubt," Daudet says, "it expressed his inmost perceptions of human passion."

Rodin himself told the Dutch critic Willem Byvanck that "the whole of life went through my mind [*toute la vie a passé devant mon esprit*] while I was working on the *Porte*." But the effort was physical as well as mental, and entailed hundreds of clay sketches—the "final" version contains more than 180 figures. The writer and critic Hugues Le Roux remembered "a time when the walls, the studio floor, the workbenches and the furniture were covered with small figures of nude women, twisted into gestures of passion or despair. Rodin was then under the influence of Baudelaire's book; he seemed intoxicated by it. With the speed of spontaneous creation a crowd of innumerable *femmes damnées* were born, 'sinful women' that palpitated beneath his fingers, some to live for an hour only to return to the clay tub. . . ." Often, by his own account, he would take one of these fleeting ideas "and work it out separately, just for myself." Le Roux recalled the single-mindedness with which he could become absorbed in one of these studies "during the time when his mind was passionately occupied with Baudelaire":

One day, around noon, the maid of one of our mutual friends opened the door to a man with a long beard, in workman's clothing completely bespattered with plaster, carrying a statuette. He told her, "Please tell Monsieur that the sculptor is here."

My friend, on receiving the message, thought that some studio assistant had arrived, and went on calmly eating his lunch. Imagine his dismay when he stepped into the anteroom and found himself face to face with Rodin.

"Oh, dear," he said, desperately embarrassed. "It's you! You've been kept waiting!"

"But no," the sculptor said, "I haven't been waiting." He had put his statuette on a piece of furniture—it was a small *femme damnée* just completed which he intended as a present for his friend. And then he had proceeded to brood over it, examining it fondly with paternal eyes. He hadn't noticed that while he was thus engaged, a full hour had elapsed on the hall clock.

Rodin had got into the habit of giving casts of his smaller *Porte* figures to his literary friends. A favorite gift was the group *Fugit Amor* (Fleeting Love)—then better known as *The Sphinx*—which went to several writers, including Octave Mirbeau and Gustave Geffroy. Guy de Maupassant also had one on his desk, though he referred to it as *The Chimera*. Not infrequently these gifts had literary repercussions. Paul Bourget devoted several pages of his *Physiologie de l'amour moderne* to a "meditation" on a marble version of *The Sphinx*—a work "I never look at without feeling melancholy." Bourget's account furnishes the most stylish and perceptive example of what Rodin's intellectual friends could read into one of his small sculptures—in this case an assemblage of two separate figures that Rodin had simply superimposed:

This piece of carved marble is extraordinarily symbolic of the terrible struggles that accompany the ending of a love affair. The woman is naked. Lying on her stomach, she arches her back in a mighty effort that is also reflected in her taut lips, her outstretched legs, the clenched hands with which she grasps

her hair. What is this effort? That of tearing herself out of the man's grasp—this man who is himself naked and lying on the woman's back as though on a rack, shoulder against shoulder, back to back. And he, too, wants to tear his flesh away from hers but is held captive by the beautiful breasts which his distraught fingers hold in a desperate grip. Never, never will he be able to part from this tantalizing bosom, and his expression reveals an almost breathless agony.

How they hate each other, these two beings—almost as much as they once loved each other. For they have loved, to the point of folly; one can sense that from the exhaustion of their tired bodies, the quivering of their contracted muscles. . . . And now that they avert each other's eyes, that they avoid each other's lips and curse each other, the chain of lust still binds them together with its unbreakable links. How was it that this sculptor, a pupil of the somber Florentine, could give such poetic expression to that commonplace last act of love's drama which we call "breaking up"?

In 1886, when Bourget published *Un Crime d'amour*, Rodin had still not yet brought his great panorama of anguished sexuality to a satisfactory conclusion. As the date on which it was to be sent to the foundry kept being postponed, his friends began to suspect that he might never finish it. Emile Bergerat, for one, decided that the *Porte* had become his "Penelope's web."

Some of the art critics felt that the problem lay with Rodin's supposed lack of an architectonic sense. For the English critic Frank Rutter, for example, the *Porte* was "a work for which Rodin was not temperamentally fitted. . . . He seemed to regard this Gate as a spacious bed in which he could safely plant any odd head, figure or group that was lying about handy. Never once did he appear to have any clear conception of the Gate as a whole with all its parts in ordered relation to each other."

Toward the end of the decade Rodin himself began to have doubts about the *Porte* and whether it really lived up to its advance notices. After a young Swiss writer for *le Temps*, Mathias Morhardt, visited the Dépôt in 1888, Rodin sent him a curious letter asking him, in all confidence, not to praise the Gates:

I should like to ask you as a friend—since we are already friends—that if you write about your visit *chez les sculpteurs*, don't say a word about (my *Porte*) my sculpture; about its *esprit* yes, if you like—but this word *Porte* has been mentioned too many times and may eventually produce a great disappointment when it is put on exhibition.

Camille Mauclair described the *Porte* as "the diary of his life as a sculptor," and modern scholars have declared it to be "his principal work, indeed the quintessential work of Rodin's life." But the evidence suggests something quite different—that it represents the "diary" or quintessence only of Rodin in his forties, and was then superseded by other works and different attitudes. Though he continued to tinker with it, and writers went on depicting him at work on his reliefs, surrounded by a "crowd" of detached fragments, the truth of the matter was that he had outgrown the Gates in the very act of sculpting them.

It had been, after all, only *une saison en enfer* and not the preoccupation of a lifetime. He himself was well aware that what he had created was the product of a particular epoch, almost a giant *pièce d'occasion*. By the time it had reached the stage where Rops could weep over it, Rodin's view of sculpture had reached a turning point and he was preparing to set off in a new direction. "I used to think that movement was the chief thing in sculpture," he told Lawton at the turn of the century, "and in all I did it was what I tried to attain. My *Porte* is the record of these strivings. It contains the whole history. There I have made movement yield all it can."

Thereafter he had begun the search for a calmer, more disciplined quality in sculpture, subject to what he came to call "geometric considerations": "*La raison cubique est la maîtresse des choses et non pas l'apparence*"—"the essence of sculpture lies in the geometry of forms rather than in the appearance of things." In his conversations with Lawton he explained that "sculptural expression" had replaced "movement" as his guiding principle:

I have come gradually to feel that sculptural expression is the essence of the statuary art—expression through modeling. This is what made the grandeur of the Greeks. There is repose,

wonderful repose and restfulness in their sculpture; not the repose of the academic style, which is the absence of nature, the absence of life, but the repose of strength, the repose of conscious power, an impression resulting from the flesh being under the control of the spirit.

For years the Gates remained the great white showpiece of Studio J at the Dépôt des Marbres. He would return to them from time to time, notably for the Paris World's Fair of 1900. But the later Rodin could not bring himself to complete what his earlier self had left unfinished. Instead he made a virtue of necessity: it became a point of honor not to have completed the *Porte*. "I find something to do on my works for years," he would tell visiting journalists. "They would be dead if they were definite."

>‡<

On January 25, 1885, Rodin signed a contract for a major new work that was to present him with an entirely different set of problems and opportunities—a public monument commissioned by the city of Calais. It gave him a second chance to prove that he was not merely a master of morceaux, as well as an additional excuse, if he needed one, for delaying the completion of the *Porte*. Among the first to be told the good news was Bergerat, to whom he wrote shortly after signing the contract, "My Calais commission is now an accomplished fact." They had been working together on a small project of their own: three months earlier, Bergerat had published his five-act dramatic poem, *Enguerrande*, in a limited edition (601 copies) containing two drawings by Rodin—his first book illustrations. "Here it is," the author wrote to Rodin when the book came off the press. "I'm ill; I have an absurd dysentery, otherwise I'd have run over to see you long since. What a success! Your drawings are magnificent." Later he extended his congratulations on the new project: "*Bravissimo pour le monument de Calais*," which was certain to be another masterpiece. And he had plans for a dinner involving Rodin, Degas, Mirbeau, "even Dalou," which would enable them to enjoy the fellowship "of *true* artists."

For a time Rodin and some of his friends talked of founding an association of independent sculptors, but the proposed society—

which was to have Frémiet as president—never came to anything. By now Rodin was no longer in need of a professional association as a springboard for his ideas. For moral support he could now rely on a phalanx of young critics and on at least one important editor— Léon Gauchez of *l'Art*, a giant folio of a magazine that was subsidized by Baron Alphonse de Rothschild. Gauchez had begun to interest himself in Rodin's work in 1880, when he published the sculptor's own drawing of *Saint Jean* still carrying the biblical staff that was removed before the figure was shown at the Salon. Two years later he commissioned a marble version of the two *amorini* known as *l'Idylle d'Ixelles*; Rodin wrote to thank him for his "strong support" and to assure him, "I have taken the little group away from the praticien in order to finish it myself." In 1883 Gauchez published nine of Rodin's drawings for Sèvres vases and for the *Porte*—an act of editorial courage then without precedent, since most of these dark, inner-directed images must have struck his readers as bizarre and outrageous. For this and other marks of special favor, Rodin was genuinely grateful. In July 1884, he wrote to the editor: "I just felt the need to tell you of my gratitude. Among the group of artists whom you support, I am one of those you have especially chosen; your taste and experience are helping to make my name with the public. An artist always needs such a powerful supporter."

Gauchez proved to be helpful in many ways—as a propagandist for the Rodin cause, as a go-between for the art-loving Rothschilds ("I am profoundly and respectfully devoted to that family," Rodin wrote to him) and as a source of financial first aid in case of emergency. Rodin sold him several of his sculptures and offered him others from time to time. "I assure you that in the midst of all my success I'll also have great need of some chicken feed [*grain de mil*]," he wrote in November 1885. If Gauchez were to purchase "the bust with the inclined head for 2,000 francs, that would allow me to hold out and deliver me from some of my present difficulties."

Though Rodin had now been "twice or thrice the hero of a government purchase," in Henley's happy phrase, he was still sporadically short of money. His expenses had soared while his income remained erratic; it was not enough to work harder than ever, *un fou furieux de travail*, as a friend called him—"a madman crazy for work," as he always was. To complicate matters, his accounts were in a state

of permanent disarray. One of his pupils of the mid-Eighties preserved a typically hasty note scrawled in Rodin's impatient hand: "Would you be so kind as to send me by mail or through the model whatever you think reasonable for the lessons that somehow or other I've given you? (It's time to pay the rent.)"

There were signs on all sides that, unlike Henri Becque, he had actually "arrived" and had caught up with the Beaux-Arts contemporaries whose Salon careers had begun fifteen years earlier than his. In 1883 it occurred to one of the younger Salon exhibitors, Jean Baffier, that "such a man ought to belong to the Salon committee," and he managed to persuade two other electors—Captier and Paul Aubé—to vote for his proposal. They were not enough to put Rodin on the executive committee, but even this nomination was a straw in the wind. Baffier, incidentally, became acquainted with Rodin as a result of this campaign, and was subsequently invited to do the fine-hewing on a marble version of the Hugo bust. "I did not make a very good job of it," he conceded. "At that time I was too little imbued with Rodin's ideas to carry them out well; but he was indulgent, as always, and accepted what I had done without grumbling. He had all the more to alter."

Rodin had good reason to be indulgent: he had worked as a sculptor's assistant long enough to understand the limitations of the métier. Besides, he knew himself to be far from infallible. "An unfortunate thing has happened to me," he wrote to a friend at about this time—

I thought I had finished my woman's bust yesterday, and I have ruined it. It will have to be begun over again. Three weeks lost! Ah! how annoying! . . . I begin to be afraid, and must now work hard. When I leave the studio my ideas, like birds, are too slow in coming back; and I spend whole days in trying after an effect. . . .

The event that placed the *estampille* on Rodin's growing reputation was the special exhibition held in December 1883 at the Palais des Champs-Elysées—a government-sponsored retrospective of the outstanding work of the previous five years, the first "Exposition Nationale des Beaux-Arts." Rodin hoped to exhibit *l'Age d'airain* and

Saint Jean in bronze—both of which had been sent to an international exhibition in the Vienna Künstlerhaus the year before—but their acceptance was not automatic. To his annoyance, as he informed Gauchez, "I received a letter from the management of the Exposition Nationale informing me that *l'Age d'airain* has been accepted but that the *Saint Jean* would have to be resubmitted for official consideration. That will teach me!"

In the end *Saint Jean* passed muster but was relegated to an unfavorable position in the gallery. The selection was said to represent the best of contemporary French sculpture and included works by most of the leading *statuaires* of the decade: Chapu, Guillaume, Delaplanche, Cordier, Falguière, Dubois, Dalou, Thomas, Barrias and Saint-Marceaux. In that exhibition "swarming with pretty objects of clean, elegant, correct sculpture," only Rodin's figures stood out as the work of an artist who had "followed the impulses of his temperament," as Arthur d'Echérac, alias G. Dargenty, told the readers of *l'Art*:

> This man did not attend the school, he belongs to no coterie, he had no maître; he sculpts because his thoughts happened to take this form. In the midst of all this conventional elegance, all these distinguished bibelots, he launches two figures of the first rank in which simplicity and grandeur are translated into exceptionally large, vigorous, daring forms. . . . [Yet] the *Saint Jean* of M. Rodin, certainly the most powerful and individual figure of this Salon, stands in poor company in the most obscure corner of the darkest bay.

The 1883 National Exhibition was the last of which Rodin could complain that his light was being hidden under a bushel. Great changes were taking place that were shaking the world of art out of its doldrums. A new wave of critics had swept into the review columns of the newspapers (which were often on the front page); dealers such as Durand-Ruel and Georges Petit were moving with the times—the former had just put on the first one-man shows for Monet, Renoir, Pissarro and Sisley; Manet, who died in 1883, received a giant if belated retrospective at the Ecole des Beaux-Arts early the following

year, and the auction sale of the 195 paintings, pastels and drawings left in his atelier brought 116,637 francs.

In Brussels, meanwhile, the modernist movement got under way in earnest with the founding of the Group of Twenty—"Les XX"—on January 4, 1884. Its twenty founders included James Ensor, Ferdinand Khnopff, Théo Van Rysselberghe and other leaders of the Belgian avant-garde, mainly of the Symbolist persuasion. Each member had the right to exhibit six works in the group show that opened at the Palais des Beaux-Arts on February 2; in addition, twenty guests were asked to participate. Rodin was among the first to be invited, together with such artists as Whistler, Sargent, Rops and Max Liebermann. On December 11, 1883—before Les XX had received their charter—he wrote to the group's secretary and organizing genius, Octave Maus, that he was "very honored to have been selected from among the many French sculptors so as to participate in the Brussels exhibition together with Les XX." It was, indeed, a distinction that placed him in the forefront of the international avant-garde. He was not sure what to send them—"but in any case I'll send the portrait of Victor Hugo which I've just completed *d'après nature.*"

The first exhibition of Les XX was a great success, and they went on to achieve international importance as a major forum of new painting and sculpture. Rodin's bust "excited a great deal of enthusiasm," as did Whistler's contribution, but the *gros scandale* of the occasion was Rops's *Temptation of Saint Anthony*, which included a nude woman in mesh stockings, crucified but very much alive. The subject was to become a sort of Vingtiste leitmotif: Khnopff and Ensor each produced a *Temptation*, but the latter's drawing was refused for indecency in 1888. The following year, when the sculptor Achille Chainage resigned from Les XX to protest against Ensor's continued presence, Rodin was unanimously elected the group's first foreign member (the second, Paul Signac, was elected in 1891).

In Paris the situation was far too chaotic to have permitted a group like Les XX to assume similar responsibilities for the whole of the avant-garde. It was a time of feast or famine for French artists, some of whom were earning vast sums while others were literally starving in a market where supply far outstripped demand. Jules Desbois, a highly competent sculptor with all the usual medals and diplomas, had written to Rodin in 1881: "Here I am once again in a desperate

situation . . . and you are my only hope." Some measure of help was forthcoming—Rodin found work for him to do for more than thirty years—but Desbois's poverty was typical of the average artist's.

By comparison with society painters like Bouguereau and Meissonier, sculptors were an underprivileged class. In November 1885, the young critic Roger Marx published an article in *le Progrès Artistique* in which he lamented the sculptors' condition as the "pariahs" of art: "Every year one hears of some unhappy sculptor who has come to a miserable end in an obscure corner of Paris, consumed by disappointment and by the impossibility of realizing his innate gifts."

The article was dedicated to Rodin, who was not otherwise mentioned by name—though Marx clearly had him in mind when he drew his idealized portrait of the hard-working, underpaid *statuaire* and contrasted it with that of the average Salon painter. How different from the ostentatious, overstuffed atelier of the successful painter was the sculptor's studio

> . . . with its blank gray walls, decorated only with a few casts and maquettes. Here there is no fashionable chit-chat, no luxuries, no intrigues or pretentiousness. The sculptor is often alone, or else in the company of a few intimates—who love art for its own sake and not as a sop to their egos. You will find him in shirt sleeves or in a long smock, his hands gray and slippery with clay, at grips with the material to which he seeks to communicate the energies of life.

Rodin rightly felt flattered and took a great liking to this twenty-six-year-old critic from Nancy whose father had been one of Napoléon III's inspectors of Beaux-Arts. He complimented Marx, in turn, for having, "for the first time, described in discreet terms, but very clearly, the philoxera of sculpture." Marx's article had appealed to rich art collectors "in their mansions or châteaux" to spend more money on commissioning contemporary sculpture. Rodin wrote to Marx rather wistfully that his kind of sculpture might not fit into such surroundings: "It is unfortunate not to have a talent that is suitable for the great houses of rich collectors. Instead, only men of letters and artists will have on their mantelpiece the works that reflect my preferences in sculpture."

In fact he had already begun selling his work to wealthy collectors like the connoisseur Antony Roux, "the first art lover who dared buy Rodins." Roux was especially fond of the small erotic groups and figures derived from the *Porte*, some of which Rodin made especially for him. The kneeling faunesse with "her arms raised in a playful gesture of seduction" known as *la Toilette de Vénus* even bears the inscription, "Made with pleasure for my friend Roux—Rodin."

But Roux customarily drove a hard bargain. Rodin sold him several such figures together with exclusive and unlimited rights to make reproductions, just as though he were selling a model to a firm of commercial bronze manufacturers. The group called *Iris*, for example ("the messenger of the gods awakening a sleeping nymph"), was sold on September 21, 1885, together with a letter warranting that it was now Roux's "exclusive property." In 1888, when he sold Roux "a small figure entitled *Jeune fille au bain*," the sculptor attested: "I hereby deliver the original and agree to refrain from making any reproductions. Two or three plaster proofs were presented as gifts to friends prior to this date." Three years later, when he sold Roux the autobiographical *Glaucus*—a grizzled sea god dallying with a nymph—the terms had become more equitable: "I hereby undertake to make no further copies, either in bronze or marble, since the original is the property of Monsieur Roux, who also agrees not to make copies whether in bronze or marble."*

The most prominent of the connoisseurs who were now beating a path to Rodin's door was Alphonse de Rothschild, head of the Paris branch of the banking family and one of the great art collectors of nineteenth-century France. Bartlett reports that "the first well-paid

*Such terms were standard business practice in the decorative sculpture industry, and Rodin entered into many similar agreements. On August 23, 1882, for example, he wrote to the dealer who proposed to make commercial copies of the last of his fantasy-busts à la Carrier-Belleuse: "Once again I assure you that this model, *Manon Lescaut*, will not be 'edited' [i.e., commercially reproduced] by anyone but you." Some of the other details of this letter are interesting technically, since they reveal that Rodin was not averse to making casts from his marbles: "If there are to be terra-cottas of the bust I must have molds made in order to cast some proofs. The work will take fifteen days. I think, therefore, that you should send for the marble in fifteen days. . . . The founder should also come to see me and give me a price for the casts if any have to be made. This delay is partly due to the present state of my bust, which is still too sketchy [*en esquisse*] for any proofs to be made. . . ."

commission that Rodin ever received" came from Rothschild. Among the Gauchez papers there is a Rodin receipt for an unnamed marble, dated March 19, 1886: "Received from Monsieur le baron Alphonse de Rothschild, the sum of six thousand francs for a group in marble which I shall execute."

Rich collectors, on the whole, preferred polished white marble to what one critic called "the golden gloom of bronze." Indeed, at about the same time Rodin sold a half-size marble version of *Eve* (70 centimeters high, including the base) to Victor Hugo's wealthy factotum Auguste Vacquerie, who had become one of the executors of the Hugo estate following the poet's death in May 1885. This time, however, Rodin had not sold the reproduction rights, and he wondered if Gauchez might like to commission another marble copy: "I will, I think, have the chance to buy some marble that is equally beautiful. As for the carving, I guarantee that it will be as beautiful as anyone can make it."

>‡<

News of Rodin's successes was always eagerly publicized by Henley, who had turned the *Magazine of Art* into a flagrantly biased propaganda medium for "the greatest of living sculptors." Readers of the magazine's "Chronicle of Art" pages learned that "M. Rodin has sold his admirable *Eve* in marble to M. Auguste Vacquerie" a month after the event. Beginning in 1882 the whole trajectory of Rodin's career could be charted more accurately in the pages of Henley's magazine than in the Paris press. That year there was mention of the "magnificent" *Man with the Broken Nose* at the Grosvenor Gallery, London, and news of the *J. P. Laurens* bust at the Paris Salon—"perhaps the most successful sculpture of the year." In 1883 Rodin sent seven sculptures, in bronze, marble and plaster, to "an interesting little exhibition of pictures and sculpture by a dozen French artists" held at the Dudley Gallery, in the Egyptian Hall on Piccadilly. The paintings were mainly by friends of Rodin—Auguste Flameng, Albert Besnard and Madame Besnard, Cazin, Roll, Gervex and others; "the interest of the gathering, however, centres in the seven contributions of M. Auguste Rodin," including "the superb *Saint Jean*" and the half-size *Eve* "of singular merit . . . the modeling is incomparably vigorous and skilful."

The following year there was a review of *The Age of Bronze* when it was shown at the Royal Academy, the most prestigious showcase in London. Rodin's contribution was "incomparably the best thing of all" in the sculpture gallery that year: "The thing is like a Donatello, its style is charged with originality and distinction, it reveals a great master in every line."

When Rodin came to London to visit these exhibitions he stayed with Natorp at 70 Ennismore Gardens, Knightsbridge. But despite the support of his English friends and pupils, many of the local critics were not at all sure what to make of this disturbing Frenchman whose work, as a member of the Royal Academy wrote to the *Times*, "is too realistic and coarse even for the strong stomachs of the French public." The *Portfolio*, as opposed to the *Magazine of Art*, described the *Saint Jean* as "a powerful but disagreeable study without prophetic dignity. The figure looks like a corpse that has lain in the Morgue and been galvanised into life and action." To Edmund Gosse of the *Fortnightly Review* (June 1, 1882), Rodin's very manner of handling the clay seemed fraught with perils for the future of sculpture:

> . . . the danger of M. Rodin's manner is, it seems to us, to attempt to do with the modelling-tool all that the painter does with his brush. The limitation of sculpture is one of its principal charms, and we should like to see this picturesque manner, these broken lines and exaggerated forms, tempered by sobriety, although of the talent of the sculptor there is no doubt.

Henley's publishers, Cassell & Co., also grew alarmed and asked him to adopt a less aberrant editorial policy: the fact that he had greatly improved the magazine does not seem to have counted for much. Will Low reports that Henley's "gallant campaign" on Rodin's behalf brought him many "indignant protests from his scandalized readers, in whose views the publisher and the counting-house coincided." The upshot was that Henley's position became untenable and he was forced to resign the editorship in the summer of 1886.

In August he was in Paris to pose for his long-awaited bust: he and his wife stayed at the Hôtel Jacob in the rue Jacob, in the heart

of Saint-Germain. Robert Louis Stevenson, having finished *Kidnapped* in July, followed them to Paris on August 12, to stay one night at the same hotel before spending a fortnight with his old friend Will Low and his wife, who had rented Bergerat's house in the rue Vernier. It was the American painter's first chance to meet Henley, who struck him as "a great overgrown school-boy on a holiday jaunt. He played the host within the limits of a *chambre meublée* with the genial largeness which became him so well, for he was ever a most hospitable soul." Rodin was already at work on the Henley bust, and both Low and Stevenson were permitted to be present at some of the sittings.

Low thought the emerging Henley bust a "noble presentation" of the poet, though "perhaps a trifle Gallic in the pose of the head, and thus misses somewhat the essential British character of the model." The sculptor often paused in his work to talk to his sitter and his visitors, but compared with the articulate Henley and Stevenson, Rodin's conversation gave Low "an impression that I had frequently experienced in talks with the peasants."

For two weeks the painter watched Rodin "under circumstances of the frankest and freest intercourse," but although he admired the man he was annoyed by his "circle of worshipping admirers." Low was indeed the first to remark on "this atmosphere of perpetual incense that enveloped the sculptor"—an unfortunate side-effect of his growing fame. But for Rodin the flattery with which he was now surrounded made a pleasant change from the ridicule and indifference of earlier years, and Low realized that it had failed to turn his head. At Henley's invitation they had a "dilatory" lunch together, "Rodin, Stevenson, Henley and me," at the ancient and celebrated Restaurant Lapérouse on the quai des Grands-Augustins, just across the river from the Palais de Justice where Rodin's father had once been a prison warder: "Under the influence of our joint loquacity, tempered by earnestness and a sense of appreciation of the worth of our guest, much of his cautious reserve vanished. He spoke of his early struggles, of his journeyman-decorator's work in Belgium, of his employment as an assistant for Carrier-Belleuse."

When his story was told Rodin rose and apologized for having to leave, explaining that he had an appointment with a sitter at two

o'clock. "One of us took out his watch and silently pointed to the hour of five which its dial marked, at which the sculptor threw up his hands in comic dismay. Calling for pen and paper he wrote a brief note to placate the disappointed sitter, and then, before separating our various ways, we walked down the quai and stood for a time on the Bridge of Arts. . . ."

9

RODIN IN LOVE

*Triste surprise pour une artiste; au lieu d'une récompense, voilà ce qui m'est arrivé!**

—CAMILLE CLAUDEL

C amille Claudel came into Rodin's life in the early Eighties; they seem to have met for the first time in 1882, when she was not yet eighteen but determined to "establish herself in Paris and earn her living as a sculptress," as a friend reported. Her brother, the poet Paul Claudel, described her in one of his essays as a headstrong and strikingly beautiful girl: "A superb forehead and magnificent eyes of a deep blue rarely encountered except in novels . . . her large mouth was more proud than sensual; her hair was of that true chestnut shade which the English call auburn, and fell to her waist. She had an air of courage, frankness, superiority, gaiety."

She was then a pupil of Rodin's young friend Alfred Boucher, who had first noticed her work a few years earlier when the Claudel family moved to Nogent-sur-Seine, a small town near Troyes, about sixty-five miles from Paris. Boucher came from a village near Nogent, which was also the birthplace of his teacher Paul Dubois, the dis-

*"A sad surprise for an artist; instead of being rewarded, this is what I got!" (Letter from the mental asylum at Montdevergues, near Avignon.)

tinguished sculptor who became director of the Ecole des Beaux-Arts in 1878.

Camille had been born farther north, at Fère-en-Tardenois, near Soissons, on December 8, 1864. Her father, Louis-Prosper Claudel, was a registrar of mortgages and came from the Vosges; her mother, née Louise Athénaïse Cerveaux, was the daughter of a doctor from Picardie. Even as a child Camille was obsessed by everything that had to do with sculpture. According to her friend Mathias Morhardt (who wrote an article on Camille for the *Mercure de France* in 1898) the whole household came to revolve around her improvised atelier. Paul Claudel, born in 1868, recalled that she had exercised "an often cruel influence" on his childhood, for everyone was expected to do her bidding—her brother and sister, the housemaids, her schoolmates. She learned how to carve marble and then taught one of the maids, Eugénie, how to rough out marble blocks like any *metteur au point*. Before long she had produced heads of Napoléon and Bismarck, a *David et Goliath* and a score of groups and figurines inspired by literary sources such as the poems of Ossian.

Alfred Boucher took an active interest in her work from the time she was thirteen. Though still in his twenties he had been exhibiting at the Salon since 1874, and was to spend his whole life encouraging other artists to develop their talent—Chagall, Soutine, Modigliani, Lipchitz, Archipenko and Zadkine were afterwards among his protégés. But after three years at Nogent the Claudels moved to Wassy-sur-Blaise, a steel-making village in the Haute Marne. Camille went on doing sculpture and "tyrannizing" Paul's education until the day she made up her mind to go to Paris.

Paul later had good cause to remember the "terrible misfortune" of a *vocation artistique* that could make parents tremble in fear for their daughter's future, especially if she decided to be a sculptress, for of all the arts sculpture was the most ungrateful of métiers and promised the least material rewards—to say nothing of its moral pitfalls. The Claudels, moreover, had no money to spare for their daughter's education in Paris. No matter: Camille eventually organized a "colony of students" who shared the rent as well as the tutors' and models' fees. For a time she resumed her studies with Boucher, but after winning a Prix de Salon with his *Amour filial* he went off to Florence for six months. Before leaving, as Paul Leroi reported,

"he asked his teacher Paul Dubois to continue giving her the counsels and advice that had already produced such estimable results."

Dubois took one look and thought he detected a suspicious resemblance: "You've taken lessons with Monsieur Rodin?" No, Camille had not even heard of him; at the time Rodin was still known only to the initiated. But now, at Boucher's behest, Rodin was called in as his temporary replacement, to teach Camille and her lodgers, who were mainly English girls aspiring to be sculptors. Camille, "naturally, was the guiding spirit of the group," as Mathias Morhardt writes. "She chose the models, she indicated the pose, she assigned the tasks, she decided the seating arrangements."

Her mother and the two younger children followed Camille to Paris, while her father commuted to the city from posts in Rambouillet and Compiègne: they moved into an apartment at 117, rue Notre-Dame-des-Champs in Montparnasse that was little more than an annex to Camille's studio. For a time she also took classes at the Atelier Colarossi, a nearby studio run by an Italian sculptor, while her brother attended the Lycée Louis-le-Grand, where his classmates included Romain Rolland, Marcel Schwob and Léon Daudet.

Rodin, then forty-two, came regularly to the rue Notre-Dame-des-Champs to teach Camille and her "colony." Years later Paul remembered seeing "Rodin, with a few blows of his modeling tool, remake his pupils' maquettes from top to bottom." The young Auguste Beuret was invited to take part in these sessions, but Rodin must have had eyes only for Camille's work: it was inevitable that he should fall in love with "this superb young woman, in the full bloom of her beauty and talent," as Paul described her. Curiously, his memoirs fail to mention the physical defect that the critic Robert Godet regarded as one of the shaping forces of her personality—"a slight limp caused by a dislocation of the hip; a small imperfection that made her all the more determined to achieve perfection in her art."

Morhardt, who knew her more intimately than any of the other reliable witnesses, writes that Camille became Rodin's *élève* and disciple "without a moment's hesitation" or regret for the hard-won originality of her early work. She realized intuitively what the public and critics were just beginning to recognize—that here was the great virtuoso sculptor of the epoch. "She knocked on Rodin's studio door because she is an artist, and because he is the only sculptor who

genuinely cares about art." By putting herself in his hands she "submitted to a will that was not her own, but parallel to her own. It was not an abdication but the very opposite, a step in the right direction on the road to art."

Having seen what she could do in her own studio, Rodin took her into his atelier at the Dépôt des Marbres, where she impressed visitors as his most silent and industrious apprentice. He put her to work modeling the hands and feet of many of his sculptures—a remarkable proof of his confidence in her abilities, since hands and feet were the very quintessence of his art; he had done thousands of them. Unlike his other assistants, Morhardt reports, Camille had no time for idle chatter. "Wholly absorbed in her work, she kneaded the clay and modeled a foot or hand for the figurine in front of her. Occasionally she would raise her head to look at a visitor with the quizzical, persistent gaze of her big blue eyes, and then turn back to her work."

The relationship between Camille and Rodin ripened by slow stages into a full-fledged love affair. She began as his pupil, then became his assistant, modeleur, mistress and confidante; his "<u>sagacious and clairvoyant collaborator</u>," and finally, it is said, the mother of two of his children. Although Rodin was twenty-four years older, Morhardt saw them as brother and sister rather than master and pupil. Indeed, as so often happens when an older man falls in love with a young woman, the tables were turned and it was Rodin who reverted to playing the younger brother to Camille's "older sister." Psychologically, both of them were thus cast in the role in which they felt most comfortable. Rodin had been a practicing sculptor for nearly thirty years; his facility with clay was the envy and despair of every *statuaire* in Paris. Yet "not only did he give her all he could of his vast experience; he also consulted her in everything," as Morhardt writes. "He would deliberate with her on every decision that had to be taken, and not until she was in agreement would he venture to take a decisive step."

Traces of this childlike dependence appear in the letters that he wrote—not the ones to Camille, which have been either lost, stolen or quietly suppressed,* but the notes and telegrams he sent to Jessie

*René Chéruy, Rodin's confidential secretary during the years 1902–1908, later recalled that a "collection of letters from Rodin to Camille" had been presented to the Musée

Lipscomb, one of the English lodgers, who became Camille's best friend. A gifted sculptress who had won the Queen's Prize and the National Medal for Art before coming to Paris, Jessie Lipscomb shared most of the alarums and excursions of the Rodin-Claudel affair during the mid-Eighties. Rodin regularly used Jessie as his go-between when, as often happened, Camille was in one of her unreceptive moods. Rodin emerges from these letters as anything but the irresistible lover he was later reputed to be: there was something of a schoolboy's clumsiness and uncertainty in his courtship of Camille. And since in this case the master proposes but the pupil disposes, she was clearly far from being his docile and obedient doxy.

In 1885, while Jessie was living with Camille in the rue Notre-Dame-des-Champs, Rodin would send her rather desperate notes and telegrams: "Can you send me news of Mlle Camille?" Or again, "You did not come last night and could not bring our dear stubborn one; we love her so much and it is she, I do believe, who leads us. I thank you for the ardent and discreet affection you bear her."

Later, in the spring of 1886, Jessie took Camille with her to England, where they spent most of their time with the Lipscomb family at Wootton House in Peterborough, Hampshire. Camille was still being stubborn, and Rodin bombarded them with letters from France, then traveled to London at the end of May, complaining of "the overwhelming sadness which I have brought with me from Paris." It was unexpectedly cold in England. "Make sure your little Parisienne doesn't suffer from the cold," he wrote to Jessie, "and continue as always to show her the friendship and kindness that makes you so precious to her." Again there were urgent messages to be transmitted to her friend: "I have written to Mlle Camille. . . . continue

Rodin by Mathias Morhardt. A former curator of the Musée, however, "told me very little about it," and what little Chéruy heard persuaded him that the correspondence would be kept secret: "I don't think X—— will ever publish the letters by discretion." The writer Lucien Descaves, who once had the privilege of reading this "heart-rending intimate correspondence," and who knew Camille—"Rodin's pupil and perhaps his victim"—wrote that these letters had "disclosed her misfortune" to him, but that he "did not have the right to say more." Yet the correspondence has disappeared from the Musée, and as the present curator rightly points out, the handful of Rodin-Camille documents in its archives "contribute nothing new" to Cladel's published narrative. Was the original correspondence destroyed by a guardian of Rodin's reputation—like Ruskin burning the erotic Turners—or has it been misplaced or purloined?

to plead my cause even though it may be hopeless: if she says yes, telegraph me."

Camille had evidently decided to avoid him for a while, and Rodin was not ashamed to admit how unhappy he was without her. "My poor spirit, wholly exhausted, is in need of encouragement," he confessed, for he was living "alone and with my fantasies." In Camille's absence even "the adorable reality of a countryside bathed in sunlight, my *belle France*, now says nothing to me." He wrote to Jessie's parents thanking them profusely for "the kindness and friendship you have shown Mlle Camille, who is so unassuming yet so abundantly gifted."

Yet none of these hints and promptings seemed to produce the desired result. "Ask your friend not to be so lazy about writing," he had to remind Jessie. He hoped they would not laugh at his predicament and his "piteous letter," or if they did, that it would not cost him their affection and esteem. He wanted to be helpful, and had obtained an assignment for Camille from Léon Gauchez of *l'Art*, who wanted to publish a drawing of the bust she had just finished for the Baroness Nathaniel de Rothschild—a portrait of Paul Claudel at eighteen draped in a Roman toga. (It was to prove prophetic: Paul became a noted diplomat as well as a poet and dramatist, serving as French ambassador to Japan, the United States and Belgium.)

Rodin had persuaded Gauchez to let him act as a go-between, and he wanted Camille to have *l'Art*'s fee as soon as possible. Would Jessie make sure she accepted the money? "You have had the goodness to send me your friendly greetings and those of Mlle Camille; perhaps it was only an act of charity but in any case I thank you."

Although the Lipscombs invited Rodin to visit Wootton House that summer, his meeting with Camille was not a success. The sculptor's presence made her moody and irritable. Twice when Jessie began singing Scottish ballads for him, and "just as I discovered you were a musician and took pleasure in listening to you," as he wrote to her afterward, "our sweet darling decided that she had had enough. I was wrong [to allow her to interrupt us] but you know what power she has over everyone who comes near her, and also over you."

Something about this episode nettled him, since he referred to it again in another letter: "You were compassionate and understanding on those two unforgettable evenings when, among other things, you

sang the Scottish romance for me. By now the notes of that melody
have faded from my memory and I no longer hum them. Our dear
Camille did not want to stay to listen. . . ."

He had to return to France in August but hoped to meet both
women in Calais on their way back to Paris at the end of the summer,
when he proposed taking them on a tour of Belgium and northern
France. "I know all this depends on your arrangements, and on the
caprice of Mlle Camille," he conceded. But Jessie would surely
understand how useful he could be as their guide. "It would make
me happy, and furthermore as your teacher I can be useful to you
and to our dear and great *artiste.*" At last, shortly before leaving
England—she had also been to see the Isle of Wight—Camille re-
warded his patience with a letter whose jaunty style reflected the
sisterly tenor of their whole relationship:

Dear friend,
 I'm very sorry to learn that you are still unwell. I'm sure that
you have once again eaten too much food at one of your accursed
dinners with that accursed circle of people I detest, who steal
your time and health and give you nothing in return. But I
won't say anything, since I know that I'm powerless to preserve
you from the evil I see.
 How can you work on the maquette of your figure without a
model? Tell me; I'm very worried about it. You reproach me
for not writing sufficiently long letters, but you send me only
a few banal and indifferent lines that don't amuse me. You're
right in thinking that I'm not very vivacious here; I feel that
I'm far away from you! And that I'm a total stranger to you!
Here there is always something that annoys me.
 I'll tell you about everything I've done when I see you. Next
Thursday I'm going to stay with Miss Fawcett; I'll write you the
day of my departure from England. From now until then please
work, and save all the fun for me. A fond embrace,
 Camille

Another of her surviving letters to Rodin, also undated, concerns
a statement she had been asked to write for Gauchez, whose influence
Rodin was anxious to enlist on her behalf: "Monsieur Rodin, I have

begun a note for Monsieur Gauchez in which I've become hopelessly entangled. As you can see it's certainly very stupid. Would you correct it for me please? Make me a beautiful *tartine** about movement and the search for nature in art, etc. Return the corrected statement as soon as possible; otherwise you know that M. Gauchez will scold me again."

Whatever had caused the tension between Rodin and Camille in 1886 had still not been resolved in March 1887, when Jessie Lipscomb and Miss Fawcett returned to Paris after a prolonged absence. "You know that we have come from England especially for your tutoring," Jessie wrote to Rodin, "and you promised to give us your counsel. We won't stay with Mlle Camille if that upsets you, and the differences between you are none of our business. I hope, therefore, that you will give us lessons just as before, and we will do exactly as you ask. Tell us frankly what you intend to do with us—so we'll know whether to stay here or return to England." Rodin readily agreed to resume his lessons, since he still hoped to use Jessie as his errand lady: "If it would please Mlle Claudel and also Mlle Fawcett, come for the day on Saturday. Please, as soon as possible, *tell me her news, and also yours, by return mail.*"

Jessie eventually returned to England to marry a clergyman, William Elborne, but she remained in touch with both Rodin and the Claudels. Her recollections, fortunately, were not subject to being hushed up by the guardians of great reputations, and it is her testimony which establishes the long-suppressed fact that "Camille gave birth to two illegitimate children of which Rodin was the father." Apparently Rodin paid their boarding school fees, but he did not want to acknowledge these two sons any more than he had legally recognized Auguste Beuret. Like Jean-Jacques Rousseau, the *philosophe* who sent his five natural children, one by one, to a foundling home, Rodin thought that paternity was for other people. He and Camille both had more important things to do than rear children. Long afterward Judith Cladel questioned him on this point, and the record of her conversation in her notebooks is not quite as respectful

*"Overblown phrases larded with emphatic words, ingeniously called *tartines* in the argot of journalism."—Balzac, quoted in Lorédan Larchey's *Dictionnaire de l'Argot Parisien*.

as the version she chose to publish. Cladel: "But everyone says you had four children by your mistress [*amie*]." Rodin (evasively): "These are just stories. In that case my duty would have been clear."

But in the 1880s Rodin's course was far from clear; rather than commit himself either to his new mistress or the old he left both of them dissatisfied but himself free to come and go as he pleased. In 1885, when Camille made an auspicious debut at the Salon with two Rodinesque pieces—portraits of her brother and of her old nurse-maid, Hélène—she appeared in the catalogue simply as "pupil of M. Rodin," and gave 117, rue Notre-Dame-des-Champs as her home address. In the 1888 catalogue, however, she listed herself as "pupil of MM. Rodin, Bouché [*sic*] and P. Dubois"—and her address had changed to 113, boulevard d'Italie (now the boulevard Auguste Blanqui). She had, in fact, been obliged to move out of the Claudel home: the strain between mother and daughter had become intolerable, though Louis-Prosper was inclined to take a more lenient view than his relentlessly moral wife. "How terribly he suffered—yes, he too!— when he learned the truth about your relations with R——," Louise Claudel wrote to her wayward daughter. "And the disgraceful comedy you performed for us! Here I was, naive enough to invite the 'Great Man' to Villeneuve [Villeneuve-sur-Fère was her family home] with Madame R——, his concubine! And you; you played the sweet little thing, and were living with him as a kept woman!"

Camille's new atelier was located on what were then the southern fringes of the city. After 1889, however, she spent much of her time with Rodin just down the street, at No. 68, boulevard d'Italie, in a decaying colonnaded mansion known as the Folie Neufbourg,* which became Rodin's favorite studio and trysting place. One wing had been demolished to make room for a new street; there were cracks in the boundary wall and the garden was overgrown with crabgrass. "The house was in ruins," remembered the critic Arsène Alexandre, one of the intimates to whom Rodin accorded the privilege of admission to this sanctuary. "It had once been an opulent residence and now,

*It was also known as La Folie Le Prestre, having been built in 1763 by the *conseiller du roi* Michel-Edmond Le Prestre de Neufbourg, former receiver of finances at Caen. It overlooked the Bièvre upstream from the Gobelins. Before it was demolished in 1909 Rodin had pieces of its ornamental masonry removed or copied by his plaster casters.

in its decadence, still had a wonderfully aristocratic air. In its vast empty rooms we spoke with a certain trepidation as though afraid of disturbing its resident ghosts." Here Rodin gradually accumulated "the hundreds of sketches—experiments with line—that sprang from his impatient hands," as well as "unpublished works, fragments that had been re-worked and recomposed; a stream of ideas which the sculptor was constantly modifying, transforming, destroying." Upstairs and downstairs, all the rooms and even the closets were eventually crammed with figures, groups and bas-reliefs.

Camille worked at his side both in the boulevard d'Italie and at the Dépôt des Marbres. Rodin had decided that she was on her way to becoming a great sculptress, and having made up his mind on this point, he did not keep his discovery a secret. Soon all of his influential friends were asked to help him launch her career. "I'd like you to be so kind as to invite my pupil Mlle Camille Claudel who has talent," runs a typical letter—to Octave Maus of Les XX in Brussels. "If your rules permit you to do so, that would give me great pleasure." It was a new experience for him to consort with a fellow artist: before Camille his affairs had all been with models or grisettes. Camille, by contrast, brought him a pleasure he had not known since the days when Maria was still alive—"the happiness of always being understood," as Morhardt writes, "of always being exceeded in his expectations. As he himself said, it was one of the great joys of his life."

Camille worked under Rodin's aegis for more than a decade and dominated his life "for four, perhaps five" of these years; in terms of his sculpture, from the final stages of the *Burghers of Calais* to the initial phases of the Balzac monument. During the time she worked as his assistant he exploited her gifts very much as Carrier-Belleuse had once used Rodin's talents. She modeled innumerable details for him, enlarged his maquettes and carried out his designs, his instructions. He also used her as his model and did several versions of her portrait. One of them, of Camille in a Breton cap, buries her chin in the clay base—while the better-known marble version, entitled *la Pensée*, shows even less of her chin than the original terra cotta now in the Leipzig Museum. It was Rodin's way of showing how much he loved her, for he would rarely condescend to flatter his sitters, and Camille's weak point was her receding chin. Another of Rodin's sculptures shows Camille as a rather forlorn waif, this time without

a hat and with her chin tucked in: it was to serve as the basis of several later sculptures, notably *la France* and *Saint George.*

Not to be outdone, Camille produced a bust of Rodin that was arduously modeled in 1888–89 and attracted a good deal of attention at the Salon of 1892: Rodin declared it to be "the finest sculptured head since Donatello." (An edition of fifteen copies was sponsored by the *Mercure de France*, but afterwards pirated copies were for sale at cut-rate prices in bric-a-brac shops.)

It was an immensely exciting time for both of them. On Rodin's side the ebb and flow of their affair could almost be charted by the rise and fall in the number of erotic images which he produced each year between 1884 and 1894. Some have titles and numbers in the Musée Rodin catalogue—indeed they cover the entire spectrum of sensualism from *le Baiser* to *la Fatigue*—but countless others were part of the great outpouring of anonymous clay sketches which he was perpetually "modifying, transforming, destroying," and which he referred to merely as "embryos."

These figures—many of them destined for the *Gates of Hell*—represented Rodin's conscious attempt to "realize his ideas about love," as he told Willem Byvanck when the Dutch critic came to the Dépôt des Marbres in 1891. Byvanck was struck by the power and variety of Rodin's sexual imagination:

> To begin with there was a lascivious bacchante, madly seizing the body of an old satyr in a stormy embrace. His face is hard and sad: the overflowing sap of youth seeks to impart its reckless ardor to wisdom, the child of sadness and impotence. Next there was a group consisting of a young hero and a woman, *le Printemps* or *l'Amour*. She throws herself across his path and offers herself to him, if only he will take the trouble to desire her, with all the treasures of her beauty. . . . A third group symbolized the ecstasies of passion; a young man on his knees whose lips touch his beloved's abdomen.

Rodin told Byvanck that he had set out to depict "*l'Amour* in the various phases and poses in which it appears to our imagination. Or rather I want to say *la Passion*, because above all the work must be alive." As he spoke he brought out terra-cotta groups from the four

corners of the room and placed them in front of the critic: "Yes, above all my figures must have life—because as the saying goes, *Un chien vivant vaut mieux qu'un évêque mort* ['A live dog is worth more than a dead bishop']."

Camille, meanwhile, produced her own, rather less agitated version of *l'extase de la passion*. She won an honorable mention at the Salon of 1888 with a sculpture of a man on his knees clasping a seated woman who is about to fall into his arms. Its title, derived from Hindu mythology, is *Çacountala*—the name of the hermit maiden who secretly bears the king a child in the forest. Needless to add, none of the critics understood the allusion, and the group has become better known as *l'Abandon* (Surrender). Paul Claudel thought that *l'Abandon* was as exalted and idealistic as Rodin's *The Kiss* was sordid and commonplace; in *The Kiss*

the man is so to speak *attablé* [sitting down to dine] at the woman. He is sitting down in order to make the most of his opportunity. He uses both his hands, and she does her best, as the Americans say, to *deliver the goods* [original in English]. In my sister's group, spirit is of the essence: the man on his knees; he is pure desire, his face lifted, yearning, clasping that which he does not dare to seize, this marvelous being, this sacred flesh which, at some higher level, has been bestowed on him. She yields, blind, mute, weighted down, succumbing to the gravity that is love; one of her arms hangs down like a branch broken by its fruit, the other covers her breasts and protects this heart, the supreme sanctuary of virginity. It is impossible to imagine anything more ardent and at the same time more chaste.

But Paul's magnificent and fatuous prose says more about his own idealized notion of Camille than about the real nature of her art. He wanted to see his sister chaste and *spirituelle*: it was the view of a man who, by his own admission, was not introduced to the fullness of conjugal bliss until he was thirty-two, "after ten years of Christian life and absolute chastity." Camille, however, was quite unabashed about her own sensuality and not unwilling to express it either personally or in clay. Apart from its relevance to her own condition as

a "falling" woman and secret mother, *Çacountala* was only a more restrained treatment of a favorite Rodin theme, the choreography of desire at the moment of surrender.

Stylistically she was gradually moving away from the fussy, rather wrinkled realism of her early work to a looser, more imaginative kind of storytelling sculpture. With virtuoso figures like the marble *Clotho*, spinner of the threads of fate, she liked to give bravura displays of her unmatched skill as a stone carver, for unlike Rodin and virtually every other sculptor in Paris she enjoyed carving even more than modeling. "Excuse the dust on my smock," she would say to visitors to her studio, brandishing her file. "It's I myself who carve the marble: I cannot bear entrusting a work to the 'zeal' of a praticien."

The culmination of her years with Rodin, however, was a spectacular piece of clay modeling in the emerging art nouveau manner, *la Valse*—a man and a woman locked in an ecstatic waltz: "the couple seem to want to lie down and finish the dance by making love," as the irreverent Jules Renard noted in his diary the first time he saw it. She gave a copy of *la Valse* to the young Claude Debussy, the most elusive and audacious composer of her generation, who had conceived a great liking and perhaps a passion for her. She encouraged his interest in Japanese art and he, in turn, taught her to like music, or at any rate his music, for people continued to say that she was basically tone-deaf.

Debussy would play for her in his cold apartment, as Godet recalled, and when "the pianist left his piano with freezing fingers she would tell him, as she led him toward the fireplace, 'You have left me speechless, Monsieur Debussy.'" He placed *la Valse* on his mantelpiece and cherished it for the rest of his life (though it disappeared mysteriously after his death in 1918). It seems quite plausible that, as has been suggested, Camille was the unnamed woman of whom Debussy wrote to Godet in February 1891:

Indeed I am still much distressed by the sad and unexpected end of the episode I told you about; a banal ending with recriminations and words that should never have been spoken. I noticed a bizarre transposition as these harsh words fell from her lips; at that very moment I heard within me the most touching and adorable words she had once said to me. And these

(alas only too real) dissonances clashed with the ringing memory of her voice still living within me.

During these years Camille's relationship to Rodin was broken off at least once and then resumed. In their halcyon days they often went secretly to the Loire valley, a landscape that held particular fascination on account of its châteaux. In 1887 they paid their first visit to the countryside around Tours, "the garden of France," to which they returned repeatedly in succeeding years. They found a summer retreat at the Château de l'Islette in the town of Azay-le-Rideau, a castle whose owner rented them several rooms in which Rodin, as Lawton learned, "carried on his modeling in surroundings that renewed his health and refreshed his ideas." One of Camille's surviving letters to Rodin was written at l'Islette while he was busy in Paris: it bears no date but the balance of power has already shifted, for now it was her turn to be concerned about his movements:

Since I have nothing else to do I'm writing to you again. You cannot imagine how lovely it is at l'Islette. Today I ate in the middle room, the one used as a conservatory, from which you can see the garden on both sides. Mme Courcelle suggested (without my having said anything) that if you liked you could eat here from time to time, or indeed all the time (I think she'd like that very much). And it's so pretty there!

I've gone for a walk in the grounds; everything has been harvested, the hay, the wheat, the oats; you can walk everywhere, it's delightful. If you'll be kind and keep your promise we'll be in paradise. The old woman will be at your feet, I think. She told me that I should bathe in the river, where her daughter and the maid bathe without the least danger. With your permission I'll go ahead and do this since I'll enjoy it and it will spare me the trouble of going to the heated baths at Azay. Would you be good enough to buy me a little bathing costume—deep blue with white piping, in two pieces, blouse and pantaloons (medium size) in serge, from the [Grands Magasins du] Louvre or Bon Marché [department stores], or in Tours?

I go to bed naked to make myself believe you're here, com-

pletely naked, but when I wake up it's no longer the same.
Kisses,

Camille
Above all, don't deceive me again with other women!

As so often in letters between lovers, the postscript contains the essential message, but that, precisely, was asking too much of Rodin. At this stage of his life he was quite incapable of focusing all his attention on any one woman. In his late forties and early fifties he was more inclined than ever to make up for time lost during the lean years when he had been too poor, and too closely watched, to enjoy other women. Rose, with time, had become more or less resigned to his sudden and unexplained absences from home; in any case she had little choice but to tolerate his vagaries. Camille, who was far more exigent, "reproached him with his infidelities with all his models," as the writer Gabrielle Réval noted. Still, Rodin was not to be coaxed or bullied back into monogamy. The Paris art world had long prided itself on its sexual permissiveness, and Rodin had only to swim with the tide.

Now that he had the money to hire models (at fees ranging from two and one-half to four francs an hour) a whole new world of sexual exploration was open to him. There was an accepted code of conduct for artists and models: "One draws them by day and cuddles them by night—though the term cuddle is perhaps too mild," as Zola remarked. A sculptor of the 1880s could not possibly produce his *Nymph* or *Joan of Arc* without a model. Fortunately there was never any difficulty in finding one, since the weekly model market, the Marché des Modèles, was held regularly on Monday mornings, first around the fountain at the place Pigalle, then at the corner of the rue de la Grande Chaumière and the boulevard Montparnasse, near the Atelier Colarossi. Any artist looking for a suitable face or figure would be certain to find one here among the young girls, many of them dressed in Italian peasant costume, who constituted the most striking part of the crowd of models offering themselves for hire.*

*Statistics for 1880 reveal that a total of 671 models, both male and female, were employed professionally by the painters, sculptors and photographers of Paris during the year. Of these, 230, or more than a third, were Italian (many of them, like Adèle

The yearly influx of new faces kept the artists on their toes. "Certainly models play a very considerable part in the lives of the artists," Emile Bergerat writes in his memoirs. "These lovely creatures with their elite forms cannot pass through the ateliers with impunity, for beauty cannot 'pose' without being exposed to the love which it inspires. Hence the great passions that have sprung up between artists and models." It was hardly surprising that the members of this sexually mobile stratum of society took a more casual view of morality than the French middle classes.

Rodin, at any rate, made the most of this stream of complaisant young women, few of whom expected to pass through his atelier "with impunity." Though his passion for the "glorious sight" of their nude bodies was constantly vented in drawings and sculptures, he also tried to give it verbal expression: in one of his *aperçus* he speaks ecstatically of how the female body arouses him with "its tender planes, its inflammatory lines and that extraordinary fragment, the breast, which is a masterpiece in itself." Rodin's friends began to notice that there were times when he could not get enough of gazing at any young woman who attracted him, and even those who were accustomed to the casual lovemaking of artists and models were shocked by the obsessive urgency of his behavior. "He is capable of anything," Octave Mirbeau told Edmond de Goncourt in July 1889, "even of committing a crime for a woman; he himself is the fearsome satyr he depicts in his erotic sculpture." Mirbeau, whose sadist fantasy, *Le Jardin des Supplices* (The Torture Garden), was to be sumptuously illustrated by Rodin, was not a bourgeois moralist indulging in spiteful gossip: he belonged, in fact, among Rodin's most unshockable admirers. But the sculptor had just been his houseguest for a month—and that, as Goncourt learned, had turned out to be a sobering experience. "Mirbeau told me that when they went to dinner at the home of Monet, who has four grown and beautiful daughters,

and Anna Abruzzesi, from the poorer regions of Italy); 130 were French, 80 German, 60 Swiss, 49 Belgian, 45 English, 30 American. The great majority were between the ages of sixteen and twenty-one; only 130 were over twenty-one. Many models were also actresses, but more than 70 were seamstresses and dressmakers, and 35 had been flower sellers before taking up modeling. In 1885 an Italian named Socci had the idea of opening a model agency in the boulevard de Clichy where painters and sculptors could make their choice from photographs and plaster casts of the available models.

Rodin spent the whole dinner looking at them, but looking at them in such a way that, one by one, each of the four girls was obliged to get up and leave the table."

Indeed, his new status as one of the successful sculptors of Paris had enabled him, at last, to become what was then called *un érotique*, a serious collector of interesting women. Many younger and better-looking artists began to be uncomfortably aware of him as a potent rival and *priapatriarche* (a term that Paul Claudel coined for him). The poet and novelist Pierre Louÿs, for one, tells a rueful story of an encounter with Rodin in which the youthful bon vivant was quietly outmaneuvered by a man thirty years his senior:

> I met a charming little model in a bar on the boulevard St. Germain. She became my mistress and moved in with me. She never left my side, and accompanied me everywhere. I was just becoming seriously attached to her when, one night, she disappeared. First I was worried, then irritated and chagrined by her unheralded departure. I tried to learn if my friends knew anything, but several days passed without any news of her.

Then Louÿs happened to drop in on Rodin, "a friend of mine whose name was just becoming well known."

> When I entered his studio I let out a scream: here before my very eyes was my little mistress, posing completely nude, hiding her face in her folded arm! On the spot I made a terrible scene. She broke into tears. I decided to take her away with me but he wouldn't let her go. "What you've done is not very fair," I told him. "Why didn't you let her come back to me?" "I knew you'd be jealous and would have kept her with you," he said. "But good Lord, she was mine!" "That's precisely the reason."

Louÿs looked around the studio and saw the figure on which Rodin was working. "Her image, already alive, was rising out of the clay, more beautiful than ever. Before this nascent figure my anger subsided." Rodin asked him not to be angry: "If you were me you'd have done the same thing. This little girl whom I met at your place—she has a magnificent, unique body. She's indispensable to me!" Louÿs

grudgingly conceded defeat and "bid her the most tender farewells." Whereupon Rodin "nearly went mad with joy" and asked him to accept a small sculpture in exchange, a piece "like a delicious Tanagra figure." Then he ran over to kiss the girl: "You'll stay here; Pierre Louÿs has given his consent!"

Despite such adventures, Rodin persisted in treating both Camille and Rose with the most husbandly solicitude and affection. When his wine-making friend Captain Edmond Bigand-Kaire offered to ship him a barrel of what was evidently the new wine of 1890, the sculptor asked him to "send it *chez* Mlle Claudel, 11, avenue de la Bourdonnais, since it would help restore her rather delicate health; I'll draw off a few bottles from it for myself." Camille had moved to a house in the shadow of the newly built Eiffel Tower (and a short walk from the Dépôt des Marbres); it was Rodin who paid the rent. But when the former sea captain offered to send another barrel not long afterward, Rodin bethought himself of Rose and informed his "too-generous friend" Bigand that "Mlle Claudel still has some. Send your everflowing barrel to M. Rodin, 23, rue des Grands-Augustins"—the eighteenth-century house near the Seine to which he had just moved with Rose. Evidently this order of deliveries reflected the relative priority of the two recipients in Rodin's life at the beginning of the 1890s.

Yet it was easier to support two households than to satisfy the conflicting demands of two women, each knowing about the other and each with legitimate claims on his time and attention. For a time he succeeded in living a sort of double life, but Rose, for one, never forgot their terrible scenes and "the dreadful life he had led her with his two *faux ménages*," as Marcelle Tirel testifies. Even as an old woman she still "quivered with rage and jealousy" at the mere recollection of it.

In place of the long, rambling letters of former years he now wrote Rose peremptory notes inquiring after her health and urging her to look after herself. He had befriended a physician, Dr. Paul Vivier, who had come to her aid during a heart attack purportedly brought on by caffeine poisoning and emotional strain: when the doctor arrived she was delirious and "railing against Rodin's mistresses." It was to Dr. Vivier's home in Le Châtelet-en-Brie, a village thirty-five miles southeast of Paris, that Rose was sent for convalescence, while Rodin

made one of his periodic sorties into the Loire valley and quietly dropped out of sight.

It was his work that was keeping him there, he assured her from Saumur on September 10, 1890: "My dear Rose—Don't be impatient. Stay a little longer with the Viviers. I am more and more fascinated by my studies here. I feel as though I had come to life in another century. . . . I am turning into an architect, because there are things to be done about my *Porte*. . . . My love to you and please get all the benefit you can from the country air." And then again: "You mustn't give in to your foolish notions. Take advantage of this fine weather and build up your strength. . . . Don't make me worry so much about you that I can't work properly at my architecture." And from Loches a few days later: "Write to Tours immediately, *poste restante*. I'm very anxious about you. You know, dear Rose, how much I love and admire you. Write to me and put my mind at rest."

He had no intention of breaking Rose's heart, and was not entirely shamming when he wrote, "I'll be so glad when we are together again in our little apartment in the rue des Augustins and can go on Sundays to Notre-Dame and stroll along the quays." Ideally he would have liked to keep both Camille and Rose, for he was genuinely torn between them. Once, in England after he had gone off in hot pursuit of Camille in 1886, he wrote to Rose in all sincerity, "I dreamed of you last night, and if I had written immediately this morning I would have said many tender things to you. You must love me a great deal to put up with all my whims."

Much as Rodin "lived each day's life for itself," as Morhardt says, the strains and deceptions of this triangle began to wear on his nerves. One of Judith Cladel's youthful memories was of Rodin in 1892, when he still lived in the rue des Grands-Augustins. When she passed his house, "I often saw a woman watching me intently from behind the curtains at one of the second-story windows." It was Rose, to whom the Cladels had not been introduced, and whose capacity for jealousy had not diminished with the years:

Sometimes I would meet Rodin himself and listen to a confused apology for something—perhaps for never asking us to visit him. He said he was suffering from neuralgia and could not sleep; he seemed older and there were dark patches on his

clear complexion. His reddened eyelids and the tense expression in his eyes betrayed care and anxiety; he smiled rarely and alluded several times to serious trouble, the annoyance of which he seemed to be trying to get rid of by means of involuntary upward thrusts of his shoulders. He was clearly going through a most distressing experience of some sort.

Camille Claudel had begun to sense that Rose was gaining the upper hand. Morhardt later recalled that "she wanted Rodin to repudiate his poor old Rose, who had been the companion of his early years, and who had shared his poverty. He could not bring himself to do that, though both as a man and an artist he was passionately in love with Camille Claudel. 'She has no sense of fair play,' he told me one day, 'just like all women.' "

For a time the outcome hung in the balance, for Rodin was emotionally dependent on them both and Camille was not one to give up without a fight. Certainly Rodin's "victim" was made of far sterner stuff than her brother's sentimentalist essays would suggest, for it was not only in her sculpture that she displayed what Mirbeau described as "une révolte de la nature." When Gabrielle Réval went to see her she came away with the "bizarre impression" of a personality "that attracts you by its charm and repels you by its savagery."

But Rose, too, had the instincts of a "wild animal"—at least according to Rodin—and there are unconfirmed reports that the two women came to blows when Rose blundered into the Folie Neufbourg and found him together with her rival.* Camille retaliated by taunting Rodin with a series of unladylike caricatures that exposed his dilemma and revealed her own violent hatreds: Rodin on bread and water,

*There are many unsubstantiated rumors about the unhappy relations between these two strong-minded women. Georges Reyer heard that one day, after Rodin told her he was going on a holiday in the country, Camille went out to Meudon and found him there with Rose. A furious argument ensued and later, at the Folie Neufbourg, Rodin walked out when Camille issued an ultimatum: "It's her or me." But Reyer died shortly after publishing an article about Rodin and Camille in *Marie-Claire* (September 1975) and left no documentation. Similarly, Kenneth Clark wrote of "the most pitiful dramas" between Rose and Camille, "in the course of which Camille appeared in the shrubbery at Meudon and Rose shot at her" (*The Romantic Rebellion*, New York, 1973, p. 554), but he, too, died before he could answer my query as to the source of his information.

chained to the wall of his cell, while the witch-like Rose carries her housemaid's broom—title, *le Système cellulaire*; Rodin asleep on the bosom of his wakeful, shriveled mistress, who taps him with her index finger to remind him of his conjugal duties. Most vitriolic of all is her sketch of Rodin nude and pulling on a tree trunk in an effort to free himself, but glued buttock to buttock to a haggish Rose with pendulous breasts, supporting herself on all fours like an animal. Camille's caption, *"le Collage—Ah! ben vrai! [sic] ce que ça tient!"* ("Ah, sure enough, how that sticks!") involves an ironic play on words, for *collage* meant not only a gluing together of things but, in Parisian argot, "a liaison that is difficult to break off."

Her own liaison with Rodin came to an end by stages, just as it had begun. In June 1893, she wrote him a letter reflecting their growing estrangement and also, perhaps, the beginnings of a persecution complex:

> I was out when you came because my father arrived yesterday. I went to dinner at my parents' house. My health has not really improved because I cannot stay in bed, having to get up constantly. Undoubtedly I won't leave until Thursday. Just now Mlle Vaissier [Alix Vaissier was a friend and art collector] came to see me, and she told me all sorts of stories that are circulated about me at l'Islette. It seems that I leave my tower window at night suspended from a red umbrella with which I set fire to the forest!

At least she was again on speaking terms with her parents, and her brother was beginning to make a career for himself both in literature and in the Foreign Ministry. Paul Claudel had been admitted to the Foreign Service examination thanks to a letter of recommendation from Rodin, who had known the foreign minister, Eugène Spuller, since the days of Mme Liouville's soirées:

January 6, 1890

My dear Minister,
 Permit me to solicit your support on behalf of a young man of good republican family (he is very intelligent) who is studying

law after having completed his studies at the Lycée Louis-le-Grand.

He would like to sit for the consular and diplomatic service examinations on January 15, and for this his name needs to be entered on the list of candidates. . . . The young man is Paul Claudel, 31 boulevard de Port-Royal, Paris.

Yet after his appointment the new junior officer in the Foreign Service was not inclined to be grateful, either to his sister or her lover. On the contrary, he left his friends in no doubt that he regarded her attentions as something of an embarrassment. In January 1893, Renard noted in his journal that Paul Claudel had "an insufferable sister who constantly wrote to him, 'I'm proud of you. People say I resemble you.' "

Edmond de Goncourt, on the other hand, was clearly charmed by Camille when he met her for the first time on March 7, 1894: "This evening, at the Daudets', the little Claudel, student of Rodin, in a *canezou* scarf embroidered with large Japanese flowers, with her child-like head, her beautiful eyes, her original sayings, her heavy country-like way of speaking." In May this indefatigable recorder of gossip heard more about her intimate history:

[Roger] Marx spoke to me this morning about the sculptress Claudel, of her *collage* with Rodin, an affair during which he saw them working together as amorously as the painter Prud'hon and Mlle Mayer must once have worked together. Then one day, no one knows why, she escaped from this affair for a time; later she resumed it, but then broke it off completely. When that happened, Marx saw Rodin in his studio completely upset and in tears, saying he no longer had any authority over her.

That summer, indeed, she went to Guernsey with Georges Hugo, Victor Hugo's grandson and one of her brother's former classmates. He was four years younger than Camille, "plump, florid and altogether gentle and caressing," as Goncourt describes him—a kind of antidote to Rodin. He gave her ideas for sculptures and she did a study of him, entitled *le Peintre*, while he was busy painting seascapes.

Rodin was still trying to be helpful. At the Champ-de-Mars Salon of 1894 she exhibited her bust of *la Petite châtelaine*—the daughter of the owner of l'Islette—which is said to have required sixty-two sittings. Though in fact it was one of her weaker works, Rodin did his best to impress public opinion with its importance. "This bust hit me like a blow of the fist," he announced to the press. "It has made her my rival."

Yet for some time Camille had been anxious to escape his too-overwhelming influence on her career, and that, in the end, may have been her principal reason for leaving him. Morhardt writes that she was "impatient to devote herself exclusively to her own work." She rented a new studio at the rear of a large courtyard at 113, boulevard d'Italie and set to work on "the marvelous ideas that demanded realization."

Paul Claudel spent most of 1893 and 1894 as a consular official in New York and Boston: in the latter year he received a long letter from Camille filled with news of her life and descriptions of the projects on which she was working:

My dear Paul—

Your latest letter made me laugh a lot; thank you for your flowery present from America, but I have already received a whole library of them; pieces with snow effects, flying birds, etc. English stupidity knows no bounds—even savages wouldn't produce such amulets. Thank you for offering to lend me money: this time I shan't refuse because I've spent the 600 francs from Maman and my rent is due, so if it's not inconvenient please send me 150 or 200 francs.

I've had some disasters lately; a mouleur who wanted to revenge himself on me destroyed several finished pieces in my studio. . . .

She sent him thumbnail sketches of some of the "many new ideas that will please you immensely," including one of "three people listening to a fourth in front of a folding screen" (which was to be known as *les Causeuses*, The Gossips), and another of three farmers in their Sunday best perched on a high wagon on their way to church (*le Dimanche*). "You see it's not at all Rodin, and the figures are

dressed," she explained. "I'm going to make small terra cottas. Hurry up and come back to see all this!"

She was on her way to creating a new genre of narrative sculpture that anticipated the pop art of a later age. "It's only to you that I'm confiding these discoveries. Don't show them to anyone! I take great, great pleasure in my work."

When Paul returned to France for a few months early in 1895, Jules Renard was invited to dine chez Claudel. His diary records that it was a bizarre evening marked by Paul's ill-disguised exasperation with Camille:

> His sister told me, "You make me nervous, Monsieur Renard. You'll ridicule me in one of your books." Her powdered face was animated only by her mouth and eyes. Sometimes she seemed dead. She hates music, and says it at the top of her voice—while her brother rages silently, his nose in his plate; I felt him clenching his fists in anger, and his legs trembling under the table. . . . I didn't hear a word her mother said. And yet she responded to whatever we said, made little remarks to herself or emitted a sigh.

Camille was hardly to be blamed for cutting herself off from this unprepossessing family and retreating into the solitude of her studio where, "when she was not working, she would spend her time looking at the people who passed by her window," as Morhardt reports. "She lived there one, two, three years without receiving anyone, without hearing a single friendly voice. She experienced such solitude that sometimes she would get the terrible feeling that she was losing the habit of speech, and would talk to herself aloud . . . or go down to the concierge, forcing herself to take a momentary interest in neighborhood gossip."

She spent long hours in museums—the Louvre, the Musée Guimet—and went on rambling, aimless walks through the city. "It was the streets and parks that inspired her. . . . A passerby, a group of people she had seen, a swarm of busy workmen, gave her a thousand ideas. As soon as she came home she would go to work with her modeling clay, recording an impression, a gesture. . . ."

There was an autobiographical marble figure of a woman alone,

her back to the viewer, kneeling by a chimney and staring into the fire. Her parting shot in the Rodin affair was entitled *l'Age mûr*—an old man with Rodin's big feet and "butcher's" hands allows himself to be led away by a desiccated old woman, the spirit of old age, while a young, beautiful nude tries vainly to hold him back. Paul Claudel called it "a petrified moment . . . a petrified situation" in his 1951 memoir, *Ma Soeur Camille*. "This young nude girl is my sister! My sister Camille, imploring, humiliated, on her knees; this superb, this proud young woman has depicted herself in this fashion. Imploring, humiliated, naked and on her knees!" He blamed her subsequent mental illness on her disappointed passion for Rodin: "At thirty, when she realized that Rodin did not want to marry her, everything collapsed around her and her mind was unable to bear the strain," he noted in his diaries in 1943. But the documentary record, incomplete as it is, suggests a rather different sequence of events, and under the circumstances *Ma Soeur Camille* almost sounds as though it were written to forestall any possible criticism of—Paul Claudel.

Camille lived for twenty years without Rodin before her family succeeded in having her committed to an insane asylum as a ward of the state for the rest of her life, a matter of thirty more years. Rodin, for his part, continued to provide limited amounts of financial and moral support, though usually through intermediaries. He secretly petitioned the government on her behalf, with the result that the ministry of Beaux-Arts nearly committed the gaffe of ordering a bronze cast of *l'Age mûr* in 1898. But her dossier at the ministry closes with the laconic annotation: "New instructions: cancel the commission."

He went on writing letters to critics and journalists trying to drum up favorable notices for Camille's work. In one of them, undated but evidently written in 1895, he thanks Octave Mirbeau for an article containing kind words for "Mademoiselle Claudel, who has the finest talent of the Salon of the Champ-de-Mars, yet is virtually unappreciated."* He wondered, too, whether Mirbeau might succeed in bringing him together with the sculptress:

*Mirbeau had published an imaginary dialogue of two visitors to the Salon (*le Journal*, May 12, 1895) which described Camille as "a great and marvelous artist . . . something unique . . . a woman of genius. . . . *les Causeuses* are a delightful group . . . its composition deliciously imagined, its interpretation of nature truly miraculous, its crafts-

I do not know whether she would agree to come to your house the same day as I: it is now two years that we have not seen one another, and that I have not written her; I am not in a position, therefore, to let her know; all depends on you. She will have to decide if I should be there. Things are going a little better for me at the moment whenever I'm happy, but indeed life is cruel.

Camille, however, usually rejected any assistance if she knew that it came from Rodin. Before the opening of the 1896 Salon at the Champ-de-Mars she sent him a characteristically double-edged telegram: "Monsieur Rodin, thank you for your kind offer to present me to the President of the Republic. Unfortunately I have not left my studio in two months and have nothing suitable to wear for the occasion."

Until the end of the decade they still communicated, though at an uneasy distance. Morhardt recalled that on one occasion, "long after she left his studio, she came to have lunch with Rodin at my house (avenue Rapp 32)." But afterward she "asked me not to bring her together with Rodin again." Still, her ex-lover continued to value her opinion, and when the all-important *Balzac* went on view in 1898 he asked his *réducteur* Henri Lebossé (who in fact enlarged rather than reduced his sculptures) to find out what Camille thought of it. Her answer proved that she had lost none of her acuteness of vision: "I find it very grand and very beautiful, and the best of all your studies of the subject. Especially the very accentuated effect of the head, which contrasts with the simplicity of the drapery; you have hit it exactly, and it is very striking indeed. I also like very much the idea of the empty sleeves which are very expressive of the negligent man of intellect that Balzac was."

Her letter concluded, however, with a neurotic outburst against her numerous enemies, real or imagined: "You know very well what dark hatred women conceive against me as soon as they see me appear;

manship skillful and supple. . . . This young girl has worked with a tenacity, with a passion, a will of which you can have no idea. . . . But one must live! And she cannot live off her art, you know! So discouragement takes her and crushes her. . . . She is thinking of giving up this art."

they use all their weapons until I crawl back into my shell." She had moved to No. 63, rue de Turenne and was made to pay extortionate storage bills for the plasters she had left behind at the boulevard d'Italie. In 1899 she moved again, to No. 19, quai de Bourbon on the Ile St. Louis, which was to remain her home and studio for the next fourteen years.

Rodin was still doing his best to help her from behind the scenes. In May 1899, he sent her two young sculptresses who had come to him for lessons. One of them, the twenty-three-year-old Scottish artist Ottilie McLaren, reported that Mlle Claudel would make a "stunning" teacher: her work "is big & simple & seems to have that womanly quality which I like so immensely. She herself is very charming, has none of the airs & graces of the great artist, while realising the value of her works & telling me quite frankly which she likes best."

After agreeing to teach the two women, Camille suddenly changed her mind: "she writes on the eve of the first lesson to say that she prefers her solitude." Her prospective pupils then learned that "for the last three years she has cut herself off from everyone even Rodin. Rodin was anxious as much for her sake as for ours that this should come on." She was persuaded to give them lessons after all, but a few days later "Mlle Claudel was off in the tantrums again" and wrote from the country "saying that on no condition whatever would she give lessons."

Rodin was very apologetic: "He says he thinks poor Miss Claudel is overworked & that she is really ill, that this mania against seeing anyone is really an illness & that she can't be held altogether responsible for it. He therefore says that she will probably come around in time & that . . . he will undertake the teaching of the two young women in the meantime & will give us a lesson a week & will take no fee of any kind." Miss McLaren was undismayed by this turn of events. "What remains," she wrote to her fiancé, William Wallace, "is to woo & win Rodin & pray that Mlle Claudel stays off her head in the country!!!"

Meanwhile, Rodin had persuaded Floury, the publisher of Léon Maillard's *Auguste Rodin* of 1899, to commission illustrations from her—two marvelously relaxed etchings of the maître at work. He found other pretexts for sending her money. When she sold the splendid *la Vague*, in plaster but with reproduction rights, to Henri Fon-

taine for 175 francs, it was Rodin who gave Morhardt the money to buy it back for her. On another occasion he disguised a 500-franc payment by transmitting it through the ministry of Beaux-Arts. During the preparations for the 1905 centenary of the revolutionary Auguste Blanqui, Gustave Geffroy obtained a 1,000-franc advance for her: she was to go to Blanqui's birthplace in the south of France, Puget-Théniers, and prepare a maquette for a suitable monument. Her dealer Eugène Blot delivered the money, but when he called again to ask about the project she told him she had not bothered to go.

"You don't say! And the money?"

"I've spent it."

"Well, it doesn't matter: it wasn't mine anyway—but what about the maquette?"

"No thank you! Never in my life will I create a maquette so that afterward they can give the commission to Rodin!"*

She had convinced herself that Rodin had plagiarized her work. "She talked about Rodin with hatred; a real Gorgonne," Gabrielle Réval remembered. "She reproached him with everything . . . with stealing her ideas, her projects. It was a really fierce hatred." In her studio on the quai de Bourbon she told Blot in all seriousness: "You see I'm too close to the ground here. Rodin comes around to the windows, gets on a chair and looks in to see what I'm doing." One of her last notes to Rodin, scribbled in pencil, ends with the admonition: "Above all, don't dare to approach my atelier."

Henry Asselin, a civil servant who befriended her in 1905, writes that Camille at forty could "go from the darkest melancholy to the most delirious gaiety," and there were occasions when she would "rend the air with great outbursts of laughter that chilled me to the bone." Yet he also found her generous and unassuming, a woman of exceptional intelligence and judgment. "Her generosity knew no limits," and on the rare occasions when she had money she would throw a party for the whole neighborhood: "Worldly women, well-known people, art students, models, disheveled poets and two or three *clochards* collected that same day on the banks of the Seine. . . ."

She had become a harmless eccentric, creating her sculpture in

*In fact it was Maillol who eventually did the monument, *la Liberté enchaînée*, in honor of Blanqui.

a state of euphoria and destroying it during one of her depressive moods. She developed the habit, at the beginning of each summer, of demolishing all the works that had accumulated during the preceding year. "After that she would, for good money, hire a drayman to haul away the cadavers and bury them in the fortifications of Paris; then she would disappear for three months without leaving an address."

>‡<

Paul Claudel was rising rapidly in the ranks of the Foreign Ministry and in the esteem of the literary world. In August 1905, he published an article on Camille in *l'Occident* which, among other things, compared her work to that of Rodin, whom he did not mention by name. The latter was "the heaviest, most materialist" of sculptors: "Certain of his figures cannot even escape from the clay in which they are bogged down." Instead, they thrash about in the mud,* animated only by a certain erotic furor—"in short, boorish work, produced by a twisted mind and a dull, dismal imagination." Camille's sculpture, on the other hand, was animated, spiritual and inspired; it caught the light "like a beautiful bouquet."

Paul also wrote a companion piece, *Rodin ou l'homme de génie*, which he was well advised not to publish. It attacked Rodin as a boor and a lecher, "destined by nature to be a studio assistant, a churlish lout," who was still turning out bits and pieces "for an imaginary employer." His myopia would "only permit him to see nature at its most gross," and his success was due to the fact that his pieces seemed alive while the Salons were filled with deadly statues.

Paul had, by now, developed a fastidious aversion to the messiness of most modern art: nothing was quite neat enough for him. The autumn Salon of 1905 disgusted him, he said, because the Fauve paintings then on view for the first time reminded him of "the vomit of drunkards"; art was now subject to the "reign of guttersnipes."

*Claudel, with his poetic sixth sense, had an inkling of the psychological connection between "dirt" and clay modeling. In one of his journal entries he described Rodin as "a demon who snuffles about in *la merde* with an enormous nose . . . like a pig's snout."

When he left to take up a post in China, Camille's relations with the rest of the family became still more tenuous. Neither mother nor sister wanted anything more to do with a woman who had "covered our name with shame." Only her elderly father continued to take a sympathetic interest, paying her butcher bills and sending gifts of clothing and small sums of money. "Up to now, no one has wanted to involve himself with her," he wrote to Paul in 1909. "She asks for 20 francs and we send 100 francs, or she asks for nothing and even so we send her 100 francs, often several times a quarter." But when Louis-Prosper died on March 3, 1913, there was no longer anyone to protect Camille from what a member of the family has called the "conspiracy" against her.

Paul had returned to Europe to find his sister "quite raving." He wrote to a priest and confidant, the Abbé Fontaine: "What struck me most was that *her voice had changed completely*. Currently she does not go out, and lives with the doors and windows locked in a really disgustingly filthy apartment." He was convinced that "like most so-called cases of insanity, hers is a veritable case of possession," and he was moved to ask the priest, "Is it possible to exorcize at a distance?" In any event, "I shall no doubt have to go to Paris to have her put in an asylum."

A week after their father's death Paul Claudel had Camille legally committed—as a third-class patient at Ville-Evrard, a public insane asylum with 1,060 beds. "My sister was taken to Ville-Evrard, without any resistance and scandal," he wrote to the Abbé Fontaine. "We were not a little surprised, going into that filthy room where she lived, to find a prayer book and fourteen crucifixes cut from the newspaper, *La Croix*, and pinned to the wall. . . . My sister is calm and appears satisfied."

"I was miserable indeed during that whole week," Paul noted in his journal. "The mad women of Ville-Evrard. The doddering old women. The one who babbled in English the whole time in a soft voice like a sick starling. Those who wander about without saying anything. Sitting in the corridor, head in hand. The terrible sadness of these souls. . . ." For Camille, who was to spend the rest of her life in this environment, the circumstances of her committal were even more traumatic. Long afterward she wrote of "the disagreeable

surprise of seeing two tough warders enter my studio, fully armed
and helmeted, booted, menacing. A sad surprise for an artist; instead
of being rewarded, this is what I got!"

According to a younger member of the Claudel family, Camille's
removal amounted "to a kind of plot." Some of her friends were left
with the same impression, and there was an outcry in the newspapers
when her case became public knowledge. On May 28, 1914, *la
République radicale* carried a front-page editorial by its editor, Paul
Vibert, a leading spokesman for law reform and civil rights:

> The monstrous law of 1838 continues to claim victims: anyone
> can be thrown into a madhouse without a psychiatric exami-
> nation, solely on the word of a physician . . . it's simply mon-
> strous. Unfortunately victims like the poor, great artist Camille
> Claudel are thrown brutally into an asylum and locked away
> for life at Ville-Evrard and no one can do anything to liberate
> this brilliant sculptress!
>
> Since Camille Claudel is the most illustrious pupil of Auguste
> Rodin, it is for him to intervene in order to obtain her release
> from Ville-Evrard. It is also for him to unmask the people who
> have been guilty of this crime, no matter who they might be.

Rodin had, in fact, made an effort to visit her within a week of
her internment, and was first granted, then refused, permission to do
so. Other visitors were also barred, and for a time she was forbidden
to write or receive letters. During the thirty years in which she was
kept in confinement—first at Ville-Evrard, then at Montdevergues
asylum at Villeneuve-lès-Avignon—neither her mother nor her sister
ever came to visit her. The new asylum was no better than the first
but remote from public opinion: she was not permitted to prac-
tice her art even as a form of therapy. When the staff psychiatrists
wanted to have her released into the family's custody, Madame Clau-
del refused to hear of it: "She has all the vices," she wrote to the
director. "I don't want to see her again; she has done us too much
harm."

Jessie Lipscomb and her husband visited her at Montdevergues
and came away convinced that "it was not true that she was insane."

Mathias Morhardt ventured the opinion that she had been betrayed by her family. "Paul Claudel is a *nigaud* [simpleton]," he wrote to Judith Cladel in 1934. "When one has a sister who is a genius one doesn't abandon her. But he always thought that he was the one who had the genius."

By then Paul had reached ambassadorial rank; in 1926 he had bought the Château de Brangues, near Grenoble, to which he retired in 1940. When the subject of Camille came up he talked about her as though she were already dead. He felt that there was a moral to be drawn from her case: art was a dangerous profession. In July 1943—three months before her death—he told a reporter from *Panorama*, the arts magazine published under the German Occupation, that Camille had "suffered a terrible fate; genius is a heavy thing to bear. I was a witness to the tragedy of my sister's life, and I don't encourage anyone to follow the path of the arts."

Camille herself never reached this pessimistic conclusion. Her letters from the asylum show that she remained lucid and self-possessed, though she could not reconcile herself to the loss of her art. "All that has happened to me is more than a novel, it is an epic, an *Iliad* or an *Odyssey*, but it would need a Homer to recount it," she wrote to her former dealer after twenty years of silence. "I live in a world that is so curious, so strange. Of the dream which was my life, this is the nightmare."

Camille Claudel died at Montdevergues on October 19, 1943, aged 79. In his journal, after going to see her on her deathbed, Paul Claudel expressed "bitter, bitter regret at having thus abandoned her for so long." She was buried in an institutional grave; years later, when the family expressed its wish to erect "a tomb worthy of the great artist she was," they learned from the authorities that the plot in question had been requisitioned "in accordance with the exigencies of the service. The grave has disappeared."

Ironically, her best-known sculptures are those that repose in the Musée Rodin, still in the shadow of the man whose crushing influence she had been trying to escape. In 1914 Morhardt persuaded Rodin to reserve a room for her work in his future museum. The sculptor himself was then seventy-four, but he had never forgotten his "sagacious and clairvoyant collaborator," his favorite *élève*, and her face

had continued to appear in his later sculptures. Yet it had been an unfortunate affair, and the memory rankled. One day in the last year of his life the old man paused meditatively before a terra cotta bust of Camille. "She's shut up at Ville-Evrard," a visitor said. Rodin reacted as though he had been stung. "You could not have touched on a more painful subject!"

10

BEHOLDE HERE
WE SIXE

*And he took all of the hundred and compressed
them into six.**

—RAINER MARIA RILKE
on the *Burghers of Calais*

he 1880s were the best of times for the makers of public
monuments. Paris was in the process of acquiring a spate
of new statues—of Alexandre Dumas *père* in the place
Malesherbes, of Diderot in the place Saint-Germain-des-
Prés, of Voltaire on the quai Malaquais, of Lamartine at Passy, Louis
Blanc in the Place Monge, Rabelais at Meudon. . . . The whole of
France was suddenly in the grip of *la statuomanie* as communities
large and small ransacked their past for military or civilian heroes
whose effigies could be erected in the town square.

Some of the smaller cities were hard put to find suitable candidates
for the honor, but the municipality of Calais was not at a loss for
local heroes: its town council had decided long since to erect a
monument to the famous Burghers of Calais whose self-sacrifice had
saved the town in 1347, during the Hundred Years War. There were
six of them, led by the merchant Eustache de Saint-Pierre. Their
story is told in Froissart's chronicle: how, when Calais was compelled
to capitulate to the English after a long siege, King Edward III offered
not to sack the city provided "sixe of the chief burgesses of the towne

*"*Und er nam alle hundert an und machte aus ihnen sechs.*"

[244]

come out bare heeded, bare foted, and bare legged, and in their shertes, with haulters about their neckes, with the keyes of the towne and castell in their handes, and lette theym sixe yelde themselfe purely to my wyll."

The chronicle goes on to relate how courageous Eustache was "the first to putte my lyfe in jeopardy" and was soon joined by Jacques de Wissant, his brother Pierre, two of their cousins and another merchant, who dressed themselves in the prescribed manner and left the city amid "great lamentacyon made of men, women, and chyldren at their departing." At the English camp they kneeled before Edward and "helde up their handes and sayd, gentyll king, beholde here we sixe, who were burgesses of Calays and great marchantes: we have brought to you the kayes of the towne and of the castell, and we submyt oure self clerely into your wyll and pleasure, to save the resydue of the people of Calays." Although Edward was disposed to make an example of them his wife, Queen Philippa, interceded on their behalf, and "the quene caused them to be brought into her chambre, and made the haulters to be taken fro their neckes, and caused them to be newe clothed . . . and set at their lyberte."

The nineteenth-century citizens of Calais deemed these burgesses to be worthy of a commemorative statue. During the 1840s David d'Angers had been commissioned to create a monument to Eustache, but its sponsors had been unable to pay for it. The idea was revived during the 1860s—this time Auguste Clésinger was one of the proposed sculptors—only to become a casualty of the Franco-Prussian War. At last, in 1884, the project was taken in hand by the city's energetic new mayor, the forty-seven-year-old notary Omer Dewavrin, who had particularly urgent motives for wanting to erect a monument to *les Bourgeois de Calais*. For economic reasons the ancient port city on its walled island was about to be amalgamated with its mainland rival and suburb, St. Pierre, the center of the French lace and tulle industry. To facilitate the physical merger of the two towns the ramparts of the citadel were to be torn down, leading to fears that Calais would lose its historic identity.

Accordingly the municipal council appropriated 10,000 francs toward the purchase of a Calais monument which, it was estimated, would cost 30,000 francs. The rest was to be raised by national subscription—for the six burgesses were seen as a symbol of more

than local significance. Like Joan of Arc (who was to be canonized—though not until 1920—at the insistence of the French clergy) they personified French courage in the face of adversity and defeat. Calais in 1347, like France itself in 1870, had been defeated by overwhelming odds; British-occupied Calais, moreover, had set Prussian-occupied Alsace and Lorraine an historic example by remaining loyally French in spirit and returning to the fold after 200 years of foreign rule.

As president of the *comité d'érection* Mayor Dewavrin personally undertook to find an eminent sculptor for the proposed monument. For professional advice he turned to the young Calais painter Alphonse Isaac, then working as an *élève* in the studio of Jean-Paul Laurens (he happened to come from an influential family that had supported Dewavrin in the 1878 elections). Isaac asked his *maître* if he knew of a French sculptor worthy of being invited to submit a maquette, and according to Bartlett, Laurens aswered, "Certainly, Rodin is the one." On October 17, 1884, Isaac wrote to Dewavrin that "Monsieur A. Rodin, whose name is doubtless known to you, is the one whose robust talent would be the most suitable to the subject"; Laurens and "many other competent judges" had vouched for him.

Dewavrin was in a hurry and lost no time going to see Rodin in Paris to explain what was wanted. "The original intention of the committee was a single statue of the principal personage," as Bartlett reports. But Rodin, having read the relevant excerpts from Froissart in a booklet published by the Calais council, seems to have decided from the first that he would depict the six hostages, not just one, in the act of leaving the town and descending toward the English camp. Rilke heard from him long afterward that the chronicle had made him see the hostages in his mind's eye: "In Rodin's imagination a hundred heroes rose up and thronged to the sacrifice. And he took all of the hundred and compressed them into six."

On November 3, Rodin wrote to Dewavrin that since their initial meeting "I have been very busy on the monument, and have been fortunate enough to hit on an idea that pleases me, and which will be original when executed." It would be very different from the monuments erected by other cities, which were usually pyramidal in shape and tended to be very much alike. By November 20 the clay

maquette was ready to be cast in plaster and sent to Calais. The idea was completely original, he assured Dewavrin; indeed "it is the subject itself which is original and imposes a heroic conception; this group of six self-sacrificing figures is powerful and expressive. The pedestal is triumphal and has the rudiments of a triumphal arch in order to carry, not a quadriga, but human patriotism, virtue, and self-denial."

The first maquette showed the figures clustered together and clinging to one another, their necks encircled by a rope—a compact, simple form designed to keep foundry costs to a minimum: "It will make the bronze casting less expensive. I expect that 25,000 francs will cover all costs, and there would be nothing else to pay except the sculptor's fee."

He was exceptionally satisfied with his work. "Seldom have I succeeded in giving a sketch such élan and sobriety." The mayor was also pleased, and sent congratulations on the 23rd, but not without an important caveat: "All those who have seen the group have been thrilled, but their second thought is that it will be very expensive." Rodin calculated that the casting would cost about 15,000 francs and the stone for the pedestal 4,000; his own fee would amount to 15,000 more, for a total of 34,000 francs. For the present he asked for an advance of 3,000 francs to cover the cost of making the maquette, and an assurance "that no one else will be asked to execute my sketch."

Dewavrin had also approached several other sculptors, two of whom—Emile Chatrousse and Laurent-Honoré Marquestre—had actually submitted models. Rodin thought it advisable to bring a little subtle pressure to bear on the committee. "My friends Cazin the painter and Alphonse Legros the painter will come to visit you and ask to see my maquette," he wrote to Dewavrin on Christmas Day. "I shall be most grateful if you extend them a warm welcome; both are *célébrités artistiques*."

Legros had just come over from London to visit his aged mother, who had moved from Burgundy to Boulogne to be nearer her son; Cazin was a native of the Pas-de-Calais who spent much of his time painting landscapes there. After their inspection tour of the Calais maquettes Cazin wrote to Rodin that everything had gone according to plan:

We made it quite plain that our visit to Calais had been prompted solely by the desire to see the projects intended for the town square; they showed us everything and thereupon we expressed our admiration for your remarkable sketch in well-chosen, serious words of appreciation. Of course we also examined the other entries, as was only proper, and then pointed out the merits of your excellent proposal in detail. Legros compared your competitors' solitary, banal figures to gingerbread men, and I explained that by including Eustache de Saint-Pierre's companions one would be paying still greater tribute to the population as a whole. In a word, all was for the best and there was never any suggestion that you had inspired the truth we had to tell them. . . .

Before making the final decision Dewavrin wanted to be certain the foundry costs would not exceed Rodin's estimate: "This is an important point . . . Certain of your competitors are shouting from the rooftops that your project is so impracticable that it would cost 100,000 francs." Chatrousse, moreover, had scored another telling point with the committee—he wanted to depict Eustache alone, addressing the people and declaring his willingness to die for the city. "That surely is the most beautiful moment," he argued, "the only one not humiliating for the spirit of patriotism. A public monument must not show your heroic compatriots at the feet of the king of England."

Other dissenting opinions had begun to appear in the local newspapers, yet the committee preferred Rodin's maquette. He was asked to come and discuss it with them, and to examine the proposed site for the monument, opposite the new post office then under construction. Rodin made the trip on January 21, 1884—the eight o'clock train from Paris brought him to Calais at 12:25—and persuaded the monument committee to give him their unanimous support. "M. Rodin has departed from the well-trodden path," one of them noted. "He has presented us with a project so exciting that he received all our votes."

The formal contract was signed in Calais and countersigned by Rodin in Paris on January 25. It stipulated that Rodin was to execute the six figures in plaster: "The figures are to measure no less than

two meters in average height [the first maquette was thirty-five centimeters high]" but before proceeding to the final version he was expected to submit "a plaster maquette one-third the size of the final monument, needing only to be enlarged and perfected." He was also obliged to "carry out any changes in the said maquette which may be suggested by the committee, and apply them to the final group." A clause inserted as an afterthought added 2,000 francs to Rodin's 15,000-franc fee, to cover the cost of preparing the full-scale plaster model. Pending delivery, the fees were to be held in escrow at Sagot's Bank in Calais.

Although he had agreed to submit it "in the shortest possible time," Rodin took more than half a year to complete the promised one-third model. He had declared his intention of studying "some expressive portrait heads in the Calais region" in order to find suitable faces for Eustache's companions, but it seems unlikely that he actually went head-hunting in the Pas-de-Calais. Instead he remembered that Cazin came from there and suggested he pose for the principal figure. Cazin wrote that he would be happy to oblige: "You've had a most friendly thought. I am quite prepared to pose for your figure of Eustache de Saint-Pierre, the rope around his neck, barefooted and bare-armed"— the more so as his mother's family were thought to be descended from Eustache.

A similar offer came from Coquelin *cadet*, one of the leading actors of the Comédie Française: "I was born at Boulogne-sur-Mer, hence truly of the Pas-de-Calais. I'd be natural for the part, and it would give me great pleasure to pose for the great sculptor Rodin."

In these initial stages, however, Rodin was still concerned primarily with the overall composition of the six figures—"I am fully engaged and in mid-search," he wrote to Dewavrin on March 18. The two towns had been formally merged into greater Calais by then, but Dewavrin, though no longer mayor, had remained an alderman and president of the monument committee. While the *Bourgeois* were taking shape, he too was to be portrayed in clay: "Perhaps, if you have some time at your disposal . . . I could begin making a sketch of your portrait and perhaps with a little additional time we could finish it." If Dewavrin could not spare the time to come to Paris, Rodin might go to Calais, "in the spring, when the long days will be more favorable and I could finish your bust."

When spring came he announced a forthcoming visit to Calais only to cancel it with a laconic telegram: AM ILL AT THIS MOMENT EXCUSE ME RODIN. Dewavrin began to wonder whether the sculptor had made any progress, but as usual Rodin was not to be hurried. He would be finished in June, he wrote on May 25: "The work is going well, but to arrive at the essential solutions of the problems of the monument I cannot rush my thinking [*je ne puis réfléchir trop vite*]." In fact the one-third model was not ready until Bastille Day, at about the same time as his portrait of Dewavrin as a bluff, crewcut man of action.

The second maquette was very different from the first, and when he dispatched it to Calais Rodin evidently had an inkling that the committee would react unfavorably. For one thing, its sketchy quality might be held against him:

The group will be sent on Wednesday by slow train [he wrote on July 14]. It is made for working purposes, and therefore the lack of certain details should not be surprising because generally all drapery is done again on the full-scale model. The shape of the folds varies because when one drapes the cloth in a figure it does not fall the same way twice.

My nudes are done, which is to say that the bodies beneath the draperies are done, and I am having them prepared in their definitive state so as not to lose time. You see, it is the part one doesn't see—the most important part—which is finished.

Otherwise I would be doing a lot of useless work simply to charm the eye of the Calaisiens; I would have to waste 300 francs merely to clean up here and there, which would bastardize the work and benefit only the public since from the artist's point of view the sketch is better as it is.

Rodin went to Calais on July 26 to supervise the unpacking and assembly of his new maquette, which consisted of six figures on separate bases united on a common pedestal and arranged so that, as *le Patriote* reported, "Eustache appears in the front rank, standing, his head lowered, his upper body bent slightly forward, the arms dangling in front of the legs, the palm of his hand turned toward the knees. . . . At his right, one of his companions presents the keys of

the city on a cushion, for King Edward. At his left, and turning his back toward him—that is, leaning toward the right side of the monument—stands another of the six burghers, pulling at his hair and evidently abandoning himself to transports of anger. . . ."

Instead of the favorable reaction Rodin had every reason to expect from the press, *le Patriote* greeted his maquette with a blast of derision. A writer signing himself *Un passant* (A Passerby) poured scorn on the supposed attitude of the *Bourgeois* pulling his hair: "If your pain is so intense, if you regret your sacrifice so much, why didn't you stay home?" Besides, it was absurd to invent poses of nobility "for six gentlemen in shirttails." In place of its six standing figures, all of the same height, the monument ought to be redesigned so as to form a pyramid, which would attract the public's attention and "stand out against the horizon in graceful, elegant lines."

Rodin had to listen to most of the same criticisms when he showed the new maquette to members of the committee. "It was not like this that we envisaged our glorious fellow citizens proceeding to the king of England's camp. Their dejected attitudes are an offense to our religion." The silhouette was deemed insufficiently elegant; Eustache was "clothed in a thickly draped material which does not correspond to the thin garment recorded by history." The committee felt "bound to insist" that the sculptor alter both the attitude of his figures and the composition as a whole.

Now it was Rodin's turn to be upset, but he did his best to head off what was threatening to become yet another exasperating *affaire*. To Dewavrin he explained that his figures were not, as the newspaper had reported, arrayed before the English king; he had chosen the moment when Eustache "leaves the city and descends toward the camp; it is that which gives the group that aspect of marching, of movement. Eustache is the first to descend, and for my lines he has to be thus." As for monuments in conventional pyramid form, they conformed to wholly arbitrary laws "made by the school" which were made to be broken:

I am entirely opposed to this principle, which has been prevalent in our epoch since the beginning of the century, and which is in complete contradiction to earlier great epochs of art; it makes works conceived in this spirit cold, lifeless and

conventional. . . . The man staggering in despair is the only
figure which can be modified; if you make certain of this, my
group is saved—these gentlemen fail to realize that this con-
cerns a one-third model and is not a discussion about doing
the work over again.

It was small consolation that Rodin's admirers had praised his
model in the Paris newspapers as "one of the most remarkable of
monuments." What mattered now was to placate this uncompre-
hending committee of living bourgeois of Calais, which included the
presidents of the chamber of commerce and of the choral society,
two lace manufacturers, two shipowners, the municipal architect,
several businessmen and the banker, Monsieur Sagot. The polemics
in le Patriote did little to change their minds. As Dewavrin wrote to
the sculptor on September 26, "We are embarrassed; public opinion
has pronounced strongly against the attitude of Eustache; we do not
dare continue raising funds by subscription before being able to say
that changes will be made."

Rodin had already retrieved his model, on which he had spent
five months of intensive thought and study. Evidently he himself was
not entirely satisfied with the second maquette since, despite his
assertion that only one figure could be modified, he now set about
making changes that altered not only the Bourgeois' gestures and
expressions but the basic form of the monument. Meanwhile the
committee regained its confidence in his work, for on October 27 he
received his first check, for 5,000 francs. When he asked Dewavrin
for a further advance of 2,000 francs on January 11, 1886, he was
able to report: "Of six figures, three are very advanced, and the other
three are being worked on."

His six figures were still designed to stand on level ground in a
kind of broken circle, but in the process of giving them their definitive
form he changed his mind about some of them. For one thing, the
nude figure evidently based on Cazin which he had used for the sec-
ond maquette was replaced by that of an older man, based on the
"wolf," Pignatelli, who was already on his way to becoming famous
in the Paris studios as "Rodin's model."* The "Cazin" Eustache

*Rodin went on using Pignatelli as a model—if sometimes only for details, such as his
bony hands—until he reached a ripe old age. In November 1900, he sent Pignatelli to

strides forward with his weight on his right foot; the "Pignatelli" Eustache is an aged and skeletal figure, moving on stiff legs with his weight on the left foot. "Eustache braces himself," as Rodin explained this figure to Jeanès not long after its completion. "It's he who is going to speak. He doesn't want his voice to tremble. He is immobile but he is going to walk. . . . This is something I've thought about a great deal. For a long time I thought movement was everything, the ultimate desideratum. But a statue doesn't move. One has to make it seem as though it could move."

There was more tension, now, in all of the figures, whose hand gestures and body movements had been adjusted with the care of a choreographer. "Each of these *Bourgeois*," he told Jeanès, "expresses his feelings, his torment . . . or fear." His young admirer noted the enormous feet for which Rodin was being taken to task by his critics— "the hands, the monstrous accents of form, the theatricality of the gestures . . . in short, all the things that bowled me over with emotion." Many of the changes affected seemingly minor details: Jean de Fiennes,* for example, is only half covered by a shirt in the second maquette, while the final version has him dressed to the neck in flowing drapery, like the rest.

Years later Judith Cladel heard from Auguste Beuret that he had posed for "the head, the nose" of the figure of *le Bourgeois à la clef*. Rodin's son turned twenty in January 1886, and that year he entered the army and went off to join his regiment at Nancy. "Try to get your stripes at any rate, you imbecile," were the sculptor's parting words. "You're no good for anything else!" Still he sent the recruit twenty francs every month to augment the pittance he received from the army. If Auguste had indeed posed before he left, it must have been

pose for his *élève*, Ottilie McLaren, who was helping him turn the *Ugolino* into a *Nebuchadnezzar*. Ottilie described him as "a magnificent chap" and rather amusing: "he talks the usual broken French & Italian patois. He tells me that he brings *'la chance— Tout le monde attrapait la médaille quando travalians con moi'* [Everybody caught the medal when they work with me]. I think to *'attraper'* a medal is a lovely idea."

*In his correspondence, the only one of the six figures to which Rodin refers by name is Eustache de Saint-Pierre. The rest were assigned names—from Froissart and other historical documents—by a latter-day curator of the Musée Rodin, Georges Grappe, and these designations have been retained for convenience's sake by later generations of art historians.

for the strikingly youthful figure, in the second maquette, of the "Jean d'Aire" carrying two keys on a cushion—a prop that was discarded in the final version, which has two men each holding a key: Jean d'Aire and Jacques de Wissant. Searching for a resemblance, Cladel thought she could detect "the sloping forehead and firmly rooted nose of the Rodins" in the face of the finished Jean d'Aire. Almost certainly it was this strong, stubborn face that caught the eye of a military visitor to the sculptor's studio, General François Achille Thomassin, "who asked me to give him a cast of one of the heads, in which he sees a simple, ardent expression of heroism," as Rodin wrote to Dewavrin on January 11, 1886. But the pugilist's body used for his nude study of the full-scale Jean d'Aire could hardly be that of a young man of twenty, and the head also seems to be that of a much older man—though some existing plaster and terra-cotta studies have led to suggestions that Rodin may have "aged" his sitter in several stages. It seems more likely that the young "Auguste Beuret" disappeared into the clay bin.

In any case, whatever model or models he may have employed for the head of Jean d'Aire, he used the same face again on the second key-carrier, Jacques de Wissant, this time thinly disguised beneath a beard and mustache, and a third time on Andrieus d'Andres—the despairing man who holds his head in his hands "in order to compose himself," as Rilke explains. Rodin had already played this game of sculptural sleight of hand with the multiple heads of the *Porte*; it was an ancient professional prerogative, part of a tradition that allowed sculptors both to play god and, as it were, *épater les bourgeois*. The moral that looks are deceiving is one that Rodin drove home repeatedly in dozens of transposed heads and bodies, both before and after the *Bourgeois*. But if this intractable face was indeed based on his son's features, then he was being more than usually devious in giving three of his six medieval heroes the face of a blockhead just bright enough to get into the army.*

*The 1977 catalogue, *Le Monument des Bourgeois de Calais*, reproduces the "portrait of an unknown man"—a photograph by Pierre Petit, dated about 1885: "Certain resemblances can be established between this face and that of Jean d'Aire," the caption explains. The *inconnu*, however, is actually César Franck, for whose tomb Rodin was to make a funerary medallion in 1891. The medallion was based, in part, on the Petit photograph, and also on Rodin's memories of Franck. It is fascinating to think that the

Rodin had rented another studio in which to work on the Calais project—a vast, barnlike room at 117, boulevard (not rue) de Vaugirard, stretching between what was then one of the outer boulevards of southern Paris and a small garden in the crowded working-class quarter adjoining the Montparnasse station. When the young critic Gustave Geffroy came to see it he noticed that the light in this studio was "cold and gray, like that of a church," which gave the sculptures a somber cast. "The room is packed with stands, maquettes and small sketches, and is dominated by a figure once entered in a competition, of a vanquished France with one tragic, broken wing. In the midst of this mass of work rise the statues of the men of Calais, larger than life. . . ." Another visitor who saw them there was the English critic Cosmo Monkhouse, of *Portfolio* magazine, who reported that they were in various states of completion, "some waiting only for the finishing touches of the master, others being built up in clay by his assistants"—who, as it happened, included Camille Claudel and Jessie Lipscomb.

It was in the Vaugirard studio, on April 17, 1886, that Edmond de Goncourt first met Rodin face to face. As the "field marshal of French letters" afterwards noted in his journal,

He is a man with the traits of the common people; a fleshy nose, clear eyes blinking beneath sickly red eyelids, a long, yellowish beard, hair trimmed in a short brush cut, with a round head quietly stubborn in its obstinacy—a man such as I imagine Christ's disciples to have looked like. I found him in his studio in the boulevard Vaugirard, his ordinary studio with the walls spattered with plaster, its wretched little cast-iron stove, and the cold damp emanating from all these immense *machines* of wet clay, wrapped in rags, and with all these casts of heads, arms, legs, in the middle of which two emaciated cats resemble the effigies of fantastic griffons. And there in the midst of it all, a half-naked model with the look of a dock

Burghers of Calais might conceal a secret and multiple portrait of the composer of the D Minor Symphony.

worker. Rodin turned on their stands the life-size clay figures of the six hostages of Calais, modeled with a powerful realism and with those beautiful hollows in the human flesh that Barye used to put into the flanks of his animals.

Goncourt had been brought to the studio by their mutual friend Félix Bracquemond, who had earlier arranged for Rodin to send the writer one of his drypoints. Prints and drawings were one of Goncourt's specialties: at sixty-five he was the most knowledgeable of collectors in a field crowded with connoisseurs.

Rodin's gift had made a deep impression on him. "You've given me great pleasure and I thank you for it," he wrote to the artist on February 9. "I was amazed by your etching, which I hadn't seen before, and which I regard as a little marvel of power and delicacy. Please allow me, in exchange, to send you an art book dedicated to the memory of a friend, and to ask your permission to see your *Porte*, which Bracquemond has described with such admiration. . . ."

But Goncourt was one of the busiest and most sociable people in Paris. The second floor of his house in the boulevard de Montmorency in Auteuil—the celebrated *Grenier* (attic)—was the regular meeting place of the influential literary set which was ultimately to be formalized into the Académie Goncourt; during the 1880s it included Alphonse and Léon Daudet, Huysmans, Zola, Mirbeau, Geffroy and a dozen other writers. It was more than two months before he actually undertook the half-hour journey from Auteuil to Montparnasse.

After showing them the *Bourgeois* Rodin took Goncourt and Bracquemond to the Dépôt des Marbres to see the *Gates of Hell*. In spite of everything he had heard about them, the sight of the great white doors took the fastidious Goncourt by surprise:

On these two immense panels there is a jumble, a muddle, a confusion, something like a petrified mass of a madrepore's coral branches. Then, after some moments among the seeming madrepores the eye discerns the projections and recesses, the protrusion and hollows of a whole world of delicious little figure studies, stirred into animation, so to speak, in movements which Rodin's sculpture tries to borrow from Michelangelo's *Last Judgment* and from certain crowd scenes in Delacroix's paint-

ings—all this in a relief without precedent, which only Dalou
and he have dared to attempt.

Their last stop was Rodin's storehouse on the Ile des Cygnes, in
the middle of the Seine, where the sculptor chose a piece at random
from among a pile of casts on the floor and made them look closely
at what turned out to be one of the figures from the *Porte*. Goncourt
was enthralled by this and other "admirable torsos of small women."

Rodin excels in modeling the curve of the back and, as it were,
the beating wings of their shoulders. He also has a superbly
imaginative sense of the conjunctions and enlacements of two
amorous human bodies knotted together, like leeches rolling
on top of each other in a bowl. . . . The man seems to me to
have the touch of a genius but lacks a personal conception; his
mind is a hotchpotch of Dante, Michelangelo, Hugo, Delacroix.
He also strikes me as a man of projects, sketches, scattering
himself in a thousand directions in his fantasies and dreams,
but never bringing anything to its final realization.

Rodin had passed muster at any rate, and was duly admitted to
Goncourt's *Grenier*, though only to the outer circle reserved for ac-
quaintances rather than friends. "Sometimes I found myself ill at
ease with him," Rodin later confided to Coquiot. "He was as moody
as an old maid; he would listen sweetly when one talked about him
in flattering terms and became dry and distant when someone else's
work was mentioned. He got along very badly with Zola, another vain
personage, but very well with the subtle, sensitive Daudet, who knew
how to cope with him even in his bad moments."

Goncourt's visit happened to coincide with a crisis in the financial
affairs of the Calais monument. The French economy had taken a
downward turn: earlier in the year there had been a series of bank
failures in Calais, and the monument committee's funds had been
caught in the crash of Monsieur Sagot's bank. Rodin, who had thus
far received less than half his promised fee, had reason to fear for
the rest. "The poor devil has really had no luck with his hostages of
Calais," Goncourt noted, yet despite the city's financial straits, "the

work is so far advanced that it must be completed—and to finish it will cost him 4,500 francs for models, studio, etc. etc."

Rodin had written to Madame Dewavrin that he was "saddened" by the misfortune that had befallen Monsieur Sagot and had also affected the Dewavrins: "I am concerned for you and not for me, since I can still wait." Even so the ensuing months proved to be a particularly trying period, fraught with financial anxieties and the exasperations of his courtship of Camille. The Calais committee's fund-raising activities came abruptly to a halt: Rodin received assurances that he would be paid further installments of his fee—by May another 2,200 francs was forthcoming—but the casting and erection of the monument would have to await the city's economic recovery.

Meanwhile, there was an unpleasant surprise from a wholly unexpected quarter. Rodin, who had submitted nothing to the 1886 Paris Salon, received a rejection slip for the one piece which he sent to the annual spring exhibition of the Royal Academy in London—an innocuous *Idylle* of two bronze *enfants* known in England as *The Children's Kiss*. The *Saturday Review* promptly berated the selection committee for having made a laughingstock of the Academy: "*Bourgeoisie oblige*, and these gentlemen have shown themselves worthy of the trust reposed in them." There had, in fact, been extenuating circumstances: the *Idylle* was a charming but conventional piece of decorative sculpture, and its authorship was unknown to any of the judges until after its rejection.

When Rodin went to London late in May to spend a fortnight with Natorp in Kensington, he learned that the whole affair had done his career more good than harm. "Your campaign in London has been a complete success," he wrote to Léon Gauchez, who had been hard at work among his friends, trying to repair the damage:

I have seen Frederick Leighton, and he was very friendly and asked me if I had come to assassinate him. He gave me passes to art galleries. But this *affaire* has been the subject of a lot of conversations. . . . Among the sculptures at the Grosvenor Gallery there is a little statue by [Alfred] Gilbert, a bronze of a young girl, which is good; at the Academy Leighton's figure is good in its movement but crudely modeled; the other little

bronze figure is also fine in movement, less good in its modeling. . . . Fantin-Latour and Sargent have the most beautiful portraits, to my way of thinking. It is diffiult for me to remember the English names.

He had come to England hoping for a glimpse of his errant *élèves* Camille and Jessie, who had gone to Peterborough together and proved maddeningly indifferent to his repeated pleas for letters. "I often look into my mailbox," he had written to Jessie just before leaving France. "Sometimes I return suddenly from far away, from the country, from anywhere, thinking about a letter from England." Cheerful and confident as he sounded in his business correspondence, his private letters were morose and full of self-doubt: "All my strength has fled into a corner and remains there, deadened and vacillating; will it return? I have no idea."

Then the experience of Hyde Park in the springtime helped dispel the gloom: "The sight of lovely children and of beautiful women (and beautiful trees) in the park today has assuaged a little the overwhelming sadness which I have brought with me from Paris." And when he heard that the Lipscombs and Camille were coming to town to see him—"Ah, I assure you London holds no more fogs for me!"

Sir Frederick Leighton had arranged for him to be admitted to some of the city's great private collections, enabling Rodin and his two favorite pupils to see, among other things, the Duke of Westminster's picture gallery. But after a frustrating visit to the Lipscombs in Hampshire he beat a hasty retreat across the Channel, pleading the pressure of urgent business. By way of farewell he asked Jessie to "write me in Paris about the details of your walks in the country. Now that I have seen those beautiful meadows I shall keep seeing them in my mind's eye, and they will return to me often like the Scottish ballad that brought tears to my eyes." To prove to her that he was no longer without a knowledge of English he ended the letter with a triumphant flourish, twice as large as the rest: "GOD BUY. . . . A. Rodin."

But the fuss over his rejection by the Royal Academy was not, after all, permitted to die down without further repercussions. On August 30, 1886, the *Times* published a letter from the elderly history painter Edward Armitage, R.A., complaining that too many outside

works were being admitted to the Academy's exhibitions as it was, and Rodin's piece had deserved to be rejected owing to "the intrinsic badness of the work itself. Not having seen the statue in question I can express no opinion about it, but I know that in Paris M. Rodin is called the Zola of sculpture. . . ."

This time it was Robert Louis Stevenson who took up the cudgels on his behalf—shortly after their memorable luncheon at Lapérouse. Stevenson could not bear to see his new friend tarred with the same brush as the notorious amoralist Emile Zola. On September 6 the *Times* published his long and indignant rebuttal:

M. Zola is a man of a personal and forceful talent,* approaching genius, but of diseased ideals; a lover of the ignoble, dwelling complacently in foulness, and to my sense touched with erotic madness. These defects mar his work so intimately that I have nothing further from my mind than to defend it. . . . To M. Rodin the first words of the above description may be applied, and the first words only. He, too, is a man of a personal and forceful talent, and there all comparison is at an end. M. Rodin's work is real in the sense that it is studied from the life, and itself lives, but it has not a trace of realism in the privative sense. M. Zola presents us with a picture, to no detail of which we can take grounded exception. It is only on the whole that it is false. We find therein nothing lovable or worthy; no trace of the pious gladnesses, innocent loves, ennobling friendships, and not infrequent heroisms by which we live surrounded. . . . Hence we call his work realistic in the evil sense, meaning that it is dead to the ideal, and speaks only to the senses. M. Rodin's work is the clean contrary of this. His is no triumph of workmanship lending an interest to what is base, but to an increasing degree as he proceeds in life the noble expression of noble sentiment and thought. I was one of a party of artists that visited his studio the other day, and after having seen his later work, the *Dante*, the *Paolo and Francesca*, the *Printemps qui passe*, we came forth again into the streets of

*Stevenson had written "forceful"; the *Times* misread his letter and printed "fanciful." (Cf. letter from Henley to Gauchez in the Austrian State Archives.)

Paris, silenced, gratified, humbled in the thought of our own efforts, yet with a fine sense that the age was not utterly decadent, and that there were yet worthy possibilities in art.

Rodin was delighted to be the object of Stevenson's attention. He had told Gauchez about his remarkable new friend, and hoped to bring them together. Gauchez, he wrote to Stevenson, "would be very happy if you could write something for his magazine *l'Art* concerning your impressions of sculpture or painting, or whatever it might be, expressing it in the form of a letter. He appreciates the extraordinary finesse with which you view the world." Reading Stevenson in French translation had whetted Rodin's appetite for his books. "Really, *Treasure Island* is a masterpiece of life—I needn't say more," he wrote to the author. "The other [*The Suicide Club*] is singularly original. I dare to tell you what a literary ignoramus thinks; in any case, I devoured it ravenously. Later I'll go back and re-read some of the passages."

Stevenson wrote from Bournemouth that he was proud and happy that Rodin had been so kind to "my bastard offspring." Even in French he was a master of literary conceits: "I think—I would almost say I hope—that what you say is the result of a friendship for the author rather than a weakness for his work. For, to tell you the truth, I would rather earn a grain of your personal affection than all the admiration you might bring to a Dante or a Homer. At our age one doesn't become enamored at first sight; one tends to remain satisfied with the friends one already has. For me it was a great surprise to have been seized by such a sudden sympathy; it would please me to think that this feeling had been reciprocated." He was not unwilling to write for Gauchez but the idea struck him as impractical. "I love France; it would please me enormously to address myself directly to the French. . . . But is it feasible? What would he do to correct my errors? What style would I adopt? What would Paris think of it?"

Rodin confessed that he was utterly charmed by the Scotsman's letters, and now regarded him as one of the very few people in whom he could confide:

In any case I am very much your counterpart; I have anticipated your sympathies and friendship, and I think we have unknow-

ingly traveled along the same path. Yes, a new friendship that has come late but works well. I even want to take advantage of it at once and tell you how tiresome I find everything at the moment. I certainly understand the Suicide Club which you created with your black sense of humor. We pay for our liberty with our secret pain. My monster will not leave me in peace.

You've published a new work [*Kidnapped*]. English friends passing through Paris have told me about it and praised it enormously. I see that you have the gift of life in creating literature. I've almost sold my group *Printemps* in bronze to Monsieur de Rothschild, but I'll save the plaster for you—the plaster of that poor colorless imagination which does not have the wickedness of real life. Write me now, or on a day of friendship.

True to his word, Rodin sent *Mon grand ami* Stevenson a plaster version of *l'Eternel Printemps* (Eternal Spring), the kissing couple which was to rival *le Baiser* as one of his best-known sculptures. Stevenson was cautioned to be careful when unpacking it, but "if anything is broken it can be repaired, since it's plaster, by one of the mouleurs employed by the museum."

In the same breath he thanked Stevenson profusely for sending him a letter and some short stories. Clearly Rodin was in need of someone to whom he could unburden himself, and here seemed to be the ideal confidant: "I think that at my age a man turns a very difficult corner and is submerged in discouragement. Still, around me all is going well; my reputation—thanks also to you and your letter to the *Times*—is growing, and exaggerated praise is a daily occurrence (a sign that mediocre minds are also turning my way)."

None of Rodin's recent friendships had affected him quite so intensely, and he was frank to admit it: "It is so rare to experience such pleasure as I had in your company, when your true intellect and real sympathy charmed me: it seems to me sometimes that if I had the pleasure more often of holding a conversation with a man like you, dear poet, it would restore my spirits. In the spring I shall be your guest, as you suggested."

Stevenson, however, was both too ill and too busy to maintain the momentum of this correspondence. It had already become rather one-

sided by October 26, when Rodin wrote to him: "I don't ask you to write me letters, though they give me enormous pleasure—it would be robbing the public for one person alone to take just for himself two pages of one of his favorite writers. As for my letters, the shorter the better, as long as I've made you understand the passionate friendship [*la violente amitié*] I have for you." He could not refrain from adding how much he admired Stevenson's writing: "It's so good to read something well written . . . the pleasure remains. One feels that one has been touched and is grateful without being aware of it. I believe you are in London; at least Henley told me that you would be spending this past Sunday together. He is truly happy and I envy his happiness; sometimes I talk with intelligent people but one thing doesn't replace the other; I admire the fact that your stylishness, on the surface, does not detract from the force of your observation, and I also love the way you express yourself so well, with complete mastery."

Eventually a letter came from Stevenson explaining that though he owed Rodin letters by the dozen, "I am still only so-so"; his tuberculosis had forced him to flee London "through fear of murderous fogs" and he was only just strong enough to send a few lines:

The *Printemps* duly arrived, but with a broken arm; so we left it, as we fled, in the care of a statue-doctor. I am expecting every day to get it, and my cottage will soon be resplendent with it. I much regret about the dedication; perhaps it won't be too late to add it, when you come to see us; at least I hope so. The statue is for everybody; the dedication is for me. The statue is a present, too beautiful a one even; it is the friend's word which gives it me for good. I am so stupid that I have got mixed up and don't know where I am; but you will understand me, I think.

I cannot even express myself in English. How can you expect me to do so in French? I am more fortunate than you are; the Nemesis of the arts does not visit me under the form of disenchantment. She saps my intelligence and leaves me agape without capacity, but without regret; without hope, it is true, but also, thank God, without despair. A mild astonishment has

taken possession of me; I cannot accustom myself to being so blockheaded, but I am resigned. Even if it should last, it would not be disagreeable; but, as I should certainly die of hunger, it would be at least regrettable for me and my family.

I wish I had the power to write to you; but it is not I who hold the pen. It is the other, the animal, who doesn't know French, who doesn't love my friends as I love them, who doesn't appreciate the things of art as I appreciate them, whom I disavow, but whom I always dominate sufficiently to make him take pen in hand and write twaddle. This animal, my dear Rodin, you don't love; you must never know him. Your friend who is asleep at present, like a bear, in the depths of my being, will shortly awake. Then, he shall write to you with his own hand. Wait for him. The other doesn't count. He is a sorry and unfaithful secretary, with a cold heart and a wooden head.

He who is sleeping, my dear friend, is ever yours. He who writes is commissioned to inform you of the fact, and to sign for the Firm.

<div style="text-align: right">

Robert Louis Stevenson
and Triple Brute (per T.B.)*

</div>

Rodin had never been addressed like this, and Stevenson's letters prompted him to become almost literary in an effort to reply in kind. "I am less disagreeable with myself today," he wrote on the day after Christmas, 1886. "I shall take advantage of the opportunity and talk to my friend the poet, and send him heartfelt greetings born of the most ardent friendship. Your letters are like a charming flower that I breathe in from time to time; you tell me such nice things that I am acquiring a taste for them, but I musn't take all the pride for myself—and I shall leave all the virtue to you. Do not be too self-effacing, my dear friend; it is a sign of your exquisite friendship, but you are doing yourself an injustice; I believe that in acquiring your friendship I have got the best of the bargain."

*This is Frederick Lawton's translation, which takes a good many liberties with Stevenson's text but succeeds perfectly in re-creating the bantering tone of this Jekyll-Hyde letter. The original, in French, can be found in *The Letters of Robert Louis Stevenson*, edited by Sidney Colvin (London, 1911).

Rodin had never taken so much trouble with a gift sculpture as he did with Stevenson's *Eternel Printemps*. He told him exactly how high the work should be mounted—2.1 meters from the floor—but these technical details were merely an expression of the tender concern he felt for his mortally ill young friend:

To return to the regards I wanted to send you and to entertain you a little in my letter—I am afraid I'm clumsy in this genre and can only make you smile, a little maliciously. . . . Yes, poet, I want to tell you beautiful things with the mind of a sculptor. Now if I should split myself in two like you, neither of the halves would be worth very much in terms of subtlety of intellect; the rougher of the two is always the stronger and permits the other no liberty. It's true that he allows him to do sculpture but that's all.

Once more there was a rather ominous silence from Stevenson, who did not reply for more than six weeks. He had been ill again— "a stringy and white-faced *bouilli* out of the pot of fever," as he wrote (in English) to Henry James. Writing to Rodin in February, he hoped that "you'll excuse me on that account. Certainly I don't forget you, and I assure you I never will. Whenever I don't write, say that I'm ill—it's too often true; say that I'm weary of scribbling, that will always be true, but do not say that I am indifferent. I have your portrait before me, taken from an English newspaper (and framed at my expense), and I look at it with friendship, even a certain complacency—though it may be false coin—as a certificate of youthfulness. I had thought myself too old—at least forty years too old [he was thirty-six]—to make new friends; and when I look at your portrait, and when I think with pleasure of seeing you again, I feel that I was mistaken. Write me, therefore, a short note to tell me that you don't begrudge my silence, and that you plan to come to England soon. If you delay too long, I shall be the one to badger you."

Rodin was delighted to hear that Stevenson was at least well enough to write, "and to know that you thought about me," but he was now very much preoccupied with his work, and the tone of his reply is one of only slightly mitigated gloom:

I have had a bad time, a time of work badly done, which I am doing over again in different parts, but now things are going better! And my "novel" about the *Bourgeois de Calais* also goes better. But what bad years I have just gone through, and ironically it was during this time of despair that my reputation grew in Paris. One can't have everything: if one has nothing, if one is unknown, obscure, one is happy for no apparent reason. But if one becomes well known and favored by public opinion, then one manages to make a martyr of oneself. For that matter, for a long time now the life of men who employ their intelligence has not seemed very enviable to me. "Drink, eat, sleep and love" strikes me as the vegetative wisdom; the rest is beyond our control and places us in a position of inferiority.

>✠<

At least some of Rodin's unhappiness during this winter of discontent stemmed from the fact that he was grossly overworked. Too many projects were competing for his time, and he was forever having to apologize for being late: "You know that this French habit is even more pronounced among artists," he wrote to a friend to excuse his tardiness in replying to a letter. Rodin's procrastination became so pronounced as to be something of a personal trademark, which he put down to absentmindedness. It was true that he now had far more to think about than ever: the unfinished *Porte*, the equally incomplete *Bourgeois* and numerous other commissions and occasional pieces. A catalogue of his sculpture lists fifteen titles for 1886, the year in which Roger Marx proclaimed what many younger critics had long suspected, that Rodin was "the first sculptor of our times."

The monument to the Chilean admiral Lynch occupied him for part of the summer and required revision that autumn because the pedestal was *trop menuiserie*—"too carpenterish." Though the ambassador was eventually "proud and happy" with the maquette, its chief defect, from Rodin's standpoint, was that nothing ever came of it. A more fruitful commission had come his way after the death of his friend Jules Bastien-Lepage—of stomach cancer, at thirty-six— in December 1884. The following year a group of the painter's friends and admirers opened a subscription for a monument to be erected at

his birthplace, Damvillers, a village of 800 souls halfway between Verdun and Montmédy. From the outset it was announced in the newspapers that "the monument will be confided to M. Auguste Rodin, one of the most original sculptors of our time, who was also an intimate friend of Bastien-Lepage."

By the spring of 1887 Rodin had produced a maquette of his proposed monument—the painter bareheaded, with his legs wide apart, a palette in his left hand and brush in his right, as though before an imaginary easel, but stepping back to judge an effect in a picture on which he is working. Since Bastien-Lepage was essentially an outdoor painter the figure is dressed in country boots, gaiters and the cloak he habitually wore.

On June 3 Rodin submitted the model to a fourteen-man committee headed by an eminent architect, Antoine-Nicolas Bailly. He knew there would be criticism, but he counted on his friends to carry the day—Cazin, Roger Marx, Antonin Proust and Alfred Roll were all voting members of the panel. Cazin, however, was unable to attend the crucial meeting, and Roll was also absent from Paris. "I am far away in Normandy and to my great regret I cannot be in Paris on the day you indicate," Roll wrote. "You know my opinion, my dear Rodin, but let me state it again in case it might carry some weight with my colleagues of the committee. You knew Bastien-Lepage and you are a very great artist . . . therefore I vote for giving you the commission and allowing you every freedom . . . I expect to see you *aux pris de rhum.*"*

At the committee meeting the collector Gustave Dreyfus did indeed propose that the maquette be accepted and the sculptor be given a free hand to make whatever modifications he saw fit. But the minutes show that the motion was not carried without difficulties of the usual sort:

> *M.* [*Simon*] *Hayem* [*art patron*]: The maquette does not depict Bastien-Lepage as we all knew him; this is not the maître

*The club, *les Pris de rhum*, a bad pun on Prix de Rome, was yet another of the flourishing dining groups in which Rodin met "that accursed circle of people" detested by Camille: it included, besides Cazin and Rodin, Gervex, Roll, Maupassant, Louis de Fourcaud, Léon Hennique and Vincent d'Indy.

who was the founder of a school, and posterity will not recognize him in it.

M. [Louis] de Fourcaud [critic]: It is difficult to make an intelligent judgment based on a maquette. One should watch over the work as it takes shape and then, if necessary, ask for modifications. M. Rodin is a great artist and the committee should rely on his judgment.

M. Antonin Proust: An artist of M. Rodin's stature, who has produced masterpieces and asks nothing more than to go on producing them, should be given complete freedom. Later one can always ask for changes. M. Rodin will never refuse to make them. All his other works were modified considerably between the rough sketch and the definitive execution.

In the end they named an advisory subcommittee that eventually approved an 8,000-franc version of the monument in which Bastien still held brush and palette but stood more upright than the earlier sketch. As Rodin explained, "I have represented Bastien-Lepage starting in the morning through the dewy grass in search of landscapes. With his trained eye he espies around him the effects of light on the groups of peasants."

For Rodin the unveiling at Damvillers in September 1889 was to be a state occasion—the first one on which one of his free-standing works was erected in a public place other than in a museum. Roger Marx accompanied him to the ceremony, which was attended by government dignitaries and addressed by the recently appointed director of fine arts, Gustave Larroumet.

By then Rodin had known for some time what it was like to be a committeeman himself and sit in judgment on other people's work. But it was too much to expect that his first experience of art-jury duty would not be marked by some dramatic incident. Bartlett's notes record part of the story in Rodin's own words: "In '86 the minister of fine arts sent Laurens* and myself to Bourges' Center of Drama,

*Not Jean-Paul Laurens but the painter W. J. S. Laurens, another friend of Georges Hecq at the ministry, who arranged this assignment in June 1886.

to judge art in an exposition there. Laurens and I then judged the whole thing. There was a medal of honor and honorable mentions. We gave the first to an unknown sculptor . . . Jean Baffier was his name; he had a Louis XI bust and bas-reliefs, etc. Now the mayor of the city was one of the Brissons [Henri Brisson had briefly been premier in 1885], and he had to do with a school of art with a director by the name of [Charles] Pètre who supposed he was to get the medal of honor. Then we dined at Brisson's and the poor director was dead with disappointment."

In talking to Bartlett, Rodin neglected to mention that he was already well acquainted with Baffier, who had nominated him for the Salon jury. At all events the rest of this curious tale is told by Bartlett in the third person:

> Brisson tried to get Laurens and Rodin to reconsider their judgment, but they would not recede—Brisson was so surprised; asked Rodin about it. Rodin said, when you make an exposition don't get all the rot from Paris, but attend to the people about you—encourage your own men—you have got all the rot of Paris here, and your own man [Baffier] is better than all. Brisson listened to this, and Rodin says he will do better next time. Baffier was from Bourges, lived in Paris and mixed in politics. He came from the same place as Saint-Just [one of the firebrands of the French Revolution] and in studying him he became mad and tried to kill a deputy. [Baffier made a harebrained attempt to kill the Député de la Seine, Germain Casse, with a sword-cane in the Chamber of Deputies on December 9, 1886.] He was acquitted after a trial.

Bartlett thought that they had "incidentally encouraged a crazy man," but Baffier quickly regained his sanity and lived for another thirty-three years as one of Rodin's most productive protégés and the foremost neo-Gothic sculptor of the epoch.*

*When Rodin, now on the Salon jury, proposed him for a second-class medal in 1888, Baffier wrote him a "joyful" letter of thanks, adding that he couldn't suppress an ironic smile "since you, *cher grand maître*, never got more from them than a little third-class medal."

Rodin's increasing aversion to the "rot of Paris" manifested itself, among other things, in his absence from the Salon of 1886. Instead he was represented by ten sculptures at an important international exhibition held at the Georges Petit Gallery. Founded in 1882 by a shrewd dealer who was the son and grandson of art dealers, the Petit Gallery was located in the rue de Sèze, off the Place de la Madeleine, in an ornate building that echoed the Opéra in its marble and onyx décor. Petit's acute instinct for public relations had made it the central meeting place for the *haute bohème* and the city's richest art collectors, who attended his exhibition openings in full evening dress.

The pieces that Rodin chose for his début at Petit's struck the critic Gustave Geffroy as the very antithesis of what had been shown at the official Salon—"eight groups or figures and two busts that overturn all accepted attitudes and show just what banalities are normally installed in the Salon; they reveal a new way of looking and perceiving." Besides the busts of Dalou and Rochefort—"at once an artist's masterpiece and a historian's document"—there were such sculptures as *Eve*, *Je suis belle*, the *Crouching Woman* and the *Fallen Caryatid*. "With his penchant for meaningful gesture and silent, violent expression, Rodin comes to us now, as the century draws to a close, to depict human physiology in all its diverse aspects," Geffroy wrote in *la Justice* on July 11, 1886. "He takes up the art of sculpture where Barye left off; from the lives of animals he proceeds to the animal life of human beings."

In Gustave Geffroy Rodin had found a prodigious champion and friend, fifteen years younger than himself but already on the way to becoming "the foremost of our French critics," as Léon Daudet described him. He was small and slender, with "the clear blue eyes of men who live on the sea or its shores," according to J. H. Rosny, but a native Parisian born to be a critic of art and literature. When Clemenceau founded his socialist newspaper *la Justice* in 1880, he hired Geffroy as a staff writer at 100 francs a month. "I still see him," Clemenceau remembered—"small, thin, puny, timid, almost happy, when he first came to *la Justice*." There were two women in his life: an imperious mother and a retarded sister, to whom he was utterly

devoted and whom he supported with his writing. Friends thought this burden gave his work a certain melancholy cast. Apart from that, other writers were much taken by his style. "You are the writer with the finest pictorial language," Goncourt told him, "a language as brightly colored as it has to be . . . the loveliest French there is."

Geffroy's lifelong friendship with Rodin began in June 1884 (according to Lawton it was Bazire who first introduced them) when the critic invited his "charming and ingenious" new acquaintance to visit him at the office of *la Justice* in the faubourg Montmartre, so that they might have dinner together—"you shall talk to me about sculpture and I promise not to talk about journalism."

They often dined together during the next few years, not only privately but at the special *dîners de la banlieue* (suburban dinners) organized by Jean-François Raffaëlli, the Impressionist-naturalist painter who specialized in the petit bourgeoisie of the Paris suburbs. Among their fellow diners were Monet, Jules Chéret and Léon Daudet, who recalled that "at these suburban dinners Rodin would speak in a low voice, stroke his beard, make brief but pithy remarks and greet our jokes with great outbursts of laughter."

A lively camaraderie sprang up between Rodin and Geffroy; in their voluminous correspondence the artist praised the writer for their "similarity of taste, of judgment" and for the sharp-honed edge of his criticisms—"the truth is incisive." When the first three full-size *Bourgeois de Calais* were unveiled at the Galerie Georges Petit in the spring of 1887, it was Geffroy who performed the necessary chore of reconciling the Calaisiens with their monument-to-be. Writing in *l'Avenir de Calais* of June 9, 1887, he explained to the still unenthusiastic citizens that their sculptor had "transfigured and amplified" the town's favorite subject:

> He has bestowed on his figures the human expression which is indispensable to the work's ultimate purpose. But as usual he has been working toward something permanent and symbolic; a synthesis. He has remained a workman yet risen to the level of philosophy. The figures that pass before us are of all times and places—marked with the sense of tragedy which is an ineluctable aspect of all great works of art.

Rodin's three first-born *Bourgeois* had already received a rapturous welcome from his other great partisan among the critics, Octave Mirbeau, whose article in the newspaper *Gil Blas* of May 14, 1887, called him the greatest sculptor in France and compared him to Phidias, Donatello and Michelangelo: "He has taken sculpture, which used to be only a perpetual rehash of Greek art and the Renaissance, and brought it back into the realm of metaphysics and of passion."

Mirbeau was a prolific novelist and critic who had spent some time working for the conservative *la France* before emerging as a major figure of the literary left. He had decided early in his career that Rodin was one of the great men of the century: "Yes, my dear Rodin, I love you in unwavering friendship," he declared in one of the first of the nearly 200 letters he wrote to Rodin during the next thirty years. He became one of the sculptor's most trusted friends and influential apostles: in the words of an unconverted rival, "Rodin is great and Mirbeau is his prophet."

He was ten years younger than Rodin, five years older than Geffroy, who shared many of his aesthetic and political convictions. "We were very good friends, all four of us," Geffroy wrote long afterwards about himself, Mirbeau, Monet and Rodin, "despite the differences in our age and situation; it gives me a certain melancholy pleasure to say that we remained friends, until Rodin's end, until Mirbeau's end."

Mirbeau was tall and athletic, with reddish hair, light-brown eyes and a ruddy complexion—"a Norman pirate," according to J. H. Rosny, who was struck by his "variable, ferociously expressive face." Mirbeau, moreover, gained the reputation of being "our most sparkling conversationalist; a rich repository of surprises, rude jokes, comic utterances and earthy epithets." He was given to vehement personal and artistic likes and dislikes that were apt, in time, to reverse their magnetic field; he lisped slightly and chewed his fingernails; whenever he lost his temper, as Daudet observed, "his ironic eyes would take on a golden glint like that of some exotic lizard."

Mirbeau and Geffroy made many of their discoveries together, or at more or less the same time—Raffaëlli, Monet, Gauguin, Van Gogh, Pissarro. Mirbeau wrote time and again about Rodin, and Geffroy followed suit. When the latter published his essays in book form, the former wrote complimentary articles about them: "He shows us day by day, so to speak, the whole of today's history of art, its disasters

as well as its triumphs. He follows the crowds through the disheartening galleries of the official exhibitions—but one always finds him wherever there is anything to see . . . nothing of any consequence in art escapes him."

Both soon owned sizable collections of Rodin drawings and sculptures, as well as their portrait busts sculpted by him. Geffroy protested that he, for one, could repay Rodin's generosity only with ephemeral ideas on perishable sheets of paper, while Mirbeau wrote self-deprecatory thank-you notes. Both writers were favored recipients of the embracing female nudes, or *femmes damnées*, in which Rodin addressed the theme of lesbianism, and which he was fond of bestowing on his friends—such as the *Jeux de nymphes* which he gave to Mirbeau. This recurrent theme of lesbian love did not derive merely from the artist's fantasies: it was a familiar enough phenomenon among the women of Rodin's circle. Goncourt's journal records the sexual proclivities of Mirbeau's wife, for example—the actress Alice Regnault, whose ex-lover, the actor José Dupuis, remembered that

> . . . one day she remained for a long time in her bathroom with a woman friend, and when she told Dupuis that her friend had peed into her hand he began to suspect, as was afterwards confirmed, that she loved women. And after that day, one or the other of them would pick up a woman at the theatre and take her home, where they slept together *à trois*. . . . One night Monsieur Dupuis lifted the coverlet and said, gazing at the way their bodies were entwined, "Look, it's the group by Carpeaux!"* Afterwards this became their private expression, and the two lovers would say to each other: "This evening, shall we do the *groupe de Carpeaux*?"

Mirbeau put his own and his wife's manifold experiences to good use in several of his autobiographical novels and short stories: *le Calvaire* of 1886 painted a ruthlessly honest picture of a young man consumed by his love-hate for a kept woman. A decade later his confessional realism culminated in a minor erotic classic, *le Jardin*

*He meant, of course, *la Danse* in front of the Opéra, with its male central figure ringed by female dancers.

des Supplices (The Torture Garden), which was to provide the occasion for one of Rodin's rare forays into book illustration. Among the literary critics the author of *Sébastien Roch*, the *Diary of a Chamber Maid* and *The 21 Days of a Neurasthenic* fell just short of being considered a great maître. Perhaps he was essentially a caricaturist, as Geffroy suggested, but of a very special caliber—without Daumier's bonhomie, "but with the nightmare qualities of Goya, and Swift's cruel verve."

><*<

While Mirbeau and Geffroy were propagating Rodin's reputation in *le Figaro*, *Gil Blas* and *la Justice*, Roger Marx was busy doing the same thing at the ministry, where—in September 1887—he had become secretary to Jules Castagnary, the director of fine arts. Despite his youth the hard-working Marx had already made a name as "one of the most reliable and best-informed judges" of contemporary French art. It was Marx who arranged for Rodin to be named to the government's commission in charge of fine arts for the 1889 Universal Exhibition—which reported to Antonin Proust—and he saw to it that the sculptor was at long last made a chevalier of the Legion of Honor.

Officially Rodin's appointment to the Légion d'honneur dates from the last day of December 1887. His friends used the occasion to organize a round of banquets in his honor. On January 21, at the Auberge des Adrets, they gave him an intimate dinner at which, while the dessert was being served, the poet Paul Arène delivered a fourteen-stanza eulogy couched in the purest doggerel: the gist of it was that while he loved the *Porte* and the sphinx and the sirens sculpted by Rodin's "sovereign hands,"

> *Yet most I love, be not surprised,*
> *Though still in fear of her caresses,*
> *The female who is on her knees,*
> *Poised on her fists and wreathed in tresses.*

Three days later a second banquet was held by the Bons Cosaques at the Lyon d'Or for both Rodin and Albert Besnard, who had also received the Legion of Honor. This time it was a formal dinner for about eighty people; the principal after-dinner speaker was Antonin

Proust, who praised both "the great kneader of human flesh" and his colleague "the passionate painter of outdoor light."

Finally, on February 17, there was another Rodin-testimonial dinner which had Goncourt as president and Clemenceau "with his round Kalmuck head" sitting beside him. Meanwhile, the cards and letters of congratulations had come pouring in. Stéphane Mallarmé, for one, had left one of his lapidary calling cards: "I had hoped to shake your hand yesterday but wasn't able to. Yet even from a distance I can see the tail end of a ribbon which, in your case, was for once not mistakenly bestowed." Legros wrote from London congratulating his old friend "with all my heart," but relations between them had cooled; Rodin suspected that Legros had grown jealous of his success.

Mirbeau also sent a letter beginning "Just two words" that ran to five or six paragraphs: "I want to see you happy, honored as you ought to be, on account of your unique talent. . . ." Yet the fact that Rodin had accepted the decoration that Mallarmé called a "vain bibelot of inanity" made Mirbeau uneasy, and he preached a sermon on the subject, "The Way of the Cross," in *le Figaro* of January 16. "Each time I hear that an artist I love, a writer I admire has been decorated, I wince and say, 'What a pity!' " The cross was for soldiers, or a bauble for businessmen. What could the debased currency of national recognition do "for a genius like Rodin"? It had come too late in any case: "Ten years ago he was known only to a few friends, today success is coming his way, tomorrow glory awaits." Rodin was furious and refused to answer any of Mirbeau's letters. The latter had to ask Monet to intercede for him, and the painter wrote to Rodin from Antibes, asking him to forgive his erring disciple: "You know the man, his passion and the way he adores your talent; don't be angry with him and do write to him; you will make him happy. But don't make it seem as though the idea came from me."

Rodin promptly forgave Mirbeau; after all, the critic had called on the authorities to give him commissions instead of medals: "Put Rodin's genius to use instead of granting him illusory rewards like those with which one flatters rubber manufacturers and politicians." In fact the government had just accorded him a further mark of favor— a 20,000-franc commission for a marble version of *The Kiss*, formerly *Françoise de Rimini*. The ministerial order also entitled him to one of the blocks of marble—No. 221—stored at the Dépôt: "Monsieur,

I have the honor to inform you that a block of Italian statuary marble of the first quality, measuring 2.25 meters by 1.35 meters by 0.88 meters, has been placed at your disposal for the execution of the group entitled *le Baiser*."

It was a seemingly uncomplicated assignment, involving the translation into marble of the life-size Kiss already shown in Brussels. But the marble was to be larger than life, and enlargements entailed certain technical problems of which he spoke to Goncourt toward the end of February: "Rodin told me that for the things he executes to satisfy him completely he needs to work on them in their full size; enlarging them from a smaller model deprives them of some of their movement. It is only by studying the full-size figure, for months at a time, that he comes to understand what it is they have lost in the enlargement. He restores this lost movement by taking off their arms, etc., and putting them on again only when he has got back their dynamic energy and lightness."

Rodin was worried lest he have insufficient time to prepare the marble Kiss as carefully as it deserved. Other work also had to be rushed; just after Christmas he had told Goncourt that he was in the midst of illustrating a copy of Baudelaire's *Fleurs du mal* for the art collector Paul Gallimard, and that he had wanted to "plumb the depths" of these poems, but that "he had not been able to do it because he was being paid too little—2,000 francs—and could not give it enough of his time." Many of these illustrations were in fact redrawn from some of his earlier studies for the *Porte* or adapted from such sculptures as the *Penseur, Je suis belle* and *The Death of Adonis*. He drew twenty-two of them directly into the margins of Gallimard's copy of the first (1857) edition of the *Fleurs*, and did five more that were inserted as separate sheets. Whether or not they were done in haste and without due process, the result was a fascinating recapitulation of his thoughts on Dante, Baudelaire and human sexuality. He told Goncourt, however, that since this was to be merely a private copy, not for publication, and "would remain locked up in the client's cupboard, he does not feel the same passion and fire as he would for illustrations commissioned by a publisher."*

*Gallimard, then thirty-seven, was "an extremely intelligent and artistic fellow who doesn't do anything," as Frantz Jourdain described him to Rodin on February 22, 1887,

One of the things that kept him otherwise occupied during the spring of 1888 were the preparations for the official Salon. For the first time in three years he exhibited one of his sculptures—the portrait of Luisa Lynch, described by fifty critics as the best piece at the Salon. Dalou's bronze bust of Rochefort ran a poor second. He had made the mistake of courting comparison with Rodin's Rochefort bust—"and it cannot be said that he issues a victor from the competition," as Claude Phillips wrote in the *Magazine of Art*. The jury, of which Rodin was now a member, declined to award a gold medal that year. But Rodin no longer had need of medals; instead he used his influence to obtain an honorable mention for Camille Claudel's *Çacountala*.

Camille's bust of Rodin was beginning to take form, though the modeling sessions were exasperating: the patient, indefatigable sculptor had proved to be an impatient and insufferable sitter. He posed so irregularly that at one point the clay dried and cracked. "Fortunately they were able to save it by making a squeeze in fresh clay," Morhardt reports. "The work was completed using this moulage and then cast in bronze."

In the meantime Rodin had been sitting for his first literary portrait. A conscientious American artist and critic, Truman H. Bartlett, had undertaken to write an extended account of his life and work, which was to be published in lengthy installments by the Boston-based *American Architect and Building News*. Born in Dorset, Vermont, on October 25, 1835,* the bearded, rather shaggy Bartlett had been trained as a sculptor and had come to Paris with his gifted son, Paul

in the letter proposing this arrangement. But after years as a bibliophile, collector, traveler and critic Gallimard became a publisher: in 1918 he brought out a facsimile edition of twenty-five poems of the *Fleurs* illustrated with all twenty-seven of Rodin's drawings.

*Albert Elsen's introduction to the only modern reprint of Bartlett's work—in *Auguste Rodin, Readings on His Life and Work* (1965)—states that he was born in 1865. But this is his son's birth date. The fact that Truman Bartlett was five years older than Rodin is of particular significance since it made him immune to the hero worship that distorted the writings of the younger biographers. Bartlett also wrote essays on Frémiet, Aubé and Millet, and on the physiognomy of Abraham Lincoln. His most notable sculptures are a widely reproduced statuette of Lincoln and a statue of the discoverer of anesthesia, Dr. Horace Wells, on the grounds of the State House in Hartford, Connecticut. He died in Boston, after a long and distinguished teaching career, in 1923.

Wayland Bartlett, who studied sculpture under Frémiet and Carriès. Not only was he the first to write systematically about Rodin's life: he had a New England Yankee's pragmatic interest in his subject's day-to-day affairs—how much money he earned, what methods and materials he used.

Accordingly his ten-part biography became one sculptor's view of another sculptor's problems and solutions: not for him the transports of Symbolist hyperbole that came so easily to his French admirers. There were days when Rodin exasperated Bartlett. "Does R. lie?" he jotted on one of the scraps of paper on which he kept his notes. "He is a cuss anyway." Yet he liked and respected the younger man enormously, both as an artist and a human being. "Rodin is bold, proud and simple," he summed up in the last of his articles. "He has something to say, and the good fortune to say it."

Bartlett paid his first visit in November 1887—and his initial impression of Rodin's studio in the Dépôt des Marbres was "one of astonishment and bewilderment; astonishment at the size of the door and the style of its design, and bewilderment at the extent and variety of the forms that compose it." He was struck by the vast number of detached plaster figures "in every conceivable position" that covered half the floor and most of the available wall space. Soon he was back for a series of informal interviews that yielded an extraordinary amount of information about the sculptor's early years—of which Rodin, at forty-seven, still had vivid and accurate recollections. With this American visitor he was also inclined to be unusually candid about his self-doubts and anxieties. In his notes for "Eve'g Dec 9, '87," for example, Bartlett records: "Rodin says that almost always it is only at the last moment that he finds his idea in a figure or bust, and generally he wanders about in the deepest despair for a long time before he finds what he wants. Sometimes he casts a work in plaster, thinking it about right, and afterwards, seeing what he wanted and did not get, he reproduces it in clay and makes it right."

When he had taken down the story of Rodin's early years Bartlett was moved to ask, "Have you ever felt like complaining as a man and artist of your country or of mankind?" The answer was no:

I never felt slighted or frustrated, because I never thought much of attaining a high position. . . . In many respects I have had

the best of luck. Nearly every writer is in my favor. A few of the best artists feel the same way. Some of these writers are anxious to declare war against the crowd of so-called sculptors who work from casts from nature, and support me in working entirely from life. But I am too old to enter such a campaign. All I ask is peace to work and a quiet life. I have no taste for luxury, society or fine dinners. My work is my comfort, and it is sufficient to satisfy me. I want my tranquillity—my time, not fights. I can live now fairly comfortably, not too much pressed for money. . . . I have made everything that I have lived and loved.

On other occasions Rodin sounded far more bitter and pessimistic. One day he told Bartlett that "the world is *bête* [stupid]," and that a lot of artists, presumably himself included, had made things that were far too good for this ungrateful world: "Our century is a lie in sculpture and without taste, though there is a little left in France."

In the published version of the interviews, which began to appear in January 1889, Bartlett was at pains not to make his subject sound too much like a crank. It was difficult enough to explain his sexual attitudes to readers of the *American Architect*. Admittedly, "the early Puritans would have burned Rodin at the stake," and their successors would want to attach fig leaves to many of the figures of the *Gates of Hell*:

The fault of too free representation of the passion of love was first found at the time of the exhibition at Petit's galleries of some groups and sketches of the figures made for the door, and again referred to by some English artists who visited Rodin's studio. The pleasing terms used to designate these works were "vulgar," "indecent," "illogical," "exaggerated effects." Private criticism has denominated their author as "crazy" and a "fool."

In modern France, fortunately, there were no laws against making sculptural representations of "love's manifold expressions." Indeed, the younger generation saw him as a great liberator of sensual symbols and gestures—though Bartlett did not quote from the review that

Huysmans had published in *la Revue indépendante* in June 1887, praising his work for embodying "the blazing cries of a creature in rut, the violent embraces of the flesh like the superb *phallophobies* of Rops. The contorted couples are convulsed with rapture." Bartlett preferred to let his readers think that Rodin, far from being a high priest of erotica, was one of the "purest and most delicate souls that ever touched clay into loveliness and grace."

Bartlett may well have been mistaken on this point. Yet his articles as a whole are so factual and well-documented that every modern Rodin biographer is infinitely indebted to this middle-aged American sculptor who was the first, and almost the last, to treat the maître as a man rather than a monument.

>‐<

Rodin had told Bartlett, among other things: "I have many friends in art. . . ." His artist friends now came from increasingly distant parts of the world; there was even the Australian painter John Peter Russell, a friend of Pen Browning's, whom Rodin found immensely entertaining and soon made a member of his inner circle. Russell came from Sydney and was eighteen years younger than Rodin—a big, energetic artist who had earned something of a reputation as an amateur boxer. He had studied in London under Legros until 1884 and had gone on to Cormon's studio in Clichy, where he made friends with Van Gogh, Toulouse-Lautrec and other Post-Impressionists. The sale of his father's business interests in Australia brought him a large private income that allowed him to live very comfortably, and before long he was living together with the Italian model Marianna Antonietta Mattiocco, whom Rodin is said to have called "the most beautiful woman in Paris." Frémiet used her, in armor, as the model for one of his statues of Joan of Arc; Rodin did her portrait in wax early in 1888, the year of her marriage to Russell.

The finished bust of Marianna with its classical features became one of Rodin's favorites; later he was to use it again as the basis for *Minerva with a Helmet* and other quasi-Grecian sculptures. He was anxious that the Russells be equally pleased. "I have just sent you the proof of the bust of Madame Russell," he wrote to the painter. "Tell me what you think of it, and how it looks on its pedestal. I hope that Madame Russell will also tell me frankly what she thinks

of it. You're hard at work I suppose, or at least you work despite your despair. [They had recently lost their second child.] I am still in a sorry state, harried by so many things to do, and which I cannot do quickly. I ought to be more philosophical and not allow myself to be distracted by the things that tear at me from all sides. . . ."

Russell was delighted with the bust. He and his wife were building a house overlooking the sea on the landscape painter's island of Belle-Ile-en-Mer, off the coast of Brittany. From there he wrote to Van Gogh on July 22, 1888: "Before I left Paris I lunched with M. Rodin (who has finished a fine head of my wife) and M. Claude Monet; saw ten of M. Monet's pictures done at Antibes." He had met Monet at Belle-Ile quite by chance two years earlier and had grown fond of both the man and his pictures; eventually he would also talk Rodin into making the journey to his "eagle's nest" on the Atlantic coast. The young painter belonged to a generation for whom both Rodin and Monet were no longer controversial figures but the acknowledged leaders of the "mighty revolution in art" which he described to a fellow Australian, Tom Roberts:

Of course the followers, the ragtag and bobtail, make Impressionism ridiculous as the leaders of the movement well know. But what glorious work I have seen by Degas, Claude Monet, Rodin in sculpture, Raffaëlli (not lately though), Renoir in figure, Whistler, Pissarro, Gauguin, Guillemain and Caillebotte and a lot of younger ones, some of whom have revolted from Cormon's rule. . . . Rodin is very satisfying. I am happy in possessing several things of his (in trust for Australia) a bust in silver of my wife. He is a [illegible] man—Simple—wrapped up in his work, with a head and beard that recalls the great Jove of Michael Angelo.

Some of Rodin's old friends had begun to see him in the same light. After admiring his work at the Brussels exhibition of 1887, Juliaan Dillens wrote his former comrade a letter calling him "the Christopher Columbus of this art. . . . We went to see you as we would have gone to a Donatello, a Michelangelo." The plaster *Kiss* shown in Brussels was a painted cast of the original clay group and bore all the marks of Rodin's careful workmanship—it was more

nervous and alive than the cool marble soon to be cut by a praticien. Rather than ship it back to Paris, Rodin made a present of it to another old Belgian friend, Paul De Vigne, who had moved back to Brussels four years before. "It gives me enormous pleasure to witness your triumph," De Vigne wrote to him that autumn, "and to see the development of your steadily growing gifts."

It was a further measure of his hard-won success that other established artists were now anxious to obtain his opinion of their work. Berthe Morisot, for example, did a bust of her daughter which she exhibited at Petit's in 1887, and wanted to know what Rodin thought of it; her friend Monet was asked to serve as a go-between. "As you'll be able to judge for yourself," Monet assured her, "he is the best of men, with an exquisite taste, which is rare among sculptors."

These friendly feelings were warmly reciprocated. Rodin had a special fondness for Monet, perhaps because the taciturn painter thought him eloquent and always listened attentively when he spoke. At one point Rodin discovered, or thought he discovered, that he and Monet had been born on the same day, November 14, 1840, though in fact he was two days older, having been born on the 12th. No matter: in his eyes there was a predestined affinity between himself and this quasi-twin, *"mon compagnon de route."*

In 1886 Rodin had spent a fortnight with Mirbeau and his wife on the island of Noirmoutier near the mouth of the Loire, and afterwards Mirbeau had written to Monet: "We were talking about you, so many times; if you knew what respect, what tender admiration Rodin has for you! In the open country or on the sea; a view of a distant horizon, the wind stirring the leaves or the movement of a changing tide—he would cry with an enthusiasm that says everything, 'Ah! that's beautiful . . . it's a Monet!' He had never seen the ocean before [though Rodin had crossed the Channel several times and had seen the North Sea from the Belgian coast, this was his first look at the open Atlantic]; he recognized it from your pictures—you gave him the exact and vibrant sense of it."

In the spring of 1888 the Durand-Ruel gallery invited Rodin and Monet to participate in a major exhibition of Impressionists that was to include seventy-five paintings by Renoir, Sisley and Pissarro. Rodin declined politely when he heard that Monet had fallen out with Durand-Ruel. "You've come to the studio and I'm sorry not to have

been there," he wrote to the gallery owner on May 10. "I received a letter from Monet who told me that he will not take part in the exhibition. As a favor to him, though I have nothing on hand, I might have exhibited a small plaster, but I prefer to wait for a comprehensive exhibition at which I can be represented by many things."

A year later the tactful and persistent Georges Petit managed to organize a major retrospective of both Monet and Rodin—"no one but you and me," as the painter wrote in February when he first proposed the idea. The gallery in the rue de Sèze provided the perfect showcase for 145 of Monet's pictures covering the years 1864 to 1889, and thirty-six sculptures by Rodin ranging from *The Man with the Broken Nose*, refused by the Salon in 1864, to all six of the *Bourgeois de Calais*, making their first public appearance as a group. Yet the effort of putting the show together cost the artists more trouble than they had bargained for. When it came to hanging the pictures and placing the sculptures Rodin revealed a side to his character that took everyone by surprise. As Goncourt noted, "It seems that terrible scenes took place in which the gentle Rodin suddenly erupted as a Rodin unknown to his friends, shouting, 'I don't give a damn for Monet, I don't give a damn for anybody, I'm only interested in me!'"

Monet was heartbroken when he saw the result: the painting on the back wall, "the best in my exhibition, is absolutely lost since the placement of Rodin's group. The evil is done . . . it's devastating for me," he wrote to Petit on June 21, 1889. "If Rodin had realized that, as joint exhibitors, we ought to have agreed on the placements . . . if he had thought about my requirements and paid some attention to my works, it would have been easy enough to arrive at a good arrangement without interfering with each other. . . . I left the gallery completely crushed. . . . I had trouble containing myself yesterday, seeing Rodin's strange behavior. . . . All I want now is to go back to Giverny and find some peace."

The public heard nothing of all this, and the exhibition was celebrated in the press as an unmitigated triumph for both artists. Petit's catalogue had a preface by Mirbeau for Monet's pictures—"the outdoors is his only atelier. . . . There he creates the most beautiful, most significant works of our time"—and a preface by Geffroy for Rodin's sculptures: "like all great artists he might be defined as an

Ego coming to grips with Nature." Writing in "a touching spirit of friendly rivalry," both had produced windy and ecstatic essays. "If they hadn't stopped us," Geffroy recalled, "we would have written whole books in the full flush of our enthusiasm."

Mirbeau went on to publish a glowing account of "this colossal, smashing success" in *l'Echo de Paris*. "What is so poignant about Rodin's figures is that we discover ourselves in them, that we recognize our disillusionment in them, that—to use Stéphane Mallarmé's lovely phrase—*'elles sont nos douloureux camarades'* [they are our suffering comrades]."

The six *Bourgeois*, in plaster, were listed as No. 1 in the catalogue and were the most heatedly discussed sculptures at the exhibition. For Firmin Javel, writing in *l'Art Français*, they "embodied a revolution, in the sense that they have overturned all the most solemn traditions." Alphonse de Calonne, in *le Soleil*, wrote that Rodin's figures reminded him of "clowns in our lowest form of entertainment." Still, the critical consensus was that Rodin had struck a powerful blow for modernity: "*la victoire est complète.*"

Only the sculptor himself was feeling less than triumphant. Friends who met him at the exhibition found him depressed and discouraged. When Henri Cheffer congratulated him at the opening, Rodin thanked him and added, "You know, I still don't have a *sou.*" It was only a figure of speech, of course, but it was true that he was supporting two households—and several assistants—on a still modest and unpredictable income. To Omer Dewavrin he confided that he was at that moment "at the end of my tether." The ex-mayor had written to say that the city of Calais had resumed its efforts to finance the monument, and that the president of the Republic, Sadi Carnot, had promised a government subsidy. Rodin was seemingly unimpressed by the news. "I shall take two months off to get some rest, and on my return I'll give the matter my attention. . . . I'm sorry not to be in Paris to receive you and discuss all this, but I'm simply worn out."

Yet he had not been too exhausted to visit Georges Hecq at the ministry and to inquire about the ways and means of applying for a subsidy. When he heard that there was nothing to be done until September or October, when the next year's budgets were to be drawn up, he set off immediately for the provinces—*un voyage circulaire*, as he explained to Roger Marx. "I have gone on an excursion; I need

it badly and was in such a hurry to get some rest that I did not come to see you before leaving despite the fact that you have begun to set the *Bourgeois de Calais* affair in motion. I've been to see Hecq and he is with us heart and soul. . . ."* Marx had just been appointed chief inspector of national museums, and Rodin did not neglect to add his congratulations and his high hopes for "the great influence which one day I expect you to exercise on our French art."

Rodin's holiday took him by stages to the south of France, and Camille must have accompanied him at least part of the way. Rose had a letter from him dated August 9, written in the gruff managerial style he usually used when he had a bad conscience. She was to give his private mail to Desbois, who had the responsibility of forwarding the mail that had accumulated at the studio: "Give him the letters that were not included in my suitcase; you made a mistake and left some of them out, while putting in some of those which were not supposed to be included. Look for anything that has to do with the exhibition in the rue de Sèze." It was signed "your devoted friend Rodin" and contained only the sketchiest news about himself. "I am making some progress in architecture, and am at this moment in Toulouse. You can spend a few more days with our friend [Dr.] Vivier. . . . Don't forget to go to the Exhibition very often."

>✠<

It was the summer of the Universal Exhibition of 1889, the most spectacular world's fair of the century. No other city could rival Paris as a setting for an event of this kind, and no effort or expense had been spared to celebrate not only the centennial of the French Revolution but the emergence of France as a great industrial and colonial power. An immense variety of displays was housed in a vast city-within-a-city stretching from the Trocadéro to the Champ-de-Mars and the Esplanade des Invalides. Besides the more conventional exhibits of commerce and industry there were transplanted samples

*Hecq (1852–1903), who had been so forthcoming as Turquet's assistant, remained permanent *chef du secrétariat des Beaux-Arts au cabinet du ministre*—an exceedingly influential post. He also lent a helping hand in promoting Mlle Claudel's career, and received his earthly reward in the form of a Rodin bust. It adorns his grave in the Capuchin cemetery in Bourges.

of colonial Africa and the mysterious East: a Buddhist temple, a Moroccan bazaar, a Chinese pavilion, a Senegalese village, a whole Cairo street in replica, a Vietnamese theatrical troupe, a Javanese kampong and much else.

Overshadowing this babel of styles and cultures was the Eiffel Tower, at 300 meters the world's tallest structure, which had been specially erected for the occasion. While it was still in its initial stages many of the city's most eminent artists and writers had signed a petition against the impending desecration of Paris: "All our historic buildings, our monuments of rare and appealing beauty, are dwarfed and humiliated by this monstrous apotheosis of the factory chimney whose odious shadow will lie over our city like a gigantic and shameful stain." Meissonier, Gounod, Sardou, Bouguereau, Maupassant and the younger Alexandre Dumas had been among the protesters, but the modernists had prevailed, and when the elevators of the Eiffel Tower were inaugurated on May 19, even some of its erstwhile opponents began to discover unsuspected virtues in the hideous thing. Edmond de Goncourt, who had regarded it as an affront to the eyes of an old man of taste, made the ascent on the balmy evening of July 2 in the company of Zola, Abel Hermant and several other literary lions: "The lift in motion feels something like a ship getting under way, but it doesn't make you seasick. From the top you can see, farther than you could ever have thought, the extent, the grandeur, the Babylonian immensity of Paris."

Among the exhibits at the fair were two giant displays of French art, past and present, in which Rodin was necessarily represented as only one among many, by *l'Age d'airain* and *The Man with the Broken Nose*, as well as the busts of Proust, Dalou and Victor Hugo. The real excitement of the occasion, however, was generated not by the static displays in the Palais des Beaux-Arts but by the living dancers and musicians of the Algerian café, the theatre of Cochin China, the Egyptian belly-dance troupe and the Javanese kampong in the Dutch colonial section. It was in this Javanese section that Claude Debussy first heard the unforgettable sound of gamelan music which, as he said, made Palestrina's counterpoint seem like child's play by comparison. Rodin had gone there to make sketches of the dancers, who were every bit as fascinating to him as their music was

to Debussy. But not until two years afterward did he discuss his impressions with Goncourt:

> While we were walking before dinner, Rodin spoke to me about his admiration for the Javanese dancers and of the sketches he made of them, quick sketches not sufficiently penetrated by their exoticism, which therefore still retain something of the antique. He also talked about similar studies of a Japanese village transplanted to London, where there were also Japanese female dancers. He finds our dances too jumpy, too fractured, whereas in these dances it is like a succession of movements that engender and produce snake-like, wave-like effects.

The Javanese were a great favorite with the intellectuals, but the largest crowds at the exhibition would assemble at night, on the Champ-de-Mars, to watch the latest marvel of scientific Europe—electrically illuminated fountains in changing colors which were turned on at 11:00 P.M. Luminous jets spurted from the base of the Eiffel Tower in azure, gold, scarlet and emerald, then gradually shifted to more delicate hues.

France had just experienced five years of economic crisis and technological unemployment; the reins of government had changed hands almost every year, and politics were in a chronic state of turmoil. It was not a coincidence that the underlying theme of the Universal Exhibition was movement, change, "progress" and all it implied. To an elderly misanthrope like Goncourt, the whole of society had been infected by it: "Paris is no longer Paris but a sort of open city where all of the world's thieves, having made their fortunes in business, come to eat badly and to sleep snuggled up against the flesh that calls itself Parisienne."

At a time when the zeitgeist itself was out of joint there was something vaguely inconsistent and troubling in the marble statues arrayed in the fine arts pavilion: it was as though the artists were expected to furnish a stable center for a society that was now inherently unstable and unpredictable. Rodin's recent experience had provided a perfect case in point: the city fathers of Calais had asked him for an immutable monument in bronze at the very moment when

their banks failed and their textile industry collapsed. Some of the painters and poets had already moved into new regions of ferment and ambiguity, into pointillism, Post-Impressionism, Symbolist spiritualism; the shifting verbal sands of Mallarmé and Verlaine. Debussy, having listened to the Javanese percussion players, was about to open a new chapter in French music with the shimmering, inconclusive harmonies of *Pagodes*. It seemed as though only the sculptors were expected to go on acting against the spirit of the times, producing images of solidity and permanence in an age of flux.

Rodin's thirty-six sculptures at the Georges Petit gallery had been intended as an amplification of the handful of his works which were to be seen at the exhibition, and the critics treated it as such. Félix Jeantet wrote that the show at the rue de Sèze was the "ultimate extension" of the centennial exhibition, for "Rodin is without doubt the last word in sculpture." Even in the semi-official *Revue de l'Exposition Universelle* Rodin's "powerful and enigmatic works" were the first to be mentioned in the section devoted to contemporary sculpture, ahead of Dalou, Chapu, Falguière, Mercié and a host of academicians. The most visible mark of his modernity was precisely his refusal to create the expected, definitive image: he knew, from his innumerable intermediate-stage plaster casts—or so-called squeezes—that a work of sculpture has nine lives during its gestation period. The point at which he took the onlooker into his confidence now occurred earlier and earlier in that process. Increasingly he was exhibiting figures without hands, torsos without heads, unfinished sketches, casts with their mold marks left on them as geometric dividers and design elements.*

When Goncourt went to see the Monet-Rodin exhibition a few days after ascending the Eiffel Tower, he sensed that this rebellion against determinism was one of the decisive aspects of Rodin's work—though his own ingrained classicism made him deeply suspicious of it. "Rodin a man of talent," he noted in his journal on July 11, 1889, "a sensual sculptor of the lascivious or passionate undulations of the human

*The idea of showing cast marks and making a virtue of technical necessity is one that can be traced back to the bronze founders of Shang dynasty China (ca. 1500–1000 B.C.). Rodin, however, was the first to use it as the modern sculptor's equivalent of Mallarmé's teaching that "poetry is made with words."

body, but with defects of proportion and almost always with extremities that are not fully executed. Amid the present infatuation with Impressionism, when all of painting remains in the sketch stage, he ought to be the first to make his name and *gloire* as a sculptor of unfinished sketches. As for Monet, my vision is not made for these landscapes, which strike me, at moments, like pictorial birds of passage. . . ."

>*<

Rodin returned from the Midi by way of Albi and Clermont-Ferrand. Early in September he was back in Paris, arranging with Geffroy to visit the Daudets and writing to the winemaking Captain Bigand-Kaire to thank him for his friendship and patience: "I have only just read your letter, on returning from a journey. With me you will not be surprised by my lack of punctuality. I have been suffering from this malady ever since I was born."

Not long afterwards a friend happened to meet a disheveled Guy de Maupassant walking along the boulevard Haussmann in a highly agitated state, talking to himself or some imaginary person. "I have just come from the studio of a friend," the novelist explained, "a famous sculptor who has enormous hands and does very small and beautiful objects." He had been to Rodin's atelier, and he went on raving about the huge hands that had produced such minute, fragile things. At the time Maupassant was working on his last novel, *Notre Coeur*, which was to contain, as its most interesting character, a sculptor called Prédolé who "had gained a great success and had captivated all Paris some two months before by his exhibition at the Varin gallery," i.e., the Galerie Georges Petit. Prédolé is introduced as a celebrated yet retiring artist who has "rediscovered the tradition of the Renaissance and added to it the sincerity of modern art"— and Maupassant goes on to draw a memorable if not always flattering portrait of Rodin as he appeared to his friends at the age of forty-nine:

> He was a large man of uncertain age, with the shoulders of a peasant, a powerful face with strongly marked features, framed by hair and a beard that were beginning to turn gray; a prominent nose, fleshy lips—and an air of timidity and embarrass-

ment. He held his arms away from his body in an awkward sort of way that was doubtless attributable to the immense hands that protruded from his sleeves. They were broad and thick, with short muscular fingers, the hands of Hercules or a butcher, and they seemed to be conscious of being in the way, embarrassed at finding themselves there and looking vainly for some convenient place to hide themselves. His face, however, was illuminated by clear, piercing gray eyes of extreme expressiveness, and these alone seemed to impart some degree of life to the man's heavy and torpid expression. They sparkled, moreover, with tremendous éclat, mobility, curiosity. They were constantly searching, inquiring, scrutinizing, darting their rapid shifting glances here, there and everywhere, and it was plainly to be seen that these eager, inquisitive looks were the animating principle of a deep and comprehensive intellect.

The real Rodin meanwhile was working on sketches for a new large-scale monument destined for the marble halls of the Panthéon. On September 16 he had received the formal commission for a *monument à la mémoire de Victor Hugo* whose allocated fee—75,000 francs—indicated its importance to the government.

It was a commission for which several leading sculptors had been competing ever since Hugo's death on May 22, 1885. During the preparations for the poet's state funeral, the Senate and Chamber of Deputies had resolved that the church of Sainte-Geneviève was to be deconsecrated, henceforth to serve as a national shrine and tomb for illustrious Frenchmen—beginning with Victor Hugo. The idea of converting this immense building into a national memorial had first occurred to the revolutionary government of 1791, which had renamed it the Panthéon and had added an inscription to the pediment: *Aux grands hommes la patrie reconnaissante*—To Its Great Men, from a Grateful Nation. These words had been effaced after the Bourbons regained the throne, and were restored after the July Revolution of 1830. Under Napoléon III the original name, Eglise Ste-Geneviève, was revived, but the inscription remained and people went on calling it the Panthéon. Now, to signalize its return to the republican fold, the ministry of public instruction appropriated three-quarters of a

million francs to fill the shrine with monumental sculpture on such subjects as the Spirit of the Revolution and the Orators of 1830.

Only the best-known of French sculptors, including Dalou and Mercié, were to be entrusted with the work. Dalou had exhibited a maquette for a Hugo memorial, using his death mask of the poet, at the Salon of 1886. But Rodin's bust of the living Hugo had struck the critics as more "implacably and boldly" true to life. To create his Hugo monument Rodin had merely to integrate his portrait bust into a full-length figure of some kind. He proposed to do this by depicting "Victor Hugo in exile, the one who had the steadfast courage to protest for eighteen years against the despotism that drove him from his native land," as the selection committee noted in its minutes. "He has represented him, therefore, seated on a rock at Guernsey, and behind him, rising on the volute of a wave, the three muses of Youth, Maturity and Old Age, offering whispered inspiration."

As usual there had been a good deal of backstage maneuvering before the final commissions were announced. The director of fine arts, Jules Castagnary, had died in 1888, after less than a year in office. Rodin had willingly sculpted a monument to his friend which was erected in Montmartre cemetery—a bronze portrait of Castagnary as he looked at his desk, "his vest open and his cravat negligently tied, his right hand holding a pen against his chest in a characteristic gesture." His successor, Gustave Larroumet, was twelve years younger than Rodin and not nearly so well disposed toward him: he had been a theatre historian rather than an art expert. Yet Larroumet claimed to have the Hugo monument at heart: "If I've allowed it to slumber," he assured Rodin on February 4, 1889, "it was by reason of necessity, and it will soon be reawakened." In October he sent an encouraging reminder: "Don't forget to let me know in advance when your Victor Hugo maquette is ready to be viewed. I'd like very much to be the first to see it."

Rodin produced two preliminary studies of his Hugo on a rock; one nude, the other clothed. By now he was well acquainted with the ways of selection committees, and he could not have been too surprised by the difficulties that arose when he showed his nude sketch to the Panthéon consultants, a group headed by Larroumet that included Dalou, Chapu, Paul Mantz, Charles Yriarte and the veteran

director of national museums, Albert Kaempfen. Rodin's proposed monument was so unusual that the committee insisted on trying out a painted canvas and cardboard mock-up in the place it was to occupy, in the left transept of the Panthéon. It gave them a pretext for rejecting the idea as unsuited to the site: "However admirable they might be when finished, the three women who dominate the poet's head form a confused mass when seen from a distance. . . ."

It was Kaempfen who insisted that the monument would not "silhouette" properly, and the others concurred: Rodin was asked to prepare another maquette. *Le Temps* reported that the sculptor had taken this rebuff in good grace. "He is very annoyed by the uproar this little incident has created and is going back to work in order, as he says, to 'try to satisfy the committee.' " When Mirbeau questioned him about it, Rodin answered, *"Travaillons, travaillons. Le reste n'est rien."* ("Let us work, work; the rest is nothing.") Goncourt, as usual, heard a different version: "Rodin says that he gave way too easily and that if he had listened to Bracquemond, and if perhaps he had listened to Goncourt, he might not have knuckled under so easily."

Mirbeau, in *le Figaro*, fulminated against the "saddening and scandalous" circumstances that could bring Rodin to such a pass: "Who is M. Kaempfen to oblige an artist of Rodin's standing to begin a work over again?" These attacks only served to annoy Larroumet, who wrote an article in *le Figaro* a few years later accusing "mediocre, inconsequential" writers—i.e., Geffroy and Mirbeau—of having turned Rodin's head. Still he was diplomatic enough to find a way of averting another scandal: instead of one statue Rodin would do two—a new site would be found for the nude, seated Hugo, while a different, standing Hugo would be created for the Panthéon. The former would go to the Luxembourg Gardens where, as Larroumet wrote, it would "take its place on the very path where, at the age of twenty, Victor Hugo used to dream of his fiancée."

The two monuments took up most of Rodin's time when he returned from his summer holidays with Camille. "I must work hard this winter," he explained to Rose, "for I'm frightened when I think about my unfinished works and the Hugo which I have to begin again after having worked on it all last winter." At last, on December 8, 1890,

he notified Larroumet that the seated Hugo was nearly finished, and that he had prepared a maquette of the other one:

> I hope you'll give some thought to the Victor Hugo commission you've awarded me. Its execution in marble should cost 45,000 francs; bronze would be a little less expensive but the work would lose something. As for freezing spells, there is no need to worry about them. Puget's marbles suffered very little damage, and only after a very long time, though they have many grooves, which is why I cite them as an example. . . . I should also like to show you the new composition for the Panthéon (on which I've made great progress). I'm doing an apotheosis, since the building's pediment is inscribed with the words *Aux grands hommes la Patrie Reconnaissante.* Victor Hugo is crowned by the Genius of the nineteenth century; a descending Iris resting on a cloud crowns him too, or rather their hands hold flowers, some laurels, above him. Lower down I am making a powerful figure that raises its head and contemplates him in his apotheosis; it is the crowd that gave him his unforgettable funeral; it is all of us, Vox Populi. At any rate I should like to ask your advice about it. Victor Hugo is on a rock and a Nereid, or the wave, brings him a lyre; behind the monument, Envy flees into a low fissure in the rock.
>
> There you are, my dear *directeur*, it's not like the other one, a compact mass, but shoots upward and "silhouettes" in accordance with our program. I want to show it to you as a friend who will give me his advice before I show it officially. I'll be very pleased if I have the honor of seeing you on Wednesday.

Larroumet took care to obtain an expert evaluation before committing himself to the second Hugo commission, but since the report was prepared by a Rodin supporter, Paul Lefort, the result was a foregone conclusion. Lefort recommended its purchase for the Luxembourg Gardens after examining the clay group "in which his thought has been definitively expressed." To execute it in marble, as Rodin had explained, would entail carving four separate figures: "That of Victor Hugo, those of the two *génies* which symbolize his poetry, and

that of Justice." These supporting figures were later to be known as the three muses, each named for a volume of Hugo's poetry—*les Châtiments, les Contemplations* and *les Voix intérieures.* Lefort estimated that the sculptor had spent 12,000–13,000 francs on the preparatory stages of the monument; that the work of the marble carvers would cost 5,000 francs and that Rodin would still have to do a certain amount of work on the heads and faces before turning them over to his praticiens. If the ministry furnished the marble, 38,000 francs would be reasonable for the finished work. Larroumet settled the matter generously by scrawling his instructions across the report: "Fix the price of the commission at 40,000 francs."

Of this allotted sum Rodin collected two payments totaling 11,000 francs during the next four years, but he was in no greater hurry to complete the Hugo monuments than he had been to finish the *Porte.* Perhaps their incompleteness denoted a certain inward confusion and uncertainty as to what these monuments were supposed to convey. Yet it was also a symptom of Rodin's increasing dislike of the whole genre of monumental sculpture, with its literalism and pomposity. He had come too far along the road to freedom to turn back now and appease an outworn aesthetic. His revolt took the tactile, physical form of taking off heads, amputating limbs, slicing off backs. Iconoclasm was his intuitive way of breaking out of the tyranny of kitsch. Accordingly, rather than finish his monuments to Hugo he really preferred tearing them apart. (The standing Hugo was eventually abandoned altogether.) As with the *Porte* he proceeded to use the Hugo projects as a quarry for other figures and detached fragments that began to lead a life of their own. The muse of *les Voix intérieures,* for example, originally a child of the *Porte,* was to become one of his best-known partial figures—the armless *Meditation,* or *The Inner Voice.*

>✷<

His days and weeks, in the late Eighties, were busier than ever. His working day began at dawn, as Goncourt reported: "He rises at seven, enters his atelier at eight, and interrupts his work only for lunch, then continues until nightfall, working on his feet or perched on a stool, which leaves him thoroughly worn out at night, and ready for bed after an hour of reading." In addition, there were journeys, visits,

meetings, dinners: he was now "a sculptor of national importance," as Arsène Alexandre wrote in the *Journal des Artistes*, and one day his art would be as famous as that of the Greeks. Though people thought of him as a revolutionary, "nothing could be further from his mind than to make a revolution. Rodin is the calmest, most placid of men . . . very gentle, a terribly hard worker, with a tawny beard and an eye that sees everything without seeming to."

His studio was fast becoming an obligatory port of call for foreign artists and writers. The young poet Arthur Symons and the future "sage of sex," Havelock Ellis, were typical of his English callers: they came armed with letters of introduction and were invited to watch him at work. Another fascinated visitor was the thirty-four-year-old Belgian Emile Verhaeren, the Walt Whitman of French literature, who had connections to the Paris avant-garde via Les XX in Brussels. "I've spent the day going to see some of my friends here," he wrote to his wife on October 26, 1889. "Rodin, Mallarmé—whom I venerate as the greatest of living poets—Signac and Seurat. We talked about art, a great deal. Rodin showed me a recently made figure which is one of the most sinewy and contracted things I've ever seen. It's a mad entanglement of bodies, yet despite everything, by I know not what magic of art, it is somehow chaste." Wealthy collectors were also flocking to see groups such as *l'Emprise* (The Possessing) and *le Péché* (Sin) which were then on view in Rodin's studio. Henri Thurat was proud and flustered to be able to bring a princess and a marquis to his "cousin's" atelier on a Sunday afternoon.

There were countless invitations to dinner with old friends and new acquaintances; to a costume ball chez Juliette Adam, and to a winter visit with the poet of the *Névroses*, Maurice Rollinat, a member of the Cladel circle who had fled the neuroses of Paris for the country pleasures of Fresselines, not far from Limoges. He lived there in a tiny house with a petite amie who was the sister of an actress in Sarah Bernhardt's theatre company, and he invited a succession of his old Paris friends to be his guests—notably Monet (who painted a series of landscapes nearby), Geffroy, Rodin and the playwright Louis Mullem, an editor of *la Justice*. Rollinat would entertain them at the piano, improvising songs to poems of Baudelaire—which he did "incomparably" well, though as Rodin said, he sang "in a voice that sounded wounded [*une voix comme blessée*]." The novelist Lucien

Descaves never forgot "the Christmas Eve supper festivities at Fresse-lines, with Geffroy and Rodin, after returning from midnight mass, said by the Abbé Daure and accompanied on the organ by Rollinat."

In Paris Rodin's social circle had expanded enormously, but he had still not learned how to make small talk at the dinner table. "When he came to dine at my father's house," remembered Francis Jourdain, son of the architect and critic Frantz Jourdain, "Rodin never took part in the lively discussions that animated their dinner parties. To me his impassiveness and silence were rather frightening. He seemed to be embarrassed by the attentions lavished on him from all sides. As a result he was neither restless nor bored; in fact he displayed no emotion whatever. His shyness was so evident that I used to ask myself why the devil he accepted invitations that gave him no pleasure."

Jourdain's elders told him that Rodin was "living in his dream," but the boy felt that this was just a polite way of saying that the sculptor was sunk in his own thoughts and waiting patiently to go home to bed. "There was nothing of the dreamer about him; this heavy-set man . . . was an imposing figure. He emanated a sense of power that was extraordinary and animal-like. . . . He had something of the superb architecture of an elephant."

Occasionally this difficult, taciturn man would put in an appear-ance among the most articulate writers of the avant-garde. The Symbolists and Decadents invited him to their Monday-evening sessions at the Café Voltaire on the place de l'Odéon in the Latin Quarter. Verlaine attended these meetings more or less on his last legs, his neck enveloped in a twisted scarf and leaning on a stick; with him was Jean Moréas, author of the Symbolist Manifesto; the young poet Charles Morice; Maurice Barrès, and a dozen other writers, as well as Eugène Carrière and Paul Gauguin.

According to John Peter Russell's daughter Jeanne, Rodin also encountered Gauguin at the Australian painter's winter quarters at the Villa des Arts near the Montmartre cemetery. One evening Russell invited Rodin, Van Gogh, Gauguin and Toulouse-Lautrec to spend an evening in a Montmartre cabaret, where Lautrec and Russell proceeded to draw on the walls. "After that," Rodin recalled, "they made us visit a ghastly dive [*infâme caboulot*] beneath Les Halles

that was full of Apaches [street toughs]. I confess I was very scared that evening."

>×

Rodin turned fifty in 1890, a time of upheavals in the Paris art world, both for the old guard and the new. The poet Léo Larguier put his finger on the pulse of the times in five brash lines of doggerel:

> *Monsieur Degas devient bougon et misanthrope,*
> *Van Gogh va se tuer, Cézanne fuit Paris,*
> *On parle avec ferveur des fresques de Puvis,*
> *Paul Verlaine entre à l'hôpital et Whistler donne*
> *Le bras à Mallarmé pour aller chez Colonne.**

The old distinctions between officially approved and unacceptable art were fast disappearing. In the autumn of 1889 Monet raised nearly 20,000 francs by public subscription to buy Manet's *Olympia* as a donation to the Louvre. "It is a fine homage to his memory and at the same time a discreet way of aiding his widow, who owns the painting," he wrote to Rodin on October 25, saying that he and a group of like-minded donors would be happy to "count you as one of us. . . . Please reply as soon as possible." Monet himself had contributed 1,000 francs from the money that had come rolling in from their joint exhibition; Sargent subscribed 1,000, Alfred Roll and Jacques-Emile Blanche each gave 500, Carolus-Duran and Paul Gallimard 200 each; Toulouse-Lautrec sent 100 francs. But Zola refused to contribute anything, on the flimsy grounds that one should not have to buy Manet's way into the Louvre. And Rodin, like Dalou, contributed only twenty-five francs. "They're just for putting my name on the list," he explained to Monet. "I am confronted by a financial crisis which does not permit me to give more."

*Degas has become a grumbler and misanthrope, Van Gogh seems bent on killing himself, Cézanne has fled Paris, Puvis de Chavannes arouses fervent admiration with his frescoes for the Sorbonne and the Hôtel de Ville, Verlaine has been hospitalized— and Whistler, the gentlemanly visitor from London, offers his arm to Mallarmé en route to the fashionable Colonne concerts at the Châtelet Theatre.

Monet had underestimated the siege mentality prevailing among the Beaux-Arts officials. After *Olympia* had been duly purchased from Mme Manet the Louvre refused to accept the gift on the pretext that not enough time had elapsed since the painter's death. Antonin Proust had contributed 500 francs to the fund but refused to help Monet and his friends impose the picture on the Louvre. Tempers flared as angry editorials appeared in the press: the polemics led Proust to challenge Monet to a duel on January 27, 1890. Monet appointed Geffroy and Théodore Duret as his seconds and they, fortunately, saw to it that cooler heads prevailed: the duel was called off.*

At the same time the aftermath of the Universal Exhibition precipitated a still more acrimonious battle of wills among the artistic temperaments of Paris—a great falling-out among the leading painters that led to a schism in the Salon and with it the breakdown of the machinery of state-supported medals and awards. For years things had been going from bad to worse at the Salon, though its affairs were now conducted by a committee elected by the artists themselves. Maupassant, in one of his 1886 feuilletons for *le XIXᵉ Siècle*, declared that the whole thing had become so scandalously inbred and inept that it ought to be abolished. Instead, its problems multiplied. There were too many privileged exhibitors: artists who had won medals in previous years were automatically exempt from having to submit their work to the jury, and were entitled to send in two works. Since eighty-five medals were awarded each year, the number of exemptions got out of hand. By 1888, 3,586 pictures had to be crowded onto the walls of the long-suffering Palais de l'Industrie, where the annual Salon was held.

For 1889 the special selection committee—to which Rodin belonged—was appointed by the government for the huge international Salon held in conjunction with the Universal Exhibition, which replaced the regular Salon that year. Its awards, however, irritated the conservative leadership of the Société des Artistes français, since

*Eventually a compromise was reached whereby the government agreed to take *Olympia* into the Luxembourg Museum as the first "new" painting in the national collections. It was not transferred to the Louvre until 1907, and then only at the insistence of the doughty new prime minister, Georges Clemenceau.

many established names were passed over in favor of younger, more adventurous artists. Moreover, a total of 493 medals had been bestowed on foreign artists. If these were also to receive automatic exemptions the next Salon would have to provide space for more than 4,000 pictures before any new painters could be admitted. Accordingly, Bouguereau and most of his colleagues on the regular Salon committee decided that awards granted in 1889 would not confer exemption privileges for future Paris Salons.

The matter came to a head at the annual meeting of the Société, held on December 26, 1889, at the Palais de l'Industrie. Meissonier, who had been president of the international committee, and others who had served on it—including Puvis, Carolus-Duran, Cazin, Gervex and Roll—argued that to deny recognition to these medal winners would be a national disgrace: "France should not diminish the value of awards that foreigners have received publicly from our hands." When the question was put to a vote Meissonier's faction was roundly defeated, 405 to 82, with more than a hundred abstentions.

As soon as the results were announced the embattled minority walked out of the meeting and reconvened at the nearby Ledoyen restaurant in the Champs-Elysées, to discuss plans for a new and more liberal association, the Société Nationale des Beaux-Arts. It was essentially a revolt of the moderates and independents against the old-guard academicians—called *pompiers* (firemen) in art-student argot because they liked to paint pictures of Greek or Roman heroes wearing helmets like those of the Paris fire brigade. Rodin sided with the dissidents, who included such comrades-in-art as Carrière, Félix Régamey, Besnard, Fantin-Latour, Sargent, De Vigne, Constantin Meunier, Desbois and Bracquemond. He even papered over his differences with Dalou in order to establish a strong sculpture section for the breakaway Salon, which was to be held in the Galerie des Beaux-Arts on the Champ-de-Mars, one of the buildings left standing after the Universal Exhibition.

The new society consisted of 104 founding members, each entitled to send in six works of art exempt from scrutiny by the selection committee; there were also a number of associate members with the privilege of entering one work in the annual exhibition. Meissonier became the first president; Dalou, vice-president for sculpture. No medals were to be bestowed; instead, several 3,000-franc fellowships

would go to deserving exhibitors. Among the first recipients were Rodin's protégés Baffier and Desbois, while his star pupil Ernest Michel-Malherbe figured on the list of those whose work was purchased by the government. Rodin's major contribution to the first Champ-de-Mars Salon, also bought by the ministry, was the marble *Danaïde* that had evolved from one of his studies for the *Porte*—"a figure that has thrown itself from a kneeling position down into a wealth of flowing hair," as Rilke described it, with a sensuously curved back and a "face that loses itself in the stone."

Rodin also exhibited his recently cast silver bust of Marianna Russell: he had written to her husband asking him if, "before sending it to Sydney," he would allow it to be shown at the new Salon; it had been badly displayed at Petit's because the patina was "horrible and looked like boot polish." In addition to the re-patinated silver bust Rodin also sent a bronze cast of what was now called *Nude Old Woman* and a number of small sketches; it was a pity, said Albert Wolff in *le Figaro*, that they should take up so little space in so vast a gallery.

The first Salon of the Société Nationale opened on May 15, 1890, and ran until the end of June—with both critical and financial success, since it earned 170,000 francs at the box office despite the fact that its larger rival on the Champs-Elysées was playing to packed houses at the same time. Gustave Geffroy reported that above all it was Puvis de Chavannes's dreamlike *Inter Artes et Naturam* that caught everybody's eye: an allegory of the ideals of humanity peopled by "women with charming bodies, men with serious faces."

Rodin, who had long been an admirer of Puvis's art, was now all the more fascinated by the man himself. "It was a treat to spend hours with him at the committee meetings of the Société Nationale," he recalled in later years. "At that time, because of him, I missed not one of the sessions of our committee. I was happy at the thought that I would find him there—the artist I most admired, and a man of such perfect distinction." Puvis agreed to sit for his portrait, and Rodin sculpted him as he saw him, "the consummate man of the world," transfigured into a sort of Renaissance prince. "He carried his head high," Rodin remembered. "His skull, solid and round, seemed made to wear a helmet. His arched chest seemed accustomed

to carrying a breastplate. It was easy to imagine him at Pavia, fighting for honor by the side of François I."*

Rodin wanted to show him with classically bare shoulders and chest but Puvis objected: he was accustomed to seeing himself in a wing collar and a frock coat. To keep the peace Rodin was obliged to add these essentials, as well as the rosette attached to the button-hole, in a final overcoating of furiously punched and kneaded clay. Even so Puvis was not pleased; he is said to have "pointed to his mirror and to his photographs to prove that he was not like his bust." Rodin was "really upset" when he heard of Puvis's verdict. But the government paid him 3,000 francs for a marble copy of the bust, and he further consoled himself with the thought that it was the painter's wife, Princess Cantacuzène, "who had applied a lot of pressure to influence his opinion."

After the first Salon at the Champ-de-Mars there could no longer be any lingering doubt that "M. Rodin has definitively triumphed," as William C. Brownell informed the readers of the *Century* magazine in November 1890, which happened to be the month when Rodin celebrated his fiftieth birthday. Brownell, too, was an American in Paris, but unlike Bartlett he specialized in opinions rather than facts. Before writing on Rodin he had made an exhaustive survey of French sculpture, with fulsome praise for all the leading contemporaries: Mercié, Dubois, Saint-Marceaux and the rest. Still, the last article in this *Century* series was devoted to those who were moving against the academic stream, Rodin and Dalou, and he was perceptive enough to realize that "M. Rodin's service to French sculpture becomes at the present moment especially signal and salutary" because French sculpture was becoming more and more conventional.

From England came an even more enthusiastic appraisal of Rodin's achievements at fifty, in the form of an article by Henley, now pre-siding over the literary destinies of the *Scots Observer*, soon to become the *National Observer*, the cradle of Kipling, Shaw and H. G. Wells.

*At Pavia in 1525 the French army was annihilated and François I was taken prisoner. "All is lost save honor," he is supposed to have said; his actual words, in a letter he wrote to his mother after the defeat, were: "Of all things, nothing remains to me but my honor and my life."

It was Henley in fine fettle, with his rolling cadences, holding forth on one of his favorite subjects, Rodin and his *Porte*, "the most prodigious monument to Dante and the *Commedia* that has yet been done." Henley, once properly launched into a sentence, could scarcely bring himself to end it: "The hand that modelled these austere yet passionate statements of virile force and suffering and endowment, and expressed their sculpturesque quality in such terms of art as recall the achievements of Donatello himself, can on occasion create such suggestions of elegance and charm, as put the Clodions and the Pradiers to blush, and enable you to realise, in the very instant of comparison and contrast, the difference between the art that is great whatever its motive and its inspiration, and the art that only passes for great because it happens to be gracious and popular."

Henley's friendship and admiration impelled him to reach for new superlatives. Nowhere between Michelangelo and the present was there "so lofty a head as Rodin's"—indeed, "he is our Michelangelo; and if he had not been that, he might well have been our Donatello." This was an enviable balance sheet for a self-taught sculptor who had spent thirty-five of his fifty years with his hands in wet clay. "And with Rodin," Henley ventured to predict, "as with Rabbi Ben Ezra, 'the best is yet to be.' "

11

A TEMPEST IN THE OFFING

A work that is truly superior . . . won't stand a chance.

—RODIN on public
monuments, 1888

nd your statue of Claude Lorrain," asked a reporter from the newspaper *le Progrès de l'Est* on October 18, 1891, concerning the monument Rodin had been asked to create for the city of Nancy. "Would you be so good, *cher* maître, to tell me about the latest developments?"

"Eh! What can I say? I'm sorry the maquette is no longer here but at least you can have a look at some of these photographs."

The reporter had already seen the pictures; everyone who cared about art in Nancy had seen them, and critics admired "the noble and inspired attitude which M. Rodin has bestowed on his image of our great landscape painter." They had also read of his plans for "the admirable pedestal, with its superb sense of movement." The bronze figure of Claude Lorrain was to stand on an unusual socle of light gray stone, representing Apollo guiding his two-horse chariot—a composition clearly inspired by the famous eighteenth-century *Horses of the Sun* with which Robert Le Lorrain (no relation) decorated the Hôtel de Rohan in Paris. Only the forequarters of the horses and the upper portion of the god's body were to be fully disengaged from the block of stone. Guiding his rearing horses with his right hand and pushing back a dark mass of clouds with his left, Phoebus-Apollo

was to symbolize the overwhelming importance of sunlight in the landscape paintings of Claude Lorrain.

"I wanted the ensemble of the monument to radiate the general impression of sunlight," Rodin told his visitor. "This is the only proper way of honoring the memory of the subtle artist who was one of the greatest virtuosi in the handling of the transparency of light. You know, just as I was working on it I saw a landscape of Claude at the home of a wealthy collector . . . it was an apotheosis of light which I tried to celebrate in the allegory of the pedestal. But I won't be completely satisfied unless this apotheosis strikes everyone as emanating from the work as a whole; from the bronze of the statue— which will show Claude with his gaze lost in the blue of the sky— and from the stone of the pedestal."

"And what can you tell me about the work being done on the monument just now?"

"Not very much. We still have a lot of time to think about casting the statue. But the stone for the sculptured part of the pedestal has just arrived in Nancy, where my praticiens are going to start carving it. This block is of the sort known as Euville stone, very hard and therefore rather porous, with quite a lot of fissures. There might even be reason to worry about this—that some invisible cracks might freeze and scar the surface in very cold weather. Still, I expect that by taking the proper precautions . . ."

The decision to award this commission to Rodin had, as usual, been preceded by a lengthy bureaucratic gestation period. The municipality of Nancy had been interested in a memorial to Claude Gellée, alias Claude Lorrain, since the 1850s, and a fund drive had been launched in 1877. When Sarah Bernhardt heard of it she offered to do the monument herself; sculpture was her avocation, and if the authorities would let her know "the appropriate historical costume" in which to dress the immortal artist she would be "delighted and honored" to execute a statue of Claude.

The committee declined her offer. Instead, fourteen noted sculptors were invited to participate in a competition. Rodin studied the problem and arrived at a figure of Claude "wrapped in air and light" which was to be clothed in seventeenth-century costume, with features based on an engraving—the only surviving portrait—by Claude's biographer Joachim von Sandrart. The final form of the maquette

came to him quite suddenly one day when he went to Jules Desbois's studio to discuss the project. Rodin, on his way home from some official function, was still dressed in his best suit and wearing a top hat. He had come to ask Desbois to make a maquette twice the size of a rough sketch he intended to send him. But then Rodin himself began making the maquette on the corner of a workbench. He was suddenly seized by a fever of creation, as Desbois told Cladel, and "without taking the time to change his clothes, his topcoat over one arm and still wearing his top hat," he amazed the younger sculptor by improvising a maquette in three-quarters of an hour. "It was sixty centimeters high, very complete and vibrant with life and energy." Desbois thought it remarkable that "while modeling he accompanied his work with verbal instructions that were less quick and less precise than those he was providing with his hands."

The chairman of the eleven-man Claude monument committee was a venerable landscape painter, Louis Français, but its most influential member was Roger Marx, a Nancéen and Rodin's agent-in-place at the Ministry of Fine Arts. Among the other members were Paul Dubois, Henri Chapu, Achille Cesbron and the art historian Philippe Burty. The selection took place on April 8, 1889: six votes were cast in favor of Rodin's project and four went to the runner-up, Falguière. Evidently Burty's eloquence had helped tip the scales, for Rodin wrote to him the next day thanking him "for the goodwill you displayed so forcefully during the vote on the Lorrain competition. It was fortunate for me that my sketch appealed to you and that you came to its defense."

Work on the monument proceeded with fewer complications than usual. By the following July the pedestal figures of Apollo and the horses had been approved by Français and Marx, and were ready to be cast in plaster. Yet the "statue of Claude Lorrain is still far from finished," as Rodin wrote to the mayor of Nancy, Emile Adam, from his studio in the boulevard Vaugirard. Two months later he assured Adam that "this winter I shall complete the figure of Claude Lorrain, which is still in the nude, and as the casting process goes quickly, we shall be ready to inaugurate the monument next spring."

Spring came but the figure of Claude was still unfinished. On May 26 Français and Marx were "enchanted" when they inspected the work in progress at "the outdoor site [at the Folie Neufbourg] to which

Rodin has transported the Cl. Lorrain in order to finish it," as they informed the mayor. "It's new and elegant. Rodin will write to you: he'd like you to have the foundations prepared so that the stone blocks can be delivered within the month, and he can begin the work on the pedestal, which will be a masterpiece."

Rodin had already left Paris for his and Camille's favorite hiding place. He was feeling "*un peu fatigué*," as he wrote to Marx on May 23, but grateful for having received an advance on the monument. To Emile Adam he sent a letter from the Château de l'Islette on May 29: "I am in the country where I'm doing a bust. . . . I think the monument has come out very well. It is finished except for the Claude, whose form is complete though he still needs to be dressed . . . While I dress him the stone work will be executed . . . the praticien will be in Nancy a month from now to commence the roughing out."

In July plaster casts of Apollo and the horses were shipped to Nancy in two crates, express collect, to the annoyance of the monument committee. Rodin's praticien, Rigaud, followed soon after to translate the plasters into Euville stone. It was a difficult assignment since it represented Rodin's first attempt, as he later told René Chéruy, "to use a new technique of a 'hazy' and pictorial effect in sculpture to suggest the rising of the sun and also recall the technique of Claude, 'the painter of the sun.' "

The formal unveiling of the monument took place on June 6, 1892. The presence of the president of the Republic, Sadi Carnot, and the minister of public instruction, Léon Bourgeois, shed official luster on the proceedings. But after the speechmaking the crowd began making fun of Apollo's horses: no Nancy coachman had ever seen their like. The figure of Claude was found bizarre and melancholy; a senator who professed to speak for the local tastemakers declared the whole thing to be a failure: "We are not stupid, and we find this a bad statue!"

Next day *l'Espérance* commented that the monument was "enigmatic or incomprehensible and lacks grandeur." A few days later another hostile critic published a diatribe in *la Dépêche Lorraine*:

What is this pose that makes Claude Gellée seemed knock-kneed and shivering with cold—an allusion to his name [*gelée-frozen*]? And this brush ready for painting that makes you look

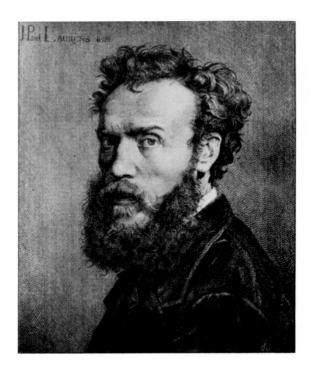

Laurens by Laurens.

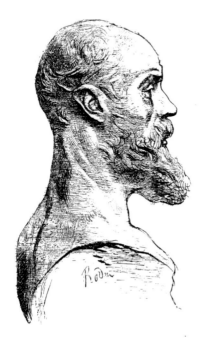

Rodin's drawing of his bust of Laurens.

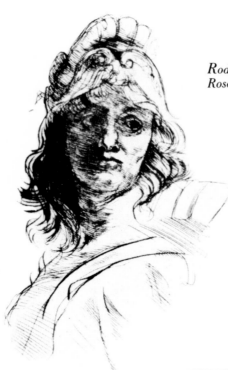

Rodin's Bellona, *for which Rose Beuret was the model.*

Rodin's bust of W. E. Henley, engraved by O. L. Lacour for The Magazine of Art.

Rodin's drypoint version of his bust of Antonin Proust.

*Rodin's rendering of his bust of Henri Becque,
seen from three points of view.*

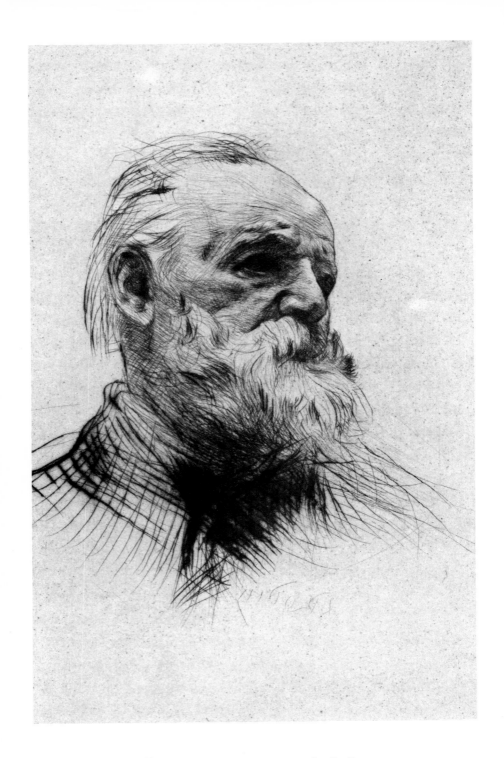

The Hugo bust, in a drypoint by Rodin.

Some of the sculptor's sketches for the Hugo portrait.

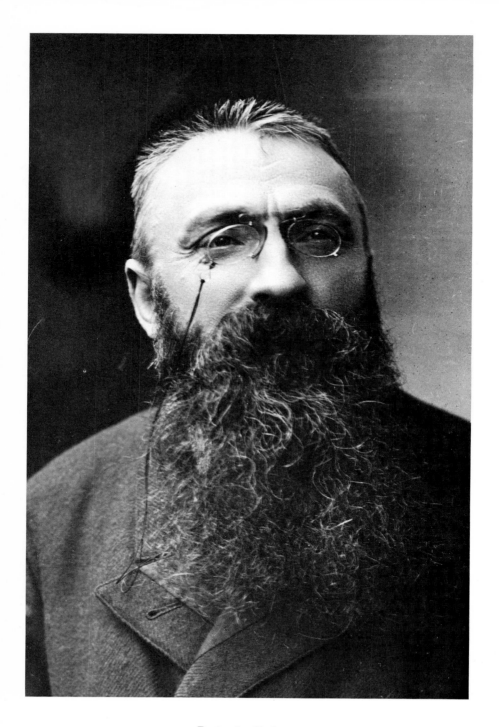

Rodin by Nadar.

Ugolino and His Sons,
engraved by Leveillé.

La Toilette de Venus.

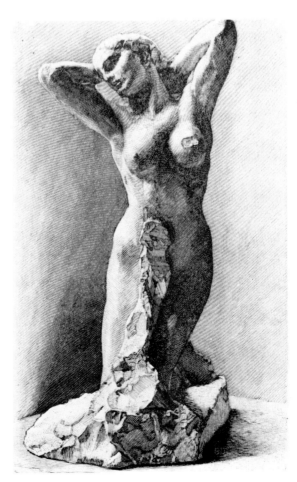

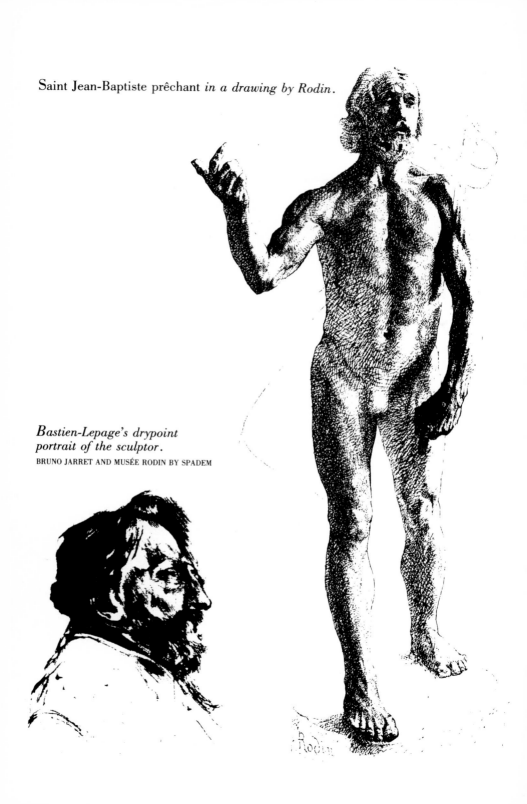

Saint Jean-Baptiste prêchant *in a drawing by Rodin*.

*Bastien-Lepage's drypoint
portrait of the sculptor.*

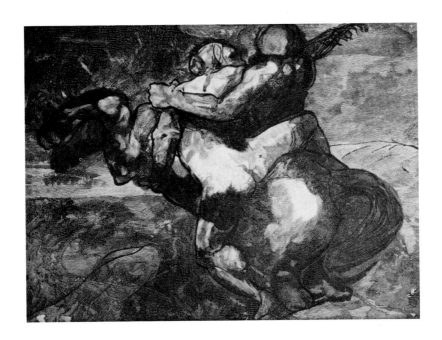

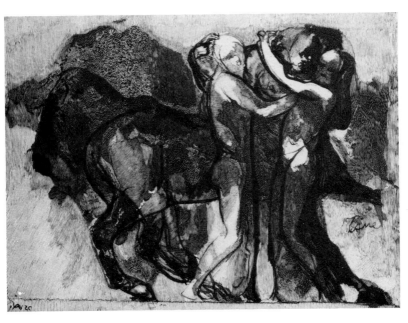

Two "Dantesque" drawings engraved for l'Image:
Force and Guile *and* The Centaur's Feast.

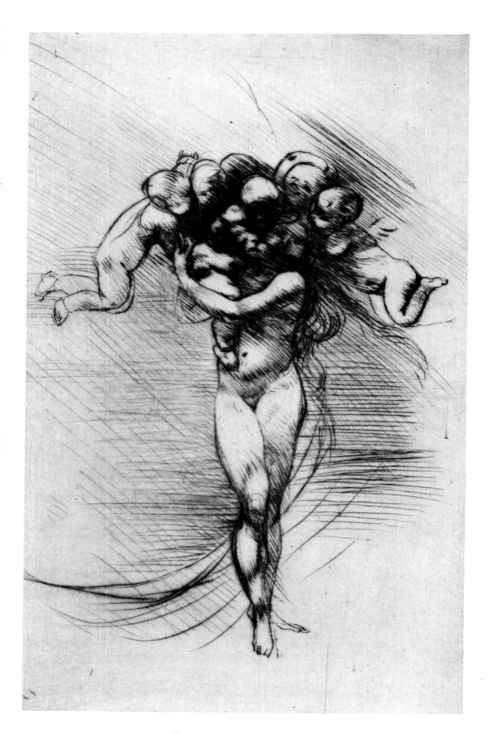

Rodin's drypoint Spring.

Carrière by Carrière.

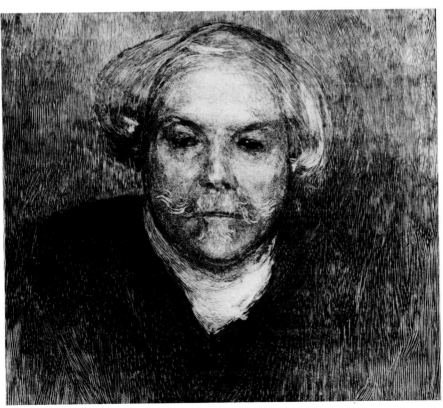

Edmond de Goncourt by Carrière.

The Thinker *engraved by Leveillé*.

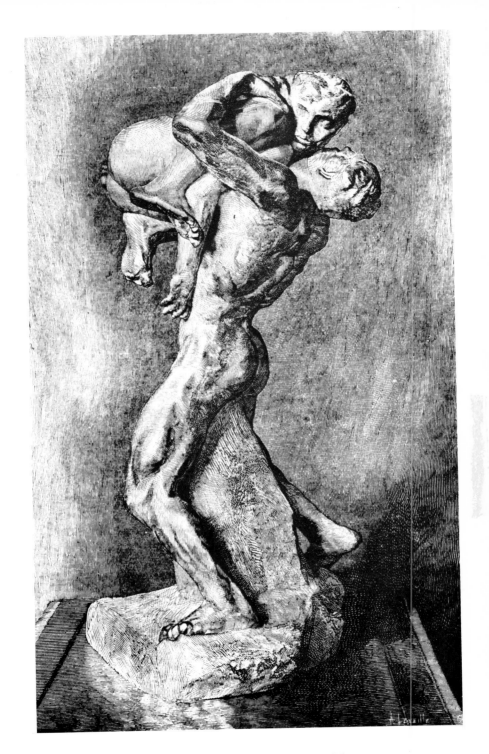

L'Enlèvement *alias* I Am Beautiful.

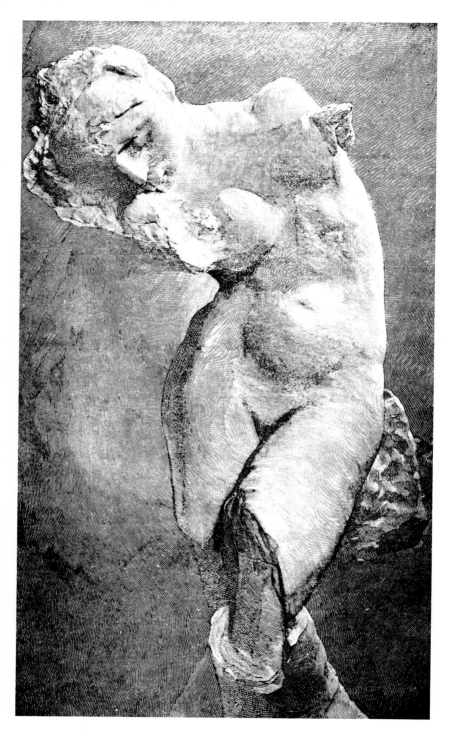

La Méditation *or* The Inner Voice.

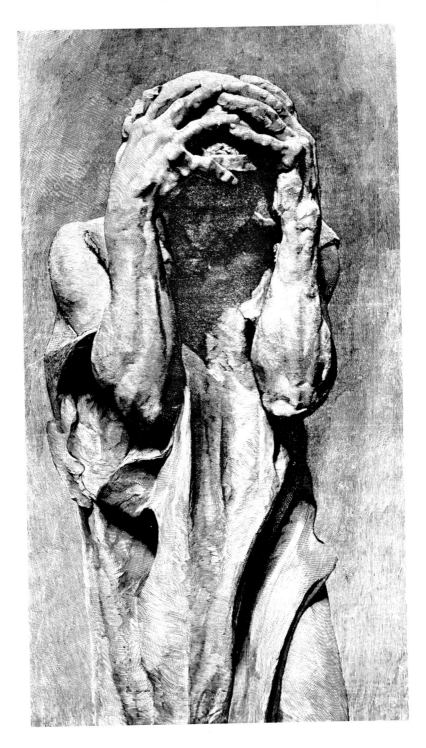

Andrieus d'Andres, the "Weeping Burgher."

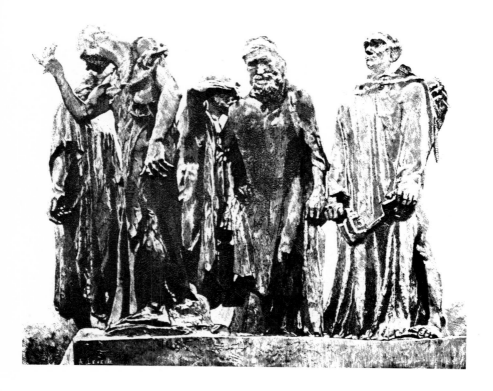

The Burghers of Calais *engraved by Leveillé*.

for the canvas and easel? And the knee bent inward like a cripple's? And the half-open mouth that could just as well signify weak-mindedness as inspiration? Rodin wanted to break out of the mold of banal statues that look as though they were posing for their photograph. But he went too far. . . . Though one can admire the energy and vigor of the pedestal—the horses are so excited that one has broken its leg at the knee—it agrees not at all with the placidity of the statue. . . . Despite the praises of the "professionals" and of the committee, I belonged to the great multitude who expressed their disappointment last Saturday, and I am forced to conclude these reflections with the words—*Encore un raté*! [Yet another flop!]

Rodin's admirers rushed to his defense. *La Lorraine artiste* insisted that there had been a cabal against the monument even before it was unveiled; Nancy was afraid of modernism in art. Emile Gallé, the great Nancy master of applied art, explained to the readers of *le Progrès de l'Est* that while they might have expected Rodin to give them an Adonis, he had given them a gaunt Champagne peasant, a great mind in a timid body, "urged to the attainment of a radiant idea." He, for one, was happy to see "the fusion of two great personalities in a single work, Claude and Rodin."

The sculptor came to feel that his troubles with the monument stemmed from a failure in public relations. Whenever such disputes arose, he told Lawton, it was always some slight misunderstanding that set the ball rolling: "In the case of the *Claude Lorrain* it was an invitation to a public dinner which I refused, being tired and desirous of escaping further fatigue." In any event he was obliged to accede to the committee's wishes respecting Apollo's horses, and to have them recut so as to look less hazy and more precise. Rigaud was put to work again, to bring the horses further out of the clouds and give them a sharper outline. "They made me kill my sculpture," Rodin said afterward. "They made me ruin my horses."

>≭<

There was hardly time to worry about the repercussions of the Claude affair. For nearly a year Rodin had been deeply engrossed in a commission that meant much more to him—the monument to Balzac

that was to become one of his most important works. He himself remembered it afterward as the most troublesome work of his career: "Never has a statue caused me more worry or more work, or put my patience so severely to the test."

Paris, despite its legion of statues, still lacked a monument to the author of *The Human Comedy*. Alexandre Dumas *père* had tried to erect such a monument not long after Balzac's death in 1850, but his campaign had run afoul of Balzac's widow and had been abandoned. In 1888 the writers' association of which Balzac had once been president, the Société des Gens de Lettres, had decided to do its duty at last, and had raised 36,000 francs for a monument. "Almost all of it was extracted from the poor devils of literature which, as you know, our profession has never lacked," reported Philibert Audebrand. The eighty-year-old Barbey d'Aurevilly had climbed the stairs of the society's offices in the chaussée d'Antin in order to pay his contribution in person: "I didn't want to die without having personally flung a gold piece into the crucible from which Balzac's image will be poured."

The original commission had gone to Chapu, who had already produced workmanlike statues of Flaubert and Dumas *père*. His Balzac project had only reached the maquette stage, however, when he died of pneumonia on April 21, 1891, at the age of fifty-seven. Emile Zola, who had inherited Balzac's mantle as the best-known and most prolific of French novelists, had been elected president of the Gens de Lettres in April of the same year. Just turned fifty-one, he had lost the Balzac-like paunch of his earlier years and was now the "thin Zola," slim and energetic—thanks in large measure to an unusually stimulating extramarital relationship with the beautiful Jeanne Roserot, the young woman who presented him with his children, Denise and Jacques, in 1889 and 1891.

As president of the Gens de Lettres, as in the writing of his novels, Zola proved to be nothing if not conscientious and methodical. During his four one-year terms in office—from 1891 to 1894, and again in 1895–96—he attended virtually every one of the society's weekly meetings. Chapu's death presented Zola with his first serious administrative problem. The subscribers to the Balzac monument wanted to see results; three years had elapsed and 5,000 francs had been spent, to little avail. Charitably enough, the twenty-four-man exec-

utive committee decided to permit Chapu's family to retain the advance, and added another thousand francs for expenses. Chapu's maquette, however, struck Zola as a lackluster piece of work: it showed Balzac in the monk's robe he liked to wear as a dressing gown, attended by an allegorical woman and a cherub. Although it had been approved by Mercié, Falguière and Dubois, critics thought it "competent and conscientious but without force or character."

Evidently it was Léon Cladel who urged Zola to ask Rodin to undertake the commission, an idea heartily seconded by Frantz Jourdain, who was to design the pedestal. Zola could only act, however, after consulting the executive committee, and the matter would require a good deal of tact. For one thing, Rodin was already on record as being unwilling to participate in any open Balzac competition. When a reporter for *le Temps* had sounded him out on the subject in 1888, just as the committee went to work, Rodin had denounced the whole system of commissioning monuments:

> When a number of people, no matter how expert and intelligent they might be, come together to judge works of art that have been submitted to them, they will be able to agree only on a work that is utterly neuter. A work that is truly superior and very personal, but which manifests some sort of peculiarity or audacity, or some defect inherent in the artist's manner, won't stand a chance. Unless the conditions were very special, I wouldn't take part in a [Balzac] competition if they were to hold one.

When Zola dispatched his vice president, the novelist Gustave Toudouze, to ask whether Rodin would do a new statue in place of Chapu's, the answer was "I most certainly will do it." Moreover, "to have been chosen by you, dear Monsieur Zola, will not be the least of my satisfactions."

On July 1, 1891, Zola wrote to Jourdain that he hoped to resolve the question at the executive committee meeting of the 6th. Would he, therefore, "go to see Rodin as soon as possible; persuade him that the statue should be at least four meters high, and see if the whole thing can be executed and erected for the sum of 30,000 francs. If so, Rodin should write me at once, offering to execute the statue

(including the pedestal, for which you will be responsible) for this sum of 30,000 francs. In his letter he should promise delivery on May 1, 1893."

Rodin submitted the requested letter two days later: it included a promise which, in view of his past record, was recklessly unrealistic: "I offer to execute a Balzac in bronze, about three meters high, with pedestal to match, within eighteen months from the receipt of the commission, for the sum remaining in the subscription fund." He added that he had always been interested in Balzac "and have often studied him, not only in his works but in his native province." Indeed, Balzac's birthplace was Tours, and the Château de Saché, where he wrote *le Lys dans la Vallée* and portions of other works, was only a stone's throw—eight kilometers, to be exact—from Rodin's and Camille's summer retreat at Azay-le-Rideau.

When Rodin's name came up for discussion Zola used all of his powers of persuasion to convince the committee to support his candidate: "His name is our guarantee, which is a great advantage because he covers for us. M. Rodin is one of those who can be trusted to assume responsibility for what they do. Suppose people dislike the statue when it's finished; no one would dream of blaming us for it. Rodin is one of the foremost sculptors of our time. If he makes a mistake, even our severest critics will have to pardon us for having chosen the artist who created *la Porte de l'Enfer*."

When he heard that his offer had been tentatively accepted Rodin broke the news to a reporter from *l'Eclair*. This indiscretion upset Toudouze, who warned him to "say nothing more to the newspapers until the official announcement has been made." But the sculptor was irrepressible. "I found Rodin full of joy and gratitude toward you," Toudouze informed Zola on July 10, "and all fire and flame for his Balzac. He's going to plunge in immediately and take advantage of the summer holidays to visit Tours and steep himself in the Balzac atmosphere, observing the people and exploring the museum, the countryside. I think he'll produce a splendid work and the society won't regret having chosen this impassioned artist."

Rodin had already dashed off an exultant note to Zola: "Thanks to you here I am, the sculptor of Balzac, under the patronage of Emile Zola. What a great honor—I'll do my best to deserve it." He hoped to consult Zola at Médan the following week. "You could be of great

help to me with ideas for the monument, since as yet I haven't any, and you have certainly thought about it." Yet he had already begun thinking about his figure in very specific terms. "Will I dress Balzac in the famous monk's robe he wore when he worked, if legend is to be believed, or will I leave him in street clothes?" he wondered aloud during an interview published in *l'Eclair* on July 11. "These are questions I can't answer at the moment. I can only say that I won't begin my work before discussing it at length with Monsieur Emile Zola."

On the same day the first signs of a distant storm could be detected in the pages of *la France*, which published a pseudonymous letter accusing Zola and Jourdain of having used underhanded methods to obtain the commission for Rodin—and to scuttle a rival project submitted by the amateur sculptor Anatole Marquet de Vasselot, a self-proclaimed Balzac authority who had already produced a dismally academic bust of the novelist. Zola paid no attention: on August 14, after coming to an arrangement with Chapu's heirs, he notified Rodin that the committee voted twelve to eight in his favor, adding that he hoped the first sketch would be ready by November. Rodin assured him that "to please you, I have been working actively on this project to the exclusion of all others . . . my sketch will be ready for you in November."

He had already been in touch with the Balzac specialist Charles Spoelberch de Lovenjoul, and had examined the seven or eight lithographs of Balzac in the print room of the Bibliothèque Nationale, as well as having someone photograph "a very beautiful pastel" of Balzac, by Gérard-Séguin, in the Museum at Tours. He spent the rest of the summer immersed in Balzac, trying to learn all he could about the man and his life; reading the books that Mirbeau had suggested to him and exploring the countryside around Tours and Saché.

Balzac had left neither a life mask nor a death mask; there was only a stylized bust by David d'Angers that Rodin had originally regarded as a suitable prototype—the sculptor of any Balzac monument would be obliged "to copy it more or less exactly," as he told *le Temps* in 1888. But now that he himself was that sculptor it seemed to him that David's busts had been impossibly idealized—"they all resemble one another, whether they represent Balzac, Victor Hugo,

Goethe or Frédérick Lemaître," he told an interviewer who came to see him in the course of his work on the monument. "All these figures seem to belong to the same family because they're all made the same way. Hence I'm not inspired by David d'Angers's bust; on the contrary, I want to *forget it.*"

He wanted to arrive at a historically plausible Balzac, based not only on the existing busts, portraits and caricatures but on living people who reminded him of the Balzac he imagined. As a point of departure he had Alphonse de Lamartine's description of the writer:

> It was the face of an element; big head, hair disheveled over his collar and cheeks like a man whom the scissors never clipped; very obtuse; eye of flame; colossal body. He was big, thick, square at the base and shoulders; much of the ampleness of Mirabeau, but no heaviness. There was so much soul that it carried that lightly; the weight seemed to give him force, not to take it away from him; his short arms gesticulated with ease.

In the Loire valley where Balzac had grown up Rodin expected to find "the same influences of earth and sky" in local faces as those that had molded Balzac. Geffroy reported that during his travels through the region Rodin did, in fact, discover "a certain Touraine type which is the Balzac type. He chose several of those who were most deeply marked by these traits and modeled their mask with scrupulous attention to detail." Some of them resembled "Balzac to the life," especially a study of a "smiling, almost laughing peasant" who seemed to personify the jovial Balzac described by his friends— a beaming extrovert named Estager who worked as the driver of the public coach running between Azay and the nearest railway station. "He reminded me of the young Balzac," Rodin explained, "as I imagined him from drawings and lithographs."

His quest for a living Balzac became so time-consuming that Geffroy felt compelled to warn him against putting too much faith in the exercise. "I don't want to disturb your studies of heads and people from Touraine, but please don't lose sight of the fact, my dear Rodin, that Balzac's family origins were in the south of France. Do you have his collected correspondence . . . ? It's there that you can best become acquainted with this great and admirable man."

At Saché Rodin encountered Balzac's former tailor, the octogenarian *Père* Pion, who still had the writer's measurements on file. It turned out that his chest and waist measurements were identical—104 centimeters—and that his trousers were only 92 centimeters long from waist to cuff. Few sculptors had ever been faced with the dilemma of creating a heroic statue of such an unprepossessing figure—a pot-bellied colossus on gnome's legs, with a profile that Gavarni had compared to an ace of spades. Rodin had *le Père* Pion make him a suit in Balzac's size and told him, laughingly, "This is what I'll wear to my inauguration into the Academy." But the empty clothes were little help in fleshing out the character that Rodin was trying to establish. Mathias Morhardt remembered seeing the vest and trousers lying about in the Dépôt des Marbres: "They could give him nothing; they gave him nothing."

In November he had to tell Zola that the promised maquette was not yet ready. "I haven't lost any time. . . . I've worked and made sketches. . . .Nothing is yet as I want it, for the moment; you'll be the first, dear maître, whom I'll ask for an opinion." He thought he might have a maquette by the end of November but it was nearly Christmas before Zola was shown the tentative sketch of a standing Balzac: they discussed certain changes that still had to be made. By January 15 Rodin had carried them out: "I have rearranged the leg; have raised it and set it back; the figure has gained a great deal, so much that it makes me happy, and I take up the clay and set out, impatient to produce a work that will be to your liking." He had already received a 5,000-franc advance but now requested another payment of an equal amount: "It's in the agreement; after the first sketch it helps defray the initial expenses."

Meanwhile, the executive committee had seen the sketch and given its approval. Older members like the novelist Hector Malot, who had known Balzac, agreed with Rodin's evident intention "not to turn Balzac into an Apollo," and for a time it seemed that all would be well. Toward the end of February 1892, Roger Marx published an enthusiastic assessment of the maquette in *le Voltaire*; it was "already far advanced, very precise, definitive and superb. It shows Balzac standing, draped in the Dominican monk's robe which was the shroud in which he was always wrapped."

This monk's robe was firmly documented in the memoirs of Balzac's

contemporaries. "At home one always saw him in a large white cashmere robe tailored like a monk's, lined with white silk and fastened with a white cord," testified Lamartine in *Balzac en négligé*, and Léon Gozlan's *Balzac en pantoufles* describes "Balzac, wrapped in the ample folds of a monk's robe that had once been white . . . with fire in his eye, hair disheveled, his lips moving, with flaring nostrils, legs set apart, arms tensed like a sidewalk pitchman's. . . ."

Like Chapu, Rodin had seized on this monk's robe as a way to avoid the necessity of dressing Balzac in a *Père* Pion suit. "There is nothing more banal than these statues of recent notabilities, to be seen in every big city of Europe, masquerading as tailor's models of their ugly period," he once explained to an American visitor. Balzac's habit of wearing a *houppelande*, on the other hand, "gave me the opportunity of putting him into a loose flowing robe that supplied me with good lines and profiles without dating the statue."

Yet the longer he worked on the nude figure that was to stand beneath the robe the more dissatisfied he became. What had begun as an attempted reconstruction of a dead man now turned into a quest for essences. "Rodin told me how he had conceived his Balzac," writes Aleister Crowley in his memoirs:

> He had armed himself with all the documents; and they had reduced him to despair. . . . He was seized with a sort of rage of destruction, abandoned his pathetically pedantic programme. Filled with the sublime synthesis of the data which had failed to convey a concrete impression to his mind, he set to work and produced the existing Balzac. This consequently bore no relation to the incidents of Balzac's personal appearance at any given period. . . . The real Balzac is the writer of the *Comédie Humaine*; and what Rodin has done is to suggest this spiritual abstraction through the medium of form.

It took him the better part of seven years, however, to arrive at the definitive Balzac, and the resulting delays and uncertainties exasperated even his supporters among the Gens de Lettres. In the spring of 1892, before the unveiling of the Claude monument, Rodin was still confident of his ability to complete the project in short order:

when the critic Henry Lapauze asked him for news of the Balzac, Rodin assured him that "after my return from Nancy I shall go back to work on it for two months. . . ."

There are conflicting accounts and chronologies of the subsequent evolution of the "Naked Balzac," for which Rodin found short-legged models of the requisite paunch. About fifty preparatory Balzac studies have survived—figures without heads, heads without bodies, even empty robes cast in plaster—and many more must have gone back into the clay bin. When the young writer Jules Bois came to the studio in July the first thing that struck him was the unfinished figure of the nude Balzac that dominated the atelier: "It's still only a sketch, made and re-made countless times! But it palpitates with all the life and power, the heavy musculature of the great novelist. He is on his feet in his customary pose, one leg forward, the hamstrings outstretched, arms crossed against an inflated chest, like an athlete confronting an adversary. The face is still in a state of chaos, though illuminated with the blows and thumb-prints of the sculptor who is going to discover the secret of that giant physiognomy."

Bois was astonished by the stark nakedness of this Balzac. "Yes," Rodin explained, "I'm in the habit of sculpting my marble children first without clothes; Rude did the same thing. Later I only have to throw a cloth over them and everything vibrates at the points where it touches the body [*tout vibre aux adhérences*]; thus the figure is made of flesh and blood, not a cold effigy."

Rodin had read the memoirs of Edmond Werdet, Balzac's publisher, and had underlined his description of the writer as a "courageous athlete." It was this new vision of Balzac as a sort of wrestler that Séverine—Caroline Rémy—described in one of her first articles on Rodin. He had shown her "a *bonhomme* in clay, furiously hammered with blows of the thumb. . . . Close up it was very ugly; the skin as if flayed, the face barely indicated—and quite naked, what a horror! But the arms were folded over the powerful pectoral muscles, and the placement of the legs in the line of advance, striding forward with a conqueror's step, suggested the taking possession of the ground, the feet as though attached by roots to the native earth. And from the unformed face, pitted with holes, with a grin like a sabre cut, the nose like a beak, cannibal-like jaws, a rugged forehead beneath a

mass of hair like a clump of weeds, there emanated such a sovereign spirit, imperious, almost superhuman, that an austere shiver, known to intellectuals, ran down my spine."

"It's my Balzac," Rodin told Séverine softly, and then in a timid voice he began again. "I mean the maquette . . . one of the maquettes I'm using."

"It's rough and beautiful," she said.

"No, no, only *pas mal*; with sufficient movement. But the feeling, the inner sense of the man; that's what has to be rendered . . . and with it—if you think it's easy—the soul of Balzac!"

Séverine noted that Rodin spread out his arms in a gesture implying that a psychological burden was weighing him down: "I'm searching, I'm searching. It's very difficult. But I'm quite certain I'll get there."

When the Gens de Lettres were shown an early version of this naked Balzac in 1892 they were shocked and uncomprehending. "Say, you're making a Triboulet!" exclaimed one of Rodin's friends, alluding to the hunchback anti-hero of Victor Hugo's *le Roi s'amuse*, the model for Verdi's Rigoletto. They were all the more disappointed, according to Charles Chincholle of the committee, because they had been counting on Rodin for a pleasant surprise. "With all due respect it was pointed out to him that he had the right to depict Balzac at an age when he had less of a belly and when his neck had not yet disappeared beneath layers of fat—in short when he was the young man shown in Devéria's superb lithograph. Rodin understood. He asked for an extension of his delivery time, which was granted immediately." Writing in 1894, Chincholle noted that "since then he has often modified his maquette but is not any the more satisfied. . . . What a pity that he has still not emerged triumphant from the struggle being waged in his artistic soul between physical truth and ideal truth."

In June 1893 the newspapers announced that "the statue of Balzac will not be erected in Paris for about another year." The Gens de Lettres had agreed to a two-year extension, and Rodin had promised to do his best to deliver a finished maquette by the spring of 1894, which would have enabled him to enlarge and cast the statue by the beginning of 1895. Afterward he had reason to regret "this new mistake, for which I had to pay dearly. As if it were possible, *while one is searching*, to be ready on a fixed date!"

The monument progressed at the rate of three steps forward and two steps back. "I assure you I'm working only on the Balzac," Rodin wrote to Zola in July 1893, in the course of congratulating him on his promotion to Officer in the Legion of Honor. There were thanks, too, for a gift copy of *le Docteur Pascal*, Zola's latest novel, about an older man's love for a young woman.* Rodin and Zola were the same age, and both were now subject to the various kinds of malaise that afflict men in their fifties, but thanks to Jeanne Roserot the writer had managed to surmount them while the sculptor, deprived of Camille, was just beginning a long struggle with what the French call the *démon de midi*, "noonday crisis." Goncourt noted in his diary for Sunday, April 16: "Rodin complains that this year he finds himself devoid of energy, that he feels feeble, as though he were coming down with influenza; he has worked, but has only executed things of no importance."

To complicate matters the model for the first version of the naked Balzac failed to turn up one day and then disappeared altogether, forcing Rodin to abandon his maquette. "To look for a new model, to hang the muscles of one individual on the skeleton of another? He would have considered it a sacrilege," reported Gaston Stiegler in *l'Echo de Paris*. "The first maquette was forgotten forever, and with it a year's labor. Courageously he went back to work, but a second maquette was no more successful than the first."

When he had finished a third maquette, friends heard him say, "This time I've got it." He was so pleased with the result that he decided to take a holiday in the south of France and the Engadine. But when he returned in October he had fallen out of love with his maquette. "Rodin no longer recognized his Balzac," Stiegler reported in November 1894. "It filled him with disgust; he began at once to sketch out a fourth one."

According to another account he had been just about to call in the committee—but now he ordered his stupefied assistants to destroy the offending clay figure.

"But the committee?" he was asked.

"When I'm happy with it, the committee will be, too."

*Zola inscribed one copy of the deluxe edition "To my beloved Jeanne . . . who has given me the royal feast of her youth and allowed me to be thirty again."

Séverine had seen the by-products of all these experiments—a heap of discarded sculptures "like the jumbled bodies left behind after a massacre, with severed limbs and fragmented torsos, sketched or finished, from which protruded a piece of paper with a sketch hastily made from life, drawn in the heat of inspiration."

Besides the steady procession of bodies there was Rodin's continuing search for an appropriate head. He had made studies resembling five or six of the better-known portraits—by Devéria, Boulanger, Gérard-Séguin, Benjamin Roubaud, Emile Lasalle—but as he told Gabriel Ferry (author of *Balzac et ses Amis*) toward the end of 1894, "After studying them thoroughly I've decided to take my inspiration from a daguerreotype of Balzac taken in 1842. In my opinion it is the only faithful and lifelike portrait of the great writer. I've studied this document at great length; today I've captured him: I know Balzac as though I'd lived with him for years."

Nadar—the pioneer photographer whose real name was Félix Tournachon—had made Rodin a copy of the anonymous daguerreotype usually attributed to an even earlier photographer, Louis-Auguste Bisson.* He also invited Rodin to pose for his camera, and furnished advice on several of his current projects. "I am immensely grateful to you," Rodin wrote to the aging photographer on September 13, 1892. "I shall come for Balzac, to examine the admirable daguerreotype, and then for Baudelaire; your long friendship with him will make me all the more appreciative of the conversation you have so kindly promised me along with the portraits."

><

In April 1894, Zola relinquished his post and the Gens de Lettres elected Jean Aicard as its new president. Aicard was a gentle poet from the south of France who also wrote plays and novels; like his predecessor he was an admirer of Rodin's work. At the time Zola had just completed his controversial novel *Lourdes*, about faith healing and the conflict between religion and science; he was forging plans for a sequel dealing with the emerging social conscience of the Vat-

*Nadar had published a retouched copy of it in his magazine, *Paris-Photographe*. The daguerreotype had belonged to Gavarni, whose son gave it to the photographer Silvy, from whom Nadar obtained it.

ican. Rodin received a copy of *Lourdes* in July but did not tell Zola what he thought of it until September 24, shortly before the author left for Italy to gather material for *Rome*:

> It has taken me a long time to read *Lourdes*; I have finished and shall leave it to those better qualified than myself to praise you. But it seems to me that I've read that you have been attacked; hence I come with my small protest to tell you how very honest and impartial I find your book. It is astonishing how well you penetrate states of mind that are so different from the usual. The life of Bernadette . . . with what three-fold beauty you've crowned it! Your impartial book sheds brilliant light on the true saints, these girls who have nothing but their devotion and self-sacrifice, adorable creatures who do so much to disprove the lie that women are inferior to men. They create an atmosphere of tenderness without which we could not live. . . . Awesome, too, is your portrait of the crowd. It's very much needed, what you've said about this commercial art of religion, which is so simple-minded.*

Zola had not forgotten the nagging problem—wholly ignored in Rodin's letter—of the unfinished Balzac. Before leaving Paris he discussed the matter with Aicard, who made a record of their conversation. "I've left you with the unresolved and very stormy question of the Balzac," Zola said. "Let me give you a piece of friendly advice: it's going to give you a lot of trouble. . . . In any case, be conciliatory. The best thing for everybody would be for you to discuss the matter with Rodin's friends. Together you can try to come to an understanding. It would be terrible if you fail. A court case would waste the artist's time and do nothing to raise the society in public esteem."

Zola felt that "a tempest is in the offing"—not a difficult forecast to make in view of the clouds already on the horizon. The committee,

*"*Si niais*"—which could also be translated as "so inane"—was Rodin's term for this "*art d'industrie religieuse*." He used the same word in replying to a correspondent who asked his opinion of the religious statuettes sold in the Place Saint-Sulpice. "Sculpture is always the faithful embodiment of the soul of its age," he wrote. "Firm sculpture, firm hearts. If the sculptures are flabby and rather inane [*un peu niaises*], thus the age."

headed by Aicard, had been to see Rodin's latest Balzac at the Folie Neufbourg on May 31, and its members had been even more appalled than in 1892. This time, according to one account, they were shown "a plaster cast representing a man dressed in the fashion of 1830; swallowtail coat, knee breeches, stockings attached to the breeches with garters; on one arm was a piece of cloth." They decided that in its present state the statue was "artistically inadequate . . . an unformed mass, a thing without a name, a colossal foetus."

At the time, Rodin seemed so tired and ill—he was beginning to suffer from chronic anemia—that Aicard suspected he might never finish the work; not, at any rate, in time for the Balzac centenary in 1899. But it was nearly summer, a season when Parisians defer serious questions until the autumn. Rodin, too, deserved a respite: he went off to tour the Auvergne, the Dauphiné and the Swiss Alps. "I continue to be in poor health and have taken refuge in the country," he wrote to Zola on August 1. "But after my return in October you'll be the first person I'll visit." When they met again, Zola was full of good advice on how to cure the creative doldrums from which Rodin was suffering.

Though Aicard's enlightened attitude seemed to promise an acceptable solution, the long-delayed storm finally broke at the executive committee meeting of October 12, 1894. Edmond Tarbé, a minor novelist and former editor of *le Gaulois*, proposed a motion that would have required Rodin "either to deliver his project within twenty-four hours or be made to return the 10,000 francs already received, and to pay a one-franc fine" in punitive damages. Tarbé was supported by a vociferous majority. As one of their spokesmen, the historian Alfred Duquet, afterward told *le Temps*:

Even now, though M. Rodin has had this commission for almost four years, if we could see at least the beginnings of a statue, or some progress toward it, we would continue to be patient. But the sculptor shows us only maquettes that are more than peculiar, which fail to satisfy him—one can see why—and which he destroys as soon as they are completed. This game of massacres doesn't satisfy the committee, especially since the most competent judges—artists, journalists, Beaux-Arts of-

ficials—tell us that M. Rodin will never be able to deliver a statue.

Aicard argued that an artist should not be treated like a manufacturer: Pope Leo X would never have imposed a one-franc fine on Michelangelo for having failed to paint the Sistine ceiling on schedule. His arguments fell on deaf ears: the militant majority would agree only to postpone their threatened legal action while he tried to arrange an amicable settlement. After talking with Geffroy and Rodin, Aicard became convinced that the sculptor should be allowed to finish the statue at his own pace. To help him placate the committee Rodin sent him a formal letter whose measured phrases betray the hand of Geffroy:

> What I desire above all is that neither you nor your colleagues should misconstrue my intentions. I am still determined to complete a Balzac monument that will meet with your approval, to give you a work which I am striving to make worthy of its subject, of your society, and of your desire to honor Balzac. I ask you to understand that a work of art . . . must not be subjected to outside interference or to fixed time limits. Works of art, as everyone who has struggled with them knows, require peace and untrammeled reflection. This is what I should like you to grant me so that I can bring my work to a prompt and satisfactory conclusion. . . .

But the anti-Rodin majority had already decided that the Gens de Lettres must come to a new financial arrangement with the sculptor. He was known to be in poor health; if he died their 10,000 francs of earnest money would be buried with him. Rodin understood their concern: "If the Society thinks I'm going to die and cost them 10,000 francs, I have 10,000 francs ready to put on deposit as a guarantee," he told Aicard. His lawyer and the society's legal counsel drafted a new letter of agreement placing the worrisome 10,000 francs in escrow with the society's notary, and at the same time freeing Rodin of all timetables: the money would be returned after the work was completed.

Aicard, however, was strongly opposed to the idea of a new contract. Not only had the letter been drafted against his wishes; his dignity as president had been insulted "by the words and attitudes of most of his colleagues" on the committee. At a special meeting on November 26 he announced his intention of resigning and read a long, vehement statement denouncing the committee's attitude "toward an artist whose feelings have been hurt." Six other board members resigned with him.

Geffroy, too, was upset when he heard about the draft agreement. "Clemenceau and I have again discussed your *affaire*," he wrote to Rodin. "Don't sign anything without seeing us again, above all without seeing Clemenceau, who is so farsighted and quick to make decisions; as you know you can find us any day at six o'clock at *la Justice*." Shortly afterward it was reported in the *Journal des Débats* that after talking it over with Aicard, Clemenceau, Geffroy and others, Rodin had decided not to sign the accord.

The affair caused an uproar in literary circles. There were rumors that the presumptuous Marquet de Vasselot—who had his own group of supporters among the Symbolists who called themselves Rose + Croix—had already been chosen as Rodin's replacement, and that *l'incident Rodin* was merely "the point of departure for a campaign organized by certain members of the society against the probable reelection of M. Emile Zola as president."

A crisis was narrowly averted at the general meeting of November 29, when the society elected a compromise president, the veteran journalist-boulevardier Aurélien Scholl. "*Saperlipopette!*" Goncourt wrote in his journal when he heard the news. "They've picked the man who is president of the Fencing Society—hardly the right choice at a moment like this!" Scholl, though skeptical, managed to soothe feelings on both sides. Léon Deschamps, editor of *la Plume*, arranged for him to meet Rodin in his office and personally guaranteed the sculptor's expenses in case the society were to default on its payments. Though the 10,000 francs would be held in escrow, Rodin could thus continue his work without worrying about the financial consequences.

Scholl described their meeting as "a very friendly interview"— Cladel reported that they were "embarrassingly polite" to each other— in which Rodin had been at pains to explain his position. "He would like to realize the Balzac of his dreams—and up to now, has run his

head against a refractory image that refuses to let itself be turned into bronze or stone." Rodin assured him that it would be finished in a year or at most eighteen months. "The reconciliation," Scholl told *le Temps*, "is cordial and complete." It was sealed early in December with an amicable dinner at the Restaurant Durand in the place de la Madeleine.

But after more than eighteen months had elapsed and "Balzac is still waiting," Scholl vented his frustration in *l'Echo de Paris*: "Let him finish it at last—finish it, or resign the commission. . . . Rodin is the genius who created the *Porte de l'Enfer* . . . and ten other masterpieces, but the statue of Balzac eludes him just as a drama in five acts always eluded Balzac."

It was not just the cynics who were growing impatient. Zola, too, was deeply concerned about the fate of the commission he had initiated. He wrote to Rodin from Venice on December 9:

You know what admiration I have for you, and how happy I was that the great sculptor you are was given the responsibility for honoring the greatest of our novelists, the father of us all. And it is for this reason—without waiting for my return—that I am sending you this ardent plea. I beg you, in the name of genius, in the name of French literature, not to make Balzac wait any longer. He is your god as he is mine; spend your days, your nights if necessary, to insure that his image may finally reign in the heart of our immortal Paris. It depends on you; you alone can delay its consummation. Certainly your rights as a conscientious artist are absolute; I have never hurried you, but Balzac is waiting, and his glory should not suffer much longer on account of the legitimate concern you have for your own. Please do me this favor; it is my heart that speaks to you for the sake of your own honor, for I love you as much as I admire you.

Rodin still refused to be hurried. "Ever since my youth I've had an exceptionally quick hand," he once told Dujardin-Beaumetz. "I could do things quickly if I wanted to, but I produce slowly in order to do well. Besides, it was never in my nature to hurry; I ponder more, I want more. An artist should be patient as well as skilled."

In this case he was waiting for time and intuition to show him a way out of the Balzac impasse. At the right moment a solution would suggest itself.

>✠<

Although Camille's *l'Age mûr* of 1893 showed him being led off gently into old age, Rodin was, in fact, in the prime of life—and in the forefront of those regarded as the culture heroes of the avant-garde. Not only had all the official doors swung open; for the younger artists and intellects of Paris he was now the only living sculptor who mattered. In this as in many other respects the young poet Jules Renard summed up the feelings of his generation when he wrote, after his first visit to Rodin's studio (on March 8, 1891), that he had experienced "a revelation, an enchantment" on seeing

> this *Porte de l'Enfer*, and that little thing, no bigger than my hand, which is called *The Eternal Idol*; a man, his arms behind his back, vanquished, kisses a woman under the breasts, gluing his lips to her skin; the woman has a melancholy air. It's difficult for me to tear myself away from that. And an old woman in bronze, a horribly beautiful thing, with its flat breasts and wrinkled belly, and a still-beautiful head. And bodies and arms intertwined, and *le Péché originel* [Original Sin], the woman clutching at Adam and tearing him towards her with all her being, and the Satyr moving as if to disembowel the woman he holds in his arms, one of his hands between her thighs—these contrasts between men's calves and women's legs. Oh, Lord, give me strength to admire all these things!

As usual Renard was watching himself closely in order to analyze his own attitudes and poses. It struck him as amusing that, amid all these impressions, "I play the man who has discovered Rodin." He studied his host and decided that he resembled a sort of shepherd: "He questioned Daudet naively and asked him what to call his stupefying creations. He finds little commonplace titles taken, for instance, from mythology. One maquette is a nude Victor Hugo, something perfectly grotesque." Reflecting on this visit a day later, Renard noted in his diary that "at Rodin's it seemed to me as though my eyes had

suddenly burst open. Up to now sculpture has interested me as much as work done on turnips." All at once he was seized by the desire "to write the way Rodin sculpts."

When Renard discussed the matter with Marcel Schwob a few days later his young friend compared Rodin to Aeschylus: he saw structure and artistic discipline where the veteran Bracquemond had found disorder—a lack of "all sense of composition." Schwob, though only twenty-four at the time, was—with Catulle Mendès—in charge of the literary supplement of an important daily, *l'Echo de Paris*, and by general consent the most perceptive of the avant-garde critics. In a series of interviews with influential writers his newspaper had just established that Naturalism was now a dead issue and Symbolism the order of the day. In April, when the forty-two-year-old Dutch critic Willem Byvanck came to Paris to sound out the situation in the arts, Schwob arranged for him to meet those he regarded as the significant figures of the epoch—including Rodin, Monet and Carrière, as well as Verlaine, Richepin, Barrès, Rosny and Moréas.

They went to see the artists in their studios and the writers in their favorite cafés and cabarets, the Chat Noir and le Mirliton. Rodin, after showing him the contents of his atelier (see page 221), called his attention to something new of which he was very proud, and which he had just described to Gauchez as "a very beautiful thing"—a helmeted version of the Marianna Russell bust, shown to Byvanck as "a warrior virgin." They talked at length about the sculptor's ideas on love and art; then the conversation veered around to technique and Rodin grew very excited: "Do you know what is the greatest enemy of the artist? Talent, the gift he's born with; facility dexterity. In a word, *chic** is what spoils us and ruins us. We think we've arrived at the summit of our art no sooner than we've produced something, and we look no further. And not only that; we then underrate those who don't have the same facility."

Afterward Byvanck discussed these ideas with Mendès, who agreed that Rodin's doctrine "could be applied to poetry as much as to sculpture." There seemed to be a remarkable degree of unanimity among the leading spirits of the avant-garde. It was not only that they

*Rodin used the word *chic* in the pejorative sense, one of the seven given in Larchey's dictionary of Paris argot: "Banal facility, devoid of serious study."

aspired to a similar aesthetic; the political atmosphere of the early 1890s was grim rather than gay, and unconventional thinkers found themselves isolated from the Philistine majority and dependent on one another for moral support. The decade was rife with right-wing conspiracies and anarchist bomb incidents. General Boulanger, on whom the French reactionaries had pinned their hopes, blew out his brains on his mistress's grave when "Boulangism" turned sour, but the anarchist enemies of the Republic were less easily discouraged. In 1891 they began sending parcel bombs to leading government figures, and the following year they set off a series of explosions in public places that claimed several lives and provoked harsh reprisals from the police.

Only a handful of the literati were actually in favor of violent revolution, but many of them opposed the persecution of left-wing intellectuals like Jean Grave, author of an anarchist critique of "The Dying Society" for which Mirbeau wrote the preface. Instinctively the embattled writers and artists drew together for mutual protection and encouragement; hence the heyday of anarchist agitation coincided with the "Banquet Years," in which the social life of Paris was punctuated with frequent testimonial dinners in honor of painters, poets, and musicians. They served as public displays of class solidarity, reassuring the members of the creative professions that, whatever the bourgeoisie might think, they were not the pariahs of the Belle Epoque.

Increasingly, Auguste Rodin was to be seen at the head table on such occasions. He, Zola and Verlaine were among the luminaries who attended the famous banquet in honor of Mallarmé given by *la Plume* on February 9, 1893. It was a memorable occasion in that it set the seal on the triumph of Symbolism—and for once the after-dinner verse turned out to be superb. Mallarmé rose from his seat and, in a voice trembling with emotion, recited a toast to his assembled fellow poets: a sonnet entitled *Salut* that was one day to stand at the head of his own edition of his poetry. In it he compared the banquet hall filled with writers to a ship with himself at the stern and the younger writers forward, where the bow cuts the waves, embarking on a voyage of danger and adventure in literature.

Later that year, on June 17, Rodin and Mallarmé were both guests

of honor at the Victor Hugo memorial dinner that marked the post-humous publication of Hugo's *Toute la Lyre.* For the occasion a maquette of Rodin's *Apotheosis of Victor Hugo* had been set up in the center of the restaurant.

On December 9 it was Rodin's turn to be president of another of the dinners given by *la Plume*, this time with Zola and Mallarmé on either side of him, and a guest list headed by Verlaine, Laurent Tailhade, Stuart Merrill and Jean Moréas. When he rose to speak Rodin said he regretted lacking the eloquence of previous banquet presidents: "Unfortunately I am nothing but a simple manipulator of modeling tools, and since sculpture is mute I surely have the right, if not the duty, to keep silent." Still, as a "workman of art" he proposed a toast to the health of poets and novelists, "above all to those younger than myself"—a sign that he was, after all, beginning to think of himself as middle-aged.

That very afternoon an anarchist had set off a bomb in the Chamber of Deputies, injuring forty-seven people but, miraculously, killing no one. During the dinner a reporter asked Mallarmé for his reaction: The poet agitated over a suitable aphorism and changed it twice before deciding on the definitive, "Books are the only bombs I know" ["*Je ne connais d'autre bombe qu'un livre*"]. It seemed to range him on the side of the anarchists and promptly made him the target for a campaign of abuse in the conservative press. Rodin, however, was growing steadily fonder of his fastidious and controversial friend. "It's always a pleasure for me when I see your name in the newspapers or the magazines in which you reign like a demigod, *cher poète*," he had written to Mallarmé during the previous summer. "I rise in my own esteem when I think that I am your friend and can boast of calling myself your friend."

Camille Mauclair, who knew both of them well, sensed that there was an unconscious bond of sympathy between them that transcended their admiration for each other's work. Their voices even sounded alike and they had the same elliptical way of speaking. "You are a monster," Rodin once told Mallarmé after listening to his ideas at one of his Tuesday evening literary gatherings. "I certainly hope so!" was the answer. Perhaps both were thinking not only of his literary extravagances but also of his emotional double life—as a meticulous

family man, utterly devoted to wife and daughter, and as the preferred lover of Méry Laurent, the ex-model whose lavish existence was underwritten by an expatriate American dentist.

Rodin made Mallarmé a present of a plaster faun-and-nymph and planned to do his bust—but there seemed to be no particular urgency, especially since Whistler had just done the superb lithographic portrait used as the frontispiece of the poet's *Vers et Prose* of 1893. "I've seen Mirbeau and Rodin who were enthusiastic about the little portrait," Mallarmé wrote to Whistler. "For after one is finished shaking hands one always talks about Whistler." Rodin had read some of Mallarmé's poetry and spoke of it affectionately to Arthur Symons. It was full of compression and foreshortening, he said, and "many people don't understand foreshortening."

Mallarmé was one of the prime movers of the committee formed in 1892 to raise money for a monument to Baudelaire. Rodin, despite his Balzac troubles, agreed to furnish whatever form of memorial would ultimately be decided on: "statue, bust or medallion." When Mallarmé was offered the presidency of the committee he declined the honor: "In the domain of poetry there is one name that must be reckoned with, that of the much admired and respected Leconte de Lisle," who had been a personal friend of Baudelaire's. Rodin felt uneasy about the choice. Leconte was in his mid-seventies and his "Olympian, marble-like talent" had little in common with the "tormented nature" of Baudelaire. "Monsieur Leconte de Lisle does not share the taste of his committee," Rodin told René Malliet of *le Rappel* in October 1892. Worse yet, the Baudelaire committee was long on names but short on money. Despite urgent appeals hardly anyone subscribed to the fund and Rodin's project remained an unfinished sketch.

At the outset, however, Rodin took a vivid interest in the problem of portraying Baudelaire, now twenty-five years in his grave at Montparnasse. "At first I thought about a medallion with satanic allegories," he told Malliet, "then about a bust with bas-reliefs expressing the character of *Fleurs du mal*. . . . Of course if we're rich we'll do a monumental group like Dalou's *Delacroix*." He had heard a great deal about Baudelaire from Léon Cladel and had studied many portraits, notably Fantin-Latour's admirably "lifelike" study of the poet

in *Hommage à Delacroix*. "That smooth, complex physiognomy of Baudelaire's has me literally riveted; it's as attractive as a problem and painful as reality. There is something of the priest in it, of the comedian and the Pierrot, with a sort of British allure. The way his gaze darts out beneath the high thinker's forehead—and the whole poem of irony that can be read in the firm design of his clenched lips."

Again he searched for a living model who would embody his vision of Baudelaire, and the artist Louis Malteste fitted the description; afterward Malteste's head in plaster, neatly severed at the neck, was all that remained in Rodin's studio to remind him of the whole unfortunate episode. "The subscription was opened seven years ago and has brought in very little," he told a visitor in 1899. "You know, there are some dead people who are unlucky, and the author of *Fleurs du mal* is one of them."

>✠<

A more fortunate subject, sculpturally speaking, was the composer of *les Béatitudes*. César Franck had died in November 1890—a month before his sixty-eighth birthday—of complications arising from a traffic accident: while riding in a cab he had been struck in the chest by the carriage pole of a passing omnibus. The following year, when his remains were transferred from Montrouge to Montparnasse cemetery, a group of his disciples raised a small fund for a portrait medallion to be placed on Franck's tomb. Two of his most devoted pupils, Ernest Chausson and Augusta Holmès, came to Rodin's studio and commissioned him to execute the medallion. Rodin did as they asked, working from a photograph of the composer. "The medallion is a good resemblance," he wrote to Vincent d'Indy, "and has cost me a good deal of effort. . . ."

But the clay was hardly dry when he received a visit from the architect of the tomb, who told him that several of Franck's pupils, including Chausson and Henri Duparc, now favored an unadorned slab bearing only the composer's name. "So here I am with the medallion for which Chausson came to ask me with such insistence," Rodin wrote to Augusta Holmès, the wealthy Irish-French composer who was the mistress of Catulle Mendès:

It's almost a portrait bust, since it's in high relief and required the same amount of study. I didn't want the commission, knowing the great difficulty of the work, which nonetheless I managed to surmount. So now there is the prospect that the medallion may be refused. Please intercede for me, my dear artist, and write to Chausson, since it was he who came to the studio with you to commission the work. You know that I asked for a fee of 1,500 francs whether executed in stone or cast in bronze. You can see that this charge is most accommodating for the purses of Franck's pupils. In any case, *ma chère grande artiste*, I don't want the public to be let in on the secret of these small details which are best not discussed with anyone. I rely on your gracious and charming influence. . . .

Rodin's confidence was not misplaced, and his medallion was duly affixed to the tomb. Yet when he saw the architect's drawings in April 1892, he objected vehemently to the design, which had the medallion tilted backward at an angle: "It won't get enough light and doesn't seem in its proper place and gives the impression of being rejected by the monument," he wrote to Augusta Holmès. "It will be raining into his nose, as the vulgar expression has it."

He asked d'Indy, the most influential of Franck's pupils (and a former Bon Cosaque), to make sure that "our great maître Franck is not placed like a rosette among the acanthus leaves." The one-meter tombstone was too low; it must be raised to eye-level at 1.70 meters, and the medallion must be placed in an upright position, not "laid down like a book; it wouldn't get any light." In the end Rodin's instructions were followed, and the finished monument has the medallion upright, in bronze and at eye level. But it is hemmed in so closely by surrounding monuments that the effect is, after all, rather like that of a rosebud among the thistles.

>✠<

In February-March 1893, Rodin made a drastic change in the landscape of his private life* and moved with Rose from the dark, narrow

*"In my experience, what cut the deepest channels in our lives are the different houses in which we live—deeper even than 'marriage and death and division,' so that perhaps

rue des Grands-Augustins to a sunny house set amid a large garden at No. 8 and 8-bis, chemin Scribe in suburban Bellevue, between Sèvres and Meudon. The house was called le Chien-loup, after the door knocker in the shape of a wolfhound that decorated the main gate. Situated on a hillside sloping toward the Seine, it occupied some of the land that had once belonged to the residence of Eugène Scribe, the prolific playwright who wrote the libretti for Meyerbeer's *les Huguenots* and Verdi's *I Vespri Siciliani*.

It was a rambling three-story house—since demolished—with six bedrooms and a large terrace. On the top floor, which had seven windows, Rodin installed a studio that afforded a sweeping view of the river, which makes a long loop at this point, and of Saint-Cloud and Paris in the distance. At the foot of the hill was the landing stage of a regular boat service that took passengers up and down the Seine; it enabled Rodin to get to the rue de l'Université with only a short walk at either end. As Maillard noted, the whole of le Chien-loup was soon overflowing with the usual mélange of sculptures—"in upstairs rooms, on the furniture, on tables and chests of drawers there was nothing but clay sketches, first ideas or more detailed studies, figures and pieces roughly detached from some ensemble that hadn't satisfied him, and here and there a classical head, a piece of sculpture or a Greek vase."

The gardener of the house later recalled Rodin's fondness for going on long walks through the nearby woods at the crack of dawn, and his singular preference "for what was outside the garden rather than in it." With his neighbors, the Philibert Renards, he was friendly and outgoing; they liked to spend summer afternoons chatting across the fence with Rodin and Rose. Soon after their arrival he developed a taste for the local wine, Clos de Lampes, and for the local strawberries which, with his customary eye for detail, he would order especially "with the stems still on them." The neighbors were also treated to Rose's jealous recitals of Rodin's infidelities. Though she had emerged the victor in her terrible contest with Camille, there was sufficient cause for complaint about new transgressions. "But

the chapters of one's autobiography should be determined by the different periods in which one has lived in different houses."—Leonard Woolf, *Beginning Again, 1911–1918* (London: 1963).

Monsieur Rodin loves you," said Madame Renard, trying to console her. "There are other ways of loving!" was Rose's bitter reply.

With his move to the suburbs Rodin had deliberately placed a certain psychological distance between himself and the day-to-day problems of the Paris art world. He was now "Rodin, who lives away from everything," as Camille Mauclair described him in his novel *la Ville Lumière*. In July 1892, he had risen a step in the hierachy of government recognition by being promoted to Officer in the Legion of Honor, and the following year brought further honors and distinctions. His peers at the Société Nationale elected him president of the sculpture section to succeed Dalou—with whom he had quarreled again, this time over the placement of Camille's Rodin bust, which had earned her associate membership at the Salon of 1892. At the same time he was among the elite group of sculptors whose work represented France at the World's Columbian Exhibition in Chicago, which opened for six months on May 1, 1893 (only the grounds had been dedicated in October 1892, on the actual anniversary of Columbus's discovery of America).

That summer Rodin paid a visit, not to Chicago but to Brittany and the Channel Islands with his friends Gustave Geffroy and Eugène Carrière. He had proposed the idea to Geffroy—"I'll advise *l'ami* Carrière"—outlining an itinerary that included a stop at Caen on the return journey. But they arrived in Brittany by separate ways, and it was not easy to coordinate the schedules of three such independent temperaments. Carrière, an inveterate family man, first kept Geffroy waiting for three days at Morlaix while he tarried at Saint-Brieuc "waiting for his wife and children instead of coming to see me," as Geffroy wrote impatiently to his mother. "And all the while I was waiting for him as though for the Messiah of painting." Later, both of them had to wait for the Messiah of sculpture to arrive from Paris. "Rodin has written me to ask when we leave for Guernsey," Carrière wrote to their mutual friend Madame Ménard-Dorian, who had invited them to join her on the island. "I am at his disposition and soon I and our excellent friend Geffroy will have the pleasure of shaking your hand." On Jersey and Guernsey they visited the houses where Victor Hugo had lived, and Rodin, as Lawton heard, "familiarized himself with the poet's rock of exile, which he wished to bring into his monument to the author of *Les Misérables*."

Carrière, whose enjoyment of the holiday was diminished by the desperate poverty he observed in peasant Brittany, had become Rodin's best friend among the artists of Paris. "It would have been difficult to find two temperaments that were more unalike," as Charles Morice noted, yet they thrived on each other's art and company. Mauclair wrote that Carrière was "the man to whom Rodin was closest, and on whom his genius had the greatest influence." His paintings allied him to the Symbolist poets, who loved his work. Critics compared him to Mallarmé but had difficulty classifying him, since he belonged to no school—though he had an instantly recognizable style of his own that plunged his subjects into deep shadows: a mysterious *sfumato* technique that Guillaume Apollinaire once described as *l'idéal brumeux* (the fog-bound ideal).

Born in 1849, Carrière had been a prisoner during the Franco-Prussian War and had endured years of grinding poverty; his first one-man show was not held until 1891. His favorite subject, depicted in countless canvases, was mother love, especially as manifested by his wife toward their children (one of the six had died when they were still too poor to buy medicines for it). Goncourt came to admire Carrière as the foremost talent among the younger painters: "the only original, a spectral realist, a psychological painter who doesn't paint the portrait of a face but the portrait of a smile." Seeing his many pictures of nursing mothers, Goncourt wrote in his journal that this was "the painter of breast-feeding" par excellence, especially in what Carrière called *intimate gestures*, "admirable studies of the embracing hands of mothers and the heads of nursing infants."

When Carrière painted Goncourt's portrait—not once but twice, and then a third time—the old gentleman found him "amusing and devilishly witty." That was what most people felt about this likeable, rather enigmatic artist. Yet Frantz Jourdain, another close friend, describes him as a solitary figure, at odds with the tastes and fashions of the age: "Carrière was of middle height; he had the fair complexion of Alsatians, plebeian hands, a short neck, square shoulders. . . . He usually dressed in a worn redingote, a vest that was too large for him and pants scuffed at the knee. He would hardly have been noticed if it hadn't been for his bushy, disobedient blond hair and a head as massive as a lion's, illuminated by clear, piercing eyes and terminating in an energetic chin."

Carrière had in mind assembling "a sort of Panthéon of our time" for which he painted a remarkable succession of portraits: Verlaine, Alphonse Daudet, Jean Dolent, Morice, Roger Marx, Chausson, Isadora Duncan, Anatole France, Clemenceau, Gallimard, Puvis de Chavannes . . . and, of course, Rodin, whom he painted twice in his most crepuscular manner. It was easy to make fun of this style, which enveloped the sitter in a sort of mist that obscured all but his most salient features. Degas said that Carrière's work reminded him of "an ill-bred man smoking a pipe in the bedroom of a sick child." But Rodin made no secret of his conviction that Carrière was a *grand maître*, and traded several of his sculptures for some of his friend's pictures—which, he said, made him feel "very happy and quite overcome" by their beauty. The writer Aurel (Aurélie Mortier de Faucamberge) once overheard a visitor discussing his work with Rodin:

"I don't *feel* Carrière; he puts everything in a fog."

"Ah, indeed! And a blow of the fist, you don't feel that in a fog?"

>✲<

Since his rise to prominence Rodin had been increasingly beset by such people, the perennial snobs and sycophants of the Paris art world. Now that his work was selling briskly some of them did a predictable about-face and began to dismiss him for being too commercial. When the German museum curator Alfred Lichtwark, director of the Hamburg Kunsthalle, descended on Paris in June 1893, he sent his board of directors an exceptionally unvarnished account of what the smart people were saying about Rodin, "whose talent is much admired, though his current activities are universally condemned":

He has become the fashion and has been selling individual subjects from his *Porte*, executed in marble, by the dozen. In his studio one always sees five, six of the small groups of figures locked in every conceivable kind of embrace, and then some; and when you come to the studio of a young sculptor with the reputation of being a skilled, sensitive marble-carver, you will surely find him working on one of these sculptures: *C'est pour l'Amérique, vous savez*. The awful thing is that while these wild

subjects may be justified as part of the *Porte*, Original Sin, Eternal Damnation and the Last Judgment, as individual pieces they are often simply indecent. *"Rodin n'est plus qu'un faiseur de fesses"* [Rodin is nothing but a sculptor of buttocks], one of these gentlemen told me rather crudely though correctly, since the common denominator of all these little sinners is that they press their face against or into the stone, yet compensate for this by exposing to view another part of the anatomy which is, on the whole, regarded as less suitable for expressing the anguish of the soul.

Whatever the gossips might have said, their influence was easily outweighed by the support Rodin received from some of the important new recruits to his circle of admirers, notably the Norwegian painter Frits Thaulow, the poet Charles Morice, the young sculptor Antoine Bourdelle, the journalist Séverine, and Anatole France, whose novel *le Lys Rouge* (The Red Lily, 1894) contained yet another fictionalized portrait of Rodin, thinly disguised as the sculptor Dechartre. France describes him as an artist-egotist with "a tormented and tormenting imagination" who lives "too tightly enclosed within himself and his inner world"; he is moody, difficult, passionate, and has "a mad fixation for beautiful hands." Dechartre is also "a lover of women" without any real hope of emotional fulfillment. At one point he asks the woman to whom he is making love, "Are kisses, caresses anything but an act of delicious despair?"

The character is authentic and well-drawn—yet women like Séverine saw the real-life Rodin very differently: as warm, generous, charming, lovable. Among his new friends it was Séverine who caught his eye, and of whom he chose to do a portrait; he allowed her to see sides of him that Anatole France would not have suspected. She fired his imagination because she was that extraordinary phenomenon, a liberated woman who had lost neither her missionary zeal nor her sense of humor. To the literary critic André Billy she was the greatest woman journalist of France since Madame de Sévigné; the feminist Marguerite Durand called her "the greatest journalistic figure of modern times." These were tributes not so much to her writing, which tended to be breathless and elliptical, as to her lifelong devotion to social justice and her activities on behalf of the poor. Not content to

write an endless series of articles and appeals concerning the desperate plight of France's paupers, she also ran her own private charity for the neediest cases of Paris. As she explained to Rodin, she could not hope to defeat poverty single-handedly but she could save someone every day: "At the end of a month that makes thirty; at the end of a year, it makes 365. . . ." In one of her first letters to Rodin she thanked him for his contribution to "my little protégés."

Their friendship began in June 1892, when, after a visit to his studio, Rodin offered her one of his small figures and she wrote back to say how grateful she was. She had been awestruck by his "titanic conceptions" but this little figure was more accessible to "my ignorant ecstasy." After seeing it in his atelier "it haunted me, this little figure. . . . I thought about it all evening . . . and then your telegram arrives, offering it to me, and here I am, so happy I don't know how to thank you."

Rodin had known many women but none quite as formidable as this attractive, strong-willed Parisienne who was one day to deliver an impromptu funeral oration over his grave. She was thirty-seven when they met: "A compact oval face with tender eyes, a large mouth with beautiful teeth and an air of kindness," as Goncourt observed earlier in the year, when he met her for the first time. He was surprised to learn that this soft-spoken lady writer with the limpid blue eyes and charming voice published six articles a week. She told him that she had an iron resolve "that nothing could discourage, that could not be rebuffed, and that she always succeeded in what she set out to do." She had married at fifteen, had been badly abused by her first husband, and had become the secretary and favorite disciple of Jules Vallès, the novelist-reformer who had founded the left-wing newspaper *le Cri du Peuple*, which she directed for three years following his death in 1885. She was offered a parliamentary candidacy and refused, on the grounds that she would rather be with the ambulances than at the speakers' table. "Whenever the barricades went up anywhere she was on the right side," wrote her friend Lucien Descaves. "She loved the poor, justice and work well done."

Rodin heard her speak in public and was "ravished" by this "angel of eloquence." She, in turn, was flattered and excited to have become the object of his attentions. "To be so appreciated by you!" she wrote to him in August 1892. "You know it would be quite enough to give

me a swelled head if I didn't realize you were merely being indulgent with me." She was invited to sit for her portrait and the result was a series of "curious" séances: "He would feel your skull as a phrenologist would (fortunately my hair was my own!) and grow ecstatic over this bump and that one. 'And these maxillaries,' he would say. 'How solid, well placed and well covered they are!' " But he was accustomed to touching his models not just on the head but all over; she relates that he became progressively more eager in his advances. "He was a passionate artist who had trouble restraining the ardor of his senses. At the first sitting he was respectful. At the second, less so. At the third he ceased altogether." Séverine took offense; though she went on seeing him, the sittings were adjourned, the bust left unfinished.

For the readers of le Journal in November 1894, she painted him in a very different light from the usual newspaper portrait of the maître in a plaster-covered smock:

The redingote is splendid and the watch-chain as well, both of them elegant, correct and nicely set off by the rosette of the Legion of Honor. This man will belong to the Institute. . . . Yet a certain gracefulness sounds a note of discord with the predictability of this ensemble: the spicy flavor not of La Bohème but of the people and the soil. It's really nothing much; a little uneasiness in the shoulders, a gesture of scornful distaste for clothes that are too tight and restrictive; a horror of being dressed in one's detested Sunday best. This game of moving joints, rippling muscles, fits badly into a contemporary suit, anti-aesthetic as it is. And this man from the forests lost in our city squares, a demigod dressed by the tailors, seems in his coat of fine cloth to be the last of the ancient family of satyrs. His hands? Strangely like those of a priest or a surgeon; not at all brutal, as one might expect from such work, but hands that could give extreme unction, obstetrical hands, delivering nature of her masterpieces. And beyond the solidity of the ensemble, a revealing mask—a rugged complexion, strong nose, immense reddish beard, tightly helmeted by close-cropped hair; while beyond the pince-nez his timid, brilliant blue gaze moves and ripples like the sea seen through a window pane.

Séverine had been a radical socialist but gradually became something of a mystic. Her first book, *Pages rouges*, was followed by her *Notes d'une frondeuse* (Notes of a Woman Rebel), then by her *Pages mystiques*, in which she pleaded with the Church to adopt a new set of social priorities: "These are tomorrow's allies, the overall and the cassock, the priest and the worker!"

Her devotion to Rodin—and her pride in having "worked in honor of your glory"—was shared by some of the younger artists who helped fill the place left vacant by the apostate Camille. Bourdelle, who became one of his most trusted assistants, remembered having undergone a sort of Pauline conversion long before he met the maître in person: "I had seen your head [of Luisa Lynch] at the Luxembourg; I went to her when she called me from afar; I had not so much seen as felt her presence. Since that day, without interruption, I have directed my steps toward the Fountainhead you are."

Bourdelle was not quite thirty-two when Rodin first employed him as a stone carver. A native of Montauban who spoke with the resonant rolled r's of the Languedoc, he had studied under Falguière and worked for Dalou before taking up the chisel on Rodin's behalf. Being invited to carve marble for Rodin was regarded as a compliment but not a lucrative one: François Pompon, whose differences with the maître had to be submitted to arbitration in 1893, was paid the unmunificent sum of two francs an hour for his labor. Even Rodin's most gifted assistants of the 1890s were no better off than he himself had been while working for Carrier-Belleuse. "I work for Rodin, as you know, but under pretty bad conditions," reported the young Swiss sculptor Auguste de Niederhäusern-Rodo in a letter to his sister Julia:

> The maître doesn't have any money so I never know when I'll get what I need; from time to time a twenty-franc piece which is quickly spent, and then it starts all over again. I eat badly. And I get very tired. In the morning it takes me an hour to cover the 5 1/2 kilometers from the rue de La Tour-d'Auvergne to the boulevard d'Italie so as to be in the studio at eight o'clock; at night I get home very tired and never before midnight because I go to see this or that person, write letter after letter concerning my work, run to the Salon. . . . The atelier in which I work is

an old château . . . whose roof leaks like a sieve. It's so damp
and chilly that I've caught a head cold, bronchitis, catarrh and
rheumatism.

An assistant of later years, Charles Despiau, described the priv-
ilege of working for Rodin as an experience both "splendid and
atrocious." Bourdelle, however, acquitted himself so well in the initial
stages of their relationship that later on he could do no wrong. As
the first real test of his abilities he was given a marble bust to recarve;
if that worked out well he was promised further work in stone, his
favorite medium. On September 20, 1893, when the bust was nearly
finished, Rodin came to the young man's studio to see how he was
getting on. "It's too good," the maître said when he saw the bust. "I
just wanted a simple recarving. I won't give this to the collector for
whom it's intended; I'll keep it for myself. It's like a Carpeaux, your
marble."

Years later, when Bourdelle carved him an *Eve* in pinkish stone,
Rodin was so taken with it that he called it "Bourdelle's Eve." Their
friendship lasted a long time and was rooted in similar attitudes and
tastes. Both were largely self-taught and took pride in the craft of
sculpture; both detested the Academy and admired Rude, Barye and
Carpeaux. But there was a father-son aspect to the relationship that
gave it an Oedipal cutting edge. As Judith Cladel once summed up
for the art dealer René Gimpel: "At the beginning he adored Rodin,
then little by little he said to himself, 'Why not me?' "

Another young sculptor aroused Rodin's curiosity and enthusiasm in
1893—the Italian Medardo Rosso, who exhibited some of his work
in the foyer of the avant-garde Théâtre Bodinier in November and
December. There was something startling in the young man's work
that prompted a letter of congratulation. "My dear Rosso," Rodin
wrote to him on January 17, 1894. "You have given me *immense
pleasure*; on arriving at the atelier I was struck by a mad admiration.
I didn't write to you because I no longer had your address. I'm happy
if you want to lunch with me on Saturday; I shall be delighted. See
you soon, your friend Rodin."

Born in Turin in 1858, Rosso had been living a hand-to-mouth

existence in Paris for nearly five years: his works were known only to a small circle of cognoscenti. It was said that he "sculpted with a brush and painted with a modeling tool," but Degas admired his painting, and others besides Rodin were struck with a mad admiration for the audacity of his sculpture. He had created a style of his own that was usually termed Impressionism, though it had more in common with Carrière's *sfumato* variant of Symbolism; his figures and busts were mysteriously "veiled in twilight" as though the wax had begun to melt in a kiln. The very indistinctness of his sculptures obliged the observer's eye to search out their meaning, which was only hinted at in titles like *Man in the Hospital, Conversation in the Garden* and *Impression on the Boulevard at Night*. He had, moreover, arrived at a carefully thought out theory of sculpture as a function of its shadow that anticipated the Futurists and was summed up in the maxim *Rien n'est matériel dans l'espace*.

He was the son of a railway stationmaster and he, too, claimed to have taken up sculpture because "paints were too expensive." Unlike Bourdelle he never ceased being poor, but wore his poverty proudly, as a badge of independence. Acquaintances described him as restless, brash, opinionated: "A forehead furrowed by two deep lines of energy and obstinacy, topped by a mass of curly, bushy hair that shades over into auburn and cascades over a Herculean neck; a dense, bushy mustache; the body and musculature of an athlete."

Rodin was so taken with his work that he paid Rosso the rare compliment of exchanging sculptures with him—and in bronze, not plaster. Of course Rosso was flattered and delighted "when I think that my piece is on display at your house amid the Egyptian things, and that you yourself have done me the honor of letting me choose one of your works."

Rodin also received a copy of the classic head of the Roman emperor Vitellius which Rosso kept in his studio to illustrate the little lectures on comparative sculpture he used to give his visitors. "Did the *Vitellius* give you pleasure?" he wrote to Rodin in his shaky French. "Write me a word. I don't want any recompense except a little time with you over a good lunch like the other time. I need to spend some hours of good fellowship with you. I'm really a bit stunned." Rodin had given him the job of adding an artificial patina to one of his bronzes—a task for which Rosso was well qualified, since he was

knowledgeable about metals and did his own bronze-casting. "This week you'll have the bronze I took for *patinage* and I hope it will please you. I put it off a little because I had a lot of things to do which prevented me from spending as much time on your work as it deserves."

When Rosso went to London in 1896, letters of introduction from Rodin opened important doors for him: "Once again I owe you much of my life," he wrote to his benefactor. "I don't know how to tell you more. Here too your attention has helped, and you wouldn't believe the effect it has produced for me. . . . Obliged and obliged and forever devoted and affectionate M. Rosso." All the same, relations between them were gradually approaching a crisis. As Rosso afterwards told the story, he "gave Rodin advice on his work" during the *Balzac* years, and "the good advice I gave to this famous man" was very different from the panegyrics the maître was accustomed to hearing: "Despite all your efforts you've only put new varnish on the old house; you haven't changed course, haven't abandoned the material conception of sculpture. You've retained, as always, the statuary interpretation which regards sculpture as something one walks around and touches with the hand."

Indeed it had always been one of Rodin's articles of faith that sculpture was something one should be able to circumambulate with a candle in one's hand. Yet here was a presumptuous young sculptor who maintained that no work of art could be dissociated from its setting, "for all depends on the ensemble and on the ambiance of the subject." By the same token, sculpture should be seen from certain predetermined points of view, as an ornamental adjunct to architecture: "One should no more walk around a piece of sculpture than one turns a painting around to see what's on the backside."

Rodin may not have made very much of these theories, but he paid close attention to the sculptures he saw in Rosso's Montmartre studio. The Italian was then at work on a number of curiously slanted figures that look as though they might have been dipped in hot wax, such as *The Bookmaker*—an impression of a man-about-town dressed for the races in top hat and redingote, leaning on a cane and holding a pair of binoculars to his chest. There was nothing quite like this debonair personage in the whole canon of nineteenth-century sculpture. It leans sideways and backward much as Rodin's *Balzac* was

to lean backward a year or two later. This physical and perhaps psychological resemblance later led Rosso and his admirers to accuse Rodin of plagiarism—a vexed question that has exercised several generations of critics and art historians.

It may indeed have been Rosso's example that finally helped Rodin cut the Gordian knot of his problematic monument. Among his Balzac studies the penultimate figure is the most obviously Rosso-influenced of them all: evidently the Rodin who had learned from the Greeks and primitives, from Donatello, Michelangelo, Puget, the Gothic cathedral builders and the Breton folk sculptors was not too set in his ways to learn a thing or two from a young Italian with revolutionary ideas. Rosso's bitterness stemmed, not from the fact that Rodin had borrowed from him, but that the world refused to acknowledge that he had been "the precursor, the illuminator and in a certain sense the teacher" of the sculptor of *Balzac*. It would have been too much for anyone but an angel to acknowledge such an ill-defined debt. Rodin certainly did not, and he refrained from giving further aid to this troublesome colleague. That was one of the reasons why Rosso's works were permitted to molder away for years in the storerooms of the Luxembourg Museum.

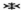

The praticiens who were carving Rodin's marbles at the Dépôt des Marbres were just on the point of completing the government's 20,000-franc *Baiser* when Armand Silvestre paid an official call on behalf of the ministry in January 1894. "The figure of the woman may be considered finished," he was happy to report to the minister of public instruction and fine arts. "That of the man—apart from the head, which is in the same state of completion as that of the woman—has the hand and left foot barely emerging from the block; the rest is more or less done."

The 40,000-franc seated *Victor Hugo*, on the other hand, was still in the clay and plaster stage. Only a maquette "on a very reduced scale" was to be seen in the studio, though the sculptor assured him that it had already been "cast in plaster in its definitive size." Rodin had begun working with Henri Lebossé, the so-called *réducteur* who henceforth did the enlargements of his life-size statues. Lebossé owned his own workshop at 26, rue du Moulin-Vert where he produced large

plasters from small maquettes with the aid of an enlarging machine—a sort of pantograph device that transferred selected "points" from a small model to a larger copy that had first been roughed out in clay or plaster. Such machines were also used commercially, but Rodin was at pains to publicize the fact that there was nothing mechanical about the way he reproduced his sculptures. When the young writer Rémy de Gourmont came to see him a few weeks before Silvestre's visit, Rodin emphasized the fact that he alone was responsible for the finished result. "Rodin does not reproduce his works industrially," de Gourmont reported in *le Journal*. "The reproductions in marble are made under his eyes and with his constant and direct intervention; he couldn't tolerate seeing even the least of his statuettes dishonored by a hasty and oversimplified execution."

Two of his latest marbles were being shipped off to America, where he now had an affluent new admirer, the Chicago streetcar magnate Charles T. Yerkes. In an effort to break into New York society, Yerkes was building and furnishing an art-filled mansion on Fifth Avenue designed to rival the Frick collection. Rodin wrote to him on July 23, 1894, confirming that *Cupid and Psyche* and *Orpheus and Eurydice*—the former had just been crated and sent off—were the first two original Rodins especially made for an American collector: he hoped they would "do honor alike to Monsieur Yerkes of Chicago and Monsieur Rodin of Paris." At the same time he sent instructions that the *Orpheus and Eurydice* were to be placed somewhat against the light. "The mass of the marble, which represents the portal of hell, should be a gulf of shadows from which the couple emerge, Orpheus on the threshold, already outside, and Eurydice in the shadows ready to leave. The parts that seem not sufficiently finished are purposely left so. It is this which gives my sculpture its atmosphere."

He was not too busy turning out works *pour l'Amérique* and continuing his Balzac studies to do a small but significant favor for Edmond de Goncourt, into whose personal copy of Mirbeau's *Sébastien Roch* he drew a pen-and-ink portrait of Mirbeau as a frontispiece—"two profiles and a frontal view whose construction is that of a great manipulator of clay," as Goncourt noted in his journal. The old literary lion had gradually amassed a unique collection of such "assocation copies," which contained their authors' portraits drawn or painted by leading artists of the day: Daudet and Geffroy by Carrière, Madame

Daudet by Tissot, Huysmans and Zola by Raffaëlli, Rodenbach by Alfred Stevens and so on. Although Mirbeau had hoped that Rodin would draw his portrait from life, the actual drawing was based, as usual, on the portrait bust already in existence.

Goncourt later heard from Mirbeau that the original bust had been something of a problem piece. "You know Rodin had begun my bust [in 1889] but he was not happy with it. He intended retouching it later—but then one day, all of a sudden, he took a length of wire and sliced it in half like a mound of butter,* turning it into a mask that he stuck on the wall." Geffroy pronounced it a masterpiece: "Just as it is, it's the most beautiful thing he's done." Séverine, seeing it in the studio, described it as "not just a portrait but a psychological translation." Mirbeau himself thanked Rodin for "your bust of a certain Mirbeau, so firmly and forcefully modeled," but years later he confided to Paul Léautaud that the bust bore him "not the least resemblance."

Rodin's old alliance with the "group that I love"—Mirbeau, Geffroy and Monet—was still very much in force. On November 28, 1894, they held a memorable reunion at Monet's house in Giverny, where together with Clemenceau—now the leading socialist politician and newspaper editor—they met Paul Cézanne, who had come north from Provence to renew his acquaintance with Paris and his friendship with Monet. Cézanne, then living at the local *auberge*,† turned out to be pathologically shy and self-conscious. "He struck us all as a singular personage; timid and violent, and extraordinarily emotional," Geffroy recalled. "He gave us proof of his innocence and confusion when he took Mirbeau and me aside to tell us, with tears in his eyes, 'He's not proud, Monsieur Rodin; he shook my hand! A man decorated with the Legion of Honor!' And again, after lunch didn't he go down

*The magazine *les Hommes du jour* reported that Rodin had, in fact, thrown the mask into a corner in a fit of pique. Only when one of his disciples called his attention to it as "admirable, a work of genius!" did he become aware that he had created another chef-d'oeuvre.

†The inn at Giverny became, for a time, a mecca for dozens of young Impressionists and would-be Impressionists, all looking to Monet for guidance and approval. According to Will Low, one of them brought his canvases to the maître for inspection and Monet asked, "This is the way you see nature?" "Oh yes, that is the way I see nature." "Impossible," was Monet's reply, "for that is the way I see nature *myself*."

on his knees before Rodin in the middle of a path, to thank him for having shaken his hand!"

Afterward there were to be calmer meetings in Paris, where Cézanne had lunch with Rodin at Druet's café-restaurant in the Place de l'Alma. "He has genius . . . and he has a full purse," Cézanne told his Boswell, Joachim Gasquet. "He arrived with his blouse splattered with plaster and sat next to the building workers. He's a sly fox, and his remarks shut them all up. But I love what he does. He's intense. People don't understand him yet, or if they do it's for the wrong reasons. You have to have a tough temperament to withstand the buttering-up he receives from all these little writers. It would give me the jitters. But he's lucky; he achieves things." Rodin, for his part, never knew what to make of his strange contemporary from the Midi. At the mention of his name, as Paul Gsell noted after the turn of the century, the sculptor shrugged his shoulders as if to excuse himself: "This one I do not understand."

A few days after the excursion to Giverny came the news that Robert Louis Stevenson had died in Samoa at the age of forty-four.* Rodin never forgot "our friend Stevenson who was so dear and left only his glorious name." In later years he often spoke of him with deep regret to their mutual friend John Peter Russell, who translated Stevenson's *The Black Arrow* for Rodin's benefit. According to Jeanne Russell, this obscure novel about the Wars of the Roses became one of his favorite books.

Rodin's circle of literary friends had recently sustained other important losses: Léon Cladel had died in 1892, aged fifty-seven, and Guy de Maupassant a year later, at forty-two. But the saddest news came from Henley: in February 1894 he lost his five-year-old daughter

*Stevenson had taken Rodin's plaster *Printemps* with him to the South Seas, and there is an apocryphal story to the effect that these embracing lovers were much admired by some Samoan chiefs who inquired politely, "They are your relations?" The reality was more mundane. Stevenson and his wife held Sunday-night prayer meetings for Samoans at their plantation house, Vailima: in a letter to George Meredith he remarked how strange it was "to see the long line of the brown folk crouched along the wall with lanterns at intervals before them in the big shadowy hall, with an oak cabinet at one end of it and a group of Rodin's (which native taste regards as *prodigieusement leste*) presiding over all from the top—and to hear the long rambling Samoan hymn rolling up."

Margaret, the golden-haired girl whose friendship with James M. Barrie inspired the character of Wendy in *Peter Pan*. By his own account Henley was never the same afterward. "I believe my verses won't all perish," he wrote to Rodin. "And yet what is the use of speaking about it? I am dead; my wife too is dead. We lost all in losing that marvel of life and wit, our daughter. You would have cared for her too. She had everything, everything."

12

THE COLOSSUS

—Et si c'était d'un autre?
*—Ce ne peut-être d'un autre.**

—JEAN DOLENT
Devant le Balzac

O n the evening of January 16, 1895, some 600 artists, intellectuals and men of affairs attended a testimonial dinner in honor of Puvis de Chavannes, who had recently celebrated his seventieth birthday. It was held in the vast, opulent Hôtel Continental in the rue de Rivoli and was to be remembered as the most splendid artist-dinner of the decade. For Rodin, who presided, it represented the high-water mark of his career as a banqueter.

Rodin had, in fact, suggested the dinner: it was organized by a group of Puvis admirers who were also friends of Rodin, notably Carrière, Mirbeau, Geffroy and Roger Marx. Mathias Morhardt served as secretary of the organizing committee, a loose-knit group that met regularly at the Café Riche in the Place de la Madeleine to draw up the long lists of people who were to be invited: with the exception of the guest of honor and two government ministers everyone would have to pay for the privilege of attending. Rodin, though too busy to be of

*"And if it were by someone else?"
"It can't be by anyone else."
—A conversation between two visitors to the Salon, on seeing Rodin's *Balzac*.

much help, bombarded Morhardt with cards and letters: "Are Fal-
guière and Mercié well placed? And above all Clemenceau."

He saw to it that they invited representatives of the academies of
letters and of fine arts; of the Salon of the Champs-Elysées as well
as of the Champ-de-Mars, of which Puvis was president, yet he wanted
to avoid giving the impression that the banquet was being held "in
order to please the Academy and the Institute," as he wrote to Mor-
hardt. "We want to see them with us so as to broaden participation
at the feast, but not exclusively; otherwise I'm afraid that people will
think we're trying to sponsor his candidacy." He was especially anx-
ious to avoid any suggestion that he was trying to curry favor with
the Gens de Lettres: "Aicard and Scholl should also pay for them-
selves, or people will say we've invited them merely on account of
l'affaire Balzac."

While the list of participants grew steadily longer—it came to
include most of the celebrated men of Paris—Rodin began to think
about the words which he himself would be expected to say at the
banquet. He jotted down a series of stream-of-consciousness notes
about Puvis and his *gloire*: "You are the chevalier of art. . . . You
are one of our intellectual centers . . . you console our eyes . . . like
that beautiful river the Loire running silently. . . . Like that beautiful
river which is not useful for navigation, only useful for poets. . . ."

With the remark, "Here are some thoughts, excuse me if they're
useless," he handed these scraps to the administrator of the Dépôt
des Marbres, Jean Marras, who wrote plays in his spare time. Marras
expanded them into a long, coherent speech lauding Puvis as a
"perfect workman" and a "sculptural" artist whose genius allowed
him to "magnify the images of nature in order to transfer them from
concrete reality into the realm of art." At Rodin's behest Geffroy then
pared the script back to essentials, though retaining the reference to
Puvis, like "an ancient knight," striding majestically through troubled
times "like a river without end."

Preparations for the banquet aroused the interest not only of the
press but of the practical jokers who abounded in the Paris art world.
Toward the end of December an anonymous wag confused everybody
by sending out bogus invitations from a committee of "admirers of
M. Rodin" who wanted to offer a "banquet to the glorious sculptor."
In *le Figaro*, meanwhile, Gustave Larroumet could not resist making

invidious comparisons between the guest of honor and the president of the impending Puvis dinner, both representatives of the waning century—"the one as calm as the other is feverish, the one as cultivated, poised and in control of his medium as the other is ignorant, unpredictable and clumsy." Fortunately Larroumet was no longer at the ministry; he attended the dinner in his new capacity as director of an arts-industry association.

On the day before the banquet there was public consternation when the president of the Republic, Casimir-Perier, resigned unexpectedly. It was the first of a long series of political shock waves touched off directly or indirectly by the arrest and deportation of an obscure Jewish army captain named Alfred Dreyfus, falsely convicted three weeks earlier of having sold military secrets to the Germans. But the real impact of the Dreyfus affair would not be felt for several years: as far as the Puvis dinner was concerned, it meant merely that the two ministers who attended—Georges Leygues, minister of public instruction, and Raymond Poincaré, minister of finance—represented a nonexistent government, since the Senate did not elect a new one until the next day. (In the ensuing reshuffle, Poincaré took over Public Instruction and Leygues became minister of the interior.)

At seven o'clock on the appointed evening Rodin and Morhardt set out in a hired carriage to fetch Puvis at his studio in the Place Pigalle. They were traveling in a two-horse landau of the sort usually reserved for wedding parties. "Very well, so I'm the bridegroom," Puvis said amiably. They drove their guest to the Hôtel Continental where, at precisely eight o'clock, the maître d'hôtel announced in stentorian tones, *"Monsieur Puvis de Chavannes est servi!"* There were ten speakers and toastmasters; the menu listed fifteen courses that, in themselves, constituted a kind of monument to the epoch: *Potage renaissance*—crayfish bisque—assorted hors d'oeuvre—salmon trout in sauce *vert-pré*—leg of venison *à la grand veneur*—fattened pullet with truffles *à la chevalière*—pheasant and partridge *sur croustade*—salad—lobster *à la Bagration*—artichoke hearts and asparagus tips—ice cream Danicheff—orange mousse cake—basket of fruit—petits fours. The beverages included Madeira, an 1881 Pommard, an 1884 Fronsac and iced champagne.

No one seems to have heard very much of Rodin's speech, which he mumbled into his beard: it accompanied the presentation of an

album of testimonial verse and a silver plaque by Victor Peter based on Rodin's bust of Puvis. When it was all over Puvis wrote a letter thanking "you, my dear Rodin, who discovered the idea for this feast in your heart," for the portrait in silver, "a work that affects me so profoundly for so many reasons"—whatever annoyance it had once caused was now mercifully forgotten.

An incidental beneficiary of the banquet was the uninvited Camille Claudel,* for whom Morhardt raised 1,100 francs among the guests, with Rodin contributing another 1,000 francs. The money was used to commission her to do a marble copy of her *Clotho* for the Luxembourg Museum. The finished work was exhibited at the Champ-de-Mars and then sat in Rodin's studio for years before being transferred to the Luxembourg, which proceeded to lose it. Since the subject is one of the Norns—a desiccated old woman spinning the thread of fate—it was inevitably compared to Rodin's *Belle Heaulmière*. Camille, however, defended herself vehemently against the suggestion that she had copied it from her teacher. "My *Clotho* is an absolutely original work," she wrote to a critic who thought otherwise. "I take my works only from my own imagination, since I have too many ideas rather than too few. M. Rodin, who accuses others of copying from him, would do well not to publish . . . his *Génie de la guerre*, which is entirely copied from Rude."

>✜<

Not to have organized a dinner for Goncourt would have bordered on lèse-majesté after the Puvis banquet. On the first of March, therefore, some 300 of the same eminent males dutifully filed into the Grand Hôtel, boulevard des Capucines, to eat an equally fattening meal and listen to a similar list of speakers pay homage to the greatest literary gossip of the nineteenth century. It was, however, "less attended, less cordial, less enthusiastic than that of Puvis," as Paul Signac noted in his journal. "In the compliments of these writers one cannot

*The dinner was for men only. Séverine had proposed a *salle de femmes* and Rodin seconded the notion, suggesting that women like Juliette Adam and Camille Claudel be included. But as Morhardt recalled, "We didn't dare invite them! At that time the presence of women at a banquet of this kind would have been regarded as a piece of quasi-revolutionary temerity; that in itself wouldn't have bothered us, but it might have detracted from the solemnity of the occasion."

help feeling a tiny bit of envy. While when they praised the painter they went to it wholeheartedly."

Clemenceau made a speech that Signac thought a "hollow" performance; Zola was nervous, Goncourt "most dignified, perfect." He was seated between Poincaré and "a frightful Daudet," as Signac describes him, "suffering from locomotor ataxia, his valet behind him, giving himself morphine shots under the table." Afterward Goncourt talked to Rodin, who "complained of his fatigue and spoke of his need for rest." It was, indeed, a particularly difficult period for the sculptor, who seems to have been suffering from depression as well as anemia. At one point he became so exhausted that, as an acquaintance reported, "the doctor ordered him to stop modeling clay for at least ten months." When Goncourt met him again in July 1895, he found Rodin "truly changed and very melancholy about his state of despondency, about the fatigue his work causes him at this moment." They were taking the train to Paris from Carrières-sous-Poissy, where both had been guests of Mirbeau, and Rodin used the occasion to air his grievances against fine-arts commissions—"instead of helping an artist with his work they only waste his time with their projects, questions and demands for specifications."

Evidently Rodin was thinking of his unresolved problems with the Balzac, yet he had just seen his Calais project come to fruition: for once the whole monument-production process had culminated in something besides disappointment or exasperation. After years in storage in the cluttered stable at 17, rue du Faubourg Saint-Jacques, the *Bourgeois* had been resurrected in the autumn of 1893 by means of a 1,000-franc subsidy arranged by Omer Dewavrin. At first Rodin had seemed unexcited by the prospect of a revival, and Dewavrin had felt obliged to prod him: "Is it because you aren't interested in your glorious *Bourgeois* anymore that you don't answer me? . . . Don't be so indifferent to your glory; don't wait until you're dead to enjoy it a little; bestir yourself and answer us."

Rodin replied that he hadn't lost the sacred fire—"it's just that I'm at work on several things that must be done. . . . I've given the *Bourgeois* more of my time than any other work but it's a colossal monument and doesn't conform to the current notion of how quickly everything should be produced. I don't want to make any promises because I might not be able to keep them."

Dewavrin had opened a new subscription to raise the money needed for casting and erecting the monument: "I do so want to get our *Bourgeois* out of the stable, where they must be aging terribly fast." The sale of 45,000 one-franc lottery tickets and a government subsidy finally made up the necessary sum. Still there were innumerable delays, partly because, as Rodin wrote from Grenoble in April 1894, "I am too busy at the moment to put the finishing touches on the *Bourgeois*."

The problem of the pedestal put him once more at loggerheads with the Calais city council. He wanted to see the six figures standing either on a high plinth like the Breton calvaries or, preferably, very low, almost at ground level at the center of the city, where they would be "more intimate and immediate, enabling the public to enter more easily into the drama of suffering and sacrifice." He would have liked to try it out in situ, as he wrote Dewavrin, "for I make judgments only when I can see things in place."

The council, in any case, paid no attention to his wishes. Preparations were made for placing the monument in the Place Richelieu on a plinth of normal height, fenced in by a wrought-iron grille and, to Rodin's dismay, flanked by a public convenience known as a *chalet de nécessité*. Meanwhile, the foundry originally entrusted with the work had changed hands and Rodin negotiated a new contract with the firm of Leblanc-Barbédienne, which agreed to cast each figure in one piece and all six for 12,000 francs, plus 900 francs for packing and transport.

Dewavrin was in a hurry to celebrate the unveiling and grew annoyed with the sculptor for putting off delivery of the finished plaster casts. It was becoming obvious that he was unwilling to tear himself away from the figures and give them their definitive form. An emissary, Louis Gallet, was sent from Calais to look after things in Paris. On January 17, 1895, he reported that he had just seen the plaster figures being completed and that everything was now ready for the foundry: "I watched as Rodin gave them a last look and final touch of his hand . . . he is rather unhappy to see his group go off to the foundry not because, as you may have thought, he wanted to give them a few caresses of detail, but because he still dreamed of making certain lines more harmonious."

The official inauguration of the monument on Sunday, June 3,

turned out to be a huge success. The festivities began on Saturday night with a band contest and a parade: three hundred local musicians, horsemen, torchbearers and artillerymen marched through streets draped with flags and bunting. Next day there were more parades, a musical festival for twenty-six orchestras and choirs, a *bal populaire*, fireworks, a banquet. The two ministers who were to have attended— again Leygues and Poincaré—had both caught colds and sent excuses, to be replaced by the minister of colonies and Roger Marx, now inspector of fine arts. The ceremony was also attended by two senators, two deputies, a general and other dignitaries, several of whom took the opportunity to say a few words.

Rodin was accompanied to Calais by Geffroy and Carrière. "Are you satisfied?" he was asked by a reporter for *l'Echo de Paris*. "People say you're not happy with the position of the monument."

"My first idea was to have them on a very low pedestal—still, though it's higher than I wanted it to be, the architect has satisfied me with this pedestal." Clearly Rodin was anxious to keep the peace.

"Will you soon be showing us some other works?"

"I won't exhibit anything unless it's completely finished. When I show maquettes people judge me too rashly. Besides, I've been loafing a good deal lately."

>≭<

He had, in fact, been producing far less than usual and he was still feeling very tired. Yet he temporized when the Russells invited him to take a holiday on Belle-Ile. "You and Madame Russell are friends with hearts of gold," he wrote to them in August, "and though I do not answer I can say hopefully that I am on the point of coming. I have a little spurt of work and am taking advantage of it. But, dear artist, you well know the trouble, the anxiety one has with one's work, especially when one is in poor health, as I am." When he did set off later in August it was in the opposite direction, to Menaggio on Lake Como, and for brief visits to Milan, Lugano and Zurich.

After his return to Paris in September he received a visit from an exceptionally knowledgeable American art lover, Henry Adams, who had come to France to gather material for his book *Mont-Saint-Michel and Chartres*. Adams had lived in Paris thirty years before and was appalled at "seeing about me the France of to-day, and the deadly

twang of my dear country-people on the rue de la Paix," but what he found most exasperating was that "the shops offer no good pictures." In an effort to find some worthwhile contemporary art "I am going, as a last resort, to call on Rodin, and try to buy one of his small bronze figures. They are mostly so sensually suggestive that I shall have to lock them up when any girls are about, which is awkward; but Rodin is the only degenerated artist I know of whose work is original." After calling on the sculptor at the Dépôt des Marbres, he wrote to a friend on September 27, 1895:

> I have passed an hour with Rodin in his studio looking at his marbles, and especially at a Venus and dead Adonis which he is sending to some exhibition in Philadelphia, and which is quite too utter and decadent, but like all his things hardly made for *jeunes personnes* like me and my breakfast-table company. Why can we decadents never take the comfort and satisfaction of our decadence.

Adams's decision not to buy anything could hardly have mattered to Rodin, who had recently acquired a wealthier and more free-spending client in the Western Hemisphere—a committee in Buenos Aires from which he received 75,000 francs to create a monument to Domingo Faustino Sarmiento, the great educator who served as president of Argentina from 1868 to 1874. Now, seven years after Sarmiento's death, Rodin had agreed to do a statue, using a portrait photograph of his subject taken in the United States and another, full-length photograph as his primary sources. Sarmiento had founded the first teachers college in South America and had pressured successive Argentine governments into spending millions on public schools. "Tell Monsieur Rodin that half a million men are indebted to his influence for their knowledge of reading and writing," wrote the chairman of the monument committee, Del Valle, to his Paris agent Marco del Pont.

Rodin also heard from Del Valle that "the figure on the pedestal ought to be the expression of intelligent force." Sarmiento had said that his book *El Facundo* was like a rock with which he had destroyed barbarism and illiteracy in the Argentine republic; Del Valle thought "we might give material form to the idea by representing a Titan

boldly hurling a huge piece of rock." But Rodin had ideas of his own that derived from his studies for the Claude Lorrain monument. He contracted to give the committee a bronze Sarmiento two meters high standing on a five-meter pedestal: "One part of the pedestal shall consist of a single block of white marble, 3.5 meters high, with a figure on it in full relief, representing Apollo fighting with a hydra."

It was once again Apollo the god of day and of beauty, his legs apart and his arms outstretched like those of Blake's "Glad Day," vanquishing the serpents of ignorance and hatred. The figure of Sarmiento, too, stands poised "like a walking man who is prepared to turn on the spot, as though to embrace with a single glance the multitudes who had gathered to hear his speech," as the Argentine critic Eduardo Schiaffino wrote in *la Nación*. Still, Rodin's maquette produced the usual shocked reaction in his clients. The Argentine minister to France, Miguel Cané, who took over del Pont's liaison duties, insisted on giving Rodin an elaborate description of the educator-president and wrote to him in October 1896: "I hope that you have paid attention to the observations I made you on the subject of the physical type of the personage, and that now I shall see the true Sarmiento."

Later Cané became one of Rodin's most articulate defenders, assuring his skeptical countrymen that the sculptor had succeeded in symbolizing the movement, energy, "even the idealism, the intense gaze, the extraordinary life" of their late president. Of course the casting and carving took longer than anyone had anticipated: the bronze figure and its 20,000-kilo base were not erected in Buenos Aires until the spring of 1900. Most of the local critics were aghast when they saw it: "a cross between a gorilla and a Mia'-Mia' from central Africa," one of them wrote; "a horrible *chuchumeco* [puppet]," said another. No one seemed to notice the pedestal, which incorporated one of Rodin's most remarkable marbles, a splendid corrective to his disappointment over Claude's horses.

The sinuous lines of this new Apollo seemed more like trailing vines than rays of sunlight, and they consorted perfectly with the rippling lines of the new style that had suddenly sprung, fully clad, from the collective efforts of the Symbolists, Decadents, Nabis; from designers like Gallé in Nancy and illustrators like those of *la Revue Blanche* in Paris. The year of the Sarmiento Apollo, 1895, was also

the year of Edvard Munch's *The Cry* and Baron Horta's Maison du Peuple in Brussels; in December of the same year Samuel Bing, a naturalized Frenchman from Hamburg, opened a new shop of fine and applied art, the Galeries de l'Art Nouveau, whose name was to become synonymous with the movement as a whole.

To make room for art nouveau Bing had sold the splendid collection of Japanese art with which he had already revolutionized French taste.* When he opened the doors of his establishment on the rue de Provence just after Christmas it was mobbed by the leading representatives of the Paris art world. His first exhibition consisted of 662 works by 150 artists and craftsmen—a cross section of all that was new in painting, books, ceramics, decorative leather, furniture. Pieces by Rodin and Bourdelle dominated the sculpture section, though there was also room for Constantin Meunier, Jean Dampt, Fix-Masseau and several others, and for Camille's bust of Rodin executed in stoneware by the ceramicist Emile Muller of Nancy.

Among the painters and printmakers the Nabis were heavily represented—Maurice Denis, Bonnard, Vuillard, Sérusier, Ranson— together with Toulouse-Lautrec, Besnard and Carrière. But what most agitated the connoisseurs was the section devoted to *l'art utilitaire*, with glassware by Henri Cros, Tiffany and Gallé, and furniture by Henry Van de Velde, the artist-designer who had been made a member of Les XX at the same time as Rodin. In his memoirs, Van de Velde describes the crowd at the opening as "loud, belligerent and indignant":

> The cream of Parisian society, eminent personalities of the French academies, artists, noted scholars, aesthetes and art critics, were all aware that here we were attacking the traditional styles and making a revolutionary break with the past, which struck them as unforgivably insulting. One heard murmurs of protest, imprecations, spiteful remarks. . . . Back on the street, at the door in front of the façade that had been

*"The Japanese have taught us that nothing in Nature is to be despised, and that a grasshopper is as well constructed as a horse," writes Alfred Stevens in *A Painter's Philosophy*. Rodin arrived at a similar maxim: "A woman, a mountain, a horse—they are all the same thing; they are made on the same principles."

"vandalized" by the architect [Louis] Bonnier . . . people who had been furious in the gallery began to calm down. Groups formed around the best-known personalities. Edmond de Goncourt, who had conducted himself as a quiet gentleman inside, raised his arms on the street as a sign of disgust. He told anyone who wanted to hear his opinion that the most laughable among the exhibitors, Van de Velde, designed his furniture in accordance with the principles of shipbuilding. It seemed he practiced a sort of "yacht-style." Rodin came to Goncourt's aid and reproached [Julius] Meier-Graefe for having persuaded Bing to desert French tradition and join the ranks of the detestable internationalists. "Your Van de Velde," he shouted amid applause from the crowd, "your Van de Velde is a barbarian!"

Van de Velde chose to regard this as a backhanded compliment; hadn't the "barbarians" built the Gothic cathedrals of which the sculptor was so fond? But Rodin's outburst marked a significant change in his attitude toward new movements in art: it was the first time he had sided with the conservative majority in a controversy of this kind. His displeasure, in any case, was directed against Van de Velde's stark functionalism and not against the tendril curves that characterized so many other manifestations of art nouveau. Indeed, Rodin himself came to be admired as a major figure in the new movement—as the man who produced "the glorious epitome of the Baroque side of Art Nouveau."

Goncourt's distinctly ungenerous reason for rejecting Van de Velde's work was that it was not *French*. What he had seen at Bing's, he wrote in his journal, were forms that deserved the prize in an ugliness contest, and colors that reminded him of goose *caca*. "Really, are we going to be de-nationalized, conquered morally by an invasion worse than that of the war—now that there is no place in France for any literature that is not from Moscow, Scandinavia, Italy or for all I know, Portugal? And it seems that now there will also be no place in France except for Dutch or Anglo-Saxon furniture. Is this how France is to be furnished in the future? No, never!" By the same token Goncourt could dismiss the most important arts magazine of the decade, the *Revue Blanche*—the sounding board for Lautrec, Bonnard, Vuillard, Roussel, Redon, Jules Renard, Proust, De-

bussy—as "a nest of young sheenies." His belief that France was going to the dogs and being threatened by alien influences was shared not only by the lower middle class (the original chauvinists,* for whom the term had been invented) but also by his more "patriotic" colleagues in the literary establishment, among them the Daudets, Paul Bourget, Maurice Barrès, and François Coppée.

The issue was about to take a political turn: with the Dreyfus case as a catalyst the whole of intellectual France was soon to be embroiled in a battle over xenophobia. But for the time being Rodin was absorbed in more personal concerns. On December 19, 1895, he had been the high bidder, at 27,800 francs, at the forced sale of a house on the heights of Meudon, the Villa des Brillants. It was a three-story red brick building with a sharply pitched roof, dormer windows and monumental chimneys in the manner of Louis XIII; its principal attraction was a magnificent view of the outskirts of Paris—Sèvres, Saint-Cloud and across the plain of Grenelle and the Seine to the distant city as far as the Trocadéro. Rodin often said the panorama reminded him of the hills of Tuscany.

The villa had been built only a few years before by a painter and sculptress of some note, Mme Delphine Arnould de Cool, and thus it already possessed a two-story studio annex whose long outer wall was a series of windows and whose roof was pierced by skylights. Mme de Cool had been obliged to sell it—to satisfy a legal judgment against her—just as Rodin was thinking about leaving Bellevue. Life at the *Chien-loup* had been spoiled for him when the gardener, perhaps acting on instructions from the proprietress, tore out the crabgrass between the paving stones in the front yard.

"I lived down there on the other side and had troubles with my landlady," Rodin explained to Maurice Guillemot not long after moving to Meudon. "I thought about leaving; when I went for a walk one Sunday I saw this house and wanted to rent it. At that very moment it was put up for sale. I went to Versailles; on the day of the sale the notary talked to me and when I returned that evening I said to my

*The French equivalent of jingoism is named for the veteran soldier Nicolas Chauvin of Rochefort, whose idolatrous admiration for Napoléon was ridiculed by his comrades. His name became synonymous with flag waving in an 1831 vaudeville sketch containing the celebrated line, *"Je suis français, je suis Chauvin."*

wife, 'I think I've bought it; I'll know tomorrow.' " The original deed included two parcels of land totaling just over 2,500 square meters— a little more than half an acre—to which, little by little, Rodin eventually added another 12,000 meters. For now he was content to be, for the first time in his life, a *propriétaire* who could order things to his own satisfaction.

Around the yard there were outbuildings that might have served as stables but which were converted into coops for Rose's pigeons and canaries, and into a repository for Rodin's papers. The villa was surrounded by abandoned fields and chalk pits: "All around is light and air and wide expanse," noted Charles Quentin, who was not the only visitor to imagine himself hundreds of miles away from the city. A long, tree-lined driveway connected the house to the then-unpaved thoroughfare that changed its name, while he was in residence, from avenue des Mécardes to avenue Paul Bert.*

To get to the Villa des Brillants from the railway station at Moulineaux "one crosses a sort of suburb with dingy tumbledown cottages and takes the route to Fleury, which turns as it rises," Guillemot reported. "One passes under the railway and then crosses over it. At last, in the avenue Paul Bert, a short distance from a *guinguette* for open-air dancing and dining, with a red windmill turning above the entrance, you find a white gate and a long, straight driveway that leads to the house; at the end of it you hear dogs barking, Tom at the head." Rodin would come out of the studio to greet visitors, "his feet in sandals, his head topped by a worn, dented panama hat . . . and with a red rosette in the buttonhole of his jacket."

The house itself was full of surprises. "You open a door and plaster phantoms appear," Guillemot noted. "Beside some rabbit hutches a sort of shed has been turned into a museum of curiosities—pieces in bronze and glass, fragments of figures, the residue of antiquity found at second-hand dealers along the quays and in bric-a-brac shops. One of these objects, of no interest to ordinary eyes, will cause Rodin to wax eloquent in praise of ancient art, the harmony of its curves, the splendor of its lines. 'It's a soul, a kind of question mark,'

*Paul Bert was a distinguished physiologist and educator who had belonged to Gambetta's circle. Appointed resident-general of Annam and Tonkin, he died of dysentery at Hanoi in 1886.

he says. 'I deliberately keep from looking at it very often. . . . the Greeks are gods.' "

Since he wanted no modern distractions among the antiques he hung most of his friends' pictures on the second floor, where he gradually assembled a sizable collection of contemporary paintings— by Bracquemond, Bastien-Lepage, J.-P. Laurens, Monet, Carrière, Ribot, Roll, Thaulow, Russell and so on. Later the portraits that others had painted of him were hung in the reception hall. The bedroom had Oriental bronzes on the mantelpiece and Egyptian statuettes in a glass-fronted cabinet; the dining room contained Roman mosaics. In the large studio—drawing room on the ground floor he displayed a few examples of his own work: a large bust of Victor Hugo on a pedestal, a bas-relief, and one of his Sèvres vases. There were boxes full of drawings in his new contour-and-wash style, an illuminated Persian manuscript on a separate stand and a bookcase filled with presentation copies of works written by friends and admirers. Yet with all this there was no gas in the house, and no electricity. Rodin was afraid of fire, and used only candles or lamps filled with vegetable oil.

Once he had shown visitors his treasures Rodin always came back to the view from his hilltop. "I have the loveliest Puvis," he would say, pointing toward Paris and the Seine. In the distance there was "the immensity of Paris sometimes bathed in a cloud of golden dust, sometimes in a silver fog," as Arsène Alexandre wrote before the day of the all-enveloping smog. The view stretched from the Billancourt bridge to the bridge of Saint-Cloud but was dominated by the "gentle, noble gray of the old Pont de Sèvres," as Jean Lorrain noted in his journal; it was a landscape "that reminded one of Watteau."

Although the city seemed far away Montparnasse station was only six kilometers from Meudon and there was frequent train service. Rodin, however, preferred to take the Seine passenger boat whenever practicable. "He boards the boat at the Pont de l'Alma, admires the setting sun during the journey, doesn't read the newspaper, doesn't talk and remains sunk in thought," Guillemot noted when he accompanied the sculptor on his way home one evening. Camille Mauclair came to the conclusion that the Villa des Brillants served as a sort of Wahnfried for the Wagner of sculpture—a sanctuary to which he could withdraw whenever he felt the need to restore his energies.

Perhaps that was why his purchase of the house signalized a general upturn in Rodin's affairs. His health suddenly improved and friends were happy to see him in a far more optimistic frame of mind.

"Mirbeau spoke to me of Rodin who seems to have triumphed over the physical and moral fatigue of these last years and now produces altogether extraordinary things," Goncourt wrote on February 4, 1896. Rodin had shown Mirbeau some of his earlier pieces and declared that he now found them "detestable": "At this moment he is inaugurating a new kind of sculpture in search of a kind of modeling based on the interplay of lights and shadows."

His search for a new style coincided with an upsurge of interest from foreign collectors. One day Frits Thaulow arrived at the studio together with the exuberant Prince Eugen, Duke of Nerike, son of the reigning king of Sweden and Norway: the thirty-year-old prince had been studying painting with Bonnat, Puvis and Roll, and was beginning to acquire a major collection of French and Scandinavian art. He urged Rodin to send some of his works to an exhibition of French art that was to be held in Stockholm from May to October of 1897—"some of your marbles and the superb bust of M. Dalou. . . . you know how much I admire your work and the importance I attach to your participation."

Rodin sent the Dalou bust in bronze and the plaster *Voix intérieure* of the Victor Hugo monument, one of his most daringly incomplete sculptures. When purchases were made from the exhibition the Stockholm National Museum of Fine Arts turned down the opportunity to buy the bust, which was then snapped up by the museum in Oslo— for Norway was on the verge of breaking away from the Swedish crown and wanted to assert its independence even in matters of art. But the Stockholm museum snubbed him far more painfully when Rodin decided to make them a present of the *Voix intérieure*—and the accessions committee voted unanimously to reject the offer. Prince Eugen was profoundly embarrassed by the whole affair. "I am in Italy at the moment," he wrote to Rodin on December 20, 1897,

and have just learned that the commission of the Stockholm National Museum has found it inadvisable to accept the sculpture which you had the kindness to offer them. I know they have informed you of this directly. I don't have to tell you how

astonished and above all indignant I was about their lack of consideration for you both as a person and as an artist so highly regarded in France and throughout Europe. I would be even more unhappy if you were to draw the conclusion that this was a reflection of public opinion in general and that artistic ideas are still so backward in my country. I think it should be seen, rather, as a somewhat comical affair reflecting only the narrow-minded taste of a commission that has already distinguished itself by other such rejections.

Fortunately the prince's father, Oscar II, had already resolved the problem with a stroke of royal diplomacy: he purchased the *Voix intérieure* for his personal collection and appointed the sculptor a Commander of the Royal Order of Vasa, whose white cross and green ribbon looked quite splendid on Rodin's frock coat beside his decoration as an Officer of the Legion of Honor.

Even so, the Stockholm incident provided a forceful reminder that Rodin's position vis-à-vis the conservatives had not really improved. During the summer of 1897 some of his works were exhibited in Italy and were held up to ridicule because "the women flaunt their stomachs and backsides in absurd poses." This was no more than what the conventionalists had been saying for fifteen years. Yet lately his work had also been drawing fire from some of the malcontents of the avant-garde. When Captain Bigand-Kaire suggested to his literary protégé, Léon Bloy, that Rodin might contribute a frontispiece to his latest book, *la Femme pauvre*, Bloy replied with an angry blast affirming that nothing anyone could draw could "equal the proud nudity" of an ordinary publisher's edition: "Rodin? The false genius adored by everyone—take care—whose studio I left filled with ennui and even lightly penetrated by horror!"

There were equally adverse reactions among the Symbolist painters, who ought to have been Rodin's natural allies. Their leader, Odilon Redon (another member of the generation born in 1840), was to note in his journal: "All this humanity in Rodin's work isn't really human. These beings who twist and turn hysterically seem to be moved by a sort of electricity of death; the soul is absent." Octave Mirbeau happened to be with Redon at the 1897 Salon of the Champ-de-Mars while the painter was looking over the Victor Hugo monument

in plaster, Rodin's main contribution to the exhibition: " 'And what do you make of it?' I asked him. M. Odilon Redon raised his arms to heaven with an expression whose infinite sadness would be impossible to describe. 'Certainly, certainly,' he said. 'But how sick all this is!' "

Rodin had sent five pieces to the Salon that year, including a marble *Amour et Psyché—Eternal Springtime* by another name—that attracted a great deal of attention. But the group that aroused the greatest controversy was the disturbingly unfinished monument—a third variant of the seated *Victor Hugo*, nude except for some roughly gathered folds of cloth, with the *Tragic Muse* hovering above his right arm and the *Voix intérieure* at his back. The whole group was still visibly under construction, as it were, with a gaping hole at the point where Hugo's left arm met the shoulder, and a good part of the supporting armature still showing. The state of unreadiness of the monument, especially of the two Muses, was regarded as a deliberate provocation, almost a declaration of war against accepted standards of what constituted a "finished" Salon exhibit. Caught off guard, even the pro-Rodin critics hardly knew what to make of this object lesson in the *non finito*. It was a superb work, conceded the artist-critic Georges Jeanniot in the *Revue encyclopédique*, and it conveyed "a savage force and austere majesty."

Yet if someone were to suggest that this is intended to be a finished work I would be seized by terrible doubts. Its very uncertainty of form gives the ensemble a curious charm and strange grandeur that I would compare to certain photographic enlargements. What will become of this charm, this grandeur, when the plaster is translated into marble, which makes different demands? What will become of the still-so-unfinished Muse that dominates the group? What will become of the short, crippled legs of the other Muse? What about her missing arms? What part will they play in the group; will they contribute to its beauty or jeopardize it? What praticien will find the right expression in marble for all this uncertainty? Unless M. Rodin does go back to work on this piece, listening only to his artistic conscience and not to the praises of his noble but blind admirers.

Several of Rodin's assistants, including Desbois and Bourdelle, were on hand to express their admiration for the *Victor Hugo* on the day of the opening. But the man who had lately become his most trusted praticien-disciple, the Lyonnais sculptor Jean-Alexandre Pézieux, told Jeanès that from a marble cutter's viewpoint the plaster model was a disaster. "He won't do it," Pézieux said. "The joining is impossible. He'll give it to a praticien—me, perhaps—and it will be a terrible lot of trouble. Why abandon things before finishing them? The shoulder must be completely reworked and the surrounding area as well. And you can do what you like—he won't be happy. It would have been better to have left the arm as it was. Once again it's one of these fool literati who has put it in his head. I would have left it in block rather than detach it like that. Well, that's how he is. . . . And then, don't you think he could at least have worked on the neck? Of course no one is going to notice it anyway; Desbois didn't notice it, or at least he didn't say anything. Still, it's enough that *I* notice it. There are things around the jowls that could make me scream. If he were unable to do it, all right—but Rodin? He's so skilled it wouldn't have cost him any effort.

"He thinks it will all arrange itself in the marble. But I'll tell you this: he doesn't understand the material. Anything to do with clay he's unbeatable, but he doesn't know marble. When I work for him he makes holes in my work, and then he takes a rough file . . . before long he'd *kill* the marble!"

In spite of this mutinous outburst Pézieux was utterly devoted to Rodin—"he adored the *patron*," as Jeanès says. He was ten years younger than his employer; a skilled stone carver who had won several prizes with his own work, including an *Echo* at the Luxembourg and a nude *Jeanne d'Arc* in the Tuileries; an artist respected by his colleagues as "a simple, serious, meditative man" and according to Jeanès "the one whom Rodin esteemed most highly among all his collaborators. He listened to Pézieux, who had, I dare say, considerable influence on the later stages of Rodin's career."

Pézieux carved an *Eve* for him—and was even a frequent and privileged witness to what Jeanès called "the scenes of Rodin's *vie passionnelle*," his sexual *historiettes*. The young sculptor was also perceptive enough to realize that the most exciting new element in the Victor Hugo project was the figure of the *Voix intérieure* half

hidden at the back of the monument. "Almost no one saw the real, fresh beauty of the *Voix* except Pézieux: the figure of Victor Hugo monopolized everyone's attention." While working at the Dépôt des Marbres Pézieux had witnessed Rodin's struggle to retain the three Muses he had originally envisaged for the monument. But combining the three with the seated Hugo had proved impossible. "He tried every way of doing it," Pézieux reported. "I told him it wouldn't work. He even got angry. He managed to place the *Voix intérieure* at the side, in the back; that's all. He won't leave it there. It's incredibly beautiful! But people don't talk about it, have you noticed? The male figure is nice but the *patron* has already done other things like it, just as good. Except the head; the head is magnificent. . . . But he could have worked harder on the hand that's on the ear. That's going to be another tough piece of work for the praticien. And yet if anyone knows how to do hands it's Rodin—he's done hundreds, thousands. But he's never made a woman like this before; it's wonderful! And it's only the beginning, you'll see; if he doesn't let all those writers mix him up, or the women—he's so dominated by his prick, the brute! [*il est tellement queutif, le bougre!*]"

Pézieux would probably have been given the *Hugo* to carve in marble but in 1898 he had a nervous breakdown; not madness, merely an attack of "neurasthenia," as Mirbeau noted. He went for a rest cure to a private mental asylum in Epinay-sur-Seine where he fell into the clutches of a brutally authoritarian psychiatrist, Dr. Trarius. Rodin paid him a bedside visit and found him in good spirits; they had a long, animated discussion of *choses admirables* that Dr. Trarius later dismissed as "delirious verbiage." A few days later Pézieux's sister found him unconscious in his bed, bleeding and badly injured: he never regained consciousness. According to Dr. Trarius he had jumped out of the window; Mirbeau, on the other hand, had reason to suspect he had been the victim of a sadistic attack by one of the hospital guards.

>*<

During the preparatory stages of the Hugo monument Rodin had fallen in love, not so much with the *Voix* as with the most refractory of his Muses, the "still-so-unfinished" *Tragic Muse*, with her tentative face and fragmentary body. In February 1896, his work had been warmly

received at the Musée Rath in Geneva, at an exhibition devoted to Puvis, Carrière and Rodin—"this trilogy, almost a trinity," as Léon Riotor wrote. He made the museum a present of a bronze mask of *The Man with the Broken Nose* and when they approached him for a bronze copy of the *The Thinker* he offered to charge them only the casting costs provided they would also accept a female figure on the same terms.

Together the foundry charges came to only 3,900 francs, yet the museum's director, Théodore de Saussure, was far from pleased with his purchase. He had ordered the enlarged *Tragic Muse* without knowing what sort of "crouching figure" he was letting himself in for, and when the crate was unpacked it made "a deplorable impression." In the executive committee's minutes for March 9, 1897, the figure is described as "a goitrous woman whose left wrist must have been broken and badly set by some quack doctor, and who seems eaten away by leprosy or venereal disease. She has lost two fingers of the right hand, a muscle of the left arm, half a breast and part of her face." At the director's behest the new acquisition was not placed in the galleries but stored in the cellar.

It seemed to Mirbeau that even at this stage in his career Rodin had to have an iron constitution to withstand the cumulative effect of so many snubs, criticisms and gratuitous insults. "If Auguste Rodin did not have a strong soul and a firm mind," if he allowed himself to be even faintly influenced by other people's judgments, he might become hopelessly disoriented. Yet Rodin had never lost his way; on the contrary no artist had ever possessed a more unerring sense of direction. The underlying logic and intuition of his development was instantly apparent as one leafed through the huge collection of his drawings, *les Dessins d'Auguste Rodin*, published in 1897 with an introduction by Mirbeau. Issued in a limited edition of 125 copies, it consisted of "129 plates comprising 142 drawings reproduced in facsimile," including many of the "black" Dante drawings. A well-known firm of art dealers, the Maison Goupil, appeared on the title page as publishers, but the moving spirit behind this extraordinary enterprise was Rodin's friend Maurice Fenaille, a young industrialist and art historian who paid for the cost of the project and personally supervised the reproductions.

It was one of the most astonishing art books ever published, not

least because the drawings were reproduced "with all faults," just as they had emerged from the artist's pockets, on scraps of notepaper or anything that came to hand. The facsimiles were superb, as Mirbeau pointed out, since they "preserve the firmness, the subtlety, the elasticity, the intensity of color of the drawings themselves. One couldn't do better; one couldn't do more." The result was an almost graphological survey of Rodin's unconscious in which one could retrace the way "the germ of a future work moved the hand across the paper." Mirbeau thought these drawings revealed the whole spectrum of "intuition and form" that had characterized the man's career as an artist: "a volcano-like spirit, a stormy imagination, a brain perpetually on fire—and yet he is wise and prudent."

>‡<

Rodin repaid Fenaille by doing a bust of his wife, Marie, that had the terseness and understatement of a T'ang dynasty figure. He spent most of September 1897 at the Fenailles' country estate, the newly restored Château of Montrozier near Rodez in Aveyron. It was a time for quiet stock-taking and for writing overdue letters to his friends. Raymond Poincaré, twenty years his junior, had moved from the Ministry of Public Instruction to become vice president of the Chamber of Deputies but had continued to take a "very affectionate" interest in the sculptor's affairs: Rodin was happy to discover an unexpected link between Poincaré and his hosts at Montrozier. On September 14 he wrote to the young politician: "I'm just staying with Monsieur Fenaille, who paid for the cost of reproducing my drawings, a man of infinite modesty and generosity, brother-in-law of Monsieur Colrat, your secretary, who is with us at this very moment and speaks of you in terms of affection and admiration. Which gives us as much pleasure as it gives him. . . ." He wrote to Gustav Natorp as well, to remind him of their "true friendship" and encourage him to continue his career, but their sporadic correspondence was beginning to take on the nostalgic overtones of middle age. The most revealing letter from Montrozier was addressed to Monet and is dated September 22:

> Your letter made me very happy: our mutual preoccupation with the pursuit of nature leaves us little time for overt demonstrations of friendship, but the same sense of brotherhood,

the same sense of art has made us friends forever; hence I was all the more delighted to receive your letter. At our age it would be so unfortunate to lose a friend, or rather to see him become indifferent; that thought also depresses me, *mon cher ami*. I still have the same admiration I always had for the artist who helped me understand light, storm clouds, the sea and the cathedrals I already loved, but which touched me anew in your translation of their beauty in the morning light.

More than ever before Rodin was genuinely moved by signs of friendship and support from the peripheral members of his circle. "Your letter is worth all the bronzes in my studio," he wrote to Jules Claretie in November, and a month earlier he had replied to an invitation from Mallarmé: "I read your letter with great emotion and joy, knowing that I'll be seeing you on Sunday." Earlier in the year Rodin had helped organize another of the Mallarmé banquets, given by a small group of friends to celebrate the publication of his *Divagations*. It was held at Le Père Lathuile in the avenue de Clichy, one of the oldest restaurants in Paris, with Mallarmé seated between Rodin and Léon Dierx. But the evening was something of a disappointment. "I was prodigiously bored," Debussy wrote to Pierre Louÿs. "Mallarmé appeared to share my feelings, and delivered a coldly embarrassed little speech in the voice of a melancholy puppet."

A year earlier Verlaine had surprised everyone, after so many false starts, by actually dying, and that entailed organizing a committee for a Verlaine monument. Mallarmé was named president, Rodin vice president, but this time he took care to let someone else do the work. His hard-pressed pupil Niederhäusern-Rodo received the commission, based on a bust he had made of Verlaine several years earlier.

One by one the old literary lions were disappearing from the scene. Goncourt died half a year after Verlaine, in July 1896, to be followed, in December 1897, by Alphonse Daudet, who had been born the same year as Rodin. There seemed to be no one of a caliber to take their place. It was a sign of the times that one of the Rodin faun sculptures in the Goncourt collection went to Count Robert de Montesquiou-Fézensac, a gentleman-poet whose way of life was more remarkable than his poetry. The Count, "whose very arrogance had

a seductive charm," became a self-appointed Rodin apostle and a link to the rarefied world of such titled aesthetes as his cousin, the Countess Greffulhe, and the poetess Anna de Noailles.

"I'm happy that this brute of a faun is with you after having been with Goncourt," Rodin wrote to Montesquiou on March 24, 1897, "and that he is seen by the poets, the thinkers; he doesn't like those who find him ugly. It intimidates him, and me too." The Count had invited Rodin to dinner but that was asking too much: "On account of my poor health my life is rigorously regimented, or rather my jealous work won't allow me out at night." He would, however, be happy to join Montesquiou for lunch at Ledoyen's "any day you choose."

That spring Alphonse Legros developed "an itch to revisit Paris and see some of his old friends," notably Rodin. He brought with him an ex-pupil, the young British painter Will Rothenstein, whom he had promised to introduce to Degas and Rodin. Rothenstein recalled having received an unexpectedly warm welcome at the Dépôt des Marbres: "I had long revered Rodin from afar . . . now I was face to face with the man, and his works." He was shown the *Gates of Hell* and was even more impressed by the "grand and arresting" Victor Hugo monument:

> There were other figures and busts on which Bourdelle, then acting as Rodin's assistant, was busy. . . . Every word Rodin said seemed pregnant with meaning, as I watched him working the clay with his powerful hands. When I drew him I felt I had never seen a grander head. I noticed how strongly the nose was set in the face, how ample its width between the brows, how bold the junction of the forehead with the nose. The eye was small and clear in colour, with a single sweeping crease from the corner of each and over the cheek bone, and the hair grew strongly on his head, like the hair of a horse's mane, like the crest of a Grecian helmet; and again I noticed the powerful hands, with the great thumbs, square nailed.

Rodin invited Rothenstein to Meudon for a few days, for a leisurely look at his sculptures. "Besides many now well-known pieces, he showed me a cupboard full of maquettes, exquisitely modelled. He

would take two or three of these and group them together, first one way and then another. They gave him ideas for his compositions, he said." The young painter learned that Rodin's marbles, executed by praticiens under his supervision, sold much more readily than the bronzes and provided his most dependable source of income. "The great vogue for Rodin was not yet; indeed, he complained bitterly of neglect, of being passed over, alone among contemporary sculptors, each time a public commission was given."

> In the evening we walked in his garden, and looked down on the Seine and on the distant panorama of Paris, bathed in the warm glow of the evening mist. During a walk, Rodin embarrassed me by remarking: "People say I think too much about women." I was going to answer with the conventional sympathy, "But how absurd!" when Rodin, after a moment's reflection, added, "Yet, after all, what is there more important to think about?"

Rothenstein felt powerfully attracted to Rodin's paganism and his sexual "preoccupation with unusual subject matter." He was no less fascinated by the maître's new style of drawing, very different from the black drawings of the Dante period. "Rodin was always drawing; he would walk restlessly round the model, making loose outline drawings in pencil, sometimes adding a light coloured wash. And how he praised her forms! caressing them with his eyes, and sometimes, too, with his hand, and drawing attention to their beauties."

When Rothenstein assured him that British collectors would jump at the chance to buy some of these drawings, Rodin gave him a selection to take back to London and made him a present of one. "They were magnificent drawings and I was enthusiastic about them." Before long the English artist reciprocated by sending two proofs of the lithograph he had made of his drawing of Rodin—a portrait that won the sitter's unstinting praise: "Our maître Legros must have found it good."

>✴<

The statue of Balzac had at last entered its final phase. Occasionally its detractors still taunted him about this interminable enterprise: "M.

Rodin doesn't work in clay, wax or stone, in plaster or marble, but in stalactite!" declared a humorist in *le Journal*: the sculptures took shape drop by drop, "each leaving a small calcium deposit," until the finished work stood revealed. In a figurative sense the caricature was not far from reality. Yet now that the wind was in his sails the work suddenly went very quickly. During the first half of 1897 several observers reported seeing him at work retouching his figure of Balzac striding forward with arms crossed. But later that year, according to Morhardt, he abandoned this figure and began another based on a new model, "solid, thick-set, powerfully muscled."

This new naked Balzac was a "courageous athlete" of another kind—more static in his pose, standing with his weight on his left leg and clutching his erect penis. The body leaned backward slightly, rather like Rosso's *Bookmaker*. To this powerful body he added the head of an idealized Balzac with Lamartine's "face of an element": hollow eyes, a disheveled mane of hair and heavy jowls. It was a bold, almost casual synthesis of all the heads he had modeled in preparation for this one. Morhardt remembered a day in the Dépôt des Marbres when Rodin had his assistants prepare six identical casts of the half life-size figure of the composite naked Balzac. "In a corner was a roll of cloth. It was cut into six more or less equal lengths and each was draped around one of the maquettes in accordance with Rodin's instructions: thus the *Balzac* was born."

I can still see these six figures standing upright one beside the other at the rear of the studio. Already they are vibrant with life. The cloth, soaked in wet plaster, has acquired stiffness and substance. Each figure has a different personality. At left, the first two or three are in the classical tradition; the cloth falls in small, regular folds. But the others become progressively more dramatic. The cloth expands and grows more ample. The last figure has something imperious and grandiose. It is this figure which is to become the basic idea of the definitive *Balzac*.*

*Unconsciously Rodin was thus covering the nudity of his phallic figure with the "mantle symbol," a psychoanalytic penis symbol first described by Freud in 1913 and analyzed in more detail by Ernest Jones ("The Mantle Symbol," *International Journal of Psycho-*

Later the cloth mantle was retouched to become a dressing gown with empty sleeves thrown over the shoulders; the feet were encased in carpet slippers. "I wanted to show the great worker at night, haunted by an idea, getting up in order to go to his desk and put it on paper," Rodin explained at the time. He himself had experienced what Balzac must have felt at such moments, anticipating "the new attacks to which he would be subjected, and which he would resist courageously, scornfully." Evidently this final *Balzac* was to be another chapter in Rodin's sculptural autobiography.

A decade later he explained his intentions more fully to Paul Gsell. It was absurd that public statues were supposed to depict great men in theatrical attitudes. He had reached the conclusion that "there was only one way to evoke my subject: I had to show Balzac in his study, breathless, hair in disorder, eyes lost in a dream; a genius who in his little room reconstructs a whole society piece by piece in order to bring it to tumultuous life . . . who never rests, turns night into day, drives himself vainly to fill the holes left by his debts. . . ."

The Société des Gens de Lettres was growing increasingly impatient. A group of subscribers to the Balzac fund had threatened to take Rodin to court in order to force him to relinquish the commission. Zola had been replaced as president by Henry Houssaye. Marquet de Vasselot was waiting in the wings, still hoping to take over the commission with his Balzac-with-the-body-of-a-sphinx so much admired at the Salon of Rose + Croix in 1893. Rodin had not improved his relations with the Société by being of two minds about what he was doing. Everyone knew that he had told one member of the society, "*Je le tiens* [I have it]," and then, months later, told another member, "*Je ne le tiens pas.*"

Finally he arranged with the Société that he would exhibit the *Balzac* in the 1898 Salon of the Champ-de-Mars. When he was satisfied with the half life-size version it was sent to Lebossé, who enlarged it into a looming plaster colossus that was stored at the Dépôt des Marbres for a time before being shipped to the exhibition hall on the Champ-de-Mars.

analysis, 1927). The crypto-phallic nature of the *Balzac* was perceived by many of Rodin's contemporaries when they referred to it as a "menhir"—i.e., a prehistoric stone symbol of the indestructible power of the life force.

He had decided to exhibit the *Balzac* together with a newly enlarged marble of *The Kiss*, now duly catalogued as *le Baiser*. As the marble group left his studio it passed in front of the *Balzac*, still standing in the courtyard. "I had not been unhappy with the simple vigor of my marble," Rodin told Mauclair a few days later, "but when it passed in front of the other I had the sensation that it was weak, that it fell down before the other . . . and I felt in my heart that I was right. Whatever people may say, my essential planes are in it, and would be less so if I 'finished' it more in appearance. Polishing and repolishing toes or locks of hair means nothing to me; it just compromises the essential idea, the *grande ligne*, the soul of what I wanted to achieve."

Jeanès saw Rodin shortly before the official opening and ventured to predict that in a few days he would be celebrating a triumph. "I'm not so sure," was the reply. "People criticize me a lot. I don't think they'll understand it right away. Perhaps it's a bit too simple. I couldn't do any better, or anything more. But I have no confidence in the public, especially after the objections I've already heard from my friends."

Thus Rodin was not unprepared for the ensuing torrent of abuse. Paris had witnessed countless art scandals, but nothing to equal the fury of the storm that now broke over the *Balzac*. From the very outset the critics and opinion makers split into two irreconcilable camps over "this heap of plaster hacked and punched together," with its "spongelike face, with that vascular gibbosity called a neck." Félix Faure, the new president of the Republic, deftly sidestepped the issue when Rodin, as head of the section, showed him around the Salon's sculpture exhibits the day before the opening. He stopped in front of *The Kiss* to congratulate Rodin on it, then turned his back on the towering *Balzac* as they walked past, to admire something in the opposite direction without having said a word about the most explosive object in the hall.

Everyone else, however, had something to say about the *Balzac*. On opening day, April 30, Rodin stood nearby while thousands of visitors milled around the statue. Some were reduced to silence; others laughed and made fun of the figure. Arsène Alexandre and a rival critic, Philippe Gille, published some of the remarks they overheard among the crowds in front of the statue, most of the time within

earshot of the cheerfully impervious Rodin: "That's Balzac? It's a snowman!—He's going to keel over; he's drunk too much.—No, it's Balzac just getting out of bed to receive a creditor.—It's Balzac in a sack.—A bag of plaster.—He hasn't got any eyes.—That's Balzac? It's a calf!—A statue that hasn't been unwrapped.—It's an unsteady menhir!"

It was clear that the upholders of the status quo detested the *Balzac* as yet another challenge to established authority, while the avant-garde admired it as a symbol of the freedom to which they aspired. *The Kiss* was a charming work, Bourdelle said at the opening, summing up for the pro-Rodin faction, but it "didn't exist" compared to the other: "The *Balzac* is a hundred times more powerful. What a piece of sculpture! Rodin is showing everyone the way to go."

The opposition had the advantage of being able to use the more colorful language and the more striking metaphors. *Balzac* was "an obese monstrosity," a libel on a great man, "a colossal foetus." *Le Correspondant* saw it as "an actor in a colossal Punch and Judy show." *Art et Décoration* labeled it "a monstrous abortion," and for *le Monde Illustré* it was another piece of eccentricity by an artist who had already "worked too often in the incomprehensible." To Jean Rameau of *le Gaulois* it was proof "of the degree of mental aberration at which we have arrived at the end of this our century."

Rochefort ridiculed it in *l'Intransigeant*: "Never before has anyone had the idea of extracting a man's brains and smearing them on his face." For Léon Bloy it was "an inconceivable piece of folly." Léon Dierx dismissed it as a practical joke; for Jules Hoche it had "the face of a lemur"; Jean Lorrain declared that "Rodin has become the Michelangelo of the goiter"; for Benjamin Constant the *Balzac* was "painful to see." Paul Leroi, an ex-Rodin supporter, told the readers of *l'Art* that this "maddening caricature" which didn't even "possess the vulgar merit of being upright" was just what one would expect of the "pitiable" taste of its sponsor, Emile Zola. "No, the French spirit will never live in this German larva, in this beer-filled thing which is at the Salon," asserted the *Revue du monde catholique*. Others called it a "monument to insanity and impotence"; art lovers were exhorted to "take a pickaxe and smash the shameful block."

A group of six young artists had indeed hatched a plot to vandalize the *Balzac*, in the best tradition of the inkpot flung at Carpeaux's *la*

Danse. But one of Rodin's sometime assistants, James Vibert, got wind of the affair and stood guard over the statue on the appointed day. The conspirators were noisy and belligerent when they arrived; evidently they had drunk a good deal to bolster their courage for the attempt to knock *Balzac* off his pedestal. "I'll bash the first man who lays a finger on the thing," Vibert told them so menacingly that they beat a hasty retreat. When Rodin heard about it he sent Vibert a heartfelt letter of thanks for this valiant defense of his embattled menhir.

The statue was a godsend for cartoonists, and there were countless caricatures, even a three-dimensional lampoon—a statuette of *Balzac* metamorphosed into a seal, with flippers in lieu of loose sleeves. Amid the uproar it was noticeable, however, that the more thoughtful and important writers sided with Rodin and recognized the statue for what it was, one of the great achievements of the century. Anatole France stood for a long time "contemplating this powerful and magnificent figure, made with a hand that was both strong and caressing, and saw not so much a man as a genius." Léon Daudet thought it a magnificent expression of everything Balzac stood for; Antonin Proust was reminded of the great monuments of the eighteenth century. Georges Rodenbach, on the front page of *le Figaro*, recalled the battle against Wagner in Paris, 1861, and compared the *Balzac* to *Tristan* and *Parsifal.* Here was a revolution of comparable magnitude: "It is evident that M. Rodin wanted a decisive simplification. He broke with the inane tradition that requires a statue to be a portrait, an exact effigy." On reflection it seemed to the Belgian poet that Rodin had managed to capture *le démon intérieur* of Balzac:

Geniuses are not so much men as monsters. That is what M. Rodin had understood and expressed magnificently, and why he wanted his work to be not so much a statue as a strange monolith, a millenarian menhir, one of those prehistoric stones in which volcanic action has accidentally produced a human face.

Next to this "colossus, rugged and powerful," noted Paul Signac in his journal, "most of the sculptures around it look like hairdresser's dummies." André Fontainas wrote in the *Mercure de France* that it

was a block "trembling with passion and muscular energy, a block feverish with life itself." Claude Bienne of the *Revue hebdomadaire* saw it as one of Goya's monsters turned to stone, "the proudest and most intense expression of energy ever realized by the art of the sculptor." Armand Dayot in the *Nouvelle Revue* called it "a strident, savage cry . . . a meteorite with disquieting shapes."

As the debate heated up, *le Figaro*, trying to be evenhanded, balanced favorable reviews by Rodenbach and Alexandre against hostile articles by Gille and Benjamin Constant. In *le Journal* the splenetic Mirbeau published a counterblast against Jean Rameau, whose "spittle could not sully the brilliant work: doesn't Notre-Dame rise into the sky triumphantly and always beautiful, despite the dogs that piss on its walls?" When Mallarmé sent Rodin a letter in praise of the *Balzac*, he received a touchingly grateful reply: "Your letter of loyal friendship, dear Mallarmé, has been read and re-read many times, for at the moment I receive nothing but the echoes of a war that seems to be turning wholly against *Balzac* and me."

Jules Renard went to the Salon later than most of his colleagues, on May 26. "Only the statue of Balzac attracts my eye," he wrote in his journal. "Seen from a three-quarter view, at twenty meters, it has a striking attitude. And those hollow eyes, that grimacing head, the narrow forehead, this man entangled in his robe, is really something."

Some of the most vivid and accurate reporting of *Balzac* at the Salon came from foreign writers unaffected by the biases of French literary politics. Oscar Wilde, recently released from Reading Gaol and now an exile in Paris, found the statue "just what a romancier is, or should be. The leonine head of a fallen angel, with a dressing gown. The head is gorgeous, the dressing gown an entirely unshaped cone of white plaster. People howl with rage over it." Wilde's friend Frank Harris—soon to join the Rodin circle—wrote what was perhaps the most perceptive of all articles on the *Balzac* for his struggling magazine, *The Saturday Review*:

The first impression made upon me is that of an extraordinary grotesque, a something monstrous and superhuman. Under the old dressing-gown, with its empty sleeves, the man stands with

hands held together in front of him and head thrown back.*
There is something theatrical in the pose, something uncanny
in the head. Yes, uncanny; the great jaws and immense throat
that seems to rise out of the chest and form part of it; the
cavernous hollows of the eyes without eyeballs or sight, and
above, the forehead made narrow by locks of hair—a grotesque
of extraordinary power. The personality of the figure is op-
pressive: there is in it a passion of labour and achievement, of
self-assertion and triumph, which excites antagonism and vague
fear. Here is a Titan who had made a world, and could unmake
as well. There is something demoniac in the thing that thrills
the blood†. . . . Here at last is a statue of a great man worthy
of the man's genius, and naturally enough it was rejected by
the most eminent society of amateurs in France.

Harris was writing in June, when the executive committee of the
Société des Gens de Lettres had already announced its decision to
reject the *Balzac*. For Rodin, the polemics in the press mattered less
than the debate within the Société, which had, after all, commissioned
the piece and owed him 30,000 francs for it. This time the anti-Rodin
faction finally succeeded in getting its way. At a meeting of the
committee on May 2, Rodin's nemesis Alfred Duquet, now one of the
vice presidents, proposed a resolution that would have "forbidden"
the sculptor to have the statue cast in bronze, and which stated flatly:
"The committee refuses to accept a work which has no resemblance
to a statue." When objections were raised the decision was postponed
for a week, but on May 9 the committee—now consisting almost
entirely of literary nonentities—approved a new resolution drafted
by the novelist Henri Lavedan: "The Committee of the Société des
Gens de Lettres regrets that it has the duty to protest against the
rough model exhibited at the Salon by M. Rodin in which it declines
to recognize the statue of Balzac."

*Harris, who was to become known for the sexual candor of his memoirs, was the only
observer to mention the hands beneath the mantle.

†Otto Rank's theory of why a monument like a menhir or the "Stone Guest" in *Don
Giovanni* should thrill the blood is set forth in my essay, "Rodin's *Balzac*" in the Spring
1976 issue of *Horizon*.

Rodin had expected trouble but was unprepared for this new slap in the face. Charles Chincholle went to see him at the Dépôt des Marbres shortly after the decision was announced and found him quietly defiant: "You know, I think I've absolutely realized my dream. . . . Modern sculpture cannot be photography. The artist has to work not only with his hands but also with his head. . . . The only thing I've noticed is that the neck is too thick. I felt I had to make it so thick because modern sculpture should exaggerate forms. With this exaggerated neck I wanted to express strength; I realize that what I've done has exceeded my intentions. Still, have you looked at my statue from the right, standing twenty paces from the pedestal?"

Rodin could have sued the committee, but his lawyer, Maître Chéramy, was in full agreement that he ought not to waste his time fighting a lawsuit. Eventually it was arranged for him to sign a letter annulling the contract with the Société and releasing the 10,000-franc advance, plus interest, that was being held in escrow. On May 11 Rodin told a reporter from the *Journal des Débats* that all this represented "a financial disaster for me." Though he was not yet rich he had already acquired the protective habit of pretending to be less affluent than he actually was. "I'm poor, but what does it matter? Thanks to my poverty I have honest days and good friends."

His friends, however, were not nearly as willing to accept the Société's decision without a fight. As Carrière wrote to Morhardt, also on May 11: "Are we to disregard this outrage committed against an artist in whom our country takes such pride?" Morhardt called a council of war at the Dépôt des Marbres: Mirbeau, Geffroy, Carrière, Georges Lecomte, Arsène Alexandre, Charles Frémine. "We were all of us trembling with rage." They drew up a strongly worded letter of protest declaring the committee's action to be "of no significance from an artistic point of view" and encouraging Rodin to continue his work: "in a country as noble and refined as France, he will not cease to be the object of the respect and esteem to which his integrity and his admirable career entitle him."

A printed copy of the letter, signed by the authors as well as by the crusading journalist Francis de Pressensé and—at Rodin's request—by Jean-Louis Forain, was circulated among friends and acquaintances. Within a few days scores of well-known people had

affixed their signatures. The list reads like a *Who's Who* of the fin-de-siècle's artistic and literary elite, ranging from Jean Ajalbert and Henry Becque to Toulouse-Lautrec, Paul Valéry and Félix Vallotton. There were some notable abstentions. Jules Dalou, for one, made it very clear that they had approached the wrong man: "The excellent memory of the friendship that once united us, Rodin and myself, prevents me from participating in this new inanity into which he has been led by his foolish friends."

Yet on the whole the first appeal was so successful that on May 20 its sponsors launched a subscription drive to raise 30,000 francs for the purpose of buying the *Balzac* and erecting it in a suitable public place. At Rodin's request Mallarmé agreed to join the committee of sponsors: "I accept with great pleasure, very touched that Rodin has thought of me"—it was a matter of "saving the honor of the city." As money and letters came pouring in, dozens of important names were added to the list of subscribers. Fenaille and the naturalist René Quinton each contributed 1,000 francs; Alexandre and Thadée Natanson collected nearly 800 francs at the *Revue Blanche*; among those who gave 500 francs were Mirbeau, Monet, Lucien Guitry, de Pressensé and the American painter Thomas Alexander Harrison; lesser amounts came from Chausson, Renoir, Daudet, Mendès, Cézanne, Besnard, Pissarro, André Gide, Anatole France, Verhaeren, Clemenceau, Forain, Gallé, Legros, Ajalbert and innumerable others. There were five francs from the penniless Alfred Sisley and ten francs from Charles Morice, who had been obliged to borrow money from Rodin not long before and would ask him for another loan in July.

Rodin, in the meantime, had come to regard the subscription drive as a distinct embarrassment. For one thing he had already received two other offers for the *Balzac*. One came from Auguste Pellerin, an art collector who had made his fortune in amusement enterprises and wanted to purchase a marble version. The other proposal came from his Belgian friend Edmond Picard, founder of *l'Art moderne*, who asked him to "cede" the statue to Brussels, where Balzac was much admired and "your work would be placed in one of our public squares."

The main reason why Rodin was worried about the subscription was that, with the solitary exception of Forain, all of its sponsors were identifiable Dreyfusards. The "battle of *Balzac*," as Morhardt

called it, thus became hopelessly enmeshed in the Dreyfus affair, by now the most burning issue of the day. Rodin, it was clear, hoped to avoid a linkage between the two issues. "He took care not to run any risks during the Dreyfus affair, and that made him a very worried man," recalled Francis Jourdain. "In effect he wanted to antagonize neither his usual supporters, who were all Dreyfusard, nor the authorities, who were anything but." Caught between two fires, Rodin was unwilling to admit that "his tendencies were vaguely reactionary. He was a tepid and above all discreet if not shamefaced anti-Dreyfusard. His embarrassment bordered on comedy as much as drama when the *Balzac* affair became superimposed on the Dreyfus affair."

Rodin's dilemma was compounded by the fact that it was Zola of all people—Zola who had just reaffirmed his support of Rodin and the *Balzac*—who had chosen to become the public champion of the imprisoned Captain Dreyfus. At the beginning of the year, on January 13, Zola had published his famous open letter *J'Accuse* in Clemenceau's *l'Aurore*, castigating the army high command for having conspired to send an innocent man to Devil's Island. The letter had precipitated an open split between the rightist, conservative forces of France and a small but militant minority of left-wing intellectuals. The drama was played out not only in the newspapers: there were riots in the streets, beatings, murders, duels, brawls in the Chamber of Deputies. In February Zola was tried for libeling the army and found guilty by a biased judge and a complaisant jury, in a courtroom besieged by a mob waiting to lynch the defendant if he was acquitted. In April a court of appeals quashed the proceedings, but during the retrial in July Zola abruptly left France and took refuge in England— to await the vindication of Dreyfus which was not to begin until the following year.

Meanwhile, the activists of the right mounted a concerted attack against Zola, Dreyfus and their supporters. One of their most effective and vitriolic propaganda organs was the weekly broadsheet *Psst . . . !*, published and illustrated by Forain and Caran d'Ache (Emmanuel Poiré), two of the most gifted caricaturists in Paris: among other things, Forain drew Zola as a German Jew and as an agent for the Kaiser. His signature on the *Balzac* appeals was thus supposed to serve as a signal that this was a bipartisan, nonpolitical effort. Indeed Charles Maurras, another prominent rightist, wrote to Morhardt that

"Forain's name is, for me, a guarantee that your activities will not be misinterpreted as exceeding their proper limits."

Still, in that supercharged atmosphere not even an art subscription could remain above the battle. After the publication of *J'Accuse* virtually everyone in Rodin's circle became politicized. Mirbeau congratulated Zola on his "act of courage" in challenging the government: thanks to him "justice, charity and pity have at last returned." Mirbeau himself began to write and lecture on behalf of the cause; just before Christmas he was dragged from the speaker's platform, beaten and shot at when he tried to address a public meeting in Toulouse. Séverine entered the lists with a score of articles and essays supporting Zola; Geffroy became an ardent Dreyfusard; Anatole France appeared as a witness for the defense at Zola's trial; Carrière drew a poster for *l'Aurore*; Monet lauded the "admirable courage, the absolute heroism" of Zola.

The literary salons of Mme Ménard-Dorian and Mme Arman de Caillavet provided aid and comfort to the intellectuals of the left, while those of the right gathered in the drawing rooms of Juliette Adam or the Countess de Loynes. Old friendships and alliances were dissolved over the issue: as Marcel Proust wrote to Anatole France, "there are no friendships now but political friendships." Camille Claudel broke with Morhardt because she was a vehement anti-Dreyfusard and he was a founder of the League for the Rights of Man; Jules Renard quarreled with Paul Claudel over the meaning of "tolerance"; Degas and Renoir, who were anti-Dreyfusard, stopped speaking to Pissarro, who was Jewish and Dreyfusard.

Amid the general uproar Rodin's stubborn silence—and his refusal to sign the manifesto of intellectuals on behalf of Zola—infuriated the hot-blooded Jean Ajalbert: in a newspaper article later republished in book form as *Sous le Sabre* (Under the Saber) he berated all the lukewarm writers and artists who had failed to support Zola in his hour of need. Rodin, he reported, "doesn't sign. For four years he was writing suppliant letters to Zola concerning his *Balzac.* . . . He has refused to give Mirbeau his signature—owing to his convictions? No, he knows nothing about nothing; it's because he suffers from a case of official pusillanimity." When Ajalbert's book appeared Lucien Descaves took Rodin to task in *l'Aurore* for the same sin of omission:

I saw your name among that sorry lot and hastened to turn the page, for I felt that the creator of so many admirable works, among them the *Porte de l'Enfer*, had the right to live outside our time and remain untouched by its turpitude. Certainly I was disquieted that your indifference was attributed solely to the desire to retain the two studios at the Dépôt des Marbres which the government allows you to use free of charge. It made me feel all the more respect for the professors at the university who risked official displeasure by publicly declaring their stand. Some of them risked more than their income and their careers; they risked their daily bread. Still, they didn't hesitate to take the very bread out of their mouths in order to shout "Justice!" But you're not in that situation. Your art, though it hasn't made you rich—as is only right—has made you independent and given you an enviable place on a peak that is inaccessible to petty reprisals. . . . So it's true, Rodin, that you are afraid of being *compromised*, associated with signatures that are, alas, both on your subscription list and on the protests on behalf of Zola! . . . Rodin, you pain us; your precautions leave us with the bitter taste of ashes!

Georges Clemenceau reacted to some of these same precautions with a curt, icy letter to Morhardt dated May 29: "Since M. Rodin has told an editor of *l'Aurore* that he was afraid of seeing too many of Zola's friends among the subscribers, I must ask you to remove my name from the list in your possession." When Morhardt tried to talk to Rodin about the problem, his answer was: "Do you want to add to my difficulties? My fight for my sculpture takes all my time and strength. And even then I don't win."

Many of his Dreyfusard friends did not begrudge him his evasiveness. "I'm for Rodin before everything," Mirbeau insisted. Within a surprisingly short time they had raised the 30,000 francs needed for erecting the *Balzac*, and a committee was dispatched to the Dépôt des Marbres to bring him the good news and discuss the matter. They arrived just as Rodin was talking to the Norwegian writer and artist Christian Krohg, a close friend of Thaulow's. Krohg reported that one of the visiting gentlemen "took out a sheet of paper and read a statement containing a lot of flattering words. 'That was very lovely,'

Rodin said smilingly when they were finished." But he kept the committee waiting while he escorted Krohg to the door:

> I said good-bye. He wanted to accompany me out past all the marble blocks that filled the courtyard. I thought about the waiting committee. "I can find my way out," I said. "Yes, but there is something else," he said. "You have to take a look at this." He pointed out a room where they were carving a *Victor Hugo* in marble, and then he went to rejoin the committee.

Rodin had good reason for keeping the gentlemen waiting: he had already decided not to sell them the *Balzac*, which would have associated him publicly with a cause he detested. Privately, in fact, he was not nearly as tepid or discreet in his opinions on the *affaire* as his friends wanted to believe. "Rodin is a glowing anti-Dreyfusard and anti-Semite," Krohg noted on a later occasion, "a fact that is difficult to understand when one talks with him about other subjects, on which he has approximately the same views as the Dreyfusards."

Apparently it had not occurred to Krohg that a man could be a radical innovator in art without also being progressive in politics. But Rodin read right-wing newspapers like Rochefort's *l'Intransigeant* and believed what he read in them. When Krohg talked to him three years later, after Dreyfus had been freed and Zola had returned in triumph, Rodin still refused to acknowledge the fact that Dreyfus had been innocent all along. The Norwegian writer asked him about it: Rodin "opened his eyes wide with astonishment that there were still people who were not aware that of course he was guilty; the only reason why it had not been possible to prove his guilt beyond any doubt was that the German Kaiser had threatened war if certain documents were published."

According to Morhardt, Pellerin's offer to buy the statue struck Rodin as his best means of "escaping the subscription we had organized, with its obviously Dreyfusard nuances." The Swiss writer made him see, however, that he could not do his friends the disservice of refusing them the *Balzac*, "for which they had fought the good fight," and then selling it to Pellerin instead. The upshot was that Rodin decided not to accept any of the offers, and to keep the statue as his private property. In a letter addressed to "My dear friends"

he explained his reasons to the campaign's organizers and contributors:

I have made up my mind to remain the sole possessor of my statue. My interrupted work, my reflections, all make it imperative that I do so. All I ask of your subscription drive are the names of the generous people who appear on your list, accepting their support as the justification and reward for my efforts. And to you even more ardent enthusiasts, my old friends; you who have always been my friends and to whom, perhaps, I owe the very possibility of doing sculpture—to you I say thanks with all my heart.

After the closure of the Salon the plaster *Balzac* went back to its creator to await the day when it, too, would be vindicated and, as *le Temps* put it, "justice would be done." The Gens de Lettres, meanwhile, were badly in need of a statue to take its place. Almost immediately they awarded the commission not to Marquet de Vasselot and his Balzac sphinx but to the safest, most reliable sculptor they could have chosen—Alexandre Falguière, member of the Academy and sculptor of worthy monuments to, among others, Lafayette, Lamartine and Charcot.

It was not true, as was afterwards reported in the press, that the once and future sculptors of *Balzac* were bitter rivals; on the contrary, Falguière had been among Rodin's earliest supporters. To reaffirm their long-standing friendship he made Rodin a present of one of his big paintings—*Hylas and the Nymphs*—which was promptly installed over the mantelpiece in the dining room at Meudon (it was so large that there was no space for a frame). To prove to the world that all was well they also undertook to model each other's portraits. It was Falguière's way, Rodin said, of "demonstrating his friendship and showing me that he did not agree with my detractors." Judith Cladel got the impression that he took a certain mischievous satisfaction in this turn of events, but in public statements he always stressed that he was delighted that "my friend Falguière" had received the commission.

In less than six months and without any great soul-searching Falguière produced the plaster model for his proposed monument: a

seated, conventional figure, also dressed in a monk's robe. It was shown that December in the Falguière exhibition held in the rue St. Honoré and excited little comment. Most artists felt, with Ottilie McLaren, that "Falguière's *Balzac* is a foolish thing which might have passed for great if it had not been for Rodin's."

Rodin's bust of Falguière was one of the four sculptures he sent to the Salon of 1899, where it went on display not far from Falguière's plaster *Balzac*. "Some thought it strange that in the same exhibition where he displayed his model I should exhibit a bronze bust of Falguière himself," Rodin later recalled, "but he was my friend—at least I could do that for him." There was no doubt that he enjoyed the irony of the situation. He wrote to Bigand-Kaire, who was planning to visit Paris: "I shall show you the Falguière bust when you come (it's *drôle*)." More than that, it was one of his most expressive portraits, with a face furrowed by wrinkles and bumps "like a land ravaged by storms," as Paul Gsell said, with heavy bags under the eyes and an old soldier's mustache.

Falguière, in turn, produced a rough-textured, almost Expressionist head of Rodin with an immense beard, beady eyes and cabbage ears. He too was an accomplished portrait sculptor but as he told Ambroise Vollard while the sittings were in progress, "It's difficult to do a face in which you find, at one and the same time, Jupiter and an office manager." Falguière was in poor health at the time, and suffering from a chronic liver ailment. In April 1900, with the Rodin bust still not quite finished, he went to Nîmes for the inauguration of his Daudet monument and became so ill that he had to be taken back to Paris for an abdominal operation, from which he died the next day, aged sixty-eight. Rodin helped his widow dispose of her husband's works—and in deference to his memory attended the unveiling of Falguière's *Balzac*, which was erected at the intersection of the rue Balzac and the avenue Friedland in 1902. Ironically, the new president of the Gens de Lettres, Abel Hermant, apostrophized both Falguière and Rodin in his inauguration speech: "For even in the presence of the actual, tangible *Balzac* we see here, the other persists, haunting, obsessive and unforgettable." At that the audience rose to its feet to give Rodin a standing ovation. Only then did he come to feel that he might, after all, have won the battle of *Balzac*.

In the immediate aftermath of the storm, however, he regarded the episode as a defeat. "Are you bothered by all this nonsense about the *Balzac*?" Krohg had asked him. "Of course I'm bothered," Rodin said. "It keeps me from working." To Monet, who had congratulated him on his "absolutely beautiful and great" piece of sculpture and protested against "*tous ces imbéciles*," he wrote: "You make me happy with your praise of the *Balzac*. Your opinion is one of those that give me strength. I've had a broadside like the ones you got when it was the fashion to laugh at your invention of putting air into your landscapes."

On November 14, 1898, he unburdened himself to Henley in a letter that summed up the bitter aftertaste of his experience with the most splendid of his sculptures: "Our lives are, in truth, somewhat similar; and I have had, too, terrible sufferings in affection. Profound, pleasureless melancholy has come upon me. The struggle I must carry on still wears me out. . . . What a sorry time we live in! Some believe in progress because there are telephones, steamships, etc.; but all that is only an improvement of the arm, the leg, the eye, the ear. Who shall improve the soul, which will soon disappear?"

13

1900

*I remember thinking that beneath his hands
the marble seemed to flow like molten lead.*

—ISADORA DUNCAN
My Life

Stéphane Mallarmé had been in the front rank of Rodin's partisans during the battle over *Balzac*, and the sculptor was profoundly grateful to this friend whom he addressed as the "dear great poet with the sensitive soul." Mallarmé's opinion meant so very much to him, Rodin wrote, "because you are one of the decisive people in Paris, an Areopagite. Without such people we would be utterly lost. I tell you this in order to let you know how happy I am always to be supported by your vivid friendship. . . ."

As usual Mallarmé was spending the summer months at his country house in Valvins. But during the early hours of September 9, 1898, he died suddenly of suffocation, and Geneviève was obliged to notify his closest friends: "Oh dear Sir, Father died this morning. He'll be buried on Sunday afternoon." Rodin's reply was a barely coherent *cri du coeur*: "What a great, noble man he was! Poets and artists, we are overwhelmed."

About thirty of Mallarmé's friends gathered for the funeral held on September 11 at the cemetery of Samoreau, near Fontainebleau. After the burial Rodin turned to some of his fellow mourners and said

quietly, "How much time will nature need to make another brain like his?"

Mallarmé's death added immeasurably to Rodin's post-*Balzac* depression. With most people he tried to put a brave face on his present situation: to Russell, for instance, he wrote that "they've covered my *Balzac* with dirt but I'm not bitter." Jeanès, however, noted that his famous friend was "like a felled oak" and thoroughly demoralized; nothing anyone could say would cheer him up and he had even lost his will to work. "He used to say 'Whenever I'm in my studio I have a good time,' but now even his models ceased to interest him." Jeanès thought he knew the cure for Rodin's melancholia and took him to the home of "an actress whom I had persuaded to take off her clothes for him so that her magnificent body would rekindle his desire to work with clay":

> We dined at her home with her lover and her brother. . . .
> Afterward this great beauty went to take off her clothes before
> calling us in to look at her. . . . But even in the nude she
> remained an actress, having lost both her naturalness and her
> awkwardness long before. Rodin gazed at her in utter calm;
> not for a moment did I see him narrow his eyes or incline his
> head. She wanted to dazzle or charm him and became lasci-
> vious. He turned toward me with a tired, exasperated look.
> Later he invited her to pose for him but he did nothing with
> her. To thank her he sent her a torso, a palpitating study of
> womanhood. When she showed it to me she said, "I don't think
> he's able to do justice to my rounded forms."

Whatever Rodin himself might have felt about the *Balzac* affair it had certainly not harmed his reputation. On the contrary, it had brought him more publicity at home and abroad than three decades of quiet hard work, and his name had become something of a house-hold word. Now that he was an international celebrity he was besieged by journalists of many nationalities asking for interviews and opinions. The British, especially, were now firmly convinced that, as the *Manchester Guardian* had it, he was "the most interesting of sculp-tors," and after his squabble with the Gens de Lettres the *Pall Mall Gazette* rose gallantly to the defense of the man "whom no set of timid

literary men can prove other than the most exalted, most personal, most feverishly imaginative of living sculptors."

British taste was in the midst of a great spring thaw: the younger generation of painters had turned their collective back on the Royal Academy and were looking to the French Impressionists for guidance. In London an important group of young artists and patrons had formed the International Society of Sculptors, Painters, and Gravers for the purpose of creating a regular forum for important foreign works as well as those of British artists. The committee of founders was headed by Alfred Gilbert and included John Lavery, William Strang, James Guthrie, Will Rothenstein, Charles Ricketts and Charles Shannon: the proprietors of the fashionable Princess Skating Club in Knightsbridge allowed them to use the building as an art gallery once the skating season was over.

Whistler, who had been living in Paris since 1892, was elected president of the International Society, and the bilingual painter Anthony Ludovici was sent to Paris to enlist Degas and Rodin in the group's first exhibition. Accompanied by Ludovici, Whistler went to see Rodin at the Dépôt des Marbres in the middle of April 1898. The author of *The Gentle Art of Making Enemies* was sixty-four, yet Arthur Symons declared that he had never seen anyone as feverishly alive as this incessant talker and verbal virtuoso with "his dark eyes, under their prickly bushes of eyebrow, his fantastically creased black and white curls of hair, his bitter and subtle mouth, and, above all, his exquisite hands, never at rest." Symons saw Whistler and Rodin as temperamental opposites: "This little, spasmodically alert, irritably sensitive creature of brains and nerves could never have gone calmly through life as Rodin . . . goes calmly through life, a solid labourer at his task, turning neither to the right nor to the left, attending only to his own business."

Rodin showed Whistler and Ludovici the contents of his studio. "He was then at work on an important group, which was, if I remember rightly, for the Argentine Republic, as well as busts, over life-size, of Rochefort and Victor Hugo," Ludovici writes in his memoirs. "He brought out a portfolio full of line drawings of the nude, slightly tinted, which were so odd and unacademic that we could not make out why they were done at all." Whistler was not interested, "but Rodin explained that he drew them with a continuous line without

looking at the paper, declaring that he did not wish to lose sight of the model, or models, for a moment: he often had two models standing together in momentary movements."

The three artists went to lunch at Druet's *café-tabac-vins-liqueurs* in the Place de l'Alma, where they were joined by the critic Arsène Alexandre and "Rodin listened to all Whistler had to say." The painter spoke affectionately of their mutual friend Mallarmé, then still among the living, of whom—too late, as it turned out—he planned to do another portrait. "We talked about you," Rodin wrote to the poet a few days later, "or rather I listened to Wistler [*sic*] who does not admire people easily and for whom you are the Elect."

After lunch, as the two painters drove off in a fiacre, Ludovici was surprised to hear from Whistler that he thought Rodin's work was not really "sculpturesque," except for the Sarmiento monument. "When I pointed out what I thought was Rodin's maxim, which was to make his figures more living by adding colour through the shadows, leaving marks or pellets of clay instead of polishing it up, Whistler maintained that a sculptor should remain within the bounds of sculpture, and not attempt to make it realise another side."

The International Society's first exhibition opened in May and turned out to be dominated by French artists: Degas, Manet, Monet, Toulouse-Lautrec, Puvis, Fantin-Latour, Jacques-Emile Blanche. Rodin had five pieces on view; among the sculptures, said the *Guardian*, "the finest things are a few characteristic scraps by Rodin, in which his astonishing power to model is combined with his surprising re-luctance to create." He had sent them a sixth figure, *The Fallen Angel*, which Ludovici thought so sensuous that it might have offended the guardians of public morals and led to the closure of the exhibition. Fortunately, "luck was in our way, for the figure was very difficult to pack, and was so much broken when it arrived that we could not exhibit it."

A far wider selection of Rodin's work was to be seen at the in-augural exhibition of the Vienna Secession, which also took place in the spring of 1898. The Secession was an artists' association dedicated to opening up Austria to the new currents in painting and sculpture, especially art nouveau. Rodin sent them fifteen of his works, ranging from fragments of the Victor Hugo monument to the bust of Dalou and *le Péché*. The Secession was soon to have its own distinctive

gallery but for the time being they borrowed a building from the Landscape Gardening Association that was large enough to house more than 500 works by such artists as Puvis, Sargent, Whistler, Böcklin and the new society's president, Gustav Klimt.

To help them make contact with French artists, Klimt and his friends turned to an emphatically "modern girl" and writer on art, the redheaded Berta Szeps-Zuckerkandl, whose father was a prominent Viennese editor and whose sister had married the dynamite manufacturer Paul Clemenceau. Through Paul's brother Georges she had made friends with both Rodin and Carrière—the latter painted her portrait in 1894—and it was in her salon that the idea of a Viennese opening to the West was first discussed. She was delighted to render "pioneer service" as the unofficial liaison officer between the art nouveau of Paris and the Viennese avant-garde. The Secession movement was at least partly an Austrian response to Prussian Germany's increasing dominance of political and economic affairs: an artistic alliance with France would prove, as Szeps contended, that "to be Austrian did not mean to be German; Austrian culture was the crystallization of the best of many cultures."

It was a measure of Rodin's growing prestige that in addition to his impressive display at the Secession from March to June he was represented by five sculptures in the rival Golden Jubilee exhibition held almost simultaneously in the Vienna Künstlerhaus to celebrate the fiftieth anniversary of the accession of the Emperor Franz Joseph: normally, Secessionists were not supposed to exhibit with the group that ran the Künstlerhaus. During the next few years the Secession continued to take a special interest in Rodin's work, exhibiting the large bust of Rochefort in 1899 and that of Falguière in 1900: that year Berta Szeps prevailed on him "in the name of the artists of Vienna, of the Viennese public, of all those who have felt awe before your works of genius," to send the *Balzac* and other major pieces, such as *Eve* and the *Saint Jean*, to the Secession exhibition of January-February 1901.

Meanwhile, the Secession magazine *Ver Sacrum* (Sacred Spring) chose to laud Rodin as a "Gallic" sculptor who could be considered an ally in the struggle against German hegemony. At the Berlin National Gallery, as Oskar Fischel wrote, Rodin's bust of Dalou "stood opposite the bronze bust of Böcklin by [Adolf] Hildebrandt, and this

simple juxtaposition is highly instructive: art, culture and nationality are here engaged in silent battle."

The traveling exhibition that Rodin sent to Brussels and Amsterdam in 1899 struck *Ver Sacrum* as an equally salutary lesson that "art, fortunately, does not always conform to the principles of art history." For the first time in his life Rodin had assembled a show that afforded the critics a chance to see the whole of his creation "in all its breadth: this extraordinary man unites within himself gifts that are normally distributed among several individuals." And only a Frenchman, Fischel said, could have transmuted his inner life into such a seemingly effortless outpouring of sculpture.

In later years Judith Cladel claimed that she was the one chiefly responsible for persuading Rodin to send a traveling exhibition to Belgium and Holland. Léon Cladel's literary daughter, who had turned twenty in 1893, had joined the Rodin circle in the mid-Nineties and was soon acting as a sort of personal assistant. She helped him assemble more than sixty sculptures that were sent, in turn, to Brussels, Rotterdam, Amsterdam and The Hague. More than a third of these pieces were sizable works like the *Eve* and the *Bourgeois de Calais* (which were offered for sale either singly or as a group, in plaster or bronze).

In Brussels the show opened on May 8, 1899, in the spacious galleries of the Brussels Maison d'Art: Rodin himself had arrived three days earlier to supervise the arrangements. His placements disregarded the conventional rules of symmetry, "the cream-puff of museum curators," as he put it, but he was all the more particular about the lighting. Cladel noted that he was courteous toward the women who were present, but "when he spoke to the men he was curt and starchy. The young director of the Maison d'Art asked him a question in an extremely deferential tone and the reply was (I never understood why): 'I'm the master here; I'm the one to give the orders.' For the first time I became aware of the lion's claws."

At Rodin's behest both Cladel and Charles Morice gave lectures on his work at the Maison d'Art. Her father's loyal friend Camille Lemonnier praised her performance in *l'Art Moderne*: "It is a young goddess who speaks of a god and removes a succession of veils as though in a ritual. Wasn't she herself the daughter of a great hero?" Her lectures had demolished "the myth of a Rodin whose works are

arrested in mid-sketch by some mysterious failing." On the contrary, Lemonnier wrote, his partial sculptures were among his best:

> At the Maison d'Art there is a torso that seems to have been spewed out from the furnaces of a Gomorrha. It has been savagely torn and splayed the way a fissure in the earth cracks open, as though a crucible were exploding in its depths. Though barely larger than life-size it is immense; it has the giant dimensions of a symbol. And yet it is no more than a simple form with its essential lines, and lives like one of the great antique torsos—the fragment of a temple or idol of a cult, indestructibly majestic even in death.

Judith Cladel's lectures in Brussels launched her on what was to become a lifelong career as Rodin's spokeswoman, factotum and biographer. At the outset it was evidently a case of girlish infatuation. In her earliest letters to the maître she tried to impress him with the intensity of her devotion: since she never saw him face to face, she wrote, she shook the hands of his sculptures and kissed them. Later she confessed her disappointment at the noncommittal welcome he gave her after a three-month absence, and though she wanted him merely as a *bon camarade* her heart began to pound in her chest when she as much as approached the street where he lived.

Rodin, for his part, seems to have realized from the first that this star-struck young woman had untapped managerial talent: "You've gone off, *chère amie*; are you already far from here? I'd like to ask you for some more advice. . . ." She was at his side as he welcomed important visitors to the Brussels exhibition. Among them was Constantin Meunier, as energetic and broad-shouldered as Rodin himself. She recalled what a pleasure it was to see the two sculptors stroll through the galleries together, speaking in low voices and stopping frequently to discuss this or that work: "They had the perfect entente of two powerful animals long harnessed to the same yoke."

The Brussels retrospective attracted so much attention that the city's Royal Museum of Fine Arts was moved to purchase its first Rodins—a small *Thinker* and the *Fallen Caryatid* in marble. Meanwhile the exhibition was sent on to the Art Circle of Rotterdam. This time Rodin relied on Cladel to deputize for him: "I have confidence

in your unerring good taste, and also in your friendship for me. . . . You give me so much of your precious youth—and are doing all this for my *gloire*. Ah, my dear, my dear sweet girl!" She agreed to repeat her Rodin lecture for the Rotterdam Circle and wrote about the show's opening day—June 29—for the Paris newspaper *la Dépêche*: "The members of the Art Circle decorated the lobby of the Salon very naively and prettily with tall plants and sweet-smelling white flowers. 'That's how we decorate our Paris churches for big weddings,' I told them. 'But you see,' the vice-president replied, 'thanks to M. Rodin we're celebrating the mystical wedding of the city of Rotterdam and Great Art.' "

When the show moved to Amsterdam, where it was to be held at the prestigious Arti et Amicitiae Society under royal patronage, Rodin decided to supervise the placement himself. It was sunset when Cladel met him at the railway station, and he was enchanted by his first view of the city. As they rode past the canals with their twinkling lights on the way to the Amstel Hotel he murmured ecstatically, "It's a city out of the Arabian Nights!"

Next day they paid their respects to the Rembrandts in the Rijksmuseum. Rodin lingered before *The Night Watch*, the *Jewish Bride*— "obviously Rembrandt's wife, since she's been painted with so much love"—and *The Syndics*: "Ah, they're getting up; they are going to talk to us!" He himself had been called the Rembrandt of sculpture, and he felt a kinship for the painter because he too had made a conscious effort to broaden and simplify his art. "I'm glad I've been to see Rembrandt," he told Cladel. "It's as though he had come back to tell me, 'You've made no mistake; you've done well.' "

Rodin returned to France before the official Amsterdam opening in mid-August, having diminished his welcome by his refusal to pay the customary courtesy calls on the local painters—many of them members of Arti et Amicitiae—who were expecting to show him their studios. He was back in Holland in October, however, for the opening of his exhibition at the Haagsche Kunstkring, the Art Circle of The Hague. A group of Dutch artists took the opportunity to invite him to dinner in the nearby seaside resort of Scheveningen. When the painter-engraver Philippe Zilcken proposed a toast in his honor, Rodin thanked him with the simple act of gazing slowly and in turn

at each of the artists sitting around the table: as Raffaëlli once re-marked, "Rodin had every kind of power, even that of silence."

He returned to Paris by a roundabout route, taking a Maas riverboat from Rotterdam to Dordrecht in the pleasant company of two young Dutchwomen. He told them that the river landscape fully accorded with his soul: "Nothing has changed here; it's Cuyp, Van Goyen, Salomon and Ruysdael; it's just as it was then." On the riverbank the windmills turned slowly as their boat moved upstream. "How reposeful your river is," he murmured. It persuaded him that *"la lenteur est une beauté* [slow is beautiful]."

>‡<

In Amsterdam he had just missed meeting Whistler, then on a tour of Holland, but later in the year he took Judith Cladel to see the painter in his sixth-floor walkup studio in the rue Notre-Dame-des-Champs. They hoped he would show them some of his paintings, but Whistler did not remove the dropcloths that covered his pictures and passed the time cleaning his palette and making sarcastic remarks about other people, mainly his fellow Americans. Presently he rum-maged in a corner and placed a cylinder in a hand-crank phonograph, the latest triumph of American technology. They were regaled with what Cladel describes as a *chanson nègre*, perhaps "Swanee River" or an early example of ragtime. His visitors failed to appreciate this well-intentioned effort to introduce them to the music that was soon to sweep Europe off its feet—one of the sculptor's secretaries recalled that "Rodin could hardly control himself when speaking about Whis-tler's 'eternal gramophone.'" It struck Mlle Cladel as bizarre that this *fantasque artiste* should treat them to no other entertainment.*

It was from Whistler that Rodin had inherited his first American sitter, the young art collector Arthur Jerome Eddy, afterward the author of *Cubists and Post-Impressionism* and already "known to fame

*Difficult as he was whenever they met face-to-face, Whistler could be supremely courteous in his correspondence with Rodin. On an earlier occasion he wrote to the sculptor to say that "your visit to my studio gave me great pleasure. I also want to thank you for the trouble you've taken to obtain Monsieur Mirbeau's article in *la France* for me. It's wonderful to have a defender like him. I am sending you a proof of the *Sarasate* and am most grateful for your kindness."

and Chicago as 'the man Whistler painted.' " He had earned this distinction in 1893 when he came to Paris for less than six weeks and prevailed on the dilatory Whistler to paint his portrait in that unconscionably short time. "Well, you know," the painter said when it was finished, "he is the only man who ever did get a picture out of me on time, while I worked and he waited." When it was Rodin's turn five years later he did a portrait bust of the still collegiate Mr. Eddy decked out in a jaunty bow tie, vest and coat: evidently he felt that it would be impossible to bestow on this rather gauche young man the Roman dignity of nakedness with which he had ennobled such sitters as Dalou, Laurens and Victor Hugo.

><<

Early in 1899 the firm of Charpentier and Fasquelle published Octave Mirbeau's novel *le Jardin des Supplices* (The Torture Garden), which compounded a curious mixture of sadism, debauchery and compassion into a sweeping indictment of a world in which "murder is the foremost human preoccupation." Written partly in response to the Dreyfus affair, its thesis is that society is governed by the threat of physical violence and death; by forces of enormous erotic as well as social potency. Not even the supposedly gentle sex was exempt from the blood lust of mankind: "Why do you see women in the street, at the theatre, at the guillotine, watching scenes of violence and death with avid eyes?"

On a voyage to the East, Mirbeau's narrator has a shipboard romance with a mysterious English girl, daughter of a Canton opium dealer—"I belonged to Clara the way coal belongs to a fire that consumes and devours it." She takes him to her private palace in Canton and introduces him "to the very depths of love and death." Whereupon, for the book's last 200 pages—roughly half its length—Mirbeau provides a blow-by-blow account of the most diabolically refined torture garden in French erotic literature. It could be read either as a parody of sex or as a plea for social justice; metaphorically the whole of life was a torture garden.

A special edition was published in a printing limited to 500 copies, with a private run for Les XX of Brussels. As a frontispiece it had a drawing by Rodin of a woman undressing; Mirbeau's ironic dedication was printed in a kind of ecclesiastical red and black: "To

priests, soldiers, judges; to the men who educate, direct and govern mankind, I dedicate these pages of blood and murder."

But Mirbeau wanted to collaborate with Rodin on a far more elaborately illustrated edition of his book, or at least that portion of it which actually takes place in the torture garden. After his proposal was turned down as too risky and problematic by several publishers it was taken in hand by the art dealer Ambroise Vollard, who agreed to do it but on very one-sided terms. Mirbeau furnished the text and Rodin promised to deliver twenty *compositions originales* in color— for which, in lieu of pay, they were each to receive four free copies. In the end Rodin delivered eighteen of his colored wash drawings and two in black and white. They were transferred to stone by Auguste Clot, the outstanding art lithographer of Paris. After months of experimenting with the ways and means of reproducing Rodin's sinuous lines and transparent washes Clot succeeded so well that "the maître had trouble distinguishing them from his originals." Indeed, after working with Clot at his studio in the rue du Cherche-Midi,* Rodin became convinced that "when he is gone lithography will be a lost art."

The result was one of the most striking *livres d'artiste* of the century, though most of the drawings have only the most tenuous connection with the text. According to the humor magazine *le Canard Enchaîné* Rodin had "neglected to read the novel" before delivering the illustrations. Actually he did make some preparatory studies of nude women undergoing torture but these were left out of the book: where the text speaks of agonies and ecstasies Rodin merely shows calm, lyrical nudes that may well have come from his existing stock of such drawings, already mounting into the hundreds. Clot completed most of his preparations by 1900 but the book was not off the press until May 1902. The edition was limited to 200 copies—priced at 250, 450 and 600 francs, depending on the paper. In keeping with Vollard's announcement the lithographic stones were afterward sanded down so that there could be no question of a cheaper reprint.

*The print expert Loys Delteil heard that five of the *Jardin* illustrations were "executed directly on the stone" by Rodin himself; A. Hyatt Mayor contends in *Prints and People* that these five were made on lithographic transfer paper, while Victoria Thorson argues in *Rodin Graphics* that there is so little difference between those attributed to Rodin himself and those transferred by Clot that Delteil must have been mistaken.

In the dedication of one of these copies Rodin described the author as "my dearest friend Octave Mirbeau," which may very well have been an accurate description of their relationship at the turn of the century. Other critics felt that the garrulous Mirbeau, having "invented Rodin just as Zola invented Manet," had long ago overstepped the bounds of permissible enthusiasm. Even the amiable Jules Renard came to feel that Mirbeau went too far in "shrouding the simplicity of this artist in tenebrous words," since he was merely "a robust workman with a shrewd and penetrating eye." Rodin himself sometimes had trouble understanding his most eloquent friend. While *le Jardin* was in preparation, he discussed drawings with Mirbeau but the talk "was all about publishers, *des affaires d'éditeurs*," as he wrote to Bigand-Kaire, "and I didn't understand anything."

In fact the machinery of French publishing was beginning to work overtime on his behalf, and Rodin was not displeased at having become the object of so much editorial attention. Under the direction of the young poet Félix Faillet, who signed himself Félicien Fagus, the *Revue des Beaux-Arts et des Lettres* devoted an entire issue to Rodin on the 1st of January, 1899. It contained a sheaf of articles by members of the old guard and pieces by Fagus and other young writers, comparing Rodin to Dante, Shakespeare, Baudelaire and Wagner. For Léon de Saint-Valéry he was even "the Messiah of Art."

Fagus's issue also announced the imminent publication of the first full-scale Rodin monograph, Léon Maillard's *Auguste Rodin Statuaire*—an earnest, profusely illustrated study that had been "erected piece by piece during the past few years." Most of the photographs for it had been taken by the restaurateur Eugène Druet, at whose modest but grandly named Café du Yacht-Club Français Rodin had been eating regularly for years. Fagus reported that Druet had "done photography as an amateur" before becoming interested in taking pictures of his famous customer's sculptures. "Encouraged and advised by Rodin, he graduated his exposure times, adjusted the nuances of lighting, modified his technical procedures" and gradually arrived at photographs that resembled paintings or lithographs: excitable friends said they resembled Rembrandt and Leonardo.

The more significant plates in Maillard's book, however, were the work of four well-known printmakers: Auguste Léveillé—whose wood engravings of his busts Rodin had exhibited beside his own work in

Geneva—Tony Beltrand, Auguste Lepère and Charles Coutry. They produced meticulous two-dimensional renderings of the major sculptures using what were essentially eighteenth-century techniques, which Rodin much preferred to photography. Despite his praise for Druet's "superb clichés"—and later for other photographers—he was never really satisfied with the medium as such. "Rodin finds photography unsatisfactory for the reproduction of sculpture," noted Charles Quentin in the *Art Journal*, and the Czech writer Miloš Jiránek heard from Rodin that "drawings are always more intelligent than photographic reproductions." The reasons for his dislike of the camera were later spelled out in *les Cathédrales de France*:

> Photographs of monuments are mute for me; they don't move me, they don't allow me to see anything. Since they fail to reproduce the planes properly, photographs to my eyes always have an unbearable hardness and dryness. The lens, like the eye, sees in low relief. Yet in front of the stones themselves I feel them! I touch them everywhere with my gaze as I move around them to see from all directions how they soar into the sky, and I search out their secret from all sides.

This attitude made him all the more receptive to the ideas of the young wood-engraver J.-L. Perrichon, a giant of a man who wanted to "revive the techniques of the old *imagiers*" of eighteenth-century France. They met at Jean Dolent's "cottage" on the heights of Belleville in 1898 and Perrichon was soon a frequent visitor to Meudon, of which he did a woodcut that was reproduced in Fagus's special issue.

Rodin told the young artist how disappointed he was by the reproduction of his latest drawings in art magazines and complained about the "softness" of the impressions: would Perrichon try his hand at translating the drawings onto wood blocks? Like Clot, Perrichon could not resist the challenge of working for the most exigent maître in Paris. "With what infinite solicitude he tried to follow the original and capture its subtlety, freedom and elasticity," wrote Georges Grappe. "He printed his paper on felts with carefully calibrated thickness and inked his blocks with the minute care of an alchemist." Rodin was so happy with the results that when *la Plume* and the *Revue Blanche*

asked him for drawings, he told them to work from Perrichon's wood engravings.

They made plans to collaborate on an illustrated edition of Ovid, whose poems had long played a major role in Rodin's choice of subjects—or rather in finding titles for his sculptures: in his private library there were several French translations of the *Metamorphoses* and of the *Ars amatoria* that bear signs of frequent use. Yet despite his continuing interest in "our" Ovid, Rodin's line drawings for the *Elégies Amoureuses d'Ovide* were not published during his lifetime. There were simply too many other projects that demanded his attention more urgently.

The business side of running a sculptor's studio was consuming more of his time than ever before. In 1898 he signed contracts with the art-bronze firms of Leblanc-Barbédienne and Fumière et Gavignot authorizing them to make and sell reduced copies of such works as *The Kiss*, *Eternal Spring* and the *Saint Jean*. The ceramist Edmond Lachenal, a friend of Carrière's, had already obtained Rodin's consent to make ceramic replicas of *la Douleur* (Pain), though on condition that "no copy will leave my firm without your express consent." Yet while he profited from the proliferation of his sculptures Rodin remained wary of the ease with which they could be duplicated behind his back.* For that reason he had Lebossé make only five reduced copies of the six *Burghers of Calais*—"The best sellers being the *Bourgeois* with the key and the one with the arm raised, showing heaven [Jacques de Wissant]," as René Chéruy remembered. "But Rodin as he told me himself was afraid that someone, sometime, somewhere might try to reconstruct the original group, and he disliked the idea of bibelots. This also was the reason for him to have in his Paris studio—where he had many visitors on his 'open Saturday afternoons'—only one small *Bourgeois* at a time, and only once in a while, disliking the idea of his working studio looking like a sales room."

Still, the essential purpose of these Saturday receptions at the Dépôt des Marbres was to attract buyers: many of the leading painters

*Another sculptor had got hold of a set of his piece molds, for example, and in the words of his pupil Ottilie McLaren, "there were more copies of the Victor Hugo bust going about than he wot of" in the spring of 1901.

and sculptors of Paris had their weekly *jour de réception* at which one could meet the artist and make discreet arrangements to purchase his work. Carrière held open house on Fridays; Besnard on Sunday afternoons. "Foreigners are admitted upon presentation of their visiting card," explained the *Guide des Plaisirs à Paris*, which carried Rodin's name and address together with a capsule description of what to expect when one got there: "Great intensity of life. Is searching for a new path in sculpture. Receives on Saturdays."

Later he held *jours de réception* at his far more spacious studio in Meudon. On such occasions he would go to great lengths to impress the ladies, though sometimes with indifferent results. "One Saturday when I was down there," recalled the American photographer Edward Steichen, who visited Rodin for the first time in 1900,

> there were three or four men, and a woman came in and he got real fussy. He found her a cushion to sit on and looked around—found a rug that was just right for her legs. She was pleased—nothing would induce her to leave that seat. Then, later on, in came an Italian countess. He found her another cushion—then saw the rug he had found for the other woman and pulled it right from under her: it wasn't meanness or anything like that—it was just that he saw the rug and took it.

In time his atelier became a meeting place for visiting artists from all over the world who knew more about Rodin than the French did. At one of Rodin's Saturdays Gabriel Mourey heard from a painter newly arrived from the antipodes that in Australia "all the young people who cared about art had photographs of his work." It struck Arsène Alexandre as a disgrace that Rodin should be "far better understood and admired abroad than at home," as he complained in *le Figaro* on July 21, 1899. "The Americans who are best informed about French art have told me more than once, 'The artist we know and like best in France is your Rodin.' "

Of course there were also many Frenchmen among the young artists converging on the Dépôt des Marbres. Among them was Henri Matisse, who turned thirty in 1899: "I was taken to Rodin's studio in the rue de l'Université by one of his pupils who wanted to show my drawings to his maître," Matisse remembered in later years. "Rodin,

who received me courteously, was moderately interested. He told me that I had a *main facile*, a natural facility—which was wrong. He advised me to make *dessins pignochés* [drawings with fussy, niggling strokes] and show them to him. But I didn't go back."

The people who came to see him on business were more persistent, and Rodin became increasingly involved in a series of foreign sales and private exhibitions. Scenting an opportunity to make his long-delayed fortune, Frank Harris arranged to bring a number of Rodin bronzes to London, where he held an exhibition at the Carlton Hotel in January 1900, pending the opening of his own gallery: "I am going to have the *best* shop in London soon—soon. . . ." The exhibition was attended by large crowds but ignored by the press, whose attention that moment was fixed on "the stupid war in the Transvaal," as Harris's partner Henry Davray informed Rodin. The best shop in London thus became a casualty of the Boer War.

A more serious and successful effort at starting a new London gallery was undertaken by Will Rothenstein's friend John Fothergill, who founded the Carfax Gallery in Ryder Street, St. James's. With Rothenstein in charge of the selections they began by selling small Rodin bronzes and drawings but eventually set their sights on larger commissions. One plan proposed by the art critic of *The Spectator*, D. S. MacColl, was to raise a subscription for a major Rodin sculpture to be presented to the (just re-christened) Victoria and Albert Museum. MacColl had the *Balzac* in mind, but "MacColl always gets hold of the wrong end," as Whistler told Joseph Pennell when he came to London in 1900, because he "admired Rodin for the things, like the *Balzac*, which are least admirable."

The sponsors of this project included Legros, Rothenstein, the sculptor John Tweed and John Singer Sargent, who also expressed a preference for one of the early Rodin sculptures, which seemed to him "far finer than most of his later things." Rodin himself suggested *l'Age d'airain* when he heard what was afoot:

I think that 4,000 [francs] for a good bronze would be about right. With a fine patina. The price for a marble is double that, perhaps more when you add the cost of the block. *L'Age d'airain* or *l'Homme qui s'éveille* would be in marble for the first time and in that material I see it as twice as expressive, for in that

state of suffering there are nuances that could only be rendered in marble; if possible in Greek marble. . . . I'm praying for this to happen.

Instead, a bronze copy of the *Saint Jean* was purchased by subscription; the contributors included Alfred Gilbert, Sir Lawrence Alma-Tadema, Lawrence Binyon, Pen Browning, Roger Fry, Henley, T. Sturge Moore and Charles Ricketts. Meanwhile, the Carfax Gallery also arranged the sale of *The Kiss* in marble—a complex and costly enterprise commissioned by the rich American collector Edward Perry Warren. A dedicated Latin scholar with an interest in archeology, Warren had moved from Boston to a manor in Sussex, Lewes House—described by Rothenstein as a monkish establishment "where women were not welcomed"—which held a superb collection of gems and Greek sculpture. After going to Paris to inspect the existing marble of *The Kiss*, Warren agreed to pay a total of £1,000—then 25,000 francs—for another one, which was to be carved in accordance with a detailed set of specifications that included:

M. Rodin is to choose the marble.
The genital organ of the man is to be represented in its entirety.*
The work is not to take longer than eighteen months.

Rodin, who judged correctly that "your archeologist is not an ordinary man," explained that one could never be sure of marble and that accidents happen: the first marble *Baiser*, for example, had a patch in the back to cover up a fault, though in other respects it was a superb piece of carving by the expert Jean Turcan. Accordingly, he persuaded Warren to spend 5,000 francs—three times as much as usual—for a block of the finest Pentelican marble. A firm of dealers in marble, Henraux, was commissioned to find him a special block from their quarrier at Serravezza but it took a long time to obtain a perfect block of the required size; despite the contractual deadline the full-fashioned *Kiss* was not completed until 1904. Since Turcan

*The existing marble of *The Kiss* had fudged this question. "If I could have I'd have shown the male member," Rodin explained to Rothenstein, but for reasons of propriety he had omitted it.

had died in the meantime (in desperately poor circumstances) the carving was entrusted to the sturdy Rigaud, who had executed Apollo's horses for Nancy. Warren came to Paris to see him working on the marble at an atelier in the impasse du Maine in Montparnasse, opposite Bourdelle's studio. "I was amused by Mr. Warren's appearance informally clothed in English tweeds with a Baedeker in one pocket and the *Odes* of Horace in the other," Chéruy recalled, "and during the train ride from Meudon reading his Horace like a priest would read his breviary. He was delighted with the work of Rigaud."

Will Rothenstein writes in his memoirs that his missionary activities on Rodin's behalf did not go unrewarded. "I want to do something for you in return," Rodin told him during one of his visits to France. "I have engaged the most beautiful model in Paris; you shall come and draw her":

What a charming acknowledgment from an old artist to a young one, I thought. The model was indeed beautiful. I drew her— how I longed to draw better!—under Rodin's approving eye; but his eye was shrewd as well as approving. When I asked the lovely creature—what could I do less?—to dine that evening, she promised to come, but I waited in vain; and the next day I found that Rodin knew all about it. "She shall sit for you, *mon ami*, as often as you please, but no dining! I have lost too many models that way!"

Although Rodin had good reason to complain to Rothenstein of being passed over for public commissions, there was no lack of orders from other quarters. When Puvis de Chavannes died in October 1898, Rodin was the logical choice to create the monument, and the Société Nationale formally commissioned him to produce one. His maquette was intended to pay homage to the Greek quality of Puvis's work: it combined the Puvis bust with a dreaming youth and a symbolic apple tree of life—but for a variety of reasons he never completed this memorial to the artist he most revered among his contemporaries.*

*For the psychological stresses and inhibitions attendant on erecting a monument to a father figure, see Theodor Reik's *The Haunting Melody* (New York, 1953), which deals with Gustav Mahler's difficulties in solving a comparable problem.

Less problematic and therefore finished on time were the commissions he received from Baron Joseph Vitta, a banker and art collector who had already consulted Rodin on the design of his villa La Sapinière at Evian on Lake Geneva—an art nouveau showcase to which Falguière, Besnard, Jules Chéret and Félix Bracquemond all contributed elements of décor. "You know that I have long wanted to have a work of yours in our villa at Evian," the Baron wrote in September 1899, to inform Rodin that he had "two spaces reserved for the bas-reliefs my mother would like to commission from you." Rodin obliged him with two frontons in Estaillade stone that were installed above the doors in the vestibule of La Sapinière. Both depicted two seasons, each personified by a reclining "young woman with heavy breasts," as *Art et Décoration* described them. In the same vestibule the Baron installed two massive Rodin jardinières that held potted plants and were encircled by a playful *ronde* of Rodin's old favorites, the *génies enfants*.

Later he combined two cherubic *enfants* with a single *jeune femme aux seins lourds* in a smaller bas-relief destined for the Vittas' town house on the Champs-Elysées, a work for which the Baron was happy to pay 10,000 francs. Vitta also commissioned one of the fin-de-siècle's most extravagant pieces of applied art, a hand mirror jointly produced by Bracquemond, who created the basic design; Rodin, who supplied the bas-relief of Venus Astarte which was cast by a goldsmith as a gold plaquette in February 1900; and Alexandre Riquet, who did the elaborate enameling of the oval plique-à-jour frame.

For a few months it also looked as though Rodin might begin a new career as the director of a school. In response to the growing demand for his services as a teacher, especially among foreign art students, he had joined forces with Bourdelle and Desbois to establish an "Académie Rodin" with ateliers in the boulevard Montparnasse. Among his pupils there were such gifted young sculptors as Clara Westhoff* and Karl Albiker: the German magazine *Kunst und Künstler*

*"Rodin has started a school for sculptors and Clara Westhoff goes to it," Paula Modersohn-Becker wrote to her parents on April 13, 1900. "Yet he comes only once or twice a month to comment on the students' work; the rest of the time his assistants substitute for him." During one of these sessions Rodin told Fräulein Westhoff: *"Rien à peu-près* [Never do anything in a vague sort of way]."

predicted that his courses would soon offer serious competition to the state-supported Ecole des Beaux-Arts. It was well known that Rodin was a perceptive and immensely stimulating teacher—"Once you had seen him, once you had talked to him, you wanted to go to work right away." Yet at this point in an increasingly harried career he had few hours to spare for the school's *séances de correction* and was soon obliged to let Bourdelle take over his teaching duties.

He did, however, take the trouble to go on teaching two private *élèves* of whom he was very fond, Ottilie McLaren, from Edinburgh, and a young American artist from San Francisco, Sarah Whitney. "I never could have believed that anyone could be so good & patient & courteous & at the same time so good a teacher," Miss McLaren reported in a letter to her fiancé, William Wallace, in July 1899, not long after she began studying with Rodin:

> Smaller men try to make a mystery of their work & pretend there is nothing in it that can be taught, but there's a very great deal that can be taught if there is someone who has the power to teach. Of course I don't suppose Rodin would bother with anyone whom he did not consider had something of the artist in them & everyone admits that there is only a certain amount which can be taught. He is so simple & makes no mystery about the thing. He chooses the simplest language to express himself in, but the wonderful thing is that what he says to one as a rule applies to everything & not just to the particular piece of work in hand. . . . Another thing I like so much is that when he is talking of individual things—our drawings for instance— he will always show you what he *does* like about a thing, which is a very much more difficult thing to do than to say what one doesn't like & infinitely more helpful.

The young women worked in their own studio and brought their drawings or sculptures once a week to the Dépôt des Marbres. Sometimes he was too busy for a formal lesson, but he would try to give them a careful critique even if it meant putting off a dinner engagement. One day Ottilie went to see him with her work just as it was getting dark—and the Dépôt had neither gaslight nor electric illumination: "He asked the guardian if he could get him a light of some

kind & the only thing he could get was a sort of Shaker lantern . . . a sort of glass thing with a wire cage & handle. So we set it on a table & we sat round in a circle & looked at my work & the long and the short of it is that I had two excellent drawings and another head to cast in bronze."

Ottilie noted that the reason he took so much trouble with her and Sarah (as well as a Russian girl named Posbolska) was that "he feels he is getting old & his one idea is to leave a few pupils of any nationality who understand his ideas & who will continue the work he has begun. He looks on all his pupils simply as disciples of his creed who will in turn teach others so that work will not cease with his death. He has told us all this at various times."

He taught them to take their compositions from nature—"We don't want ideas we only want nature and she is always there if one looks the right way." Ottilie wrote in January 1900 that she had already heard him expound this theory, "but I never could see it before. People laugh & say it is all very well for him to say so when all his work is teeming with ideas! but I can see now (though dimly) what he means. Rodin in talking of the necessity of being in touch with nature to produce works of art said something which interested me very much & which perhaps accounts for his interest in his female pupils. He said that he thought women were as a rule much nearer to nature than men. He puts it down to the fact of the education of men for generations."

At that moment Rodin had little time for anything except the risky, ambitious undertaking that absorbed virtually all his energies for more than a year, beginning with the summer of 1899—the erection and management of a "Rodin Pavilion" at the Exposition Universelle of 1900. Paris had decided to usher in the new century by building an even more imposing world's fair where the exhibition of 1889 had stood, on the esplanade des Invalides and the Champ-de-Mars. A great white city of temporary structures in a wild mélange of exotic styles was going up on the banks of the Seine. The best of contemporary architecture was embodied in several permanent new buildings: the Grand Palais and Petit Palais, designed to serve as the fine arts core of the exhibition, and the Gare d'Orsay, Victor Laloux's steel-and-glass railway station built on the site once intended for the unrealized museum for which the *Gates of Hell* had been commis-

sioned. Now the *Porte* itself was to become one of the great sights of the exhibition: Rodin, alone among the world's artists, was to have a pavilion all to himself. Though not officially a part of the Exposition, it was to stand on public land as a municipal concession immediately adjoining one of the busiest squares in the exhibition district, the place de l'Alma.

Eugène Druet later claimed that he was the first to suggest that Rodin "show the whole world" his gigantic oeuvre. But in the sculptor's newspaper interviews during the summer of 1899 he said merely that after his successful experiences with the Brussels exhibition he now had the idea of "assembling all my work and presenting it to the public." The land on which he had set his sights was a triangular garden plot bordered by tall trees, where the avenue Montaigne meets the Cour-la-Reine. His proposed use of the site was endorsed both by the minister of public instruction, Georges Leygues, and his director of fine arts, Henry Roujon, on the grounds that "when M. Rodin offers us such a demonstration of his genius one should not place the least obstacle in his path."

There were strong objections, however, from members of the city council, who were reluctant to permit any one artist to use public land for private profit: "If Paris had been Italy in the time of the Borgias I should have been poisoned," Rodin said afterward. Some of the municipal authorities tried "to throw every imaginable impediment in his way," reported Léon Roger-Milès in *l'Eclair*. In the end it was Leygues, a politician-poet still in his early forties, and Paul Escudier, a councilman from Montmartre, who pushed the project through the reluctant Conseil Municipal. Rodin praised Leygues in particular as "the most charming and artistic government minister one can imagine. It seems he loves my sculpture and it is mainly to him that I am indebted for the acceptance of my proposal." It was a debt of honor that he eventually discharged in his usual princely fashion by modeling Leygues's portrait bust.

To raise the 80,000 francs required for the construction of his pavilion he drew a quarter from his own savings and borrowed 20,000 francs from each of three bankers: Joanny Peytel, Albert Kahn and Louis Dorizot. (Both Peytel and Kahn were prominent art collectors who also loaned some of their Rodin bronzes to the exhibition.) He had commissioned the prize-winning architect Louis Sortais to design

the building in accordance with his own ideas: it was to be a hexagonal Louis XVI garden house in pale yellow stucco (over reinforced concrete on a steel frame) with high, green-painted windows through which the daylight came pouring in from all sides. "For me sculpture is an outdoor art," he explained to a reporter from *le Petit-bleu*. "It is unworthy of a sculptor to produce works that should be viewed only under light that falls from a certain angle." In addition to nearly ideal lighting conditions the pavilion would give him 400 square meters of floor space in which to display his work properly: "I won't have to pile one work atop another the way they do at the annual Salon. A piece of sculpture should be surrounded by its own atmosphere; a zone of freedom that permits a visitor to examine it from all its diverse points of view."

"His work at present is chiefly mending and going over numerous works which have been shoved aside and injured," Ottilie McLaren reported on March 2, 1900. "His exhibition is going to be magnificent. He is going to show everything of his that he can lay his hands on and lots of his drawings. For the smaller works he has got a beautifully severe little antique column which he is having numerous replicas of. Anything which is not 'big' looks trivial on it but it is a beautiful setting for anything of his." The finished pavilion dazzled its visitors with its scores of white plaster casts on white bases and columns set against white walls. Through the arched windows one could see the only striking touch of color—the green of the plane trees just outside.

A few days before the formal opening on June 1, 1900, he asked Ottilie and Sarah to help him hang drawings and address invitations to the reception. "We have got to know Papa Rodin so well," Ottilie wrote. "It is nice wandering about among his men & receiving his orders & being 'in it.' Then whenever he wants to rest a few minutes he comes & sits down beside us & watches us work & wonders at how quick & systematically we go." The opening was a huge success: "It was a horrid wet afternoon but people came all the same. It was so nice for they didn't come to see each other & show themselves off as is generally the case at these functions, but they came to see his work & see it intelligently. It was nice to see the enthusiasm & dear old Rodin looked really happy & serene for the first time since I have known him."

Rodin's pavilion stood not far from the Grand Palais, which housed

the two official exhibitions of French nineteenth-century art. The Centennale, directed by Roger Marx, contained highlights of the years 1800–1889, while the Décennale, selected by a committee of Academicians, covered the last decade of the century. The Décennale revealed its prejudices only too clearly—twenty-three rooms full of pictures without a single Impressionist or Post-Impressionist; the only Rodin on view was the marble *Kiss*. Marx had been more evenhanded with his selection, which included M⸻, Monet, Renoir and Pissarro, as well as ⸻ ⸻ ures.

⸻ ⸻ sented at all had ⸻ ⸻ on." The resulting re⸻ ⸻ g display of what one man had accompli⸻ ⸻ his two hands in forty years of hard work. No one, including Rodin himself, had ever seen so many of his sculptures assembled in one place. The catalogue of the exhibition lists 165 sculptures large and small, including most of his major works— though some of them appeared in unfamiliar versions, such as an armless, headless *Saint Jean*. The *Balzac* occupied a prominent place: this time Jules Renard saw it as "an act of defiance, a challenge to other men." Many of the embracing couples were disturbingly erotic even for the literati. "There are breasts that melt in the lover's hand," Renard noted with interest, and he was struck by "*les Amants* turning one on top of the other as if to say, 'How shall we take each other so as to make love as no one has ever made love before?' "

The catalogue had Carrière's lithograph of Rodin sculpting *l'Eternelle Idole* on the cover and Falguière's bust of Rodin as a frontispiece. The introduction, by Arsène Alexandre, compared Rodin to Wagner, and there were testimonial letters from Besnard, J. P. Laurens, Monet and Carrière. Admission to the exhibition was free on Sundays and cost a modest one franc on weekdays—except on Fridays, when Rodin charged five francs and received visitors in person. Yet he was "very much averse to anything savouring of '*réclame*' [advertising]" and the general public paid little attention to this "Rodin Museum." While tens of thousands crowded into the fair's tribal villages, music halls and belly-dance café, Coquiot noted, "the Rodin desert" remained conspicuously underpopulated. Perhaps "empty" was too strong a word; Gabriel Mourey preferred to describe the Pavilion as "a refuge of silence and pure beauty."

[410]

In mid-July the more plain spoken Jean Lorrain reported that "there's not even a cat at the avenue Montaigne. . . . It's the solitude, the terrible solitude of the proscribed. The great man complains about it but he is a brave man and it's charming to watch how he consoles himself: 'I don't attract quantity but I do get quality. Yesterday, for instance, Countess Potocka came to see me, and the poet Oscar Wilde.'" The latter, already on the verge of "dying, as I have lived, beyond my means," wrote to his friend Robert Ross that the visit had been quite wonderful. "Rodin has a pavilion to himself and showed me anew all his great dreams in marble. He is by far the greatest poet in France, and has, as I was glad to tell myself, completely outshone Victor Hugo."

Plainly the real significance of Rodin's retrospective lay not in its attendance figures but in its impact on artists and writers outside his usual circle. It was only now, in 1900, that "Paris, Europe and America awoke to [Rodin's] haunting visions," as the New York critic James Gibbons Huneker put it. Confronted by the sight of this extraordinary array of white sculptures the Austrian critic and playwright Hermann Bahr decided that Rodin was the "ruthless giant" and "necessary barbarian" whose destiny it was to capture the zeitgeist of a difficult age: "A few foreign visitors open their eyes wide in shocked astonishment and take to their heels. But one also sees young men who are completely overwhelmed and in a fever of excitement; who can hardly tear themselves away. Perhaps no other artist has ever fanaticized people to such an extent: he has only deadly enemies or apostles."

Among the young enthusiasts was a group of Belgian artists who took the train to Paris several times that summer not to see the rest of the fair, as Gustave Fuss-Amoré reported, "but to immerse themselves in that one small enclave where they could contemplate the work of Rodin." The young Gutzon Borglum—future sculptor of the colossal American presidents on Mount Rushmore—was typical of the Americans who sought out "the greatest man in modern art" in his private pavilion. "He was not in when I called," Borglum remembered, "and after a hasty look around I left to find him in a nearby restaurant to which he had gone. I shall never forget my first meeting. Of course I should have awaited his return, but I sought him with the eagerness of a lost child for its father."

He had left the restaurant and stood at the end of the bridge just to the left of his exhibition building. I almost stormed him—pushed into his hand the ticket of introduction. "Ah," he said, "so you—have seen . . ." "Yes," I replied, now quite ashamed of my haste. But I stared. He was rather short, of middle size, turning a bit gray, a strong, rich, nut-brown beard and hair. He wore a light, thin suit; it was hot. Then he asked me into the atelier. There were no formalities. He treated me at once as a friend and as one in complete sympathy with his art.

The visitors included Russians, Japanese, Swiss, Italians and far more Germans than ever before, since the German Reich was officially represented at a Paris fair for the first time since the Franco-Prussian War. The German elite had known about him by reputation for some time, and Rodin found himself besieged by aristocrats like Sophie von Beneckendorff und von Hindenburg, daughter of the German ambassador Prince Münster von Derneburg. Sophie's husband was a Prussian general—a first cousin of Paul von Hindenburg, who was to become a field marshal and the last pre-Hitler president of Germany. She was accompanied by her twenty-one-year-old daughter Helene, who took one look and found herself undergoing a sort of mystical experience: "We gazed at the two embracing figures around which the universe seemed to revolve, *Amour et Printemps*.* And then something strange happened to me. Waves of light seemed to envelop the marble. For the first time in my life I was so deeply affected by a piece of sculpture that my eyes filled with tears."

Suddenly Rodin came up behind her. "He must have felt that his work had given me an extraordinary experience," Helene writes in her memoirs. He said little then, but when she returned the next day "he quietly gave me a small pink rose he had picked in Meudon." A few days later mother and daughter were invited to visit him at the Villa des Brillants. Afterward there were some pro forma letters to the mother but it was clear he had taken a fancy to the daughter. On

*The catalogue lists no such title. Perhaps she meant *Amour et Psyché*, a title that appears twice in the supplement. But Rodin tended to make up new titles when speaking about his works.

July 6 he wrote to the *Chère et honorée Demoiselle* concerning the group of angel-like figures he called *les Bénédictions*—the first of many high-flown letters in what was to be his most ethereal correspondence: "*les Bénédictions* are lovely intermediaries, not yet of the sky and still of the dear earth. They come from afar, adorned with grace; they support the poet."

He had spent a good deal of time showing the ladies his plaster sketches, his "*idées modelées*," and had listened raptly to Helene's comments. "You have transfigured them," he told her. "If they were beautiful before you have made them more beautiful; if formerly they stammered, now they speak of life." Perhaps it was her cool German beauty or her social position—as well as the watchful presence of Sophie von Hindenburg—that prevented him from hazarding a more than literary flirtation with this young woman, with whom he was soon on the best of terms though he did not so much as try to kiss her for several years.

There were other attractive women visitors with whom he was rather less inhibited. The American dancer Isadora Duncan was the same age as Helene; at the Rodin Pavilion she found herself standing "in awe before the work of the great master," and since she was in the habit of translating her enthusiasms into action she eventually went to beard the lion in his den at the Dépôt des Marbres. "My pilgrimage to Rodin resembled that of Psyche seeking the God Pan in his grotto," she writes in her memoirs, "only I was not asking the way to Eros but to Apollo":

> He showed his works with the simplicity of the very great. Sometimes he murmured the names of his statues, but one felt that names meant little to him. He ran his hands over them and caressed them. I remember thinking that beneath his hands the marble seemed to flow like molten lead.* Finally he took a small quantity of clay and pressed it between his palms. He breathed hard as he did so. The heat streamed from him like a radiant furnace. In a few moments he had formed a woman's breast that palpitated beneath his fingers.

*Paul Margueritte had a similar impression when he saw Rodin at work in his studio a year or so earlier: "He creates life. It flows from his fingers like a river."

Rodin wanted to see her dance. He took Isadora by the hand; a cab drove them to her studio where she changed into her tunic and danced "an idyll of Theocritus" for him. When she stopped she tried to explain her theories for a new dance, "but soon I realized he was not listening":

He gazed at me with lowered lids, his eyes blazing, and then, with the same expression that he had before his works, he came toward me. He ran his hands over my neck, breast, stroked my arms and ran his hands over my hips, my bare legs and feet. He began to knead my whole body as if it were clay, while from him emanated heat that scorched and melted me. My whole desire was to yield to him my entire being and, indeed, I would have done so if it had not been that my absurd up-bringing caused me to become frightened and I withdrew, threw my dress over my tunic and sent him away bewildered. What a pity! How often have I regretted this childish miscomprehension which lost to me the divine chance of giving my virginity to the Great God Pan himself, to the Mighty Rodin. Surely Art and all Life would have been richer thereby!

They did not see each other again until two years later, when she returned to Paris from Berlin and the embarrassment was forgotten: "Afterwards, for years, he was my friend and master." Meanwhile, despite an occasional contretemps of this kind, the exhibition season of 1900 passed pleasantly enough. Though the masses stayed away, the cognoscenti were more willing than ever to demonstrate their admiration for the once-anonymous sculptor who had become a kind of national monument. *La Plume* published a Rodin *Numéro Exceptionnel* in six installments and held another banquet in his honor on June 11, at the Café Voltaire in the place de l'Odéon. It was attended by more than 120 luminaries; Karl Boès—who had become editor of *la Plume* following Deschamp's death in 1899—proposed the evening's principal toast to "the brother in glory of our great Puvis de Chavannes," and "one of those who prevent tired nations from despairing of themselves."

In the special issue there were articles on many aspects of Rodin's art, including a translation of Harris's essay on the *Balzac*. Though

two years had passed since the furor at the Champ-de-Mars, it was still the *Balzac* that most of his admirers came to see at the Pavilion and talked about afterward. Yet Rodin himself repeatedly singled out the *Porte de l'Enfer* as the focal point of his exhibition. He had gone back to work on it intensively two years before, when the *Porte* studio at the Dépôt des Marbres was once more cluttered with disassembled pieces. "Everywhere, on tables, the floor, on plinths, on modeling stands, there are pieces in preparation, casts of arms, torsos, legs, heads, fragments of his works," reported Léon Maillard. "He works on it constantly and hopes to have it in its definitive state for the exhibition of 1900." Rodin also showed the Gates to Krohg in their disassembled state: "There were pencil strokes and inscriptions on it. On one empty spot he had written the word *draperies*. 'These are corrections,' he said. 'I shall correct it with plaster.' "

In March 1900 Rodin told Serge Basset of *le Matin*, "My *Porte* is now more or less finished. Apart from a few details all will be ready for the Exposition." Yet once again this was merely wishful thinking, for he could not make up his mind to finish it.* The Gates were taken apart and reassembled in the Pavilion but minus the figures in high relief. "M. Rodin was obliged to remove most of the figures since their darker tint failed to harmonize with the whiteness of the [rest of the] plaster," explained *l'Art décoratif.* Yet for admirers of the *Porte* the effect was still electrifying. "Even in its present state," wrote Anatole France in *le Figaro*, "with its panels shorn of the figures in high relief that belong on them, it is a work of profound meaning and powerful expression. I know of nothing more moving":

> The evil spirits who torment these men and women are their own passions, loves, hatreds; their flesh and their thoughts. . . . Without trying to delve too deeply into what this sublime work-man wanted to say, it is impossible not to recognize the sense of pain and tragedy in this work of a master who knows how to convey with incomparable power the touching weariness of flesh ceaselessly worked upon by movement and incessantly devoured by life. I am deeply touched to discover that Rodin's

*The *Porte* remained unfinished at Rodin's death. The bronze Gates now owned by several museums are posthumous casts based on a reconstruction of Rodin's intentions.

hell is no longer an *Inferno* of retribution; it is an *Enfer* of tenderness and pity.

In conjunction with the giant *Porte* Rodin displayed a small model, *la Tour du Travail* (Monument to Labor), which created the impression that he was about to embark on another major project—a sort of "epilogue" to the Gates, as Frederick Lawton called it. The tower had been designed in 1898: it consisted of a massive central shaft covered with bas-reliefs, with a staircase winding around it from base to summit. The structure as a whole rested on an ornamental crypt and was intended, as Rodin wrote in a prospectus, "for the glorification of work." The sculptures on the shaft were to represent successive stages of mankind's progress and redemption through human labor:

> The bas-reliefs covering the frieze of the crypt depict the underground labors of miners and divers. On either side of the platform above the crypt rise the statues of Day and Night, symbols of the eternity of work. The ascent begins: a stairway winds around the column, accompanying the succession of bas-reliefs—a spiral without end, like progress. Loggias allow air and light to stream through on every side and permit the sculptures to be seen. The bas-reliefs that circle the shaft represent workers at their occupations, dressed in costumes of the period—from the masons, blacksmiths and carpenters to the artists, poets, philosophers. A sheaf of corn forms the top of the column, on which have alighted *les Bénédictions*, two winged genii who descend from heaven like a beneficent rain to bless the labors of mankind.

There were eight turns around the column, and "each higher stage shows processes more and more freed from primitive material bondage," as Rodin explained. The plaster model bore an inscription indicating that his intention had been "to combine the beehive with the lighthouse." The whole curious notion had been proposed some years earlier by Armand Dayot, an art historian and inspector general of Beaux-Arts who envisaged a "glorification of human toil" as the capstone of a century of progress. Since it seemed too vast an un-

dertaking for any one artist he hoped to get several sculptors to collaborate on it but soon realized that this would raise formidable questions of precedence. "Self-denial is a virtue not much practiced by modern artists," commented Gabriel Mourey when he discussed Dayot's efforts in *l'Echo de Paris*; the obstacles seemed insuperable.

Rodin, however, had been much taken by the idea and "felt it germinating within him," as Mourey reported, eventually arriving at a solution that combined a tower with bas-reliefs. He had been inspired by Trajan's Column, he told an English visitor, Ernest Beckett: "Why not put the Column of Trajan into the Tower of Pisa?" It was a spiral-staircase design foreshadowing the snail principle of Frank Lloyd Wright's Guggenheim Museum. He had a scale model built in hopes that the government would commission him to execute it—a golden opportunity, Mourey thought, to "demonstrate that a great artist need not have great ideas in vain." If the ministry would find the money, Rodin would decorate the Tower "with the help of a group of artists chosen by himself" who would work "like an orchestra of sculptors performing under his baton," as Gustave Kahn put it. It was to be a collective masterpiece. "After the isolation into which he had been forced by the Academy," Kahn noted, "it would be splendid to appear as the commanding general of an army of talented artists, with Bourdelle and Despiau at their head—all the non-academic sculptors collaborating with him on a monument!"

His potential co-workers were less enchanted. Jules Dalou, for one, refused to hear of it. "He says that for nine years he has worked at this scheme himself and is opposed to its being the work of several artists," reported Charles Quentin in July 1898. Dalou, indeed, had long wanted to do a *Monument aux Ouvriers*—significantly, his was to be dedicated "to the workers" rather than "to work." Rodin, however, preferred to credit Meunier's sculptures of miners and workmen with having furnished the precedent for his *Tour*.

Rodin roughed out his tower—despite the costumes mentioned in the prospectus, the figures on the maquette were nude, not clothed— and then proceeded to entertain impossibly high hopes for it. "Erected in some spacious square—the Champ-de-Mars, for instance—where it might with advantage replace the Eiffel Tower, an elevation of a hundred yards would be possible," Lawton wrote, recording an ambition that verged on the idiotic. Paris was not about to tear down

the Eiffel Tower and replace it with what one critic described as "a hastily invented series of workmen niched in a ridiculous tower." Later there were periodic reports in the press that someone in a foreign land would provide the money to erect it—America was the favorite venue, though Germany was also mentioned. But the "epilogue" to the *Porte* remained a sketch; the only two figures to be completed were *les Bénédictions*, and they may well have had an independent existence before being assigned to the *Tour*. "No one has ordered it," Rodin sighed when Anna Seaton-Schmidt interviewed him in 1905. "I had hoped [Andrew] Carnegie might when he came to Paris last summer, but his wife was taken ill and he could not get to Meudon."

The majority of visitors to his exhibition paid little attention to the monument maquettes in any case; apart from the *Balzac* it was the sensualist sculpture they came to see, and there were vast quantities of it. Lawton, who wrote two lengthy accounts of the Pavilion and its contents, reports that even those who knew his work best were taken aback when they saw it concentrated in one spot for the first time: "The amount of it was overpowering, the variety seemed to be infinite and the execution such that each piece was worthy of study." He was struck by the fascinating range of nude female figures, standing, sitting, prone or prostrate, "some leaning or bending, some squatting or cowering," but all in postures indicative of "mind agitation." Among the single male figures, which were in the minority, *The Prodigal Son* made the strongest impression: "Kneeling and suppliant, the arms flung aloft and the face straining upward, it presented a most pathetic picture of deep contrition and ardent yearning for forgiveness." But above all it was the whole panorama of amorous groups that provided viewers with frissons of fin-de-siècle sexuality. Some showed only women, "sirens mingling with the waves, chaste Graces, careless nymphs or woebegone light o' loves:"

But in most of them the two sexes were represented, with an additional interest supplied by the relation of one to the other. Here it was love's dalliance—*A Dryad and a Faun*—there, love's fiercer desire—*A Satyr Struggling with a Maiden.* Novel in conception and powerfully executed, the *Flight of Love* bore a couple through the air back to back. Elsewhere, *Saint Anthony*

on his knees strove to hide himself with his mantle from a fair temptress that stooped over him. Nor did the love myths of *Venus and Adonis* and *Daphnis and Lycenion* lack their sculptural presentment. Legends of another order were also interpreted. *Niobe and Her Children, Vulcan and Pandora,* and *Perseus and Medusa*, the last group exhibiting the hero just as he has cut off and holds on high the Gorgon's head. And there were gentler themes. A *Mother and Her Babe*, with a grotto to enclose them, and an *Elder Sister with a Tiny Brother Clinging to Her*, nude forms of surpassing loveliness. . . . Lastly, there were treatments—the *Hand of God*, and *Man and His Thought*, for instance—from which one saw that the sculptor would now and again begin his modelling without any distinct notion of what he was going to produce, his *Demon* prompting him but not revealing the goal of arrival. . . . The whole was a weird, plastic rendering of the mind's mystery.

The Exposition Universelle closed its gates on the 12th of November, having sold more than fifty million tickets in the space of six months. Rodin received an insultingly curt notice to vacate his temporary premises within four days; as Mirbeau pointed out, it was just another pretext for the Paris bureaucrats to vent their spleen on the city's best-known artist. Of course Rodin had no intention of letting his expensive pavilion go to waste. It was taken down and reassembled in Meudon as a *musée*-studio in the garden of his house.* It had, indeed, amply served its purpose. After the 1900 Exhibition the sculptor was firmly established as a Paris landmark "rivaling the Eiffel Tower." His retrospective had demonstrated conclusively that, as Huneker put it, "Rodin makes the fourth of that group of nineteenth-century artists—Richard Wagner, Henrik Ibsen, Edouard Manet—who taught a deaf, dumb and blind world to hear, see, think, and feel."

He had even confounded the pessimists who predicted financial disaster for "the Rodin desert." Despite disappointing ticket sales—and a bitter quarrel with Druet, who held the photographic conces-

*It was torn down after his death on instructions from the Musée Rodin's second curator, Georges Grappe.

sion—Rodin had every reason to be satisfied with the results. "I must tell you," he wrote to Bigand-Kaire, "that the moral outcome of my exhibition is very fine and that financially I shall cover my expenses. I have sold 200,000 francs' worth and I hope even a bit more. And some commissions as well. Nearly all the museums bought from me: Philadelphia, *la Pensée*; Copenhagen, 80,000 francs' worth for a room to myself in their gallery; Hamburg, Dresden, Budapest, etc. . . . Not many Americans, not many English, but a great many Germans at my exhibition. So you see how things always turn out different than one expects. Entrance fees, on which I was relying, were not numerous, but there were many purchases. Of the 200,000, I deduct one-third for costs, marble, bronze; I have 140,000 left, and my other expenses were 150,000. So I am well content, and that is the news I have for you my friend; I hope to see something of you. —Aug. Rodin."

14

LIBERATION

*I wonder what made Rodin put a woman
in that position?*

—GEORGE MOORE
Memoirs of My Dead Life

Though he was still subject to periodic attacks of anemia and fatigue, Rodin could write to Robert de Montesquiou in June 1901: "I am in a happier period—it heralds my liberation." It was a happier time because, for one thing, he was surrounded by a widening circle of appreciative young women who had, like Helene and Isadora, experienced a sort of satori at the Rodin Pavilion. The most intriguing of these new admirers was Jelka Rosen, a moody young painter in her early thirties and "strikingly fair . . . fresh and winsome," as Sir Thomas Beecham later remembered her. "She had an undeniable gift for painting, impressionistic naturally, was well read, fond of music and . . . could sing a little, her favourite composer being Grieg."

She had fallen in love with his work at the Exhibition and had visited his studio with another woman painter, Ida Gerhardi. "We are so happy, my friend and I, enveloped by your work's intoxicating atmosphere of beauty," Jelka wrote to Rodin in October 1900. "It gives me courage to go on struggling and searching, and raises me above all the petty miseries that oppress me." Jelka's father came from a distinguished north German family; her mother was the daugh-

ter of Ignaz Moscheles, a noted pianist-composer who had settled in London during the 1820s. She owned an old stone house in the village of Grez-sur-Loing, near Fontainebleau, and in December she sent Rodin the last leaf that had fallen from the ivy that wreathed the window of her guest room: it was intended as a reminder that "the room is always ready to receive you. How happy I would be if you were to come here for a little repose. But the season is bleak—here you will find only my friend and myself, a very simple welcome, our infinite devotion to you and the beauties of nature."

Rodin agreed to come but for the present he was too busy to go in search of "*la fleur mystique de l'amitié.*" Meanwhile, the remedy for petty miseries was work. "Let us work. Thus we are united. . . ." Jelka was not ready to give up so easily: "I think of you so much— it makes me unhappy to see you so tormented by a thousand disagreeable matters and to be unable to do anything about it. I wish I could surround you with a magnetism so strong as to ward off all these worries. I live here in absolute solitude; there is only an old Breton woman who looks after me. In the great silence of this huge empty house and the tranquil, dormant garden I feel myself smaller than ever."

Even this tempting invitation was not enough to bring Rodin to Grez in the middle of winter. But he read her letter "with great joy" and decided she was a poetess, really. "Am I your brother?—Perhaps, if my age didn't place too great a distance between us." She was certain that his age would not come between them. "Yes, be my brother! You will always be young! And the youth that springs from an intense, creative soul; from observing nature and constantly interpreting beauty—this youth, isn't it a thousand times more beautiful than that which adorns us poor mortals for an instant and soon departs?"

She treasured his letters; he kept one of hers in his wallet "in order to read it several times over." When time passed and he had still not fulfilled his promise to come and see her she went to visit him: Paris, after all, was only an hour and a half away by train. This time she felt even more enchanted by his presence, and like many young artists she came to see him in a roseate frame of reverence. "In my heart I still hear the continual noise of the hammers of the young assistants in your studio," she wrote on March 20, 1901. "The

noise intoxicates me and you become the Good Lord who created and inseminated all this so that only obedient effort was needed to cut into stone the work that loomed large around us. And I was so close to you that I felt God-like during these sublime moments."

She sent him violets in April and he agreed to come to Grez—but kept putting it off because he was "in poor health" as well as "prey to my worries." She scolded him, which she must have known instinctively was the best way to win his affection. "Of all hands, mine would be the gentlest upon your brow of genius—it would know how to calm and soothe your torments. My dear, you see I am not modest; I am the *amie* who understands and who has seen pain, and wants only to give joy and tranquillity to souls that are beautiful."

Toward the end of April, however, her tone became less insistent and a new factor suddenly entered the equation. "Could I tempt you," she wrote tactfully, "by telling you that there is a musician here, very *artiste* and a fervent admirer of your art, a great enthusiast of your *Balzac*, who would be very, very happy to make your acquaintance?" The musician was Frederick Delius, with whom Jelka had been living off and on for several years, and who had just returned from an extended visit to Germany. His presence in the house at Grez made it a good deal less empty than it had been in February, and when Rodin finally arrived on June 9, Jelka was evidently less forthcoming than her letters had led him to expect. "I am a little ashamed of my egotism which has prevented me from doing *more* for your happiness," she apologized afterward, but by now he was used to well-bred young ladies who aroused his hopes without requiting them. He stayed for only two days—a visit to Octave and Alice Mirbeau in nearby Veneux was also on the agenda—but for Jelka they were unforgettable days. "If only you knew how I drank with an ardent heart what I had so much thirsted for—your words so true and grand, the beauty of everything seen through your eyes, your infinite tenderness. The joy of you shines and sings in my heart. . . ."

One result of Rodin's stay at Grez was that he became acquainted with Nietzsche: Jelka had evidently given him the French translation of *Also sprach Zarathustra*, to parts of which Delius was then composing *A Mass of Life*. "I am still reading Nitsche [*sic*]," Rodin reported a month later, "and I find him a man of genius, often obscure

but sometimes one understands him. I envy you for having arrived at his level. Write me!" She went to see him again and he gave her "a lovely little fête" for which she was duly grateful: "What a joy it was to listen to you and look at your handsome, noble features." But the wind had gone out of their correspondence. Henceforth Jelka was to be useful to Rodin mainly as an errand lady in his business dealings with the German collector Karl-Ernst Osthaus, then busy assembling a notable collection of modern art for the Folkwang Museum in Hagen. And on September 14, 1903, she wrote to Rodin, shyly: "I've spent some weeks in Holland, mainly at the seaside. . . . I was with my friend Delius, and now we are going to be married on the 25th of this month. I am a little apprehensive of the ceremony at the town hall in Grez, but undoubtedly one must learn to be ridiculous gracefully."* Rodin sent them his blessing—"I congratulate you. . . . It's the ancient custom, and there ought to be a consecration of your union"—which sounded all the more curious coming from someone who had always refrained from subscribing to the custom himself.

Fortunately not all the young women he knew were as Nietzschean and ethereal as Jelka. There was the earthy Scottish sculptress Kathleen Bruce, "unquestionably his best woman pupil" of the time, at least according to Aleister Crowley, who was in love with her. Crowley wrote reams of bad poetry for and about her in which their adventures—"Whip, whip me till I burn! Whip on! Whip on!"—are interlarded with their admiration for Rodin's sculpture:

> But—oh! these nudes of Rodin! I
> Drag one more linnet from its perch
> That sang to us, and sang a lie.
> Did Rodin strip the clothes, and find
> A naked truth fast underneath?
> . . . So did I pry beneath the robe. . . .

In Crowley's *Confessions* Kathleen Bruce is remembered as a woman whose "brilliant beauty and wholesome Highland flamboyance were

*Delius, equally apologetic, wrote to Grieg that they "found it really more practical to legalize our relationship—get everything cheaper & one gets free and without further ado a certificate of respectability & good morals. . . ."

complicated with a sinister perversity. . . . She initiated me into the torturing pleasures of algolagny on the spiritual plane."* In her own memoirs she mentions none of this but does write affectionately of Rodin, whom she got to know when she came to Paris as a student in 1901, "before that grand old sculptor's executive powers began to wane." He gave her pointers in sculpture and they became fast friends: "I delighted in my friendship with this old man and kept very quiet about it." She found him hard to follow when he spoke to her, "but he wrote me letters that I understood well and cherished. He would flatter me and my work. He would call me '*Un petit morceau grec d'un chef-d'oeuvre*,' and I would look at my stalwart arms and legs and not feel at all fragmentary. But I looked for the days when I was allowed to lunch with him at Meudon and watch him work":

> . . . I would walk often with him round his studio, and he would open small drawers, such as one is used to find birds' eggs in, and show dozens and dozens of exquisitely modelled little hands or feet, tiny things, of a delicious delicacy to compare with the grand rough *Penseur* or his *Bourgeois de Calais*. He would pick them up tenderly one by one and then turn them about and lay them back. Sometimes he would unwrap from its damp cloth, generally an old shirt, his latest work, and, spreading out his hands to it in uncritical ecstasy, exclaim "*Est-ce beau, ça? Est-ce beau?*" Sometimes he would call a model to pose for him, and taking pencil and water-colours would hastily draw. I would watch in amazement to see him draw, never taking his eye off the model, never looking at all at his paper. Sometimes he signed one and wrote my name on it and gave it to me.

*Crowley: "She took delight in getting married men away from their wives, and the like. Love had no savour for her unless she was causing ruin or unhappiness to others." She saw the problem from a different perspective: "Schopenhauer says somewhere 'that in the overcoming of obstacles one feels the full delight in existence,' " she wrote a decade later in the diary she kept for her first husband, the Antarctic explorer Captain Robert Falcon Scott. "Do you like me for knowing that? And what lots you will have overcome if you read this, if you ever do." In fact, Scott perished before he had an opportunity to read her diaries. Cf. "Self-Portrait of an Artist," by Lady Kennet (Kathleen, Lady Scott; London, 1949).

One day Rodin invited himself to lunch at her studio. "I thought that would be grand fun, but funds were at their lowest ebb, and I was a rotten cook." She improvised a lunch table from two wooden boxes, fried some eggs and put some fresh pomegranates on the table, hoping that he would not be too hungry and that he would be content to eat bread and cheese. "He did, but he also ate a pomegranate. Suddenly I became aware that he appeared to be eating the pomegranate, hard pips and all. Anxiously I watched. No pips appeared. This was dreadful." Could he be swallowing the seeds? She was deeply concerned but too polite to say anything. "Long after lunch I saw in a looking-glass the old man hastily approach my open window and rid himself of the million seeds. But for his beard he could never have kept up such good manners for half an hour!"

Apart from these occasional sorties into the still-fascinating world of pretty models and complaisant art students, Rodin had become a stay-at-home, preferring to spend his nights and weekends at the Villa des Brillants. "He lived a double life," Alexandra Thaulow writes in her memoirs. She and her husband Frits had become close friends of Rodin and Rose. "When he arrived home in the evenings, tired of work and people, he enjoyed the peace and quiet which reigned in the simple rooms where there were hardly any chairs to sit on."

Rose spent her life in Meudon, far from the bustle of Paris. "She had remained the simple human being she had always been, and had not been able to follow or comprehend the radical process of change that had led to his great fame. When he brought strangers home with him she would muster them with a quick, suspicious glance. I had won her confidence on our first visit by entering the kitchen at once, seating myself on the threshold in order to help her shell the peas for our dinner." Rose's main diversions were her tame monkey and her parrot. For years she did all the housework herself, and when guests came for dinner she waited at table and could not be induced to sit down with them. In public she always addressed her companion as "Monsieur Rodin." The sculptor did not object to the arrangement: he rarely introduced anyone to Rose in any case. "Mme Rodin seemed no different from the ordinary old woman whom one sees attached to most French households," an American journalist reported a few years later. "There is always a 'Marie' or a 'Hortense'—usually aged—in

every family. One day, when some friends were dining with Rodin, one of them said to him in confidence: 'Monsieur, why don't you get rid of that terrible old woman who prowls about the place? What you need is a fresh young housekeeper, who would make your life worth living.' "

Rodin enjoyed the joke immensely, though if Rose overheard the remark she would not have been amused. The same observer noted that apart from nursing him and keeping his health in order she seemed to "hold no place in the great sculptor's life other than that of general household drudge." Indeed, days went by "during which neither speaks a word to the other, saving to mention what is wanted for the dinner."

The Italian writer Ugo Ojetti came away from Meudon in 1900 with a vivid impression of the imperious manner in which Rodin clapped his hands and summoned her: "Rose, Rose, you've forgotten our lunch!"

At the top of the stairs there appeared a spare, unkempt, per-spiring old woman, all nose. She too was in slippers, and had the sleeves of her blouse turned up. She held up two bottles of wine to defend herself from the reproof. Under one arm she was carrying the folded tablecloth. She came down and set the table. "*Vite, vite,*" Rodin repeated harshly. The lunch, washed down with iced claret, was savoury and abundant: an omelet like the sun, a beefsteak large as a flag. That good little old woman, standing up, her hands on her hips, watched us eat, pleased by our appetite, if not by our talk which left the food cooling in our plates; but she watched over us, and often with a corner of her napkin which she held in her right hand she chased away a fly. . . . After the coffee, Rodin poured out another glass of wine and with a regal gesture, without looking at her, said to the woman: "Rose, sit down here. You're going to drink a glass of wine with us." Rose sat down timidly, and at every swallow carefully wiped her lips.

Other observers have testified that "the very best of understand-ings" existed between Rodin and Rose, and that she was indispens-able to his existence. She would get up at half-past five every morning

to prepare his breakfast, since he rarely began the day later than six o'clock. "He dons a huge dressing gown, made of flannel, very thick in texture, which Madame has previously warmed for him." Sometimes he had taken an unfinished sculpture to the bedroom the night before so that he could begin working on it at the crack of dawn. "As soon as he is dressed his breakfast is placed on the table—he takes the usual French coffee and roll at this meal—and, even while disposing of this simple repast, he works at his modelling. He has usually on the table before him a cast of what he wishes to work at . . . and while drinking his coffee and munching his roll Rodin works, oblivious to the surrounding world. Madame attends upon him, standing a few feet away from his chair, dutifully fills his cup or replenishes his plate, and never a word is spoken between the couple."

Rodin would then work in his studio until eleven o'clock, when he returned to the dining room for a regular French workingman's breakfast. "At this meal the same reticence was observed as at the early meal, the sculptor placing before him on the table some piece of modelling or book and working while at his repast."

Despite Rose's insistence on calling him *vous* in public, in the brief letters she wrote to him when he was away she always addressed him with the familiar *tu*. It was not true that she was illiterate but writing was a chore for her, and her notes were never longer than they had to be, to keep him informed of her devotion and her numerous complaints. When she had a headache it was a *"mal de taite,"* and "I dreamed of you last night" was *"J'ais reve a toi—cette neuits."* She suffered from insomnia: *"jene dore pas tre bien."* Yet her affection and solicitude were as unbounded as ever: *"Je t'embrase de coeurs celle qui taimera toujours Mon melleurs compagnon"* ("A heartfelt kiss from her who loves you always My best companion"), or again, "I only live for your well-being"—*"je ne vie que pour ta bein."* She was often unhappy and had sundry good reasons to feel sorry for herself: *"Mon cher auguste un mots de grasse je suis si Malheureuse pour quoi,"* she wrote in an undated letter—" . . . a word from you I beg you I am so Unhappy why."

He tried to make amends by treating her to an occasional pleasure jaunt. During the summer of 1901, when the Thaulows were living at Quimperlé in Brittany, "he wrote to us that he wanted to come and visit us with his wife," as Alexandra Thaulow recalled. "He had

so often promised her that she, who had never been further from Paris than Meudon, should see the ocean."* When Rodin and Rose arrived in Brittany the Thaulows could hardly wait to learn what impression the ocean would make on someone who had never seen it. "We drove in a coach up a hill and were eagerly pointing at the horizon when the sea at last appeared before us in all its majesty. But Rose was unruffled and only asked quietly, 'Is that the ocean? Yes, I always thought it would be that way!' So our suspense was abruptly deflated."

To Rodin the wild cliffs near the port of Duellant, where the surf roared across the black stones, suggested a vivid parallel. "See the beautiful coloring of the water today," he told Christian Krohg, who had joined the party at Thaulow's suggestion. "Look at the white foam against the black cliffs. The same principle is incorporated in the costume of the Breton women. The cliffs are the black dress and the foam is the starched white linen. I think they must have got their idea this way."

>‡<

In October, Rose was left emphatically behind while Rodin went to Italy by himself: one of the reasons why he felt liberated was that he could now afford to indulge his wanderlust as often as he liked. The two Hindenburg ladies had invited him to visit them at Prince Münster's palatial villa in Ardenza, near Livorno—a fashionable spa that Byron and Shelley had frequented in their day. Helene and her mother were delighted when he stopped in "to pay my respects" at the Villa Margherita, ostensibly en route to the nearby marble quarries at Serravezza, and stayed on for more than a week. Most of this time was spent with Helene, who took him sightseeing along the Mediterranean coast.

This time the cliffs were red. "We walked along the red cliffs at the seashore, where he saw shapes and figures in the waves and the cloud formations," Helene recalled. One day they came across a red fragment that had been worn smooth by the sea. "A piece broke off, and now it looked like a human figure wrapped in a mantle with broad folds. Rodin took the stone in his hand and we recognized

*Rose had, of course, lived in Belgium with him, but it is quite possible that he had never had occasion to take her to the seaside.

Balzac; the tilt of the head, the shoulders, it was all there." He slipped the stone in his pocket, delighted with the resemblance.

They went on interminable walks together, yet somehow the relationship never progressed beyond the master-and-pupil stage. She was as eager to hear his opinions about everything as he was delighted to oblige. "I learned from him that a day could be full of greatness and dedication like a symphony," she wrote. They went to see the nearby towns, Lucca and Pisa, and trudged up the Monte Nero to visit a miracle-working shrine of the Madonna. It was better than a course in art history, Helene felt, since he always had words of wisdom that opened up new worlds for her. "The human figure is a temple and has divine forms," she remembered him saying. They saw peasant girls carrying water jugs—"Those are Greek vases," he told her. He taught her to like Perugino and Piero della Francesca but was noticeably reticent in front of pictures and sculpture: "One shouldn't try to multiply the emotions," he explained.

Sophie von Hindenburg saw to it that the evenings were filled with music: she sang "old Italian arias" and Beethoven lieder with her daughter providing the accompaniment. Helene was an accomplished pianist who played Beethoven sonatas and pieces from Gluck's *Orpheus* for their guest: sometimes he made drawings while she played. Finally, when it was time to leave, he told them by way of farewell, "*C'est la décapitation.*" Still, along with a sheaf of drawings as a house gift he left his slippers behind, prompting the superstitious chambermaid to predict that he would certainly return: "*tornera il gran artista.*"

He had, in fact, liked Ardenza well enough to come back the following year, but in the meantime there were more extended journeys—to London, Prague and Vienna—that were widely publicized and gave him his first real taste of life as a visiting celebrity. Clearly his international reputation had reached a new plateau: since the *Balzac* controversy, reported the German magazine *Die Gegenwart* in February 1901, "the whole world has become interested in Rodin"— who was now without a doubt "the most astonishing sculptor of today." Jean Lorrain said much the same thing in *le Journal* six months later. Rodin was "the most sensitive, the most thrilling of all our sculptors . . . *il est le grand artiste.*" At about the same time the critic

Henri Duhem published a booklet that began with the question, *"Aimer Rodin, pourquoi?"* and answered it with sixteen pages of reasons why he ought to be loved. By now almost anything of Rodin's was of interest to the art world. The engraver Charles Waltner persuaded him to exhibit the twenty-year-old drypoints *Bellone, Printemps* and *La Ronde* at the 1901 Salon of the Société Nationale. Even photographs of his work were considered important enough to warrant an exhibition. Eugène Druet, who had run the photo concession at the Rodin Pavilion, filled the Galerie des Artistes Modernes with scores of photographs of Rodin's oeuvre that were also on sale assembled into albums. They struck Claude Anet of the *Revue Blanche* (June 1, 1901) as a wonderful way to disseminate "the most beautiful, moving works of modern sculpture" in France and abroad.

In some circles Rodin bronzes had replaced medallions and loving cups as tokens of accomplishment or appreciation. André Antoine, for example, the distinguished director of the avant-garde Théâtre Libre, received a Rodin group as a gift from his admirers in January 1901. It was a bronze of "a man and a woman lying down," noted Jules Renard, whose *Poil de carotte* was one of Antoine's best-selling plays, but like many intellectuals he had grown indifferent to these erotic couples that now struck him as "lifeless toys"—"It seems to me I could do as well with a penknife and a carrot."

Yet there were wealthy collectors all over the world who were only too happy to buy Rodin's embracing lovers in bronze or marble—notably Dr. Max Linde of Lübeck, Germany, who had begun by ordering a bronze cast of *l'Age d'airain* and gradually built up the largest Rodin collection then in private hands. Linde, whose enthusiasm had been fired by the 1900 Pavilion, proved to be the kind of collector most artists can only dream of: a connoisseur with a keen sense of what is best in his own time. A practicing oculist with a private fortune, he owned a splendid villa which he proceeded to fill with Manet, Monet, Degas, Whistler—and pictures by his young protégé Edvard Munch, who was often invited to stay at the house. Most of Linde's sculptures were by Rodin and the Flemish artist Georg Minne: he bought Rodins systematically over a period of years— *Eve, Fugit Amor*, the *Danaïde, la Vague, la Faunesse*, the *Néréides, The Thinker* and many others.

"I thank you for having so carefully chosen the site and the proportions of the base," Rodin wrote to Linde about the marble *Eve* on July 7, 1901, "since the height and simplicity of the pedestal is a sign of taste, which few artists and architects possess. Thank you . . . you have made me very happy." Many of his letters to Linde are full of practical advice on how to place the sculpture—"put it in a decorative spot and you'll see better than anyone else if it's right"—and how to care for them: "It will be necessary to clean [the *Eve*] with pure water and a sponge and a very clean paint brush with no dye on the string around the brush."

Unlike most collectors, Linde did not forget to let the artist know what he felt about the works he had bought, and Rodin, in turn, was "touched by the feelings my sculptures give you."

> Though we live far apart we love the same things; I have always been surprised by the misunderstandings that always arise between me and many people. I thought my ideas would be shared; I see that they are not, except by those who have gone the same route as I have, and who are of the same circle. [December 17, 1900]

Among the less gratifying aspects of being world-famous was the endless drumfire of solicitations and requests to which he was exposed now that the international press regarded him as good copy and every aspiring sculptor wanted a word of praise from Rodin. Journalists from all over the world came to ask him the same questions again and again, and he gave them his stock answers with unfailing courtesy and patience. Many were surprised to find him so forthcoming. "I had taken it into my head, I scarcely know why, that Rodin was a *farouche*, something of a bear," reported Helen Zimmern in the December 1902 issue of *The Critic*. "I was therefore not a little surprised when, following the invitation of the concierge and unceremoniously pushing open the studio door . . . I was greeted with a most genial smile. . . . I felt instinctively that I was in contact with a man conscious of his own worth but free from that conceit which is the defect of smaller minds."

He was asked for opinions and testimonials on all sorts of topics

and was willing enough to oblige provided there were no political implications. When Charles Morice requested a drawing for a special Tolstoy issue of *la Plume*—France was to pay tribute to Tolstoy because under the Tsarist regime the Russians "might not have the freedom to express themselves publicly"—Rodin shot back a peremptory refusal: "I have read your several lines about Tolstoy and I demand categorically that you write to Boès and have him remove my name from that issue of *la Plume*. I admire Tolstoy and I love Russia, and detest politics. . . ."

On the other hand, when the critic Edmond Claris, also in 1901, polled a cross section of eminent artists concerning their ideas on the function of sculpture in the modern age, Rodin took the opportunity to publish a definitive statement of first principles in the *Nouvelle Revue*:

> I studied the antique, the sculpture of the Middle Ages, and returned to healthy Nature. After the first gropings I gained courage with every step, when I saw that I was in the true tradition of freedom and truth. It is I who have held fast to tradition; the Ecole des Beaux-Arts broke with it eighty years ago. I uphold the tradition of the primitives, of the Egyptians, the Greeks and the Romans. I have simply striven to copy Nature. I record her as I see her, in accordance with my temperament, my sensibility, the feelings she awakens in me. I have not attempted to transform her; I have never imposed any laws of composition upon her.*

>*<

In the English-speaking world, too, Rodin's art was now "universally recognized even by traditional critics and public as something to be

*Some critics felt that Rodin's "healthy Nature" was just a figment of his fertile imagination, a sort of jumping-off point for his fantasy. "Nature," wrote Julius Meier-Graefe, "merely affords him a means of fusing the impressions which his genius received before works of art: it is an amalgamating medium. . . . Rodin's worship of Nature is a kind of noble, unconscious modesty. 'It is honorable in an artist to be incapable of criticism,' said Nietzsche."

reckoned with," as W. C. Brownell wrote in 1901. The following spring D. S. MacColl told readers of the *Saturday Review* that it was high time for London to have a representative collection of Rodin's work: "Before the man dies, let his century see and acknowledge the giant it has produced." For the time being, however, London would have to be content with the bronze *Saint Jean-Baptiste* belonging to the Victoria and Albert Museum, for which the Rodin Statue Fund had raised 6,500 francs, and which was duly installed in May 1902. The sculptor himself came over for the formal unveiling on May 15, and was afterwards treated to a testimonial banquet at the Café Royal on Regent Street, on the doorstep of Piccadilly Circus.

The dinner—at two guineas a head—had been organized by the Scottish sculptor John Tweed, the fund's efficient secretary-treasurer and henceforth Rodin's chief London agent and factotum—"his terrible bear-keeper," as Charles Ricketts described him.* The guest list contained many noble lords and eminent artists; the principal speaker was George Wyndham, M.P., then Secretary for Ireland and "the most elegant man in England." "You would have enjoyed some of the speeches," reported the painter Adrian Stokes to his friend Rothenstein, then traveling in Germany. "Wyndham, MacColl & the French Ambassador were admirable, the Frenchman exquisite—Rodin read his dear little schoolboy effusion from half sheets of note paper pinned together & constantly lost his place." His speech was a reprise of what he had written for the *Nouvelle Revue* but his introduction was calculated to endear him to the British:

> In my life I have had some good and some bad moments; this is one of the best. The generous reception you have given me touches me to the quick. About [twenty] years ago I visited London and even at that epoch I was received with a kindness and courtesy that left me vivid souvenirs. Your splendid museums, with their marvelous collections, Greek, Assyrian,

*Ottilie McLaren thought her countryman abused his position in the Rodin circle: "Tweed has a sweet way of talking as if he and Rodin were confidential friends," she wrote to Wallace in January 1900, "and he lends colour to this by repeating little pieces of information about studio business which he seems to have got from Rodin's confidential (!) secretary. How? Tweed alone knows."

Egyptian, provoked in me an avalanche of sensations . . .
which had the effect of drawing me still nearer to nature in
my studies.

Toward the end of the dinner a group of Professor Lanteri's sculpture students at the Royal College of Art joined the guests and were
introduced to Rodin: it took him a quarter of an hour to shake hands
with them all. What happened next is described in a letter by one
of the students, Will Jones: "Almost before it had been thought of
or suggested the horse was unyoked from Rodin's four-wheeler and
a mob of fellows started it upon its career along Regent Street, Piccadilly and round to the entrance to the Arts Club [on Albemarle
Street], accompanied by a continuous roar of 'Rodin, Rodin.' It was
a sight for the gods to see the 12 o'clock crowd in Piccadilly stand
aghast, the cabbies clear out of the way and the policemen try in
vain to stop the onward rush of the barbarians and their triumphant
chariot."

Wyndham and his friends had taken hansom cabs and were already
waiting at the Arts Club—then the most exclusive artistic and literary
club in London—where Rodin became the center of an animated
group that included Sargent, Lanteri, Sir Lawrence Alma-Tadema
and Max Beerbohm. "Now it was that the flow of wine and wit really
began," Jones relates, "and we had in succession a series of *after
supper* irresponsible speeches."

Whistler, then living in London, had been obliged to send his
regrets: "The persistent weather of this otherwise graciously inclined
and clearly artistic island has, for the time being, destroyed me!"
But he invited Rodin to have breakfast with him at 74 Cheyne Walk
a day or two after the banquet: Tweed, who lived just down the street
at number 108, and Edouard Lanteri were also present. "It was all
very charming," Whistler told his friends Joseph and Elizabeth Pennell later the same day, "Rodin distinguished in every way—the
breakfast very elegant—but—well, you know, you will understand.
Before they came, naturally, I put my work out of sight, canvases up
against the wall with their backs turned. And you know, never once,
not even after breakfast, did Rodin ask to see anything, not that I
wanted to show anything to Rodin, I needn't tell you—but in a man

so distinguished it seemed a want of—well, of what West Point would have demanded under the circumstances."

For two or three days Rodin enjoyed himself tramping through the best of the London museums. "These busts, these heads of women are life, nature itself," he told a reporter from the *Daily Chronicle* who accompanied him through the Greek rooms of the British Museum. "Here are two which are types of our Parisian bourgeoises. Nature does not change. And that Faustina, what a type! What a sluttish, master-woman's face! And the same type is to be seen nowadays." He wandered among the Egyptian sculptures and went to South Kensington for a tour of the Victoria and Albert; later he "darted hither and thither" at the Royal Academy's exhibition—until he came to a sudden halt in front of Sargent's *The Misses Hunter*: "There's the Van Dyck of our time! Sargent has never done better than that!"

As always, his happiest hours were spent among the Greeks at the British Museum. The painter Sir Gerald Kelly, who was to become president of the Royal Academy, remembered as a young man accompanying Rodin on one of his visits to the Elgin marbles. To Rodin's dismay they were met by several museum officials who wanted to tell him "all about Athenian art, and what they did to sculpture on their temples, and how they painted it, and all that sort of thing. And Rodin of course wasn't listening to this at all—he was just gazing at these things. . . . So I translated to Rodin all about the painting and Rodin said, 'They weren't painted' . . . and he said, 'Who is this imbecile?' " But the curator persisted, showing Rodin traces of some of the paint still clinging to the back of one of the horses' heads—"and Rodin looked at it and said *'Oui en effet, en effet.'* And then he said to me, 'Do you think they would go away?—*Est-ce qu'ils peuvent me laisser tranquille?*' " When the experts finally left the room he heaved a deep sigh of relief "and then he turned, and he went up to that horse and he patted it and he kissed its nose and he was as happy as be damned."

Before he returned to Paris, Tweed arranged a second and more intimate party for him at 108 Cheyne Walk. It may have been on this occasion that he asked Tweed if he might try a bottle of the great English drink, "pally ally," which he had seen advertised in the newspapers. A fellow guest, the American writer William Dana Orcutt, recalled that when Tweed failed to understand what he was

talking about, Rodin "pointed to an advertisement in *The Times*, repeating the words, 'Pally ally—pally ally—.' The 'great English drink' he had in mind was Pale Ale!"

>‡<

While D. S. MacColl was still wondering aloud whether London would ever see "a representative collection of Rodin's work such as he arranged at the Paris Exhibition," the Czech art association known as the Mánes Society had already assembled that very thing for the city of Prague. The great Rodin exhibition held there in the spring of 1902 was seen by its organizers not just as a tribute to the world's foremost sculptor but as an affirmation of Bohemia's autonomy of judgment—a metaphor for the political autonomy which the Czechs were trying to wrest from their reluctant Austrian overlords. The local authorities regarded it as a matter of pride that Prague had stolen a march on Vienna, Berlin and London in this respect: the size and scope of the exhibition, declared the city's mayor, Vladimir Srb, would send a message to the world that as a center of the arts, Prague was once more "endowed with the same splendor as that which it enjoyed in its golden age."

The idea for the Prague exhibition had originated with Rodin's Czech studio assistant Josef Mařatka and with two painters from Prague, Miloš Jiránek and Arnošt Hofbauer, who had gone to Paris to see him on behalf of the avant-garde review *Volné Směry* and had been utterly captivated. When Hofbauer, on a visit to Meudon, asked for some drawings to reproduce in the magazine, Rodin willingly gave him carte blanche:

> By means of a narrow stairway we arrived at the second floor, where parcels of many hundreds of Rodin's drawings lay on the floor and on the chairs amid rolled canvases. "Go ahead, look through these and select what you like," he said. "I'll look at them afterwards and see what you've chosen." I stood without knowing where to begin . . . and began turning over pages, looking at all these drawings and imagining the reaction of our readers. . . . I would have liked to take them all; still I selected 60 all told. While going through them I learned to read Rodin's shorthand and realized that this way of drawing had become

his favorite occupation. . . . How cheerful Rodin is when he works was indicated by the sound of his singing and whistling which floated up from his studio on the ground floor, where he was working on a clay group. When I was called downstairs shortly before noon I took my booty with me so as to submit it to the *maître*'s judgment. He found everything in order and promised to add yet another drawing.

Hofbauer and Jiránek persuaded the Mánes Society to sponsor a Rodin exhibition that would rival the 1900 Pavilion as a showcase for the sculptor's work. The Prague city council provided the funds to build a temporary gallery for it—a spacious "greenhouse" with light-diffusing ceilings, gravel paths and indoor lawns designed by the avant-garde architect Jan Kotera and erected in the Kinsky Gardens at the foot of the Hill of St. Laurence. Altogether there were 163 items of which about half were drawings; most of Rodin's major pieces were represented among the eighty-eight sculptures. It was easily the most sumptuous of all the Rodin exhibitions held in his lifetime, and made a profound impression on many of the young artists of central Europe.

The exhibition opened on May 10 but Rodin did not arrive in Prague until the 28th. Mařatka and the best-known Czech artist of the day, Alphonse Mucha—a celebrity since the appearance of his Sarah Bernhardt posters in 1896—accompanied him on the train from Paris. En route they stopped off in Dresden, where the director of the sculpture gallery, Georg Treu, gave him a conducted tour of the Saxon art treasures. In Prague he was "welcomed with cheers, just as though he had been a crowned head," reported the *International Studio*, and there was a banquet in his honor.

He left Prague after only three days, for Mucha had persuaded him to go sightseeing in his native province of Moravia. They went first to Velká Bíteš, where the painter Joža Úprka and "assembled dozens of lads and girls in national costume, set up a barrel of his wine and had a pig killed." A fellow guest, Zdenka Volavkova-Skorepova, noted that "Rodin was bewitched" by the Slovak peasant songs he heard that day. But he was less enchanted when he arrived at the famous Macocha Gorge, north of Brno, to find a small army of firemen in uniform at the railway station, waiting for him to make a

speech. "He hated making speeches," Mucha relates. "He hoped that he would get out of it by muttering a few thanks into his beard and shaking the hand of the speaker. But he underestimated the Czechs. Immediately, five hundred firemen's hands shot out eagerly expecting to be shaken."

Hundreds of curiosity seekers had come the twenty-odd miles from Brno to watch Rodin paying a quasi-state visit to the Moravian equivalent of the Grand Canyon, a steep gorge that drops to a depth of 138 meters. As the two artists began to climb to the point overlooking this scenic phenomenon, "Rodin drew me aside and asked where we were going. 'To the top of the precipice to see the beauty down below.' He grabbed his prophet's beard in a typical gesture and said: 'If we have to climb up to see what's below, let's stay down here. We can see it better.' I agreed, and we turned off the road into a small clearing in the middle of which, like a beautiful posy, grew a young, slender oak. I took out my penknife and cut our initials into the trunk of the young tree as a memento."

They managed to send a boy for a picnic basket containing roast chicken, ham, rolls, fruit and three bottles of wine. Suitably refreshed, they mingled with the crowds inspecting the scenery and made their way back to the station without being recognized. After his return to Paris Rodin sent Mucha a small bronze as a souvenir of their adventure, together with a note of thanks containing the thoughtful offer, "If the subject doesn't please you I'll have them cast something else!"

Rodin's next stop was Vienna, where the redoubtable Berta Szeps-Zuckerkandl was waiting to take over Mucha's duties as guide-interpreter. He had not seen the Secession Exhibition of the year before, in which a special section had been set aside for twenty-two of his works—including the *Bourgeois de Calais* placed at ground level—and he had sent nothing to the exhibition then in progress. But he wanted to see the group's radically new building, designed by Josef Olbrich, and to become acquainted with its choice of artists. Berta Szeps took him to see the exhibition, which was built around two major works displayed in the same gallery—Max Klinger's seated *Beethoven* in marble and bronze, a monumental piece of kitsch, and Gustav Klimt's extraordinary *Beethoven Frieze*, with its Symbolist interplay of snakeskin patterns and gaunt, tousle-haired women.

The Klinger monstrosity sat in the middle of the room. "Rodin looks and keeps silent," Berta noted. But when they were alone he told her: "It contradicts the essential purpose of sculpture . . . it has nothing to do with the art of sculpture. The human body has to be reconstructed layer by layer if one wants to re-create it in sculpture."

Klimt's Beethoven fresco was another matter—and the painter himself was standing beside Rodin as he gazed up at it. Again there was a long silence, but "this time his silence was one of profound admiration. He took Klimt's hands into his own and said, 'What an artist you are! You understand your métier.' " Later, Rodin told a group of Secession artists who had come to greet him that he knew of "no city other than Vienna and no group of artists other than your own which has chosen to solve such difficult problems . . . even at the risk of being misunderstood."

Beethoven's music was also on the agenda: friends took him to one of the open-air Grädener concerts, where he heard the *Eroica* and "became terribly excited and quite beside himself," according to the critic Ludwig Hevesi. Rodin was cheered by the students of the Academy of Fine Arts when he made a tour of the city's Greek and Roman sculptures.

Toward the end of his visit Berta's husband, the anatomist Emil Zuckerkandl, invited him to an afternoon coffee party—a typical Viennese *Jause*—at Sacher's garden restaurant in the Prater. It was a bright June day and the artists of the Secession had assembled for the occasion. Klimt, their president, was in a happy mood and sat next to Rodin, "who talked to him enthusiastically about the beauties of Vienna," as Berta writes. "I had the coffee served on the terrace. Klimt and Rodin seated themselves beside two remarkably beautiful women—Rodin gazing enchantedly at them . . . Alfred Grünfeld sat down at the piano in the big drawing-room, whose double doors were opened wide. Klimt went up to him and asked, 'Please play us some Schubert.' And Grünfeld, his cigar in his mouth, played dreamy tunes that floated and hung in the air with the smoke of his cigar. Rodin leaned over to Klimt and said: 'I have never experienced such an atmosphere—your tragic and magnificent Beethoven fresco; your unforgettable, temple-like exhibition; and now this garden, these women, this music . . . and round it all this gay, childlike happiness . . .

What is the reason for it all?' And Klimt slowly nodded his beautiful head and answered only one word—'*Austria.*' "

Rodin had become so accustomed to being feted and fussed over that he began to think that manifestations of pomp and circumstance were invariably intended for his benefit. Alphonse Legros heard that at some point during this trip—perhaps in Saxony—a German regiment and its brass band crossed the path of Rodin's carriage: "Rodin slowly got up, touched his hat, and sat down again waiting for events; he thought the band was there to meet him."

>✠<

Rodin in his sixties still exercised a profound influence on many of the young artists of the century. Paul Klee, aged twenty-two, saw some of the sculptor's drawings at the Rome Salon of May 1902 and instantly recognized their relevance to his own work: "Above all, Rodin's caricatures of nudes—caricatures!—a genre unknown before him. The greatest I have seen were among them; a stupendously gifted man. Contours are drawn with a few lines of the pencil, a brush filled with watercolor contributes the flesh tone, and another dipped in a greenish color, say, may indicate clothing. That is all, and its effect is simply monumental."

Rodin himself was no less receptive to new impulses and ideas—such as the primitivizing tendencies of Aristide Maillol. During the last two weeks of June 1902—just after Rodin's return from Vienna—Ambroise Vollard arranged Maillol's first one-man show in his little gallery on the rue Laffitte. Among the twenty-two pieces of sculpture, Mirbeau liked the playfully voluptuous *Leda* (without a swan) so well that he bought it, along with a small wooden figure. Rodin bought a bronze cast of a figure originally carved from wood, then cast in wax—a highly unusual chain of processes.

"The other day Rodin came here," Mirbeau later wrote to Maillol. "He picked up your *Leda*, just as I had done, and looked at it intently, examining it from every angle, turning it round in every direction. 'It is most beautiful,' he said, 'what an artist!' He looked at it again and went on: 'Do you know why it is so beautiful and why one can spend hours looking at it? Because it makes no attempt to arouse curiosity.' "

Unfortunately young artists of Maillol's stature were few and far between, and Rodin's studio was regularly besieged by far less talented sculptors. When the young Jacob Epstein came to Paris from New York in 1902 and made his way to one of Rodin's Saturday afternoons in the rue de l'Université he was surprised to find that "one large low table was laden with hundreds of small studies and sketches brought, I should say, by aspiring sculptors and 'mothers of genius' for Rodin's inspection. How all these people with their incompetent sketches must have taken up the Master's time, and how anyone had the impudence to impose on him in this fashion, is incomprehensible to me." Ottilie McLaren had been equally surprised by these sessions: "Rodin is the only one I know of who will open his studio to any serious student and will give a criticism to any serious piece of work brought."

Still, his proverbial kindliness and patience did not extend to the studio assistants who worked for him. Maurice Cladel, Judith's brother, wanted to become a sculptor but had to give up the idea of studying with his father's famous friend. "He made a slight attempt at the beginning of his career," reports René Chéruy, who became Rodin's secretary in 1902, "but immediately could not stand Rodin's brutality and harsh treatment." On the other hand Rodin did his best not only for the prodigious Maillol but also for the more pedestrian John Tweed, who spent part of the summer of 1902 at Meudon with his wife and children.

The chemist Marcelin Berthelot also came to the Villa des Brillants: together, he and Rodin visited the nearby laboratory of organic chemistry that adjoined the astronomical observatory of Meudon. Small and frail, the septuagenarian Berthelot was one of the eminent men of France—a noted statesman and writer on science as well as a pivotal figure in the development of organic chemistry. Rodin did a bust of him that succeeded in capturing both the sitter's intellectual distinction and a certain "*mélancolie raisonnée*" of old age that made Berthelot an unhappy man: life, he said, "is so full of physical and mental suffering that I wouldn't want to live it over again."

A more difficult and time-consuming portrait was the bust Rodin made of the stately, cherubic Mrs. John W. Simpson, née Kate Seney, wife of a prominent New York lawyer and herself a major collector of Rodin sculptures. He depicted her as a sort of Gibson girl in

décolletage rising out of a marble block: before he had achieved the precise effect he wanted she had posed for him no less than sixty times. Half of these sessions, which usually lasted about two hours, were for the clay version of the bust; the rest after the praticiens had got the marble into focus. "He told her that no model had ever consented to pose for that length of time," recorded the art dealer René Gimpel. "That's why the bust of her was the best he'd done." He was so proud of it that he exhibited it at Bing's Art Nouveau gallery in 1902 and again at the Salon of 1904—and for once the sitter was utterly delighted. "My bust is the joy of my life," she wrote to him more than a decade later. "How you penetrated my soul!"

Increasingly it was the American millionaires who were beating a path to his door. The formidable Mrs. Potter Palmer, née Bertha Honoré and wife of the owner of a noted Chicago hotel, the Palmer House, also commissioned a portrait of herself. She was half French, half Southern—"a faultless example of Southern beauty, with skin as white as a jasmine flower, dark hair and romantic dark eyes," as a friend described her. She was also so busy and ambitious that she failed to adjust her globe-trotting schedule to the exigencies of Rodin's portraiture, and had to content herself with what is arguably the most conventional of Rodin's later busts. It was his experience with New York and Chicago society women that led Rodin to write the very gallant and Gallic eulogy of American womanhood with which he replied to some journalist's query:

L'Américaine, with her admirable health and beauty, has the further advantage of having preserved something of the light-colored fashion of Louis XVI and above all in her manners something of the Louis XVI style, which is a delightful mixture of gracefulness and simplicity; she remains natural in her luxury.

It is very doubtful whether this description could have been based on the *Américaine* he knew best, Loïe Fuller—a bumptious stage personality from Chicago whose "Serpentine Dance" Rodin had long admired, and who had performed very un–Louis XVI dances on the stage of the Folies-Bergère. Loïe was often at Meudon in Rodin's company, and it was she who accompanied Pierre and Marie Curie—

"the former brown, tall and thin, the latter slight and blonde"—when the two scientists came to see him in the spring of 1902. The discoverers of radium were "just as simple as the master himself," Loïe noted. "When I introduced them not a word passed. They grasped each other's hands, and looked at each other. . . . That was all. . . . Rodin, with his peculiar figure, his long beard, and his eyes that gaze right through you, was matched, as regards simplicity, by this husband and wife."

He showed the Curies around his three studios, quietly fondling his sculptures *en passant*. "We made our way, slowly, silently," Loïe writes. "In the two hours we passed in the temple hardly ten words were spoken." The writer Eve Curie later remembered her parents establishing friendly relations with Rodin, and she describes them "talking peaceably in the sculptor's studio among the clay and the marbles." When Pierre Curie was run over and killed by a dray on April 19, 1906, Marie and a group of his former students asked Rodin to do a memorial bust. But despite his profound respect for Pierre— "I understand the force of his genius and his modesty"—the sculptor was obliged to explain that they were asking the impossible: "In principle, making a bust based on no other documents except photographs is always a difficult thing for me. Only living nature can make a bust strong and beautiful, for the sculptor does not invent, he only takes the forces of nature, and only his faithfulness in reproducing it allows him to achieve a strength of expression which he himself does not always completely understand. The living play of the features explains, by disturbing them, the passive lines formed by calm and repose."

With Loïe Fuller, meanwhile, a more problematic personage had entered Rodin's circle of friends—"an odd, badly dressed girl, with a Kalmuck face innocent of make-up, her eyes as blue as a baby's," in Eve Curie's words. She was also one of the most famous women in Paris; the only one to have a theatre of her own at the 1900 Exhibition. Anatole France and Jean Lorrain sang her praises in prose and Robert de Montesquiou in verse; Chéret and Toulouse-Lautrec were among a score of artists who drew her dancing the "Serpentine Dance" and the "Flame Dance" amid swirls of floating silk scarves illuminated by colored electric lights—the art nouveau spectacle par excellence.

She had begun her singular career in Chicago as a child temperance lecturer; later there were some perfunctory singing and dance lessons. When she was a young actress someone gave her an immense white silk scarf that accidentally taught her the mesmerizing effect of fluttering silk: "Golden reflections played in the folds of the sparkling silk, and in this light my body was vaguely revealed in shadowy contour. This was a moment of intense emotion. Unconsciously I realized that I was in the presence of a great discovery." She brought her new act to France and became an overnight sensation, playing a run of 600 performances at the Folies-Bergère.

Loïe was nothing if not professional; offstage she was hard-working, methodical and businesslike. Rodin came to her rehearsal sessions to get a better idea of her technique—and as Francis Jourdain recalled, "in Loïe Fuller's studio there was only one god: Rodin." Like so many French artists he was entranced by Loïe's dances: "*C'est une femme de génie.*" He grew very fond of her, writing her a testimonial which she was proud to quote in her autobiography: "Paris and all the cities in which she has performed are under obligation to her for the purest emotions. She has reawakened the spirit of antiquity."

She was happy to return the compliment: at the very entrance to his villa she could feel her heart "leap for joy, like the dog that precedes one in quest of the master of the house." Yet Loïe, at forty, was more than just another doggedly devoted worshiper at the shrine. Her instincts were those of an entrepreneur rather than a handmaiden, and she used her American contacts to organize a Rodin exhibition at the National Arts Club, Gramercy Park, New York, in September 1903. Though modest in scope, it was Rodin's first one-man show in America: included were plasters of the large *Age d'airain*, *Adam*, *Eve* and *The Thinker*, bronze heads of *Victor Hugo* and *Balzac*, and Edward Steichen's photograph of Rodin silhouetted against the *Victor Hugo* and the *Penseur*. *The New York Times*, in an unsigned review, compared Rodin's work to Wagner's music, for it too "seizes and carries one along despite all protests; it excites and disquiets one."

>≉<

On Monday the 1st of September, 1902, a young Austrian writer, Rainer Maria Rilke, introduced himself to Rodin in Studio H of the Dépôt des Marbres: he had been sent by the Berlin publisher Julius

Bard to write a short book about the sculptor and his work. Rilke had already published several volumes of the exquisite poetry and prose that would make him one of the great lyric poets of the German language, yet he was only twenty-six—an unprepossessing little man with protuberant eyes, an abbreviated mustache and a struggling goatee.

He had been married in 1901 to Clara Westhoff, a student at the "Académie Rodin" in 1900, but following the birth of their child, Rilke had come alone to Paris to write his book. When he came face to face with his subject for the first time, at three in the afternoon, Rodin was hard at work. "He had a model. A girl—had a little plaster thing in his hand at which he was scratching away. He put the work to one side, offering me a chair and we talked. He was good and mild. And it seemed to me as though I had always known him, as if I were merely seeing him again. . . . I am very fond of him. I knew it right away."

Next day Rilke was invited out to Meudon, and afterward he sent Clara a carefully detailed report of what he had seen. The trip had taken twenty minutes from Montparnasse station, and the villa was not beautiful, though the view was interesting:

The whole "picturesque" disorder of the Val Fleury spreads out in front of it, a narrow vale in which the houses are shabby and resemble those in Italian vineyards. . . . One rounds the corner of the small red-and-yellow house and stands—before a miracle; a garden of stone and plaster figures. His pavilion, the one that stood near the Pont d'Alma during the exhibition, has now been transferred to his garden: evidently he has divided it up among several studios in which stone carvers are at work, and in which he himself works. Then there are rooms for firing clay and for various other activities. An incredibly large and curious impression is made by this huge, bright hall with its dazzling white figures which peer out of the many high glass doors like the denizens of an aquarium.

Rilke stayed on until the early afternoon. About midday Rodin asked him to lunch: "it was consumed out of doors and was very strange. Madame Rodin (I had seen her before—but he did *not*

introduce me) looked tired, irritable, nervous and slovenly." Rodin
was already dressed to go to town, and he complained that the meal
was late, whereupon Rose became upset: "a flood of rash and ve-
hement words came pouring from her lips; they did not sound angry,
exactly, nor ugly, but as though coming from a deeply offended person
whose nerves would snap the next moment. An agitation possessed
her whole body—she began throwing things around on the table so
that it looked as if the meal were already over. All the things she
had laid out so carefully beforehand were left strewn around as if we
had already used them."

For the next few months Rilke lived in Paris, staying in small Left
Bank hotels and paying regular visits to Meudon and the rue de
l'Université to take notes for his book, which was duly completed
before the end of December. In his eyes the sixty-two-year-old maître
was *"ein Greis"*—a venerable old man—though Rodin would have
resented the description: he still thought of himself as vigorously
ageless. Not until three years later did he confide to Helene von
Hindenburg that "I am astonished to see myself old when I look in
the mirror."

Inevitably Rilke's seventy-page *Auguste Rodin* turned into a kind
of hagiography that enveloped its subject with the halo of an intensely
personal hero worship. Even before starting out on this assignment,
he wrote to Clara, "I had felt such a strong clamorous instinct that
drove me toward him; such a mighty, unappeasable understanding
of his importance." To Rodin he had confessed that writing this book
was *"une vocation intérieure,* a feast, a joy, a great and noble duty,
toward which my love and zeal direct me." It seemed to Rilke that
he had at last found the master who would give his life a new meaning
and direction. "It isn't just to write a book that I've come to see you,"
he wrote to Rodin on September 11. "It was to ask you, how ought
one to live? And you replied, 'live by working.' And I understand
that. I sense that to work is to live without dying. I am filled with
gratitude and joy."

Rodin, on the other hand, was not overly impressed by his new
disciple. It was, from the first, an uneasy and ambiguous relationship
in which Rilke invested his love and Rodin gave ground only grudg-
ingly and with profound suspicion. Afterward he could tell Rilke that
he was among *"mes bons souvenirs"* on account of his "hard work,

courage and temperate intelligence"—and for seven months in 1905–1906 Rilke was to serve as Rodin's clerical assistant and amanuensis. Yet although their relationship survived for ten years, the submissive poet was never promoted to the position of confidence to which he aspired. "Rodin despised him so instinctively and thoroughly that he did not even introduce him to me," remembered the American writer Agnes E. Meyer, who became acquainted with Rodin later in the decade. "If we were together in a room Rodin pretended he didn't exist, and spoke to me as if we were alone, till Rilke slunk away. Since this slavish self-abasement struck me as inexplicable I asked Rodin who this man could be. 'Oh,' Rodin said scornfully, '*c'est un Allemand qui écrit sur moi* [It's a German who writes about me].' "

Even so, Rilke's book is an extraordinary love letter from one great image-maker to another, its pages crowded with perceptions, aphorisms and intuitions. His hero is a kind of Proteus, the sea magician capable of transforming himself and the world around him. And the prose has a biblical cadence that gives this breviary, despite its effusions and *Schwärmerei*, a unique place in the Rodin bibliography:

> One thinks of how small human hands are, and how quickly they grow tired and how little time is given them to move. And one longs to see these hands that have lived like a hundred hands, like a nation of hands that rose before sunrise to achieve the broad measure of this work. One asks for the man who is the master of these hands. Who is he? [page 2]

> This John the Baptist was the first walking man in Rodin's work. Many others follow. There are the Burghers of Calais beginning their weighty, burdensome walk, and all this walking seems to prepare the way for the mighty, defiant step of the *Balzac*. [page 25]

> Among Rodin's works there are hands, small independent hands which, without belonging to a body, are alive. Hands that rise, irritated and angry, hands whose five bristling fingers seem to bark like the five throats of the Hound of Hell. Hands that walk, sleeping hands and hands that are awakening; hands

with hereditary criminal tendencies, and hands that are tired and no longer want anything, and have lain down in some corner like sick animals that know no one can help them. But hands are a complicated organism, a delta into which the many divergent streams of life flow together in order to pour themselves into the great sea of action.*[page 28]

It is as if Rodin would prefer to perceive the face of a woman as a part of her beautiful body, as if he wanted the eyes of her face to be the eyes of her body and the mouth of her face to be the mouth of her body. [page 50]

Thus a long time passes during the creation of each bust. Its substance grows partly through drawings, recorded with a few strokes of the pen or a few lines of the brush, partly from memory. For Rodin has trained his memory to be a convenient and reliable means of assistance. During the sittings his eyes perceive much more than he can execute during these hours. But he forgets nothing, and often when the model has left he commences his real work, based on the fullness of his memory. His memory is broad and vast; the impressions do not change within it but they become accustomed to their dwelling place and when they rise from his memory into his hands it is as though they were his natural gestures. [page 51]

His life proceeds like one single working day. [page 68]

He has several studios; the better-known ones in which visitors and letters catch up with him, and others that are out of

*Even in the age of the reckless metaphor this was thought to be a hilarious passage, and Rilke promptly got his comeuppance in the Munich satirical weekly, *Jugend*: "Rainer Maria is mistaken if he thinks that only the hands Rodin creates are so fabulously interesting—the feet are no less so! Among Rodin's feet there are large, soulful flat feet, left feet that belong to no right foot and right feet of which none has a left partner, though each can wear out its respective shoe; feet that stand on their heads, full of longing and tenderness, feet whose every toe cries 'Meeow' and whose corns cackle 'Cock-a-doodle-doo!' Feet that play the violin and snore, perverse and neurasthenic feet, feet that are never washed, feet that sit down sorrowfully like hens unable to lay eggs. Such feet are a parallelogram into which pours all the nonsense which decadent critics have written about our great artists!"

the way and no one knows about. These are like cells; bare, poor and gray with dust, but their poverty is like the great gray poverty of God out of which the trees bloom in March. [page 69]

Rilke was already in Viareggio, near Pisa, when his book came off the press late in March 1903. Clara Westhoff was in Paris, however, and undertook to deliver a presentation copy. By way of introduction Rilke wrote a long letter informing Rodin that this was by no means the end of his devotion: "For with this little book your work has not ceased to fill my thoughts . . . from this moment on it will be contained in every one of my works, in every book."

After the book had made its appearance—in Richard Muther's series, *Die Kunst*—Rilke toyed with the idea of writing "a bigger or a big Rodin book," but for the time being he confined himself to writing some laudatory verse that came perilously close to doggerel: "*Ein grosser Bart geht aus aus seinem Kinn / und fliesst jetzt langsam hin in weissem Lichte*," one of them runs—"A great beard comes out of his chin and now flows slowly in the white light."

Having exhausted the subject in prose, Rilke was merely repeating himself in verse and could never quite achieve the great Rodin poem he intended to write. There were other German poets who tried to vent their Rodin enthusiasms in verse, though with indifferent success. Perhaps the most interesting example of the genre is a long poem about *The Kiss*, "*Vor Rodin's Kuss*," written in the summer of 1904 by the twenty-three-year-old Wilhelm Lehmbruck, soon to emerge as one of the great sculptors of the twentieth century. *Es strömt das Leben hin zum Leben* . . .

> *Life flows to life.—*
> *He lifts his hand as if in benediction*
> *And, trembling, she feels the pulse of life*
> *As if warm life bestowed the blessing;*
> *the life that glows within this marble loveliness.*

>✠<

Rodin had become accustomed to varying his Paris routine by making frequent sorties to see friends and acquaintances in the provinces,

or to revisit his favorite Gothic cathedrals. Some of these journeys took him no farther than an adjoining Département—to Léon Riotor and his wife at Jouy-les-Oiseaux on the river Orge, for example. Riotor lived in a converted mill and wrote novels, plays and critical essays: he had performed the heroic task of compressing Rodin's life and work into a forty-six-page booklet that was sold for one franc— in six languages—at the 1900 Exhibition. "You've made me very happy with the seriously beautiful way in which you've studied your friend's sculpture," Rodin wrote to him, giving Riotor all the more reason to be proud of the bronze *Adam* that stood in his garden as a token of the sculptor's gratitude.

Florence and Ardenza were on Rodin's schedule later in 1902: he had told Helene von Hindenburg that "seeing the primitives in Florence in your company will give me back my strength." He arrived in mid-October, when the streets were still full of fruits and flowers, and this time he and Helene spent much of their time looking at Perugino and Michelangelo. At the Palazzo Vecchio, in front of Michelangelo's *Victory*, Rodin told her that he, too, disliked "holes" in monuments—"a monument should be able to roll down a mountain and still remain intact, an organic block." To Roger Marx he reported that "I am at home, the real home" in Florence, whose people had the good sense to respect their great artists, and whose primitive painters soothed his soul. They went to Ardenza for a few days, and he made a small preparatory study of Helene that was later to be superseded by a larger bust. But the head was not all that interested him. According to a friend's reminiscences, "Rodin wanted to sculpt her in the nude. . . . Naturally her background, upbringing and position would have made such a thing absolutely unheard of." Yet there are also reports that she regretted not having complied with his wishes: "She would have been proud and honored to have assisted in perpetuating Rodin's genius." In any case, it was his last visit to the Villa Margherita.

By far the wildest and most spectacular destination on Rodin's list of holiday resorts was the Atlantic island of Belle-Ile-en-Mer off the coast of Brittany, to which Monet and so many other artists had preceded him. John Peter Russell had prevailed on him at last to visit the Russell "château" which he had built on a rocky point high above the inlet at Port-Goulphar, looking out over the sea and the

rocks. It was a perfect place, as Russell said, to take "the great air of our island, far away from all the noise and anxieties of society." The walk along the Dantesque coast might well give Rodin fresh ideas, and there was potter's clay for the asking in a nearby dale.

On Belle-Ile Rodin was instantly taken to the bosom of Russell's numerous family, presided over by Marianna, once "the most beautiful woman in France" and now the mother of five boys and a girl (Jeanne, the future writer of important Rodin memoirs). Certainly Madame Russell was not the least of Goulphar's attractions that summer. Rodin was soon to be found in the kitchen, watching Marianna bake small cakes. "When I eat her *gâteaux*," he told the painter, "I enjoy a double pleasure: the delicious taste and the visual enjoyment of a perfect beauty—a goddess making pâtisserie."

Russell took Rodin sailing on his yacht the *Waratah*—named for the native tulip of Australia—and they nearly came to grief when its keel smashed against the rocks at the entrance to the Pigeons' Grotto at Port-Coton. Nevertheless they managed to explore the grotto with its stalactite ceiling, which reminded Rodin of "the nave of some cathedral in the Orient seen in a dream." When Russell dove to the ocean floor to retrieve a large piece of the keel, Rodin called him a South Sea island native and "Triple Triton"—a name Russell justified the next day by going spear fishing in the bay of Goulphar and catching a bonito for their supper.

One day, when Rodin went to sleep in a deserted corner of the garden after lunch, Russell set his enormous boarhound to watch over his guest: "Roméo, *garde!*" He had business elsewhere for half an hour and wanted the dog to stay behind, expecting to return long before Rodin awakened. But something came up and Russell was gone for the whole afternoon. Rodin awoke to find himself being held prisoner by a monstrous watchdog that bared its teeth every time he tried to get up. Since he could not be seen from the house no one realized his predicament for several hours. Finally Russell returned and called off the dog. Rodin received his host's excuses "wearing his most Jupiter-like mien," but eventually saw the humor of the situation—though he also promised to get even. Jeanne Russell recounts the elaborate practical joke he concocted together with a fellow houseguest, the painter Achille Cesbron:

Roméo had a special predilection for a certain bed of roses where he liked to curl up in the freshly turned soil, creating havoc among my mother's flowers and fury among the gardeners, who didn't dare lay a hand on him. . . . Rodin, helped by Cesbron, took some clay and made a superb effigy of Roméo, life-sized, lying down and to all appearances sound asleep. Cesbron then painted the sculpture so that it looked exactly like the dog, and when everyone went into the house for lunch, they carried the false Roméo out to the rose-bed. . . . The coachman, whom they had taken into their confidence and who was delighted to play a joke on his enemy the gardener, had locked the real Roméo into one of the horse stalls with a bone to keep him quiet. . . . After lunch everyone went out on the veranda to have coffee. It overlooked the garden and my mother saw right away that Roméo was lying amid her most beautiful roses. "Look John," she said indignantly, "your miserable dog has once again camped out on my loveliest roses!" My father, embarrassed, cried, "Roméo, here!" but of course to no avail. Surprised, he got up and cracked his horse-whip: still the dog wouldn't move. Now furious, he went down to the rose garden and slapped the false Roméo with his leash, which left him still unmoved. At that very moment, however, we heard loud barking and Roméo, who had escaped, bounded up to my father and covered him with kisses. At that point Rodin, who had hardly been able to contain himself, burst into Homeric laughter—and all of us, including my father, followed suit. Roméo received many a lump of sugar and we all admired his double. Unfortunately the clay, taken from the dale of Goulphar and badly prepared, cracked when it dried and finally fell apart.

On a moonlit night, Russell and Rodin went fishing for conger eels and caught one so large that it gave the latter visions of demons in the Inferno. He also accompanied the family when they collected their lobster pots at dawn. Yet Rodin made it clear that he did not entirely approve of Russell's self-imposed isolation and his South Sea way of life: for one thing it made no sense for a painter to live so far from the Paris art world. "You're wrong to shut yourself up on your

island like a savage," he told Russell. "You have to show yourself, show your work. What a pity you have money [Russell had an income of £3,000 a year, a fortune in those days]; it has deprived us of many a beautiful exhibition."

The very precariousness of the Russells' clifftop house was what Rodin remembered best about Goulphar. When he wrote to them from Paris on January 2, 1903, to wish them a happy new year, he added: "Your little eagle's nest with its terrible surroundings frightens me still." Although he did not accept their offer to return to Belle-Ile with Rose the following summer, he saw a good deal of the Russells during the winters they spent in Paris, where the boys went to school and Jeanne studied the piano: eventually she got in the habit of coming to play the piano for him at the Dépôt des Marbres while he worked. And Rodin did, after all, come to understand why Russell chose to immure himself on the island for the rest of the year: "You are in your element, Triple Triton, and you return to the grottoes of Amphitrite, or rather of the marine monsters," he wrote in the spring of 1904. "Have fun and don't forget that your painting is the precious thing of this moment and of the future."

>✠<

Early in 1903 the effusive Aleister Crowley brought the maître two sonnets he had just written. One concerned the *Balzac* and began, "Giant, with iron secrecies ennighted, / Cloaked, Balzac stands and sees. Immense disdain. . . ." The other was entitled "Rodin":

> *Here is a man! For all the world to see*
> *His work stands, shaming Nature. Clutched, combined*
> *In the sole center of a master-mind . . .*

Though he didn't read English Rodin liked what his friends told him about the poems. He sent them to Marcel Schwob, who lived nearby on the Ile Saint-Louis with his actress wife, Marguerite Moréno, and a Chinese servant he had picked up at the 1900 Exhibition. Crowley was flattered and delighted, since Schwob was "admittedly the finest French scholar of English," having rendered *Hamlet* and *Macbeth* into French for Sarah Bernhardt. Schwob's translations of the two sonnets were, in fact, a vast improvement over the originals:

"*Gigantesque, enténébré de fer noir, enfroqué . . .*"; it was as though Crowley's uncut stones had been sent to a diamond cutter. Rodin, at any rate, was very happy with the results, which were published in *les Maîtres Artistes* later that year.

"The upshot was that Rodin invited me to come and stay with him at Meudon," Crowley reports. "The idea was that I should give a poetic interpretation of all his masterpieces. I produced a number of poems, many of which I published at the time in the *Weekly Critical Review*, an attempt to establish an artistic entente cordiale." The young Englishman's impressions of his host were, to say the least, very different from Rilke's: "He had no intellect in the true sense of the word; his was a virility so superabundant that it constantly over-flowed into the creation of vibrating visions. Naively enough, I haunted him in order to extract first-hand information about art from the fountain head. I have never met anyone—white, black, brown, yel-low, pink or spot-blue—who was so completely ignorant of art as Auguste Rodin! At his best he would stammer out that nature was the great teacher, or some equally puerile platitude."

Crowley wandered about among the sculptures at Meudon and found something to say about many of the major figures, most of the time with rather ham-handed sentimentality but occasionally with great irony and sophistication, as in the case of *la Femme accroupie* (The Crouching Woman):

Swift and subtle and thin are the arrows of Art:
I strike through the gold of the skin to the gold of the heart.
As you sit there mighty in bronze I adore the twist
Of the miracle ankle gripped by the miracle wrist.
I adore the agony-lipped and the tilted head,
And I pay black orisons to the breasts aspread
In multiple mutable motion, whose soul is hid. . . .

There was even a sonnet addressed to *Madame Rodin* that must have given her immense pleasure when he translated it for her, and which began: "Heroic helpmeet of the silent home! . . . Behind the great there is ever found the good . . . the unseen mother and the secret spouse." Rodin liked what he could make of this poetry, which he praised for "its unexpected flower of violence, its good sense and

[455]

its irony." He gave Crowley a set of his nude drawings with which to illustrate the collection, which was published in London four years later as *Rodin in Rime.*

Meanwhile, John and Edith Tweed had returned to Meudon for Easter, 1903—"You can come back now," Rodin had written, "your little house is ready for you"—and not long afterwards he was back in London for another gala visit. This time Tweed arranged a banquet especially for the art students who had greeted him so warmly the year before. Alfred Gilbert, then forty-nine, presided over the dinner. He recalled in later years that he had found Rodin surrounded by an admiring crowd, "looking as though he wished himself elsewhere." Although Gilbert was Rodin's favorite English sculptor they had never met before.* "After a formal presentation, accompanied by endless bows, eulogies, and panegyrics, in true French style, a tacit feeling seemed acknowledged, both on the part of our guest and myself, that each was the other's victim. I know I felt it keenly, and soon learnt there was reciprocity of sensibility, when on offering my arm to our guest on dinner being announced, he said in suppliant tones, *'Ayez pitié de moi, je ne sais pas faire des discours'* (Have pity on me, won't you? I don't know how to make speeches)—to which I replied, feelingly, *'Moi, non plus!'* "

Rodin's London calendar was crowded with more dinner parties than ever before, most of them formal occasions. On May 26 he had dinner with Sir Charles and Lady Dilke—the latter, née Emilia Frances Strong, was a noted art critic and authority on eighteenth-century French art while her husband wrote copiously on such subjects as army reform and the British Empire. On May 31 Rodin was the guest of Ernest Beckett, the millionaire connoisseur who, on the death of his uncle two years later was to become Lord Grimthorpe: the party included Frank Harris and Sir Claude Phillips, who had become keeper of the Wallace Collection. "Rodin is a strangely impressive man with a head expressing daemonic force," noted Sir George Sitwell, father of the three famous Sitwells. "He talked little at Ernest

*Rodin had known and admired Gilbert's work for many years. On a visit to the Royal Academy in 1888, when the critic M. H. Spielmann told him that the English placed Gilbert beside Benvenuto Cellini, Rodin exclaimed: *"Oh, mais bien au-delà, bien au-delà!"* ("Oh, far beyond that!")

Beckett's, but the place to meet him is in his own studio, where he explains and makes you feel everything."

On June 3 Rodin dined at the home of Sir Edmund and Lady Davis who, thanks to mining interests in South Africa, were among the wealthiest art collectors in Britain. "The company was ill-assorted and shy owing to the presence of the Great Man," Charles Ricketts wrote in his diary:

> Rodin is less interesting to look at than I had anticipated. The head, belly and hands are large, there is no waste nor useless forms such as legs, arms, neck: these are afterthoughts. The bones are large, he is *trapu* and powerful in appearance, the eye small and a little *troublé*. He talks slowly in a small polite voice. He evidently felt he was in for being bored, and was politely apathetic the whole evening. Once or twice his face lit up, when he found I had seen his old exhibition thirteen years ago, and over Jordaens, but as he said nothing fine or even intelligent, one felt he had grown callous under his masks. I fancy I made a slip in speaking to him of his old friend Legros. He was greatly taken by the Houdon bust, hardly conscious, I think, that I was a rather more than ordinary man, who probably knows and understands his work better than any man in Europe. I do not blame him. I had rather dreaded the interview.

Will Rothenstein took Rodin to Lewes House for dinner with Edward Perry Warren. At table they talked about art, and Warren said something to the effect that the Greeks had a monopoly on beauty. However passionate he was about Greek sculpture Rodin was not prepared to accept this proposition without an argument. "Let me go out into the street," he said, "and stop the first person I meet; I will make a work of art from him."

"But suppose he were ugly?" Warren asked. "If he were ugly he would fall down," Rodin assured him. This was too much for Warren, Rothenstein recalled, and the conversation turned to other topics. Warren's taste was not confined to the Greeks; in addition to the unexpurgated *Kiss* he bought four other sculptures from Rodin, including *The Man with the Broken Nose*. He did, however, own a

Greek head of a girl—thought to be a fourth-century B.C. Aphrodite—
that sent Rodin into transports of delight when he saw it at the
Burlington Fine Arts Club during a short visit to London later that
summer. "All my life I shall remember the definitive impression it
made on me the first day I saw it," he wrote. "This immortal bust
entered my life like a gift of the gods." He wrote an article on *la
Tête Warren* for *le Musée*—or rather, he dictated it to the editor,
Georges Toudouze, who obtained several Rodin articles in this fash-
ion. The head was a masterpiece that had helped him understand
Praxiteles, he insisted, and had eclipsed even the Elgin marbles—
"for me, who thought the Parthenon the summum of art."

Having fallen in love with the "Aphrodite," he made a heroic
attempt to persuade the owner to part with it. "I have found it so
beautiful that I dreamed it belonged to me, and my dream remains
always with me," he wrote to Warren on August 13, 1903. "I venture
to ask you therefore if you would agree to an exchange. If so please
let me know which of my marbles would please you and perhaps we
could come to an understanding." A month later he proposed a more
specific exchange to Warren's friend and secretary John Marshall:
for the "Aphrodite" he was prepared to give "the figure with legs
apart in bronze and the marble of the *Danaïde*. Would this combi-
nation tempt you? Or perhaps some other . . . ?" In October he made
a further suggestion: "I would keep the head of Aphrodite only so
long as I live, and when I have disappeared it would return to you."
Still Warren refused to budge; he held on to the head, which must
have seemed all the more valuable to him by now, and which even-
tually found its way into the Boston Museum.

Thanks to Ernest Beckett, Rodin had become interested in a living
woman whose head fascinated him—the strikingly pretty Eve Fairfax,
daughter of Colonel Thomas Fairfax of the Grenadier Guards. The
prospective bridegroom commissioned Rodin to do her bust in 1902,
when Beckett was forty-six and Eve was thirty. "He was in love with
me," she recalled many years later. "He thought I would marry him."
Accordingly Eve went to Paris to sit for Rodin early in 1903 and he
was utterly enchanted: "Mademoiselle Eve Fairfax?" he said to Jacques-
Emile Blanche. "A Diana and a Satyr in one; how flat-chested they
are—oh, those planes and the bony structure of these English-
women!"

They spent the modeling sessions talking to each other—"I in broken French," as Eve remembered. "Rodin liked me very much, and I say it quite humbly. He found me refreshing because at the time he was very popular and many French women were running after him. I think I appealed to him because, unlike most other women at the time, I was not prepared to jump into bed with him at every occasion. This, I think, appealed to Rodin. The fact that I treated him rather indifferently made me different from all the others."

He worked on her "*beau et mélancolique portrait*" sporadically during the first half of 1903, though some of the sittings had to be postponed when Mlle Fairfax was taken ill. The news made him unhappy: "Alas my very dear model, you have a great soul and your body suffers from it; that is what happens to everyone with more than just an interest in themselves." In August, after she had been in Paris for more sittings, he sent her an affectionate progress report: "At my age, how quickly the happy minutes go by; doing your bust has given me such pleasure. I'm very fatigued and I don't know if I could go to Dublin this time. Life's difficulties add to my own and tire me out more than a little. I'll do the drawings and send them to you. I'm working on your bust and I *désire beaucoup*; often I come home with a headache because, as I've told you, I *désire beaucoup*."

In September he wrote to her, "Yes I am tired of my life, perhaps of my whole life—but not of having worked on your bust." It took him nearly a year to finish her portrait in clay, but he was immensely pleased with the result: "*Grande amie*—allow me to call you that; your generous turn of mind and of body, your genuine grandeur, have always touched me, and of my own volition I have become one of your *serviteurs*. Hence I'm so happy to tell you now that your bust will be worthy of you; it turned out very well, two months after you left; my esprit needed this time so that the germ of beauty and character you left in my soul could develop and flourish."

On Christmas Eve 1903 he thanked her again "for the masterpiece you've helped me create. For now I can say it. After your departure my memories of you came together forcefully and in a happy moment I achieved success. You have a way of overcoming obstacles with determination and serenity—and the bust shows it." But during the summer of 1904, while the marble version was still in the hands of a praticien, Eve Fairfax broke off her engagement to Ernest Beckett,

the new Lord Grimthorpe, who promptly canceled the commission—though he did not cancel his order for another work in progress, an enlarged version of *The Thinker*.

Rodin, by this time, was so fond of the sitter that he went ahead with the marble anyway. Chéruy reports that the maître was not entirely pleased with the first version of the marble and commissioned Bourdelle to make another that finally satisfied him completely. With one bare shoulder emerging from the rough marble of the base, "the figure gave an impression of *effort*, as struggling against an opposition. Rodin, who that day was in a good mood, told me, 'You see she is struggling,' giving me to understand that the young woman was, or wanted to be, an actress against the will of her family."

Eve Fairfax lived in Paris for a time though she had "hardly any money," and after her return to England Rodin made her a present of the Bourdelle version of her bust. "After the exhibition," he wrote to her on May 27, 1907, "I shall have them make a plaster cast of your bust for me and will send you the marble original. It will be a souvenir to keep with you, a souvenir of the time you spent in Paris." It was a princely gift: at that time Rodin charged 25,000 francs for a marble bust (his expenses for the marble and praticiens' fees usually came to about 16,000 francs). Clearly he was delighted to be able to express his affection for this young woman "who both in her heart and in her form resembles one of the figures of Michelangelo."*

>≍<

On June 30, 1903, to celebrate Rodin's promotion to the rank of Commander of the Legion of Honor, a group of friends and pupils arranged an al fresco party at a garden restaurant in Vélizy, near Versailles. Among the 150 guests were old friends such as Mirbeau and Besnard, and a large contingent of younger admirers—notably Isadora Duncan, who had just scored her first big Paris success dancing to the Colonne Orchestra's Beethoven at the Châtelet Theatre. "We wanted to pay spontaneous tribute to the man of character, the artist who owes his fame solely to his courage and the constancy of his ideals," declared Jean Baffier, one of the three Rodin disciples

*Eve Fairfax outlived every other subject of a Rodin portrait: she died at the Retreat, York, on May 27, 1978, at the age of 106.

who acted as toastmasters. "Today your name is famous not only in
Europe but far beyond the seas."

Bourdelle proposed the second toast—to "Rodin the father of
passions and of tears . . . father of the Olympian *Hugo* and of the
prodigious *Balzac!*" Finally there was Lucien Schnegg, another de-
voted assistant who had won important honors: he spoke of hard work
and toasted "Madame Rodin!" After lunch the group had its photo-
graph taken around a column surmounted by a plaster cast of the
headless, armless figure soon to be known as *l'Homme qui marche*,
the Walking Man;* then the patriarchal giant Frits Thaulow tuned
up his cello and people began urging Isadora Duncan to dance.
"Isadora had a long, white, high-waisted Liberty frock on," reported
Kathleen Bruce, whom Rodin introduced to Isadora in the course of
the party. "She said she could not dance because her frock was too
long. Somebody said, 'Take it off,' and the cry arose, 'Take it off.'
So she did, and her shoes too, and . . . Isadora, in a little white
petticoat and bare feet, began to move, to sway, to rush, to be as a
falling leaf in a high gale, and finally to drop at Rodin's feet in an
unforgettable pose of childish abandonment. I was blinded with joy.
Rodin was enchanted."†

Rodin had indeed become a European figure, "going from capital
to capital, receiving homage, sitting at banquets," as Will Rothenstein
noted, "and what was still more agreeable, selling his work to the
great museums." Yet there was a price to be paid for all this, and
Rothenstein was not the only one to sense that Rodin's head had been

*René Chéruy recalled that he himself had been responsible for the resurrection of this
much-discussed figure. "Rodin took me for a tour of some small studios in Meudon
unused for work but where he stored small plaster figures and sketches. My attention
was attracted by a dusty half life-size figure in a dark corner—no head, no arms but
so powerful that I could not help exclaiming, 'Oh, M. Rodin, how beautiful this is!'—
It was really the original study for the *St. John* with the walking effect perhaps somewhat
more energetic, the feet being a trifle more apart (1878). Rodin looked as if he had met
again an old friend and asked me to bring it in the house. The next day he asked the
foundry man to cast a bronze of it, then M. Limet who made the beautiful patinas put
it in shape. And shortly after Henri Matisse the painter came to visit the studio of
Meudon and bought the bronze about one yard high for 1,000 francs. . . . Then Rodin
decided to have an enlargement made by Le Bossé and it was exhibited at the Salon of
1907, and that is the story of *l'Homme qui marche.*"

†"How I regret that I was never able to make drawings of her [while dancing]," Rodin
told his secretary Mario Meunier a decade later. "But—is it because there was no

turned: "he played up to worshipers and became something of a social lion and, worst of all, he spent overmuch time as his own showman. . . . Whenever I stayed with him, I wondered at his patience with fools, and with adoring, exotic ladies."

His international success had all but silenced the opposition that had emanated from the Beaux-Arts establishment for so many years. The change of climate was epitomized by the eleventh-hour conversion of Eugène Guillaume, the great neoclassical sculptor and former director of the Ecole des Beaux-Arts, who had once insisted on relegating the *Nez cassé* to the dustbin. "He was certainly my worst enemy," Rodin recalled, but one day he had the quiet satisfaction of seeing this same Guillaume, eighteen years his senior, try to make amends "and even to visit me in Paris and at Meudon. By that time I had become a great artist for him, I'm not quite sure why." After Guillaume had "showered God knows what praises on me and honored me with countless confidences," Rodin rewarded the octogenarian maître with one of his most tachist portraits—a bust that bears the imprint of his thumbs and fingers almost as a deliberate affront to the smooth-skinned neoclassicism preferred by Guillaume and his school.

That some of Rodin's erstwhile supporters should have turned against him now that he was famous was also not surprising. In June 1903, just as his well-wishers were about to celebrate his promotion in the Legion of Honor, *l'Art* published a particularly mean-spirited exposé entitled *"Comptes Eloquents!"*—i.e., Accounts That Speak for Themselves, or "What M. Rodin Owes the Ministry of Fine Arts." He had, it seemed, committed the unpardonable offense of accepting advances for public monuments that were still unfinished years after they were ordered. *L'Art* claimed that he had received 24,700 (actually 25,700) francs for the *Porte de l'Enfer*; 30,000 (in fact, 25,000) francs

music?—I was never able to get her to dance for me. In my only drawings of her she is in repose"—and he pointed to a box of five or six pencil drawings of Isadora Duncan at rest. When Meunier asked her why she hadn't cooperated she said: "Rodin has often asked if I would come and dance for him while he drew. Each time I promised I would. Each time I went to see him I brought my dance costume—and when I was ready to dance I found I couldn't make the slightest movement for him. He is too great for me. As soon as he appears I feel like a nymph before a centaur . . . before the very force of nature."

for the Panthéon *Victor Hugo*; and 11,000 francs (this sum was correct) toward the second *Victor Hugo*, intended for the Luxembourg Gardens—yet none of them had been delivered. For *l'Art*, whose editors had done so much for Rodin at the time of the *Porte* commission, the case was a scandal. "Whether M. Rodin does or does not finish his *Porte*, it may not be a great loss to art. What is certain is that the taxpayers will be the losers."

Financially Rodin was now in a position to shrug off this attack, but it precipitated a hardening of attitudes toward him at the ministry. The new director of fine arts, Henry Marcel, felt obliged to launch an investigation and to despatch an inspector to the Dépôt des Marbres "to determine precisely the actual situation of the work in progress." This unenviable task fell to Eugène Morand, a writer and *contrôleur* of government commissions, who reported that the Gates, with their "host of magnificent and tragic images," were far advanced but that Rodin did not expect to finish them for another three or four years. The standing *Victor Hugo* for the Panthéon, in which "the poet is depicted entirely nude, in a walking attitude, listening to the inspiration of a winged messenger," was ready to be carved in marble, but its intended height of 7.5 meters "will make it extremely difficult to find the necessary blocks of Carrara marble. . . . It would not be surprising if the search takes one or two years." In fact the monument was abandoned and never mentioned again.

The Luxembourg *Hugo* was to consist of three figures: "That of the [seated] poet, executed in marble, was exhibited at the Salon of 1901. The second figure, that of the Tragic Muse, has been partially roughed out and the praticien's work has commenced, but a large part of the block is still in its rough state. The third figure, *la Voix intérieure*, has not yet been begun. M. Rodin estimates that this monument will require another four years of work and expects to ask for another payment of 8,000 francs in 1905." The upshot was that the ministry decided to do nothing, and to give Rodin as much time as he needed to finish his commissions—though the 35,000 francs that had been set aside for casting the Gates in bronze were now allocated to projects promising a more immediate return.

Meanwhile, Rodin's reputation for unreliability had already cost him several important commissions. In the course of a long article on Rodin in the *Fortnightly Review*, Arthur Symons reported that the

famous maître was still being subjected to humiliating rebuffs from
the people in charge of buying public art. "The civic authorities of
Paris ordered from M. Rodin a bust of Victor Hugo, to be set up in
the Place Royale. M. Rodin set to work immediately, and produced
the bust, which is now to be seen in the Salon; the bust was pho-
tographed, the photographs sent to the Hôtel de Ville, and the same
evening an official letter was received by the sculptor telling him to
consider the order null and void, seeing that an arrangement had
been made with another sculptor on better terms." Rodin had, in
fact, contracted to supply the bust for only 2,500 francs, which barely
covered his expenses: Barreau, the sculptor who agreed to furnish a
Hugo bust "sous de meilleures conditions," eventually submitted a
bill for 25,000 francs.

When Emile Zola died on September 30, 1902—accidentally as-
phyxiated by carbon monoxide from his fireplace—Rodin was point-
edly passed over and the monument was commissioned from Constantin
Meunier, who had supported Zola at the time of the Dreyfus affair.
Some of Rodin's Dreyfusard friends were incensed by this patently
political decision. "I am profoundly sorry that Rodin will not be
entrusted with the Zola monument," Monet wrote to Théodore Duret
in January 1903, "since this concerns a question of art, the homage
of a great sculptor to a great man, and in such cases the question of
politics should not arise."*

Rodin was thus all the more grateful to private collectors like
Linde, Beckett and Mrs. Simpson, who now provided the bulk of his
income. Dealing with wealthy individuals was a very different matter
from doing business with ministries and monument committees. "I've
never been so happy and honored as the day you felt my work was
in harmony with one of the Beethoven symphonies performed at your
house," he wrote to Linde on December 30, 1902, "for Beethoven
is my god and I think that he is perhaps like Rembrandt, the great
and most powerful solitary artist." When he wrote to Beckett in a
similar vein, thanking him for his interest in The Thinker, the English
collector replied that he had been deeply moved by Rodin's "words

*But monuments are often intensely political affairs. Meunier's Zola monument was
destroyed by the French authorities, acting on German instructions, during the occu-
pation of Paris in World War II.

that strike, touch and enlighten the imagination. Especially did you please me by telling me that I brought you luck by my faith in you. As one of our great poets expresses it, 'I needs must worship the highest when I see it.'* . . . My faith and the luck it brings you are only the reflection of your own genius in the spirit of your numerous enthusiastic admirers."

Rodin lost one of the first and foremost of these admirers when W. E. Henley died on July 11, 1903. The poet was only fifty-three; his tuberculosis had returned with a vengeance after an accident in which a train dragged him along a platform at Woking station. Rodin heard of his illness and sent him an affectionate greeting that reached him on his deathbed: "From my heart to my faithful friend Henley. How well I remember your sweet home and Madame Henley's affection for you. . . . Your old friend who loves you."

Six days after Henley, Whistler died at his house on Cheyne Walk; he was sixty-eight and had been suffering from pneumonia and heart disease. His death left the International Society of Sculptors, Painters and Gravers without a president, and many names were suggested until "one of our members had the brilliant idea to propose M. Rodin," as Anthony Ludovici recalled, "and he was elected without a dissentient voice." John (afterwards Sir John) Lavery, the Society's vice president and prime mover, went to Paris with Ludovici as interpreter to find out if Rodin would accept the presidency of a society based in London and with a mainly British membership: it was an age of punctilio in which such matters were not left to the mails or the telephone. At Meudon, "the maid showed us into one of the studios with its large double doors opening out on to the surrounding landscape, showing up the statuary as it should be seen, against a background of trees and grass. M. Rodin soon appeared, wondering what our errand could be." Ludovici explained that they had come to offer him the society's presidency, "as we could not think of any artist more worthy to take the place of our celebrated late President, Mr. Whistler."

Rodin was delighted to accept, especially since it was the first time a sculptor had been invited to become president of an important art association. From the very outset, indeed, he took the job more

*Tennyson, in *Guinevere*: "We needs must love the highest when we see it."

seriously than Whistler had. "Rodin, it seems, is like a child over his election to the presidency of the International," Charles Ricketts noted in his diary. "He thinks he holds England in his hand!!!"

He traveled to London for his first taste of presidential privilege on January 8, 1904, accompanied by a cuadrilla of painters who were fellow members of the society: Charles Cottet, Frits Thaulow, Jacques-Emile Blanche and Charles Milcendeau. When they arrived at Victoria Station London was shrouded in fog, and Rodin took the opportunity to congratulate the waiting reporters on their city's estimable climate: "I do envy London its grays, toning everything down, its light and dark grays, giving outlines soft and velvety, such as we rarely get at home. Think how my predecessor in the presidency of the society, Whistler, utilized them! I can almost envy him his chances." After describing the sculpture he had sent to that year's International Exhibition—notably the enlarged version of *The Thinker* and *Une ombre qui descend pour consoler une femme désolée* (one of his longest titles ever)—he set off for his hotel in an electric brougham. As the *Morning Post* reported, "His luggage had been rescued from the railway vans, so our representative took his leave. As he turned away he overheard one porter say to another: 'Bill, who are all them chaps?' The reply was: 'I dunno, but I expect they are Chamber of Commerce fellows.' "

It was an understandable mistake. Dressed in a fur-lined coat with an astrakhan collar, the visiting sculptor was clearly presidential timber. "A white silk scarf, entwined about his long fair hair that was gray and his stream-like beard, enwrapped him up to the ears," Blanche testified. "His old re-ironed top-hat 'with eight high-lights' seemed like a shoot growing from his highly polished boots that were just visible above his snow-shoes." Beneath the overcoat he wore a tailor-made frock coat like a diplomat's, with the rosette of a Commander of the Legion of Honor in the buttonhole. "In my trunk I have my foreign orders, just in case I have to appear at Court," he informed Blanche. "Rose worries me since she has found out that gentlemen have traveling suits; however, when I go to London, which is an aristocrat's city, I dress as when I go to garden parties at the British Embassy." The result was perfectly calculated to appeal to the sartorial British eye. A reporter for the *Daily News* sized him up as

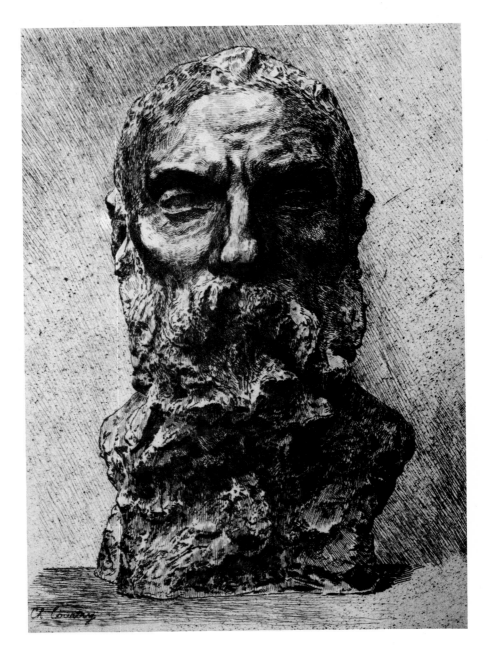

Camille Claudel's bust of Rodin engraved by Charles Courtry.

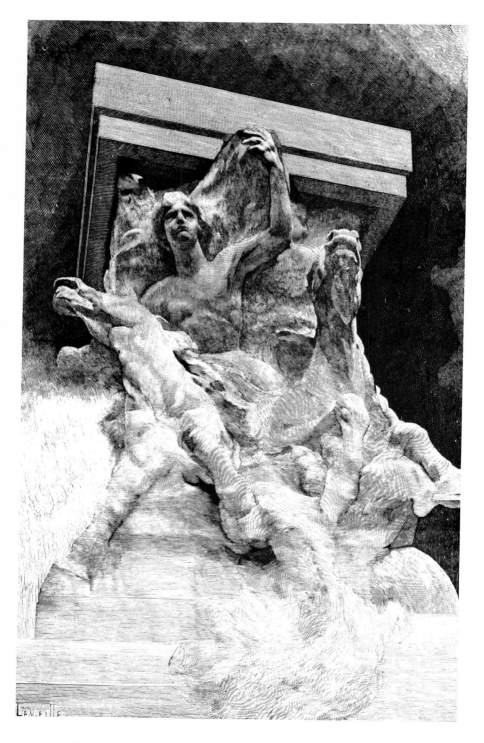

The Horses of Apollo *from the Claude Lorrain monument.*

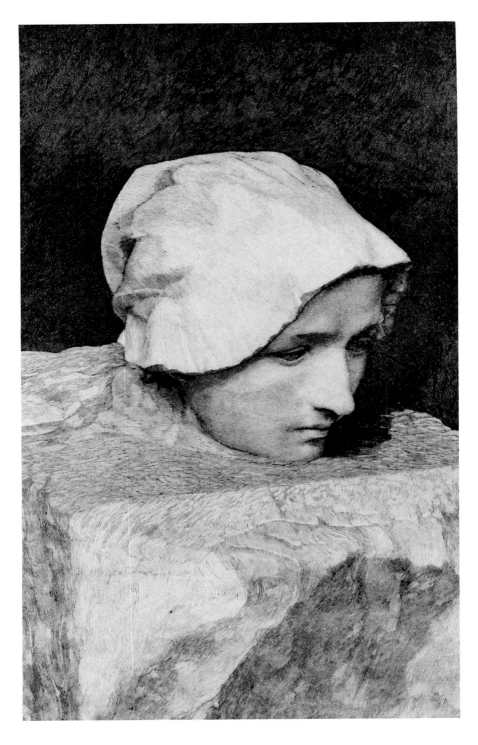

Rodin's la Pensée—*a portrait of Camille Claudel in a Breton cap.*

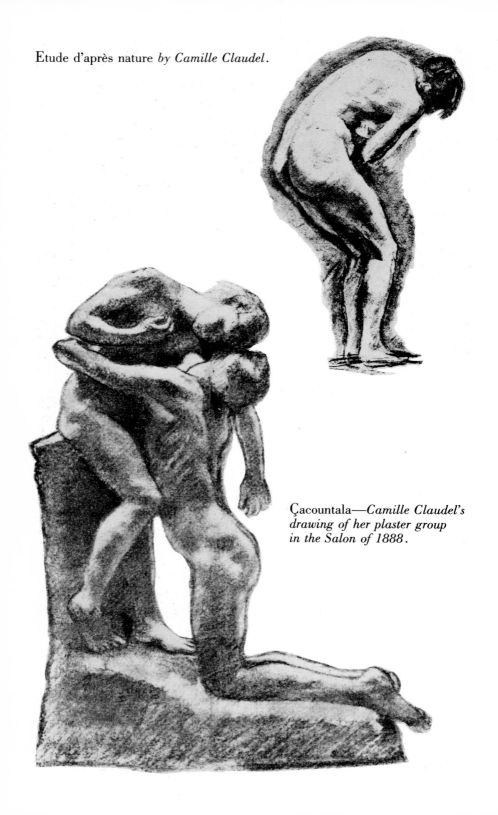

Étude d'après nature *by Camille Claudel*.

Çacountala—*Camille Claudel's drawing of her plaster group in the Salon of 1888*.

*Camille Claudel
in a photograph by César.*

*The young Paul Claudel in a bust
by his sister entitled* A Young Roman.

*Camille Claudel's drypoint
impressions of Rodin at
work in his studio.*

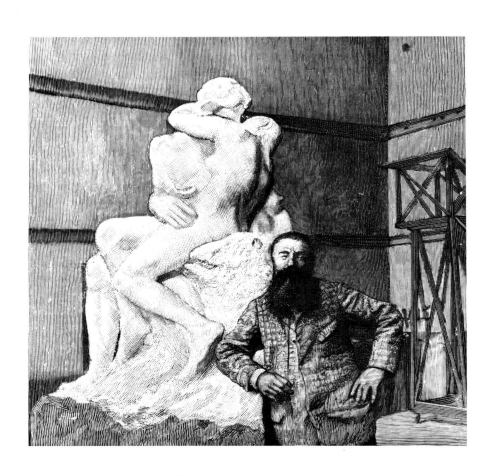

The Kiss *and its sculptor*.

Rodin's drawing of his bust of
Luisa Lynch de Morla Vicuña.

*Rodin's pen-and-ink study
of Octave Mirbeau
drawn onto the cover of
Edmond de Goncourt's copy of
Sébastien Roche, 1892.*

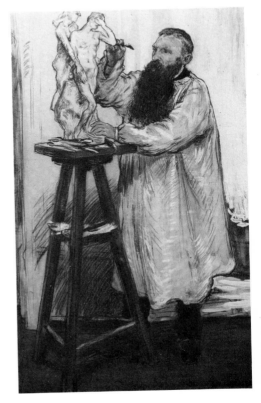

Rodin in His Studio
by Jean François Raffaëlli.

COURTESY OF THE ART INSTITUTE OF CHICAGO.
BLACK CHALK AND WATERCOLOR, 23 INCHES ×
15½ INCHES (58.2 CENTIMETERS × 39.6 CENTI-
METERS), 1918.358. GIFT OF ANNIE SWAN COBURN.

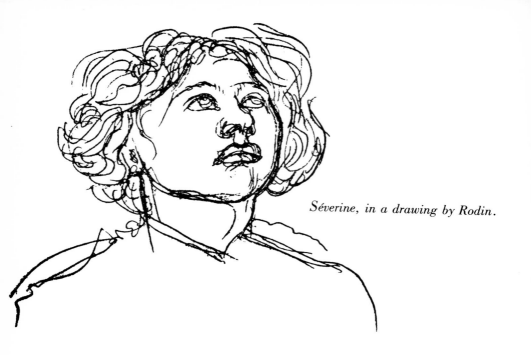

Séverine, in a drawing by Rodin.

Jean-Louis Forain: a caricature for the cover of Psst . . . ! *—Zola appeals to the Kaiser for help by waving* J'Accuse!

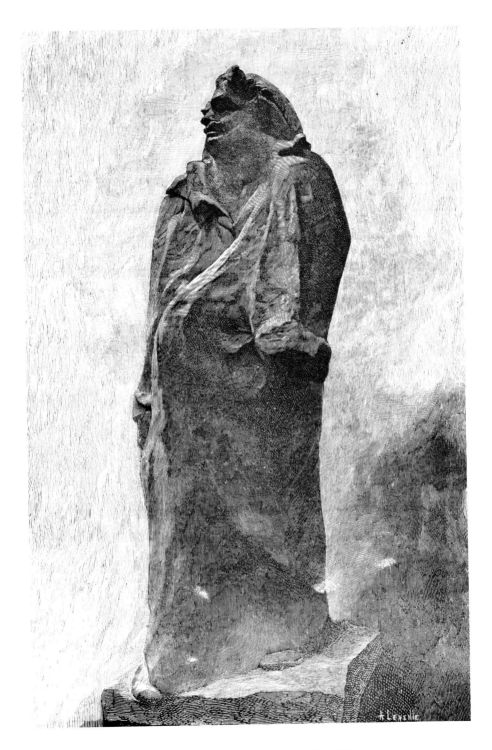

Rodin's Balzac *engraved by Leveillé.*

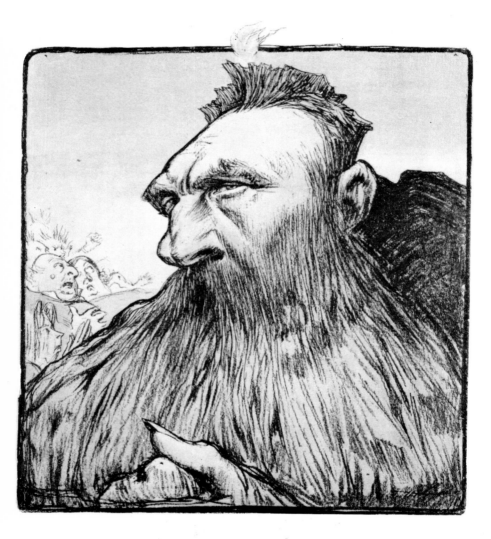

Rodin, the August Sculptor *by Charles Léandre, 1898.*

Balzac *at the Salon of 1898, lampooned by* Le Rire.

"The Rodinophobe" in Le Rire, *1905*.

Rodin *by Ramón Casas*
MUSEU D'ART MODERN, BARCELONA

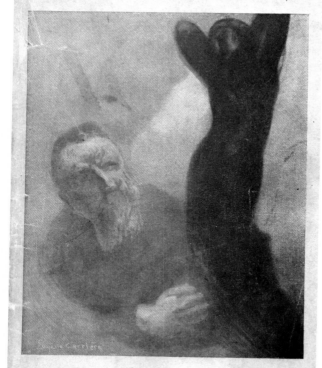

*Cover of the 1900
Rodin Pavilion
catalogue with a
lithograph by Carrière.*

Gwen John in the watercolor self-portrait she gave to Rodin.
BRUNO JARRET AND
MUSÉE RODIN BY SPADEM

Rodin shows a visitor around his studio— a caricature by Paul Iribe for l'Assiette au beurre, *1903.*

Rose Beuret by Henry Tonks, autumn 1914.

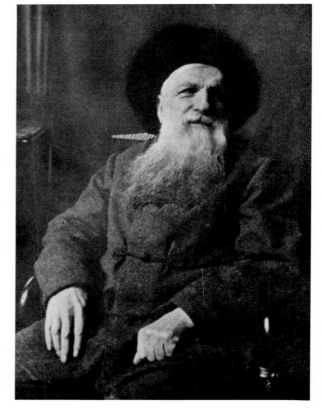

Rodin, photographed by Choumoff two months before his death.

. . . a stately, suave, intellectual-looking gentleman with broad
brow and wide square-cut beard, who might have been an
eminent statesman or a successful engineer, and whom one
would not have suspected of being French except for his lan-
guage and a subtle grace of gesture which an Englishman would
find hard to copy. In short, M. Auguste Rodin looks the picture
of the normal, the successful, the respectable, the very anti-
thesis of the man who was at never-ceasing warfare with his
kind. Yet he has known, like Whistler, what it was to be an
Ishmaelite in the world of art.

That evening, while a barber dressed the flowing hair he now wore
in place of his military brush-cut, Rodin worked with Blanche and
Cottet to concoct a little speech for the first dinner given by his
English admirers: "England gives me great moral force . . . a sense
of security. Hence I am very happy to be here, where it seems my
efforts are better understood. . . . How could I fail to love this gra-
cious city which encourages me by accepting my sculptures and taking
them into the intimacy of the English *home* [here he used the English
word]."

During the next few days he availed himself of the pleasures of
London: one of them was simply driving through the city at a slow
trot. "We drove from Kensington past Hyde Park and along Piccadilly
in a hansom," he reported, "with the sun shining on the scene from
behind us, and the window of the cab in front framing it all. It was
a picture!"* According to one account he shocked a group of his
English hosts with the ingenuous question, "Are there no gay estab-
lishments in London?" But his choice of hotels proved that he already
knew his way around this curious city. "Rodin wondered why his
friends, when they took him back to his hotel, ordered their carriages
to stop some way from the door or even in front of the restaurant,"
Blanche noted. "We stayed there so as to be at hand, and soon found
that our President had not chosen the hotel because everyone spoke
French, but on account of the ladies who came to see him. In France

*Thaulow, the landscape painter, told reporters that he would love to paint London, "if
there were not so many Englishmen in the streets."

we have an expression for establishments of this kind. The names of the visitors are not divulged. Lavery begged Rodin to stay at the Carlton, but he was immovable."

The dubious hotel, on Jermyn Street, discovered that it had a celebrity on its hands: "There were hundreds of telephone messages, telegrams and notes, brought by messenger boys, needing answers, which turned the hotel upside down." On January 11 Rodin presided over the International's gala reception at the New Gallery on Regent Street, where he shook hands with a large percentage of the two thousand guests. "All the English aristocracy had met together," he told a reporter a few days later. "It was a magnificent spectacle, this reunion of beautiful women tastefully dressed and 'artistically low-necked.' Their dress has retained all the exquisite savor of the eighteenth century." In his brief address to the society's annual banquet Rodin paid tribute to Whistler, "a great master, a hard worker, whose keen mind was so austere in art." The principal speaker was Edmund Gosse, who had pointed to "the danger of M. Rodin's manner" twenty years earlier and now hailed him as "one of the intrepid conquerors of the world of art."

By far the most important piece of sculpture in the society's exhibition was Rodin's new enlargement of *The Thinker*, still in plaster, known informally as *le Grand Penseur*. In the eyes of the *Daily Mirror* "it dominates the gallery as eternity dominates life. This great, white, brooding figure has the elements of that rare art that outlives the present." There were also dissenting opinions: *le Grand Penseur* "is not what any of us would consider to be the type of man who is over-labouring his brain," objected the Yorkshire *Daily Observer*. "The brain is very small from a phrenological point of view, and the hands and feet are tremendous."

The question of the "over-developed strong-man's" prominent feet was hotly debated: some critics thought that "the wave of passion" passing over the mighty body caused the muscles of the feet to "undulate in union with the soul," while others seriously doubted whether "the curiously nodular and hummocky toe-joints can have anything to do with the concentrated agony that is focused in the Titanic figure's despairing face." Among the smaller pieces it was the group with the *femme désolée*—an assemblage of figures now known as *le Rêve* (The Dream)—that drew fire from the art critic of *Truth*:

He has so modelled a nude woman, lying face downward, that her legs bend up at a right angle to her body, thus causing the soles of her feet to face the heavens. The reasons for this curious pose for *une femme désolée* is apparently that the spirit descending to comfort her, which is supposed to be floating immediately above her, may rest its legs on those upturned soles and thus be suspended in a horizontal position above the woman. The effect, to my mind, is anything but graceful. In fact, the group is more suggestive of a favorite feat at hypnotic seances or of some novel gymnastic effort than of a happy thought from the brain of a sculptor of genius.

The one point on which all the critics were agreed was that, for better or worse, Rodin "is getting such a reception in this country as has never fallen to the lot of any other foreign artist." Certainly his reception in London did wonders for his morale, and when he got back to Paris he was delighted to tell Georges Toudouze about his experiences for an article in *le Musée*: "I have just come back from London (fervent mornings of love!) where I saw the *Three Fates* and the *Theseus* again [at the British Museum], and where I saw whole blocks of buildings held up only by wooden beams to keep them from collapsing."

This pragmatic English way of shoring up crumbling buildings interested him at the time because he wanted to apply the same principle to the restoration of French cathedrals rather than "renovate" them in the manner of Viollet-le-Duc. "Every support used to prevent a temple or statue from falling should be made of wood or masonry, it doesn't matter which, so long as it is a natural, unpolished and massive material. Let us never employ the disrespectful cutting and polishing with which we like to profane our monuments, big children that we are!" Only such undisguised, *brut* methods of restoration could stem the tide of prettified church façades that was sweeping France. The fault lay with the pseudo-Gothic architects, whose "ravages" led Rodin to coin the phrase *Nos Cathédrales, c'est le médecin qui les tue*—it's the architecture doctors who are killing our cathedrals.

>✠<

Rodin invited Eugène Carrière and his young son Jean-René to join him at the foundry for the casting of the colossal bronze *Penseur*. In his memoirs, Jean-René recalls that this exciting operation took place at night in the foundry of Alexis Rudier in the rue de Saintonge, near the Place de la République. "There was little light; the place looked like a cave. Men dressed in thick, heavy clothing busied themselves with the crucible and molds." Preparations for the actual casting took many hours. At last everything was ready, with both the metal in the crucibles and the waiting molds heated to the desired temperature: it was so hot in the foundry that the workmen's protective clothing had to be constantly wetted down to keep them from catching fire. When the plug was finally pulled and the molten bronze flowed into the mold, "there was a loud noise; the metal entered in a rush, spewing fire and smoke in all directions, while the men scurried to extinguish the objects that had caught fire all around. Thus Rodin's *Penseur* was cast in one piece—a rare procedure, and one that succeeds even more rarely."

Jean-René had begun studying sculpture at an early age, and often accompanied his father when he went to visit Rodin at the Dépôt des Marbres or in Meudon. He remembered that one day at Meudon they found Rose terribly upset—"Rodin, or rather Monsieur Rodin, as she called him, was expecting a visitor he disliked; he had taken all the bedsheets in the house and covered up his sculptures with them." The boy learned a good deal during these visits, but the day came when his father decided to leave him at home: " 'I won't take you this time,' he told me, 'because I've noticed that when you're with me he shows me very little. I suppose he looks on you as a sculptor and distrusts you.' I was twelve at the time."

The elder Carrière, however, remained on the best of terms with Rodin, and it was not unusual for them to spend hours together, talking about art. In January 1904, Carrière sent Rodin a long letter setting down the gist of a conversation the two old friends had held while wandering through Rodin's exhibition rooms. There had been many areas of agreement—notably that "through art, man becomes conscious of his identity with Nature." And both of them distrusted art schools because "they made the mistake of obliging children and young people to copy antiquities and the works of the masters though they were incapable of understanding them."

Carrière was one of the noncomformists—among them Vuillard, Bonnard, Marquet and Félix Vallotton—who joined Frantz Jourdain in founding the Salon d'Automne, the Paris equivalent of the German and Austrian Secession movements. Launched in 1903, the group made its name with the Autumn Salon of 1904, which dazzled Paris with a brilliant selection of pictures by Renoir, Carrière, Cézanne and Toulouse-Lautrec. Rodin quietly encouraged their efforts but as one of the directors of the Société Nationale he was caught in a conflict of interest: Carolus-Duran, president of the Nationale, at first threatened to expel any member who exhibited in the new Salon. Jourdain was naturally resentful of his friend's ambivalent attitude. "Rodin, among others, covered me with flowers and declared that our project would revolutionize the world of art," he writes in his memoirs. "But there was a catch. Not knowing whether we would succeed, and unwilling to risk being tarred with the brush of failure, he preferred to wait and see how we fared, enrolling in our ranks only when . . . the battle was won."*

In 1904 Rodin was represented only by photographs, but a group of his works finally appeared in a special room at the Salon d'Automne of 1905—the year Jourdain also gave the Fauves a whole room to themselves. The young André Gide, whom Verhaeren had introduced to Rodin earlier in the year so that he might "spend some time tête-à-tête with your masterpieces and with the man who made them," took a *Promenade au Salon d'Automne* for the *Gazette des Beaux-Arts* and decided that the maître represented a vanishing tradition. His sculptures were "admirable, palpitant, significant, filled with the clamor of pathos," but upstairs there was a seated female figure by Maillol that made an even greater impression: "She doesn't signify anything; it's a silent work." It was like listening to Bach after hearing Beethoven, Gide felt: "I can easily imagine [Rodin] tormented by a sculptural idea the way Beethoven was by a musical idea . . . searching feverishly for the way to express his troubled state of mind."

>‡<

*Caught up in the inexorable onward march of modern art, Jourdain eventually became frightened by his own audacity. When World War I broke out he was heard to say: "At least it will rid us of the Cubists!"

Verhaeren had brought another young writer—the Austrian poet Stefan Zweig—to meet Rodin at the Dépôt des Marbres in the spring of 1904. Zweig, at twenty-two, had already worshiped Rodin from afar; at their first meeting "the words stuck in my throat. I could not say a single thing to him, and stood among his statues like one of them. Strangely enough, my embarrassment seemed to please him, for at parting the old man asked me if I did not want to see his real studio in Meudon, and even asked me to dine with him." At the Villa des Brillants Zweig found his tongue, and at the end of a simple meal consisting of meat, a few olives, fruit and *vin du pays* they conversed "as if this old man and his wife had been known to me for years." Afterward they went over to the main studio, where Rodin showed Zweig his latest work, "a portrait of a woman"—probably Eve Fairfax—which was still covered with wet cloths:

> *"Admirable"* escaped from my lips, and at once I was ashamed of my banality. But with quiet objectivity in which not a trace of pride could have been found, he murmured, looking at his own work, merely agreeing: *"N'est-ce pas?"* Then he hesitated. "Only there at the shoulder . . . just a moment." He threw off his coat, put on a white smock, picked up a spatula and with a masterly stroke on the shoulder smoothed the soft material so that it seemed the skin of a living, breathing woman. Again he stepped back. "And now here," he muttered. Again the effect was increased by a tiny detail. Then he no longer spoke. He would step forward, then retreat, look at the figure in a mirror, mutter and utter unintelligible sounds, make changes and corrections. His eyes, which at table had been amiably inattentive, now flashed with strange lights, and he seemed to have grown larger and younger. He worked, worked, worked, with the entire passion and force of his heavy body; whenever he stepped forward or back the floor creaked. But he heard nothing. . . . He had forgotten me entirely.
>
> So it went on for a quarter or half an hour, I cannot recall how long. . . . Rodin was so engrossed, so rapt in his work that not even a thunderstroke would have roused him. His movements became harder, almost angry. A sort of wildness or drunkenness had come over him. Then his hands became

hesitant. They seemed to have realized there was nothing more for them to do. Once, twice, three times he stepped back without making any changes. Then he muttered something softly into his beard, and placed the cloths gently about the figure as one places a shawl round the shoulders of a beloved woman. He took a deep breath and relaxed. His figure seemed to grow heavier again. The fire had died out. . . . He stepped to the door. As he started to unlock it, he discovered me and stared at me almost angrily: who was this young stranger who had slunk into his studio? But in the next moment he remembered and almost ashamed, came towards me. *"Pardon, Monsieur,"* he began. But I did not let him finish. I merely grasped his hand in gratitude. I would have preferred to kiss it.

There were other busts in the offing but none that would engage Rodin's interest half as much as the head of Eve Fairfax. His next British subject was George Wyndham, "the most elegant man in England," who came over to Paris at the end of May "to be 'busted' by Rodin," as he proudly informed his friends. Wyndham stayed at a hotel in Bellevue while the sculptor worked on his portrait. "You may imagine how I delighted in Rodin for four or five solid hours a day," he wrote to his sister Pamela on May 24. "I stand for ¼ hour and then talk for ten minutes. We have run over the whole Universe lightly, but deeply. His conversation runs something like this:— 'Beauty is everywhere; in the human body, in trees, animals, hills, in every part of the body, in old age as well as youth. Everything is beautiful. The *modelé* [the form or surface] is unique. God has made it to reflect light and retain shadow. . . . I don't read Greek; the Greeks speak to me through their works. . . . All right, yes, look . . . let's take a rest . . . (showing one of his groups) . . . This is *la Main de Dieu* [The Hand of God]. It rises out of the rock, out of chaos, out of the clouds. It has a sculptor's thumb, certainly. It takes the dust of the ground and from it Adam and Eve are created. Woman is man's crown. Life, energy is everything. . . . These gates? Yes, they'll soon be finished. I have worked on them for twenty years. But I have learned a lot during that time. At first I was in search of movement. Later I realized that the Greeks found life in repose. It's all that matters. Where there's life, the sculpture pleases.' "

Wyndham spent much of his time in Paris with friends and acquaintances among the French aristocracy, whose opinions both fascinated and appalled him. After lunching with his legitimist friend the Duchesse de Luynes he wrote to his sister that they were "children, arrested in intelligence," and hopelessly narrow-minded: "They hate us (as a nation; love us as friends), hate Jews, Americans, the present and last two centuries, the Government, Rodin, the future, the Fine Arts . . . '*nous détestons Rodin.*' "

At least some of these attitudes were endemic in the French upper class, yet there were many aristocrats with at least as many quarterings who thought the world of Rodin, both as a sculptor and a dinner guest. The Duke of Rohan, who traced his origins to the kings of Brittany, was soon to sit for his portrait, as did the Baron Paul d'Estournelles de Constant, a distinguished diplomat and political figure whose activities on behalf of international conciliation earned him a Nobel Peace Prize in 1909. (It was for d'Estournelles de Constant that Carrière painted *le Baiser de la Paix* in 1903.) But of all the aristocrats whose heads passed through Rodin's hands during the decade, the most remarkable was that of Countess Anna de Noailles, the sloe-eyed "*princesse orientale*" who was also a fashionable poetess. Rodin had been carrying on a mild epistolary flirtation with the Countess since 1901, when she had sent him her first slim volume of verse, *le Coeur innombrable*, and he—with an inattentiveness not at all usual with him—had thanked her for "your book *Ames innombrables* . . . your poetry is natural, with an antique air of ease that also strikes me as wholly natural."

Marcel Proust told her that she dominated literary Paris like "that Carthaginian goddess who inspired in all men the stirrings of desire, and in some the instincts of piety." Anatole France thought she had "genius"; she became indispensable to Maurice Barrès and to Jean Cocteau, who fell under the spell of "the beauty of this little person, the lovely sound of her voice, which she placed at the service of a wonderfully droll sense of descriptive humor." Born in Paris in 1876, she was the daughter of a Rumanian prince and of a Greek princess. At twenty-one she had married Count Mathieu de Noailles, whom she bore a son three years later. But her real passion was reserved for the literary life, to which she devoted all the sensitivity and

brilliance that made her, by general consent, "one of the most remarkable people of our epoch."

The Countess wanted a portrait of herself by Rodin and he was happy to oblige, inviting her to pose for him early in December 1905. The sittings took place behind closed doors at the rue de l'Université, but afterwards she related her adventures with Rodin to Barrès, who recorded her account word for word in one of the *cahiers* that served as his diary:

"Rodin. The first day. I arrived late. He was about to leave the studio. He took me by the hands, by the arms, and made me sit down. He threw quantities of coke into the furnace and I said, 'But Monsieur Rodin, I should be doing that.' He showed me all his statues. I guessed when I shouldn't look and I talked without looking, without having seen, and passed on to the next. I said my piece about every object. A woman who was present left the studio. He told me, 'No, you stay.' How can one disobey a genius?

"He was on his knees before me. He held my feet in his hands, and it struck me as natural. He told me, 'I have never really seen you before; I never see when I don't look [*Je ne vois jamais quand je ne regarde pas*]. You have the head of a little Greek primitive. I want to do your bust.' We agreed that I would come on Tuesday. He smells of wine, it's as though he were in a dreamlike fog but at the same time he has a sly eye. He has a very bad reputation; he's got himself into trouble. But he respects me so much; all his gestures are reverential: this old man accompanied me bareheaded all the way to my car.

[Later, at the first sitting:] "He showed me some drawings, magnificent drawings of women, but ought one to think of drawing such things? One in particular, how could that shameless woman have dared take her melancholy pleasure in front of that old artist? He was watching to see my reaction. Very respectfully. I avoided looking at them and I said ever so naturally, '*Allons*, Monsieur, I'm no longer cold; let's start working.'

"Genius is a remarkable thing: in an instant he had put the nose, the mouth, the eyes, the ears in their place, with a wonderful sense of order and tranquillity; the resemblance is already there.

"I maintain my reserve, my air of seriousness. I don't say, 'Is my eye large enough, Monsieur?' No pleasantries . . . He turns the key

in the door; that frightens me. People say he takes off his clothes. He points to the drawing and says, 'What a beautiful drawing one could make of you.' He says it between his teeth as if talking to himself. Perhaps I'm not supposed to hear. He plays the fool so as to try a lot of things and still be in a position to draw back. If the gendarmes arrive such people just look away and start to hum. One could also get the impression that he is motivated by an excess of respect for me: he kneels down, suddenly leaving his work, when I've recited some verse, and seizing my midriff he seems to do a tapping examination at waist level. I repulse him lightly and say, 'Let us pose Monsieur Rodin.' Since I'm sitting too low, he puts some blankets on a chair for me, and he wants to hold them there and not remove his hands till I've sat down. This is a false fool who manages to get his way thanks to his feigned air of distraction. I say 'I'm going to take my hat off.' He says quietly, paternally: 'Certainly, make yourself comfortable. What does it matter? Nobody can come.'

"He says he doesn't know what is meant by beauty; that the Mona Lisa is old, ugly and yet beautiful. What he loves in me is the expression of contemplative sensuality. He is so intelligent, he understands everything intelligent one says to him; he achieves order with great certainty, without fumbling. He tires me out with his way of looking at me, of imagining me naked; I'm worn out by the need to fight for my dignity against his hunter's gaze."

Predictably there was trouble over the portrait when, after years of intermittent work, it was finally executed in marble. The Countess was accustomed to seeing herself full face in society portraits that minimized the bump on the bridge of her nose. Rodin gave her what may well have been her first real opportunity to see herself from the side, as others saw her. In any case she disliked the result and decided that the bust "did not resemble" her.

Rodin, though reportedly incensed, wrote her a polite letter apologizing for having had "the bad luck not to be able to please you." Fortunately the rejected bust did not lack a buyer: it was one of ten works which the Metropolitan Museum bought from the sculptor during the summer of 1910, thanks to a gift of $25,000 from the financier Thomas Fortune Ryan. Rodin duly asked the Countess's permission "to call it either by your name or *Minerva*, since the bust should not simply be a *buste inconnu*." She objected that it resembled her so

much "that the arbitrary name *Minerva* won't make it sufficiently impersonal"—it ought to be made unrecognizable before going to the Metropolitan. She came to Meudon in person to express her dissatisfaction "not in poetry but in sufficiently vehement prose," as Marcelle Tirel records. "I have no luck with women," Rodin said afterward, "even when they are poetesses."

The marble entered the Metropolitan's inventory as "Madame X," and the accompanying checklist noted the sitter's refusal to accept the bust, as well as Rodin's comment that "otherwise she was a very intelligent person." Even so he did not really bear her a grudge. "I am still and will always be your admirer," he wrote to her gallantly, "being profoundly cognizant of your so very natural and powerful talent. And later I could still do my utmost to please you by making a great many modifications in the bust."

>✠<

Rodin had gone to London to open the International Society's Whistler Memorial Exhibition on February 22, 1905, and in the spring he accepted a commission for a monument to Whistler that was to be placed at the western end of the gardens on Chelsea Embankment, facing Cheyne Walk. The monument was sponsored by an offshoot of the International Society—a committee of Whistlerians that included George Wyndham, the publisher William Heinemann, Joseph Pennell and the new Lord Grimthorpe. It was not to be a statue of Whistler but an allegorical figure, a Winged Victory symbolizing Whistler's triumph—"the triumph of Art over the Enemies," as Pennell described it to Rodin. The sculptor readily agreed to produce something of the kind, delighted that he was not being asked for a posthumous portrait: "As he said, he had never made a portrait of Whistler and would not think of faking one."

Rodin offered to undertake the commission without charge, "save for the casting and other technical work, the cost of which he estimated at 50,000 francs, then $10,000 [or £2,000]."* The money was to be

*The offer was less generous than it sounded. Little more than ten years later the first curator of the Musée Rodin, Léonce Bénédite, estimated that if the monument were sold for the agreed price of 50,000 francs, casting costs would amount to 20,000 francs and the rest would be clear profit.

raised mainly among British and American contributors; the town of Lowell, Massachusetts, agreed to purchase a second cast of the monument, to be placed before the house in which Whistler was born. To launch the enterprise Gosse gave a fund-raising speech in which he declared that Whistler deserved this monument "because he added a sense of beauty to our world. Let no one call that a little matter."

Some of the painter's friends objected that "Whistler wished no memorial of himself by Rodin," but the Pennells could remember no such caveat; only that Whistler had once said that he wanted to have no portrait, like Rossetti's in the same garden, "with a tap in his tummy." Rodin, at all events, was at pains to emphasize the cordial relations that had existed between Whistler and himself. "Whistler liked my form of sculpture," he told the *Pall Mall Gazette* in February, "but he never said so to me personally. He was very reserved in his praise. I knew him well. The last occasion I saw him was in London, just before he died. I lunched with him and two or three friends."

It was sheer chance that the model he chose for the Whistler monument was an English—or rather Welsh—art student, Gwen John, who had studied with Whistler in 1898 at the so-called Académie Carmen in Paris. Whistler, moreover, had praised her work, which had already won her a prize for figure composition at the Slade. "Your sister has a fine sense of tone," he had told Augustus John, then regarded as one of the most promising of young British painters. It was Augustus who had written to Gwen in the spring of 1904, when she returned to Paris and took up modeling for a living: "Why not call on Rodin. He loves English young ladies."

Gwen John turned twenty-eight on June 22, 1904. She met Rodin through the Finnish sculptress Hilda Flodin, who was twenty-seven and worked as one of the studio assistants at the Dépôt des Marbres. Flodin's sculpture appealed to Rodin not only because he slept with her on occasion. "You take your work very seriously," he told her, "and you do good work—extremely good work!" Although she was pert and pretty she considered herself unattractive, and her earnest attempts to cater to Rodin's wishes tended to go comically awry: once, when she invited him to visit her studio, he arrived an hour early to find Hilda on hands and knees, scrubbing the floor with her skirts rolled up, and flustered to be caught in such an attitude. Rodin, of course, was utterly delighted.

Gwen John was thus introduced to Rodin by a young woman who had both a sexual and professional relationship with him, and soon found herself in the same position. The maître, who decided she had "*un corps admirable*," began by hiring her to pose for him and then got in the habit of sleeping with her when the posing sessions were over and the other assistants had gone home. Sometimes Hilda Flodin would join in their lovemaking to form what Alice Mirbeau would have called *le groupe de Carpeaux*. But it was Gwen who was the more passionately in love with Rodin, and who became neurotically dependent on him.

Neither Hilda nor Rodin had any idea at the time that Gwen John would one day be regarded as one of the great British painters of the century—and that her drawings would be more avidly collected than his.* Rodin liked her anonymously, as it were, both as a body and as a woman. He took a paternal interest in her welfare, arranging for her to move out of her hotel on the boulevard Edgar-Quinet to a room of her own in the rue St-Placide—within easier walking distance of his studio. She was touchingly grateful for such favors, or indeed for any sign that he reciprocated something of the obsessive emotion he had aroused in her. "Rodin suggested my leaving my room this afternoon and taking an unfurnished one—wasn't it kind of him," she wrote to her friend Ursula Tyrwhitt, a former fellow student at the Slade. "Because he knew nothing about my room—he thought it would be nicer to be '*chez moi*' & he is going to pay the 3 months' rent which one has to give in advance, also to furnish it, if I will allow him but I don't think I shall allow that."

As long as she still posed for him regularly her life revolved entirely around Rodin and their frequent lovemaking. It was quite true that he loved English young ladies; there were times when her body felt worn out and yet she pleaded for more. When she lost weight she became worried about maintaining her *corps admirable*: "I am getting quite thin. Rodin says I am too thin for his statue & that I don't eat enough—but I rarely have time to eat."

She was very shy with him, she said, because his thoughts were beyond her in wisdom and she felt stupid by comparison. Thinking

*In 1946 Augustus John made a prediction that seems well on the way to fulfillment: "Fifty years hence I shall be remembered only as the brother of Gwen John."

that perhaps the way to his heart was through art, she brought him drawings of her cat for his approval. He did, indeed, praise what he saw of her work, and she reported proudly to her brother that Rodin had told her, *"vous êtes bel artiste."* But although he was to have an inestimable influence on her life, Gwen John meant little to him—in fact, he knew her not as Gwen but as Mary John, or *"votre obéissante modèle Marie."* To the sculptor's friends and employees she was just another of the "hysterical models," as Judith Cladel referred to them; a rather embarrassing by-product of the maître's overabundant sexuality.* "Miss John signed Marie John when writing to Rodin—perhaps on account of Rodin's inability to pronounce foreign names," as René Chéruy recalled. "She became of course like many others Rodin's mistress, and like many others he broke her like a stem of glass when, the posing being over, she continued to visit the studio too often. Rodin being very independent did not suffer to be imposed on."

He did several head studies of what Chéruy called "the unattractive face of Gwen John" (presumably on account of her large nose and receding chin)—although it "seemed to have enthused Rodin, who made several copies of it." He also did two or three figure studies of the nude Gwen John in a curious pose—bending over and with her left foot resting on a high support, so that her knee was level with her breast. One version of this figure, partly draped in a sort of sarong dipped in plaster, was exhibited at the Salon of 1908 as the main element of the future monument to Whistler, though now it was no longer a Winged Victory but a Muse Climbing the Mountain of Fame. In the maquette the Muse's arms were cut off below the breastline; it was reported that when completed the figure was to bend over a portrait medallion of Whistler, as though to render him homage.

Yet for a variety of reasons Rodin failed to take the Muse beyond the armless stage. And after he had modeled Gwen's admirable body in clay she herself was dismissed from the center of his sexual stage and banished to the wings. From then on her role was to wait for his

*Cladel thought she was called Mary Jones. But Rodin was never under the impression that her name was John Marie, as some writers have suggested. "Mlle John, Marie" was, and still is, for old-fashioned Frenchmen, the standard form of addressing a letter to someone named Marie John.

weekly visit with mounting desperation and uncertainty: "What a life you give me now! What is it I have done to you, *mon maître?* You know that my heart is profound. . . ." She moved again, first to an attic room in the eighteenth-century Hôtel de Montmorency in the rue du Cherche-Midi, then to a studio space in a narrow backstreet full of artists, the rue de l'Ouest.

She would shut herself up in her room, painting a little and waiting for him, often for days on end, while she grew increasingly anxious to see him and communicate with him. The act of lovemaking was terribly important to her, but usually he was with her only once a week; a little more often at the beginning. She did not have enough coal to keep her room warm all day, but she made a point of keeping it well warmed during the hours she expected him.

The French have a name for this kind of relationship: she had become his *cinq-à-sept,* the lover one sees from five to seven, after work and before going home. In her case the caresses lasted barely an hour: he would make love to her, give her an orgasm, and then go instantly off. One problem was that Rodin believed in the old superstition that loss of semen meant loss of strength and creative potency. As time went on he became less and less willing to expend it on his *cinq-à-sept.*

In his autobiography, *Chiaroscuro,* Augustus John tried to read some redeeming love interest into Rodin's surviving letters to his sister, but most of them are little more than perfunctory messages of assignation: "Till Saturday at nine o'clock or half-past nine," or "Five o'clock Saturday afternoon," punctuated with exhortations—*"Ne vous désespérez pas"*; "Don't make yourself ill"; "Take care of yourself because you are pale," and *"Ma bonne petite amie, courage."* He gave her well-meant advice: "This letter is to tell you to continue taking your *promenades* because you'll soon be posing. I'm thinking of coming to see you today at half-past twelve, affectionately. . . ." Sometimes the tone was more romantic: *"Courage, petite amie;* I'm tired and old but I love your little devoted heart . . . patience and no violence." Her devotion had led to humiliating scenes with his concierge, who now had instructions to keep Marie John from pestering the maître. When Rodin did want to see her in his studio he was obliged to add, "Take this letter with you to show to the concierge if necessary."

On the one hand she was quite prepared to accept this marginal existence as a perpetually waiting woman. "One can be more free & independent in the mind & heart sometimes when one is tied practically. The girls in some harems of I forget where I read it, are more wonderful & advanced than any other women." Yet she was also possessed of a terrible impatience that drove her to write him three letters a day for months on end, protesting all the while that she did not want him to be burdened by her love any more than by the wind in the country or the leaves that fall from the trees. The total came to 2,000 letters whose existence he acknowledged only on rare occasions: "I am your friend, alas very tired, but who reads your letters (very touching) and who loves you."

Many of her letters were addressed to an imaginary confidante named Julie, to whom she could relate her adventures with Rodin in a little-girl style, almost as though she were writing a children's story. "Dear Julie," she writes on February 28, 1906. "I have dressed and washed today and was with my master by 5 o'clock. . . . The concierge, as so often, disturbed us, but Rodin was calm at once. Anyway, I have promised to tell you of daily events, and not to speak too much of love. When Rodin and I left he took my coat and said, 'Are you coming with me, Mademoiselle?' (Because we were in front of the concierge.) We walked side by side to the station, having a most interesting talk. As usual he said he was old but for me he is young. When I got back to my room I went on my knees and gave thanks."

After a time Gwen John began to realize that she was being much too kind and devoted to hold his interest. "I have had some scenes with Rodin & he is always adorable at the end," she informed Ursula Tyrwhitt in June 1908. "I see these scenes are necessary to him, but I wish they did not make me so ill":

I have been very stupid in never scolding him enough. I see now that I should have done so much more—there is no one else but me to do it; everybody spoils him. I scold him therefore now, but what I say runs off him like water off a duck's back. I have been inspired to write things, to make them more serious, & found it answered only too well—he came like a poor punished child & then I had remorse. In my letters I said dreadful

things—I said "if you met a dying dog you would still be too '*bousculé par le monde*' *pour faire attention* [too "bothered by everybody" to pay attention]." Do you think that was very bad? He is always saying he is too "*bousculé par le monde.*" I said other things, & called him "*Impoli*"; that is a dreadful thing to say to him. I adore him & so it is dreadful to be angry with him—I see that I must be so, though.

"Nobody suffered from frustrated love as she did," Augustus John noted in *Chiaroscuro*. Perhaps if he had been blessed with an authoritarian personality like Paul Claudel's, he would have had his sister locked up in an asylum. As it was she survived the alarums of living with and without Rodin, and became a great painter. When it came to her art she was as tough and inviolable as if nothing else existed. Once she was asked her opinion of an exhibition of Cézanne watercolors. "These are very good," she said in her scarcely audible voice, "but I prefer my own." Alone in her room, she painted some of the most sensitive interiors and portraits in the history of painting. She wrote to him that her room was so pretty that it inspired her— with *Pamela* (one of his favorite books) in the bookcase, her drawings above the bed and flowers on the mantelpiece; she would draw herself reflected in the wardrobe mirror, in the Dutch manner.

Her drawings evolved, among other things, into two Dürer-like self-portraits, or quasi-self portraits, suffused with a surrealist intensity: *A Lady Reading*, now in the Tate Gallery, and *Girl Reading in the Window*, in the Museum of Modern Art. It is not known whether Rodin ever saw these paintings, or what he thought of them if he did; perhaps he knew only her drawings and watercolors. Gwen John, in any case, felt that the professional lessons that Rodin had given her were well worth the emotional anguish they cost her. She never stopped looking to him for instruction in the essence of her art. "I should like to be able to tell you things Rodin says," she wrote to Ursula Tyrwhitt in November 1908:

I will try to, or at least something of what he means—as to his own words I can't remember them or sentences or phrases. No I can't even do that—but I know he is *in love* with Nature & by such virtues as patience & humility he has got to understand

her. But after all when one is in love there are no such virtues as patience & humility because being in love means everything. But if one did not say Rodin is in love with Nature one might say he works with humility & patience.

Most people who think they are following Rodin are contemptible & detestable too, because they are dishonest. They imitate certain appearances of his work, they think they have taken a short cut—but they have missed everything. There is only one way to follow Rodin & that way is to study Nature with this humble & patient love. Some artists who admire him are afraid to be accused of being under his influence. But if you are *really* influenced by him you are strong. It is the same as being influenced by Nature, by Life. Your work need not resemble his except in that it is good.

He would say very little if he came round to give you a lesson because he never says much in criticising, he would never tell you to think of the old masters or say anything that they say in schools but in a moment he would make you see how good or bad your work is. . . . If we wanted to do an arm, for instance, we should try to do a portrait of it. Not think of any theories & maxims. Observe the grace of life, make it without timidity—not be preoccupied by the details but not leave gaps either.

No great artist has ever had a more gifted and receptive pupil than Rodin had in Gwen John. But he had reached the stage where he sensed the need for something different: a woman who offered more resistance, a kind of emotional friction that would make him feel stimulated and alive. In lieu of the unassuming woman who signed her letters "your obedient model" he chose a restless society woman of forty who signed herself *ta petite fureur*—your little fury—and called herself the Duchesse de Choiseul. Actually, this soi-disant duchess was, like so many titled ladies of fin-de-siècle France, a well-connected American from New York—née Claire Coudert in 1864 and married in 1891, in St. Patrick's Cathedral, to the impecunious Charles, eighth Marquess of Choiseul-Beaupré, who afterwards assumed the *style* of duke on the rather shaky grounds that as "head of his house" he could revive a quondam Choiseul title that had

become extinct. No matter: France was a republic, and titles were something one printed on visiting cards.

For Rodin, at least, she was a duchess and something more: a woman who brought a breath of fresh air into the increasingly stuffy atmosphere of a studio filled with sycophants. She had a sense of humor and loved elaborate practical jokes; she knew something of the great world and thought it was time Rodin belonged to it. What if she was "a vain American termagant" and "ignorant as a fish about art"—henceforth the great sculptor had a duchess as an Egeria, a "quick, brisk little figure of a woman with brilliantly dyed hair, a tiny, wiry waist, great eyes and red lips," as Alice Lowther once described her, "looking oddly alert and modern in a fashionable dress and a gay hat." With Gwen John he had always talked about feeling old, but the Duchesse de Choiseul made him feel like a child—"he is like a big baby with her," reported Edward Perry Warren's friend John Marshall. "She leads him a life at times, I think, but he recognizes her devotion and repays it fully. It is beautiful to see them walking together, like father and daughter, or husband and wife." In the company of such a woman, Rodin felt, life could well begin at sixty-five.

15

THE SULTAN OF MEUDON

*Any man who, being a contemporary of Rodin,
deliberately allowed his bust to be made by
any one else, must go down to posterity (if
he went down at all) as a stupendous nin-
compoop.*

—BERNARD SHAW

After she dropped out of Rodin's life people could think of
only awful things to say about the Duchesse de Choiseul—
that she had been a circus performer in America, for
instance, and had horsewhipped her husband into mar-
rying her. In fact there had been no need for such extreme measures.
Charles de Choiseul had been so short of money when he first came
to New York that he and a friend had been obliged to live in furnished
rooms above a French restaurant on West Thirty-sixth Street, ac-
quiring "a reputation for parsimony that antagonized all the *garçons*
in the house," as the gossip-mongering *Town Topics* reported. His
marriage to Claire Coudert solved his most pressing financial problems
and, as the saying went, "refurbished the coat of arms" of Choiseul-
Beaupré, a distinguished family that traced its ancestry to the tenth
century. Claire, too, was of French descent: her father, Charles Cou-
dert, was a socially prominent lawyer—"When I was a little girl I used
to say that I was the daughter of the Coudert Brothers of New York"—
and one of her five sisters was the glamorous Mrs. Condé Nast, wife
of the publisher of *Vogue.*

The young couple went to live in France—in Paris, Versailles
and the Château du Bois-le-Houx, in Ille-et-Vilaine. Claire had been

[486]

the life of the party in America, and her French château gave her even more scope for practical jokes. Her new neighbors were staid, rich and fearful of Parisian morality. To tease them she arranged a party for a "Parisian dancer" at which everyone expected to be scandalized. Instead, they got to see Claire disguised as a shepherdess, "dressed up in a peruke and leading a lamb" in a series of pseudo-rococo dances that bored everyone to tears: they could have brought the children after all.

The Duc and Duchesse had, however, been exceptionally unlucky in their efforts to produce an heir. Their first child, a boy, lived for only two years; another son also died in childhood and something went wrong when she was expecting her third baby: a caesarean operation was performed and "the child was cut piecemeal out of her body." In the aftermath she suffered terribly from peritonitis and developed a lasting case of bulimia: people were shocked to find that after eating a meal she would excuse herself and rush to the bathroom to throw up. After the caesarean and the death of her second child she met Rodin by chance at the home of a friend and decided that "the greatest artist living" needed someone intelligent to look after him. "Something in his face" told her that Rodin liked her, but he struck her as "very poorly dressed, gauche in his manner, disheartened and almost beaten."

She made up her mind "to do what she could for him, to act as his daughter and protect him from his many enemies." The Duc—"being a gambler with no moral sense," as Chéruy testifies—offered no objection: on the contrary, he was proud of the relationship his wife formed with the famous sculptor. The real stumbling block was "Madame Rodin," whom the Duchesse came to regard as "one of his main enemies"—since she was not really his wife but only an illiterate servant who would never be able to understand Rodin's greatness, and secretly "longed that he should remain poor."

At first Claire denied any intention of separating Rodin and Rose; she wanted him merely to be "freed from her influence." Afterward she made no bones about having used her wiles "to get hold of him." Yet weaning him away from Rose was no easy matter, especially since Rodin had grown increasingly fond of taking Rose on his evening walks and Sunday excursions.

Instinctively the Duchesse began her campaign in an area where

no one could compete with a pragmatic American society woman—
Rodin's sales. A few years later she could boast of having raised his
income from 60,000 to 400,000 francs a year. She persuaded him
to let her take over the task of receiving visitors at the Dépôt des
Marbres, and her sales technique was simple but effective: "Rich
Americans come in and I show them his work. How much is that?
Five thousand dollars [then 25,000 francs]. They think it too much:
but they go round the studio till they find a work which they like
much. How much must I pay for that? Twenty-five thousand dollars,
and you won't get it then."

Chéruy, the long-suffering secretary, noted disapprovingly that all
at once Rodin's prices shot up, and that "under the evil influence of
the marquise, Rodin who was so modest in his prices before, began
to lose the notion of right and wrong." The *Ombre* (Shade), for ex-
ample, which he used to sell in bronze for 18,000 francs, went up to
60,000. Chéruy himself, who left Rodin after more than six years
and made a trip to the United States in 1908, remembered being
"dumbfounded and heartbroken" to discover, on his return, "what
the influence of the marquise had done to my dear old master." An
American friend had asked Chéruy to buy for him a certain small
bronze—an early Rodin group—and the sculptor agreed to the normal
price of 8,000 francs. Before placing the definitive order, however,
Chéruy wrote away for confirmation, and by the time he received the
reply Rodin had changed his mind. "You understand," he told his
former secretary, "that when I sell the *Ombre* to Ryan for 60,000
francs I cannot be interested in little things!"

"But M. Rodin," Chéruy said, "you had given me your word."

"Well, if I gave it, I take it back."

By then the Duchesse was firmly in charge of Rodin's Paris sales,
and as she told Marshall, she "put all his money in the bank and
made it sure that he shall have money in plenty during his old age."
Their personal relationship had, during 1906 and 1907, gradually
escalated into a passionate affair—though for Rodin, of course, it
was only one among several. Now it was her turn to send him endless
protestations of the kind he was accustomed to receiving from so many
women. "I would like to be this piece of paper," she wrote, "to be
held for a few instants in your dear hands." She showered him with
baisers and told him he was *mon idole*; "I re-live the blessed hours

when all my happiness was to be at your side and loving you—caressing you!" It had been unforgettable "to have been yours in the sweet hours of the night."

She had the annoying habit of representing even her ailments and indispositions as the stigmata of an undying love. "My poor heart beats weakly but it beats for you, my dearly beloved," she wrote to him on March 26, 1907. "In these hours of physical and moral suffering your dear memory has been my sole consolation. The memory of the blessed hours passed in your arms has kept me alive. *Je t'aime* . . . ! But now you know how much! Since the supreme moment when I gave myself to you! I have given you the greatest proof of love because you are the only being in the world who has had me body and soul *dans l'amour*." Yet for the time being there was no question of Rodin leaving Rose or discontinuing his visits to Gwen John. She contented herself with taking over the management of his diet as well as his finances. "She has made him far stronger than he ever was before and quite happy," Marshall decided. "He allows her even to see him at work with a model—a thing no one has ever been allowed to do before."

Before long she herself had become one of his sitters. Her faunlike face fascinated him, and he experimented with different approaches to it. One of his busts has her head turned to one side and her face convulsed in laughter—conceivably during one of her not-infrequent moments of tipsiness. Rodin said it made her look "like a petite Bacchante," but when she objected to it he dutifully produced a calmer, more conventional bust which, in token of its importance, was executed in the finest Parian marble from the Greek islands. According to her own account there was also another bust: "a most unfortunate affair—a number of accidents happened to that bust before it was completed, and finally, when it was ready and was to be shipped to the exhibition another accident occurred and the work was destroyed. That bust was one of the very finest works of the master."

The sittings for these busts were sporadic and emotionally charged affairs. "Some days Rodin thought she looked tired; other days he felt she had done her hair badly," recalled Marcelle Tirel, a relative of the Duchesse's dressmaker who joined the Meudon staff as a secretary in 1906. "When the clay was well advanced he suddenly

noticed that she wore false hair to disguise her sparse, graying hair. From that day on he paid attention only to the structure of her face. Madame de Choiseul lay down on the floor on her back, her head turned towards the light, her neck held firmly between his knees, while he modeled with blows of the thumb, first touching her flesh and then the clay—with his thumb still warm, so to speak, from touching her. During one sitting at which I was present he told her that the skin was becoming flabby: she jumped up brusquely and ordered me out. After that they kept the door locked for more than an hour."

What does emerge from the many jaundiced accounts of Rodin's self-proclaimed "Muse" is the fact that she brought a sense of fun into his studio and did wonders for his morale. She made him buy a gramophone and a set of records ranging from early church music to Caruso singing *Tosca*. On occasion, after having fortified herself from the liqueurs kept in Rodin's antique Norman cupboard, she would "slip an American cakewalk on the phonograph, which brayed it forth with a whistling accompaniment while she danced rowdily." But Rodin's particular favorite was a certain bourrée, a high-stepping folk dance from the Auvergne. "The Muse would dance to this and Rodin would take his notebook of *pensées* and move to a corner. . . . The Muse draped herself in a black or green shawl—he called it her aegis—and danced for him. . . . As a matter of fact her performance was a parody of the bourrée: with her high kicks, forward and backward contortions and her scarf ballooning through the air, it was more like a burlesque cancan."

Mademoiselle Tirel would wind and rewind the gramophone to play the same piece a dozen times over while Rodin jotted down the thoughts he later polished into a sort of prose-poem for *l'Art et les Artistes*:

> She begins. She has within herself that instinct of pride which she displays as her hallmark. She moves the way a scimitar flashes through the air, gleaming with light; the drapery follows and seconds her. . . . The prodigious *petite amie* who dances— a conqueror like the flame. An archaic Minerva, she advances—what a charming attitude!
>
> That doubling, those taps of the foot, that balancing, that

attack, that shield borne before her. . . . she rushes with low-ered head, but when she is tired her head seems to swim on her shoulders; it's Ophelia's tiredness. . . .

While she dances she is bathed in light—my light, the pulsations of my heart, which also beats time. How much farther the voice of the body may go than that of the spirit. How his dance gives her a strangely beautiful head, now mysterious and distant. . . . !

Claire de Choiseul was not only a passionate dancer but a com-pulsive talker. Some people found her a fascinating conversationalist and Rodin thought her one of the wits of Paris. John Marshall de-scribed her as "a very fine and delightful woman . . . the more won-derful of the pair." She held him spellbound with "a wonderful exhibition of talk," as he wrote to Edward Perry Warren. "There is little in Anatole France which could beat her conversation, or rather mono-logue. 'A pity she cannot write it,' said Rodin, 'but she cannot write anything—anything.' Which means, I suppose, that she has tried." Yet despite Marshall's enthusiasm for "the woman who is running Rodin," he noted that "there isn't anything in life which she doesn't know," and on this account she was "too sure of herself, too much wrapped up in herself—she is the heroine of all her tales—she doesn't like other people talking when she is at table. She is in fact a very bright, but somewhat commonplace, Parisian lady, with a title which she values very, *very* highly, very proud of her husband—whom Rodin, by the way, once spoke disparagingly of, when she was not near—as amusing as a monkey, full of deviltry, with no manners, except what her husband has taught her."

Though Poincaré and Rochefort were said to have been fond of her, most of Rodin's friends and hangers-on detested her. Chéruy wrote that "morally she ruined him, keeping his friends away, in short, chasing away insidiously anyone who might have opened his eyes—which would have been difficult anyway." Cladel painted an unflattering portrait of the lady, "chattering ceaselessly beneath a tray-shaped hat waving with ostrich plumes; painted, powdered, her hair dyed and her mouth painted crimson, she seemed a music-hall girl turned woman of the world." Worse yet, the Duchesse interrupted serious conversations with her "idle prattle and laughter," and in-

dulged in public intimacies that seemed merely comic, considering their ages: " 'I am your Muse,' she would simper, running her diamond-laden fingers through the handsome old man's white hair. "

What most annoyed serious women like Cladel and Tirel was to see the maître bewitched by such an unserious woman; they felt that only her title could have made her interesting to an artist of his stature. "She was very proud of the name she had acquired by marriage and of her social connections, which she always pretended to have sacrificed for Rodin," Tirel noted. "She would talk of dukes, counts and marquises, and speak of Edward VII as 'my cousin' and 'our great friend.' " It was frustrating to see Rodin, "this great *naïf*," taking it all in without realizing the absurdity of her chatter. "If the king of France were restored to the throne," she boasted, "I would have one of the foremost places at court, and I would be the jewel in the crown of France." According to Tirel's version of events, there was only one point in her favor—that she brought order to his business affairs and straightened out his studios: for the first time everything was neat. Moreover, "she washed his face, put on his boots, dressed his hair, helped him put on his clothes and put up with his bad temper without complaint."

Rainer Maria Rilke also disliked her—but he was sensitive enough to understand what it was that Rodin saw in this woman. In November 1909, he wrote to Clara Westhoff that Rodin and the Muse had invited him to listen to the phonograph—"I was rather worried when I realized that they wanted me to join them." But to his surprise "it was wonderful; they've bought some records with old Gregorian chants that nobody likes. . . . Perhaps this is what Rodin really needs right now; someone who treats him carefully and a little childishly, and who descends with him from all the peaks he always lands on; he used to stay up there."

>∗<

Rilke, who had returned to Paris in September 1905, had quickly been conscripted into Rodin's household as a sort of protégé-cum-letter writer—a position vacated not long before by the young musician Edgar Varèse, who had caught Rodin's eye when he visited the Dépôt des Marbres for the first time in February of that year. After Rodin had given Varèse the run of the studio, he had asked

his bushy-haired visitor: "Tell me, young man, what did you like best?" Without hesitation Varèse had pointed to a Tanagra figurine that Rodin had just received as a gift.

Instead of being annoyed, Rodin had offered him a job at Meudon, where he was lodged in one of the outbuildings. "His duties were not arduous," writes Louise Varèse; "some clerical work, letters, and so on, and on the days Rodin spent in Paris he was expected to meet the six o'clock train which brought Rodin back to Meudon." Varèse was able to spend most of his time composing music, a subject in which the sculptor took a surprising amount of interest, talking to him at length about his plans and prospects. But Varèse—even at the outset of his career as one of the great innovators of twentieth-century music—was notoriously stubborn and hotheaded. Rodin's remarks began to irritate him. "He didn't know a damn thing about music," Varèse remembered. *"Il disait des âneries comme s'il était le bon Dieu* [he uttered asininities as if he were God almighty]." Inevitably there was a fatal quarrel, as Louise Varèse records: "Always rashly outspoken and at the moment unreasonably angered, Varèse called Rodin *'un con'* (no equivalent in English), a very insulting and indecent epithet which seemed to dart out of Varèse's mouth of its own accord whenever he was disgusted beyond words. A relief word. Nor was he deterred by the consideration that Rodin was prepared to be useful to a very ambitious and a very poor young composer and future conductor. . . . The same afternoon Varèse left Meudon and never saw Rodin again."

His hasty departure left the situation vacant for Rilke, who accepted it without recognizing its inherent potential for mischief: the incumbent was expected to be brilliant and sensitive, yet he had to be selflessly devoted to the maître's welfare. Initially Rodin made it sound like a very casual assignment: "You'll help me out a little. It won't take up much of your time. Two hours every morning." The pay was 200 francs a month and free room and board, in a cottage at the bottom of the garden at the Villa des Brillants. Rilke thought of it as an invitation to paradise. "The idea of living in such close proximity to you makes my head spin," he wrote to Rodin. "Oh, yes! I want very much to be with you and listen to you night and day with all my heart, if you'll deign to speak to me."

At first Meudon lived up to its promise. "I am very, very well off;

we do everything together, and we understand each other completely," Rilke wrote to Clara on September 17. "In the evenings we go to bed at 9, but at 7:30 in the morning we are already together again. Today (Sunday) we drove to Versailles; he showed it to me, as well as the Grand Trianon." He lived in "a cottage all to myself" that Rodin had added to the expanding complex of houses and studios on his hillside: "three rooms, a bedroom, study and dressing-room, full of charming things, and the main window with all the broad splendors of the Sèvres valley, the bridge; the villages and things."

The important thing was to be once again in Rodin's company: "I can feel the strength rushing into me; I am overcome by a joie de vivre, a capacity for living, of which I had no inkling. His example is unequaled; his greatness rises before me like a tower. . . ." A few weeks after his arrival he told his friend Lili Kanitz-Menar that he and Rodin were now united "not only inwardly, through the understanding that has grown up between us . . . but also outwardly, through my desire to help him with his correspondence."

Now that he accompanied Rodin and Rose on some of their excursions he began to see "Madame Rodin" in a new light: "And while we talk of many things, Madame picks flowers and brings them to Rodin; autumn crocuses or leaves, or she calls our attention to pheasants, partridges, magpies (one day we had to go home early because she found a sick partridge that she took with her to nurse back to health), or she collects mushrooms for the coachman, who is sometimes consulted when it turns out that none of us know the name of a certain tree."

Rodin liked to get up at dawn and have the coachman drive him to the old church at Issy, where he enjoyed making sketches, or to the Ermitage of Villebon, or perhaps through the forest of Verrières to his favorite *auberge* at Malabry, where he often stopped for lunch. Eventually he bought a horse of his own named Rataplan, as well as an old coupé and a convertible victoria: after going through a whole series of coachmen who didn't please him he found one who did— Griffuelhe, who had been in the stock-raising business and knew a thing or two about horses. "Well, yes, I had good times in M. Rodin's service," Griffuelhe remembered in later years. "But what a fusspot he was! And Mme Rodin, too, was quite something. Occasionally,

when the horse needed exercise, he'd tell me, 'Use the opportunity to take your children for a ride!' "

Rilke noticed that the Villa des Brillants had been enlarged and improved since his last visit. "Now he's become prosperous: there is much more of the world around him; he has built several small houses on the land sloping down from the museum. And everything, houses, walks, studios and garden, is full of the most wonderful antiquities. . . ." In 1903 Rodin had bought a separate property on the chemin de Fleury, a two-story former laundry known as la Goulette aux Moines (now No. 15, rue Docteur-Arnaudet), which served as a workshop for marble cutters, as a storehouse for large sculptures and as living quarters of a *gardien*. Upstairs, in a large, sunny room, he kept sketches and drawings.

The garden, overgrown with flowers and shrubs, contained a spring for which Rodin had constructed a stone basin in which he kept the swans he had been given by Camille Groult, an industrialist and art collector. The spring flowed from a stone trough on which a life-size figure of a woman with long hair, seen from the back, had been carved in bas-relief. Next to the Villa des Brillants Rodin had purchased a piece of land—in Rose's name—on which he had a contractor re-erect the neoclassical façade of the recently demolished Château d'Issy. (It had once been the pleasure palace of the Prince de Conti but was gutted by fire during the siege of 1871.) On the same piece of land he had also constructed a small "museum of antiquities," and on an artificial mound in the garden he had placed a large Khmer Buddha that intrigued Rilke, who wrote a poem about it. "I said to Rodin, '*c'est le centre du monde*,' " he wrote to Clara. "And then he gives you such a gentle look; so very much a friend. That's very beautiful and means a great deal to me."

But Rilke sensed that Rodin's fame and affluence had only complicated his life. "He can't even find a suitable secretary who relieves him of the need to write letters"—René Chéruy had gone to Germany on leave of absence—"let alone someone who really helps him actively with his work. 'My pupils,' he says sadly, 'think they have to overcome me, they have to surpass me. They're against me. No one helps me.' He's truly more alone than ever."

Auguste Beuret, who might have been expected to be of some

assistance, had turned out to be too addle-brained to help his father. He had done a little engraving, had become a roustabout and had taken to dealing in old clothes: when in desperate straits he would go secretly to Meudon, where his mother provided him with food, funds and some of his father's cast-off clothing. "The son seems to be an awful scoundrel," reported Ottilie McLaren, who heard that he had "done something awful." A friend of hers witnessed a painful scene—"Rodin white as paper saying to his son, 'I don't know you, I don't know you!' " For years Rodin was careful to keep this embarrassing person at arm's length; among the more telling documents of their fiercely Oedipal relationship is a letter from the sculptor to his son dated August 18, 1904, and addressed to *Mon cher ami, Monsieur*: "I have the honor to enclose herewith the sum of 100 francs, and ask you to accept the assurance of my most cordial and distinguished sentiments. A. Rodin."

In the absence of a son who might have measured up to expectations, Rodin tried repeatedly to establish a paternal relationship with an artist-disciple worthy of his confidence. For a time the young Spanish painter Ignacio Zuloaga seemed ideally cast for the part. Rodin enjoyed his company and liked his work so much that he gave Zuloaga three of his sculptures in exchange for a promised painting almost as soon as they met, in 1904—a gift that led the painter to write him: "I am mad with joy thanks to your three bronzes in my atelier, which I caress constantly and which inspire me to work."

It was Zuloaga who persuaded Rodin to accompany him to Spain in the spring of 1905, together with the wealthy Russian art collector Ivan Ivanovich Shchukin. They arrived in Madrid on June 4, and spent five days there before going south on a brief tour of Cordoba and Seville. Their itinerary included a bullfight, a banquet in Rodin's honor and visits to the main Madrid galleries, notably the Prado and the Ermita of San Antonio de la Florida, with its murals by Goya. "But he was not enthusiastic about either Goya or El Greco," Zuloaga recalled, "or rather, seeing them in Spain disappointed him. He thought El Greco couldn't draw. On the other hand he liked Velázquez. What impressed him most in Madrid was the equestrian statue [of Felipe IV, by Pietro Tacca] in the Plaza de Oriente, and an ancient Greek torso of a woman in the Prado."

They went to Toledo by automobile—an invention that still caused something of a sensation on the unpaved highways of Spain. "When we got to Esquivias [near Toledo] a peasant riding a mule suddenly blocked the road. The car hit him and we almost turned over. Rodin was very upset and gave the poor man, who was hurt, all the money he had in his wallet; about 800 or 900 pesetas [then more than a year's wages for a farm worker]." In nearby Illescas they looked at El Greco's paintings in the Hospital de la Caridad, but "it didn't interest him at all. What he did like was the local wine, some eggs swimming in oil and the black bread they served us in a taverna. He liked the wine so well that afterwards he had some shipped to Paris."

In Toledo he admired the city but El Greco still left him cold. "He doesn't know how to draw," he kept on telling Zuloaga, who became exasperated. The issue came to a head in Cordoba, where Rodin advised the painter against buying El Greco's *Apocalyptic Vision*, which a doctor had offered to sell him for 1,000 pesetas. "When Rodin saw it he said, 'Have you gone mad? Don't buy it!' So I asked him not to mention El Greco again." When they arrived back at the French border Rodin told him that what he liked best about Spain were the plains of Castile and the elaborately sculptured façades of the post-baroque architect José Churriguera, creator of the opulent style known as *churrigueresco*. "The emptiness and austerity of the plain, the grandeur of its spaces, had touched him deeply . . . and so had the admirable profusion of Churriguera, in whom he saw a profound relationship to the soil of Spain."

On his return to Meudon Rodin wrote to Zuloaga: "I hope you realize that you've destroyed my wine cellar. After our trip to Spain I was astonished to find that the little wine in my *cave* is only vinegar. And I haven't forgotten the landscape: it seems to me I can see Spain from my windows." He even became reconciled to El Greco's *Apocalyptic Vision* when he saw it again in Zuloaga's Paris studio, where he spent hours studying the picture (which now hangs in the Metropolitan). "I'm beginning to like it," he finally admitted. Yet there were aspects of Spain that had disappointed him. "He came back rather disgusted," as Rilke noted, "by the food, the mail service and yes, by the Spanish themselves: the revolting slaughter of horses during the bullfight and the pleasure they take in it, was almost

enough to spoil everything for him." This lack of comprehension of things Spanish also prevented his acquaintance with Zuloaga from ripening into a more intimate friendship—though Rodin continued to insist that the Aragonese painter was "the best of [living] Spanish artists . . . worth more than all the rest."

Rilke, meanwhile, who wanted nothing more than to become Rodin's artist-disciple, began to suspect that he was merely being exploited. "I write, I would gladly say, a hundred letters every day, for the maître in the morning and for myself in the afternoon," he told Clara. But later he wrote to Rodin that "instead of two hours a day, I didn't hesitate to give you almost all my time and all my energy (unfortunately I don't have too much of it) for seven months. I have neglected my own work for a long time, yet how happy I was to be able to serve you. . . ." If the work had been more interesting he would not have minded, but as he complained to Georg Brandes, "the biggest part of what goes by the name of correspondence is an unworthy affair that consumes time and energy like a hungry animal."

He was happiest when Rodin took him along on his errands and excursions—to Notre-Dame and the Latin Quarter; to a chamber music concert at the Société de Géographie, and to the monkey house in the Bois de Boulogne after eating breakfast with Prince Paul Troubetzkoy, the young Russian sculptor who had just completed a statuette of Rodin with his hands in his pockets. They also went to have tea with Nathalie de Golouboff, a statuesque Russian blonde in her early twenties who had sat for one of Rodin's most striking portraits— a bust first exhibited at the Salon d'Automne of 1905. Rodin had shown her bosom swelling as if she were drawing breath while singing, for the lady was endowed with a superb operatic voice. She lived in a vast apartment off the Bois de Boulogne with an immensely rich husband who was an Orientalist and collector of Persian miniatures. "It was a fine quiet hour amid the fragrance of Russian tea and in the presence of her slow, very Russian beauty and size," Rilke reported. "The marble resembles her more than the plaster, which only reveals the lighter side of her being. Her husband, Monsieur de Golouboff,* is the perfect Russian nobleman but mentally very agile

*Among Rodin's and Victor de Golouboff's common interests was a passion for Indian sculpture. It was for Golouboff's magazine *Ars Asiatica* that Rodin jotted down his

and with a beautiful collection (think of it!) of antique books of hours; he has large estates, a château and a park in the Ukraine, and a stud-farm where he raises Arabian horses."

On January 25, 1906, Rodin, Rose and Rilke went to Chartres by train to see the cathedral. Rodin had, as usual, been fulminating against the "barbaric restorations" then being inflicted on Gothic cathedrals, and Rilke's account of the visit echoes these strictures. "Much, almost everything has been spoiled; only here and there a piece begins to gaze, dream, smile into infinity," he wrote to Clara. "Unfortunately it's very, very cold, so that one can hardly stand still, and it's snowing. . . ." As they approached the cathedral from the station, "a wind suddenly arose like a giant and cut right through us like a cold blade." Rilke wondered aloud if a storm were in the offing. "But don't you know," Rodin said, "there's always a wind, this kind of wind, around the great cathedrals. They are always enveloped by a wind that is agitated, tormented by their grandeur. It's the wind that hits the buttresses and falls from the heights to dash in and out among the neighboring streets."

Even in this icy *vent errant* they stopped to admire the detail that most impressed them: "a weathered, slender angel, holding a sundial—opened like a book to the passage of the day's hours—and above it, endlessly beautiful even in decay, the hearty laughter of the angel's obliging face, like a reflection of heaven." The angel was shortly to reappear in Rilke's *"l'Ange du Méridien (Chartres),"* one of the sonnets in his *Neue Gedichte,* which mentions "the storm that falls upon the mighty cathedral like a heretic" and describes the "laughing angel . . . with a mouth made of a hundred mouths." Several more of these *New Poems* were indebted to his Rodin apprenticeship for their subject matter, such as "Die Kathedrale," "Das Portal," "Die Fensterrose" ("The Rose Window"), "Tanagra," "Der Marmorkarren," "Archaischer Torso Apollos" and a whole sheaf of "antiquity

meditations on *The Dance of Shiva*—a figure whose bronze body seemed "ready to spring to life, as the light changes," and whose elongated leg muscles "contain nothing but speed." Nathalie Golouboff, however, was soon to become the inamorata of Gabriele D'Annunzio, who thought this "Caucasian Diana" resembled a goddess—"Your divine mouth rendered my body divine"—and for whose voice he wrote *Fedra,* with music by Ildebrando Pizzetti.

poems." Accordingly, the second volume of *Neue Gedichte* is dedicated *"A Mon Grand Ami Auguste Rodin."*

Rodin, too, was to publish a paean to this recording angel—in the huge book on *les Cathédrales de France* for which he was gradually assembling notes and sketches:

L'Ange de Chartres! . . . Always the miracle dazzles me. This pride, this nobility! The Angel of Chartres is like a bird perched on the point of some high promontory; like a living star beaming out from its solitude over these great stone foundations.

Rilke had written a new essay on Rodin—a lecture which he delivered in Dresden and Prague at the end of October, and rewrote for inclusion in the second edition of his book on Rodin. It contained many of the Rodin maxims and bons mots that Rilke had collected during the first weeks of his assistantship; on the early morning walks, for example, when the maître went to see "the animals and the trees *chez eux*" and found himself surrounded by moral lessons. "Look," he would say, picking up a mushroom and turning it upside down, "it only takes one night; in a single night all these gills are formed. That's good work." Rilke treasured these homilies and concluded his lecture with a peroration based on Rodin's *pensées*: "In the houses of the eighteenth century and in its formal gardens he recognized, rather sadly, the last face of the inner world of a lost epoch. And in this face he saw the essence of a relationship to nature that has since been lost."

Rilke's lecture was too philosophical to mention the less exalted moments that gave life at Meudon its particular flavor, but he reported them in his letters to Clara. "Today at 6 A.M. I was awakened by a voice I didn't know, a very rich male voice, singing very loud in the garden. I saw no one . . . but at breakfast Madame Rodin came down and whispered happily, 'Monsieur Rodin got up very early today; he went down to the garden, he was down there with his dogs, his swans, and he sang, he sang everywhere, everywhere, at the top of his voice. Then he took his café and went back to bed, and now he's asleep.' "

Nothing ever seemed to annoy Rilke, who conducted himself as the most sedulous clerical assistant, but he was rather surprised to

find that kindly old Madame Rodin, whom he adored, had a miserly streak: "Madame Rodin, showed us a doll this evening which Josette [Van Rasbourgh's granddaughter] once received and which she, Mme R., has kept for herself these past four years, ostensibly because Josette breaks everything—but basically, I suppose, because she too would like to have a doll. When Rodin suddenly suggested, very generously, 'You know, *ma vieille*, you can send that doll to Monsieur Rilke's little daughter,' she was upset and almost in tears, so that I emphatically declined the offer. That really would have been too much! To have taken away the doll that Mme Rodin can show off so proudly—it has eyes that open and close, and even long dark eyelashes."

Early one morning Rodin took Rilke with him to Paris to have breakfast with Charles Morice and Eugène Carrière. They arranged with Carrière to meet them again at noon in the rue de l'Université, and when the painter kept them waiting, Rodin was quite unruffled. He "glanced at the clock once or twice while going through his mail, but when I looked up again, I found him completely absorbed in his work. That's how he spends his waiting time!" Carrière, as Rodin well knew, was already mortally ill with cancer of the throat. "I hear you've been ill," he had written his old friend by way of encouragement. "Brace yourself against the absurdities and defend yourself against the doctors!" He had presided over the testimonial dinner that Carrière's friends had organized in December 1904, when more than 600 men and women came to Clichy to pay their respects— though Carrière felt that their praises were more like "disguised farewells." He tried to put a brave face on his increasingly painful condition, but in October 1905 he painted his last picture, a portrait of his sister, flinging his brush into a corner after putting on the finishing touches: "*C'est fini, je ne peindrai plus.*"

Carrière had only five months to live, and meanwhile Rodin did his best to carry out his wishes. He wrote to John Lavery of the International Society:

Carrière, who is ill and confined to his bed after a terrible operation, has asked to be shown at our exhibition. He wants to send that beautiful canvas called *Tendresse*. I do not know if it is too late now, but in any case please telegraph me yes

or no, and tell me if there is still a place of honor for Carrière if he does exhibit. I thank you deeply for all you have done for my friends.

Rodin went to see Carrière toward the end and came away hating himself for having made a terrible scene. "I am in such a state of distress beside a deathbed that I have a mad longing to say something cruel," he explained afterward. "I said nothing but stupidities, of which I am still ashamed, when I was with my friend Carrière, whom I loved with all my heart. I suffered so much, seeing him die! If only I were a weaker man and able to shed tears! Other people's tears drive me out of my mind. Suddenly I'm beside myself and become brutal." Yet on the day of his friend's death—March 27, 1906—Rodin was among the first to call on the family and express his condolences. The next day it was his *mouleurs* who made Carrière's death mask and took casts of his hands in the presence of a police *commissaire*. Later he spoke briefly at the graveside—of Carrière, who had been poor but "showed us the wealth there is in love"; whose genius was compounded of *forces naturelles*, and whose work had "secretly fascinated" a host of admirers, to whom he had shown "that wonderful land which is ourselves."

><

Three weeks later, on April 21, Rodin attended the ceremonial unveiling of *The Thinker* outside the Panthéon—an enterprise which he regarded as one of the crowning achievements of his career, and of which Carrière and Albert Besnard had jointly been *présidents d'honneur*. It had taken two years and a major journalistic effort to raise the 15,000 francs needed for this bronze cast of the enlarged *Penseur*, and to obtain government approval for the site. The idea had originated with Gabriel Mourey, editor of *les Arts de la Vie*, who then collaborated with Gustave Geffroy in a campaign to "give our country and city this *Penseur* as an example of beauty and a lesson in existence." The choice of the site had been Rodin's own; significantly, it was only a short distance from the teeming neighborhood where he was born. His supporters saw this project as an opportunity for the world of art to make amends for past slights and injuries. Though Rodin felt, as he told Berta Szeps, that "never could mankind

make good the wrongs they have done me—not even if I live for another two hundred years," the *Penseur* subscription represented a conscious effort to show the maître that he was far more widely loved and admired than he seemed to realize.

Among the scores of prominent names on the subscription committee were Ernest Beckett, Bourdelle, Bracquemond, Frank Brangwyn, Jules Claretie, Armand Dayot (the new Inspecteur des Beaux-Arts), Emile Gallé, Paul Gallimard, Frantz Jourdain, Count Kessler, Max Klinger, Jean-Paul Laurens, Lavery, Camille Lemonnier, Max Liebermann, Maurice Maeterlinck, Roger Marx, Octave Maus, Constantin Meunier, Mirbeau, Maillard, Anna de Noailles and her brother Prince Constantin de Brancovan, Monet, Montesquiou, Poincaré, Marcel Prévost (then president of the Société des Gens de Lettres), Rochefort, Roll, Van Rysselberghe, Sargent, Séverine, Arthur Symons, Edmond Turquet, Verhaeren and George Wyndham. The list was all the more remarkable in that it brought together notables of both the left and the right—of both the pro- and anti-Dreyfus factions. "Rodin is an excellent worker for national reconciliation," an editorial in *la Liberté* pointed out. "The committee that has just been formed to buy Rodin's *Penseur* is composed of the best enemies in the world."

Paris, as Roger Marx reminded the readers of *les Arts de la Vie*, still "had no monument by Rodin to be seen by daylight in a public square." Bourdelle declared in an open letter that it was "time that Paris demonstrates that it possesses very great sculptors." *The Thinker*, said Robert de Montesquiou, would "console our public gardens for so many mediocre effigies, bourgeois deifications and paltry allegories." Elie Faure wrote that the *Penseur* would compensate Rodin "for the permanent outrage inflicted on him for so long" by the academic establishment. Carrière had seen the figure as a democratic symbol: "Its place is in the crowd, among the people. . . ." Here for once, said Pierre Baudin, was a statue whose subject was *man*—"neither prince nor lord, conqueror or bourgeois."

Support for the idea came in the form of contributions both large and small. The city council of Prague appropriated 200 crowns (210 francs) to place a Rodin statue in front of the *temple de la Gloire* where France had buried Rousseau, Voltaire and Victor Hugo. Small sums arrived anonymously, or under pseudonyms: one franc came from "*Vive la Pensée Libre*" and five francs from "Two Grateful Souls."

Most of the old guard—Pierre Louÿs, Lemonnier, Geffroy, Paul Hervieu, Van Rysselberghe—gave ten, twenty or fifty francs; they were not affluent. Wealthier admirers contributed 100 francs or more: Montesquiou, Kessler, Poincaré, Wyndham et al., and there were 200 francs from the newly prosperous Claude Monet. "Thanks to the friends who gave at the last moment the subscription has closed at a very suitable figure," Rodin announced in December 1904—he meant Fenaille and Baron Vitta, who had contributed 2,000 francs each to round out the purse.

But raising the money was not the end of the affair. Rodin was not yet everybody's culture hero, and there was a broadsheet poem denouncing both him and the *Penseur* for defying God, no less: "Your work is a terror, and to subscribe would be certain error." On January 16, 1905, when a plaster cast of the *Penseur* was actually set up in front of the Panthéon to try out its effect, it was smashed to pieces by a lunatic iconoclast who scaled the iron fence around the building by night in order to attack the figure with a hatchet.* *Le Rire* had a full page of fun with this incident: it pictured Rodin telling the apprehended malefactor, *le Rodinophobe*, "You'd do well, my friend, to knock down the Panthéon as well, because it makes a damn awkward backdrop to my statue."

Some of the critics never became reconciled to *The Thinker* even after it had been installed, in carefully patinated bronze. The Symbolist Joséphin Péladan thought the *Penseur* "has no occiput and suggests a scatological idea." Max Nordau, the critic who coined the term *Entartung* (decadence), wrote a vitriolic attack on Rodin in which he belabored "this oaf who calls himself so pretentiously The Thinker" for being a mere parody of Michelangelo. "His bestial countenance, with its bloated, contracted forehead, gazes as threateningly as midnight. He who has to interpret the figure without the help of a title will, from a back view, conclude it is someone writhing in agony on the rack; and from a front view, a criminal meditating over some foul deed." Nordau and Peladan, however, represented the rear guard of a retreating army. Most literati shared the enthusiasm of Arthur Sy-

The Thinker seems to bring out the worst in people. In 1970, a bronze cast of the *Penseur* owned by the Cleveland Museum of Art had its face cracked and its feet shattered by a dynamite bomb placed by another lunatic endeavoring to make an impression.

mons, who greeted the news of the impending *Penseur* with a poem in *The Saturday Review*:

> *Out of eternal bronze and mortal breath,*
> *And to the glory of man, me Rodin wrought,*
> *Before the gates of glory and of death*
> *I bear the burden of the pride of thought.*

Rodin worried, at first, that the *Penseur* would "have difficulty staying at the Panthéon," owing to political opposition, but in the end all the necessary permissions were obtained. It was duly unveiled with the assistance of Madame Segond-Weber of the Comédie Française, who declaimed poems by Victor Hugo, and of Etienne Dujardin-Beaumetz, the new *sous-secrétaire* of fine arts, who gave a long speech hailing Rodin as a "son of the people" who had endured trials and tribulations, and was "working at last in the radiant atmosphere of universal acclaim." The only unhappy participant in the proceedings was Henry Lebossé, who had been responsible for enlarging the *Penseur* from a small figure into a Titan. After the speech he turned naively to Rodin and said: "Yes, and not a word for me!" Rodin was not at a loss for an answer: "Well, take your share of what's been said!"

>‡<

Among the many notables who watched the unveiling was Rodin's latest sitter, George Bernard Shaw, whom Rilke—who spoke no English—had sized up correctly as a "most peculiar" author. Shaw had come to Paris to pose for his portrait, convinced that "Rodin was not only the greatest sculptor then living, but the greatest sculptor of his epoch: one of those extraordinary persons who, like Michelangelo, or Phidias, or Praxiteles, dominate whole ages as a fashionable favorite dominates a single London season. I saw, therefore, that any man who, being a contemporary of Rodin, deliberately allowed his bust to be made by any one else, must go down to posterity (if he went down at all) as a stupendous nincompoop."

Shaw, soon to celebrate his fiftieth birthday, had recently finished *Major Barbara* and *Man and Superman*, two successful plays that established beyond any doubt that this former theatre critic was the

most gifted British dramatist of the age. His wife, Charlotte, a wealthy woman in her own right, had decided she wanted a portrait bust of her husband—"before I had left the prime of life too far behind," as he put it. The price she was quoted—20,000 francs for a bust in bronze, 25,000 in marble—seemed reasonable enough: she sent Rodin a check for £1,000 and a letter expressing her conviction that this was her only chance "to assure a worthy memorial of my husband. He is like you an inveterate worker and you are the only artist he agrees to pose for."*

The Shaws had first met Rodin on March 1, 1906, during one of his brief visits to London, to open an International Society exhibition. When they arrived in Paris in mid-April they found him suffering from the aftereffects of a "horrible cold" that had confined him to bed for several days. The sittings were supposed to be held at the Dépôt des Marbres—the Shaws were staying nearby in the Grand Hôtel de la Gare on the quai d'Orsay—but Rodin wanted to avoid the strain of having to go into Paris every day: "after a little talk he asked, with some hesitation and an evident fear that he might be going too far, whether it would be at all possible for me to make daily journeys to Meudon and sit for him in his home studio," as Shaw reports, "and for the next month I spent my days at Meudon and became quite at home there." It was an unusual venue for sittings since Rodin ordinarily preferred to work in clay at his Paris studios.

Before the sittings began Charlotte Shaw said something to him about the way other artists and photographers had tried to depict her husband—whom she described as "the Voltaire of England"—as the Mephistopheles they imagined him to be: they were drawing his reputation without bothering to look at the man. Rodin, who had never read any of her husband's books, assured her, "I know nothing of Monsieur Shaw's reputation, but what is there I will give you."

Rilke had read Shaw's *The Man of Destiny* and did know something of his reputation: he was acquainted with Siegfried Trebitsch, Shaw's German translator, who had come to Paris to meet the playwright.

*Shaw, in fact, was one of the most often portrayed writers of the century, and posed *inter alia* for Paul Troubetskoy, Augustus John, Jacob Epstein, Jo Davidson, John Collier, Sigmund Strobl, Laura Knight, Neville Lytton and for Rodin's pupil Kathleen Bruce, once after she had become Lady Scott, and again when she had become Lady Kennet of the Dene.

Accordingly, Rilke was invited to watch some of the sittings. "Bernard Shaw comes to Meudon every day," he wrote to Clara, who had received classroom instruction from Rodin but had never observed him in his studio. "We see each other quite often, and I attended the first sittings and saw for the first time how Rodin actually goes about doing his work. He starts out with a sort of doll's head of hard-packed clay, which is nothing more than a sphere supported by another clay form vaguely resembling shoulders. This clay doll has been prepared for him and contains no armature; it holds together because it has been kneaded very thoroughly.—He began by placing his model a very short distance from the modeling stool—perhaps half a pace away. With a large pair of iron calipers he took the measurement from the crown of his head to the tip of his beard and at once reproduced this measurement by adding more clay to the clay sphere. Later, while working, he took two additional measurements: nose to the back of the head and ear to ear, measured from behind. After he had scooped out the arches of the eyes very quickly, so that something like a nose began to form, and had made a cut that established the position of the mouth, the way children do with a snowman, he began—with the sitter standing very close to him—to form first four profiles, then eight, then sixteen; and after every three minutes or so the sitter had to turn. He began with the front and back views and the two side views, as if he were applying four different drawings, vertically, to the clay sphere; then, between these contours, he added intermediate profiles, and so on.

"Yesterday, in the third sitting, he placed Shaw in a nice little child's chair (which gives this ironic and, incidentally, not uncongenial satirist a great deal of pleasure) and cut the head off the bust with a wire. (Shaw, to whom the bust already bore a peculiar and surpassing resemblance, greeted this decapitation with indescribable joy.) He then proceeded to work on the head, which lay flat, supported by two wedges, while looking at it from above—his view of it was more or less the same as of the sitter, who was sitting below him a step away.* Then the head was replaced on the shoulders, and the

*This was part of Rodin's usual procedure. "With absolute accuracy he slices off some clay, cuts off the head of the bust, and lays it upside down on a cushion," noted Judith Cladel during a sitting with the actress Hanako. "He then makes his model lie on a

work proceeded. Initially Shaw often stood very close to the modeling stand, so that his head was somewhat higher than the bust. Now he sits immediately next to it, just as high as the bust and parallel to it. A dark blanket hangs some distance behind him, so that the profiles show up very clearly. The maître works quickly, compressing hours into minutes, it seems to me; adding touch after touch and taking very short pauses in which he absorbs an indescribable amount, filling himself with the perception of form. One senses that these quick hands, swooping down like a bird of prey, always reproduce only one of the faces he perceives, and one can understand why he works from memory after the sittings have ended."

A few days later Rilke reported that the bust was "making tremendous progress thanks to the determination and energy that Shaw displays as a model. He stands there like something that has the will to stand. . . ." It was just as well that Shaw was a steadfast and imperturbable sitter. Rodin was in the habit of taking large mouthfuls of water and spitting them at the clay to keep it pliable: as Shaw later recalled, "He was so absorbed in his work that he sometimes missed his aim and soaked my clothes."

While the sittings were in progress Shaw wrote to Sydney Cockerell, curator of the Fitzwilliam Museum, that Rodin reminded him of his erstwhile friend and mentor William Morris: "the same stature & figure, the same way of looking quickly at his job when he is putting in a stroke of work* . . . He is perfectly simple and quite devilishly skilful at his work—not the smallest whiff of professionalism about him—cares about nothing but getting the thing accurate and making it live." And he wrote to the photographer Alvin Langdon Coburn, suggesting he come to Paris to photograph the sculptor. "No photo-

couch. Bent like a vivisector over his subject, he studies the structure of the skull seen from above, the jaws viewed from below, and the lines which join the head to the throat, and the nape of the neck to the spine. Then he chisels the features with the point of a pen-knife, bringing out the recesses of the eyelids, the nostrils, the curves of the mouth."

*Shaw later presented Rodin with a copy of Morris's masterpiece, the Kelmscott Chaucer, and wrote in it:

I have seen two masters at work: Morris who made this book:
The other Rodin the Great, who fashioned my head in clay.
I give the book to Rodin, scrawling my name in a nook
Of the shrine their works shall hallow when mine are dust by the way.

graph yet taken has touched him: Steichen was right to give him up and silhouette him. He is by a million chalks the biggest man you ever saw; all your other sitters are only fit to make gelatine to emulsify for his negative."

Coburn arrived posthaste and was introduced to Rodin at the Villa des Brillants. "I felt very shy about my sketchy French," he recalled, "but Shaw encouraged me: 'Plunge in, Coburn, your French cannot be worse than mine!' " He took photographs of Shaw and Rodin with the bust between them, and a series of portraits of the sculptor by himself: "He looked like an ancient patriarch or prophet, with his flowing beard and black scull-cap."

Shaw, who had been an art critic, was well aware that his sittings for Rodin were radically different from conventional portrait sessions, and he described them in an article published in *The Nation*.* This extraordinary sculptor, he wrote, "plodded along exactly as if he were a river god doing a job of well-building in a garden for three or four francs a day. When he was in doubt he measured me with an old iron dividers, and then measured the bust. If the bust's nose was too long, he sliced a bit out of it, and jammed the tip of it up to close the gap, with no more emotion or affectation than a glazier putting in a window pane. If the ear was in the wrong place, he cut it off and slapped it into its right place, excusing these cold-blooded mutilations to my wife (who half expected to see the already terribly animated clay bleed) by remarking that it was shorter than to make a new ear.

"Yet a succession of miracles took place as he worked. In the first fifteen minutes, in merely giving a suggestion of human shape to the lump of clay, he produced so spirited a thumbnail bust of me that I wanted to take it away and relieve him of further labor. It reminded me of a highly finished bust by Sarah Bernhardt, who is very clever with her fingers. But that phase vanished like a summer cloud as the bust evolved. I say evolved advisedly; for it passed through every stage in the evolution of art before my eyes in the course of a month.

"After that first fifteen minutes it sobered down into a careful

*For unexplained reasons, the standard American monograph, Albert E. Elsen's "Rodin," reproduces a large part of this article in an English translation from a French translation of Shaw's essay, which appeared in the newspaper *Gil Blas*—hence the discrepancy between that version and this one, which is Shaw's original.

representation of my features in their exact living dimensions. Then this representation mysteriously went back to the cradle of Christian art, at which point I again wanted to say: 'For Heaven's sake, stop and give me that: it is a Byzantine masterpiece.' Then it began to look as if Bernini had meddled with it. Then, to my horror, it smoothed out into a plausible, rather elegant piece of eighteenth-century work, almost as if Houdon had touched up a head by Canova or Thorwaldsen, or as if Leighton had tried his hand at eclecticism in bust-making. At this point Troubetskoy would have broken it with a hammer, and given it up with a wail of despair. Rodin contemplated it with an air of callous patience, and went on with his job, more like a river god turned plasterer than ever.

"Then another century passed in a single night; and the bust became a Rodin bust, and was the living head of which I carried the model on my shoulders. It was a process for the embryologist to study, not the aesthete. Rodin's hand worked, not as a sculptor's hand works, but as the Life Force works. What is more, I found that he was aware of it, quite simply. I no more think of Rodin as a celebrated sculptor than I think of Elijah as a well-known *littérateur* and forcible after-dinner speaker. His *Main de Dieu* is his own hand. That is why all the stuff written about him by professional art critics is such ludicrous cackle and piffle."

While Shaw posed he talked about himself—an activity for which he was famous—though he spoke only broken French. "As we talked and talked, in that lingua franca of philosophy and art which is common to all languages, I made myself known to Rodin as an intellectual and not as a savage, nor a pugilist, nor a gladiator. He gave that in the bust unmistakeably." The one thing that bothered Shaw was that Rodin seemed to have no sense of humor: "I think I saw him laugh once, when I took a specially sweet tit-bit from Madame Rodin and gave half of it to his dog Kap. I am not quite sure that he went as far as to laugh even then. Accordingly, the bust has no sense of humor. . . ." Shaw conceded that the language barrier might have prevented them from picking up each other's nuances. When a visitor asked Rodin whether Shaw spoke French well, the sculptor replied with his customary directness: "*Monsieur Shaw ne parle pas très bien; mais il s'exprime avec une telle violence qu'il s'impose.*" ("Mr. Shaw

does not speak French well, but he expresses himself with such violence that he makes an impression.")

Their conversations were overheard, in part, by the newly wedded Mr. and Mrs. Harley Granville-Barker, who had followed Shaw to Paris. As Lillah McCarthy she had recently played Ann to Granville-Barker's Jack Tanner in *Man and Superman*—Shaw saw her as "beautiful, plastic, statuesque, most handsomely made." Lillah writes in her memoirs that they went out to Meudon with the Shaws: the studio was "a huge room, floating like an ark upon the sea of a wonderful garden." Rodin had been working on the bust for some time when she first saw it. "It looked like the portrait of a pleasant, ordinary sort of man; but something that Shaw said at lunch that day attracted Rodin's attention and made him laugh. [So it was not true that Rodin only laughed once in Shaw's company.] From that moment Rodin watched his model like a lynx; G.B.S. was at his very best—he generally is. The next time I saw the bust it was changed. Rodin had discovered Shaw and the bust had become one of the finest pieces of his sculpture."

Rodin, at all events, saw "Bernarre Chuv"—his incorrigible pronunciation—as a man of many masks and several personae; perhaps that was why the bust had to undergo such an exhaustive metamorphosis. René Chéruy records that at one point Shaw's satanic locks, forked beard and sardonic smile prompted Rodin to say: "Do you know, you look like—like the devil!" And Shaw, who was accustomed to artists being fascinated by the red hair that grew from his forehead in "two Satanic whirls," answered with an obliging smile, "But I *am* the devil." Yet Rodin took care not to give his bust the Mephistophelean look that Charlotte Shaw had warned him against. "I am happy with the portrait, which does not have the cynicism you disliked in the painting," he wrote to her five weeks after the work was done. "On the contrary, M. Shaw has a great sensitivity which is, oddly enough, sometimes mistaken for cynicism, just as shyness is sometimes mistaken for pride. There is something in his character that is difficult to define, as in the *Giaconda*'s smile . . . nuances that cannot be interpreted quickly and at first glance." Rodin reported that many people had already complimented him on the bust: someone had called it the portrait "of a young Moses."

Later he was to expatiate at great length on the "Christlike" form and appearance of Shaw's head: *"Une vraie tête de Christ,"* he told Anthony Ludovici. But it was not true that he failed to appreciate Shaw's sense of humor, and he knew enough about Britain to recognize its source. When the American artist and writer Marie Van Vorst asked him whether Shaw had lived up to his reputation as a *cabotin,* Rodin talked to her about his model's remarkable sensitivity and "his keen Irish sense of humor. It is, in fact, to his Irish blood that Bernard Shaw, as we know him, is due. With the cold Anglo-Saxon current, only, in his veins, he would have proved the bore par excellence. . . ."

>✠<

While the bust was still in progress, Rilke wrote to Will Rothenstein—whom he had recently met in Paris—that Rodin had found Shaw the perfect model and that the portrait was already "vibrant with life and character." Rothenstein addressed his reply to Rilke personally—which infuriated Rodin when he found out about it, the more so as the German art collector Baron Thyssen had also just sent Rilke a letter that should have gone to the maître himself.

Without waiting for explanations, Rodin fired his impertinent amanuensis on the spot. "So here I am, chased from the house without notice like a thieving servant; driven from the little cottage where you yourself had the kindness to install me," Rilke wrote to Rodin as soon as he had caught his breath. "I am terribly hurt by what has happened. But I understand you." He had, in fact, been using his position as the Great Man's assistant to do a little social climbing: his carefully cultivated friendship with Sidonie Nádherný von Borutin, for example, began when he was delegated to show the baroness and her mother through the museum at Meudon. Old friends like Paula Modersohn-Becker had already come to the malicious conclusion that Rilke "wanted to increase the brightness of his small light by joining it to the shining rays of the great spirits of Europe." Still, René Chéruy—who was on leave at the time—thought it a "brutal" dismissal: Rilke had not realized that when one was working for Rodin "one had no right to know his friends. Rodin at times was most

'inhuman.' " In his memoirs, Rothenstein reasons that there must have been previous sources of irritation, and that "Rodin took any opportunity that presented itself to get rid of Rilke."

Rodin had made it very clear, at any rate, that in his present state of mind he was not a man to be trifled with. At the time there were so many tales going the rounds about his irritability and erratic behavior that Shaw felt obliged to reassure his friends: "All the stories about Rodin's madness are pure *mensonges.*" Yet Shaw's friend Arnold Bennett heard otherwise from his Parisian acquaintances, and noted in his journal on May 6, 1906: "Henri Havet stated definitely that he was going mad, was in fact mad. Of erotomania."

Certainly there were ample grounds for this assumption, since by ordinary standards he was sexually very active for a sixty-five-year-old. "The whole of Paris was talking about the not very savory details of his erotic adventures," noted the German philosopher Georg Simmel when he visited Rodin in 1905. It was true that every time an interesting young woman appeared on the horizon, the same compulsive comedy of errors was apt to be repeated—though that did not prevent him from trying again the next time. When the dancer Ruth St. Denis (née Ruth Dennis on a New Jersey farm in 1877) came to his studio for the first time in 1906,

Rodin and I exchanged our amenities in pantomime, and after a while he told me in French and pantomime that he wished to see my arms ripple and would I please remove my blouse. I was enormously impressed by this great man, but I felt a curious wave of reluctance to do as he asked. Shyly and unwillingly I removed my belt, undid the buttons of my shirtwaist, and revealed my little chemise. He equipped himself with a pad and some crayons and I turned my back on him and began to ripple my arms as I did in the *Incense.* As he worked he cried, "*Ses beaux jambes* [sic], *ses jambes extraordinaires— encore, encore!*" My vanity was fed, and I did not realize that while M. Rodin's pencil was busy his eyes were examining me questioningly. When he said I might rest I turned around, and before I could put on my blouse he came over and, kneeling beside my chair, began to kiss my arm from wrist to shoulder,

murmuring endearments. He started to embrace me, and I became very frightened.

A woman journalist entered the room at that moment and Ruth St. Denis was saved—though unlike Isadora Duncan she never regretted not having yielded to the Great God Pan. "Not only had he frightened me, but something more grave had happened. I had been disillusioned by a great artist, whom I found to be only an ordinary French sensualist."

There were countless adventures of the kind. The American-born Duchess of Marlborough, who saw him in action on both sides of the Channel, reported that Rodin "precipitated himself on every woman he met. You know—hands all over you." Even casual callers were not exempt. The daughter of an art dealer who delivered some prints to his studio never forgot the reception she got from Rodin: "His beard and hands were all over me." Friends spoke apologetically of his uncontrollable need to indulge his tactile sense, his passion for touching and caressing people and objects. As he grew older, according to one account, "in the course of a conversation his hands would caress and crush every breast and phallus within reach." Camille Mauclair called it a "superhuman sensuality, a force of nature."

Simmel, who was writing serious essays about the meaning of Rodin's sculpture, ventured to ask him whether it was true that "erotic sensuality" was the key to his life and art. "Of course I'm a sensual human being," Rodin said, "and my sensuality is continually aroused by the impressions I receive from my models—but this is not the sensuality of sex." Those who worked with him agreed that much of his libido was sublimated into clay—and the result, according to his sometime assistant Louis Dejean, was a very "delicate sensuality." Rodin "was not the old faun, of whom people have drawn a false picture," Dejean insisted, citing another praticien's experience as a case in point. One day, Jules Desbois was working on a scaffold in the studio "from where he could observe Rodin in the course of working in clay from a young female model who was stretched out on a model's table. When the sitting was over Rodin bent over the model and implanted a kiss on her belly." It was, Dejean said, a reverential gesture of gratitude for her beauty—but people who had never known Rodin could not be expected to understand the subtlety

of his "Pan-like" sensuality: "The true physiognomy of Rodin will not survive."

Indeed his perception of women was different from that of the conventional romantic temperament. "Madame," he said while working on the bust of Mary Hunter, the art-collecting wife of a British colliery owner, "your skin has the whiteness of turbot that one sees lying on the marble slabs of your amazing fishmongers; it looks as if it were bathed in milk. Ah, Madame . . ."—and with that, as Jacques-Emile Blanche records, "he kissed Mary's hand a little too greedily."

In this respect it was easier working with professional models, who did not have to be courted with elaborate metaphors. The Danish writer Georg Brandes heard from him about the wonderfully agile new model who had been posing for a series of dancing nudes. It was she who had discovered Rodin: "One day she jumped on my table while I was eating in a restaurant. Her agility surprised me. Then she disappeared. I made inquiries and found her again. Gradually she became very important to me as a model. She's exceedingly supple; she can take positions that normally only acrobats can assume. Yet she's not an acrobat, and it's not her suppleness that's important. The marvelous thing is that she's utterly primeval, the way people were in prehistoric times. . . . She has put me face to face with the earliest ages. Look at those slim legs, look at these clever feet. With these she could have climbed and lived in trees."

To have found a model like this was all the more fortunate because Rodin had become steadily more obsessed by poses focusing on the pudenda—"the arch of triumph of life, *pont de vérité, cercle de grâce,*" as he apostrophized it in one of his meditations on the Vénus de Milo. Sculptures and drawings of nudes with spread-eagled legs had by now become something of a Rodin hallmark. Erotic groups that were too shocking to be exposed to ordinary gaze were kept in a special cabinet in his big studio at Meudon. Privileged visitors were invited to follow him up a wooden staircase to a gallery with a large cupboard. "He would open its doors ceremoniously and take out small terra cottas that were delightfully lewd," as Gsell reported. "He would show them himself, or put one into his guest's hands and turn it this way and that, so that they could admire it from all angles."

The erotic drawings were more openly displayed, but presented something of a problem to writers from family magazines. Arthur

Symons went as far as an Edwardian could decently go in describing them to English readers:

> Here a woman faces you, her legs thrown above her head; here she faces you with her legs thrust out before her, the soles of the feet seen close and gigantic. She squats like a toad, she stretches herself like a cat, she stands rigid, she lies abandoned. Every movement of her body, violently agitated by the remembrance, or the expectation, of the act of desire, is seen at an expressive moment. She turns upon herself in a hundred attitudes, turning always upon the central pivot of the sex, which emphasizes itself with a fantastic and frightful monotony.

Bourdelle, in his introduction to an exhibition of Rodin drawings at the Galerie Bernheim in 1907, pointed out that for the maître "there are no beautiful or ugly parts of the body, no noble or ignoble parts." Indeed there was something quite innocent and dispassionate in these clinical drawings of the central pivot of the sex—or, as he liked to refer to it, "the Eternal Tunnel"—seen from every conceivable angle: some of them were almost topographic studies, a child's map for the rediscovery of a lost continent. Anatole France, for one, recognized their obsessional quality and decided that their "monotonous audacity" was becoming wearisome—that was what prompted his remark, already quoted, about Rodin's drawings depicting "hardly anything else but women displaying their you-know-what." Having arrived at this hypothesis, the novelist was naturally tempted to test its validity. "The other day I met Rodin at a friend's house," he told Gsell, "and he confided to me, with ecstatic delight, that he was making a series of water-color drawings of a delightful little model. 'This young woman,' he said, 'is Psyche herself. . . . But indeed, you who are a scholar, can you tell me what Psyche was like?' As I always endeavor to please people, I tried to answer his question. 'Psyche,' I said, 'was a little woman who readily displayed her you-know-what.' 'Ma foi!' exclaimed Rodin, 'that is exactly as I see her. You make me most happy.' "

But everyone was not as perceptive and understanding as Anatole France. When W. B. Yeats, Maud Gonne and the poet Ella Young saw some of these drawings during a visit to Rodin's studio in 1908—

"But you must see my pictures in the other room, my sketches. They are my great works!"—Yeats went reverently from one drawing to the next, but the women were too shocked to go on. "There is one thing I know about Rodin," Young told her companions. "He is mad, brutally and sensually mad. Perhaps it will never break out, but it shows in those sketches." Maud Gonne had already heard about the artist's madness: "It does break out. He has at times to be shut away. He is dangerous." At that point, as Young recalls in her memoirs, "a beautiful lady came in with her arms filled with red roses" intended for the maître. It may well have been his aristocratic new literary acolyte, Valentine de Saint-Point, whom Rodin compared to a Botticelli maiden, and who assured the readers of Juliette Adam's *Nouvelle Revue* that "All impurity of thought is left behind at the threshold of Rodin's studio, where the linear alchemy of sexuality and human flesh is transformed into architectural eternity."

Rodin himself had made the same point many times. "There should be no argument in regard to morality in art," he told a newspaper reporter. "There is no morality in nature." In June 1907 the magazine *Antée* published a wide-ranging literary debate on Rodin's *belles déclarations* that great art is beyond moral judgment: "In art, immorality cannot exist. Art is always sacred. Even if it takes for its subject the worst excesses of lust it can never be immoral since its purpose is truth of observation. . . . Every beautiful work bears witness to a victory its author has won over the difficulties of his task. . . . All of nature belongs to the artist. . . . What looms larger than desire? . . . Nothing is more moving than the maddened beast, dying of transports of pleasure. . . ."

Privately, Rodin's pleasures were in fact becoming more and more rarefied and epicurean. Gsell recalled being invited to watch the surrealist spectacle of several models dancing in eighteenth-century priestly vestments that Rodin had bought from a secondhand dealer. "Their faded colors—rose, mauve, sky-blue and sea-green—harmonized beautifully with their gold and silver embroidery. He asked three nude young women to put them on and whirl around in front of us. As they danced and turned, the chasubles flew open, revealing the girls' opaline flesh like the sepals of a flower glimpsed between opening petals. I think the touch of diabolism that spiced this spectacle heightened Rodin's enjoyment of it."

The summer of 1906 brought a fresh revelation: the royal dancers of King Sisowath of Cambodia, ruler of a still-mysterious French protectorate in Cochin-China. The forty-odd dancers and twelve musicians of the Cambodian court ballet were one of the principal attractions of the Colonial Exhibition then being held at Marseille. They caused a great stir among the cognoscenti but disappointed those who expected an exotic display of kootchie dancers and devadassis. For one thing the dancers were not conventionally pretty. As one surprised observer noted, "with their hard and close-cropped hair, their figures like those of striplings, their thin, muscular legs like those of young boys, their arms and hands like those of little girls, they seem to belong to no definite sex. They have something of the child about them, something of the young warrior of antiquity and something of the woman. Their usual dress, which is half feminine and half masculine, consisting of the famous *sampot* worn in creases between their knees and their hips and of a silk shawl confining their shoulders, crossed over the bust and knotted at the loins, tends to heighten this curious impression. But, in the absence of beauty, they possess grace, a supple, captivating, royal grace, which is present in their every attitude and gesture."

King Sisowath (the grandfather of Prince Norodom Sihanouk) had come to France attended not only by his dancers but by a retinue of over a hundred, including three of his ministers, four of his sons and eleven favorites, as well as chamberlains, ladies of the bedchamber and pages. When he arrived in Paris at the end of June, the court dancers first appeared at a garden party given at the Elysée Palace by the president of the Republic, Armand Fallières, and then—on July 10—at a gala performance held on the open-air stage of the Pré Catalan, in the Bois de Boulogne. Rodin was among the invited guests that evening. P. B. Gheusi of *le Figaro* saw "the great Rodin, ecstatic beside Valentine de Saint-Point, the vestal-elect of his new fervor, go into ecstasies over the little virgins of Phnom Penh, whose immaterial silhouettes he drew with infinite love. . . ." During the next few days he spent hours drawing the dancers in the gardens of the villa in the rue Malakoff where the Cambodians were staying; he also

used the opportunity to do several portrait drawings of the good-natured, eccentric Sisowath himself.

But after a few days the dancers had to return to Marseille to fulfill the rest of their engagement. "To study them more closely I followed them to Marseille," Rodin told Mario Meunier. "I arrived on a Sunday and went to the Villa des Glycines [to see the dancers]. I wanted to get my impressions on paper, but since all the artists' materials shops were closed I was obliged to go to a grocer and ask him to sell me wrapping paper on which to draw. The paper has since taken on the very beautiful gray tint and pearly quality of antique Japanese silks. I draw them with a pencil in my hand and the paper on my knees, enchanted by the beauty and character of their choric dances. The friezes of Angkor were coming to life before my very eyes. . . . I loved these Cambodian girls so much that I didn't know how to express my gratitude for the royal honor they had shown me in dancing and posing for me. I went to the Nouvelles Galeries to buy a basket of toys for them, and these divine children who dance for the gods hardly knew how to repay me for the happiness I had given them. They even talked about taking me with them."

Georges Bois, the fine arts delegate of the French colonial administration in Indochina, saw Rodin at work among the dancers: he was "feverishly excited and seemed thirty years younger thanks to this new outburst of enthusiasm." The drawings were so important to him that, for once, he became the consummate diplomat. The dancers had a short attention span: often a model would stop posing and start pouting. Rodin would go off and buy them little presents to bribe them into going on. "After a little while the model would want to escape again," Bois reported. "The maître, calm and gentle, and always patient—since he was unwilling to lose any of the short time remaining before the royal party's departure—would again submit to her whims. One day Rodin placed a sheet of white paper on his knee and said to the little Sap: 'Put your foot on this,' and then drew the outline of her foot with a pencil, saying 'Tomorrow you'll have your shoes, but now pose a little more for me!' Sap, having tired of atomizer bottles and cardboard cats, had asked her 'papa' for a pair of pumps. Every evening—ardent, happy but exhausted—Rodin would return to his hotel with his hands full of sketches, and collect his thoughts."

Thirty-five of the Cambodian drawings were among the 219 Rodin drawings displayed at the Galerie Bernheim in October 1907—an exhibition that gave the outcast Rilke a chance to assure his ex-employer of his undiminished devotion. "During these past weeks I spent nearly all my mornings at Bernheim's in a state of blissful astonishment," he wrote to Rodin. And again, a week later, on November 11: "Great and dear maître, you have entered far more deeply than you realize into the mystery of the Cambodian dances. . . . For me, these drawings were a revelation of the greatest profundity."

They also made a profound impression on Dujardin-Beaumetz, whom Rodin invited to a private viewing. The *sous-secrétaire* of fine arts thought he could detect in these drawings the seeds of "a new monumental style of fresco painting," and commissioned him to do a series of frescoes for the nationalized seminary at Saint-Sulpice, which the government intended to transform into a museum of contemporary art as an annex of the Luxembourg. In fact, nothing ever came of this project, and Rodin's response did not go beyond a few sketches, but the whole Cambodian episode served to rekindle his already considerable interest in Oriental art and Asian faces.

At the Colonial Exhibition, in addition to enjoying the Cambodian dancers, he had the pleasure of Loïe Fuller's company—she danced there four times on an outdoor stage, for audiences numbering in the tens of thousands. He and Loïe had their photograph taken in one of the rickshaws that plied the exhibition grounds; but more important, she introduced him to her protégée, the Japanese actress Hanako, who was also appearing in Marseille. Apparently he was instantly captivated by this tiny woman of thirty-eight whose theatrical specialty was melodramatic hara-kiri scenes or being murdered by jealous lovers. Her face fascinated him: he was to model it so often during the next ten years that there are fifty-three different busts of Hanako in the Musée Rodin. Though he was known for the multiplicity of his variorum readings of sitters' faces, he had never studied anyone else as intensively.

Her profession kept her traveling almost continuously. She toured Europe and America with a widely acclaimed troupe of Japanese actors performing pastiche plays that were dominated by her extraordinary stage personality. "Even her back is eloquent," wrote the American poet Edwin Markham about "the agile actress whom some

call the Japanese Duse." She was just under four feet tall. Born near Nagoya in 1868—her real name was Ohta Hisa, or alternately, Hisako Hohta—she had been a geisha and minor actress in Japan before coming to Europe in 1901 with an obscure troupe of dancers, musicians and acrobats. Loïe Fuller had discovered her talents—"she was pretty withal, refined, graceful, queer, and so individual as to stand out." Since the actress had an untranslatable name "which was longer than the moral law," as Loïe writes in her autobiography, the dancer shortened it to Hanako. Watching her play her first death scene—in a melodrama written by Fuller herself—had been a memorable experience:

> With little movements like those of a frightened child, with sighs, with cries as of a wounded bird, she rolled herself into a ball, seeming to reduce her thin body to a mere nothing so that it was lost in the folds of her heavy embroidered Japanese robe. Her face became immovable, as if petrified, but her eyes continued to reveal intense animation. Then some little hiccoughs convulsed her, she made a little outcry and then another one, so faint that it was hardly more than a sigh. Finally with great wide-open eyes she surveyed death, which had just overtaken her. It was thrilling.

Hanako began posing for Rodin early in 1907—when she was living with Loïe Fuller in the Cité du Retiro—and returned to his studio intermittently whenever her tours brought her back to Paris. Chéruy recalled what difficulties the sculptor had in communicating with her: when she came to Meudon with Loïe and a male Japanese companion "the conversation was nil, neither she nor the companion having any comprehension of French or English." In some of Rodin's portrait heads her expression is composed and serene, but many show her face distorted by rage, as she must have looked onstage miming anger and horror during her death scenes. Rodin wanted to represent her in what he called "the dying attitude." When Cladel watched him modeling one of these busts she noted that "Hanako did not pose like other people. Her features were contracted in an expression of cold, terrible rage. She had the look of a tiger, an expression thoroughly foreign to our Occidental countenances. With the force of will

which the Japanese display in the face of death, Hanako was enabled to hold this look for hours." But the actress herself conceded that holding this pose had been a terrible strain, since it was foreign to her normally cheerful countenance: "I felt funny for days afterward."

Rodin also made drawings of Hanako, and he persuaded her to pose for him in the nude—though only after Rose had talked her into it. He was delighted with her body. "She hasn't an ounce of fat," he told Paul Gsell. "Her muscles stand out as prominently as those of a fox terrier: her tendons are so strong that the joints to which they are attached have a thickness equal to that of the members themselves. She is so strong that she can stand as long as she likes on one leg while raising the other at right angles in front of her." Chéruy thought that Rodin's insistence on drawing Hanako in the nude might have sprung from "a faunesque curiosity of the aging sculptor rather than from a strictly artistic motive." Yet Rodin had never made any bones about his reasons for wanting to see his models with their clothes off. "A woman undressing, what a glorious sight!" he writes in the concluding chapter of les Cathédrales. "It is like the sun breaking through the clouds." And in his conversations with the American writer Warrington Dawson he arrived at the ultimate paradox: "The nude alone is well-dressed."

>‡<

More than ever before, Rodin was interested in sculpting real faces of living people rather than monuments to the dead, several of which remained unfinished in his ateliers. "Busts have more chance to survive than memorials, whose real place is the cemetery," he explained. Indeed every portrait bust was a challenge to the artist: "A human head is a universe and the portrait sculptor is an explorer."

The lengthening list of prominent Rodin busts was now increasingly dominated by British and American sitters. He had even agreed to go to Scotland in August 1905 to do a bust of the prime minister, Arthur Balfour, but owing to politically inclement weather the sittings were postponed and finally canceled. Instead, he did a bust of the titled Englishman whose name he pronounced as Ovardevaldant. Rodin had hired an English-speaking secretary, Anthony Ludovici— son of the painter Ludovici, of the International Society—and one of their first misunderstandings concerned this mysterious personage:

"But, young man, you are not going to make me believe that you have never heard of Ovardevaldant!" Ludovici allowed that he had not. "*Oh, ça c'est trop fort!*" Rodin cried, wondering what sort of fool he had employed. The gentleman in question, he explained, was a "*grand seigneur*"; he was "*extrêmement aisé*"; he was the head of an illustrious English family and was, in fact, "*un lord*—Lorrovarde-valdant.*" Whereupon Ludovici realized at last that they were talking about Lord Howard de Walden, or to be more exact, about Thomas Evelyn, eighth Baron Howard de Walden, who was only twenty-five when Rodin did his portrait but already one of the wealthiest men in Britain.

He had bought *les Bénédictions* for £480 and was happy to pay £1,000 for Rodin's stark image of himself as the perfect model of the aristocratic, elongated Englishman—for which he sat in November 1905. It was the first time Rodin had sculpted an English lord, and "his sense of medieval tradition was pleased," as Anita Leslie (Winston Churchill's cousin) heard from the sitter himself: "They interested each other and had many talks. . . . His power of concentration was amazing. The sweat poured off him, and he was tired out long before the model."

In England a few months later Rodin and John Tweed went to Saffron Walden to visit the young lord in his seventeenth-century manor, Audley's End. "Rodin was at ease in this old mansion" and soon "came off his perch as a *grand maître*." He took delight in observing a tame leopard his host had brought back from Africa: "It was kept in a large cage, and the sculptor waxed enthusiastic over its supple movements." When they visited the stables Rodin seemed to know a great deal about livestock, manure and crop rotation. "With farmers he talked of turnips," Leslie learned, "and with dilettantes he talked of noble aspirations."

The marble version of the bust and the first of four bronze casts were not ready to be sent to England until December 1906. George Moore had been to see Rodin about it, since he was advising Howard de Walden, an amateur poet, on matters both artistic and literary. He had also written to Lady Cunard, his lifelong inamorata, urging her to sit for a portrait as well. "Rodin is a man of sixty-five, so I would advise you to get the bust done this summer. There will always be motor cars and hunters, but when Rodin's hand begins to fail and

his eye begins to see less clearly there will be no more sculpture. The opinion of every artist is that no sculpture has been done since antiquity that for beauty of execution can compare with Rodin's. . . . Some think that what he does now is better than what he used to do. I don't. I would remind you that motor cars and hunters are passing things and drop into wreckage: but a bust outlasts Rome."

Yet it was not Nancy Cunard but Moore's "dear friend" Mary Hunter and her daughter Sylvia who made the pilgrimage to Paris and sat for Rodin busts. For Mary Hunter the circumstances were not altogether auspicious. "I have the grippe and at the same time Madame Hunter sits for me," Rodin complained to a friend. Both she and her daughter had already posed for Sargent. "Mr. Sargent is less lascivious; we discuss music together," she told Jacques-Emile Blanche. Rodin's advances, however, bothered her not at all: she was happy to have him as her houseguest when he came to London, and to add him to the list of notables—Henry James, Moore, Walter Sickert, Helleu, Sargent—who frequented the drawing rooms of her splendid town house at 30 Old Burlington Street and of her country estate, Hill Hall near Epping. The latter was a Tudor mansion which the Hunters had turned into a baroque museum filled with furniture and pictures picked up in Spain, Italy and Normandy. "I consider it my sacred duty," she told her sister, the composer Dame Ethel Smyth, "to spend every penny I can of Charlie's money." Her dinner parties in Old Burlington Street enabled Rodin to meet the most beautiful women in London.

One of the great attractions at Mary Hunter's table was the remarkable Lady Warwick, who had given the Prince of Wales—since 1901 Edward VII—nine passionate years, and who had then become equally engagée as a social reformer. She became the next of Rodin's aristocratic English sitters—and the result was a curiously Freudian image, her head rising mushroom-like out of a great mass of partly hewn marble like a traditional Hindu temple sculpture of the lingam-and-yoni. When the bust was finished, Rodin invited Anatole France to visit him:

19 February, 1908

My dear Maître—
 Friday, the day after tomorrow, would you do me the honor

of coming to see me at 182, rue de l'Université, near the boulevard de la Bourdonnais at half-past twelve? I shall show you the bust of Madame de Warwick; your presence will make her happy, and afterwards we will go with her to have lunch at the Hôtel Princesse. Later, should you be free for the afternoon, we will go together to Meudon to see my antiquities and my sculpture.

Your admirer and friend,

A. Rodin

Countess Warwick remembered the occasion in her *Afterthoughts*. Anatole France had asked Rodin whether he had ever experienced complete happiness.

"Never," Rodin sadly conceded.

"I have experienced pleasure," the novelist said, "but I do not think happiness is within reach of mortal man."

It seemed to the Countess that Rodin was indeed "a lonely soul," and perhaps for that very reason she found him "simple, unaffected, and, in some ways, strangely touching. Success meant little to him, possibly because it came when he was too old to enjoy it." When she saw him at dinner parties, "I felt that the interchange of conversation meant very little to him. Although he was always most courteous, I had the feeling that he was saying to himself, 'What have all these people to do with me? Why have I been brought here?' "

Still, Rodin had learned to conduct himself with great dignity and aplomb in the presence of the mighty: at Buckingham Palace on January 12, 1904, and again on February 24, 1906, he had his first interviews with Edward VII, who was to pay him a return visit to Meudon two years later. Rilke, as amanuensis, had found himself writing Rodin's "New Year's letters to the King of Saxony, the [Grand-] Duke of Mecklenburg and all such exalted matters. . . . Curious, that all this has to be done, if one is Rodin."

There seemed to be no end to the procession of aristocrats and captains of industry who came to Rodin's studio to be immortalized in bronze or marble. Of course, the mere ability to pay for a Rodin bust was no guarantee that he would agree to do it. Even after the price had tripled under the Duchesse's tutelage it was her boast that the prospective sitter had to merit the honor. Rodin professed to be

corrupted by the temptations of this métier which was "only another form of journeyman's work," as he complained to Frank Harris. "As soon as I became known I was tempted to do portrait busts and nothing but portraits, by the enormous sums offered me by American millionaires and their wives. . . . How can you refuse a man who offers you a blank check? It's the most devilish age for the artist, that has ever been."

In fact he was pleased and flattered to be the most highly paid portrait sculptor in the world. And often the sitters were both rich and beautiful, as in the case of Varvara Elisseyeva, daughter of the St. Petersburg banker and businessman Serge Elisseyev, whom she accompanied to Paris. Among other things the family owned the city's most grandiose grocery store (now "State Store I" in Leningrad) and underwrote the Diaghilev Ballet's first Paris performances. Varvara's bust, dated October 1906, was the first to be carved in marble by Rodin's new assistant Charles Despiau, who used it to demonstrate his mastery of the art of translating plaster into stone. "I knew you would make me something beautiful," Rodin told him when he first saw the result, "but I didn't think it would be as beautiful as this!"

A rather more problematic sitter was "the high priestess of Sappho," Renée Vivien, who wrote the best-known French lesbian poetry of the epoch. (Her real name was Pauline Tarn; she was born in 1877 of an American mother and an English father.) In her poetry she sang in luxuriant French "of the ephemeral forms of love, of pallor and ecstasy and the loosening of hair," but Rodin depicted her as a straightforward, rather stodgy young woman, almost a literary housewife, wearing her long hair pinned up like a sort of beret. Her quondam lover Natalie Barney objected that the result "bears her name but not the resemblance," and dedicated several pages of her *Souvenirs indiscrets* to a detailed literary portrait of the lady, "so as to fix her traits more truthfully than Rodin did."

Renée had been an elusive creature, compounded of "a young woman fond of laughter, and a poet nostalgic for death." In contrast to her abundant blond hair "her two chestnut eyes sparkled with gaiety, sometimes with mischief," as the novelist Colette remembered. "I never saw her triste. Often she would exclaim, adding an *h* to all her *t*'s and *d*'s: 'Ah my litthle Coletthe, how awful life is! I hope I'll soon be dhone with ith.' " She died in 1909, the year of her marble

bust; it was rumored that she had been poisoned by the servants of the rich baroness who had grown tired of her after years of maintaining her in an atmosphere of Oriental splendor.

As if to prove that he could still do portraits of women who were neither duchesses nor decadents, Rodin also sculpted a full-fledged portrait bust of a pretty young cook at Meudon, the "mischievous" Madame Grégy, who had been hired on the recommendation of Rodin's Spanish hairdresser Castro (who happened to be her lover). "Naturally poor Rose was terribly agitated when Rodin undertook to do the bust of his cook," Cladel records in her unpublished notes. "He shut himself up with her for a long time in his 'Bluebeard's bedroom'—which he didn't use for doing sculpture." He also did a portrait study of Malvina Hoffman, the young American sculptress he took on as a pupil in 1910—despite his oft-repeated insistence that he didn't take pupils.

>✠<

The slight, girlish face of Helene von Hindenburg had filled out and become far more self-possessed when he saw her again in April 1907 after an interval of almost five years. She had, in the meanwhile, married Count Alfred von Nostitz of the Saxon diplomatic service, and they had decided to take up Rodin's almost forgotten invitation to have her pose for him a second time: this time it was to be not a quick sketch but a portrait bust done with all due care and deliberation. "Noble friend, it will give me profound joy to do your bust," he wrote to her early in the spring. "For a long time the idea has lain dormant in my thoughts and my heart, as something too lovely to desire. . . . I have just done the bust of a man [Joseph Pulitzer] who was *un diable*: the contrast is good for my soul!"

He invited the young couple to stay in Meudon, at the Goulette aux Moines, where he had turned one of the rooms into a bedroom. "The windows were hung with dull green curtains," Helene recalled. "There were huge figures and plaster casts everywhere. In the shadow of the *Penseur* stood the giant Empire beds and beautiful tables on which my clothes were strewn about, for there had been no attempt to create a banal bedroom." One evening she went into one of the adjoining rooms with a candle and experienced the pleasant shock of seeing the Cambodian drawings on the wall by half-light. Rodin

called for her in his carriage in the mornings, and they drove to the rue de l'Université together: "He didn't like the train; he wanted to see the coming of spring at a gentle pace."

When she posed at the Dépôt des Marbres "he became very severe, authoritative and concentrated. . . . He commenced by studying the planes and transitional areas. For him a small surface had a hundred facets that all had to be felt and touched before unity could emerge. He also took exact measurements and often said: 'Exactitude and hard work are worth more than inspiration!' " On a harmonium that had been placed in front of the *Porte de l'Enfer* she played Gluck and Beethoven—two composers who sound terrible on a harmonium. One fine day Count Kessler invited them for lunch in the garden pavilion of his Paris residence: Maillol had also been invited. "It was lovely to see that Rodin and Maillol truly admired each other." Another day, when they dined on duckling at the Tour d'Argent, the restaurant's famous old chef came to the table with a carved wooden box and said: "You see, Monsieur Rodin, I also do sculpture." The maître looked it over attentively and handed it back "without smiling a supercilious smile."

He maintained the same attentive detachment toward Helene until one day, as he was escorting her to the garden gate of the Goulette, he tried to kiss her—and she denied him the privilege, as her son heard from her, though when she mentioned the incident "she spoke not without regret." When it was time for the young couple to return to Germany, the maître took them to the Louvre for a last look before they boarded their train. He said good-bye to them with tears in his eyes. "I'm very afraid that you'll fall into the hands of bad artists," he told Helene by way of farewell.*

But Rodin's affection for the Countess had not escaped the watchful eyes of Madame Rose. When he returned to Meudon in the afternoon

*It was a strange thing to say to a German countess, but Rodin's instincts were unusually sound. Helene von Nostitz did eventually fall into the hands of a *mauvais artiste*, the postcard painter Adolf Hitler. "Only in the Third Reich, under Adolf Hitler's leadership, did art develop a new style out of the collective Will-to-Form, in accordance with the awakened *Volk* consciousness," she wrote in her *Berlin: Erinnerungen und Gegenwart* of 1938. She meant the works of such banal sculptors as Arno Breker, "which stand in the sports stadium in beautiful harmony with the surrounding spaces and with the

her jealousy finally boiled over, as one of the studio assistants recalled: "Madame Rodin made such a terrible scene that Rodin was obliged to go down on his knees and beg her pardon."

>‡<

Rodin had meanwhile completed the bust of Joseph Pulitzer—"*un diable*"—publisher of the New York *World*, inventor of investigative reporting and a well-known patron of the arts. The relationship between the two men got off on the wrong foot when the sculptor was late for his initial appointment at Pulitzer's villa at Cap Martin, on the French Riviera between Mentone and Monaco. "The de luxe train does not pick up passengers at Marseille and it has made me miss the sitting," he telegraphed Pulitzer from Marseille on March 26, 1907. "Still I will come and work just in the afternoon. *En déférence*, Rodin."

A room on the top floor of the Villa Cynthia had been cleared for Rodin and his assistants. The sculptor soon discovered that his sitter, who was sixty years old and blind, was pathologically sensitive about undressing in front of strangers. He was, moreover, used to working through intermediaries, and Rodin's secretary had to talk to his secretary about the sculptor's desire "that Mr. Pulitzer in posing should lay bare his shoulders in order that he might correctly visualize the poise of the head." As Pulitzer's aide and biographer Don Seitz records, the publisher objected strenuously, but Rodin insisted, and Pulitzer finally agreed to cooperate when Rodin threatened to walk off the job.

It was arranged that Pulitzer would take off his collar and undo one button, but on condition that only his immediate attendants would be admitted to the studio while he was thus exposed. The work went on, but Pulitzer was now on his worst behavior, "proving very petulant and unruly and refusing to talk to Rodin, who naturally wished to

temperament of the surging masses that surround them." Evidently Rodin had taught her nothing about sculpture. But then, Helene von Nostitz was known to be very naive. When she visited Paris again in the 1920s Count Kessler was taken aback when "she asked me what the word *pédéraste*, which she so frequently hears applied here, means. I advised her to ask her husband."

relax his sitter and get some glimpse of his mentality." Yet despite the publisher's unfriendliness—or perhaps because of it—Rodin produced an extraordinary portrait that conveys the very essence of the sitter's stubbornness and blindness. According to Seitz, Rodin also succeeded in having the last word in the argument over the collar button. The contract called for both a bronze and a marble bust, and while the bronze omits the shoulders entirely, the marble does not— "and here Rodin had his revenge, for he laid a bit of ruching across the chest, playfully suggestive of the upper works of a chemise!"

The high proportion of Americans among the subjects of Rodin's later busts was a measure of Claire de Choiseul's influence. Yet the mere fact that a sitter was American was enough, even then, to damn the result in the eyes of some European critics. When Georg Brandes came to Paris to write about the latest additions to Rodin's oeuvre, his only disparaging remarks were reserved for the new bust he had seen, made in 1908, of "a young American, like so many one meets, not stupid and not intelligent, not dull and not interesting—a commission." Yet John Wesley De Kay was, in fact, something of an original: a financier and newspaper publisher in his thirties who wrote mystical stories about truth and beauty, and published *Thoughts* that owed more to Ambrose Bierce than to Pascal. Though he was only half Rodin's age he had already reached very similar conclusions about the moral decay of modern man: "A world that is ready to give up Apollo and the Muses for the telephone, telegraph and railroads, prizes information more than life."

Rodin thought that by turning De Kay's bust into a mask and leaving off his bushy hair the face took on a medieval look. He christened the result *Dante*—to the annoyance of Brandes, who felt compelled to point out that this American face lacked Dante's "greatness and nobility."

Another of Rodin's rich American clients, Thomas Fortune Ryan, seems also to have suffered from a collar fixation: Rodin portrayed him in a high wing collar, tie and neatly buttoned suit, as the living embodiment of the capitalist ethic. Ryan, apparently, spared hardly a glance for the bust but was delighted to meet a man who worked as hard as himself. The Duchesse de Choiseul, who had introduced him to Rodin and sat in on the sessions, was not one to waste such an opportunity to sell more sculptures and benefit mankind. While

Ryan was posing, as she told the American journalist Herman Bernstein, "an inspiration came to me."

> I said to him one day: "Mr. Ryan, don't be a dead man for ever. You are a millionaire, but your millions will be of no avail to you when you die. Why shouldn't you do something that will help your country?" I talked and talked to him in this strain until I succeeded. [Daniel Chester] French and [Edward] Robinson, on the committee of the Metropolitan Museum, were the judges, and they purchased for Mr. Ryan the works of Rodin which now form the Rodin gallery in New York. This collection of Rodin masterpieces in America is of the utmost importance to young American artists. For I believe, just as Monsieur Rodin does, that we have more real artists in America, more talent, more genius than other countries have. Here in Europe we have dried fruit, while in America we have vigorous young talents—but they are spoiled when they come over here, amidst these surroundings away from the environments under which they could develop naturally. America is the greatest country in the world, but if every rich American were really interested in the development of his country, America could be made still greater. America could be made greater than Greece or Rome ever were; we have enough millions there— now we want artists. By bringing over such works as those of Rodin or of other masters the young American artists could have the best examples of Europe's greatest works amidst their own surroundings, and this would tend to build up a great American art. . . .

This was a fair sample of the line of reasoning that persuaded Ryan to part with $25,000 of his money, and convinced Bernstein that Mme la Duchesse was "one of the most brilliant women in France." Ryan had far-flung business interests, in mining, railroads (Union Pacific), tobacco and insurance, though Rodin's interpretation of the man may also have caught at least a hint of his erstwhile dry-goods store background.

Ryan's fellow financier Edward H. Harriman also became the subject of a Rodin bust in 1909. "The little giant of Wall Street" had

crossed swords with Ryan in a stock-exchange battle over the Equitable Life Assurance Society: Harriman "did not think Ryan was a suitable man to have control of the Equitable with its $400 million of assets," and had tried, unsuccessfully, to displace him. Still, Harriman was considered "the most powerful single man in the United States," not least because he personally controlled 60,000 miles of U.S. railroads.

According to Harriman's son, former Governor W. Averell Harriman of New York, Rodin's portrait of the financier was done when he was in failing health, "during the last summer of his life, when he went to Europe for treatment. My sister Mary (Mrs. Charles C. Rumsey), who knew Rodin, got my father to sit for him. . . . The bust shows a man weak and ill, rather than strong and vigorous as he had always been, which was of course due to his declining health at the time." Several latter-day accounts claim that Rodin never actually laid eyes on Harriman, but a note published in the Metropolitan Museum *Bulletin* in March 1915, when the bust was first exhibited, is quite unequivocal on this point: "The work was begun on the occasion of Mr. Harriman's visit to Paris when he sat for the distinguished French sculptor for a study in clay. From this sketch, Rodin completed the portrait after the death of the sitter."

Harriman died in September 1909, and thereafter Rodin was obliged to work from photographs furnished by the family, as well as from a "stand-in" model named Alexandre Auguste, whom he encountered on the Paris-Meudon train. While the bust was in progress he consulted people who had known Harriman about whether his emerging image (whose eyes are hollows) did indeed resemble his subject: but when an American friend ventured to suggest "once the eyeballs are put in, it will look just like him," Rodin became incensed. Afterward he fumed, "One should never let anyone see a portrait before it is completely finished." The marble bust he delivered to the Harrimans is, in fact, a bowdlerized version of the tousle-haired clay, whose roughly modeled features it transforms into a merely eminent face with smoothed-down hair and a neatly trimmed mustache.*

*Rodin was in England at the beginning of the war, when the marble was being readied for shipment to America. Mrs. Harriman had insisted it be signed by the sculptor and, as Anita Leslie heard from John Tweed, this demand made him indignant: "Can you

Rodin's portrait head of the Duc de Rohan, on the other hand, was based on an intensive series of sittings and on intimate acquaintance with the subject. Unlike Charles de Choiseul-Beaupré, Alain de Rohan was a real duke—the eleventh of the house of Rohan-Chabot—and lived in a style commensurate with his rank, both in Paris and at the historic Château de Josselin, in Brittany. The Duke, who was four years younger than Rodin, sat for his portrait at the behest of his eldest daughter, the Princess Marie Murat, who arranged for the sittings to take place in the Rohan residence at No. 35, boulevard des Invalides. Usually they were held in the mornings; afterward Rodin was invited to stay for lunch.

Ferdinand Bac, a friend of the Rohans, writes in his memoirs that the Duke had an air of military jauntiness that inspired Rodin to portray him as a sort of "haughty condottiere." The Duke was not certain whether he liked the result, but was reassured by the family's unanimous praise for the bust. Bac had known Rodin years before, and watching the sculptor come and go at the Rohans' he decided that this was *le troisième Rodin*, a man in the third stage of an incredibly distinguished life: "He had arrived at the apogee of his fame, and yet I found him still the same immutably unartful genius, despite the assault that literature had made on his innocence, despite his fortune, despite the beautiful ladies. . . ." Rodin would come to the house immaculately dressed in a big frock coat and patent-leather shoes. "He walked with small steps because they pinched him," Bac writes. At lunch, "once settled in his chair, he would say nothing more. He ate slowly, with the earnestness of a alderman at an agricultural banquet. It was the same when he drank. Gently he allowed himself to be flattered and, smiling, he enjoyed the manna that fell from heaven in addition to so many other lovely things. He savored each dish conscientiously and without hurrying. . . .

"Then Rodin would gravely digest his meal in the best armchair of the small salon, leaning back and stroking his long beard, still partially blond owing to the remaining traces of a dye which he seemed

understand such a thing?" In the end he had Tweed sign it for him. "Tweed took up a chisel and hacked Rodin's name into the marble feeling guilty as if he were forging a bank check." Rodin, however, was well content: "Anyone could sign my name, but who can do my work?"

to have given up using. *Le vin était bu*: he was growing old. He had become reconciled to his age and its limitations. Passing his beautiful hands over his flowing beard, he felt soothed by this exercise, and tended to his digestion as a man who has done his duty. The other guests expected him to say something Socratic about art. Instead he settled down to sleep. But first he liked to lean over and study the box of cigars, and to take delight in their contemplation. With a subtle touch he would choose one that crackled. Taking the glass of liqueur in his left hand and the Havana in the other, he enjoyed both with an equally voluptuous pleasure. With an important, festive gesture he lifted his little finger like a man who smokes only at weddings. . . ."

Watching him in his postprandial somnolence, wrote André de Fouquières, another guest at these lunches, one couldn't help worrying "about what was going to happen to his cup of coffee and consequently to Mme de Choiseul's dress."

>✠<

Over the years Rodin had sculpted the heads of many artists and writers, but among his last commissions was one of the most important: the head of Gustav Mahler. Not since Victor Hugo had Rodin worked with a sitter of comparable significance in the world of the arts, yet like many Parisians he knew hardly anything about the composer of *Das Lied von der Erde*, whose name had once appeared on the poster of a Trocadéro concert as Gustav Malheur (Misfortune). When he came to Rodin in the spring of 1909 Mahler was nearing forty-nine; he had just completed an engagement with the Metropolitan Opera, and had made his debut with the New York Philharmonic, with which he had signed a three-year contract. Both his Eighth Symphony and *The Song of the Earth* were finished, and he was about to compose the Ninth. But he was suffering from rheumatic heart disease and had been forced to give up the strenuous hiking and mountain climbing that had allowed him to "wrest my ideas from Nature" in earlier years. He was accompanied by his restive, frustrated wife, Alma Mahler, and their five-year-old daughter Anna, who was destined to become a noted sculptress.

Alma's stepfather, the Austrian painter Carl Moll, had arranged

the commission on behalf of a circle of Mahler's Viennese admirers, and had asked Paul Clemenceau (Berta Szeps's brother-in-law) to talk to Rodin about it. When the maître heard that Mahler was "a great artist, on the same level as his own, in sculpture," he agreed to ask only a *prix d'ami*—10,000 francs to do the clay bust, and an additional charge for bronze casts. Mahler himself was to know nothing about these arrangements. Paul Clemenceau wrote to Rodin in a letter dated April 22: "If you are free to do so, please come tomorrow, Friday, at 12:30 to have lunch with us at the Café de Paris. Mahler will be there. We could arrange everything while dining. Remember that Mahler is convinced that it is your own wish to do his bust, or he would have refused to pose." According to Clemenceau, "the first encounter between these two men of genius was extremely impressive. They didn't speak but only sized each other up, and yet they understood each other perfectly."

Mahler was pressed for time since he had to leave for Vienna on May 1, but Rodin worked rapidly, in sittings lasting about an hour and a half—a matter of some difficulty for Mahler, who was of such a nervous disposition that he "couldn't keep still even for a minute," as Alma noted. Since Rodin knew no German and Mahler spoke only minimal French, misunderstandings were bound to arise. The temperamental conductor, accustomed to split-second obedience from singers and orchestra players, flushed red with anger and walked out of the studio when, as Rodin recalled, "I told him, perhaps rather brusquely, to get down on his knees. I wanted to see his head from above, to gauge its volume and contour, and the musician thought it was to humiliate him that I asked him to kneel."

Apart from this contretemps Alma remembered the sittings as a marvelous experience: "Rodin fell in love with his model; he was really unhappy when we had to leave Paris, for he wanted to work on the bust much longer." Indeed, he asked for additional time and prevailed on Mahler to return for a few more sittings in October, while en route to New York for the start of the concert season.

Alma, who had spent most of her life among the painters and sculptors of Vienna, was spellbound by Rodin's technique: "His method was unlike that of any other sculptor I have had the opportunity of watching. He first made flat surfaces in the rough lump,

and then added little pellets of clay which he rolled between his fingers while he talked. He worked by adding to the lump instead of subtracting from it. As soon as we left he smoothed it all down and next day added more. I scarcely ever saw him with a tool in his hand."

Another thing Alma noticed was that "one of his mistresses was always waiting in the next room while he worked. This singular arrangement held good in whichever of his numerous studios he happened to be; some girl or other with scarlet lips invariably spent long and unrewarded hours there, for he took very little notice of her and did not speak to her even during the rests. His fascination must have been powerful to induce these girls—and they were girls in what is called 'society'—to put up, unabashed, with such treatment." Alma also recalled that "sometimes we were interrupted by a loud knocking on the door; it was an *amie* whom Rodin described as troublesome. She was obliged to wait for hours in the next room, and she kept on knocking, which made Rodin nervous and furious."

Mahler's enemies had dubbed him "the Jewish dwarf"; Rodin discerned in him "a mixture of Franklin, Frederick the Great and Mozart." Later he saw other "remarkable" traits—"There is a suggestion not only of the Eastern origin, but of something even more remote, of a race now lost to us—the Egyptians in the days of Rameses." In the end he produced the two Mahler busts that were cast in bronze, known to scholars as types A and B; the one roughly handled and "Expressionist," the other relatively smooth-skinned and naturalistic. They represent, of course, not two separate and distinct sculptures, but two different stages in the same modeling process. As Malvina Hoffman testifies, when Rodin had sufficient time "he would make six or seven different studies of the same person—varying slightly the pose of the head or the expression of the face. Frequently I knew him to start a portrait, and after a few sittings, to call in a plaster-caster and have a mold made as a record: then he would make a 'squeeze,' that is, the fresh clay would be pressed into the negative of the piece-mold and with this stage of the portrait safely registered, he would feel more free to make bold changes or experiments, without the fear of losing what had been achieved up to that point. The first

plaster was a guide to which he could always refer if he felt himself in doubt during the subsequent sittings." Hence "Mahler A," the bolder and more experimental version, probably represents a later phase than "Mahler B."

Later, on his own initiative, he had his assistant Aristide Rousaud carve a marble version of "Mahler B," with—as so often before—the head rising out of a partially dressed block of marble (known technically as an uncut matrix). This head, however, was labeled *Buste XVIII^e siècle* when it was first exhibited, and later acquired the name *Mozart*, which it bears today in the Musée Rodin. By then Mahler was dead—he had died of endocarditis in May 1911, having lived only long enough to see the photograph of his bust that adorned the fiftieth-birthday book given to him by his admirers in 1910. It contained tributes from Hugo von Hofmannsthal, Gerhard Hauptmann, Stefan Zweig and Romain Rolland, among others, as well as a greeting, *"Au Grand Musicien G. Mahler,"* sent by Rodin.

Alma Mahler thought that it was an employee of the Musée who changed the marble Mahler into Mozart, but Rodin himself seems to have been responsible. Perhaps he had heard that Mahler's dying words were "Mozart . . . Mozart!" On the other hand, *Mozart* was a more recognizable and attractive name for a public which, if it knew of the sitter at all, had heard mainly negative things about Herr *Malheur*. As Chéruy pointed out, Rodin felt no compunctions about making such changes on even the flimsiest grounds. Just as De Kay became *Dante*, Mahler "with a new name scribbled in pencil on the plaster" could suddenly turn into *Mozart*. Chéruy recalled one such transformation involving Eleonora Duse, the famous Italian actress, whom Robert de Montesquiou brought to Rodin's Paris studio:

Some time later Montesquiou came to the Meudon studio, and noticing in a corner the plaster of the head of *Dying Orpheus*, said: "It reminds me of la Duse." Immediately Rodin took a pencil and scribbled "Duse" (as I saw much later). A few days after Montesquiou's visit came the director of the Dresden Albertinum [Georg Treu], to whom Rodin wanted to show a photograph, so he asked me: "Get me a portrait of *la Duse*." The sculptor read my astonishment on my face, for I knew all

the photos of his collections. Followed a short embarrassed silence, and then he said: "You know . . . the head of *Orpheus!*" The same head transposed in marble with the suggestion of flames had previously become Joan of Arc.

Such stories were legion. Every Paris *littérateur* had a fund of anecdotes about Rodin naming and renaming his works, especially the allegorical groups. Finding a title for some of them had, in times past, posed something of a problem, but now Rodin had turned his naming procedure into a game with which to tease and titillate his visitors. At Meudon one Sunday, as Despiau remembered, he showed visitors an as yet untitled head—perhaps this very "Duse"—that aroused universal admiration and curiosity. What was it called? "It's Joan of Arc," Rodin told them—"and everyone exclaimed how beautiful it was, and how true." Then another visitor arrived and asked the same question. Rodin said, "It's the city of Nantes," and elicited the same reaction. "Thus the sculpture changed its identity five times in one afternoon," Despiau noted, "much to the discomfiture of several befuddled sycophants."

Treu, during his visit to Meudon, thought it rather strange that the sculptor didn't know the titles of his own works but "had first to read them from a written label with the help of a pince-nez." Sometimes he seemed to be soliciting Treu's opinion: "This is the moon kissing the night good-bye—*n'est-ce pas?*" and on occasion he would read off all the alternative titles in the same breath: "*Christ and the Magdalen,* or *Prometheus and an Oceanide* or *Genius and Pity*"—it didn't seem to matter which.

Young women who went to see him exchanged notes and concluded that there was more to his naming perplexities than met the eye. He was "in the habit of showing little erotic pieces to lady visitors," as Arnold Bennett records, and of asking leading questions about their meaning. The young writer Lucie Delarue-Mardrus had a sister, Charlotte—"a very pretty woman"—who, on her first visit, was handed a saucy little water sprite with upraised posterior and asked to give her a name. "I want you to baptize it; I never know what it is that I create. . . ." Whereupon Charlotte suggested *la Source de volupté,* a title that Rodin carefully wrote on the base, "saying that the statue

would never bear any other name." Not long afterward it was Lucie Delarue-Mardrus's turn to visit Meudon. "He gave me the same line of patter, in the very same terms (he didn't know we were sisters). When I suggested *le Mystère des sources* he took out his pencil and wrote it on the marble, and told me that the statue would never bear any other name." It was, in fact, to enter the catalogues as *la Petite fée des eaux.*

People of all nationalities were enlisted in the search for suitable titles. "He has often brought me groups of figures and asked me to name them," Frank Harris wrote. "He had put a couple of figures together because of some emotional or passionate connection and he wanted a name for them: 'Could they stand for any myth?' I remember one group, a woman's figure embracing a man which I called *la Succube* and bought. He liked the name, but when I spoke of it at another time as *The Temptation of St. Anthony* he was still more delighted and declared he would make a large replica of it."

It became so fashionable to criticize Rodin for his title vacillations that Aleister Crowley felt obliged to plead the case for the defense in the preface to his *Rodin in Rime* of 1907. It was not true that, as the critics claimed, Rodin's works *"mean* nothing," though indeed some of his sculptures had undergone multiple changes of name:

> The real heart of the attack is, of course, against Rodin's intention, and it is my object to show what rubbish it is, even granting the literary basis of criticism to be valid. . . . In *La Main de Dieu*, for example, the meaning is obvious, and not to be wrested or distorted. What does it matter if we call it as at present, or
>
> a) The Hand of Creation,
> b) The First Lovers,
> c) The Security of Love,
> d) The Invisible Guard
>
> —anything in reason? These are only ways of looking at one idea, and as you are a theologian, poet, lover or mystic, so you will choose. And it is the Master's merit, not his fault, if his conception is so broad-based as to admit of different interpre-

tations. The phenomenon is possible because Rodin is the master and not the slave of his colossal technique. The difficulty of naming a masterpiece is perhaps harder work than producing it, and Rodin being a sculptor and not an illicit epigram distiller, is perfectly justified in picking up what he can from the witty and gifted people who throng his studio as much as he will let them.

Rodin himself had come to detest the fuss made over his naming practices. Of course there were alternative titles for everything. *The Tempest*, for example, with her screaming Gorgon face: "Could you not imagine that to be the aspect of a housewife when enraged by the coincidence of small domestic calamities?" he asked Alder Anderson of the *Pall Mall Magazine*. "Find me some more appropriate title and I shall be delighted to utilize it." He told Ugo Ojetti that his titles were secondary because they were "the inventions of Mirbeau, of Geffroy, of my literary friends. . . . I model human bodies as well as I can. The rest does not concern me. Sculpture is not done by words. The poets are there for that." And again, in conversation with a Viennese journalist: "I don't proceed from a thought or a story-line; I am only interested in creating a form—of a human being or an animal; in short, of the model. Once the work is done, then people come and look at it and give it a title, a name. Or they discern some thought expressed by my work. What do I care? I wanted to re-create Nature, wanted to hold a mirror to Nature; perhaps a distorting mirror of a certain kind—but nothing is further from my mind than the personification of ideas. Not reason but feeling rules the artist. What use then are titles, names, stories? Beethoven poured his emotions into symphonies and named them the First, Second, Third and so on. I sculpt my emotions."

The art dealer Ambroise Vollard suggests in his memoirs that there was also a commercial dimension in Rodin's propensity for changing names: the sculptor who called the study of a foot *Rêve enchanté* (Enchanted Dream) knew very well "to what extent a title may enhance the appeal of a work of art." Times changed, and Rodin's conception of his works changed with them. *Les Bénédictions*, described by him in 1901 as "lovely intermediaries" who "support the poet," had by

1912 been transformed into "a memorial for dead aviators who sacrificed their lives as martyrs to the great future of aviation."

>✠<

Rodin had not been to Strasbourg since before the Franco-Prussian War, but on March 2, 1907, he went there by train with Albert Besnard and his wife to inaugurate a major exhibition of contemporary French art, in which he was represented by such works as *The Thinker*, the *Walking Man* in plaster, and bronze busts of Dalou and Geffroy. He himself was honorary president of the committee which had selected the works to be exhibited in this first major attempt at an artistic rapprochement between France and Germany: the vice president and managing director of the enterprise was Léonce Bénédite, the curator of the Luxembourg Museum. Accompanied by the Besnards and Charles Cottet, Rodin spent two days in Strasbourg, which was now the capital of the German imperial territory of Alsace-Lorraine: before the inaugural banquet he took a stroll through the center of the city but failed to find traces of his earlier visit. "I remember having worked here, on a façade," he told a local sculptor, "but I haven't been able to locate it." After Strasbourg he stopped at Nancy for lunch with a local art patron, but his unhappy experiences with the city made him even more taciturn than usual and he left immediately after the meal.

A far more enjoyable luncheon took place at the Tour d'Argent on May 22, with André Gide, Theo Van Rysselberghe and Count Harry Kessler. As Gide noted in his journal, Rodin was feeling talkative and nostalgic: "We talked to the last of his 'start.' For a long time, to earn his living, he makes 'Carrier-Belleuse' of terra cotta. It is one of these poor insipid things that Druet recently exhibited in his window. With *l'Age d'airain* he arouses a protest. . . . But at that moment some friends group around to defend him. That is when he leaves Brussels for Paris."

"How old were you then?" Gide asked him.

"Forty-five."

Gide, at thirty-eight already one of the most famous of French writers, was profoundly moved by Rodin's history: "This dominated my day."

The French Academy had still not seen fit to redress an old wrong by electing Rodin as one of themselves: by now it would have seemed almost absurd to seat the long-ostracized maître among so many less qualified "immortals." Indeed, two years earlier Bracquemond had written to congratulate Rodin on the fact that he had again been passed over: "Yesterday I saw the list of sculptor-candidates for the Académie des Beaux-Arts; you cannot imagine how happy it made me to see your name absent from the list. You are Rodin; you remain Rodin, without the embroidered coat [of an academician]." Rodin also enjoyed the irony: "Thank you, Bracquemond, for your brief word. It is the only one. Had it been otherwise I would have received a thousand congratulations." In his conversations with Ludovici he rarely missed an opportunity to pour scorn on his colleagues of the Academy. "They hold the keys of the Heaven of Arts and close the door to all original talent," he told his young secretary. "But they themselves can never enter the Heaven of which they hold the keys."

Yet he himself had accepted important academic honors from abroad, especially from Germany. The philosophical faculty of the University of Jena conferred an honorary degree on Rodin in May 1905—as a sculptor who had, in the words of his *laudatio*, "expressed the beauty of the human body, both in its movement and as a vehicle for the emotions [*seelische Stimmungen*], in a wholly new and unique way."* He did not attend the Schiller centennial celebration at which the honor was bestowed, but as a token of his gratitude he sent the university a bust of *Minerva*—Marianna Russell in an elaborately decorated helmet. (Another version of the same work was later presented to the Wagnerian conductor Edouard Colonne as *la Walkyrie*.)

*Yet Rodin's reception in Germany was not altogether favorable. Early in 1906 Count Kessler organized an exhibition of Rodin drawings at the Weimar Art Museum, of which he had been appointed director as part of the young Grand Duke's plan for a "Weimar Renaissance." A local professor of painting, Hermann Behmer, promptly denounced the exhibition in the newspaper *Deutschland*: "The works on offer are so offensive that we must warn our wives and daughters against going to see them. . . . It is an impertinence of this foreigner to offer such things to our noble Grand Duke, and it is irresponsible of the Museum committee to permit the display of these disgusting drawings." Since "this foreign *Schweinerei*" had aroused the "*Zorn der Volksseele*" ("fury of the national soul") Kessler was forced to resign and modern art was banished from the museum.

He had previously been made an honorary member of both the Royal Saxon and the Bavarian Academies of Art, and in May 1906 he was named a member of the Prussian Academy in Berlin.

Like other new members Rodin was expected to send the Berlin Academy a curriculum vitae, and when he sat down to dictate one to Chéruy he saw a chance to take a slap at the French Academy: ". . . Justice has never been done to me, and all my efforts, like my works, have been misunderstood. Only in these latter years has justice come to me from foreign countries."

That same year Glasgow University was the first in Great Britain to present Rodin with an honorary doctorate—an LL.D.—though it was awarded in absentia. In 1907 Oxford University announced its intention to follow suit. This time there was no question of his receiving the degree by mail—he would go to England to collect it in person. On June 24 he stayed at Mary Hunter's town house; next day the diligent Tweed escorted him to Oxford where, as he was proud to inform Eve Fairfax, "I shall receive my honorary doctorate from the Chancellor, Lord Curzon." It was the former Viceroy of India's first year as chancellor, and that year's list of candidates *honoris causa* was an especially distinguished one, headed by the king's brother, the Duke of Connaught; the prime minister, Sir Henry Campbell-Bannerman; and the foreign secretary, Sir Edward Grey, soon to utter his *aperçu* about the lights going out all over Europe.

Among those receiving an honorary degree was General William Booth, apostrophized as the "passionate advocate of the dregs of the people, leader of the 'submerged tenth' and general of the Salvation Army." Rodin was to receive the degree of Doctor of Civil Law, a catchall category for those who were not scientists, musicians or literati. The arts were also represented by Camille Saint-Saëns, Doctor of Music and the only other Frenchman to be honored, and by Mark Twain and Rudyard Kipling, each D. Litt.

Clad in their brightest academic plumage, the participants began the ceremony with the traditional procession from Magdalen College to the Sheldonian theatre, where more than 2,000 spectators awaited them. When it was Rodin's turn to step forward in his robes of salmon and scarlet he was presented in Latin by the Regius Professor of Civil Law, Dr. Goudy, as "a distinguished Frenchman who, perhaps more

than any living sculptor, recalled . . . the world of the great Italian master, Michelangelo, in its massive grandeur combined with fidelity to nature."

Most of the spectators were jolly undergraduates bent on upholding the tradition that an Oxford Encaenia is "a great academic ceremony drowned in an atmosphere of Aristophanean chaff." A special correspondent of the London *Daily Chronicle* duly recorded the more brilliant flashes of academic wit in a story headlined "Oxford Honours":

As each man stepped forward he was received with volleys of student wit—honest, harmless nonsense, if it was not always deferential. Just as Lord Curzon was greeting Mr. Whitelaw Reid as "O honourable man, Ambassador of a great people," an unmistakable twang in the gallery said, "I guess you're right, pardner," and shrieks of laughter drowned the remainder of the Chancellor's Latin. Similarly, the Vice-Chancellor of Oxford was exhorted to keep his "pecker up"! . . . Rodin was asked, "What about living statues?"* but before he could reply, General Booth's turn had come, and the walls of the theatre were echoing the wild cheers of the great assembly. . . . And so a glorious hour passed. At about one o'clock a little white-haired man rose from his seat and walked to the foot of the steps beneath the Chancellor. It was Mark Twain, amid great cheering! *"Vir jocundissime, lepidissime, facetissime."* "What

*The great "Living Statues" controversy had for some time been exercising the best minds of the London County Council. A troupe of lightly clad young women had been impersonating "classical statues"—such as Franceschi's *la Fortune* and Lanson's *l'Age de fer*—on the stage of a London music hall. The National Vigilance Association had determined that these Living Statues were "practically nude, with the exception of a strip of cloth around the loins," and that "in this condition no one who regarded women with sanctity would approve." Although the chairman of the County Council's Theatres and Music Halls Committee saw nothing harmful in these exhibitions "provided that the subjects chosen were classical [and] that the poses were quite still," the Council voted sixty-six to forty-five to prohibit such performances. Rodin, had he understood the question put to him by the undergraduates, would certainly have objected to the immobility of the models. Another sculptor, his British colleague Hamo Thornycroft, complained to the press that "So far from stimulating interest in art, these shows simply vulgarise it."

have you done with the Ascot Cup, Mark?" shouted one gay, irresponsible voice.*

Rodin was very proud of his academic cap and gown, which he modeled for friends—and for the cook—when he got back to Meudon. But "toward the end of my sojourns in England I am overcome by extreme fatigue," as he wrote to Eve Fairfax, and he did not stay to deliver the speech he had prepared for the inauguration of the Henley Memorial in the crypt of St. Paul's Cathedral—a monument consisting of Rodin's Henley bust, in bronze, set in a niche he had designed for it. (When the organizers of the monument had applied to him for a cast shortly after Henley's death, Rodin had been unable to find a plaster copy in his own storerooms: he advised the committee to have a surmoulage made of the bronze in Mrs. Henley's possession—a technique usually employed by forgers. Eventually they located a plaster copy belonging to one of Henley's friends, Charles Whibley, and shipped it to Meudon so that Rodin's assistants could prepare new molds. Rodin took care, as usual, to cover the bronze with "a patina of my own.")

The unveiling took place on July 11, 1907, the fourth anniversary of Henley's death. George Wyndham read Rodin's tribute, in French, as well as a eulogy of his own. Though an accomplished speaker, Wyndham noted that "Reading Rodin in St. Paul's made my 'knees chatter' . . . but I wanted to honor my dead friend, and succeeded, more or less, in being monumental without being sepulchral." Rodin's message extolled Henley's enthusiastic friendship and called attention to the extraordinary environment in which his bust had been erected: "I feel that my friend's energetic traits are at home here in this great crypt of beautiful, majestic St. Paul's—a severe and elegant edifice; the vast heart of London."

*When he landed in Britain, London newspaper placards announced:

MARK TWAIN ARRIVES

ASCOT CUP STOLEN

and at a Pilgrims Club luncheon at the Savoy he felt obliged to explain: "Many persons were misled by that sentence joined together in that unkind way. I want to say, right here, I have never seen Ascot. I never got the cup. I didn't have a chance of getting it. I must confess, however, that when I was here seven years ago I stole a hat. . . ."

Meanwhile, Rodin himself had gone on to Belgium to "take a brief respite in the woods, near a rustic chapel," as he informed Eve on July 12: it was the same chapel of Notre-Dame-de-Bonne-Odeur in the forest of Groenendael where, more than thirty years before, he had "discovered my savage muse." He was becoming nostalgic for the uncomplicated days of his youth, and after this sentimental journey he often spoke about "the beautiful days of thought and silence that I spent in the forest of Soignes!"

Back in Paris, however, the fashionable world was waiting to reclaim him: for better or worse he had become one of the representative figures of France, with all the privileges and vexations thereunto pertaining. When the president of the Republic invited him to dine at the Elysée he had medals and orders enough to decorate a general, and was obliged to ask Judith Cladel and Marcelle Tirel to pin them on his tailcoat. They, however, knew as little about such things as he did, and advised him to ask a footman at the palace to pin them in their proper order.

The Villa des Brillants had become the "Bayreuth of Sculpture" and attracted, like Bayreuth, a checkered mixture of artists, cranks and aristocrats; as a result, a certain sense of discomfort was sometimes felt by one section of Rodin's admirers in the presence of the other. The supreme accolade of a private visit from *l'Oncle de l'Europe*, Edward VII, took place early in 1908, in the course of a new wave of Franco-British entente. Rodin had gone to a great deal of trouble to make a good impression, and had redecorated the main gallery. Cladel remembered the vast room looking like an extension of the flower-filled garden, drenched in sunlight and filled with the white-on-white of plaster and marble. Chéruy was proud to have been present during the royal visit: "Rodin had draped a British flag around the *Saint Georges*, which I thought was naively theatrical. When he explained to the King, *'C'est Saint Georges,'* he also had nearby a plaster of *Countess Warwick*, recently finished. This was perhaps a tactless thing to do."

The *Saint Georges* was a plaque in high relief incorporating the helmeted head of Camille Claudel, modeled twenty years earlier— "the same as the bust in the round," as Chéruy explained, "but smoother for the sake of luminosity, which was the new trend of Rodin's vision." He had made one version, entitled *la France*, in

which the head was turned to the left; when turned to the right it bore the name of England's national saint: "a little flattery in expectation of the royal visit," Chéruy surmised, "or perhaps the hope of a commission. A deception on this point."

Four years later, however, *la France* was purchased by the Comité France-Amérique as a gift to the United States to commemorate the three-hundredth anniversary of the explorer Samuel de Champlain. "We were looking for a French subject and we found the very image of our country," declared the historian Gabriel Hanotaux. "This bronze was France herself. . . ." A group of dignitaries brought the sculpture to America and affixed it to the Champlain monument—a lighthouse at Fort Ticonderoga on the shores of Lake Champlain. The delegation included Hanotaux, the Baron d'Estournelles de Constant, Louis Blériot—who had flown the Channel in 1909—and the Duc de Choiseul.

By now Rodin himself was a kind of living monument: people called him "the Sultan of Meudon." Artists and literati who might once have dropped in on him for a collegial chat now came to consult him as an oracle of the arts. There were ceremonial visits by people like Mrs. Theodore Roosevelt, Gabriele D'Annunzio (who was accompanied by a beautiful woman and a greyhound), and the opera singer Emma Calvé, who danced a bourrée for him. Isadora Duncan brought her entire dance class to perform *Orphée* in his studio-museum. Bourdelle wrote a book about him, *Rodin et la Sculpture* of 1908, that went beyond its subject and became a personal confession and a guide for young sculptors: it was "not a question of putting Rodin on a pedestal because I am his friend; I have given him only his just due. . . . In choosing an example one must take the most significant: having known neither Rude nor Barye, I have chosen Rodin."

Painting and drawing his portrait had become a privilege reserved for some of the finest portraitists of the age. Blanche, the society painter, had done it in 1904; Renoir painted one in his studio in 1905, and Anders Zorn did an etching in 1906 that is surely the most striking portrait of Rodin in his sixties. It earned him the sitter's gratitude and a testimonial calling him "a true painter for all time . . . an etcher with great brio whose drawing is always impeccable"—high praise indeed from a man who stigmatized Renoir's drawing as "atrocious."

Wanda Landowska had her harpsichord carted out to Meudon in

March 1908 to give a concert for Rodin and a select audience on the second anniversary of Carrière's death. The maître was delighted to take her on a guided tour of his antiquities: "To watch him stop at each carving was a sight to behold. He looked at it lovingly, caressing it with his sensitive hands; he became ecstatic before a woman's torso mutilated by the centuries. 'See, Madame, the refinement, the suppleness of these lines! Ah! what a pity that parts are missing!' Out of curiosity I ventured to ask, 'Cher Maître, why don't you try to reconstruct them?' He looked at me, amazed. It was obvious that this idea had never entered his mind; one had to be a musician to have such a thought. 'But, Madame, I do not feel able to do it; and even if I were, I should never dare.' "

The German poet Stefan George—leader of a group called the Kosmiker because their thoughts were rarely less than cosmic in scope—made the pilgrimage to Rodin early in April 1908 together with his disciple Ernst Morwitz, who recorded their conversation in several pages of free verse that were later published as *Der Abend in Meudon*:

George: *. . . the fist clenched for murder,*
 The striding foot that brings a blessing;
 The dancing hip that moves with pleasure and desire—
 You have known the thrill of every fear and passion.

Rodin: *The end is not yet: name not too much!*
 Look here, this green-veiled torso cast of ancient bronze
 Pulled from the sea in fishermen's nets—
 And look! this bird of black clay
 Fashioned by an early master's hand; in my whole life
 I've learned but the beginning of this art . . .
 Give me but time; I shall yet burst the stone asunder;
 The clouded air that now surrounds my work
 Will have more clarity.

Rodin had, in fact, been talking to all his exegetes—in plain prose—about his new ideal of a more luminous sculpture. "I am simplifying the *plans*," he told Blanche and his English biographer

Frederick Lawton, while showing them an enlargement of the *Ugolino* which he was engaged in modifying.* But what exactly did he mean by *plans*? "Look!" Rodin said, taking a board and holding it in front of a statuette. "You see that nearly all, if not quite all the front of this figure touches the board on this side. There are no projections that interfere with the sweep of the light across these surfaces and the illuminating of the various reliefs. Now look again. Down this side there is another *plan*. I place the board and you may convince yourselves that here, with the exception of the two heads, which I intend to bring up to the *plan*, every projection touches the same straight line."

Lawton thus learned in the most graphic way possible that Rodin's special word *plan* could be translated into English as "plane" in the geometric sense. His careful record of such conversations, and his painstaking concern for biographical detail made his 308-page study of *The Life and Work of Auguste Rodin* by far the most factual and informative—as well as the most readable—of all the early books on Rodin. Published in London by T. Fisher Unwin in 1906, it surprised and delighted Rodin himself: "It's written like a life of Charles the Fifth!" Lawton was a literary jack-of-all-trades who spent more than twenty years as an expatriate in Paris, "where indeed I have been privileged to make the acquaintance of some of her citizens eminent in politics, literature and art," and had learned "to appreciate the various admirable qualities of the French race." He lived in the rue Raynouard in Passy and supported himself by writing books on such subjects as *The Third French Republic* and *Balzac*: the latter is dedicated to Rodin in gratitude for the "many pleasant and instructive hours spent in his society." Lawton thought that his many conversations with Rodin had been "instructive, succulent and agreeable," for the sculptor spoke of his life "in an easy flow of thought expressed in simple language of deliberate utterance, leavened by a peculiarly

*He had asked Ottilie McLaren to help him "transform" the *Ugolino* into a Nebuchadnezzar by, among other things, modeling a new hand for it. Rodin praised this hand when she brought it to his studio. A few days later she mentioned the hand's subsequent adventures in a letter to William Wallace: "He [Rodin] came to me & said in a sort of undertone 'I've got an amusing story to tell you!' . . . It seems that the Minister of Fine Arts & a friend were visiting Rodin & were looking over a lot of little things of his & among them found the Nebuchadnezzar hand which I had done & proceeded to go into

rich experience and by the action of an original mind." A year after writing his first book on Rodin—a quarto volume—he wrote a 190-page octavo on the same subject, this one entitled *François-Auguste Rodin* and published by Grant Richards in London. It was "neither a copy nor a mere abridgement," but an exhausted biographer's attempt to compress and clarify his thoughts on a protean subject—to simplify the *plans*, as it were.

Not long after the gala visit from Edward VII, Rodin received a royal commission from his old admirer Prince Eugene of Sweden: "In the garden of my *palais* [Waldemarsudde] there is a small rock where I should like to place the *Penseur*. . . ." Rodin was happy to provide one, "the same size as that of the Panthéon, cast in bronze and patined . . . for 14,000 francs." It would take six to eight months, depending on the time spent on the patina. The artist-prince was delighted to purchase a cast at such an affordable price—then about 10,000 crowns—and when it was erected in the Waldemarsudde garden overlooking the sea, he wrote a grateful letter "to let you know, dear Monsieur Rodin, what pleasure the *Penseur* gives me every day." Yet as he confided to his friend C. A. Ossbahr, he had refrained from commissioning the *Penseur* in person. "I thought of going to see Rodin but I didn't because it might have been necessary for me to admire his naked ladies crawling in the marble blocks."

Rodin had long since outgrown his studios in the Dépôt des Marbres, which had served as his main Paris atelier for more than a quarter of a century. Since buying the Villa des Brillants he had gradually shifted many of his professional activities to Meudon. But suddenly, in 1908, a fortuitous set of circumstances provided him with a far more impressive setting for his sculptures in the very heart of Paris—

ecstasies over it & told Rodin he must have them each cast a copy in bronze!!! The funny part is though that Rodin in a timid sort of way said to me 'And he's the kind of man who'd be absolutely furious if he found he's made a mistake & so I didn't *dare* tell him & I'm having the two casts made for them & they think it's mine!!!' It was the comic sort of scared and yet amused way he told it that amused me & I roared. If I like it he will have a bronze copy made for me."

the Hôtel Biron, which now houses the Musée Rodin. It was Rilke who stumbled on this unlikeliest of sanctuaries when he took over his estranged wife's studio in the Hôtel Biron during her absence from Paris in September 1908. No sooner had he moved in—on August 31—than he wrote to Rodin about the charms of this extraordinary place: "You ought to see the beautiful building and the room I have inhabited since this morning. Its three bay windows open onto an abandoned garden, where from time to time innocent rabbits leap over the trellises, as in an old tapestry."

Rodin came to have a look at this phenomenon on September 2 and instantly recognized its possibilities. He also availed himself of the opportunity to have "a heart-to-heart talk" with Rilke, who was overjoyed to be reconciled with his *cher grand ami*: "It would be wonderful," he wrote to Clara Westhoff, "if he would now need us only a thousandth as much as we once needed him." Rodin, however, was far more interested in the Hôtel Biron than in his ex-assistant. Like the Folie Neufbourg the old building was an eighteenth-century mansion that had gone to seed—and the overgrown garden was one of its irresistible attractions. The house had once been one of the stateliest in the fashionable Faubourg Saint-Germain: its architect, Jacques-Ange Gabriel, had also designed the Petit Trianon and the palaces on the Place de la Concorde. It had been built during the years 1728–30 for a self-made financier from southern France, Abraham Peyrence de Moras, and was subsequently inhabited by a series of notables, such as the Duchesse du Maine, the Maréchal-Duc de Biron (who left it his name), the papal legate Cardinal Caprara and the Russian ambassador Prince Kourakin. During the nineteenth century it had become a convent school for aristocratic girls run by the nuns of the Sacred Heart, but it was taken over by the government when the law of separation of church and state came into effect in 1904.

While the authorities were debating what to do with the property it was turned over to a liquidator who rented out rooms at bargain rates. His tenants tended to be artists and writers with a taste for the bizarre and the romantic. The young Jean Cocteau discovered the place and, for a pittance, rented a second-floor room in which the nuns had taught dance and solfeggio. He set up a stove, a piano, a sofa and a packing case draped with cloth and was soon "inviting my

astonished friends to my fairytale realm, bordered on one side by the gardens of the rue Barbet-de-Jouy and on the right by the boulevard des Invalides." He was impressed by the silence bestowed on the house by its overgrown garden: "Did Paris really live, walk, drive and work around such a pool of silence?"

Rodin arranged to rent several rooms that happened to be empty, on the ground floor with its rotunda entrance, and on the first floor, for 5,900 francs a year. "Just think," Rilke wrote to Sidonie Nádherný von Borutin on September 5, "he has rented a whole series of large rooms where he intends to put some of his things and to seek refuge himself from time to time, in a place where no one will think to look for him." Rodin furnished these vast spaces with a few selected pieces of polished chestnut and mahogany furniture, five or six armchairs, a desk and a wide table, and added marble sculptures, framed watercolors, a painting by Renoir and several objets d'art. Once again he had created an interior that suited him perfectly and impressed visiting writers with its sumptuous simplicity. Indeed, far from serving as his hideaway, the Hôtel Biron quickly became his favorite place to meet the press.

A correspondent for the New York *Sun* who interviewed him the following summer was struck by the spacious forecourt that leads from the rue de Varenne to the front steps of the Hôtel Biron, "between the paving stones of which thousands of grass blades are springing and in the corners of which great masses of luscious foliage make you forget the heat of the August afternoon." Through the open door of Rodin's dining room "you get an uninterrupted view of the simple table laid for the frugal evening meal. There is a vase with a few flowers, and fruit and bread; that is all. Simplicity is the keynote of the salon studio, which still retains a certain conventual and austere air. The walls of the apartment are panelled, and the immaculate purity of the scene is enhanced by the shining marbles. There are no books, no flowers, no ornaments. The branches of the trees tapping the long windows make occasional feathery backgrounds for the statuary, and here and there a few sketches are pinned carelessly. There is none of the equipment of plaster, sculptor's tools, aprons or casts customarily assembled in like places. The only furnishings are the pedestals and a stool."

Initially Rodin left the marble carvers and plaster molders in their workshops and used the Hôtel Biron only for the tidier aspects of his work, such as modeling portrait busts or doing watercolors. But his suite of rooms also included a bedroom, which meant that he did not have to return at night to Meudon, where, as Blanche put it, "the conjugal bed, the red eiderdown, and his shrewish wife in a '*pilou*' dressing-jacket awaited him." Thus the new Muse and his new mansion both conspired to shift the focus of his life back to Paris. Still, for a long time he kept up the conjugal pretense. The Duchesse de Choiseul "has seen him to the station every night on his way to Meudon," John Marshall noted, and Rodin stayed in the city only occasionally. "If he ever sleeps at rue de Varenne, she sees him to bed and does not leave till he is fast asleep."

At the Hôtel Biron he could often be seen jotting his thoughts into the little notebooks he kept for the purpose. Not all of these *pensées* had to do with Claire's scintillating performances of the bourrée: there were pages of stream-of-consciousness ruminations devoted to his enjoyment of this decaying house and its tangled garden, which could almost have been magically created as a setting for the *troisième* Rodin. It seemed to him that getting old was much more of a pleasure than he had anticipated:

9 A.M., Hôtel Biron

 Beauty flows in all directions. . . .

 In this pretty path, one spot alone is kissed: the trees are surrounded more and more by leaves because the more authoritative sun, Bacchante of the uncombed locks, is in the garden. The tall trees are tipped with sunlight. . . . The sun has not yet reached that little avenue of oaks; the landscape has not yet seen her lover, who is already there, behind, but gives less to her than to others. . . .

 I have just put on my glasses, I see the thousand facets of the acacia like a mast whose vessel is at anchor upon the waters in fine weather which the wind stirs gently. But the tree is always in port, it has no change of moods.

 What a prodigious need for beauty does nature exact, and how happy I am to seize it as I pass through life! What joy,

that by my labors I can delve into what I have seen. . . . How long I wait, how many vexations I accept, in order to enjoy a few hours of solitude in this garden, alone with the trees which greet me amiably, alternating in beauty with the sky! My torpid thoughts, when withdrawn from their lodging, come now and run their course.

16

IN RODIN'S STUDIO

*Every time I thought it was finished he
proposed another variant.*

—JAKOV NICOLADZE

odin was becoming flagrantly absentminded: his habit of walking around with important papers squirreled away in his pockets made him the despair of his secretaries. "Letters that called for an immediate reply remained buried in his pockets, unopened," Marcelle Tirel recalled. Since he changed his clothes as often as three times a day he might not return to the same set of pockets for weeks. The accountant who came out from Paris once a week to do Rodin's books also had his work cut out for him. Ferdinand Bac heard from one of Rodin's sitters that one day, while the sculptor was at work on her portrait, he received a check from America for 50,000 francs. "He put it in a modeling stand and went on working. At the beginning of the next sitting the lady asked him if he had cashed it. He went to look for it but couldn't find it anywhere. He had simply forgotten it."

When his secretary complained he told her, "I've always been untidy. My poor mother constantly scolded me for it. But some people waste their whole lives putting things in order. . . . The Anglo-Saxons are great at it, but they do nothing but that and achieve very little artistically. In any case I like order, measure, balance. . . . It's a form of decorum." Since he couldn't keep things in order himself he

was all the more anxious that others do it for him. The young Anthony Ludovici remembered that during his six months at Meudon he was amazed at Rodin's "love of red tape," and found him "a veritable *monstre paperassier*"—a paper-collecting bureaucrat. "Two whole rooms in the Villa des Brillants were given up to this passion for the accumulation and preservation of the letters, invoices, vouchers, estimates, and receipts of a lifetime, and these papers, stored in little white deal boxes, specially made for the purpose by a local carpenter, and arranged according to genus, species, date and their order in the alphabet, represented an imposing documentary record of all Rodin's relations with the outside world. It was curious to find this hereditary trait of the old bureaucrat in one who in every other aspect must have been as unlike his father as possible."

But Rodin's commercial success was now such as to make a filing system imperative. His ateliers at Meudon and in Paris had grown from a small cottage industry into a million-franc crafts enterprise employing a staff of full-time workers and a great many part-time assistants and subcontractors who were kept busy filling orders from all over the world. "Rodin had a large technical personnel when I joined him," Ludovici writes. "Seeing that he could not carve from the marble and stone himself, and only gave the finishing touches to the work his assistants produced, his actual sales at the time I joined him were probably greater than they had ever been, although he himself was on the whole less occupied."

The business management of this enterprise took up far too much of his time. He could dictate most of his correspondence in the morning, even while the barber was curling the long hair that had replaced his crew cut, but toward the end of the day he was forced to devote another hour or two to his paperwork, signing letters and attending to the payment of workmen, models and outstanding accounts. "In all these matters he revealed an almost fearful meticulousness, which at first surprised and sometimes offended me," Ludovici writes, "but I discovered that he had so often been cheated or otherwise taken advantage of by one of my predecessors, that he had learned to be most scrupulously careful":

The first inkling I had of this was on the occasion of the dismissal of a certain workman, a plasterer, who had been in his

employ before I came upon the scene. One morning Rodin informed me that he had dismissed him, and that he would be leaving on the evening of that day. Towards six o'clock, therefore, I called the man to pay him, out of petty cash, the money still owing to him; but he informed me that Rodin in a passion had given him his wages that morning. Now, when at the end of the week, in settling my accounts with him, Rodin discovered not only that my petty cash showed an unusually large balance, but also that I made no mention of any payment to the dismissed plasterer, he asked me for an explanation. I then told him that the workman had informed me that he had received his money from M. Rodin himself, and that this accounted for my having more than the usual amount in hand. Thereupon, to my amazement—for I had no reason to suspect that my behavior was anything else than what he had been accustomed to—Rodin, with a radiant smile, thanked me most heartily for having reminded him of the fact that he had paid the man himself, and even used the expression, *"C'est vraiment bien aimable à vous de me le dire"*—meaning, obviously, I presumed, that he would not have wondered much if I had not done so and had recorded the payment as having been made by myself.

The three principal plasterers at Meudon—Dieudonné and Eugène Guioché (father and son) and an assistant named Barbier—were highly specialized mouleurs whose work was essential to Rodin's production process. The maître himself usually worked in clay and turned the result over to Guioché *père*, who supervised the production of piece molds and plaster casts. He and his son had devised new and remarkable methods of making plaster casts. "Their work was fantastically light and strong," reports Jakov Nicoladze, the Russian sculptor who worked in the Meudon ateliers for a year and took careful notes on what he learned there. "They were able to cast enormous sculptures, and their casts were so thin-skinned that, for example, one man alone was able to lift the *Penseur*."

The elder Guioché worked slowly and meticulously, making piece molds "as fine as jeweler's work: in Guioché's casts no detail was ever lost." His son, too, was a remarkable technician who "never cast a piece in a single operation, like other mouleurs. He would

take half or a quarter of the figure, and work on that." Eugène used green soap as a coating when making the casts, and mixed the pouring plaster with finely chopped straw, which he beat with a brush like a housewife whipping egg whites. "In this fashion he cast all the separate parts of the figure, and after they were assembled he would reinforce the inside of the cast with tape dipped in the same mixture of straw and plaster."

One of the elder Guioché's specialties was making surmoulages of the marbles cut for Rodin by his praticiens. "One cannot pour the plaster directly onto the marble because it is porous and soaks up the gypsum," Nicoladze explains. Accordingly, Guioché used modeling clay instead of plaster. "He kneaded the clay thoroughly and took an impression of just one part at a time, dusting talcum powder on the marble to prevent the clay from sticking. He would pour plaster into the resulting clay mold—which could be used only once because the clay becomes useless in the process. But in this way, proceeding part by part, he obtained a plaster copy of the marble from which a normal piece mold could be made."

Rodin's most important subcontractor, Henri Lebossé—who eventually took to using the more aristocratic-looking Le Bossé—had the task of enlarging his small figures into large ones, sometimes as much as five times their original size. Virtually all the best-known Rodin sculptures of his later years, from the *Balzac* to the *Walking Man* and the *Venus* of 1913 were known to the world in Lebossé's enlargements. In his work he depended on a Collas machine—a lathelike device invented by the nineteenth-century engineer Achille Collas— but in spite of mechanical aids it was a difficult métier, involving subtle adjustments to avoid the distortions caused by the enlargement. "He did not spare his strength," Nicoladze noted. "During this process the plaster is scraped repeatedly and eventually loses its hardness. Rodin's sculptures had first to be enlarged in sections and then the assembled sections had to be cast as one piece."

Lebossé collaborated with Rodin on so many of his sculptures that he stopped taking commissions from other clients. "He was a very original character," Nicoladze recalled. "He struck me as a combination of two heroes of French literature, Tartarin and Gargantua. When he came to see Rodin he would first be invited to the dining room where, before any serious talking was done, he would be served

an omelet made of 10 or 15 eggs, followed by four or five beefsteaks and a bottle of wine. Not until after this meal would the host and his guest begin to talk. He made a curious impression. He often said, 'Without me Rodin would have got nowhere. He's wrong to take all the credit for himself; it's not fair. A good part of his success belongs to me.' " And he told Nicoladze: "Don't think this is easy work. It's a real science, though Rodin doesn't appreciate that. I once asked him if he would use his influence with the government to get me the Palmes Académiques and he said, 'What good would a decoration do you?' "

At the end of the production cycle, when the bronzes came back from the foundry, Rodin relied on a boyhood friend, Jean Limet, to apply the patina in accordance with several private recipes. "Limet would begin by cleaning the bronze with turpentine to remove the oil and grease," Nicoladze noted. "He would brush the surface with a copper sulphate solution and the bronze would take on a greenish tone. To fix this tone he would heat the sculpture with a blowtorch; then he would give it a dark lilac tone and heat it again."

Nicoladze himself worked in the Meudon atelier as a *figuriste* and assistant modeler, much as Rodin had once worked in Carrier-Belleuse's studio. He had come from Tiflis to study sculpture in Paris, and had been reluctant to approach Rodin on account of his reputation as a harsh taskmaster. Eventually, however, he decided that Rodin was the only possible maître and the closest living approximation to Michelangelo. Nicoladze knew Nathalie de Goloubott's sister Dina Vasilevna, and Victor de Goloubott wrote him a letter of introduction to Rodin, who promptly gave him a trial assignment as a praticien to see what he could do. It took Nicoladze forty days to carve the *Severed Head of Saint John the Baptist*, for which he received 600 francs. Rodin liked the young man's work well enough to offer him a permanent job at Meudon after asking one pertinent question:

"Do you get up early in the morning?"

"Very early."

"Then be at Meudon tomorrow at eight A.M."

For the first few months the new assistant was put to work on a revised and enlarged *Ugolino* group. Such large sculptures were housed in the main studio-gallery, but Rodin often left his assistants to themselves while he withdrew to his private studio—a low, elongated

structure he had built at the side of the garden which contained two "monk's cells" with whitewashed walls, a rude seat and a modeling stand. There were hours when he couldn't bring himself to work in the large studio, he explained to Claude Anet. "It contains too great a throng of statues. Their glance weighs on me and puts me under constraint. Then I come here to recover my composure in the calm of these little cells."

One day he called Nicoladze into his private studio and handed him a letter: "Please go to this address. They'll give you a mask of Barbey d'Aurevilly; bring it here."

The young sculptor went to Barbey's ex-secretary Louise Read and brought back his death mask, which Rodin asked him to use as the basis of a new mask: "I want you to give it the same face as the one you see here, but make it stronger—be sure to sing louder; *chantez plus fort!*" Nicoladze worked on the mask for two months or so; when it was finished Rodin told him: "Now take it to the mouleurs and ask them to make a piece mold." That process took two days; meanwhile Rodin asked Nicoladze to round up copies of all available pictures and portraits of Barbey: "Get to know them well and start working on his bust."

"I worked on that bust eight hours a day," Nicoladze adds. "It was hard work; irritating and exhausting. One day Rodin told me, '*pas mal.*' But every time I thought it was finished he proposed another variant. Finally he brought me some more pictures of Barbey and suggested a third version. I went on working for a month and a half. I had a cast of the mask and could always refer to the documentation, so I was certain of my subject. When the third bust was done, Rodin received a new and very beautiful portrait of Barbey, in color, which he brought me, suggesting I do a fourth variant. This time I used a model who resembled Barbey, and the result pleased Rodin, who decided to use this version [for the commission he had received]. He asked me to prepare some clay for him, and since it was a Saturday, I left the studio as soon as I was finished. When I returned on Monday I saw that my Barbey had changed slightly. Rodin had not touched the face; he had merely modified the shoulders with a few characteristic touches."

These "characteristic touches" were the rough traces of fingers-in-wet-clay drawn across the chest and shoulders which, indeed,

sufficed to give this otherwise smooth, naturalistic portrait an air of immediacy that delighted Rodin's admirers and infuriated his critics. It was, as the irreconcilable Léon Bloy wrote in his journal, a "horrible caricature" of his hero Barbey d'Aurevilly, and he belabored the point in *la Flamme* after the bust was unveiled in November 1909 at the writer's birthplace, the village of Saint-Sauveur-le-Vicomte in Normandy. "This *turnip* necessarily precludes anyone else from erecting a monument to Barbey d'Aurevilly," Bloy complained; he would rather have seen a monument by someone else. "But the raking-in of the money has been accomplished by the virtuoso sculptor in an exemplary fashion that puts an end to the matter. Grass does not grow again in the fields where this Alaric has trod."

Whether the grass grew again or not, Rodin no longer had the patience to reconstruct the faces of dead notables. He deputized Nicoladze to prepare another posthumous portrait that had been commissioned as a memorial—a bust of Georgii Norbertovich Gabrichevskii, the father of Russian microbiology and founder of the School of Bacteriology at Moscow University. This time the basis for the bust was a mask of Gabrichevskii that was sent to him from Moscow.

The posthumous monument to Henri Becque, who had died a gentleman and poor in 1899, was a very different matter, since Rodin himself was a member of the memorial committee, which was headed by Victorien Sardou, the doyen of French playwrights, and included Mirbeau, Descaves, Paul Hervieu, Serge Basset and André Antoine. In this case Rodin had his assistants make a marble copy of the bust he had made of Becque more than twenty years before—and when the monument was inaugurated in 1908 it was greeted in the press as "the new masterpiece by the greatest artist of our time."

Another of his former friends, Maurice Rollinat, got somewhat shorter shrift when Armand Dayot approached Rodin for a posthumous bust following the poet's suicide in 1903. He would be unable to oblige, Rodin wrote, "for I could not depict him as he ought to be shown, this extraordinary poet who made such a deep impression on me—not having had him before my eyes as a living model. I often urged him to pose for me, but he always shied away from it. He's gone; now it is too late. But this week, in my grief over his death, with no particular end in mind but just for myself, I started a bas-relief inspired by his prodigious talent."

Perhaps he was suffering from a *lapsus memoriae*: the bas-relief in question had already been exhibited in Prague as *The Morning Star* and had also been interpreted as a drowning sailor's last vision of life, *Avant le Naufrage*. For the Rollinat memorial it was renamed *Dernière Vision*, and, as *l'Illustration* informed its readers in 1906, "its tormented and symbolic aspect recalls certain of the poet's tormented works." Still, the family refused to have the marble relief placed on his tomb: instead the curé of Fresselines, the Abbé Boithier, allowed the poet's friends to place the memorial in the outer wall of the village church: "And the memory of the restless Rollinat will be evoked on the threshold of this peaceful place."

Like many of Rodin's later marbles the *Dernière Vision* was essentially an assemblage of existing elements: the face of the quondam sailor is taken from the *Severed Head of Saint John the Baptist*, the woman's face that constitutes his last vision had originally been modeled for another purpose, and the hands that complement both faces undoubtedly came from Rodin's vast inventory of hands. Altogether the relief provides a remarkable example of the technical fluency with which Rodin's team of plasterers and carvers practiced the art of sculptural legerdemain. His storage cabinets held scores, even hundreds of component pieces that could be assembled in new juxtapositions. The plaster experiments became steadily more playful and adventurous: figures rising out of pots and vases; dancers doing the split or the cancan duplicated and superimposed into a pas de deux; couplings of twins and mirror images; decapitated heads and amputated hands from the *Bourgeois de Calais*, molded together into a bizarre conglomerate under the outspread arms of a winged Muse; small figures conjoined with colossal hands and female torsos wedded to male heads; real branches and artificial bodies growing together out of plaster gardens. The two upraised hands entitled *la Cathédrale* were not a pair but two right hands forming the suggestion of a Gothic arch.

Rodin called his unattached legs, feet, hands and arms *mes abattis* (my giblets) and he carefully preserved squeezes of them for possible future use. Sir Gerald Kelly recalled that the way to Rodin's heart was to ask him: "May I look at the hands?"—a request he was usually delighted to grant his friends and protégés. Most of the hands were quite small, as Kelly noted, "half the size of life, little things, and

he never threw one away. . . . They were arranged in drawers, shallow drawers . . . which wanted very careful opening so that they didn't stick, and there were all these little tiny hands, and I loved looking at them. And he showed me the hands and we picked out one or two that were particularly good, and I remember him with one little hand in each of his, smiling, and saying, 'How good they are!' "

Despite this vast supply of hands and feet for every occasion, Rodin still expected his assistants to make more of them. When Madame Curie wrote to him in 1908 suggesting he hire one of her protégés, "a sculptor of talent and promise," he replied that it was difficult to employ any gifted young sculptor—"to be useful here in my studio he must be particularly skilled in modeling morceaux such as hands and feet, because it's these which I have to have made for me. These morceaux are what all the people I employ leave undone, and thus I have groups which are unfinished in this respect. I'll put your sculptor to work on some of these tasks, which are very beautiful as studies and expressions."

Most of the people who worked for him were "sculptors of talent and promise" who happened to need money. "The young ones would do anything to obtain any kind of work from him; the older ones— those who had trouble impressing Salon juries—saw working for him as a way of making a living," Nicoladze reports. Experienced sculptors were now far better paid: "They received 25 francs an hour and normally worked four hours a day. Each of them only worked in Rodin's studio a few days a month; the rest of the time they were busy with their own work." But Rodin's relations with his praticiens were notoriously explosive. Nicoladze got to know one unfortunate colleague who had been working for him on and off for two years and had been fired—and rehired—five times.

Even the indispensable Chéruy was not spared this treatment: "He was a very well educated man who loved Rodin and had a profound appreciation of his art. He regarded Rodin's caprices as merely the more bizarre facets of a great man. Sometimes Rodin would fire him and Chéruy would accept no other employment for several months while waiting for Rodin to fire his successor and rehire him, as he knew would happen. He had a phenomenal memory. No one knew better than he how to deal with Rodin's business affairs and with his enormous correspondence. He knew how every visitor should be

received, and what to reply to every inquiry. He was a truly brilliant secretary."

Most of the assistants feared Rodin's temper: he was "direct, cold and sometimes even violent" when criticizing their work. The Belgian actor Lou Tellegen, who worked as his model and studio boy for a time, recalled that when his anger was aroused, "most of the words he uttered at such moments could not be found in the most comprehensive dictionary." The first time Tellegen encountered this phenomenon, "the filth of the words that he used nearly staggered me. Rodin when at home always called a spade a spade—that is, if he could think of no more vulgar name for it." Yet he was also willing to teach his studio boy the very rudiments of sculpture. With the temerity of the very young, Tellegen brought the maître his very first quarter-size figure:

He looked at it for a few seconds, and, picking up a sculptor's tool, he started to show me my faults and corrected me in such a rapid torrent of technical terms that I was dazed. Here and there, he hacked the clay. Now and then with a swift, accurate gesture he applied a piece of clay that seemed to stick wherever his steady thumb placed it. I saw the man's energetic nature actually come to life. He was dynamic. Such fluent thoughts and instant execution were uncanny. Without looking at me, the whole volcanic emotion of his true nature showed itself. He didn't spend more than half an hour correcting every detail of my first crude clay model, but as he talked all the time at lightning speed, that lesson was worth a lifetime of study and experience. When he was through, there was hardly anything left of my original figure. Of what remained, he destroyed the whole mass and saying, "Begin it over again," walked away. His whole manner of instructing was sharp, to the point, without any flowery theory. His teaching was like himself: abrupt, curt, rude!

Rodin's interest in Tellegen's work was all the more remarkable because he rarely had a word to spare for his employees. Tellegen thought he was one of the most taciturn people he had ever met:

"Sometimes I spent days in his company without hearing him utter a word." Nicoladze had the same experience. One day he found the maître sketching in the garden and as the sun had begun to go down Rodin told him, "Come, let's have a chat." Whereupon "he sat down on a bench and I on the grass, and we stayed like that the whole evening without saying a word."

The living arrangements at Meudon were rather awkward in any case, since the young sculptors-in-residence who occupied his workmen's cottages were more or less marooned on his hilltop and spent most of their time at his beck and call. One of his most gifted studio assistants, the Swedish sculptor Carl Milles, never forgot the adventure of his first night at Meudon, in the summer of 1906. He had come out from Paris for the day, but Rodin invited him to spend the night: "I hadn't expected this; hence I had no toothbrush with me, or nightshirt. They were going to lend me a nightshirt . . . and they tried to find one of M. Rodin's, but they were all away being washed, so Madame gave me one of her shirts with lace and things; it was horribly long. I was utterly embarrassed but had to take it, and they laughed at me and thought it very funny."

After supper Rodin took him a little way from the main house to one of the cottages he had built on terraces that led down into the valley like a set of giant steps. They were mainly used to store the overflow of his own plasters and miscellaneous work by other sculptors, including "a whole store of the purest Gothic fragments" which he had bought "from an Italian molder who had this treasure hidden in his plaster shop." Milles was put up for the night in a big mahogany bed—"a huge, heavy bed so large that I could lie in any direction I wanted. There was a candle beside me. Monsieur went away and when he was gone I got up to shut the door after him in the warm summer night but there was no door . . . no door anywhere. Around my bed stood six or seven or eight statues: *l'Ombre* (the Shade) was leaning over in a very original way with his huge, fantastic forms. One arm hung down; the other had been left off. The casters had made many examples of the same figure and had placed them around the big bed: these casts were standing there, gazing down on whoever had the pleasure of sleeping there. As I lay there I felt quite lonely and hoped that the candle would burn until the sun came up. But

then I heard footsteps coming nearer and nearer, and suddenly I saw an enormous Newfoundland dog standing in the door-opening and staring at me. He came up to me, sniffing and trying to find out what sort of being was lying there. All of a sudden he took a big jump into the bed, but as fast as he jumped I sprang out on the other side. This was a very big dog, and I now took my candle and tried to get him out of the bed. I held it in front of his nose—whereupon he licked it out, and I stood in the dark.

"I had to grope my way out and walk the whole way up to the house of Monsieur and ring the bell. Someone lit a candle at the head of the stairs and the head of Monsieur Rodin peered out at me from behind his big beard and asked who I was. 'C'est Milles, Monsieur. There is a big dog in my bed.' He laughed once and came down with a new candle and followed me back to the little house and there I learned how to pet the dog, who licked my hand and we were instantly good friends. Then Monsieur Rodin turned to go: 'This dog will always sleep beside you.' And the upshot was that he always slept with me."

>✠<

Cutting marbles was a thankless and time-consuming task that Rodin had always left to the professional praticiens, who produced the nearly 300 marbles known to have come from his atelier during his lifetime. He himself was "never a praticien," as Lawton was careful to specify. "Neither for himself nor for others has he ever hewn marble. He has always confined his fashioning to the clay, intervening in the fine-hewing merely to give the final corrections."

Yet when he was still an apprentice, "the need to earn a living made me learn all aspects of my métier," as he told Dujardin-Beaumetz. "I did *mise au point*, rough-hewed marble and stone, produced ornaments and worked on jewels for a goldsmith. . . ." Though he certainly knew the technique of carving he did not enjoy the art for its own sake, as Camille Claudel did. Like most nineteenth-century sculptors he did the creator's share by providing the clay or plaster model: the rest was traditionally left to those whose time was worth less than the maître's. Even in the 1880s he had told Bartlett that the only way a sculptor could "insure the exact reproduction of his model in marble is to do the work himself. But this method is prac-

tically impossible, because he cannot afford to do it for the prices he receives."

Normally the roughing-out of his marbles was done by a *metteur-au-point*—a marble pointer or rough-hewer—who reduced the block to the general outline of the plaster model, to within an eighth or sixteenth of an inch of the finished surface. At this point the fine-hewer or praticien took over, with his various instruments and measurements. The pointing of marble, as Malvina Hoffman explains, "is done with the assistance of a delicately adjusted three-point compass known as a pointing machine, which is hung on the original plaster. By means of a steel needle about seven inches long, the heights of the surface are all registered by hand and the needle is set. The compass is then transferred to the stone, and hung on three identical points to correspond with those on the plaster model. The excess stone is cut away until the needle can be pushed in to the same depth as on the original. It is not unusual to take three or four thousand points, to prepare a portrait for the final surface. If the machine shifts, or the needle is not accurately set, the entire effect will be ruined by errors in the pointing."

Rodin was well aware that something was lost in the translation. Marbles produced by this process, he told Helen Zimmern, were "a weak spot in our modern sculpture. . . . All the world sees in these days are copies, and a copy always loses something of the first freshness of the inspiration." Michelangelo might have worked directly in marble, "but we do not know how to cut direct nowadays."*

To restore an element of freshness to his marbles he allowed his praticiens a great deal of leeway to interpret his models as they saw fit. When he gave François Pompon a trial piece to cut in marble the young sculptor said, "I'm going to ask Escoula to tell me how you like people to do your work," whereupon Rodin told him not to bother:

*Ridiculous misconceptions about the way Rodin's marbles came into being have worked their way into the literature. "He had a block of marble ready, with the outlines of a figure in crayon," reported a woman who claimed to have served as one of the female models for *The Kiss*, no less. "Oh, he worked very fast. Chip-chip-chip and the marble flew everywhere. For a little man he was very strong and used a big mallet. . . . Chip, chip, chip, hours at a time. . . . We sat upon a bench for hours. M. Rodin was more terrible than ever. He never would stop, but kept the chisel going every day. . . . For weeks he kept us there." With everything that is known about his working methods, it

"My works can be interpreted in different ways! You'll do it as you feel it, according to your temperament, and the others will do it differently." As Pompon recalled in later years, "it was Rodin who taught me that instead of being one fixed, unalterable thing as we were always taught, a piece of sculpture can have infinite variations."

The otherwise taciturn maître could wax surprisingly eloquent when it came to discussing his sculptures with the praticiens. When there were several pieces waiting to be assigned he would give his favorite assistants their choice of subject, and talk at great length about each piece to explain what he wanted. But those who had a chance to observe him among the marble cutters have left very divergent accounts about how much he himself knew of their craft. Lawton, after many interviews, stated categorically that this was "the one branch of the statuary art which he has never practically learnt." George Moore remarked that "we have not a sculptor today who can wield a mallet; Rodin never raises one: he sends his plaster casts to Italian copyists, and the public prefers these copies to the bronze castings, though the bronze contains the sculptor's thought unadulterated." Pézieux, the trusted praticien who died too soon, had said unequivocally that Rodin didn't understand marble. Bernard Shaw, too, reported that one day "Rodin told me that all modern sculpture is imposture; that neither he nor any of the others can use a chisel." Yet a few days later "he let slip the remark: 'Handling a chisel is very interesting.' "

An important eyewitness account comes from Malvina Hoffman. "I have watched Rodin carving his own marbles at his studio in the rue de l'Université," she writes in her memoirs, "and have marveled at the way he could suggest soft feathers of a great broken wing, carving them directly in the block, without referring to the small plaster model. The pressure of an arm against another arm or the

seems almost beyond belief that a serious art historian could accept this apocryphal tale, told in 1930, as evidence of the fact that Rodin carved *The Kiss*—"chip, chip, chip"—from nude models kissing each other interminably upon a studio bench! In fact three marble *Baiser*s were carved during his lifetime, the first by Jean Turcan in 1886: a fourth was carved after his death by Léon Greber, for the Rodin Museum of Philadelphia—but not even then from a block of marble "with the outlines of a figure in crayon."

weight of a foot on the ground were certain problems which Rodin solved by himself, explaining to me just how the desired result was obtained in marble. He avoided any sharp edges, and used the light reflection almost as a painter would, to envelop his forms. He had a horror of deep holes or sharp outlines. . . ."

He would take Malvina to the Louvre just before closing time and apply the "candle test" to the Venus de Milo or one of the large Egyptian figures, holding up a lighted candle so that its light fell on the planes of the statues. "This is the test," he told her. "Watch the sharp edge of light as I move it over the flowing contours of these great chefs d'oeuvre of Egypt . . . you will see how continuous and unbroken are the surfaces . . . how the forms flow into one another without a break . . . no unnecessary dark cavities to break the massiveness, no scratchy lines too deeply cut into the precious *matière*. They knew—those old Egyptians!"

But Rodin's desire to emulate the ancients also created unforeseen difficulties for his praticiens. As Chéruy explained, "In the latter part of his life Rodin tried to have his marble sculpture very 'blond' and luminous; like the early Greeks. To obtain that effect he recommended to the *metteur-au-point* to *soutenir* by one millimeter [i.e., to keep it one millimeter thicker than the model], and this process applied all around the group resulted in some anatomical errors most embarrassing"—in the placement of an ear, for example. "The poor sculptor who had to finish the group had a 'hell of a time' to correct unobtrusively the mathematical error." Chéruy realized that this was a problem of mathematics rather than sculpture, "but nobody ever dared explain that to the great master."

Paul Gsell noted that Rodin virtually gave up sculpture after he moved into the Hôtel Biron and confined himself largely to drawing, and to supervising his praticiens, who were kept busy cutting small marbles based on groups he had produced in earlier years. "He showered them with advice. He would take a soft pencil and mark the spots on the marble that needed further carving. Sometimes, in order to shock some of the more timid sculptors out of their indecisiveness, he would take up a hammer and chisel and make the chips fly. The praticiens were devastated: in the wink of an eye he had unmade a good part of their patient labor. After he had finished, every-

thing had to be reworked to accommodate the area he had altered. His exasperated assistants would set to work again—and would soon have to admit that his judgment had been right all along."

In spite of every precaution, many of his expensive marble blocks were spoiled by the praticiens. The total failures which were beyond hope of salvage presented no moral problem, but there were borderline cases that were not overtly awful and yet not good enough to satisfy him: they were banished from the main studio-gallery and stored in one of the outbuildings. Yet even these proscribed marbles were sometimes fobbed off on undiscriminating buyers. Chéruy relates that the *Pygmalion and Galatea* sold to the Metropolitan Museum as part of the Ryan gift "was not among his best things, for he himself had relegated it away from the studio."

In the end it hardly mattered whether they were cut to Rodin's liking or not, since the twentieth century lost its taste for Rodin marbles soon after his death. Modernist critics like Leo Steinberg have dismissed these "dulcified replicas made by hired hands," and sculptors like Henry Moore have rejected the whole concept of turning out marbles by the factory system—"the atelier producing sculptures in his stead, his stones cut by others rather than himself, his *fabrique*. The results were as bad as those obtained by the Academicians." Yet the marbles are inseparable for an understanding of Rodin in his time. To the collectors who bought them in preference to his bronzes they represented the quintessence of sculpture as they knew it. Shaw, who was hardly Victorian in his attitudes, stated the case for marble when he described the different sorts of pleasure he derived from the different versions of his portrait by Rodin: "He gave me three busts of myself: one in bronze, one in plaster, one in marble. The bronze is me (growing younger now). The plaster is me. But the marble has quite another sort of life: it glows, and the light flows over it. It does not look solid: it looks luminous; and this curious glowing and flowing keeps people's fingers off it; for you feel as if you could not catch hold of it. . . . The particular qualities that Rodin gets in his marbles are not in the clay models. What is more, other sculptors can hire artisans, including those who have worked for Rodin. Yet no other sculptor produces marbles such as Rodin."

Rodin, indeed, loved marble as a material—not only because it accounted for the greater part of his income but because it provided

a tangible link to the classical tradition; he seemed to know everything about the various grades and kinds of marble that sculptors had used in Europe and Asia since the earliest times. Edouard Herriot, then mayor of Lyon (and later, among other things, prime minister of France), once took him to see the Roman ruins near Vienne, in the department of Isère, where he hoped to sponsor new archeological excavations. Rodin came to a halt beside a pile of marble fragments and began going through them one by one. "Look," he told Herriot, "this is from Carrara and this is Pentelian marble, very crystalline. This piece is from Egypt; this is the yellow marble of Siena, and here are fragments of the grayish limestone with undulating veins called *cipolin* because it resembles slices of onion, *cipolla*."

>✠<

The Meudon staff proved useful not only for adding morceaux to Rodin's figures but also for taking them off. When Gerald Kelly arrived one morning he found Rodin with several of his assistants trying, once more, to make the final decisions on the *Victor Hugo* monument, now definitely destined for the garden of the Palais-Royal; he was using the trial-and-error method he had always preferred, regardless of the scale. "There was the master, a little disheveled, and definitely irritable, and there was a squeeze of *Victor Hugo*—I mean a damn great big thing, heroic—and there were three cranes, light cranes, supporting the pendulous and heavy plaster women."

Rodin was still trying to achieve what he had failed to do for the Salon of 1897—combine the Muses with the seated poet. As the experiment progressed Kelly suddenly found himself in charge of the left arm of one of the Muses. "Her left arm was in the way, and something had to be done about it. So the first thing I was told was to cut her arm off—well, I didn't like to take that liberty and so I asked that one of the studio hands should come, and with a wire he amputated the . . . left arm and I was left hanging on to [the] left leg, and I worked and sweated all through that morning while these women were moved about by these cranes."

After a while Rodin told them, *"C'est affreux, changez tout."* "And so we swung these women about and we put them in other positions and during the whole of that day we moved them and I don't believe any progress was made." In the end *Victor Hugo*, in marble, was

duly installed in the Palais-Royal garden—but without the benefit of his Muses, just as Pézieux had foreseen. "None of the ladies were included," Kelly noted, "because Rodin could never get them to come right." At the unveiling on September 30, 1909, the Minister of Education, Gaston Doumergue, made a speech comparing Hugo to Dante and Shakespeare, and lauding the "kindred genius" of Rodin—who was thus able to be present at his own apotheosis, wearing a "Prince of Wales" top hat and accompanied by the Duchesse de Choiseul. Arnold Bennett, also in attendance, found it remarkable that the Hugo celebrations lasted from one in the afternoon until midnight, with only an hour's interval, though "it rained violently nearly all the time." Bennett liked the statue: it set him thinking about the significance of such symbols in the cultural life of Britain and France:

> I thought it rather fine, shadowed by two famous serpentine trees. Hugo, in a state of nudity, reclines meditating on a pile of rocks. The likeness is good, but you would not guess from the statue that for many years Hugo traveled daily on the top of the Clichy-Odéon omnibus and was never recognized by the public. Heaven knows what he is meditating about! Perhaps that gushing biography of himself which apparently he penned with his own hand and published under another name! For he was a weird admixture of qualities—like most of us. I could not help meditating, myself, upon the really extraordinary difference between France and England. Imagine a nude statue of Tennyson in St. James's Park!

Yet even in post-Victorian England, whatever shock effect Hugo's nudity might once have produced had certainly worn off by 1909. What was now regarded as a far more flagrant provocation were the fragmentary figures that Rodin persisted in imposing on a mystified public—"stumps of statues drawn from his bucket of clay," as Henri Godet described them in *l'Action*; sculptures that were "simulated ruins." Though they were used to such things in the Louvre, people were not yet accustomed to seeing torsos instead of complete figures in galleries of modern art. There seemed to be something slightly mad about a sculptor who "did pieces of sculpture and then delib-

erately broke them," as Bennett heard from his Paris friends. But didn't an artist have the inalienable right "to break up a piece that did not please him?" someone asked. "Oh, yes, but not to send it broken to an exhibition in imitation of the *Venus de Milo*." Anatole France, whose bons mots were repeated all over town, was heard to remark that "Rodin collaborates too much with catastrophe."

Rodin's last skirmishes with the critics were thus fought over works like his *Torso of a Woman* exhibited at the Salon of the Société Nationale in 1910, the headless *Walking Man* first exhibited in 1907, and the armless, legless *Méditation*, derived from the now unemployed *Voix intérieure*. Compared to his earlier battles the "stumps-of-statues" controversy was not much more than a polite debate, yet it gave the aging maître a comforting sense of grievance—the feeling of being as misunderstood as ever.

These partial figures of his later years could have come as a surprise only to those who had not followed his earlier career very closely, or seen his storehouses filled with torsos and morceaux: giving them formal sanction as exhibition objects was merely the logical outcome of a passion for simplification that had led him to remove the spear from *l'Age d'airain* in 1877, to leave the hands off the *Three Shades* of the 1880s and to exhibit a nude *Bourgeois* without a head or hands at the 1900 Pavilion. What had then been an ostinato bass now emerged as the leitmotif of his last years. "Recently I have taken to isolating limbs, the torso," he told Muriel Ciolkowska in 1910. "Why am I blamed for it? Why is it allowed to isolate the head and not portions of the body? Every part of the human figure is expressive. And is not an artist always isolating, since in Nature nothing is isolated? When my works do not consist of the complete body, with four limbs, ten fingers, ten toes, people call it unfinished. What do they mean? Michelangelo's finest works are precisely those which are called 'unfinished.'* Works which are called finished are those which are clean—that is all."

*Henry Moore felt that there is a significant distinction between Michelangelo's *non finito* sculptures and those of Rodin: "Rodin simply told his assistants to imitate the kind of thing that Michelangelo did, known as unfinished sculpture, where the subject remains trapped in the block—but the results are not like Michelangelo. Michelangelo developed the subject as he carved, and his point of departure was not a complete thing. I think that in some cases Rodin probably made a complete model first and sent that

Most of his partial figures, in fact, were not so much left unfinished as deliberately mutilated at some stage in their development. Countless stories—most of them apocryphal—were told about Rodin the iconoclast, recklessly knocking pieces off his sculptures—an activity for which he was taken to task by critics who thought he was doing it merely to be fashionably different. "There is no great harm in a sculptor knocking one of his old clay figures about for experimental purposes," Frank Rutter wrote, "but when a fool arrives in the middle of a bashing and, gazing with awe on the wreck, reverently exclaims, *'Ne touchez pas, cher Maître, c'est un chef-d'oeuvre!'* why then even an old man who had grown a trifle indolent cannot be altogether forgiven for allowing the monstrosity to be sent to the foundry, cast, and subsequently exhibited as a 'new creation.' "

One observer who claimed to have witnessed such a bashing was Ambroise Vollard, who recalls in his memoirs that he and Dujardin-Beaumetz walked in the door just as Rodin was demolishing something: "He had a great sword in his hand. On the floor lay fragments of statues, severed hands and heads. Among the persons contemplating these with consternation were Loïe Fuller, Mme de Thèbes and the venerable astronomer Camille Flammarion." One of the women was pleading with the executioner: "Maître, have mercy on such a beautiful head!" and Antoine Bourdelle, watching from the sidelines, kept repeating, in a booming voice with a Provençal accent: *"Rodein! le grand Rodein!"*

"Rodin, catching sight of one of the statues, the only one still intact . . . whirled his sword, and the head fell. 'Such a pretty head!' cried M. Dujardin-Beaumetz." Later, Rodin picked up one of the heads lying on the floor. "How much more beautiful it is without the body!" he told them. "After all, how could it be otherwise?" Actually, he explained, there were technical reasons for this orgy of decapitation: "I am giving away one of my secrets. All those trunks that you see there, so perfect in their forms now that they no longer have heads, arms or legs, belonged to an enlargement. Now, in an enlargement, certain parts keep their proportions whereas others are no longer to scale. But each fragment remains a very fine thing. Only,

to the praticiens, telling them to stop when they had reached a certain point, and to leave the subject still embedded in the block." (Cf. *L'Oeil*, November 1967, p. 33.)

there it is! You have to know how to cut them up. That's the whole art."

Vollard invented many of his anecdotes, but he may well have witnessed an episode of this kind: other sources confirm that problems caused by enlargements sometimes obliged Rodin "to suppress unsuccessful extremities by adroit breakage." Still, had he wanted to do so, Rodin could have adjusted the deformations by other means: whatever the pretext for his amputations, their underlying purpose was to divorce sculpture from its traditional sentimentality and the need for an accessory story line. Bourdelle, besides admiring *le grand Rodein* for his swashbuckling way of cutting off a statue's head, understood that in so doing the maître had, in effect, abolished the requirement that sculpture ought to "mean" something. Rodin had reached the summit of his art "in these simple figures," Bourdelle wrote, "sometimes in fragments, in torsos or in ensembles shorn of gestures, which will not allow anything anecdotal or literary to be said about them."

Sometimes Rodin still pretended, with tongue in cheek, that his abbreviated torsos could be explained in terms of some conventional storytelling rationale. When he was asked why he had left the *Méditation* incomplete the reply was: "Don't you see that I left it in that state intentionally? My figure represents Meditation. That's why it has neither arms to act nor legs to walk. Haven't you noticed that reflection, when persisted in, suggests so many plausible arguments for opposite decisions that it ends in inertia?" The truth of the matter was that the nameless fragment interested him more than the whole figure, allegorical or not. As he told Gustave Kahn, *"Le morceau est beau en soi, l'étude du morceau légitime et profitable*—the fragment is beautiful in itself; working on fragments is both legitimate and worthwhile."

His immense fame allowed him to indulge his passion for morceaux—and, what was no less important, to find buyers for them. As Kahn noted, Rodin had never done his preparatory studies with pen or pencil but had worked directly in clay, having casts made at crucial stages in the development of a figure as he worked toward its definitive form. "When he became famous all his preparatory studies became *états*, as interesting in themselves as the final realization"— and thus an étude like the *Walking Man* became salable to museums

and collectors. Meanwhile, the evolution of modern taste was also working in his favor. Georg Simmel was the first to point out that these partial figures were conspicuously in tune with the zeitgeist. "Rodin's figures are often unfinished," he explained in the *Berliner Tageblatt*. "There is one unmistakable tendency among the characteristic features of our epoch: we value stimulus and allusion more highly than a definitive achievement that leaves nothing to the imagination. . . . In taking advantage of this trait in the modern soul, Rodin succeeds, by means of his seeming incompleteness, in illuminating the relationship between form and material."

The more conservative critics objected that he was merely making a virtue of necessity. Rodin's penchant for partial figures, suggested Kenyon Cox in the *Architectural Record*, stemmed from his innate limitations as an artist with a defective sense of design: "It is not for nothing Rodin has always been willing to exhibit his work in bits. . . . The bits are all that really interest him, and their more or less successful combination is a matter of indifference when it is not a nuisance."

In her books and lectures on Rodin, Judith Cladel felt compelled to defend him against the charge that he was "a mystifier, perversely cutting off the limbs of his statues." When her first book was republished in a deluxe edition in 1908 she took care to insert a new statement from the maître spelling out his position on fragmentary sculpture:

I am an inventor; I deliver the results of my researches in the form of morceaux representing my studies of planes and modeling. I am reproached for not personally demonstrating all the applications that can be derived from these studies. Let those who come after me concern themselves with this. I must be content with having led the intelligence of the artists of my time into the environs of Michelangelo and the Antique. When Volta discovered the electric pile, he himself did not work out all the applications that have since revolutionized science; still, it is to him that we are indebted. A well-made torso contains all of life. One doesn't add anything by joining arms and legs to it. My morceaux are the examples I propose to other artists

for study. People say they are not *finished*. And the cathedrals, are they finished? This one lacks a tower, in that one the choir was never built: but he who studies and understands them just as they are will in his turn become a master.

>✠<

Rodin's didactic concern for "those who come after me" should have endeared him to the young rebels of the next generation, but in fact the best of the younger sculptors were going off in other directions. Only his praticien-disciples, such as Dejean and A.-J. Halou, turned out some notable sculptures in the Rodin mode. "This year I'm exhibiting the torso of a woman à la Rodin," one of them was heard to boast: "I cut off the arms and legs squarely." But beyond his immediate circle it was not true that "Youth claims him as a chieftain and his detractors are silent," as Mauclair believed. On the contrary, the younger generation was suspicious and disaffected, and Rodin was right in thinking that he was now the target figure whom everyone wanted to surpass.

Constantin Brancusi, for one, made a conscious effort to avoid being drawn into Rodin's magnetic field when he came to Paris from Romania at the age of twenty-eight. "One day I did a sculpture that was like a Rodin," he recalled in later years. "I couldn't live near him any more, though he liked me. I was working almost the way he did; I was copying him unconsciously, but I recognized the copy." Friends arranged for him to be taken into Rodin's studio as an assistant. "But *I refused, since nothing grows under big trees*. My friends were very annoyed, since they were unaware of Rodin's reaction. When he heard of my decision he said simply, 'At heart he's right; he's as headstrong as I am.' " Significantly, Brancusi's first major work, *The Kiss* of 1907—two embracing cubes that owed more to African sculpture than to Rodin—were like a declaration of war on the older, better-known *Baiser*.

The young Norwegian sculptor Gustav Vigeland summed up the attitudes and prejudices of his generation when he wrote from Paris that he was "bored" with Rodin: "No one is as modern and as popular as he is. And nobody dares to write or say anything of real significance about his art because they are afraid of looking foolish. . . . The

people he influences are not the multitude but the troop that marches ahead of the multitude—not the pioneers, though! Not the true elite!"

By the same token the young Jacques Lipchitz was annoyed rather than pleased when he heard that Rodin had praised a bust he had exhibited at the 1912 Salon of the Société Nationale—he thought something must be wrong with his work if Rodin liked it. "At that time I was not prepared for such praise by an artist who seemed to me to represent the older generation from which I was already attempting to escape." It was not until much later that he discovered "all the treasures and all the riches piled up" in Rodin's work.

Jacob Epstein, who admired Rodin but had gone on to a primitivism of his own, tried to enlist the maître's help in 1912, when the Paris authorities wanted to apply a fig leaf to the loins of the "demon-angel" Epstein had carved on the twenty-ton tomb of Oscar Wilde in Père Lachaise cemetery. Rodin's response confirmed the younger generation's belief that he had become old, vain and tired. A petition had been drawn up by Epstein's friends and "a beautiful Russian-English girl, who knew Rodin, volunteered to go as an emissary to solicit his support with photographs of the tomb," Epstein recalls in his memoirs. "Without looking at the photographs, Rodin started to upbraid her for bringing to his notice the work of a young sculptor who, he imagined, was her lover, and declared he would do nothing to help her. A plain girl would have been a better emissary to Rodin."

The young Henri Matisse sculpted an armless male nude, *le Serf*, that could almost have been a *Walking Man*, yet he belonged to the school that dismissed Rodin as a maker of beautiful fragments: "For him a composition is nothing but an arrangement of morceaux." Maillol, despite their public exchanges of compliments, was at pains to emphasize his differences with Rodin: "When I began to do sculpture I didn't understand him at all. His works made absolutely no impression on me. I found them bad, that's all. It was not till later that I understood what was interesting about them." To illustrate the point that he and Rodin were "at the opposite poles of the sculptor's art" he took Count Kessler to the Louvre and showed him an antique statue of Venus that had been immersed in the sea until all the details

had been smoothed out and simplified. "That figure has been my teacher," Maillol said. "Had it been the work of a Rodin, nothing would have been left. This figure showed me what is the essential quality of the plastic art. A statue must be beautiful even when its original surface has perished and it has been worn smooth as a pebble."

Rodin's relations with Medardo Rosso had reached a new low with the Salon d'Automne of 1904, when the latter had placed his own work next to photographs of Rodin's sculpture "so that the public could compare and judge for itself" whether the younger sculptor's charges of plagiarism were justified. Rosso refused to shake Rodin's extended hand at the opening of the exhibition, and their rivalry was promptly exploited by the Paris press. The controversy followed them across the Channel and became a cause célèbre in London two years later. "The reputation of Rodin, the famous sculptor, has recently been the subject of curious and damaging rumors," reported the London *Observer* on February 3, 1907. The statue that had made him famous, the *Balzac*, was plainly a work of "impressionism in sculpture," yet his earlier work had been inspired by the Greeks and the Renaissance: "What was the inspiration, the sudden influence, that had come into the sculptor's life?"

> In [1889] there had come from Italy to Paris, full of his original ideas of the art of sculpture, thrilled with a great discovery, and bringing his sculptures with him, a young man called Rosso. He was very poor, and very poor he arrived in Paris. Amongst other French sculptors to whose studios his art was his introduction was that of Rodin, and Rodin's was the first to which he went. To Rodin he poured out his theories of impressionism. With Rodin he exchanged statues. . . . Rodin was deeply influenced; his art took on a new atmosphere. Fame came to him, and honours, and wealth. Rosso was thrust on one side; Rodin was acclaimed the creator of a new school.
>
> Rosso was ignored, and had to suffer years of neglect. He was so poor that even when one of his sculptures was bought he did not dare ask for food at his hotel, lest the landlord should make it an excuse for asking him to pay his bill or go. He

dared not ask for the money from the purchaser; he came near
to starvation. At last recognition came—at the Autumn Salon
of 1904 in Paris where his works were placed near the wall
where the photographs of Rodin's work were hung. They looked
like works under Rodin's influence, until the dates were noted,
and sharp critical eyes saw that Rodin was the disciple. . . .

Then, a little more than a year after, Rosso was invited to
send his work to the "International," in London. He was "hors
concours"; what he sent would be placed. He undertook to send
if the society allowed him to place his works in a proper light;
his offer was accepted, and he placed his pieces at the New
Gallery in the central hall of the society of which Rodin was
President. When the Press day came, three of the nine works
were missing, and these the most important. If Rodin ordered
their removal, his act was beneath contempt; and the committee
of the society must have been made of servile stuff to suffer it.
If he did not so order it, the committee were guilty of an act
which must besmirch the credit of the great sculptor.

It was true that some of Rosso's sculptures had been mysteriously
removed from the New Gallery twenty minutes before the official
opening, "and with them the pedestals, so that the sculptures could
not be put back." But Rodin, interviewed at the rue de l'Université,
denied having had anything to do with their disappearance. "I am,
as you know, the president, but it is impossible for me, living in
Paris, to attend to all the details," he told a reporter for the *Pall
Mall Gazette*. "Mr. Lavery, the well-known painter, is the virtual
president, and he is assisted by a very competent committee, in-
cluding M. Lanteri, himself a great sculptor. All the work is done
before I arrive; everything is in its place. The committee, therefore,
and not myself, are responsible for any exclusions. I understand that
Rosso sent in ten works; that, of course, is excessive where space is
limited. He is not a member of the society, and not even 'sociétaires'
can expose that number. This, I suppose, is the reason that led the
committee to remove some of his work."

He also dismissed Rosso's claim to having been the first Impres-
sionist in sculpture—"Sculpture is either strong or weak; it is not
'impressionist' as a sketch might be." The rest of his rival's charges

left Rodin equally unmoved: "Yes, I know that Rosso pretends that I am his pupil. It is, of course, quite false; but things of that sort fall of themselves, do they not? There are the public: let them judge as between him and me; they know our respective work. I have not seen Rosso for a dozen years. He is an artist of great 'brio,' but it is principally as a moulder that he has attracted me."

Rosso happened to be in London at the time; he fired off the final volley in this exchange of broadsides in a letter to the editor of the *Pall Mall Gazette*:

> . . . That the public should judge is my own wish, and I have made a point, whenever I hold an exhibition of my works, of placing amongst them a torso by M. Rodin, which in the days of our friendship he gave me in exchange for my *Rieuse* and as a mark of his affection and esteem. Let the public judge by comparing my impressions of the early 'eighties with M. Rodin's traditional works of that time.
>
> If M. Rodin declares that he has not seen me for twelve years, it is easy for me to prove that his memory is at fault. Perhaps he will not recollect that we met in 1900 in the house of M. Chéramy, the well-known collector, that he then invited me to his studio to ask my advice about a new work—a large child with inclined head, that at my suggestion he made certain alterations to it, and that in one instance, when he misunderstood my words, I caught hold of his arm and said: "No, no, this is all right! Don't touch it." "You are right, my dear Rosso," was his answer. "I did not understand what you meant."

The work in question was evidently Rodin's *Faune enfant*, one of his more Rosso-like sculptures. But the Italian's arguments were all the more pointless since the influence of his *sfumato* effects had clearly come to an end now that Rodin was preoccupied with his neoclassical "blond" torsos. Rosso, however, never got over the idée fixe that he had somehow been cheated out of his just due. "He used to go to exhibits of Rodin's work and make loud speeches against it," as the sculptress Catherine Barjanski records, "constantly trying to persuade people that Rodin had stolen everything from him." Meanwhile, Rosso himself had ceased doing anything new—that was one

of the reasons for his obsession with the past. After Rodin's death Guillaume Apollinaire called Rosso "without a doubt the greatest living sculptor," but by then it was too late: his last work is dated 1906.

>✠<

One modernist who had been careful to cultivate good relations with Rodin was the young Croatian sculptor Ivan Meštrović, who came to Paris at infrequent intervals and always received a warm welcome from the maître. Meštrović's *Souvenirs* shed incidental light on Rodin's existence at the Hôtel Biron in the heyday of Madame la Duchesse, whose unwavering solicitude frequently became oppressive. At half-past seven on a Sunday evening in the autumn of 1909 Meštrović had an appointment with Rodin at the Hôtel Biron: "I was exactly on time and so was he. We ran into each other a few steps from the front door, in the courtyard. The old man shook my hand cordially and told me that he was happy to be able to spend some time alone with me, and that we could 'talk about our dreams.' Then he turned to the concierge and asked for the key. 'But maître,' was the answer, 'I've already given it to Madame.' " Rodin was furious to learn that the Duchesse had preceded him: "It's outrageous; I can never be alone. But come on, let's go."

They found the vestibule door open and Rodin's suite plunged in darkness. "A lady with a candle in her hand appeared through a door, and we could hear the sound of two other people talking in the next room, where we could see more candles. She said, '*Bonsoir, Maître*, we've been waiting for you for over an hour.' He told her, 'I'm not expecting anyone; I want to be alone,' and repeated as if talking to himself, 'It's outrageous; I can't even be alone on a Sunday evening.' "

The Duchesse's feelings were hurt, and the presence of a stranger was clearly embarrassing. When she asked, "What can I do to help?" Rodin answered, "I don't need anyone; leave me, leave me." Meštrović also felt embarrassed: "Rodin took me into his library, which was to the left of the vestibule, slammed the door behind him and began to feel around on his desk for matches, which naturally he couldn't find in the dark. He asked me if I had any matches—to make a light while he looked for candles. Meanwhile, he pulled out

one drawer after another, turning everything upside down but finding no candles. He growled that people even went so far as to steal his candles. Finally he found a package of them which he began to undo while my match burned down to my fingers and I lit another. Just then he dropped the package and the candles scattered all over the floor."

At that moment the Duchesse appeared with a candle in her hand: "Maître, in Heaven's name, what's happened? Here's a candle." A few steps behind her was another woman, also holding a candle. Rodin was in no mood to be amiable. "Nothing's happened; I don't need anything; go away, leave me alone." As the ladies turned to go Meštrović finally succeeded in lighting a candle. "Rodin put it on the table muttering, 'I wanted us to be alone and there they are in the next room.' At last he quieted down, after complaining about the nuisances he had to put up with, especially women, from whom there was no escaping. But when his anger had cooled he had to admit: 'What would we do without them?' By the light of the candle he began to show me a whole series of drawings and sketches; then we walked about the room looking at the sculptures."

Though Rodin spoke of Meštrović as "*un artiste de grande valeur,*" for the most part he was out of sympathy with the young rebels of the Cubist generation. The Post-Impressionists had been hard enough for him to digest, and what he saw of the avant-garde at the beginning of the century made him distrust the whole evolution of modern art. "*Nous sommes les avant-derniers!*" he liked to say ("We are the penultimates!") "With some apprehension Rodin saw all the old canons and traditions being blasted to the four winds," Ludovici noted. "He had little hope for the future, and in the sense that he could see about him but few whose conscience was in their work as wholly as his was, he was probably right in regarding himself as an *avant-dernier.*"

Like most artists of his generation he drew the line at Cubism and Futurism. "They're sheer decadence," he told the Spanish writer Corpus Barga. "It mustn't come to this." He refused to believe that these young people were as serious about art as he was. "Nowadays the young people want to make progress in the arts too quickly. . . . The young people are striving for originality, or what they believe to be originality, and they hasten to imitate it. Forced originality, like the

bizarre, has no reason for existence." The angularities of the new style annoyed him so much that he preferred even the least of the representational painters to the best of the Cubists. One day he was shown a picture by Marie Laurencin among a lot of reproductions of modern paintings. "At least here's one who's neither Futurist nor Cubist," he said to his new secretary, Mario Meunier. "She knows what loveliness is: she's *serpentine*."

>✠<

His dislike of what was happening in contemporary art made him all the more receptive to the ancient Greeks and Egyptians: "The older I become the more intense grows my admiration for the antique." His collection of antiquities was no longer just a minor pastime. By 1907 he had amassed some 300 classical objects—"Tanagra figures, busts, torsos, etc.," together with many Oriental, Gothic and Renaissance sculptures. As Otto Grautoff reported in *Jugend*, "This collection has grown from modest beginnings; in recent years, thanks to a greatly increased income, he has invested thousands in this collection: today it is one of the richest and most beautiful private collections in Europe." It contained bronzes, marbles and ceramics—statuettes, votive figures, fragments of monuments and funerary sculpture, bas-reliefs, architectural ornaments, a Corinthian bronze helmet, lamps, scores of red- and black-figured vases and much else. "I suppose you spend mad sums buying antiquities?" Gsell asked him in 1907. "It's true that this passion makes terrible inroads in my budget," Rodin replied, and Gsell—who had himself become a collector of Rodin's maxims and opinions—noted that "his enthusiasm for the antique is a voracious monster to which he feeds, without counting it, the money he makes with his art."

Dealers in antiquities converged on him from all over Europe, knowing that if he really liked a piece money was no object. Anatole France, who also collected Greek marbles, accused him of spoiling the market for ordinary amateurs. His willingness to lavish vast sums on Greek heads and torsos gave the frugal Rose additional cause for concern: she became "anxious and peevish," as Ludovici put it, because "she could not help being shocked by the prices that Rodin was prepared to pay for any addition to his museum. In her opinion, all dealers were untrustworthy and cunning people who knew how to

extort the most fabulous sums from her poor Auguste for the merest rubbish; and, as she knew neither the extent of his income nor the value or beauty of the treasures he used to purchase, her distress was perhaps perfectly natural."

Rodin prided himself in knowing intuitively what was good and bad among the pieces he was offered. "Taste is as rare as genius," he liked to say—and he was certain that his taste would protect him from the pitfalls of collecting archeological art. He felt he could even dispense with dealers' guarantees and certificates of authenticity. "I don't need identity papers," he assured Camille Mauclair. "I look, I touch, and since I know a little something about it, if I see it's a beautiful antique, I buy it."

The many fragments in his collection bore out his theory that a sense of the whole was conveyed by even the smallest detail: "*un sentiment se voit jusque dans le talon.*" There was one particular stump of a hand, found at a bric-a-brac dealer's, with which he liked to demonstrate the expressiveness of the *morceau* as a thing-in-itself. "It is broken off," he told Lawton, "it has no fingers, nothing but a palm, and it is so true that to contemplate it, to see it alive, there is no need of its fingers. Mutilated, it still suffices, because it is true." Eventually he became convinced that this eloquent fragment must have been the work of a great sculptor. "It's by Phidias," he was certain: "I feel it; I'm sure of it. . . . Isn't it as powerful as a hand by Titian?"

Nicoladze relates that most of the Greek marbles Rodin bought came directly from Greece, though the Greek government had prohibited their export. The statues were smuggled out as ballast on ships sailing to France or to England: "The price might be 15,000 or 30,000 francs. Rodin never haggled; he would just sign a check and hand it to the dealer." The fact that the statues were contraband meant that some of them were an unknown quantity even to the dealers, and explains Rodin's unorthodox purchasing tactics. There was a Heracles, for example, which was the apple of his eye: "It was still in a crate when I bought it," he told Gsell. "One or two boards had been pried loose, and I could see only part of the back. I stole a look at it and said quickly, 'I'll take that, I'll buy it; here's the money.' Had I waited for them to unpack this masterpiece it would have been far more trouble to obtain and might have got away, be-

cause I would have been obliged to compete against the national museums."

Despite his intuitive judgment, "Rodin's inordinate passion for collecting occasionally led him astray," as Ludovici noted. He bought an ancient Greek drinking cup fabricated in the nineteenth century, and a row of Tanagra figures produced by a faker: "I knew a Greek mouleur who excelled at this trade. All the collectors thought his pieces were genuine. Rochefort has two showcases full of them."

One evening, after a dealer had been to see him in Meudon, Rodin called Ludovici into his small studio and showed him a statuette the stranger had left behind—a small bronze Hermes. "You see this?" the maître said. "If it is genuine it is priceless. The man assures me that it is genuine, and I have persuaded him to leave it with me until the morning, so there is no time to be lost. He says he will take 18,000 francs for it. It is too little and I am suspicious. As you see, it is most beautiful and almost perfect. But somehow I have a faint recollection that I have seen something so much like it, that it might be a skillful fake—particularly as regards one of the arms, which does not seem to me quite right."

Though it was already half-past eight, he sent Ludovici to Paris to make a quick reconnaissance of all the store windows along a street in the Latin Quarter where the plaster-cast dealers had their shops: "Remember, that if you see something very like it, do not be put off if one of the arms is raised, or if there is a small staff or something in one of the hands. [The hands of the bronze held nothing.] But you will be struck with the likeness before you begin to examine details of that sort."

Ludovici took the first electric train to the Montparnasse station. The shops were still open when he arrived. He ran down the street scanning the windows and finally found precisely what Rodin had told him to look for—"a piece so faintly different from the 'genuine' antique that its very size was identical. . . . I dashed into the shop, feeling not a shadow of a doubt that I had tracked down the incriminating evidence of the swindle." He bought the plaster for a few francs and brought it back to Meudon, where Rodin was still waiting up, though the hour was unusually late for him. "He nodded his head gravely. Except for the left arm and hand, the plaster was in every respect an exact replica of the alleged antique bronze, and he con-

gratulated me. 'You see how careful I have to be!' he exclaimed, smiling sadly."

To make certain it was not just a coincidence—for he still seemed to covet the statuette—Rodin sent for an expert bronze founder to examine the figure early the next day. The hapless dealer arrived at Meudon shortly after the bronze expert had pronounced his Hermes an arrant fake. As Ludovici recalled, "the Monsieur Rodin with whom he was now confronted was by no means the same person as the enthusiastic amateur of the previous evening; for, when he was angry, Rodin could not only be offensive but terrible. After the interview I heard a quick step on the gravel outside, and standing up at my writing table, I managed to catch a glimpse of a hurrying figure, bearing away a bundle that looked like a roll of old velvet. The face of the departing dealer was bloated with indignation, and I gathered that he had had an unpleasant surprise."

In this instance Rodin had been saved by his phenomenal memory, but on other occasions when he should have been equally suspicious he was so gullible that it almost seemed as though he wanted to be cheated. Warrington Dawson, the American journalist who briefly intended to be his Boswell, jotted in his diary for October 28, 1911:

> Called on Rodin today. Helped Duchesse de Choiseul to prevent him from paying 8,000 francs for a couple of pseudo-Japanese vases, patent frauds—gold was rubbing off as on European china, the cracks were all white; there was nothing suggesting antiquity or foreign origin. Rodin said they were "decorative and pretty." I said, "So they were but that did not make them Japanese and worth 8,000 francs!!" The two men who had brought them then betrayed themselves by saying, "All right, if you won't pay our price, give us whatever you want to pay—we have to dispose of these things."

After Rodin's death his collection of antiquities was variously estimated to be worth between four million and twelve million francs. Yet it consisted almost entirely of minor pieces, and toward the end Rodin had evidently collected "more fakes than genuine pieces," as *The Connoisseur* reported. His passion for collecting had, indeed, led

him to do far too much impulse-buying. In 1945, when Nicolas Plaoutine and Jacques Roger published the French government's catalogue of 170 or so classical vases in the Rodin collection, the keeper of Greek and Roman antiquities at the Louvre, Alfred Merlin, added a highly critical preface taking Rodin to task for having failed to bring "the method, passion and effort of a true collector" to his purchases in this field. "He simply took advantages of casual opportunities, without giving his acquisitions the care and consideration they deserved. For that reason, while there may be some curiosities among the vases he collected, there is not one that belongs to the first rank. Had he wanted to, he might have acquired distinguished pieces by the greatest Greek ceramicists . . . but he did not give them sufficient attention to make a careful selection, eliminate the banal pieces and retain only those of value."

Rodin's criteria, however, had always been very different from those of the museum curators. He considered himself an *élève* of the Greek masters, and he looked for fragments that fitted into the mosaic of his vision of the classical past. Once the dealer had departed Rodin would throw himself on a new acquisition and celebrate the so-called honeymoon of the collector, "admiring the marble like a lover," as Nicoladze says. "I remember Rodin one day, gazing for a long time at a fragment of a female torso and exclaiming, 'How beautiful they were, how beautiful they were!' "

Those who knew him well reported that during his last years this was Rodin's constant refrain. "He was always smiling," Gsell noted. "He would murmur almost continuously, 'How beautiful it is!' He would repeat these words as readily before one of his own works as before a magnificent landscape or a superb naked woman: *'Que c'est beau! Que c'est beau!'* "

Rodin himself made no secret of the fact that he had every reason to be happy. "All in all I am the happiest of men because I'm the freest," he told Gsell in 1906, during one of their first conversations. "My greatest happiness is to feel inwardly free; to feel emancipated from every artistic lie." And because he felt free "I never do anything except what interests me, and whenever it suits me. Art is

something to be enjoyed: it can and should be an exertion but not a chore. . . ."

His happiness was interrupted only by occasional bouts of ill health. He felt *"un peu malade"* with the flu in July 1908, and in October he wrote to Helene von Nostitz that "for two months I have lived my life at the Goulette, where I am undergoing a solitude-cure. I am alone in that large room [where she had stayed with her husband] and receive no one; I read a little when I wake up in the middle of the night, and drink my fill of the silence. At the end of the night, through the open window the day slowly penetrates the friendly fog and the beauty of autumn inspires me." In November he had a sudden relapse and spent another three weeks recuperating, in the Goulette room whose window overlooked the swan pond.

It was no wonder that, at the Hôtel Biron, he was "pampered and fussed over by the Marquise de Choiseul," as Lucie Delarue-Mardrus writes in her memoirs. "She kept on making him sit down and wrapped up his legs as though he were a patient." Indeed, Rodin was still recovering from his illness. But it was even more worrisome when the Duchesse was physically or psychologically unwell. "At the moment," he wrote to their mutual friend Marie Hopkins, in an undated letter, "our much-loved Madame de Choiseul is ill, of tensions, business concerns; everything is killing her. . . . Six days ago I came back from Bois-le-Houx [the Choiseul château]; I gave her some respite from her afflictions. All of this has reached an acute stage and I fear for her life."

When she was in good health they often had lunch at Albert Besnard's town house in the rue Guillaume Tell, where "a sort of Mount Olympus of painters" used to gather on Sunday afternoons. Albert and his sculptress wife Charlotte Dubray were both tall, stout, eminent artists who struck Lucie Delarue-Mardrus as "having an air of crowned heads. Mme Besnard knew wonderfully how to arrange her corpulence. Her large, flowing robes simply gave the impression of great breadth filled with majesty." Forain, another regular visitor, remembered the Duchesse's bulimia and thought her three-quarters *folle*—"she would rise from the table from time to time to vomit in the toilet on account of a stomach ailment, she said."

Under Claire's influence Rodin's social life had taken on a dis-

tinctly cosmopolitan flavor. He went to hear Caruso at the Trocadéro and was occasionally to be seen at the ballet, the opera or the races at Longchamp. There were visits from Réjane, the most famous actress of the day, and a private recital by Amalio Cuenca, a Spanish guitarist whom Rodin thanked with a "drawing for a tango." He attended Zuloaga's lavish *fiesta española* on the first day of January, 1909, when the painter unveiled his latest pictures to a group of friends that included Isaac Albéniz, Nathalie de Goulouboff, Charles Cottet, Arsène Alexandre, the singer Lucienne Bréval and the novelist René Maizeroy.

The visitors who came to his studio usually received a warm welcome, though his ideas of sociability sometimes left them rather mystified. When the Swedish writer Ellen Key and her Russo-German friend Lou Andreas-Salomé came to Paris, they asked the journalist Otto Grautoff to introduce them to Rodin. Grautoff told the maître about them beforehand and mentioned that Madame Andreas-Salomé had been a friend of Nietzsche's. The day the ladies came to his studio Rodin "went up to Ellen Key, pressed her hand warmly and said, proud to be so well-informed, 'I know very well, Madame, that you were *la maîtresse de Nietzsche!*' "

Though he "had a horror of the theatre," as Jeanne Russell recalled, she and her father persuaded Rodin to accompany them to *Tristan et Isolde* at the Opéra, with Ernest Van Dyke and Felia Litvinne in the title roles. (It was probably one of the five performances with these two principals given in April and May, 1907.) After the first act Rodin got up and said apologetically: "I've got to leave, Russell; I can't stand listening to this music any longer. Like your cliffs at Belle-Ile it's so beautiful it makes me want to die."

He saw a good deal of Jeanne Russell after he installed a Steinway grand piano at the rue de l'Université, where, as she writes in her memoirs, "I played his favorite music for him for hours at a time—*Orpheus, Alceste, Iphigenia*, the sonatas of Beethoven, Mozart and Haydn, and above all, Bach." He had become a very exigent listener: one day, when she improvised a cadenza and sneaked a theme from *Tristan* into a work by Beethoven, "a lump of wet clay suddenly landed on my forehead and Rodin said with feigned anger, 'Oh, you *petite méchante*, you've chased away the lovely dream you gave me

with the serenity of your Beethoven.' " But *Tristan*, she retorted, is also beautiful. "Yes, but it plunges me into mortal anguish and keeps me from working."

Jeanne introduced him to her teacher Raoul Pugno, a concert pianist and former professor at the Paris Conservatory "whom Rodin liked very much, since his kindness and simplicity were as great as his talent." Together Pugno and his pupil played Beethoven's Second Symphony in a four-hand arrangement on Rodin's Steinway. At the end of the slow movement the sculptor told them—"God, how he must have suffered to have written that. When I heard it for the first time I saw *Eternal Spring* before my eyes just as I afterwards sculpted it—only it was more beautiful in my dream." Later, Pugno and Eugène Ysaÿe, who often concertized together, performed the Beethoven sonatas for violin and piano in Rodin's studio, and Jeanne remembered him "sunk into an armchair in the midst of his sculptures, with tears rolling down his cheeks and through the fingers with which he was covering his face."

The Steinway piano was the only serious casualty of the 1910 flooding of Paris, when the Seine burst its banks and inundated many of the nearby streets, including the rue de l'Université. Rodin was forced to buy another, but at least the sculptures were unaffected. As the young art critic Guillaume Apollinaire reported in the *Paris-Journal* of February 4:

Maître Rodin was afraid that the flooding might damage his works at the Dépôt des Marbres. He went there as soon as he could. The water still stood 80 centimeters above floor level. It had overturned the marbles, but so gently that they came to no harm. The studio also contains the maquette of Rodin's monument to Whistler. It's a plaster nude on which the sculptor has thrown clay draperies. The monument has been fished from the water, but he won't know for two or three days whether or not it has suffered any damage. Rodin, however, thinks it will be all right. "The water has caressed my works," he says. "It came to my studio as a friend and not as a malefactor. I found one of my favorite drawings floating in the water; it hadn't been damaged in any way."

The year of the flood Rodin was promoted to the second highest rank in the Legion of Honor, Grand Officier (of whom there were only about 200 in the land). His friends celebrated the promotion on June 15, 1910, with a testimonial banquet for more than 300 people in the Bois de Boulogne. Rodin was seated between Dujardin-Beaumetz and Gérault-Richard, the editor of *Paris-Journal* and deputy for Guadaloupe. Among the guests were old friends like the Besnards, Jean Aicard, Roger Marx, Edmond Picard and Rosny *aîné*, as well as a great many younger people: Cladel, Gsell, the Duc de Choiseul, Wanda Landowska, M. and Mme Lebossé, Grautoff, Zuloaga, Despiau and Cottet. By now times and customs had changed sufficiently to allow ladies to be invited to a banquet of this kind—but sadly many of them were the widows of old friends, such as Mme Carrière, Mme Cazin and Mme Catulle-Mendès. Adolphe Willette had designed the menu; there was a spate of speeches but the most eloquent was delivered by Bourdelle, who compared the maître to all his favorite predecessors, including Phidias, and pointed out that his art had a special cutting edge—something he called *l'angoisse du monument*, i.e., "monument anguish."*

Increasingly, people who wrote or spoke about the Grand Officier Rodin were driven to superlatives and to metaphoric extremes. Just after his seventieth birthday on November 12, the *Mercure de France* published an ode by the young Georges Rouault entitled *le Grand Pan (Rodin)*, depicting him as an artist who had used nature's *formes plastiques* to build himself an "impregnable rampart" so that he could say to the great God Pan, "Like you, I am *solitaire*." Yet paradoxically his position as the great solitary figure of French sculpture meant that—like the hero of Carpeaux's *la Danse*—he was perpetually surrounded by company of the kind he liked best. "My last years are crowned with roses," he told Coquiot. "I am encircled by women, these wonderfully provident creatures, and there is nothing sweeter in this world." But those who remembered him as the close-cropped,

* Bourdelle's monument anguish may have been caused by the *Gates of Hell*. "If this door is ever opened," he told Rodin one day in the course of a conversation, rakishly hanging his hat on one of the projections of the *Porte*, "I'd be afraid it might blind me in one eye. It's neither a wall nor a door."

workmanlike proprietor of the 1900 Pavilion wondered what the Duchesse had made of him as the suave new centerpiece of her Hôtel Biron showrooms. Ugo Ojetti, for example, was surprised and dismayed to see him again in the eighteenth-century drawing rooms of the Hôtel Biron, "among the glass cases of his museum; a servant in a white tie ready to receive tips; two or three perfumed ladies bent on finding the rare adjective to insert with an exclamation point; and he himself with a cap of black velvet, à la Raphael."

Mauclair thought the change was due to Rodin's new surroundings. "At the Hôtel Biron he was always melancholy," the critic remembered in later years. "He took pleasure only in the lovely garden and felt a presentiment of his approaching death in his museum-to-be. He would wander through the vast suites that had once been the object of his desire but in which there was no trace of intimacy—the atmosphere was chilling to the soul. It was a showplace where Rodin was nothing but an illustrious old man obsessed by the visits he received from Anglo-Saxons and Latin Americans, who came to see him and talk to him about anything at all. . . . He wore his hair in long white curls (à l'anglaise) and a beret à la Leonardo, had the air of a well-groomed pre-Raphaelite and expressed himself in words of wisdom and profundity. I preferred the earlier Rodin, with his crew cut and his workman's blouse, and the simple, happy way he used to sit right down on the grass in my little garden."

It is impossible to say whether it was the Duchesse who was responsible for this disquieting change in Rodin's style: Frank Rutter, who had known him earlier as "a simple, kindly, honest worker," found him "a little vain, a little slack, a little snobbish" several years before Mme de Choiseul appeared on the scene. But Georges Lecomte thought it was all her fault: "She wants to transform this simple artist . . . into an elegant man about town. She makes him trim and brillantine his thick, shaggy beard and arrange his short, rough hair into a high quiff that falls to the nape of his neck in a heavy gray chignon. He gives up his ceremonious frock coat and his suits from the Belle Jardinière and takes to wearing only suits from the best tailors." Francis Jourdain reports that Rodin was so proud of his liaison with a duchess that "it made him lose his head and wear gloves the color of fresh butter. Massive and unpolished, he had a natural Olympian serenity that was hard to accommodate to the spu-

rious elegance he was compelled to adopt in his relations with the nobility."

The rather dubious reward for his compliance in this transformation was that he became a participant in literary teas, ladies' club lectures and salon entertainments of an almost Proustian refinement. In July 1911, for example, he presided over a meeting of art-appreciative ladies, "Les Unes Internationales," at which 150 people paid homage to Valentine de Saint-Point. Her *Hymne à Rodin*, recited by a tragedienne, was part of a program described in *Comoedia* as having been "in the most exquisite taste," and by *le Cri de Paris* in more ironic terms:

Having gained her liberty by obtaining a divorce, Mme de Saint-Point has thrown herself into literary society, determined to hit hard and conquer quickly. In rapid succession she has published three novels of exquisite sensibility. In the first, she described her most intimate sensations as a woman with great precision. The second deals with a mother's incestuous relationship with her son. In the third, a woman loves herself in front of an open fire. Despite her efforts Mme de Saint-Point has not conquered the public. But she has conquered Rodin.

The city's leading hostesses had discovered that Rodin could be prevailed upon to speak to small gatherings on subjects that interested him. The Duchess of Clermont-Tonnerre got him to talk about Carpeaux in connection with an exhibition at the Jeu de Paume; the Countess Jean de Pange arranged for him to give a lecture on "The Cathedral." The day of the lecture, however, Rodin declared that he was too tired to address the meeting but would remain seated while his talk was read for him by Mlle Cladel. "Poor Judith read a banal text about medieval art that was surely not by Rodin," the Countess writes in her memoirs. "Then the maître rose, caressing his long beard, to add a few words, and launched into a strange hour-long tirade comparing the Gothic cathedral to the body of a woman, and using the most sensuous images to illustrate his point. The effect on the auditorium full of pious women was devastating. Hysterical mothers hustled their daughters out of the hall; [the writer] Fernand Laudet

was obliged to compose a circular offering our excuses for this distressing misunderstanding between Rodin and his audience."

But Rodin was blissfully unaware of the commotion he was causing—surely everyone could perceive the analogy between architecture and the human body; it was only that the former lasted so much longer.

17

LE CREPUSCULE
D'UN FAUNE

Pourquoi laisser tout ça?

—RODIN to Rilke

R odin was beginning to feel the full burden of his seventy years. In 1911 he suffered from a mysterious ailment that made him feel perpetually thirsty, and which was cured only when the doctor prescribed milk instead of wine: "Since I've taken to drinking only milk, I no longer have that irritating thirst, nor the disagreeable taste in my mouth." His repeated illnesses led to periods of depression. He told Warrington Dawson that he had been happy to be ill as a child, "when I felt free because I was cared for and shown picture books! Now, like a broken vase, an urn upturned by the years, my life allows my strength and thought to flow out together." He began thinking seriously about his own approaching death. Georg Simmel records that one day Rodin had seen Rilke, who was in Paris for a visit, and had confessed, "haltingly and in a tone of embarrassment, that today he had thought for the first time about death. And he spoke about dying, in the most primal and almost childish terms; dying as something incomprehensible: *'Pourquoi laisser tout ça*—Why leave all this?' "

Suddenly his enormous success struck him as a burden. "Success is the greatest misfortune, even in old age," he complained to Dawson. "It's only so long as the world remains to be conquered that one can

produce one's best efforts." On that account he ought to have welcomed the occasional reminder that there were limits to his fame and influence. In the spring of 1910 someone put up an immense billboard in the middle of his unspoiled view from the Villa des Brillants; like any other resident, Rodin had to join his neighbors in filing a petition to have the thing removed by order of the local planning commission. At about the same time a delegation from the Meudon town council called on him to solicit a contribution to a local charity:

"Do you want one of my statuettes or money?" he asked them.

"We prefer money, Monsieur Rodin."

From Germany, early in 1911, came word that Kaiser Wilhelm II had snubbed Rodin by striking his name from the list of candidates for Pour le Mérite, Prussia's highest civilian decoration. Rodin had, in fact, been quietly proposed and turned down for the same honor once before, in 1907, but this time the emperor's refusal got into the newspapers and caused a minor scandal. "The *kolossal* art of Germany is decidedly incompatible with French art," declared the newspaper *Gil Blas.* "Maître Rodin was to have been named a knight of the order Pour le Mérite; the Berlin Academy proposed him for it, but the Kaiser who commissioned the Siegesallee* is unable to comprehend the beauty and grandeur of Rodin's work and thus refused to decorate the French master." Rodin took the news calmly and in good grace. "I know nothing about all this," he told a reporter. "I can only say that I am a member of the Berlin Academy and have repeatedly exhibited my works in Berlin. The Kaiser didn't appreciate my works—but he also didn't appreciate people like [Hugo von] Tschudi [former director of the Berlin National Gallery]. . . . In any case, royal princes are educated in such a way that they cannot possibly understand modern art and its innovators. Hence the German Kaiser doesn't love anything that runs counter to the accepted traditions of his circle."

>‡<

The fact that he was being cosseted by the Duchesse and her friends did not prevent Rodin from maintaining tenuous links to Gwen John.

* The Siegesallee, or "Victory Plaisance," in the Berlin Tiergarten was lined with kitsch statues of ancient and latter-day German monarchs, which were quietly buried under the rubble after World War II.

Her letters had slowed to a trickle, but in 1911 she moved to an apartment in Meudon—"the top storey of an old house quite near the forest," at No. 29, rue Terre-Neuve, which cost fifteen francs a month—where she was at least within thinking distance of the great sculptor who granted her an occasional audience: "You must come Tuesday six o'clock rue de Varenne," he wrote on February 18, 1911. "I'll receive you there are you well take care of yourself."

While the Gwen John affair gradually faded, his relationship with Gwen's sculptress friend Nuala O'Donel came to an abrupt and tragic end. Rodin had employed the Irish sculptress as a praticien for several years, and she, in turn, had used Gwen as a model and made a statue of her. Bourdelle thought highly enough of her work to urge Geffroy (who had become administrator of the Manufacture des Gobelins in 1908) to use his influence to persuade the government to buy her marble bust of the actress Suzanne Horden, who lived with the sculptress. Mlle O'Donel felt a great love for Rodin but unlike Hilda Flodin she had bourgeois moral compunctions that prevented its consummation. In 1911 she lived and worked in the building next to Malvina Hoffman's studio. Malvina found her a "very talented" but morbidly sensitive young woman: "Her admiration and devotion to the Master possessed her to such a point that if he failed to keep an appointment to see how her work was progressing, she would come to me and burst into tears, imagining all sorts of exaggerated reasons for his absence. Had she cut too deeply? Was he displeased with her execution? I tried to calm her, for she was high-strung and lonely, living on the edge of an emotional precipice. Once I went to see Rodin and asked him to try to go to her studio soon, for I feared she would have a nervous breakdown."

A few months later, Nuala O'Donel was back in Malvina's studio—in the throes of another crisis. "She begged me to return with her to see what she was carving. When I admired her technical skill she thanked me for my sympathetic understanding and gave me three or four good marble tools. 'Keep these,' she said. 'They were given me by Rodin, but I feel he is no longer interested in my work. He has grown very indifferent, and I feel ill and discouraged.' "

The next morning her concierge said as I arrived, "Oh, Mademoiselle—something terrible has happened to Mlle O'Donel!"

I ran up the stairs to my friend's studio. The concierge followed me inside the door and clutched my arm. The studio was empty. "Oh, Mademoiselle," she groaned, "I smelled gas in the hallway and tried to get into her studio, but it was locked. I ran for help, and they broke open the door and found Mademoiselle lying dead on the floor, the gas tube tied over her mouth with a towel. They took her away!"

Rodin, in the meantime, had acquired a new artist-disciple who interested him far more than her rivals—though there was no comparison between her dry, rather labored paintings and the intuitive brilliance of Gwen John. Unlike the others, Jeanne Bardey was no longer a young woman—she turned forty in 1912—and she had a teenage daughter who often posed for her. Born Jeanne Bratte and trained as a musician, she was the widow of Louis Bardey, a professor at the Lyon Ecole des Arts Décoratifs, from whom she learned how to draw. Rodin, who found her fascinating in more ways than one, seemed to like her drawings and told her she had "the gift of seeing." He also taught her something of his drypoint technique and encouraged her sculpture, which was vaguely Rodinesque but otherwise undistinguished.

Madame Bardey told Mauclair that Rodin had been "very good to me, very gentle. He did me the favor of arranging my drawings in the order in which he liked them. He has always said he could do no more for me than suggest the means of expression, the linear idiom, but that one couldn't learn how to see, and that if I hadn't already had the gift of seeing neither he nor anyone else could have given it to me." He paid her the extraordinary compliment of asking her to collaborate on the designs for the Cambodian frescoes intended for Saint-Sulpice monastery: "It's a great honor for me. I've done some sketches; it's fascinating to do a fresco." But in fact the murals never got beyond the planning stage.

She had something of Camille Claudel's restlessness and curiosity. "Very early in the morning I go to the mental asylums to make drawings; there are wonderfully unself-conscious expressions on those faces! It's sad, but a good way to learn how to draw." She did portraits of patients in the Salpêtrière and at the asylum of Villejuif—but apparently her professional rounds did not take her as far as Ville-

Evrard, to which Camille had recently been committed. After these early-morning excursions she returned to her fourth-floor apartment in Montparnasse: "I'm in a hurry to get home because I have a model waiting for me. And then all the rest of the day I'm busy pulling proofs of color prints and I make pencil drawings. Sometimes I go out for a breath of fresh air, but then I make drawings in the street. . . . I tell you, it's a passion." Mauclair thought her attractive and vivacious—"a woman in whom nature has placed the rage, the mania and the genius of drawing and modeling." He detected many resemblances between her work and the maître's, but no—her art was clearly based on quite different assumptions: what "Madame Bardey has in common with him is a love of life. . . ."

Until the summer of 1912, however, Rodin's life was still firmly under the management of Claire de Choiseul, who looked after him as assiduously as ever. The new decade had begun with a crime scare as street toughs and apaches burgled homes and mugged peaceful citizens in the streets: the Duchesse had been obliged to act as Rodin's bodyguard as well as his hostess and sales manager at the Hôtel Biron. In May 1911, Alice Lowther noted in her diary that Claire told her that "two men had forced their way into the lonely *hôtel* and had tried to frighten and blackmail the old artist only a few nights before. 'But I was luckily there!' she exclaimed. 'And I had pistols too!' *'Mais oui, mais oui, elle m'a sauvé!'* he said to us. *'Elle m'a sauvé la vie!'* "

Characteristically, the other members of Rodin's entourage claimed that it had all been a figment of her imagination and that she had unnecessarily aroused Rodin's fears with her preposterous tales of the apaches. At all events, she called on the chief of the Paris police, M. Lépine, and asked him to send a detective to protect the maître. He recommended a retired detective who came every evening at six o'clock to fetch Rodin at the Hôtel Biron and to accompany him to Meudon, where he spent the night in an armchair at Rodin's bedside. A police dog called Dora was acquired as additional protection. "Both at Meudon and at the Hôtel Biron there were revolvers all over the house," Marcelle Tirel relates. "Before the introduction of all these precautions Rodin cared little enough about any danger. Now he began to be really afraid. My ridicule soothed his fears; in less than a month he found the detective a nuisance and dismissed

him. We put away the weapons and laughed at the whole affair."

That summer Rodin "suffered too much from heat to do anything or even to travel much," as he told Warrington Dawson. "We stayed here and then we did a little turn around Brittany." But the following winter Rodin and his Muse went to Rome by way of Lyon "where I have an exhibition of drawings to prepare," as he wrote to Rose. They also stopped at Gabriel Hanotaux's villa in Roquebrune, near Monte Carlo. Rose had heard from him there as well: a letter full of husbandly concern for her well-being. Apparently his fear of the apaches had not entirely disappeared: "My good Rose, are you looking after yourself? Have you done what I told you? Has the curtain of Japanese material been put in front of the window, and a telegraphic wire been strung to connect you to the coachman's bedroom at night?"

On January 24, 1912, Rodin and the Duchesse arrived in Rome, where John and Mary Marshall had made preparations for them. "They came here," Marshall informed E. P. Warren, "but the lady being very ill, they went for the night to rooms I had engaged at Hassler's [Hotel, in the piazza Trinità dei Monti]. I fear that they will hardly stay there, for she seems accustomed to luxury." Claire's bulimia was more troublesome than usual: after talking for an hour, Marshall noted, "she suddenly got up, rushed to the W.C. and vomited. Then she came back and began again. It was a wonderful exhibition of talk. Rodin sat listening to her and enjoying our appreciation of her. When she returned to talk, she said in excuse that she had had the caesarean operation performed on her seven years ago, and that ever since she had been unable to retain anything she ate for more than a few minutes. She eats, she says, every hour of the day and is always hungry. But not a bit can she retain. At night she runs a danger from fainting fits and cannot be left alone."

Even so the Duchesse was in good spirits and feeling particularly proud of her successful public relations campaign in Paris, where the authorities had been forced to rescind their decision to demolish the Hôtel Biron in order to make room for a modern development: "She has managed, so she tells Mary, to get the French Government to grant him the Hôtel Biron for life. She says she paid three journalists to write about it and got so many protests about the proposed ejection of him that the Government caved in and Rodin is now secure."

They had come to Rome in order to install a bronze cast of the *Walking Man* in the courtyard of the Farnese Palace, which houses the French embassy. A group of Rodin's admirers had bought the sculpture and presented it to the French government for precisely that purpose, but its position in the forecourt of the Farnese Palace had yet to be decided. Camille Barrère, the French ambassador, was not delighted with the idea of putting up a large, headless and armless modern figure—"only a broken statue," in his words—in the courtyard of a sixteenth-century palace designed by Sangallo and decorated by Michelangelo. The Duchesse, however, "means to run the French ambassador," as John Marshall reported. "Mr. Barrère is to be forced against his will to put *l'Homme qui marche* right in the center of the court of the Farnese. Rodin himself thinks it would look all right there, but he would be satisfied by any other position in the court. Barrère objects to the central position mainly because of its inconvenience for motors. But she *will* have it there, and nowhere else, and Rodin is as clay in her hands."

In the end the ambassador had little choice but to give in: "He said that at first he had objected, because he didn't think that it would look well there, and he was proud to have it in the middle. So the Duchesse had carried her point.* She knew it last night, or early this morning, and she told us that when she told Rodin, he said, 'This is all your work: every bit of it. What must I do for you?' She answered, 'Give me your blessing,' and knelt down while he put his hands on her head."

It was Rodin's first visit to Rome in over thirty years. By his own account "my stay in Rome was one great fête," and included a round of banquets, receptions and sightseeing tours. At first he did as much as possible of his sightseeing alone—"the study of masterpieces requires solitude," he wrote in an article published under his own byline in *Excelsior*. He had admired Bernini's work and everything to do with seventeenth-century architecture, then very much out of fashion—but "fashions will change," he predicted, "and the rococo

* Her victory was short-lived. *The Walking Man* was placed at the center of the courtyard, but its temporary wooden plinth was never replaced by the travertine base that Rodin had asked for. In 1916 Barrère had the statue removed because "it prevents his car from turning in the courtyard"; seven years later the Fine Arts Ministry had it brought back to France, where it can now be seen in the Lyon Musée des Beaux-Arts.

and 'Jesuit' styles will regain their prestige." Eventually Roman officialdom took him over: when Count Primoli and other dignitaries showed him around the Forum, Rodin complained that "there was so much explanation that he couldn't see the things." Later, at one of the museums, he told Marshall, "Don't show me great works: show me little things I haven't seen." A banquet was given in his honor at which Rodin was "feted in a way that was both magnificent and touching," as he was happy to report. "I was welcomed by the Count of San Martino [director of the Roman Salon], M. Nathan, the mayor of Rome, M. Barrère, the professors and pupils of the foreign art schools in Rome—Austrian, American, Spanish. At the end of the meal the young Italian and foreign artists all drew my portrait on the menu—and thus gave me more than a hundred different faces."

Afterwards he told Jean Lefranc of *le Temps* that he hadn't realized how magnificent Rome was: "It's truly the city of the Caesars, the eternal city . . . everything is big in this city." People-watching in Rome had given him enormous pleasure. "Even the simple passerby who speaks more with his hands than his mouth has style in his gestures. The woman of the people is without coquetry. I know the *plastique* of the Roman women because I've had so many Roman girls as models: they're beautiful and with powerful bodies. In Rome they still have beautiful gestures, but they make the mistake . . . of wanting to dress in Paris fashions."

Marshall was touched by what he saw of Mme de Choiseul's devotion when they all went for a long drive on the Appian Way: "The Duchess had neuralgia and her face was much swollen, but she kept up her spirits. Rodin took his hat off and had a good time. We stopt at a barber's on the way back, and she herself frizzed his hair and beard for the reception at the Capitol"—which was to be illuminated that night in Rodin's honor. Marshall also noted that "she helps him to dress and undress for, as you know, he cannot do it himself. . . . He is her baby, her father. He is quite in love with her—they seem as though they had been married last week."

Yet the relationship was not to last very much longer. In Paris the rest of the Rodin establishment was up in arms against the woman who boasted of her influence over the maître and whom, as a consequence, they nicknamed "The Influenza." What was at stake was

more than just a place in Rodin's affections. A number of people were already dependent on him for a livelihood, and others expected to profit from him sooner or later, if only from a mention in his will. For several years, moreover, there had been talk of founding a Rodin museum, which held out the promise of a directorship, staff appointments and other material advantages besides the obvious aesthetic ones.

The basic concept of a Rodin museum had been suggested by Judith Cladel and Gustave Coquiot around the turn of the century, but it was Rodin's move to the Hôtel Biron that had made it a practicable idea. Cladel recalled walking in the garden with him one day and proposing: "Maître, here is where you must have your museum." The government, however, had already planned to sell the property to real-estate developers. As the young American expatriate Sylvia Beach reported in the *International Studio*:

> Now notice was served on him to vacate the premises in order that the work of leveling the old dwelling to the ground might begin without delay. Imagine the shock and indignation of the old master upon receiving this announcement! His beloved Hôtel Biron was to share the fate of many another antique of Paris and fall a victim to commercial vandalism. He lost no time in arousing all art lovers among journalists, politicians, actors, men of every profession, to protest against such an act of impiety. Such an outcry was raised that *ces messieurs*, the would-be promoters of a "modern Paris," were forced to abandon their program of inconoclasm so far as the Hôtel Biron was concerned. The government proceeded to acquire the property that it might be henceforth preserved as an historic monument. Thus, thanks to Rodin, the Hôtel Biron continues to flaunt its uselessness in the face of an outraged utilitarianism.

In October 1911, after two years of legal proceedings, the government purchased the Hôtel Biron for six million francs, but in the meantime other uses for the building had been proposed, and the newspapers carried scandalous stories about the actor De Max, who had rented the convent's chapel and had begun converting it into a bachelor apartment when he was evicted. Mesdames Choiseul and

Cladel both claimed credit for having persuaded the government to create a special law that would transform the Hôtel Biron into a Rodin museum. Coincidentally, the sculptor's old admirer Raymond Poincaré became prime minister in January 1912, during yet another cabinet reshuffle, and thus Rodin was assured of support in the highest government circles.

Cladel, meanwhile, had launched a public appeal in *le Matin*— "Now is the time to create a Rodin museum in Paris!"—and had published the results in a brochure filled with testimonials, *Pour le Musée Rodin*. Once more there was an outpouring of warm feelings from leaders of all shades of French public opinion. Maurice Barrès, by then a Deputy and member of the Institute, sent *toute mon approbation*; Juliette Adam, still busy and influential at the age of seventy-six, was "with you with all my heart"; Emile Bergerat was happy to do what he could for the *gloire* of "one of my oldest friends"; Debussy wrote that "no one is more deserving than he of such special honors"; and Blanche, Raffaëlli, Anna de Noailles, Jean Ajalbert, Henri Barbusse, Mathias Morhardt, Robert de Montesquiou, Edmond Picard, Rosny *jeune*, Romain Rolland, Apollinaire, the Duc de Rohan and fifty others declared themselves in favor of the enterprise.

When Cladel's booklet appeared in April 1912, all that remained was for the government to draw up the enabling legislation and steer the bill through both houses of parliament. But within a month a new scandal erupted that threatened to spoil everything. The trouble came from an unexpected quarter—Serge Diaghilev's Ballets Russes. The Russian company had first taken fashionable Paris by storm in 1909, and its repertoire had grown more audacious with each succeeding season. On May 29, 1912, at the Châtelet Theatre, Diaghilev caused a fresh uproar when he presented Vaslav Nijinsky in the premiere of his new ballet, *l'Après-Midi d'un Faune*. There was nothing particularly revolutionary about the scenario, which was vaguely based on Mallarmé's nearly forty-year-old poem, or about the music—Debussy's almost twenty-year-old *Prelude to the Afternoon of a Faun*. The shock effect was provided by Nijinsky's faun costume—one of Léon Bakst's most brilliant and tight-fitting creations—and by his slyly erotic choreography, which ended with the young faun making love to a veil belonging to the nymph who has escaped his clutches: "the faun has married the veil he tore from the nymph," as Misia Sert

explained to an outraged Debussy that evening. Nijinsky's biographer Richard Buckle is convinced that "on the first night Nijinsky slid his hands *under* his body in such a way as to suggest masturbation."

Though there were catcalls in the audience, most of the theatre critics were, as usual, full of praise for Diaghilev's latest sensation. Only Gaston Calmette, the powerful editor of *le Figaro*, decided to make an issue of it and denounced Nijinsky's depiction of "a lecherous faun, whose movements are filthy and bestial in their eroticism" as an offense against public decency. Rodin, however, had been utterly delighted by the spectacle. "It was youth in all its glory, like the days of ancient Greece when they knew the power and beauty of a human body and revered it," he told Malvina Hoffman when they compared notes the next day: "Such grace, such *souplesse!*"

To refute Calmette's charges Diaghilev's admirers were canvassing influential friends for their support. At Roger Marx's request Rodin contributed his thoughts to *le Matin* in an article signed by himself but written by Marx. It expressed Rodin's view that Nijinsky's "beauty is that of antique frescoes and sculpture: he is the ideal model, whom one longs to draw and sculpt." Whereupon Calmette turned on Rodin with a furious blast in *le Figaro*: ". . . I need only call attention to the fact that in the former chapel of the Sacré-Coeur convent school and in the rooms once occupied by the dispossessed nuns, he has hung a series of lewd drawings. . . ." Calmette claimed to be less offended by Nijinsky's shocking performance "than by the spectacle offered every day by M. Rodin in the former convent of Sacré-Coeur to numberless swooning admirers and self-satisfied snobs. It is inconceivable that the State, that is, the French taxpayer, should have paid five million [actually six] for the Hôtel Biron, for the sole purpose of providing free housing for the richest of our sculptors. That is the real scandal; it's up to the government to bring it to an end."

At the Duchesse's behest, Rodin then disavowed his Nijinsky article—whereupon Roger Marx nearly had a heart attack. But the retraction was of no use, for the scandalmongers of the boulevard press insisted on reopening the whole question of a public Musée Rodin. Forain's caricature in *le Figaro* showed a model undressing at the Hôtel Biron, with the caption: "Maître, where should I put my things?—There, in the chapel!" In point of fact Rodin never went near the chapel, which is a separate building, but in the public mind

he was now a desecrator of churches in addition to his other sins. Although many newspapers sprang to his defense, the government decided that this was not an opportune moment to bring the matter to a vote, and it was allowed to remain in bureaucratic limbo for another four years.

Nijinsky himself came to thank Rodin just after the publication of the article—before it was disavowed. According to Cladel the sculptor was "as disappointed as a child to find him a badly proportioned little man in banal clothes instead of the soaring blithe spirit whom he had seen onstage," but he asked the dancer to pose for him. Jacques-Emile Blanche recalled hearing "from Rilke" (who was not in Paris at the time) that Rodin wanted to do a life-size statue of Nijinsky, and that the dancer came out to Meudon on a hot day: "The maître had been working since the morning. . . . Rodin, who loved Burgundy, served some to his model at lunch, though normally the temperate Nijinsky drank only tea or water. Then Diaghilev arrived at the studio unannounced. The sculptor and his model were lying down; Vaslav at Rodin's feet. They were asleep, exhausted by the 38-degree heat beneath the studio windows. The furious Diaghilev tiptoed from the room"—and supposedly it was his jealousy that kept Nijinsky from posing again for Rodin. On the other hand, Vollard reports that Rodin told Renoir that he had posed "one of the Russian dancers" on a column, "one leg bent double, the arms forward. . . . I wanted to do a spirit taking flight. . . . But that day my thoughts were elsewhere; I was dreaming of the Greeks. And little by little I fell asleep with my lump of clay in my hands. Suddenly I awoke: my model had abandoned his pose." In any case, all that remains of their encounter are some drawings that any dancer might have posed for, a small clay head resembling Nijinsky's, and a sketchy statuette of a dancer on one leg that led Richard Buckle to wonder "if this really is of Nijinsky."

The summer of 1912 was marked by two far more significant developments: Rodin suffered a light stroke, and he parted company with the Duchesse de Choiseul. The stroke occurred at table, "while he was having lunch, and his fork dropped to the floor," as Rose later described it to Cladel. "He leaned over to pick it up and when he straightened out, his arm hung stiff at his side; he could no longer move it. He got slowly better and forbade me to talk to anybody about

his 'accident.' " Still, the mouleur Guioché was quick to notice that something was wrong: "He got up later in the mornings—he, who was always such an early riser—and he went later to his studios." Guioché, like most of Rodin's employees, thought that it was all the Duchesse's fault: "She drank. While the maître worked and didn't notice anything, she would open a large cupboard, eat cookies and drink heavily. The cellar was full of empty bottles! You walked on them as on pebbles at the beach!"

In the end, the combined efforts of his friends and employees persuaded Rodin that he must give up the Muse. Marcelle Tirel claimed the credit for having enlightened him: "One day I told the maître the truth about her and gave him proofs. Poor Rodin! He cried over his love like a fifteen-year-old schoolboy. We were in the big atelier at Meudon. He sank back against the *Ugolin* shaking with sobs. 'I am an imbecile, an unhappy wretch,' he moaned." To stiffen his resolve he made a trip to Brittany with Rose, and after their return he refused to see her again. By now he had decided that "this woman had no heart." She did everything possible to effect a reconciliation: even her husband came to plead on her behalf. One day she herself came to the Hôtel Biron, swathed in dark veils. "She threw herself at Rodin's feet and commenced a dramatic scene," Tirel recalled. "Rodin rose quietly, put aside the drawing he had been working on, called the servant and pointed to the still-crouching figure of the Muse: 'Show Madame out!' " By now his private affairs had become a matter of such international interest that *The New York Times* deemed it an item of news fit to print on the front page, under the headline "Rodin and Duchess Quarrel":

Paris, Sept. 15—Paris society people who are just back from the fashionable resorts are talking of nothing but the quarrel alleged to have taken place between the sculptor Auguste Rodin and a well-known Franco-American Duchess, which, it is said, had caused the definite rupture of a friendship which was of such long standing and so well known that it is stated that it had become a recognized custom for any one wishing to approach Rodin to address himself to the Duchess first.

Exactly how the alleged rupture came about is a matter of speculation. It is said, however, by persons in a position to

know that the sculptor, who was at first somewhat flattered by the friendship of a lady of so aristocratic a name, had lately become tired of her growing ascendency. . . . News of the alleged rupture is welcomed by Rodin's admirers, while in art circles the comments are most severe on the Duchess, who, according to gossip, had exercised too great influence over the master, made him live at the rate of $40,000 a year, imposed her opinion on the sale prices for his works, and generally monopolized the sculptor's affairs.

>≭<

Four months earlier a newly formed committee had announced its intention of erecting a monument to Eugène Carrière; Rodin, who was honorary co-chairman, had agreed to do the work in collaboration with Desbois. But not even the memory of his old friend could elicit a finished monument from him now that he was doing almost nothing but drawings. "From the moment he was fully installed in the Hôtel Biron he had virtually no other occupation," Gsell remarks. "He almost gave up doing sculpture; he was satisfied with supervising the praticiens." Sometimes he went for weeks on end without touching modeling clay. Instead, he did hundreds upon hundreds of drawings—"in a way the most untramelled and revolutionary of all his works," as Kenneth Clark said.* He had installed a special drawing studio in a room overlooking the garden of the Hôtel Biron: "One couldn't dream of a lovelier atelier," Gsell reported. "An abundance of light came pouring in through the high, arched French windows. The room's sculptured paneling and perfect proportions evoked the wonderful eighteenth century that Rodin adored." Outside there was the sprawling garden with its dogwoods, untended perennials and lattice-work arches collapsing under the weight of roses, wisteria and jasmine. "He drew and drew. He shut himself up with his models

* "But in the end, how monotonous they became," Lord Clark added; he thought they lacked a vital element of concentration. "I must confess that even after a hundred or so this endless belt of sprawling women has a depressing rather than an exhilarating effect on me, and seems to reveal a kind of promiscuity which is foreign to the concentrated passions of the greatest artists." Still, because of their very haste and insistence on recording the momentary touch of pencil and watercolor brush to paper, they could be considered forerunners of tachist art.

the way a lover bolts a bedroom door. He devoted himself to depicting women in sensual attitudes and displayed a lively predilection for poses that aroused the senses. 'Art,' he said, *'n'est en somme qu'une volupté sexuelle*—is, in short, nothing but a sexual pleasure; it's only a derivative of the power of loving. When he creates, *l'artiste trompe son instinct génésique*—the artist outwits his reproductive instinct. When he draws a beautiful nude, he renders her the homage of adoration!' "

Gustave Kahn wrote that this plethora of drawings constituted a kind of encyclopedia of human movements, or at any rate of female movements, since Rodin never hired male models for his drawing sessions. Sometimes he would ask the models for specific poses or groupings—many of the scenes of lesbian love were presumably staged—but for the most part they were free to do as they liked: "To sit down, to rise, to stand up, to lie down, to bend," as Kahn observed; "to perform, depending on her fantasy or fatigue, *un mouvement, une allure, une lassitude.*" When Rodin saw a pose he liked he would ask the model to freeze and would do one of his almost instantaneous drawings—"sometimes he would not even stop her, because the rare movement he wanted was a transition between two movements."

Though the results were often dismissed as minor by-products of his sculpture, Rodin was very proud of this new genre he had created—the "one-minute drawing," as Jean Dolent called it. "Sometimes I wonder if I don't like my drawings better than my sculpture," he told René Chéruy. Ludovici, himself the son of a painter, was fortunate enough to be present while Rodin's favorite model was posing for him: "I noticed that he kept his eyes fixed on the model, and never looked down at his pencil, or at the paper on which he was drawing." Ludovici had lived among artists all his life and had done drawings of his own—but this method reminded him of the children's game "in which one was expected to draw a pig with one's eyes shut," and he wondered whether Rodin was similarly surprised when he finally looked down to see what he had drawn. "The next thing I noticed was that he seemed under some obligation not to lift his pencil from the paper, after having once begun to draw . . . and that he always tried to complete his outline of the figure he was drawing in one wavy and continuous sweep."

Ludovici watched him for a while as "sheet after sheet was torn

away and dropped like rubbish on the floor at his side," and had the temerity to ask Rodin "to explain why he had adopted this extraordinary method" with its "glaring inaccuracies." Rodin, who could be very patient when he wanted to be, did his best to make his young secretary understand what he was driving at: "Don't you see that, for my work of modeling, I have not only to possess a very complete *knowledge* of the human form, but also a deep *feeling* for every aspect of it? I have, as it were, to *incorporate* the lines of the human body, and they must become permeated with the secrets of all its contours, all the masses that it presents to the eye. I must feel them at the end of my fingers. All this must flow naturally from my eye to my hand. Only then can I be certain that I understand. Now look! What is this drawing? Not once in describing the shape of that mass did I shift my eyes from the model. Why? Because I wanted to be sure that nothing evaded my grasp of it. Not a thought about the technical problem of representing it on paper could be allowed to arrest the flow of my feelings about it, from my eye to my hand. The moment I drop my eyes that flow stops. That is why my drawings are only my way of testing myself. They are my way of proving to myself how far this incorporation of the subtle secrets of the human form has taken place within me. I try to see the figure as a mass, a volume. It is this voluminousness that I try to understand. That is why, as you see, I sometimes wash a tint over my drawings. This completes the impression of massiveness, and helps me to ascertain how far I have succeeded in grasping the movement as a mass. Occasionally I get effects that are quite interesting, positions that are suggestive and stimulating; but that is by the way. My object is to test to what extent my hands already feel what my eyes see."

He now preferred drawing, Rodin later told Gsell, "because it's a process that captures movement more quickly than sculpture; it fixes *la vérité fugitive* almost instantaneously." Of course there were times when he got tired of drawing and then "I abandon it and go back to sculpture. The change of occupation relaxes me." One beneficiary of these sporadic returns to sculpture was the prickly, influential Georges Clemenceau, whose bust—commissioned as a tribute by the Argentine Republic—had become another of Rodin's more interminable problem pieces. By the end of 1911 he had produced three different states of a Clemenceau bust; the final version entailed

eighteen sittings and twenty-three *études préliminaires*. In March 1913 he wrote to the sitter that he was nearly ready: "*Voilà*, I've worked on your bust and am now waiting for you so as to do the shoulders and some retouching. I'm at your disposition, but I'm in bed again for several days with a recurrence of my winter cold." According to one account, when Clemenceau saw the result he said drily, "It's perfect, but now I'll go to Pierre Petit [the photographer]."

Clemenceau had been prime minister for three years, until the government crisis of 1909, and his fall from power had not made him any mellower. When he sat for his bust, Tirel relates, "Rodin was afraid of him, for he always had an air of superiority. When the sitter left, Rodin let himself go and told me what he thought: 'I had promised with much pleasure to do a bust of him. The subject was worthy of me. We're equally strong, each in our own field. I've only recently come to understand politics: they frightened me at first and then all of a sudden I grasped their mechanism. It's really the simplest thing in the world. Clemenceau has politics in his blood, but he doesn't understand anything about art. He's a born fighter, and an aggressive one. But he's a contrary sort: he loves interminable discussions and has the sense of humor of a street urchin. He does all the talking when we're together, and I don't attempt to argue with him, otherwise we'd devour each other! . . . Whenever my thumbs touched the clay I could feel that he was displeased; he had a pitying smile on his face . . . his sneering expression worried and almost paralyzed me. When the first clay bust was finished he spoke to me as if to an apprentice: "That's not me: it's a Japanese you've made, Rodin. I don't want it!" I was expecting that. I've never had much luck with my busts. . . . I was told Clemenceau owns a very curious and interesting collection of Japanese masks. He was so furious at finding in these masks a likeness of himself as brought out in my portrait that he got rid of it. Apparently his wife wanted him to refuse the bust. I'm inclined to believe it, for when women don't like me, they dislike me with a vengeance! Still, it's my portrait that really brings out Clemenceau's essential characteristics.' "

While Clemenceau fretted, Rodin took extraordinary pains with his portrait: this and the bust of Hanako were the only ones for which he had his mouleurs make a whole series of piece molds and squeezes so that he could compare the expressions of all the different states.

Later he cut some of them off at the neck and "put them up everywhere like severed heads," as Cladel noted when she went to see him at the Hôtel Biron. By now Rodin was of two minds about the bust. "I'm not angry with him but I've lost a lot of money over it," he complained. "As a caprice, and because I wanted to prove to myself I could do a good likeness, I started it again ten times over." To the last the sitter had objected to being made to look like a Mongol general. "But Clemenceau," Rodin insisted afterward, *"c'est Tamerlan, c'est Genghis Khan!"* Years later it occurred to Cladel that Rodin had prophetically sculpted a portrait of Clemenceau the wartime premier, the "Tiger of France," who was to breathe new life into the flagging French war effort in 1917, when the front lines were on the point of collapse: "no likeness of him will ever surpass it."

Clemenceau himself remembered only the unpleasant part of the experience. "I don't like Rodin," he told Jean Martet toward the end of his life. "He was stupid, vain and cared too much about money. . . . When I returned from South America with the order for a bust I went to see Rodin, who said to me, 'They must be made to pay as dearly as possible.' It was his first thought."

>✠<

After his rupture with the Duchesse, Rodin let it be known that henceforth he would "let no one interfere with his life or his work." Yet he was soon caught up in the machinations of a model named Georgette who inspired fresh prose poems when she "posed at full length on a couch": he would sit leaning forward, "exploring the face encircled by her blonde hair so intently that the young woman occasionally lowered her eyes." Thanks to her "moist red mouth, serpent-like with its delicate curves" and "the beautiful tranquillity of her eyes," she took over the management of the Hôtel Biron for a time and got Rodin embroiled with dishonest art dealers before she and her guardian-mother were summarily dismissed—by telegram, at a safe distance.

A far more benign and productive kind of interference was furnished by Lady Sackville, who had been trying to get him to do her bust since 1906. The daughter of an English lord and a Spanish gypsy dancer, Victoria Sackville-West had married a first cousin who inherited her father's title and the estate of Knole, in Kent—"too homely

to be called a palace, too palatial to be called a home," as one writer
described it. She had first met Rodin in Paris at the home of Sir John
Murray Scott, a prodigious man of affairs who left her an estate valued
at about half a million pounds, but she found the sculptor "so much
less shy" at one of Ernest Beckett's dinner parties in February 1905.
Her efforts to persuade Rodin to visit *"notre château"* finally bore
fruit on June 2, 1913, when he lunched at Knole, was "delighted
with the house," and told her he would like to do a bust of her
daughter Vita Sackville-West, whom he had admired at the luncheon.
He had come to England to select a site for a cast of his *Bourgeois
de Calais*, which had been purchased by the National Art Collections
Fund and was to be erected in the Victoria Tower Gardens near the
House of Lords.* But he stayed on to see something of the London
social season. On June 5 Lady Sackville took him to dinner at the
Sassoons' and afterwards to a Louis XIV costume ball at the Albert
Hall: "I looked after him as if he was my father."

She was fifty-one and a remarkably handsome woman, with long
tresses that reached to her thighs when she let her hair down; she
was also very much attracted to the seventy-two-year-old Rodin, who
now asked her to come to Paris because he wanted to sculpt her
portrait. For a time she was busy with preparations for Vita's marriage
to Harold Nicolson, and Rodin sent a bronze statuette as a wedding
present—"a thin walking figure of a man holding his head as if in
deep thought, about 10 inches high." Then, on November 5, 1913,
she noted in her diary that on this day, in the Hôtel Biron, Rodin
had begun his bust of her in *terre glaise*: "He wears a long cape and
a big velvet Tam O'Shanter all the time, and never stops talking."
Next day she sat for him from eleven-thirty until one, and from three
o'clock until nearly five. "I was fully décolletée, and felt quite shy
over it! He does my two profiles and back and full-face. It is four
times more work than a portrait [in oils]."

There were more sittings on the third day. "Rodin never stops
talking about all sorts of things, especially his art. . . . He deplores

* This time Rodin made no attempt to have the figures placed at ground level. Instead,
he specified a plinth of the same height as Verrocchio's Colleoni statue in Venice, which
eventually led to objections that "at its present height it is almost impossible to see the
work at all, especially since the trees have grown up round it."

the fact that I can't always look after him, as I understand him well. He keeps on saying that I am so beautiful, and yet the bust is perfectly hideous up to now . . . with pouting lips. But he is a wonderful artist, and his groups are marvelous. . . . He asked me to chuck everything this winter as he wanted me to come to the Riviera where the vile weather is driving him to, and he would do me all the winter and draw me doing my long hair, which he had heard was wonderful, and he had never had a model with long hair, to twist it round her neck and plait it, etc."

On the 8th, "Rodin made me sit on the floor while he was standing on a packing-case doing the top of my hair, etc. He keeps asking me to come to the Riviera with him. The bust is no better." They were waited on by his old concierge and by a greengrocer with white gloves who brought in tea and cakes. Robert de Montesquiou had been invited to watch the sitting, and though "his conversation is all about himself, and he fills it with quotations from his own works," he also said flattering things to his host, who "looked down, so meek and so uncomfortable at all those compliments. He *is* such a dear old creature, so simple, so detached from everything. . . ."

When they were alone she told him of her loneliness, now that Vita had married: "He got up and came to me with his hands full of *terre glaise* and knelt in front of me and said, '*Pauvre amie, comme vous souffrez de son absence . . .*'—and the old dear was looking up with so much sympathy and kissing my hands so respectfully. It was very touching." On the 13th she was again half nude during the sitting "and Rodin keeps on muttering to himself, '*Ah, comme c'est beau! Quelles belles épaules! Comme c'est chaud de coloris!*' He would like me to sit like that every day, but it is too cold. He comes and kneels in front of me every day, some time or other." The next day was his seventy-third birthday: "He had heaps of flowers sent him and wines and no end of fuss."

He invited her to Meudon and introduced her to Rose. "His funny old—wife (a *collage* of fifty years) was very much nicer to me than she generally is to other visitors. She must have been beauti-ful. . . . They hardly ever talk when they are together. With me he never stops! She has been a very jealous wife, and yet he told me that he had only been twice in love in his life. I told him that I had

guessed his second love had been the Duchesse de Choiseul, and he blushed and nodded."

After the decaying splendor of the Hôtel Biron Lady Sackville was surprised to discover how frugally he lived at Meudon—"a curious agglomeration of grandeur and of great discomfort." Rose seemed incapable of managing the household properly: at supper "they generally have some soup and a glass of milk and he sleeps in her room as she has got asthma and he gets up in the night when she coughs, to arrange her pillows. He is kindness itself and so gentle with her and everybody." He gave his new sitter "a little fat Cupid kissing a lovely nude woman" and showed her one of his early busts à la Falconet, covered in a blue glaze and entitled le Printemps: "he said that head reminds him of what I must have been at eighteen." After her return to England he sent her what appeared to be a small head of Nijinsky, three inches high, in a crate that also contained two plaster legs, two plaster arms and one rather puzzling item: "What is the meaning of the thumb that has arrived all by itself, wrapped in brown paper?" she asked him in a letter dated December 28. "Is it a bad joke? Who has dared to break off your thumb?"

In January Rodin and Rose went to the Riviera, where they had rented the Villa Angélique near Hanotaux's house at Roquebrune—"my bronchitis and my wife's asthma oblige us to go there," he wrote to Captain Bigand-Kaire. When Lady Sackville came to see them late in February she was "shocked to find a three-roomed villa, very dark and tiny," as she noted in her diary. Her bust, too, was "a horrible disappointment," and she asked him to revert to an earlier state that seemed less thick-lipped and more flattering—"the finest that Rodin had ever done." On February 28 she gave Rodin 5,000 francs—"He generally charges 12,000 for that size, but he would not accept more than 5,000"—and "the old woman was furious for some reason or other and went away. He ran after her, but she would not come back to say good-bye. Poor, poor patient old Rodin. I do feel for him."

She wanted to go on to Rome and Siena, "but he is utterly miserable and he has my bust here. . . . I had to be very considerate and say I would come to Cap-Martin although the rooms are so very dear: 100 frs. a day for my suite. He has been dreadfully worried by the French Govt. over his Museum and feels as I do, very sick about this disputed gift. Mme Rose got on my nerves exceedingly, she stuck

to us the whole time and even came in the car when I took him to the Post Office in Mentone. He requested that I should go every day with *them* for drives. She is an awful old bedint [her private word for the lower class] and a leech, so peevish and says nothing or grumbles. I have a nice time before me!"

When she visited Hanotaux at his Villa l'Olivette he showed her two statuettes that Rodin had made "to illustrate the convex and concave manner of the Antique or of the Renaissance." They had a long talk about the old man's problems. Hanotaux said he "hoped Rodin would marry at last old Rose, and he was going to advise him to do so, but I said: What about that son whom he hates and whom he has never allowed to take his name? Mr. H. was so surprised: he didn't know of his existence."

Rodin was ill on the 9th of March; she went to see him and he talked to her for three hours about his worries and concerns—the Duchesse, among other things. "She still writes me sometimes to give me good advice. She's a very intelligent woman but too ambitious; without a heart!" Rose, it seemed, had taken a liking to Lady Sackville: "It's extraordinary, because she has always detested the women who interest me. Will it last? I was the sculptor of women, of love, *de l'idéal*, but she never understood!"

Rodin also told her that Kaiser Wilhelm had done an about-face and sent an emissary to ask if the sculptor would do his portrait. He had begged off on account of illness. "I'm obliged to refuse to do the bust of the emperor of Germany. I know I would have done a very beautiful one, but how could I do the portrait of an enemy of France? I turned down 125,000 francs for it, but now I have to work again because I have very little money."

For several days she did his secretarial work. "He muddles his letters as soon as I have put them in order; he does not know how to draw cheques. How has he managed till now? He is in terror of having no money in the future. . . . I see from his correspondence how generous he is and what a lot of money he subscribes to things, and how fulsome people are to him. It is wonderful how his head is not swollen or turned. He is very quiet and modest by nature." He mentioned his difficulties with the *Walking Man* pedestal and asked her to speak to people on his behalf when she went to Rome—"but I don't want to appear as a 2nd Duchesse de Choiseul!"

Next day they went for a long drive to visit Renoir in Cagnes. On the way she got up the courage to ask him to marry Rose, to which he replied: "Yes, you're right; perhaps I'll do it." As for Auguste Beuret—"I'll try to get him something to do in my museum. He has a certain charm. But he has rough, deplorable manners. He's always caused me a lot of trouble. His mother doesn't care about him at all. She's attached herself to me like an animal. I'm grateful to her, after all, but she's tough as a cannon ball. What I should have had, especially now, is someone like you, gentle and simple, and very feminine. . . . You're the kind of woman whom I feel I can love with all my heart. . . ."*

Rodin was clearly making progress, addressing Lady Sackville with the familiar *tu* and punctuating their conversation with long looks, "a charming smile and a stroke of my hand. That means so much for him." He confessed that her "sweetness and gentleness and charm and femininity" had quite conquered him: "Ah, the Duchesse was not like you!" But Victoria Sackville had other plans, and spent the next three months in Italy. On the way home to England she stopped in Paris and "found him miserably unhappy. He told me that life with old Rose was unbearable now, and he wanted to leave her. . . . He said Rose *'lui donnait des coups qui lui faisaient mal.'* I was so sorry for him that I forgot to speak about my bust. He gave me the blue one, which he says is like me when I was 18—very pretty—and he wrote on it: *Pour Lady Sackville. En souvenir de ce qu'elle était à 18 ans. A. R.*"

✳

Rodin's mood was scarcely improved by the gratuitous slap in the face he had just received from the Paris Municipal Council. The Librairie Armand Colin had, at long last, brought out the sumptuous first edition of *les Cathédrales de France*, with 164 folio pages of his text and reproductions of a hundred of his drawings. On April 6, 1914, Councillor Pierre Lampué persuaded his colleagues of the city council to accept a resolution prohibiting the purchase by municipal libraries of "a very thick book, *les Cathédrales de France* (50 francs the copy) which M. Rodin has just published." Lampué told the

* Lady Sackville's diary records these remarks in French.

Council, "I shall say nothing about the text: the only thing in this book that is certainly by him are the hundred illustrations, if I can call them that. The most mediocre student in our municipal drawing courses would blush with shame to submit such sketches."

Despite Lampué's insinuation that the text was ghost written, *les Cathédrales* is in fact a distillation of pure Rodin, drawn from thirty years' accumulation of notes and observations—on the Gothic churches of France and much else besides. Charles Morice, who helped him put the book together, said afterwards that Rodin had written it "like a prophet conducting his people to the promised land which he himself will not enter." The result was a loosely organized compendium of the maître's most rhapsodic prose descriptions of the cathedrals of Chartres, Laon, Amiens, Reims, Beauvais and so on: "The cathedral is the synthesis of the country: I repeat, rocks, forests, gardens, the sun of the north, are all epitomized in this gigantic body. All our France is summarized in our cathedrals, as all Greece is in the Parthenon."

He saw himself as the solitary champion of the Gothic cathedrals, which were being attacked by barbarian restorers and neglected by the French public: "No one defends our cathedrals." But the book is more interesting as a kind of autobiography than as a guidebook: "Little by little I have come closer to our old cathedrals and penetrated the secret of their life, which is constantly renewed beneath the changing sky. Now I can say that I owe them my greatest joys. . . . At each visit [the builders] tell me new secrets. They have taught me the art of using shadow as it should be used to envelop a work, and I have understood the lessons they teach with the puffed-out silhouettes they always have."

"Before I myself disappear," he wrote, "I want at least to have expressed my admiration for these old living stones. I want to pay them my debt of gratitude for all the happiness I owe them." Despite the book's confessional tone, most of the Paris literati were under the impression that the whole thing was a fabrication. Gustave Fuss-Amoré, for example, wrote a cynical account of a public reading of the text he had attended at the Hôtel Biron: "Charles Morice read before a large audience. Rodin listened and seemed bewildered by all the things Morice had him say—he always spoke of cathedrals with great intelligence and simplicity. In the end he had persuaded

himself that he was the author of all this grandiloquent nonsense."

Yet Morice had done no more than transcribe and edit what Rodin gave him. It was a daunting task, and the fact that *les Cathédrales* is readable at all is a testimony to his patience and devotion as an editor. Rodin had never had a more willing literary slave, even in Rilke, than this down-at-the-heels Symbolist poet who spent the better part of 1910 and 1911 assembling and deciphering Rodin's notes— which were scrawled in pencil on scraps of paper, strips of newspaper, lined notebook pages and used envelopes. Morice had to transcribe them with the help of a magnifying glass, and then made almost daily trips from Vannes to Meudon to submit the results to the maître's scrutiny—often something of a trying experience since "Rodin goes out of his way to be unpleasant to me."

Far from being a passive watcher on the sidelines, Rodin took a direct hand in the editing process, and when Morice's text failed to please him he applied for advice to Hanotaux and to the art historian Louis Gillet, curator of the Musée Jacquemart-André. Still, the text was published more or less in Morice's version, though under Rodin's close supervision. "I've finished correcting the second proofs of *Cathédrales*," the sculptor wrote to the poet in October 1911. "I have deleted some of the book's numerous heresies, and I have to reread the corrected proofs very carefully. . . ."

Unlike those of any other book on architecture, his spidery illustrations are often scrupulously detailed yet utterly casual in execution, and more like a mason's working drawings than Monet's Impressionist paintings of cathedrals. "As I have never learned perspective my drawings often wobble," he explained in an article that Lawton translated for the *North American Review*. "This defect in my education often troubles me in my architectural designs, for perspective is a useful science. What I know of perspective is by instinct. When I was young, I had an antipathy to geometry, believing it was a cold science that hindered enthusiasm. I have had perforce to acquaint myself with it, since all I do is based on geometry."

Morice, under his own name, contributed a long, dull introduction "so as to make Rodin's pages look all the better by comparison," as the *Canard Enchaîné* slyly suggested. At all events, Rodin was not the only one in France profoundly concerned with the great cathedrals. Indeed, his book happened to coincide with a great church-state

debate as to whose responsibility it was to provide for their upkeep—the state or the congregations? Rodin did not take sides in this battle for which Barrès, on the side of the angels, wrote *la Grande Pitié des Eglises de France*; what mattered to him was that the building contractors should not continue to mutilate the churches with inept restorations. Concerning Reims, for example, whose cathedral gave him "infinite" joys with its "endlessly varied spectacle" of changing profiles, he wrote of being "more shocked by the restorations here than anywhere else. They date from the nineteenth century, and after fifty years they have acquired a patina, but they deceive no one. These ineptitudes of half a century ago would like to take their place among the masterpieces!"

Emile Mâle, the leading French authority on medieval churches, reviewed *les Cathédrales* in the *Gazette des Beaux-Arts* of May 1914 and gave it his blessing. It was not a book "in which to look for a history of the cathedrals, nor the laws of equilibrium, nor an explanation of their encyclopedia in stone," but it was filled with "vibrant notes, noble thoughts, beautiful metaphors." More exigent specialists, however, found the text full of errors and misconceptions. "He makes mistakes because his historical documentation is inadequate," declared Louis Demaison in a lecture delivered before the National Academy of Reims three weeks before the outbreak of World War I. "It is Rodin's method that is at fault. He places himself in front of a monument and interrogates only its stones, interpreting their language as he sees fit and professing to understand everything thanks to his intuition as an artist."

Reims cathedral provided a particularly egregious case in point. "My eyes were hurt by the stained-glass windows of the nave," Rodin had written. "Needless to say they are new—flat effects." In fact they were unretouched thirteenth-century stained-glass windows, but Rodin had not taken the trouble to find out. He also described the capitals of the nave as "flat and ineffective" because workmen had "held the tool head-on, at right angles to the stone"—which proved to him that they had been badly restored. Yet these were the original twelfth-century capitals of Reims. Conversely, Rodin had praised the right gable of the cathedral's pediment: "It has not been retouched. From this powerful block emerge fragments of torsos, draperies, massive masterpieces. Here a simple observer can, if he is sensitive,

experience a thrill of enthusiasm even if he doesn't fully understand it. These pieces, broken in places like those of the British Museum, are just as admirable." In fact, he was talking about a gable whose sculptures had been rather badly restored in 1737. And in Laon he praised an "admirable" bas-relief of the Virgin that had been carved only a few years before, using figures from Chartres as a model.

The fourteenth chapter of *les Cathédrales* is even more fragmentary and intuitive than the rest. Its pages are devoted to a series of *pensées* and aphorisms about art and architecture in general, such as the oft-quoted "It is the intelligence that draws but the heart that models." This final chapter is prefaced with the ominous statement: "I resign myself to the death of these buildings as to my own death. Here I make my testament."

>✠<

Rodin had a brief reunion with Lady Sackville on July 2, 1914, when he came to London to help inaugurate a loan exhibition of modern French art to which he had lent nineteen of his marbles and bronzes. The Comtesse Greffulhe—Proust's model for the Princess de Guermantes—had organized the exhibition, which was held in the Duke of Westminster's residence, Grosvenor House. It was to have been a gala opening, but the court was in mourning for the death of the Austrian Archduke at Sarajevo—hence Queen Alexandra and Marie, Queen of Romania, attended a quietly subdued private showing. Rodin had sent Lady Sackville "a frantic wire" asking her to meet him at Grosvenor House, and as she noted in her diary, "I had to take him afterwards for an airing in the park, he was so tired. He says he has to go back tomorrow as he has not brought any shirts or slippers!"

He had, in fact, arrived only at the last minute and quite unexpectedly. In Paris he had been taken suddenly ill and had asked Malvina Hoffman, who happened to be in England, to deputize for him in supervising the placement of his sculptures, and to attend the formal opening as his representative. She prepared everything for the Queens' visit, and "to my utter amazement the first person to arrive when I was resting in the hallway with the movers was Rodin on the arm of the Comtesse de Greffulhe." Rodin did not return to Paris immediately, but stayed on to attend a formal ball given by the Duke,

to which members of the royal family were invited. To be correctly dressed for the occasion, he had a tailor make him a pair of knee breeches on twenty-four hours' notice. "The tailor did his best," as Anita Leslie heard from John Tweed, "but as the sculptor ascended the ducal staircase there was an ominous crack, and Rodin's black breeches split disconcertingly at both knees." Footmen rushed to the rescue and the Duchess's maid appeared with a needle and thread to stitch him up. "Rodin gazed crossly at his unaccustomed attire . . . then he moved gingerly into the ballroom."

On the return journey Rodin was accompanied by Count Kessler. At Folkestone, when Kessler asked him whether he wanted anything to eat on the Channel steamer, Rodin told him, "No, I'm not hungry; I'm looking at nature; nature nourishes me." When they landed at Boulogne the newspapers were filled with news of the Austrian ultimatum to Serbia. Kessler, who was a reserve officer in the German army, realized that war was inevitable. When they parted at the Gare du Nord that Friday he and Rodin made an appointment to have tea at the Comtesse Greffulhe's the following Wednesday—but as Kessler sadly noted in his journals, "the following Wednesday I was in Cologne," waiting for war to be declared.

Malvina, who also returned to France, recalled that the maître spent the last week of peace organizing his drawings and rearranging some of the marbles at the Hôtel Biron. On the whole, Rodin had a fairly good idea of what was happening on the international scene because he moved in exceptionally well-informed circles. Only a few weeks earlier he had dined at the American embassy with ex-president Theodore Roosevelt, Henri Bergson, Edith Wharton and Mrs. Cornelius Vanderbilt.* But like everyone else he was unprepared for the suddenness and confusion with which the war began. On August 2 the concierge at the Hôtel Biron brought him a cable from London saying that it was inadvisable to ship the sculptures at Grosvenor House back across the Channel. Rodin handed Malvina the cable and said, "There it is—war!" Indeed the French government had

* Myron T. Herrick, the American ambassador, noted that in response to his telegraphic invitation Rodin answered "that he would come if he could find his clothes, but that he didn't think it would be proper to come to the embassy in morning dress. We answered that his name and reputation entitled him to come in his pajamas if he couldn't find anything else. The old man appeared, however, in his evening clothes."

already declared a general mobilization. Rodin now owned a car which he used to drive back and forth between Meudon and the rue de Varenne, but on this day he was stopped before he passed the gates of Paris—"soldiers requisitioned the car, forcing Rodin to walk. He and his lame plaster caster started on their weary way and were finally given a lift by a passing peasant's cart. At Meudon, he found that his only horse had been seized, and his workmen called to the colors. Every means of travel had been cut off." Yet at the same time a telegram from the military authorities ordered him to remove all the works of art at the Hôtel Biron to the cellar within forty-eight hours.

Fortunately Malvina knew a colonel who lent them his car to bring Rodin from Meudon to Paris, and gave the necessary orders to the movers: "We spent the next day with six strong men, moving all the bronzes from the carefully selected positions in the galleries to the storeroom in the basement. This peremptory order was a bitter experience to Rodin. In his old age, at this tragic crisis of history, he was made to feel subservient and abandoned."

As the German army pushed through Belgium and across eastern France, many of those who remembered the siege of 1870 thought it advisable to leave Paris. Rodin planned to go to Marseille, but by chance he met Judith Cladel, who was taking her mother to stay with two sisters in England, and he decided to join them. He and Rose left Paris on the 1st of September, on a train repeatedly delayed by troop trains bringing up reinforcements for the impending battle on the Marne. In England they insisted on staying for a time at a modest rooming house in Cheltenham run by a Mrs. Gandy, where Rodin was alarmed and outraged to read of the shelling of Reims that followed a few days later. From London, on September 30, he wrote a letter to Romain Rolland, who had begun publishing a series of pacifist protests against the destruction wrought by the first battles of the war: "Everything that is happening is like a punishment that has descended on everyone, and henceforth people will speak of the fall of Reims [which was occupied by the Germans September 4–12, 1914] as they do of the fall of Constantinople. . . ." And again from Cheltenham the next day, another letter to Rolland that was an anguished postscript to the first: "This is more than a war. This scourge of God is a catastrophe for humanity that divides the ep-

ochs. . . . People are so ignorant that they think they can repair and restore a cathedral. It's like the burning of the library of Alexandria, the destruction of the Temple of Jerusalem."

Later in October he and Rose were Mary Hunter's guests at Hill Hall, in Epping, where he wrote an unusually warm letter to Gwen John, still in Paris, thanking her "for your admirable advice that we should love our enemies. Tell me what you're doing; I shall read your news with great pleasure. *De tout coeur votre ami Rodin qui pense à vous.*" Mrs. Hunter commissioned Henry Tonks to do their portraits in pastels while they were at Hill Hall, but the English artist made no secret of the fact that he was disappointed with his famous sitter: "Why, I have never heard him say anything except, *'Dieu, que les arbres sont beaux!'* "

Meanwhile Tweed had arranged for them to stay with a friend in London, Miss Emilie Grigsby, who owned a large house at No. 80, Brook Street. When they first moved in their hostess noticed that Rose could never be induced to come down for dinner, and wondered whether it was because she had no suitable clothes to wear. But when she offered to lend Rose some evening gowns the old woman confessed: "Mademoiselle—you don't understand. I'm here under false pretenses. You see, I'm not really his wife, and I shouldn't be here at all." Rodin was restless and unhappy: he spent hours in Hyde Park watching children at play. For relaxation he liked to have a long, thorough massage every day, and usually ordered his masseur to come at lunchtime. Friends of Miss Grigsby's who came to lunch hoping to meet the famous sculptor were "puzzled and dismayed by the moans and groans and strange cries that resounded down the marble staircase, for Rodin liked to leave his door open, to hear what was going on. When the ordeal was over he might appear or he might not."

The house stood on the corner of Gilbert Street, which was being used by young volunteers to practice close-order drill, and Rodin often stood at the windows, watching them: "Such beautiful men; what angels of strength and beauty! How well they move!" His admiration for these soldiers weighed heavily in the balance when he had to decide what to do with his marooned sculptures: they had gone from Grosvenor House to a loan exhibition at the Victoria and Albert Museum, and now Tweed suggested he donate the entire collection

to the British nation. Emilie Grigsby, too, urged him to "give them to the men who are drilling outside." Rodin readily agreed to present eighteen sculptures to the V&A—the nineteenth, the Harriman bust, was going to America—and when his donation was formally accepted in November, Sir Claude Phillips pointed out in the *Times* that "no foreign artist has ever made to England a gift of equal artistic importance and splendor." The newspapers also quoted the brief statement with which Rodin had announced his donation: "The English and French are brothers; your soldiers are fighting side by side with ours. As a little token of my admiration for your heroes, I decided to present the collection to England."

By then Rodin had already left London: "The guns drive me from France and the fogs drive me from England," he told Emilie Grigsby. After a brief stop in Paris on November 12 he and Rose went on to Rome, where they stayed with the Marshalls at No. 25, via Gregoriana. "I have come to Rome because I must find a place to work," he told an American correspondent. "It is impossible to work in Paris or in London, for the barbarians are too near. . . . I will stay in Rome until the war bears in upon us, for, of course, Italy will eventually enter the conflict.* French and Italians are all Latin, and must stand together against the Teuton." He had decided that the Germans were responsible for the war: "Germany is a country that has never known the meaning of art . . . for Germany represents the quintessence of brute force." He announced that he was going to create a memorial to Belgium—"a soldier bearing on his back a wounded comrade"— and that he was looking for a studio in a suitably "grandiose, inspiring palace."

Albert Besnard was now director of the French Academy in the Villa Medici, and he was delighted to have his old friend in Rome— "At least we'll talk about other things besides the war; he says the most beautiful things in the world about art and nature." Yet his enthusiasm lasted only a few days: Rodin, Besnard wrote in his diary, "has come here firmly resolved to amuse himself. At heart I think he feels that everyone is too much taken up with the war and not enough with him. He has aged and perhaps no longer works very much. He has reverted to a brush cut and given up the curled forelock

* Italy declared war on Austria on May 23, 1915.

advised by the Duchesse—this time influenced, I think, by his wife, who now accompanies him everywhere. He strikes me as silent and withdrawn from this world, though he still looks to it for support."

Sometimes, to console himself, Rodin would go to the forecourt of the Farnese Palace to take a loving look at the *Walking Man*, still resting on its temporary wooden pedestal. At the Villa Medici he spent two hours stroking the legs and torsos of the Greek statues. During the morning hours he liked to explore the city on foot, especially the Rome of Bernini and the papal architects: the piazza Navona, via dei Giubbonari and Ponte di Castel S. Angelo.

Before long he found a suitably palatial atelier where he began doing drawings of a female model—but as Besnard records, he could rent "the studio of his dreams" only during off hours: "It is a large rotunda with columns surmounted by a dome and decorated with statues. The trouble is that it's located at Latour's, the famous confectioner's and ice-cream parlor [in the Palazzo Colonna]. It would be all very well if this shop didn't open at 10 in the morning, and if the waiters, in their hurry to clean the floor, didn't sweep right under my friend's feet. True, there is one compensation: since he doesn't speak Italian and his young model doesn't know French or even the art of posing, he would be unable to communicate with her if the oldest waiter, having been to Paris a few times, didn't serve as interpreter. Having stood his broom in a corner, this garçon has even gone so far as to take the delicious and wholly naked Pompilia d'Aprile around the waist in order to put her bodily back into the desired position, taking care to place her in the center of the marble table that served as *table à modèle* and on which, soon afterward, people were going to eat ice cream." Besnard thought, rightly, that this state of affairs could not last long. "Nobody comes to see him. . . . I think that our Rodin is bored."

Fortunately there were occasional diversions to relieve his ennui. He made friends with a group of Italian musicians—the cellist Livio Boni, the pianist-composer Alfredo Casella and the violinists Arrigo Serato, Mario Corti and Giulio Natale—who played Bach and Beethoven for him at the via Gregoriana. Sometimes there were even unexpected flashes of the dolce vita. The Spanish poet Rafael Alberti remembered a day when Rome was blanketed with one of its rare snowfalls, and Rodin was walking in a garden with a group of his

admirers. "How lovely it would be to see a naked woman stretched out in this snow," the sculptor told them—"Whereupon a beautiful model answered him as though it were the most natural thing in the world: 'Maître, I'd like to give you that pleasure,' and she took off her clothes and threw herself headlong into the freshly fallen snow."

The presence of so many papal portraits reinforced Rodin's desire to do a bust of the reigning Pope, Benedict XV, that might be remembered as one of his masterpieces. Through friends of Livio Boni who were well connected at the Vatican, and with the help of the Marchese Misciatelli, he succeeded in obtaining the Pope's consent, though the sittings were not to take place until the spring. At the end of February he decided to return to Paris for a few weeks, though as he wrote to Boni just before his departure: "It's painful for me to leave here; that's the word. In Rome I've found all my gods more beautiful than anywhere else. And now they've promised me that I can do a bust of the Pope. When I think of it I feel great strength and ambition because there is the man and the whole tradition with its martyrs, Apollos, Jupiters; all that and saintliness, the sovereign product of the people's instinct for love, a sovereign power like that of Reims cathedral."

When he returned in April, he asked Ivan Meštrović, who now had a studio in Rome, to lend him a stand and some modeling clay. In his memoirs, Meštrović recalled that at first Rodin was proud and delighted with the thought of doing the Pope's portrait, but five or six days later he was back at the young sculptor's studio, discouraged and infuriated. "The first day the Holy Father posed for me for one hour," Rodin reported. "The second day he had hardly sat down when a cardinal arrived for some important business and the Holy Father told me to come back tomorrow. The following day I was told he was busy again, and the same thing happened two days in a row. At last a secretary brought me some photographs and asked me, 'Maître, the Holy Father is so occupied with important matters, couldn't you work from these photographs, which are excellent?' At these words I took off my smock, took my hat and left. And now I'm going to Paris."

Besnard had also received permission to paint the Pope's portrait—it was considered of political significance that two French artists had been thus honored at a time when the Vatican was trying to maintain a policy of strict neutrality. But Besnard, too, was granted

fewer sittings than he would have liked, and he sympathized with his friend's predicament. "Rodin, who came to Rome a second time for the bust of the Pope, has left again," he noted in his diary. "He was discouraged because his model wanted to give him no more sittings, saying he was tired of having to sit still for the sculptor. 'I don't want to continue; I don't want to pose any more,' he told someone in his entourage. It seems that, while Rodin tried to explain his way of doing a bust, Benedict XV cut him short with 'Finish, finish, Monsieur Rodin.' Above all he didn't understand the artist's need to see him in profile. When Rodin walked around him in a circle in order to study him from the side, the Pope persisted in facing him the entire time. And he refused to allow the sculptor to look down on him from above. Rodin on high and the Pope at his feet—that would never be permitted. But what do you expect? This is a young Pope, and sitting still is tiresome for him. 'Why don't you copy the bust that Count Lipai [the Austrian sculptor] has made of me,' Benedict XV said to our Rodin; 'it would go more quickly then.' "

Rodin had asked for twelve sittings and had gone home after three of them—yet he was not entirely dissatisfied with the result. John Marshall carried the fragile clay bust, uncrated, to the railway station for him, and Count Boni de Castellane, who happened to be on the same train, says in his memoirs that, as a favor to Rodin, he held the bust in his arms "like a holy relic" during the entire trip to Paris.

Rodin worked on it at the Dépôt des Marbres and wrote to Livio Boni in May that the bust was "perfectly preserved. . . . I've saved the bust and on Monday morning at 7, in Paris, I worked until evening, and then kept at it for six days. The bust is incredible; it has the resemblance, but you know I am far from having achieved the masterpiece that it could have been, had I been able to work patiently. . . ." Later he told Renoir indignantly that "this Pope doesn't understand anything about art: I wanted to have a good look at his ear, but he had positioned himself in what he regarded as the most flattering pose and made it impossible for me to see anything of his sacred ear. I did my best to move to a different point of view, but as I moved, so did he. . . . Gone are the days when François I picked up Titian's brushes!"

By the spring of 1915 Paris was no longer in imminent danger and the contending armies were bogged down in a war of attrition in

the trenches of Flanders and the Champagne. Life in Paris resumed something of its normal tempo and Rodin moved back into the Villa des Brillants with Rose, on whom he was now more dependent than ever. Indeed, he had become much more appreciative of her ministrations. "My poor wife dropped one of my shirt buttons the other day," he told Warrington Dawson. "She cried with impatience trying to find it. I consoled her where in times past I would have insulted her." Wartime shortages, however, made it increasingly difficult for them to lead a reasonably comfortable existence. Coal was in short supply and the central heating promised him for the Hôtel Biron had not been forthcoming because the museum project had yet to be formally ratified. Rose had been seriously ill in the spring, and Rodin caught cold again in the autumn. "If I haven't written you," he informed Captain Bigand-Kaire on October 2, 1915, "please put the blame on age and illness. At the approach of winter my health undergoes its annual eclipse."

Four months before the outbreak of the war, Armand Dayot had announced in *l'Illustration* that the government had definitely decided to go ahead with its plans, and that the Musée Rodin was "virtually in existence." He was now very sure of his ground because the museum's bête noire, Gaston Calmette, had just been conveniently shot and killed—by the wife of the finance minister whom Calmette had been persecuting in the pages of *le Figaro*. So long as the editor was alive the government "had dared not take favorable action," as Dayot admitted, but "with the removal of Calmette and his obstruction the real desire of the French nation to possess these treasures from the hands of one of its most distinguished sons has no further barrier opposed to it." It was generally agreed that Calmette had got no more than he deserved. Charles Ricketts, for one, noted in his diary that he did not regret the editor's death: "His infamous attacks on Nijinsky and Rodin, with their appeals to bare moralistic prejudices, class him; and I see no objection to the tyranny of the modern Press being tempered by assassination." The Paris jury felt the same way, and acquitted the distraught Mme Caillaux as though she had committed a *crime passionnel.*

The war inevitably delayed things further—and so long as Rodin had not yet made over his property to the state, his fortune remained

a matter of avid interest to several women who hoped to figure prominently in his will, notably Jeanne Bardey and Loïe Fuller. But the government, too, was vitally concerned with the eventual disposition of his worldly goods, and in the spring of 1916 the legislative wheels began turning in earnest. The support of Etienne Clémentel, the prestigious minister of commerce, did much to silence the remaining opposition to the idea of a Rodin Museum. As so often before, Rodin wanted to express his gratitude in the form of a bust. He began working on Clémentel's portrait but in July 1916, before he could complete the fourth stage of the bust, he suffered another stroke—apparently it caused him to fall down the stairs at the Villa des Brillants.

Though he eventually recovered much of his physical strength Rodin never finished the bust because he was no longer in full possession of his faculties. "Poor Rodin!" Marcelle Tirel wrote. "He died before his death." She noted that for many months he lived in a "very curious" state of health. "Some days his mind was perfectly lucid the whole day long. He lived in a sort of intellectual lethargy of varying duration. An expression of gentle and beatific joy lent a certain majesty to his fine face. Then all at once, *pouff!*—he would begin counting his fingers, the light would go out of his eyes, his lip would droop and he would cease talking. 'Look at him,' his poor wife told me. 'You see him; he's losing his wits.' It was heartbreaking to watch him. We broke down and cried."

It was in this condition—on September 13, 1916—that Rodin signed the deed of gift leaving everything to the French state. His donation superseded several earlier testaments: one of them left a quarter of his estate to Loïe Fuller; another divided it evenly between Jeanne Bardey and Rose Beuret. According to Loïe, "Mme Bardey thought of marrying Rodin after getting rid of Mme Rose."

The now fifty-year-old Auguste Beuret and his ragpicker companion Nini Doré had moved to the Villa des Brillants to act as caretakers. "What about me?" he asked Tirel when he heard about his father's gift to the nation. "What am I going to get? To give millions to the State, and their son doesn't even have a decent pair of trousers!" In fact, almost everyone who now came to Meudon wanted something from Rodin: a signed photograph for the attending physician; gift drawings for those who had helped with the museum project, including

Clémentel and Dalimier, the new undersecretary for fine arts; a marble head of *Saint Jean-Baptiste* for Loïe. . . . A nurse who dabbled in sculpture obtained Rodin's permission to do his bust and proceeded to work on it in his bedroom until Jeanne Bardey hurled it out of the window; Mme Bardey herself hoped to get him away from Meudon and to her own doctor at Clermont-Ferrand. Not unnaturally, virtually all of these people disliked and distrusted everyone else in this web of eleventh-hour relationships. Cladel, who hoped to become secretary of the museum-to-be, detested Léonce Bénédite, the curator-designate, whom she dismissed privately as a "Shylock."

Meanwhile, the Senate and the Chamber of Deputies passed the laws establishing the Musée Rodin and accepting the artist's donation, though only after heated debates. Even though Anatole de Monzie reminded his fellow deputies that "the great sculptor Rodin offers you an inestimable treasure which all civilized nations envy," the anti-Rodinists resisted to the bitter end. "He has lent himself to too many disorderly and excessive manifestations," objected a deputy named Jean-Louis Breton, who felt that Rodin "had a deplorable influence" on modern art. Others thought he was setting a dangerous precedent: any well-known artist could thus, while still alive, attempt to impose his work on a reluctant nation. The bill in the Chamber granting 10,813 francs toward a Rodin Museum was passed by 379 votes to 56, but in a debate on the enabling bill in November, M. Gaudin de Villaine quoted a long screed by René Rozet denouncing Rodin as a "demented, hallucinated, possessed, convulsive" mystifier who created "newly manufactured ruins." His colleague M. de Lamarzelle declared that placing Rodin's works in the former chapel of the Hôtel Biron would be "offensive not only to all Catholics but to all who have a certain delicacy of sentiment."

Rodin was spared a knowledge of these final indignities. His mind was elsewhere. "While crossing the avenue de Breteuil he thought he was in the forest of Soignes," Cladel recorded in her diary on October 16. In December she made a note of how Rodin's bullying private nurse spoke to him now that he had become incontinent: "*Vous êtes Dieu, mais vous ch . . . partout!*" In January she wrote that Rodin wanted to get out of the house: "Sometimes he manages to escape, like a schoolboy." Those who now looked after his affairs on behalf of the government—Clémentel, Bénédite and the banker

Peytel—decided that the time had come for Rodin to marry Rose, now that his property could no longer go to his wife.

On January 22, 1917, the marriage contract was signed: "Rodin seems very happy. *Mme R. est agitée,*" Cladel wrote. On the 28th, on the eve of the wedding, three great explosions shook the house and broke window panes—a nearby munitions factory had blown up. The same day, since there was no longer enough coal to fire the furnace, the pipes froze and burst, flooding the drawing room with water: "Rodin and his fiancée, huddled up against each other with a rug over their knees, looked like a pair of the little lovebirds said to be inseparable," Tirel noted. "They were half dead with cold." The marriage, performed by the mayor of Meudon, took place the next day: among the guests were Clémentel and Dalimier, as well as some of Rodin's Cheffer and Coltat cousins. Afterward Auguste Beuret complained bitterly that nothing had been done for him—legally he was still not Rodin's son, though his mother was now Rodin's wife.

"The days that followed were lovely," Tirel reports. "Since neither friends nor ministers had sent an ounce of coal the poor old people were suffering from the cold. They stayed in bed from morning to night, holding each other's hands from his bed to hers, as they talked of their life of hardship and their younger days. It was a quaintly original honeymoon."

On February 14, two weeks after the wedding, Rose died in her bed. Cladel went to Meudon that day and found Rodin in the bedroom sitting in his armchair. Rose had "kissed her husband this morning, telling him that he had made her very happy and thanking him for it; her only regret was that she was dying before him, and leaving him alone." She was buried in a vault in the garden at the site— beneath a cast of *The Thinker*—that Rodin had selected for their joint grave, though by now he was no longer aware of what was happening around him. Bénédite, who had begun running the affairs of the embryonic Rodin Museum, henceforth functioned as the curator of Rodin as well, deciding whom he could see and what he might do. In April Bénédite permitted Juliette Bourdeau, one of the former models, to visit the ailing maître, but when Gwen John came to the Villa des Brillants to ask for the same privilege she was, as Cladel's diary has it, summarily *"consignée à la porte."*

Early in November the eighty-four-year-old Léon Bonnat paid a

visit on behalf of the Institute, inviting Rodin to present himself as a candidate for membership at last. He was made to sign a letter to that effect—and "thus the incomparable sculptor solicited the honor of succeeding Saint-Marceaux, the most insignificant of *pompiers*," as Francis Jourdain complained. In any case it was too late for him to be elected an Immortal. The cold set in again: on November 16, four days after his seventy-seventh birthday, the newspapers carried a terse medical bulletin issued by his doctor, Stephen Chauvet: "Pulmonary congestion; patient seriously weakened and in critical condition." Rodin died at four o'clock on the morning of Sunday, November 18, 1917. The watchers at his bedside reported that his last words were said in a firm, clear voice with a tinge of reproach: "And people say that Puvis de Chavannes is not a fine artist!"

The burial took place on the 24th of November. The war precluded a state funeral, but a large crowd gathered in the garden of the Villa des Brillants, and there was a detachment of Territorials "in sorry-looking uniforms"—in recognition of the fact that he had been a Grand Officier of the Legion of Honor. A catafalque draped in the tricolor was erected in front of the château ruins; on the coffin were the insignia of the Legion of Honor and his doctor's robes from Oxford University. Clémentel, the first speaker, said that at some future day when France was no longer at war, worthy honor might be paid to the greatest sculptor of contemporary France. There were other official speeches that were frequently drowned out by gusts of wind and the sound of passing trains. Many women were in attendance—Loïe Fuller "in a hideous get-up vaguely resembling a combination of nurse's uniform and the Salvation Army," as Cladel observed; Séverine; Aurel; a group of former models. Bénédite had made no provision for a woman speaker but Aurel insisted, over his objections, that Séverine be allowed to speak on behalf of her sex. She mounted the steps leading to the château ruins and gave an impassioned speech, almost as though she were at a political rally. "We will preserve his memory in the cradle of our hearts," she said. "The women he ennobled in his sculptures will be more beautiful just thinking of him."

In London the same day a memorial service was held in St. Margaret's Church, Westminster, and wreaths were laid at the foot of the *Bourgeois de Calais* near the Houses of Parliament. The service was

attended by a great many distinguished men and women, including Mary Hunter and her daughters, the Countess of Warwick, Lady Sackville, Nancy Cunard and Kathleen Bruce. The text of the exhortation read: "Let us remember with thanksgiving and with all honour Auguste Rodin, to whom it was given by God to make life more noble and more beautiful for his fellow-men."

NOTES

1. THE NEED TO TOUCH

Page	Line	Source
1	4	BENJ, p. 185
	18	DUCR, p. 193
2	3	WALK, p. 253
	7	Ibid.
	23	ANON-1, p. 126
3	2	Ibid., p. 120
4	24	ANON-21, p. 336
	32	ANON-1, p. 142
5	10	BART, p. 27
	11	CLAD-3, pp. 76–77
	11	LAWT-1, p. 10
	14	ALTA, p. 134
	16	CLAD-7, p. 71
	29	ANON-80, p. 7
	33	RIOT-2, p. 106
9	1	BRIS-3
	14	HUYS-1, p. 105
10	3	CLAD-7, p. 71
	9	DUJA, p. 111
	15	BART, p. 27

Page	Line	Source
	35	HITS, p. 474
11	7	CLAD-7, p. 74
	10	DEUT, p. 41
	18	Ibid., p. 40
	23	MOUR-1, p. 216
	26	DEUT, p. 43
	31	HITS, pp. 474–475
12	3	CLAU-3, pp. 273–274
	11	Ibid., pp. 1437–1438
	32	LAWT-1, p. 23
13	3	CLAD-7, p. 74
	25	CHER-1, p. 17
14	10	RODI-H, p. I
	18	BART, p. 27
	23	BART, p. 27
	32	BENE-4, p. 7
	36	RILK-3, p. 273
15	1	CLAD-3, p. 77
	14	RODI-10

Page	Line	Source
	25	RODI-4, p. 225
	29	COQU-4, p. 66
	33	GEOR, pp. 261–262
16	7	DUJA, p. 111
	12	CHER-1, p. 17
	24	Ibid.
	27	STOK, p. 70
	31	Ibid., p. 67
	34	RODI-7, p. 54
17	4	LUDO-2, p. 2
	9	BART, pp. 19–20
	14	LAWT-1, p. 12
18	10	PARI-4
	18	DUJA, p. 101
19	2	LECOQ-2, Pref.
	14	LECOQ-1, p. 180
	27	MEIE, p. 12
	32	BART, p. 65
20	11	Ibid., p. 27
	15	Ibid.
	23	ENCY, Vol.8, p. 553
	25	PARI-4
21	1	LAWT-1, p. 14
	6	DUJA, p. 112
	20	SYMO-3, pp. 225–226
22	8	CLAD-7, p. 78
	10	RODI-6, p. 94
	14	CHER-1, p. 17
	32	COQU-4, p. 114
23	8	PHILA
	11	DUJA, p. 112
	14	LAWT-1, p. 15
	17	CLAD-3, p. 78
	21	PARI-4
	24	DUJA, p. 113
24	6	COQU-4, p. 25
	16	GSEL-4, p. 401
	26	LEROU, p. 206
25	1	LETH, p. 40
	3	Ibid., p. 24

Page	Line	Source
	9	BOUR, p. 26
	13	Ibid., p. 25
	17	RODI-7, p. 6

2. THE BUST IN THE ATTIC

Page	Line	Source
26	6	BYVA, p. 9
	15	FUSS, p. 178
27	7	CLAD-7, p. 85
	21	CASS, p. 31
	24	DUJA, p. 113
	27	Ibid., pp. 113–114
28	13	BOUR, p. 27
	18	DEKA, p. 93
	22	LAWT-1, p. 19
29	9	ROCH-1, p. 186
	13	BYVA, p. 9
	23	BART, p. 28
	28	WASH-2
30	4	BOUR, p. 27
	15	CLAD-7, p. 79
	21	BART, p. 18
	35	LUCB, p. 56
31	2	LAWT-1, p. 15
	18	BART, p. 19
	21	LAWT-1, p. 18
	24	BART, p. 19
	33	PARI-4
	37	BART, p. 19
	38	LAWT-1, p. 19
32	4	PARI-4
33	5	BART, p. 20
	17	COQU-4, p. 25
34	2	DUJA, p. 112
	7	CLAD-7, p. 255
	14	DREY-2, p. 5
	16	COQU-4, pp. 109–110
	25	DUJA, p. 33
	29	Ibid., p. 81
	30	GRAP-2, p. 12

Page	Line	Source
	33	PARI-4
	35	RODI-4, p. 220
35	7	BART, p. 29
	16	GSEL-4, p. 401
	21	RODI-8, p. 73
	29	Ibid., pp. 73–74
	36	Ibid., p. 74
36	12	BART, p. 22
	15	JEAN
	30	TIRE, p. 68
37	5	BLOO
	23	CLAD-7, p. 84
	34	LAWT-1, p. 65
38	11	PARI-25, p. 21
	15	Ibid., p. 24
	15	CLAD-7, p. 84
	17	LAWT-1, p. 23
38	31	HERB, p. 31
	35	Ibid., p. 45
39	2	Ibid., p. 77
	13	LAWT-1, p. 23
	15	BART, p. 22
	22	Ibid.
	27	Ibid., p. 21
	34	Ibid., p. 22
40	2	SIGO, p. 19
	5	LAWT-1, p. 23
	22	NOST-2, p. 22
	24	RODI-8, p. 220
	28	RODI-10
	32	VOLL-1, p. 247

3. A HIGHER CLASS OF EMPLOYER

Page	Line	Source
41	4	DUJA, p. 115
	19	BART, p. 20
42	4	MEYE, p. 19
	15	LAWT-1, p. 25
	18	BART, p. 21
43	8	DUJA, p. 116

Page	Line	Source
	19	WASH-2
	25	WEIN-2, Pl.4
	30	BART, p. 20
	38	BENE-2, p. 5
44	5	DUJA, p. 116
	24	HOFF-3, p. 126
	27	AURE-2, p. 157
	34	SACK
45	4	DUJA, p. 116
	13	CLAD-7, p. 87
	16	DUJA, p. 117
	32	BENE-2, p. 8
46	5	DUJA, p. 118
	12	SACK
	19	SPIE, p. 141
	26	BART, p. 21
	30	DUJA, p. 119
	37	Ibid.
47	5	BENE-2, p. 8
	6	BART, p. 21
	11	DESH, p. 42
	23	BART, p. 23
	36	Ibid.
48	1	PARI-4
	6	LAWT-1, p. 171
	20	DOLE-1, p. 67
	22	WASH-2
	26	CAMP, p. 14
	36	RACO, pp. 211–212
49	6	BART, p. 29
	14	Ibid., p. 45
	18	Ibid., p. 29
50	4	ROCH-1, p. 49
	13	WASH-2
	17	HARR-2, p. 324
	29	BART, p. 29
51	11	Ibid.
	14	LAWT-1, p. 32
	16	BART, p. 29
	21	Ibid.
	31	LAWT-1, p. 32

Page	Line	Source	Page	Line	Source
52	2	PARI-25, p. 51		17	COQU-4, pp. 25–26
	26	Ibid., pp. 51–52		21	BART, p. 27
53	18	BART, p. 29		28	Ibid.
	26	LAWT-1, p. 32	61	13	LETH, p. 154
	30	BART, p. 284		18	JOSE-1, p. 87
	35	Ibid.	63	2	DUJA, p. 101
54	5	Ibid., p. 44		11	Ibid.
	25	BART, p. 44		14	Ibid., p. 102
	32	FUSS, p. 176		23	LOLI, p. 151
55	1	JEANE, p. 129		35	APOL-1, p. 249
	13	SALM, p. 70		38	JAME, p. 21
	17	LOUI, p. 85	64	15	BERG-5, Vol.3, p. 252
	19	HARG, p. 21			
	23	BAUD-1, p. 351		26	GONC, Vol.8, pp. 26–27
	32	TREU, p. 6			
56	10	HARG, p. 296	65	1	RUSS, p. 27
	15	COQU-3, p. 49		29	EMER, pp. 1493–1494
	21	LAWT-1, p. 30			
	25	HARG, p. 294		34	HOUS, p. 302
	34	WASH-3	66	21	BALD, p. 139
57	1	LAWT-1, p. 27		27	MORIS, p. 52
	7	MAIL, p. 32		35	BART, p. 28
	30	HOFF-3, p. 47	67	12	Ibid.
	33	SACK		22	TIRE, p. 9
	36	BOUR, p. 213			
58	4	BUCH, p. 50			
	12	CLAD-7, p. 87	**4. MY SAVAGE MUSE**		
	21	TIRE, p. 36	68	2	PRIN
	23	NOTT-2, p. 94	69	13	DREY-1, p. 258
	28	RILK-3, p. 36		17	Ibid., pp. 258–259
	36	TIRE, pp. 52–53	70	4	Ibid., p. 271
59	3	Ibid., p. 173		18	BART, p. 45
	6	HARR-3, p. 531		19	BRUS-1
	10	LETH, p. 185		24	DILL
	15	KROH-3		34	Ibid.
	20	ANON-1, p. 142	71	4	PIER-1, pp. 161–162
	24	GONC, Vol.16, p. 102		8	BART, p. 45
				27	CLAD-7, p. 99
	34	CLAD-7, p. 319	72	2	Ibid., p. 97
	37	AIGN, p. 536		19	PARI-25, p. 30
60	4	Ibid., p. 535	73	4	Ibid.
	11	JULL-3, p. 34		16	Ibid., p. 31

Page	Line	Source
	26	BART, p. 45
	30	PARI-25, p. 31
74	1	Ibid., pp. 29–30
	25	Ibid., p. 32
75	1	Ibid.
	36	BOEL, p. 48
76	16	BLOO
77	30	ROUS-1, p. 185
79	1	LAWT-1, p. 34
	6	BART, p. 45
	12	RILK-3, p. 260
	15	LAWT-2, p. 34
	18	CLAD-7, p. 114
	24	BART, p. 65
	27	PIER-2, p. 446
80	4	RILK-3, p. 260
	6	FUSS, p. 179
	23	BART, p. 65
	31	Ibid.
	35	MEUN-2, p. 248
	36	Ibid., p. 249
81	15	PIER-1, p. 158
	19	COQU-2, p. 221
	27	BART, p. 65
82	6	SOLV, pp. 127–129
	24	PIER-1, p. 158
	34	RILK-2, pp. 312–313
83	8	BART, p. 223
	17	PHILA
	20	BART, p. 223
	23	RILK-2, pp. 313–314
	31	SART, p. 143
	33	GONC, Vol. 16, p. 62
84	5	PARI-18
	7	BART, p. 65
	14	PIER-1, p. 154
	24	BART, p. 66
	33	BOEL, p. 107
85	2	BART, p. 66
	9	Ibid.

Page	Line	Source
	36	MAUC-4, p. 5
86	7	ANON-12, p. 180
	11	BART, p. 65
	24	BENE-4, p. 15
87	5	COQU-2, p. 40
	14	GOLD-1, p. 20
88	6	ANON-2, p. 18
	11	BART, p. 45
	22	Ibid.
	31	Ibid.
89	18	LEMO-2, p. 65
	36	BART, p. 66
90	4	Ibid.
	13	SOCI-1
	23	BART, p. 45
	27	Ibid., p. 263
	32	SMET, p. 46
	34	BART, p. 45
91	3	LAWT-1, p. 45
	7	SMET, p. 46
	18	WASH-2
	30	Ibid.
	35	BROW-1, p. 217
92	2	BART, p. 65

5. A LION IN THE SHEEPFOLD

Page	Line	Source
93	6	RODI-7, p. 88
	8	PARI-25, pp. 33–34
	9	Ibid., p. 34
	16	Ibid., p. 33
	28	Ibid., p. 34
95	17	BERL, p. 173
	20	HOFF-2, p. 160
	26	RODI-8, p. 250
	34	CLAD-7, p. 113
	37	BLOO
96	9	BART, p. 65
	32	LAWT-2, p. 38
97	8	RODI-1, p. 16
	12	BROW-1, p. 217
	14	RODI-1, pp. 16–17

Page	Line	Source	Page	Line	Source
	20	PARI-25, p. 34	107	8	BLOO
	23	CLAD-2, p. 77		14	PARI-25, pp. 39–40
	28	LOUI, pp. 61–62	108	6	RODI-7, p. 142
98	1	CLAD-2, p.77		8	MAUC-8, p. 201
	9	VALE, p. 62		15	GONC, Vol.15, p. 127
	13	BART, p. 65			
	17	WASH-2		24	LAWT-2, p. 47
	20	COQU-4, p. 100		36	MORI-2, p. 579
	36	LAWT-1, p. 45	109	1	CLAD-7, p. 130
99	9	BART, p. 263		12	Ibid., p. 127
	17	LAWT-1, p. 46		18	BLOO
	19	ROUS-2		21	AIGN, p. 535
100	5	CLAD-7, pp. 115–116		28	GONC, Vol.16, p. 102
	22	WASH-2			
	26	CLAD-7, p. 116	**6. THE THAW**		
101	5	PARI-25, p. 35			
	20	LAWT-1, p. 49	110	6	SALA, p. xvi
	23	PARI-25, p. 35	111	18	ZOLA-3, p. 179
	35	WASH-2		23	SALA, p. 156
102	4	PARI-25, p. 37		30	CLAD-7, p. 119
	10	Ibid., p. 44		35	COQU-4, p. 103
	13	Ibid., p. 39	112	10	BART, p. 99
	18	DESCH, p. 50		18	Ibid.
	33	PARI-2		22	ANON-4, p. 256
103	3	Ibid.		25	ANON-5, p. 187
	6	BOEL, pp. 135–136		30	COQU-1, p. 163
	16	PARI-2	113	12	BART, p. 99
	34	PARI-4		16	Ibid.
104	11	SOTH-1		26	DUJA, p. 82
	15	LOW, pp. 204–206	114	4	Ibid.
	20	Ibid.		14	JEANE, p. 116
	37	BART, p. 100		23	BART, p. 99
105	6	Ibid., p. 283		38	Ibid., pp. 99–100
	12	TARD, p. 108	115	7	CLAD-7, p. 119
106	1	ZOLA-2, p. 374		17	DUJA, p. 65
	14	REWA-2, p. 394		30	Ibid.
	19	Ibid., p. 387		35	Ibid., p. 66
	31	LAWT-1, p. 50	116	4	WASH-2
	35	PARI-25, p. 40		28	COQU-4, p. 112
			117	13	VIRM, p. 19

Page	Line	Source		Page	Line	Source
	25	PARI-2		130	8	Ibid., p. 102
118	3	PARI-1			16	BERG-5, Vol.3, p. 249
	9	Ibid.				
	12	Ibid.		131	4	GEFF-4, p. 65
	15	Ibid.			9	Ibid., p. 66
	32	ANON-3, p. 126			26	BERG-5, Vol.3, p. 250
119	9	COQU-4, p. 107				
	34	DELA, pp. 166–171			31	Ibid., p. 251
					35	BERG-3
120	2	LESL, p. 82		132	8	Ibid., p. 253
	16	PARI-25, p. 47			20	BERG-2, p. 110
	27	Ibid., p. 50			26	BERG-5, Vol.3, p. 253
	31	Ibid.				
121	9	MARX-5, p. 11			35	ZOLA-3, p. 297
	22	HAVA, p. 523		133	1	BERG-5, Vol.3, p. 254
122	3	MARX-5, p. 31				
	19	PREA, pp. 29–30				
	22	HAVA, p. 531				**7. PROMETHEUS UNBOUND**
	34	MARX-5, pp. 17–18				
123	13	BLOO		134	7	RIOT-1, p. 210
	33	MARX-5, p. 45			11	PARI-4
124	9	BART, p. 100		135	2	LAWT-1, p. 60
	19	Ibid.			6	ANON-6, p. 266
	31	WASH-2			12	BART, p. 283
125	13	SIMO-2, p. 205			27	COQU-2, p. 191
	25	PARI-2			33	JEANE, p. 133
	32	Ibid.		136	7	HART, p. 7
126	21	Ibid.			16	MACCO-2, p. 761
	24	BART, p. 100			24	LAWT-1, p. 98
	32	PROU, p. 90			27	MARX-4, p. 6
127	1	PARI-2			31	CLAD-7, p. 147
	24	Ibid.			34	LAWT-1, pp. 98–99
	30	BART, p. 283		137	9	COQU-2, p. 165
	33	BART, p. 100			15	ANON-8, p. xxvi
128	5	BOEL, p. 109			30	COQU-2, p. 166
	14	LEMO-1			36	HENL-4, p. 84
129	8	PRIN		138	3	PARI-19
	13	BOEL, p. 109			10	HART, p. 7
	20	PARI-4			16	RICK-2, p. 120
	30	COQU-4, p. 101		139	4	HENL-5, pp. 83–84
	32	Ibid., pp. 101–102			22	BUCK, p. 111

Page	Line	Source	Page	Line	Source
	30	LOW, p. 326		30	BUTL, pp. 37–39
140	3	PARI-19		35	GEOR, p. 263
	21	LAWT-1, p. 244	150	4	PARI-4
	31	LESL, p. 119		6	CLAD-2, p. 106
	34	OKEY, p. 276		8	PARI-4
141	7	LAWT-1, p. 244		21	Ibid.
	16	PARI-19	151	10	LAWT-1, p. 92
	20	Ibid.		12	BUTL, p. 37
	25	PARI-25, p. 54		15	Ibid., p. 38
	34	PARI-19		20	BERG-1
142	1	LAWT-1, p. 203		26	RODI-8, pp. 179–180
	19	BOST		33	PARI-19
	22	SPEA, p. 8	152	2	BLOO
	28	LAWT-1, p. 242		21	ADAM-2
143	19	WARD, p. 180		25	BAZI
	25	BROW-R, p. 136	153	14	LAWT-1, p. 83
	28	Ibid., p. 138		16	DUJA, p. 108
	31	LAWT-1, p. 243		18	RODI-8, p. 168
144	6	FITZ, p. 6820		22	BAZI
	9	LUHA, p. 117		29	BERG-5, Vol.2, p. 67
	11	LAWT-1, p. 242		35	DUJA, p. 108
	28	LECO, pp. 11–12	154	10	LAWT-1, p. 83
145	9	LAWT-1, p. 72		24	BARRE, p. 126
	15	MIRB-4, p. 13		28	ADAM-2
	16	LAWT-1, p. 72		33	BAZI
	26	Ibid., p. 67	155	5	Ibid.
146	2	MARX-5, p. 44		8	LAWT-1, p. 206
	3	BART, p. 100		20	BERG-5, Vol.2, p. 71
	20	BLOO		26	BARRE, p. 126
	23	PARI-25, p. 54		32	RODI-8, p. 169
	28	BLOO	156	2	DUJA, pp. 108–109
	37	BUFF		10	ADAM-2
147	1	PARI-25, p. 176		11	BART, p. 114
	8	Ibid., p. 29		30	RENA, p. 81
	15	BLOO	157	4	DROU, p. 828
	25	Ibid.		8	HUGO, p. 183
148	6	LAWT-1, pp. 74–75		18	MAUR-1, pp. 414–415
	21	ROSN-1, p. 179		20	Ibid., p. 429
	25	RENA, p. 74			
149	6	CLAD-2, pp. 19–20			
	12	CLAD-7, p. 34			
	26	ANON-7, p. ix			

8. A SEASON IN HELL

Page	Line	Source	Page	Line	Source
	6	ELSE-2, p. 650	193	4	DUJA, p. 64
	9	JIAN-2, p. 42		26	COQU-3, p. 60
	11	SCHM-1, p. 538		28	GONC, Vol.14, p. 115
	12	CLARK, p. 336			
	25	BART, p. 223	194	1	Ibid., Vol.16, p. 101
184	7	VIEN		23	RODI-8, p. 49
	31	Ibid.		27	MAUC-4, p. 29
185	22	MAUC-4, p. 93		31	HEVE-2, p. 199
	26	Ibid., pp. 93–94		35	RODI-8, p. 52
186	1	RODE-2, p. 281	195	1	Ibid., pp. 57–58
	13	GSEL-6, p. 146		4	LEMO-4, p. 165
	19	PARI-22, p. 24		5	BERG-5, Vol.3, p. 232
	25	PARI-19			
	28	DUJA, p. 63		19	Ibid., p. 233
187	1	MAUC-5, p. 201	196	2	PARI-7, p. 15
	11	BLOO		7	HUYS-2, p. 332
	25	GONC, Vol.14, p. 116		16	DAUD-L-4, p. 129
				22	BYVA, p. 8
	33	PARI-13, p. 101		27	LEROU, pp. 211–212
188	15	MAUC-4, p. 20			
	21	MIRB-4, pp. 16–17		35	BYVA, p. 8
189	2	Ibid., p. 17		37	LEROU, pp. 215–216
	13	Ibid., p. 16			
	29	BART, p. 225	197	26	BOURG, pp. 504–505
	30	ANON-84			
190	3	SACK	198	24	BERG-5, Vol.3, p. 254
	6	WASH-2			
	9	BART, p. 224		27	RUTT, p. 69
	11	MIRB-4, p. 16	199	1	GOER, pp. 31–32
	15	ANON-84		7	MAUC-4, p. 25
	22	BART, p. 65		8	SCHM-2, p. 406
	26	LOUI, p. 65		22	LAWT-1, pp. 160–161
191	2	MIRB-4, p. 16			
	4	PARI-25, p. 58		28	BLOO
	9	BART, p. 65		29	LAWT-1, p. 161
	20	ADAM-1	200	12	CIOL-1, p. 267
	34	MIRB-4, p. 15		21	BLOO
192	15	CHER-1, p. 18		25	PARI-19
	18	BART, p. 223	201	11	VIEN
	22	CHAM-F		18	Ibid.
	34	TIRE, p. 10		25	Ibid.

Page	Line	Source
	28	Ibid.
	33	HENL-4, p. 155
	37	COQU-3, p. 58
202	3	LIPSC
	10	LAWT-1, pp. 63–64
	23	Ibid., p. 204
203	4	VIEN
	13	DARG, p. 37
204	14	MAUS, p. 29
	22	Ibid., p. 24
	38	PARI-21
205	8	MARX-2
	17	Ibid.
	28	SOTH-1
	30	MARX-2
	33	SOTH-1
206	2	PARI-13, p. xiii
	5	Ibid., p. 94
	14	Ibid., p. 96
	15	Ibid., p. 102
	20	Ibid., p. 103
	27	BART, p. 199
	31	VIEN
207	3	VIEN
	7	GOSS-2, p. 327
	19	ANON-7, p. ix
	24	ANON-8, p. xxv
	26	ANON-9, p. i
	28	ANON-10, p. xxxiii
208	3	ANON-13, pp. 351–352
	11	ARMI
	14	ANON-11, p. 145
	19	GOSS-1, p. 746
	28	LOW, p. 326
209	6	Ibid., pp. 320–321
	12	Ibid., pp. 327–328
	17	Ibid., p. 328
	21	Ibid., p. 326
	22	Ibid., p. 327
	27	Ibid., pp. 328–329

Page	Line	Source
9. RODIN IN LOVE		
211	3	ASSE, p. 8
	6	CLAU-3, p. 277
212	11	Ibid.
	26	ASSE, p. 8
	28	CLAU-3, p. 278
	35	MORH-1, p. 713
213	1	LERO-1, p. 65
	4	MORH-1, p. 712
	9	Ibid., p. 713
	22	CLAU-3, p. 1278
	26	Ibid., p. 277
	29	DEBU-1, p. 42
	34	MORH-1, p. 717
	37	Ibid., p. 718
214	12	Ibid.
	18	Ibid., p. 719
	28	Ibid.
	37	LOND-2
215	14	LIPSC
	23	Ibid.
	32	DESC, p. 154
216	4	Ibid.
	13	Ibid.
	25	Ibid.
	37	Ibid.
217	7	Ibid.
	15	PARI-19
	36	Ibid.
218	10	LIPSC
	18	Ibid.
	35	LARC, p. 227
219	1	BLOO
	9	SOCI-2
	17	PARIS, p. 131
	30	ALEX-4
220	14	BRUS-2
	21	MORH-1, p. 719
	25	Ibid.
221	5	OSLO

Page	Line	Source
	16	ALEX-4
	17	TREU, p. 5
	19	BYVA, pp. 9–10
	33	Ibid., p. 8
222	15	CLAU-3, p. 279
	33	CHAI, p. 86
223	10	REVA, p. 520
	15	RENA, p. 185
	25	DEBU-1, p. 41
	32	Ibid., p. 94
224	7	ENCY, Vol.27, p. 107
	11	LAWT-1, p. 75
	16	DELB, pp. 257–261
225	14	BLOO
	22	KING, p. 14
226	1	BERG-4, p. 144
	12	RODI-7, p. 137
	15	COQU-4, p. 61
	21	GONC, Vol.16, p. 102
	30	Ibid.
227	12	CARDI, p. 8
228	10	PARI-25, p. 126
	16	Ibid., p. 97
	27	TIRE, p. 11
	36	CLAD-7, p. 231
229	4	Ibid., p. 232
	9	Ibid., p. 233
	13	Ibid., p. 234
	17	Ibid.
	22	Ibid., p. 230
	26	MORH-1, p. 720
	30	CLAD-10, pp. 118–119
230	8	BLOO
	19	MIRB-4, p. 209
	20	REVA, p. 520
	32	REYE, p. 146
	34	CLARK, p. 554
231	8	DELB, pp. 302–303

Page	Line	Source
	11	LARC, p. 99
	16	BLOO
	31	PARI-16
232	11	RENA, p. 105
	15	GONC, Vol.20, p. 19
	21	Ibid., p. 58
	31	Ibid., p. 72
233	5	MORH-1, p. 737
	11	Ibid., p. 730
	19	DELB, pp. 309–316
	31	Ibid.
234	11	RENA, p. 185
	22	MORH-1, pp. 730–731
235	6	CLAU-3, p. 282
	7	Ibid., p. 283
	11	CLAU-5, p. 463
	26	PING, p. 290
	30	CLAU-5, p. 627
	35	MIRB-4, pp. 209–210
236	11	PARIS-19
	16	BLOO
	24	PARI-19
	31	Ibid.
237	10	EDIN
238	10	BLOO
	24	PARI-19
	26	ASSE, p. 10
239	4	Ibid.
		Ibid.
	12	CLAU-3, pp. 274–275
	21	Ibid., pp. 286–288
	30	CLAU-1, p. 65
	34	CLAU-4, p. 998
240	3	PARIS, p. 320
	6	CLAU-2, pp. 117–118
	13	CLAU-6, pp. 114–115
	24	Ibid., p. 116

Page	Line	Source	Page	Line	Source
	30	CLAU-4, p. 247		11	Ibid., p. 115
	37	DELB, p. 455		16	Ibid., pp. 116–117
241	10	VIBE		20	Ibid., p. 117
	31	PARIS, p. 133		28	Ibid., p. 55
242	2	BLOO		32	Ibid.
	13	WILM	252	7	Ibid., p. 54
	19	BLOO		14	Ibid., p. 58
	26	CLAU-5, p. 461		27	Ibid., p. 59
	28	DELB, p. 463	253	3	JEANE, p. 132
	30	Ibid.		12	Ibid., pp. 132–133
	36	MORH-1, p. 719		22	BLOO
243	4	TIRE, pp. 11–12		24	TIRE, p. 12
				31	EDIN
			254	5	CLAD-7, p. 159
10. BEHOLDE HERE WE SIXE				9	PARI-23, p. 59
244	18	FROI, p. 174		22	RILK-2, Vol.4, p. 360
245	5	Ibid.		33	PARI-23, p. 252
246	16	BART, p. 198	255	7	GEFF-2, p. 302
	18	PARI-23, p. 31		14	MONK, p. 11
	23	BART, p. 198		19	DESC, p. 80
	30	RILK-2, Vol.4, pp. 358–359		21	GONC, Vol.14, pp. 114–115
	34	PARI-23, p. 41	256	10	PARI-19
247	2	Ibid., pp. 41–42		29	GONC, Vol.14, pp. 115–116
	10	Ibid., p. 42	257	7	Ibid., p. 116
	14	Ibid.		20	COQU-4, pp. 111–112
	23	Ibid., p. 44		33	GONC, Vol.14, p. 115
	28	Ibid.	258	3	PARI-23, p. 124
248	1	Ibid., p. 45		20	ANON-15
	15	Ibid., p. 46		28	VIEN
	31	Ibid., p. 47	259	7	LIPSC
	37	Ibid., p. 51	260	2	ARMI
249	13	Ibid., p. 49		11	STEV-1
	18	Ibid., p. 50	261	6	NEWH
	23	Ibid.		18	WAGN, p. 587
	27	Ibid., p. 52		35	NEWH
	32	Ibid., p. 48	262	18	Ibid.
250	2	Ibid., p. 52	263	1	Ibid.
	15	Ibid., p. 53			
		Ibid.			
	33	Ibid., p. 114			
251	8	Ibid.			

Page	Line	Source	Page	Line	Source
	18	LAWT-1, p. 245		11	Ibid.
		Ibid., pp. 245–246		13	MARTI, p. 215
				16	MAURE, p. 23
264	23	NEWH		18	MIRB-4, p. 65
265	6	Ibid.		27	WILD, p. 227
	17	STEV-2, p. 56		32	MIRB-4, p. 69
	19	STEV-3, p. 310		38	PARI-2
	33	NEWH	276	9	GONC, Vol.15, p. 86
266	17	CHRI		21	Ibid., p. 61
	26	CHAR, p. 156		33	Ibid.
	29	PARI-19		36	BAUD-2, Intro.
267	3	ANON-14	277	7	PHIL-1, p. 345
	18	MEDA		16	MORH-1, p. 729
	30	Ibid.	278	9	WASH-2
268	18	LAWT-1, p. 78		12	BART, p. 285
	32	WASH-2		16	BART, p. 223
269	14	Ibid.		26	WASH-2
	33	PARI-19		34	Ibid.
270	13	GEFF-1	279	13	Ibid.
	27	DAUD-L-2, p. 262		20	BART, p. 263
	28	ROSN-3, p. 38	280	2	MAIN, p. 82
	32	BROU		6	BART, p. 263
271	3	PARI-9, p. 9		13	WASH-2
	8	PARI-19		26	FINL-2, p. 22
	17	DAUD-L-1, p. 257		33	PARI-25, pp. 98–100
	22	PARI-14			
	28	PARI-23, p. 118	281	9	FINL-2, p. 27
272	5	MIRB-1		14	GALB, p. 60
	11	PARI-19		17	SYDN
	15	PARI-22, p. 98		32	PARI-21
	18	GEFF-5, p. 214	282	4	Ibid.
	24	ROSN-2, p. 11		11	WILD, p. 216
	31	DAUD-L-2, p. 260		21	GEFF-5, p. 359
	37	MIRB-4, p. 165		24	Ibid., p. 218
273	17	GONC, Vol.16, p. 178		37	VENT, p. 112
			283	7	MART, p. 22
274	7	RAIM, p. 163		17	GONC, Vol.16, p. 94
	13	JAVE-1		23	WILD, p. 250
	26	JAVE-2		35	PARI-12
275	1	Ibid.	284	1	GEFF-5, p. 215
	4	GONC, Vol.15, p. 82		5	MIRB-4, p. 97
	7	PARI-19		6	Ibid., pp. 100–101

Page	Line	Source
	13	JAVE-3
	16	PARI-23, p. 67
	18	BAZI
	22	CLAD-7, p. 173
	26	PARI-23, p. 67
	30	PHILA
285	13	BLOO
286	9	BERT, p. 105
	21	GONC, Vol.16, p. 100
287	3	Ibid., Vol.18, p. 63
	25	Ibid., Vol.16, p. 60
288	13	BUTL, p. 74
	16	FOUR-1, p. 130
	31	GONC, Vol.16, p. 106
	37	VALE, p. 62
289	11	PARI-25, p. 107
	17	VIAL, p. 419
	24	MAUP, p. 197
	27	Ibid., p. 211
	32	Ibid., pp. 211–212
291	7	FOUR-2, p. 63
	10	GOLD-3, p. 179
	21	ANON-17
	26	GOLD-3, p. 179
	29	Ibid., p. 180
292	5	ANON-18
	14	MIRB-4, p. 111
	16	GONC, Vol.17, p. 89
	20	MIRB-4, p. 116
	24	LARR-1
	31	LARR-2, p. 233
	34	CLAD-7, p. 174
293	3	PARI-2
	32	Ibid.
294	32	GONC, Vol.15, p. 61
295	1	ALEX-1
	10	CALD
	15	VERH, p. 149
	37	DESC, p. 148
	37	RUSS, p. 5

Page	Line	Source
296	1	DESC, p. 150
	6	JOUR, p. 12
	36	RUSS, p. 28
297	6	CHAST, p. 37
	14	MART, p. 217
	25	Ibid., p. 23
299	14	VIRM, pp. 40–41
300	6	RILK-2, Vol.3, p. 338
	11	FINL-2, p. 29
	26	LUCA-1, p. 46
	28	COQU-4, p. 113
	35	RODI-8, p. 177
301	8	SHAW-1
	10	COQU-4, p. 37
	16	BROW-2, p. 19
	26	Ibid., p. 26
	34	OXFO, p. 563
302	2	HENL-2, pp. 682–683

11. A TEMPEST IN THE OFFING

Page	Line	Source
303	1	ANON-20
304	30	NANC
	35	SOTH-1
305	8	CLAD-7, p. 167
	23	CLAD-9, p. 250
	30	CHAR, p. 156
	33	Ibid., p. 157
	37	NANC
306	7	PHILA
	10	CHAR, p. 157
	20	LOND-2
	30	MAIL, p. 1
	32	ANON-22
	35	EN
307	19	GALL, p. 145
	20	Ibid., p. 144
	25	LAWT-1, p. 145
	31	LOND-2
308	3	COQU-4, p. 107

Page	Line	Source	Page	Line	Source
	12	AUDE, pp. 253–257		36	PARI-8, p. 65
309	7	ALEX-2	318	2	SEVE-2
	17	ANON-16		11	FERR, p. 653
	27	PARI-6		20	PARI-6
	32	ZOLA-1, p. 735	319	4	Ibid.
310	6	SCHO		22	AICA
	17	CHIN-2		33	PRIN
	26	NEWT-2, pp. 179–180	320	4	FERR, p. 649
				7	BILL, p. 247
	35	PARI-6		15	PARI-6
311	3	NEWT-2, p. 180		24	ANON-29
	20	PARI-6		29	ANON-28
	26	Ibid.	321	13	CLAD-7, pp. 193–194
	35	ANON-16			
	37	FERR, p. 652		28	ANON-30
312	10	LAMA, pp. 16–17	322	3	FERR, p. 651
	18	GEFF-3		6	ANON-27
	27	COQU-4, p. 107		10	PARI-19
	32	PARI-22, p. 85		21	ANON-26
313	9	BRIS-2, p. 226		26	GONC, Vol.20, p. 160
	13	MORH-2, p. 467			
	16	PARI-6		35	SCHO
	22	Ibid.	323	3	ANON-31
	31	PARI-22, p. 95		7	SCHO
	34	MARX-3		16	ZOLA-1, pp. 769–770
314	1	PARI-20, p. 14			
	4	GOZL, p. 179		32	DUJA, p. 33
	9	LUDO-2, p. 111	324	12	RENA, p. 63
	19	CROW-3, pp. 351–352		28	Ibid.
			325	7	GONC, Vol.20, p. 93
315	2	PARI-27		22	VIEN
	11	BOIS-J		24	BYVA, p. 7
	26	PARI-20, p. 13		26	Ibid., pp. 8–9
	29	SEVE-2		33	Ibid., p. 11
316	17	CHIN-1		37	LARC, p. 91
	32	ANON-24	327	10	PARI-6
	37	COQU-4, p. 107		20	MOND, p. 670
317	2	PARI-6		24	PARI-5
	12	GONC, Vol.19, p. 96		33	MOND, p. 657
			328	7	BARB-C, p. 203
	18	STIE		12	SYMO-3, p. 220
	34	ANON-25		17	ANON-23

Page	Line	Source	Page	Line	Source
	23	MALL	337	3	BENE-3, p. 280
	32	Ibid.		17	SEVE-1
329	12	ANON-37	338	5	SEVE-3, p. 11
	26	SOTH-2		7	PARI-19
	32	PARI-6		12	CAMP, p. 10
330	17	Ibid.		25	BRUN-B, p. 54
	22	SOTH-2	339	5	GIMP, p. 422
	33	WOOL, p. 62		12	GEIS, p. 13
331	17	MAIL, p. 39		23	GIMP, p. 423
	25	LAWT-1, p. 120		29	MILA, p. 58
	31	LEGE-2, p. 353	340	2	CLARI-1, p. 335
332	5	MAUC-3, p. 72		8	MEIE, p. 26
	21	PARI-25, p. 140		14	SOFF, p. 97
	27	PARI-3		17	RAMB
	31	CARR-E, p. 144		26	MILA, p. 58
	36	LAWT-1, pp. 125–		33	Ibid., p. 104
		126	341	1	Ibid.
333	3	MORI-2, p. 579		7	Ibid., p. 105
	6	MAUC-2, p. 20		13	Ibid., p. 74
	13	APOL-1, p. 238		16	Ibid., pp. 74–75
	20	GONC, Vol.17, p. 50		25	RAMB
	24	Ibid., p. 63	342	14	SOFF, p. 75
	28	GONC, Vol.18, p.		24	PARI-2
		204		31	Ibid.
	32	JOURD, p. 149	343	9	GOUR
334	1	GONC, Vol.18, p.		22	NEWY-4
		206		34	GONC, Vol.20, p.
	8	VAIL, p. 173			180
	12	CARR-J, p. 52	344	6	Ibid., p. 193
	15	AURE-1, p. 211		12	SEVE-1
	25	LICH, p. 160		13	PARI-22, p. 114
335	18	FRAN-1, pp. 93 &		15	LEAU, p. 145
		160		17	GEFF-5, p. 359
	21	Ibid., pp. 93 & 282		24	GEFF-5, p. 326
336	5	PARI-19		32	FLAX, p. 3
	10	Ibid.		37	LOW, p. 450
	19	GONC, Vol.18, p.	345	5	GASQ, p. 75
		127		16	GSEL-3, p. 99
	24	Ibid., p. 128		19	LAWT-1, p. 207
	32	DESC, p. 129		31	LESL, p. 115
	35	ANON-81		34	STEV-3, p. 362
	37	PARI-19	346	3	WILL-K, p. 210

Page	Line	Source

Page	Line	Source	Page	Line	Source
	18	Ibid., p. 319		23	RODE-1
	20	Ibid., pp. 319–320		28	RODE-2, p. 290
	35	Ibid., p. 320		34	SIGN-2, p. 303
370	5	Ibid.	376	1	FONT-A, p. 385
	18	Ibid., p. 322		3	BIEN, p. 265
	20	Ibid., p. 321		5	DAYO-1, p. 520
	28	Ibid.		11	MIRB-3, p. 38
	31	Ibid., p. 323		14	PRIN
	34	ANON-32		19	RENA, p. 331
371	10	MORH-2, p. 467		27	WILDE, p. 732
	20	Ibid.		34	HARR-1
372	3	CHIN-2	377	22	CLAD-7, p. 209
	12	GSEL-2, pp. 410–		28	CLEO
		411	378	4	CHIN-2
	27	BILL, p. 350		18	ANON-34
373	4	MAUC-1, p. 23		24	MORH-2, p. 471
	14	JEANE, p. 142		29	Ibid., p. 472
	24	MERS, p. 38	379	5	Ibid., p. 475
	25	LACA		13	Ibid., p. 481
374	1	ALEX-3, pp. 16–17		33	CHIN-3
	4	LUCA-2, p. 602	380	3	JOUR, pp. 15–16
	4	ALEX-3, pp. 16–17	381	1	MORH-2, p. 478
	5	GILL		6	LIPS, p. 188
	11	CLAD-7, p. 204		14	GEFF-5, p. 357
	15	CHAM-B, p. 184		21	MAUR-2, p. 100
	17	PERA, p. 879		24	RENA, p. 386
	18	LEPR, p. 180		32	AJAL, p. 27
	20	VERO, p. 398	382	1	DESC, pp. 212–213
	21	RAME		22	MORH-2, p. 487
	23	ROCH-2, p. 36		26	Ibid., pp. 485–486
	25	BLOY-4, p. 277		30	Ibid., p. 486
	26	HOCH, p. 229		36	KROH-1
	27	LORR-3, p. 207	383	3	Ibid.
	28	CONS		13	KROH-4
	29	LERO-2, p. 1019		24	KROH-3
	29	LERO-3, p. 944		30	MORH-2, pp. 486–
	31	LERO-2, p. 1020			487
	31	MARQ, p. 135		36	Ibid., p. 488
	34	JIAN-1, p. 90	384	14	Ibid.
375	5	FONT-J, p. 48		29	RODI-8, pp. 181–
	16	PARI-22, p. 72			182

Page	Line	Source	Page	Line	Source
	33	ORCU, p. 164		25	CLAD-7, p. 49
385	4	EDIN		28	Ibid., pp. 49–50
	8	ORCU, p. 164		35	LEMO-3, p. 168
	13	CLAD-7, p. 222	393	3	Ibid.
	15	RODI-8, p. 180		23	BLOO
	21	VOLL-1, p. 224		30	CLAD-7, p. 51
	33	CHAM-B, p. 195		36	CLAD-8, p. 241
386	2	KROH-1	394	5	CLAD-1
	5	MART, p. 218		17	CLAD-7, p. 56
	6	GEFF-5, pp. 359–360		21	Ibid., p. 57
				25	Ibid., p. 58
	13	WILL-K, pp. 251–252	395	2	Ibid., p. 60
				6	CLAD-2, p. 71
				8	CLAD-7, p. 60
				9	Ibid., p. 72
13. 1900				24	LUDO-2, p. 79
387	4	PARI-5		29	PENN-1, p. 324
	13	MOND, p. 802		32	WASH-1
	15	PARI-5	396	15	MIRB-2, p. ii
388	1	MOND, p. 803		20	Ibid., p. xxiii
	5	RUSS, p. 18		25	Ibid., p. 107
	7	JEANE, pp. 144–145		27	Ibid., p. 114
				36	Ibid.
	34	ANON-35	397	15	FAGU-2, p. 13
	36	RAMS		18	VOLL-1, p. 209
389	22	SYMO-3, p. 193		23	MEUD
	26	Ibid., pp. 192–193		34	DELT
	32	LUDO-1, pp. 122–123	398	2	PARI-22, p. 115
				7	RENA, p. 400
390	6	Ibid., p. 123		12	PARI-25, p. 200
	9	BARB-C, p. 284		22	SAIN-L, p. 24
	14	LUDO-1, pp. 123–124		24	FAGU-1, p. 6
				28	FAGU-2, p. 13
	24	ANON-36	399	5	BRIS-3
	29	LUDO-1, p. 124		6	QUEN-2, p. 213
391	6	SZEP, p. 67		9	JIRA, p. 42
	18	Ibid., p. 143		12	RODI-7, p. 33
	29	PARI-17, p. 143		22	GRAP-1
				29	Ibid.
	35	FISC, p. 9	400	19	PARI-19
392	5	Ibid., p. 6		23	LOND-2
	7	Ibid., p. 13		36	EDIN

Page	Line	Source	Page	Line	Source
401	4	ANON-56, pp. 251–252		29	FUSS, p. 171
	11	NEWY-3		34	BORG, p. 152
	25	MOUR-4, p. 11	412	22	NOST-2, p. 12
	27	ALEX-4		27	Ibid., pp. 12–13
	34	FLAM, p. 166	413	1	NOST-6
402	10	PULL, p. 200		19	DUNC, p. 89
	24	PENN-2, p. 201		22	Ibid., p. 90
	31	CHART, p. 199		36	PAUL, p. 80
	33	CAMB	414	3	DUNC, p. 91
403	12	ROTH-1, p. 343		32	BOES, p. 88
	18	BURD, p. 259	415	7	MAIL, p. 23
	21	CAMB		14	KROH-1
	32	Ibid.		15	BASS
404	5	LOND-2		20	ANON-38, p. 127
	11	ROTH-1, p. 321		23	FRAN-2
405	6	WEIS, p. 300	416	6	LAWT-1, p. 116
	12	BENE-1, p. 49		10	MOUR-3, p. 16
	33	MODE, p. 214		14	RICE, pp. 40–41
	36	MODE, p. 338		28	LAWT-1, p. 117
406	3	DESH, p. 41		34	MOUR-3, p. 16
	10	EDIN	417	3	MOUR-2
407	7	Ibid.		6	Ibid.
408	8	FUSS, p. 173		10	BECK, p. 730
	11	SCHNE		14	MOUR-2
	16	MIRB-5, p. 73		17	KAHN-2, p. 83
	21	FITZ, p. 6818		25	QUEN-1, p. 195
	23	ROGE		29	LAMI, Vol.3, p. 5
	28	SCHNE		34	LAWT-1, p. 116
409	4	Ibid.	418	1	RICK-1, p. 354
	14	EDIN		8	SEAT, p. 137
	27	Ibid.		19	LAWT-2, p. 138
410	11	LICH, p. 419		22	Ibid., p. 139
	19	RENA, p. 400		30	Ibid., pp. 139–141
	32	EDIN	419	26	HERR, p. xxi
	35	COQU-4, p. 95		28	HUNE, p. 372
	38	MOUR-4, p. 9	420	1	CLAD-7, p. 241
411	2	LORR-2, p. 326			
	7	PEAR-2, p. 368	**14. LIBERATION**		
	9	WILDE, p. 831	421	3	PARI-6
	15	HUNE, p. 380		8	BEEC, p. 77
	19	BAHR, pp. 246–247		14	NOTT-1, p. 21

Page	Line	Source	Page	Line	Source
422	5	Ibid.		33	BRUN-A
	11	Ibid., p. 22		36	LORR-1
	13	Ibid., p. 23	431	2	DUHE, p. 1
	22	Ibid., p. 24		12	ANET, pp. 216–217
	31	Ibid., p. 25		18	RENA, p. 425
	37	Ibid.	432	1	LUBE
423	6	Ibid., p. 26		13	Ibid.
	8	Ibid.		26	ZIMM, p. 514
	15	Ibid., p. 28	433	4	PARI-19
	24	Ibid., p. 29		6	PARI-5
	30	Ibid.		15	CLARI-1, p. 327
	37	NOTT-2, p. 84		26	BROW-1, p. 245
424	3	Ibid., p. 85		28	MEIE, p. 34
	9	Ibid., p. 94	434	4	MACCO
	20	CROW-3, p. 600		14	RICK-2, p. 97
	23	CROW-4		18	WILL-K, p. 215
	25	CROW-1, p. 57		18	ROTH-2, pp. 17–18
	32	CROW-3, p. 600		26	ANDE, p. 336
	33	NOTT-2, p. 94		32	EDIN
425	5	KENN-L, p. 42	435	8	PIGA, pp. 179–180
	7	Ibid., p. 43		21	Ibid., p. 180
	14	Ibid., p. 42		25	ANON-40
	29	CROW-3, p. 600		29	PENN-1, p. 411
	31	KENN-L, p. 95	436	4	ANON-40
426	1	Ibid., pp. 42–43		20	BBC, No 4, pp. 2–3
	17	THAU, p. 140		36	ORCU, p. 163
	18	Ibid., pp. 140–141	437	5	MACCO-1
	34	WASH-3		17	ANON-39
427	9	Ibid.		26	HOFB, pp. 53–54
	15	OJET, p. 45	438	26	MG
	34	WASH-3		31	MUCH, p. 184
428	24	PARI-19		34	VOLA, p. 169
	37	THAU, p. 142	439	1	MUCH, p. 184
429	10	KROH-2		10	Ibid.
	23	NOST-6		24	NEWY-1
	28	NOST-1, p. 154	440	1	ZUCK, p. 58
	31	NOST-4, p. 37		8	Ibid.
430	6	NOST-1, p. 154		12	Ibid., pp. 58–59
	11	NOST-4, p. 28		17	HEVE-1, p. 396
	13	NOST-1, p. 155		26	SZEP, pp. 144–145
	18	NOST-4, p. 29	441	7	RICK-2, p. 120
	23	Ibid., p. 37		13	KLEE, pp. 105–106

Page	Line	Source
	29	REWA-1, p. 13
442	6	EPST, p. 221
	12	EDIN
	18	LOND-2
	32	LARO, p. 396
443	5	GIMP, pp. 159–160
	10	VINC-2, p. 11
	16	DEKO, p. 101
	25	PRIN
444	1	FULL, p. 125
	3	Ibid., pp. 124–125
	10	Ibid., p. 125
	14	CURI, p. 233
	18	PRIN
	29	CURI, p. 232
445	5	FULL, p. 33
	14	JOUR, p. 13
	15	GSEL-5, p. 18
	17	COQU-4, p. 125
	21	FULL, p. 122
	32	ANON-85
446	11	RILK-3, p. 25
	21	Ibid., pp. 27–28
	35	Ibid., pp. 30–31
447	15	Ibid., p. 35
	18	NOST-6
	23	HOUST, p. 248
	26	RILK-4, p. 1
	29	Ibid., p. 16
	38	SCHM-3, p. 235
448	5	NEWH
	20	RILK-1
449	27	KORE, p. 155
450	9	RILK-4, pp. 29–30
	13	SCHM-3, p. 285
	16	Ibid., p. 387
	24	WEST, p. 59
451	7	RIOT-2, p. 109
	13	NOST-6
	18	NOST-4, pp. 38–39
	21	LAWT-1, p. 203
	26	NOST-5

Page	Line	Source
	30	Ibid.
	37	FINL-1
452	1	PARI-19
	11	RUSS, p. 2
	18	Ibid., p. 6
	26	Ibid., p. 19
453	1	Ibid., pp. 20–21
	36	Ibid., p. 40
454	8	PARI-19
	15	Ibid.
	22	CROW-3, p. 353
	24	CROW-2, p. 11
	31	CROW-3, p. 355
455	1	SCHW, p. 283
	5	CROW-3, p. 355
	11	Ibid., pp. 351–352
	24	CROW-2, p. 21
	33	Ibid., p. 45
	36	Ibid., p. v
456	5	TWEE, pp. 102–103
	11	MCAL, p. 143
	31	SITW, p. 60
	36	DORM, p. 77
457	5	RICK-2, pp. 97–98
	28	ROTH-2, p. 45
458	4	RODI-2, p. 298
	13	BURD, p. 261
	20	Ibid., p. 262
	32	DONA
	35	BLAN-2, p. 114
459	1	ANON-83
	9	JOHA
460	8	LOND-2
	13	ANON-83
	15	JOHA
	31	OSLO
461	1	PARI-15
	3	VARE, p. 100
	7	OSLO
	12	KENN-L, pp. 43–44
	22	LOND-2

Page	*Line*	*Source*	*Page*	*Line*	*Source*
	34	MEUN-3, pp. 350–351		34	CARR-E, pp. 274–275
462	1	ROTH-2, pp. 45–46	471	11	JOURD, pp. 141–142
	15	COQU-4, p. 112		22	PARI-22, p. 132
	20	COQU-4, p. 112		26	GIDE-1
	30	ANON-41	472	4	ZWEI, p. 118
463	5	Ibid.		11	Ibid., p. 119–120
	12	PARI-2		35	CHAS, p. 300
	24	Ibid.	473	17	MACK, p. 479
464	2	SYMO-1, p. 966		19	Ibid., p. 480
	19	GEFF-5, p. 358	474	4	Ibid.
	27	LUBE		20	FOUQ-2, Vol.1, p. 207
	34	LAWT-1, p. 257		24	PARI-4
465	12	WILL-K, p. 284		27	MAUR-2, p. 93
	19	LUDO-1, p. 143		30	POUQ, p. 196
	26	Ibid., p. 145		31	COCT, p. 209
466	1	RICK-2, p. 101	475	1	BONI, p. 127
	10	ANON-42		9	BARRE, pp. 124–127
	25	BLAN-2, p. 113			
	31	Ibid., p. 114	476	30	PARI-4
467	1	ANON-43		32	Ibid.
	14	LOND-2	477	1	PLES, p. 15
	22	ANON-43		4	TIRE, p. 74
	26	LESL, p. 166		9	VINC-1, p. 249
	28	BLAN-2, p. 116		10	PARI-4
468	5	Ibid., pp. 115–116		24	PENN-2, p. 307
	10	ANON-49		29	Ibid.
	15	ANON-45	478	5	Ibid., p. 310
	17	GOSS-1		7	Ibid., p. 308
	18	ANON-46		10	Ibid., p. 73
	23	ANON-44		12	ANON-58
	25	ANON-47		22	JOHN, p. 66
	30	ANON-50		25	TAUB, p. 113
469	1	Ibid.		30	TIRR, p. 143
	12	ANON-47	479	4	JOHN, p. 250
	16	RODI-3, p. 68		20	CARD-1
	23	Ibid.		37	CHIT, p. 16
	32	Ibid., p. 66	480	4	JOHN, p. 250
470	5	CARR-J, p. 29		6	NEWT-1
	21	Ibid., p. 28		8	BLOO
	25	Ibid., p. 27			

Page	Line	Source	Page	Line	Source
	10	LOND-2		31	DURH
	17	Ibid.	491	12	BURD, p. 268
481	1	ROTH-J, p. 168		13	Ibid., p. 265
	25	JOHN, pp. 250–251		18	Ibid., p. 271
	32	Ibid., p. 251		30	LOND-2
482	2	CARD-1		33	CLAD-7, p. 269
	16	CHIT, p. 84		37	Ibid., p. 268
	27	CARD-1	492	7	TIRE, pp. 13–15
483	8	JOHN, p. 248		18	SCHN, p. 336
	15	ROTH-J, p. 164	493	1	VARES, p. 32
	30	CARD-1		5	Ibid., p. 33
484	30	PARI-19		14	Ibid., p. 34
485	8	OJET, p. 42		30	RILK-4, p. 66
	8	LOND-2		34	Ibid., pp. 47–48
	10	LOWT, p. 599		38	RILK-3, pp. 258–259
	14	BURD, p. 265	494	10	Ibid., p. 259
	16	Ibid., p. 274		15	HOUST, p. 251
				19	RILK-3, p. 261
				35	LEGE-1, p. 154
15. THE SULTAN OF MEUDON			495	4	RILK-3, pp. 257–258
486	9	ANON-19		26	Ibid., p. 263
	12	LOND-2		31	Ibid., p. 264
	15	BERNS, p. 112	496	5	EDIN
487	4	BURD, p. 270		12	BLOO
	6	Ibid., p. 271		23	PLES, p. 42
	13	Ibid., pp. 269–270		32	ENCI
	19	Ibid., p. 266	497	2	Ibid.
	25	LOND-2		26	PARI-26
	28	BURD, p. 266		33	ENCI
	33	Ibid.		34	RILK-3, p. 275
488	5	Ibid., pp. 267–268	498	4	BARG
	12	LOND-2		8	RILK-3, p. 298
	30	BURD, p. 266		10	RILK-3, p. 66
	36	PARI-19		16	COPE
489	5	Ibid.		31	RILK-3, pp. 270–271
	16	BURD, p. 267			
	24	CLAD-7, p. 270	499	6	BARG
	28	BERNS, p. 118		8	RILK-3, pp. 294–295
	35	TIRE, p. 70			
490	17	Ibid., p. 17		20	Ibid., p. 294
	20	Ibid., p. 16			

Page	Line	Source	Page	Line	Source
	24	RILK-2, Vol.3, p. 32		7	LOND-1
	32	RODI-9, p. 9		13	RILK-3, p. 308
	35	JULL-1, p. 184		17	PEAR-1, p. 304
	36	Ibid., p. 186		26	SCHOO, p. 465
500	1	RILK-2, Vol.3, p. 116		29	PEAR-1, p. 305
	7	RODI-7, pp. 118–119	507	2	RILK-3, pp. 314–316
	16	RILK-2, Vol.4, p. 410		4	Ibid.
	17	Ibid., p. 411		36	CLAD-6, pp. 161–162
	21	Ibid., pp. 417–418	508	12	RILK-3, pp. 316–317
	28	RILK-3, p. 279		18	SHAW-3
501	2	Ibid., p. 293		22	SHAW-4, p. 618
	17	Ibid., p. 262		35	WEIN-1, pp. 250–251
	20	CARR-J, p. 175	509	1	COBU, p. 40
	26	FAUR, p. 163		16	SHAW-1, p. 259
	30	Ibid., p. 164	510	26	PEAR-1, p. 305
	34	LESL, p. 186		38	BOOT, p. 102
502	5	TIRE, p. 39	511	7	MCCA, p. 5
	17	MORI-1, p. 218		10	Ibid., p. 66
	29	MOUR-5, p. 270		20	LUDO-2, p. 120
	35	SZEP, p. 142		24	CHER-1, p. 19
503	18	ANON-51		27	PEAR-1, p. 199
	22	ANON-53, p. 337		27	CHER-1, p. 19
	23	Ibid., p. 334		29	LOND-1
	25	Ibid., p. 338		38	SHAW-4, p. 625
	28	Ibid., p. 336	512	2	LUDO-2, p. 121
	30	Ibid., p. 335		8	VANV, p. 534
	32	BAUDI, p. 341		14	ROTH-2, p. 108
	38	ANON-52		20	RILK-4, pp. 67–68
504	5	ANON-55, p. 333		30	MODE, p. 350
	12	ANON-54, p. 133		32	LOND-2
	19	ANON-57, p. 3	513	1	ROTH-3, p. 315
	24	PELA, p. 688		6	SHAW-4, p. 665
	27	NORD, p. 290		9	BENN-2, p. 234
505	3	SYMO-2		13	SIMM, p. 198
	7	PARI-6		21	STDE, p. 86
	13	LRM	514	5	Ibid.
	18	COQU-2, p. 127		11	VICK, p. 132
	23	RILK-3, p. 312		14	DESCH, p. 197
	24	WEIN-1, p. 64		18	GIMP, pp. 373–374
506	5	SHAW-1, p. 259			

Page	*Line*	*Source*
	20	MAUC-8, p. 203
	22	SIMM, p. 195
	28	BLOO
515	1	Ibid.
	4	BLAN-2, p. 123
	14	BRAN-1, p. 504
	26	RODI-6, p. 96
	33	GSEL-5, p. 14
516	3	SYMO-3, p. 233
	14	BOUR, p. 119
	17	LUDO-2, p. 109
	20	GSEL-6, p. 146
517	1	YOUN, p. 207
	3	Ibid., pp. 207–208
	13	SAIN-V, p. 194
	16	ANON-70
	20	ANON-63, pp. 92–93
	32	GSEL-5, p. 19
518	9	PAOL, pp. 314–315
	30	GHEU, p. 175
519	4	MEUN-1
	22	BOIS-G
520	4	RILK-4, p. 73
	7	Ibid., p. 78
	12	GRAU-3, p. 100
	37	KEEN, p. 126
521	5	FULL, p. 209
	12	Ibid., pp. 209–210
	27	KEEN, p. 127
	33	CLAD-6, p. 162
522	4	KEEN, p. 127
	7	RODI-8, p. 143
	14	KEEN, p. 127
	17	RODI-7, p. 137
	20	DURH
	24	BLAN-2, p. 119
523	1	LUDO-2, pp. 118–119
	16	LESL, p. 185
	23	Ibid.
	25	Ibid., p. 186

Page	*Line*	*Source*
	36	MOOR-3, p. 39
524	10	PARI-4
	12	BLAN-2, p. 124
	21	SMYT, p. 178
	35	PARI-6
525	13	WARW, p. 174
	29	RILK-3, p. 289
526	1	HARR-2, p. 325
	17	DESH, p. 44
	20	JULL-2, pp. 111–112
	24	Ibid., p. 112
	28	BARN, p. 44
	32	Ibid., p. 45
527	6	BLOO
	9	Ibid.
	23	NOST-6
	30	NOST-1, p. 150
528	2	Ibid., p. 151
	4	Ibid., pp. 151–152
	13	Ibid., p. 152
	17	Ibid., p. 153
	23	NOST-5
	27	NOST-1, p. 154
	31	NOST-3, p. 248 & 251
529	4	NICO, p. 49
	6	NOST-6
	11	NEWY-1
	21	SEIT, p. 38
	30	Ibid.
	32	KESS-3, p. 301
530	8	SEIT, p. 38
	16	BRAN-1, p. 500
	23	KAY, p. 19
	29	BRAN-1, p. 500
531	2	BERNS, pp. 112–113
	30	Ibid., p. 112
	36	ECKE
532	2	KENNA, p. 413
	5	LOVE, p. 24
	10	HARRI

Page	Line	Source	Page	Line	Source
	28	TIRE, p. 74	542	6	PRIN
	37	LESL, pp. 262–263		14	LUDO-2, p. 51
533	14	BAC, p. 106		20	BERL, p. 61
	19	Ibid., p. 104		32	Ibid., p. 64
	24	Ibid., pp. 106–107		36	HARD, pp. 508–
534	15	FOUQ-1, p. 65			509
	31	MAHL-G-2, p. 409	543	7	PRIN
535	3	PARI-17, p. 144		17	JOHA
	8	Ibid.		25	ANON-69
	12	Ibid., p. 145		37	ANON-66
	19	MAHL-A-1	544	5	ANON-69
	24	PARI-17, pp. 146–		8	ANON-67
		147		27	ANON-67
	29	MAHL-A-2, p. 135		29	ANON-64
	35	Ibid.	545	5	JOHA
536	6	Ibid., p. 136		17	NEWH
	14	MAHL-A-1		22	MACK, p. 576
	19	KENN-M, p. 56		27	PARI-22, p. 76
	20	MAHL-A-2, p. 135		31	ANON-65
	21	MACC, p. 19	546	1	JOHA
	29	HOFF-1, p. 43		7	COQU-2, p. 221
537	16	MAHL-G-1		7	MEUN-2, p. 249
	25	LOND-2		18	CLAD-7, p. 247
	29	Ibid.		29	LOND-2
538	12	DIOL		36	Ibid.
	20	TREU, p. 5	547	8	HANO, p. 167
	22	Ibid., p. 6		9	Ibid., p. 173
	24	Ibid., pp. 4–5		16	CLAD-7, p. 292
	29	BENN-2, p. 234		25	BOUR, pp. 20–21
	32	DELAR, pp. 162–		34	BOET, p. 490
		163		36	LUDO-2, p. 80
539	9	HARR-2, pp. 325–	548	3	LAND, p. 98
		326		17	MORW, pp. 76–77
	22	CROW-2, pp. 4–6		34	LAWT-1, p. 164
540	10	ANDE, pp. 333–334	549	4	Ibid., pp. 165–166
	15	OJET, p. 47		20	CLAD-7, p. 173
	19	RL		22	LAWT-3, p. 7
	33	VOLL-3, p. 119		28	EDIN
	36	NOST-6	550	1	LAWT-4
541	1	BERNS, p. 116		3	LAWT-1, p. 155
	16	BLOO		9	LAWT-2, p. v
	25	GIDE-2, p. 213		14	STOC

Page	Line	Source	Page	Line	Source
	25	EUGE, p. 352		19	NICO, p. 68
551	5	RILK-4, p. 99		23	Ibid., pp. 69–70
	11	RILK-5, p. 41		30	Ibid., p. 29
	37	COCT, p. 182	564	3	Ibid., p. 69
552	4	Ibid., p. 181		6	TELL, p. 84
	8	RILK-6, p. 76		15	Ibid., p. 80
	22	ANON-70	565	1	Ibid., p. 69
553	5	BLAN-2, p. 124		4	NICO, p. 111
	10	BURD, pp. 266–267		14	MILL
	22	DURH	566	22	LAWT-2, p. 31
				26	DUJA, p. 81
				35	BART, p.
16. IN RODIN'S STUDIO			567	9	HOFF-1, p. 96
555	3	TIRE, p. 55		21	ZIMM, p. 518
	11	BAC, p. 108		27	TACH, p. 69
	15	TIRE, pp. 58–59	568	4	BLOO
556	3	LUDO-2, p. 52		18	LAWT-1, p. 28
	4	Ibid., pp. 52–53		20	MOOR-2, p. 210
	19	Ibid., p. 41		26	SHAW-2, p. 295
	31	Ibid., pp. 64–65		31	HOFF-1, p. 97
557	28	NICO, p. 51	569	2	Ibid.
	35	Ibid., p. 52		12	LOND-2
558	4	Ibid., p. 53		26	GSEL-5, p. 7
	9	Ibid.	570	8	LOND-2
	12	Ibid., p. 54		13	STEI, p. 331
	29	Ibid., p. 55		15	BERN, p. 33
	34	Ibid., pp. 54–55		23	SHAW-2, p. 295
559	13	Ibid., pp. 56–57	571	5	HERR, p. ix
	32	Ibid., p. 31		16	BBC
560	2	SCHOP, p. 531	572	4	LOND-3
	4	Ibid., pp. 531–532		9	BENN-1, pp. 156–157
	9	NICO, p. 36		29	GODE
	13	Ibid.		34	BENN-2, p. 234
	16	Ibid., pp. 37–38	573	4	GSEL-6, p. 144
561	3	BLOY-2, p. 280		21	CIOL-1, pp. 266–267
	7	Ibid., p. 281		32	BERN, p. 33
	28	MORT	574	6	RUTT, p. 69
	32	PARI-22, p. 125		17	VOLL-3, pp. 207–210
562	6	ANON-59			
	10	Ibid.	575	3	LAMI, Vol.4, p. 163
	36	BBC		12	VARE, pp. 104–105
563	10	PARI-10, p. 31			

Page	Line	Source	Page	Line	Source
	19	ALLE, p. 214		13	MAUC-7, p. 117
	25	KAHN-2, p. 89		18	AURE-1, p. 209
	34	Ibid., p. 88		22	LAWT-1, p. 192
576	3	BERL, p. 47		26	GSEL-2, p. 398
	13	COX, p. 335		32	NICO, p. 20
	19	CLAD-3, p. 97		37	GSEL-2, pp. 397–
	24	Ibid., p. 98			398
577	8	CLAD-7, p. 97	586	7	LUDO-2, p. 96
	11	MAUC-4, p. 110		10	GSEL-3, p. 100
	18	SCHM-3, p. 300		15	LUDO-2, p. 98
	23	JIAN-3, p. 13		27	Ibid., p. 99
	32	VIGE		35	Ibid., p. 100
578	6	LIPC, p. 7	587	12	Ibid., p. 101
	10	NEWY-2		27	DURH
	18	EPST, p. 53	588	4	SCHU, p. 110
	28	MATI, p. 47		11	PLAO, Preface
	31	FRER, p. 199		25	NICO, pp. 20–21
	35	KESS-1, p. 2		30	GSEL-5, p. 8
579	1	Ibid., p. 3		35	GSEL-1, pp. 99–100
	9	VAUX	589	3	Ibid., p. 95
	15	ANON-60, Feb. 3,		8	NOST-6
		1907		18	DELAR, p. 163
	22	Ibid.		23	DURH
580	21	Ibid., Feb. 17, 1907		31	PUGE, p. 9
	23	ANON-61		33	DELAR, p. 163
	36	Ibid.	590	1	PUGE, p. 11
581	11	ANON-62		8	PLES, p. 98
	33	BARJ, p. 160		21	ANON-79, p. 410
582	4	APOL-1, p. 437		24	RUSS, p. 26
	14	MEST, pp. 4–5		29	Ibid., p. 11
583	23	BARB, p. 16		34	Ibid., p. 10
	28	LUDO-2, p. 68	591	4	Ibid., p. 11
	36	BARG		11	Ibid.
584	1	BERNS, p. 121		26	APOL-2, pp. 90–91
	9	APOL-1, pp. 238–	592	20	VARE, p. 106
		239		27	ROUA, p. 658
	13	GRAU-1, p. 1		31	COQU-4, p. 57
	16	GRAU-2, p. 1058		32	VARE, p. 106
	25	GSEL-3, p. 100	593	8	OJET, p. 48
	29	GSEL-2, p. 394		13	MAUC-8, p. 203
585	1	LUDO-2, pp. 97–98		29	RUTT, p. 70
	10	GSEL-3, p. 101		32	LECO, p. 25

Page	*Line*	*Source*	*Page*	*Line*	*Source*
594	1	JOUR, p. 14		31	Ibid., p. 267
	13	ANON-73	604	12	CLAD-7, p. 260
	15	ANON-74		16	BEAC, p. xviii
	28	PANG, p. 243	605	8	CLAD-4
				9	CLAD-5, p. 12
				12	Ibid., p. 19
17. LE CREPUSCULE D'UN FAUNE				17	Ibid., p. 27
596	5	TIRE, p. 29		37	GOLD-A, p. 143
	8	DURH	606	2	BUCK-R, p. 284
	13	SIMM, p. 198		7	CLAD-7, p. 277
	18	DURH		10	HOFF-3, p. 118
597	9	LEGE-2, p. 355		17	BUCK-R, p. 286
	16	ANON-71		20	CLAD-7, p. 278
	23	ANON-72		36	Ibid., p. 279
598	2	TAUB, p. 129	607	8	Ibid., p. 277
	19	HOFF-3, p. 120		11	BLAN-3, p. 429
	30	Ibid., pp. 120–121		22	VOLL-1, p. 237
599	17	MAUC-6, p. 130		30	BUCK-R, p. 367
	21	Ibid.		34	CLAD-7, p. 332
	33	Ibid., p. 131	608	2	BLOO
600	11	Ibid., p. 136		5	Ibid.
	20	LOWT, p. 600		11	TIRE, p. 22
	34	TIRE, p. 21		17	SACK
601	2	DURH		20	TIRE, p. 25
	6	CLAD-7, p. 283		27	ANON-75
	10	Ibid., p. 284	609	15	GSEL-5, p. 7
	16	BURD, pp. 263–264		20	CLARK, p. 344
	22	Ibid., p. 265		22	GSEL-5, p. 8
	35	Ibid.		29	Ibid., pp. 8–9
602	8	PLES, p. 106		30	CLARK, pp. 344–345
	10	BURD, p. 271	610	3	GSEL-5, p. 9
	18	Ibid., pp. 272–273		14	KAHN-2, pp. 86–87
	27	PLES, p. 104		23	DOLE-2, p. 129
	29	RODI-5		23	LOND-2
	35	PLES, p. 107		27	LUDO-2, p. 135
603	1	LEFR		33	Ibid., pp. 135–136
	4	BURD, pp. 272–273		38	Ibid., pp. 136–137
	8	LEFR	611	5	Ibid., pp. 138–139
	16	Ibid.		29	GSEL-1, p. 99
	26	BURD, p. 273	612	2	LOND-2
				6	LOND-5

Page	Line	Source	Page	Line	Source
	12	TIRE, pp. 64–65		12	KESS-2, p. 173
613	1	BLOO		19	Ibid.
	4	TIRE, p. 65		34	MOTT, pp. 103–104
	8	CLAD-7, p. 271	624	1	HOFF-3, p. 125
	13	Ibid.		5	Ibid., pp. 125–126
	15	MART-J, p. 221		14	Ibid., p. 126
	21	ANON-75		32	ROLL, p. 65
	23	CLAD-7, p. 299		37	Ibid., p. 75
	36	NICOL, p. 24	625	12	HONE, p. 113
614	5	SACK		20	LESL, p. 259
	6	PARI-19		26	Ibid., p. 260
	8	SACK		33	Ibid., p. 258
	36	ANON-82	626	1	Ibid., p. 262
615	1	SACK		5	PHIL-2
616	16	PARI-19		12	LESL, p. 258
	22	Ibid.		16	WASH-2
	24	SACK		25	LOND-4
617	7	Ibid.		30	BESN, p. 194
618	3	Ibid.		33	Ibid., p. 195
	33	COQU-4, p. 184	627	13	Ibid., pp. 220–221
619	9	MORI-2, p. 595	628	1	ALBE
	13	RODI-7, p. 8		13	RESN, p. 378
	20	Ibid.		26	MEST, p. 9
	22	Ibid., p. 11	629	2	BESN, p. 236
	29	Ibid., p. 10		23	BONI, p. 216
	35	FUSS, p. 180		25	RESN, p. 381
620	12	DELS, p. 101		30	VOLL-1, p. 237
	19	PARI-19	630	5	DURH
	26	RODI-4, p. 227		13	PARI-19
	35	ANON-77		19	DAYO-2
621	7	RODI-7, p. 89		24	ANON-76
	8	Ibid., p. 90		30	RICK-2, p. 189
	15	MALE, p. 371	631	14	TIRE, p. 154
	19	DEMA, p. 4		15	Ibid., p. 149
	28	RODI-7, p. 91		28	BLOO
	36	Ibid., pp. 90–91		32	TIRE, p. 157
622	5	Ibid., p. 108	632	10	BLOO
	10	Ibid., p. 135		14	COQU-4, p. 169
	11	Ibid., p. 134		16	Ibid., p. 153
	23	SACK		25	Ibid., p. 186
	33	HOFF-3, p. 123		28	Ibid., p. 221
623	3	LESL, p. 251		31	BLOO

Page	Line	Source	Page	Line	Source
633	9	TIRE, p. 171		12	CLAD-7, p. 413
	17	Ibid., p. 177		16	CHER-2, p. 466
	25	BLOO		26	BLOO
	37	Ibid.		32	AURE-2, pp. 201–202
634	3	JOUR, p. 28			
	8	ANON-78	635	4	KENN-L, p. 159

BIBLIOGRAPHY

ADAM-1 Adam, Marcelle. "Le Penseur." *Gil Blas*. Paris, July 7, 1904.

ADAM-2 _____. "Victor Hugo et Auguste Rodin." *Le Figaro*. Paris, December 28, 1907.

ADAMS Adams, Henry. *Letters of Henry Adams*, vol. 2. Boston, 1938.

AICA Aicard, Jean. "L'Art au-dessus de l'argent." *Le Figaro*. Paris, December 3, 1894.

AIGN Aigner, L., and Aczel, L. "Rodins Sohn, der Taglöhner." *Der Querschnitt*, vol. 11. Berlin, 1931.

AJAL Ajalbert, Jean. *Sous le sabre*. Paris, n.d.

ALBE Alberti, Rafael. "El lirismo del alfabeto." *El País*. Madrid, February 17, 1985.

ALEX-1 Alexandre, Arsène. "Le Statuaire Rodin." *Le Journal des Artistes*. Paris, September 23, 1888.

ALEX-2 _____. "La Statue de Balzac." Unidentified clipping from the Archives Nationales. Paris, July 9, 1891.

ALEX-3 _____. *Le Balzac de Rodin*. Paris, 1898.

ALEX-4 _____. "Croquis d'après Rodin." *Le Figaro*. Paris, July 21, 1899.

ALGE Alger, J. G. *The New Paris Sketch Book*. London, 1887.

ALLE Alley, Ronald. *The Foreign Paintings, Drawings and Sculpture*. Tate Gallery catalogue. London, 1959.

ALTA Altaroche, Agénor. *Nouveau tableau de Paris au XIXe siècle.* Paris, 1835.

ANDE Anderson, Alder. "Auguste Rodin at Home." *The Pall Mall Magazine*, vol. 27, no. 11. London, July 1902, pp. 325–38.

ANET Anet, Claude. "La Photographie de l'oeuvre de Rodin." *La Revue Blanche*, vol. 7, no. 192. Paris, June 1, 1901, pp. 216–17.

ANON-1 Anonymous. *Parisian Sights and French Principles.* London, 1853.

ANON-2 _____. "Mort de Jean-François Loos." *Journal des Beaux-Arts et de la Littérature.* Brussels, 1871, p. 18.

ANON-3 _____. Untitled article. *Gazette des Architectes et du Bâtiment, Série 2.* Paris, 1879, pp. 126–27.

ANON-4 _____. "Sculpture at the Paris Exhibition." *The Magazine of Art*, vol. 3. London, 1880, pp. 256–57.

ANON-5 _____. "Grotesque Heads by Legrain." *The Magazine of Art*, vol. 4. London, 1880–81, pp. 186–87.

ANON-6 _____. "La Sculpture au Salon de Bruxelles." *L'Art Moderne.* Brussels, October 23, 1881, pp. 265–67.

ANON-7 _____. "Art Notes." *The Magazine of Art*, vol. 5. London, 1881–82, p. ix.

ANON-8 _____. "Art Notes." *The Magazine of Art*, vol. 5. London, May 1881–82, pp. xxv–xxvi.

ANON-9 _____. "The Chronicle of Art." *The Magazine of Art*, vol. 6. London, 1882, p. i.

ANON-10 _____. "Art in June." *The Magazine of Art*, vol. 6. London, 1883, p. xxxiii.

ANON-11 _____. "Art Chronicle." *The Portfolio*, vol. 14. London, 1883, pp. 144–45.

ANON-12 _____. Advertisement in *l'Art Moderne*, no. 22. Brussels, June 3, 1883, p. 180.

ANON-13 _____. "Current Art." *The Magazine of Art*, vol. 7. London, 1884, pp. 351–52.

ANON-14 _____. "Hommage à Jules Bastien-Lepage." *Le National*, August 28, 1885.

ANON-15 _____. "The Royal Academy Again." *The Saturday Review.* London, May 22, 1886.

ANON-16 _____. "Au jour le jour. La Statue de Balzac." *Le Temps.* Paris, September 12, 1888.

ANON-17 _____. "Le monument de Castagnary." *Le Temps.* Paris, June 12, 1890.

ANON-18 _____. "M. Rodin et la Commission des Travaux d'Art." *Le Temps.* Paris, July 21, 1890.

ANON-19 . Untitled article. *Town Topics*, vol. 25, no. 12. New York, March 19, 1891, p. 2.

ANON-20 . "Notes Parisiennes." *Le Progrès de l'Est*. Nancy, October 21, 1891.

ANON-21 . *An Englishman in Paris* (attributed to Philip Vandam). Paris, 1892.

ANON-22 . "Le voyage de M. Carnot dans l'Est. Inauguration de la statue de Claude Gelée." *L'Espérance*, June 7, 1892.

ANON-23 . "Le monument de Charles Baudelaire." *Le Temps*. Paris, September 27, 1892.

ANON-24 . Untitled article. *Le Journal*. Paris, June 29, 1893.

ANON-25 . Untitled article. *L'Echo de Paris*. Paris, October 10, 1894.

ANON-26 . "La Statue de Balzac." *Journal des Débats*. Paris, November 28, 1894.

ANON-27 . "La Société des Gens de Lettres et Rodin." *Le Temps*. Paris, November 28, 1894.

ANON-28 . "A la Société des Gens de Lettres." *Le Temps*. Paris, November 29, 1894.

ANON-29 . "A la Société des Gens de Lettres." *Le Temps*. Paris, November 30, 1894.

ANON-30 . "A la Société des Gens de Lettres." *Le Temps*. Paris, December 1, 1894.

ANON-31 . "La Statue de Balzac." *Le Temps*. Paris, December 6, 1894.

ANON-32 . Untitled clipping. *Le Journal*. Paris, April 25, 1897.

ANON-33 . "Critiques Italiennes de Rodin." *L'Echo de Paris*. Paris, September 3, 1897.

ANON-34 . "La Statue de Balzac." *Le Journal des Débats*. Paris, May 12, 1898.

ANON-35 . Untitled article. *The Manchester Guardian*, May 15, 1898.

ANON-36 . Untitled article. *The Guardian*. London, May 25, 1898.

ANON-37 . "Chez Rodin." *L'Echo de Paris*. Paris, February 23, 1899.

ANON-38 . "Chronique." *L'Art Décoratif*. Paris, June 1900, p. 127.

ANON-39 . "Kunst und Literatur—Die Rodin Ausstellung in Prag." *Politik*. May 11, 1902.

ANON-40 . "M. Rodin in London." *The Daily Chronicle*, no. 12546. London, May 16, 1902.

ANON-41 . "Comptes Eloquents." *L'Art*. Paris, June 1903.

ANON-42 _____. "International Art—M. Rodin in London." *The Morning Post.* London, January 8, 1904.

ANON-43 _____. "M. Rodin in London." *Daily News.* London, January 11, 1904.

ANON-44 _____. "Art and Actuality." *The Daily Mirror.* London, January 13, 1904.

ANON-45 _____. "International Art—M. Auguste Rodin's Presidency." *The Morning Post.* London, January 13, 1904.

ANON-46 _____. "M. Rodin and the International Society." *The Times.* London, January 13, 1904.

ANON-47 _____. "M. Rodin." *Yorkshire Daily Observer.* London, January 14, 1904.

ANON-48 _____. "M. Rodin." *Daily Mail.* London, January 14, 1904.

ANON-49 _____. "M. Rodin's Impressions." *The Daily Mirror.* London, January 16, 1904.

ANON-50 _____. "Art Notes—Rodinesqueries." *The Truth.* London, January 21, 1904.

ANON-51 _____. "Notes Parisiennes." *La Liberté.* Paris, June 1, 1904.

ANON-52 _____. *"Le Penseur* de Rodin—Première liste de souscription." *Les Arts de la Vie.* Paris, June 1904.

ANON-53 _____. *"Le Penseur* de Rodin offert par souscription publique au peuple de Paris." *Les Arts de la Vie.* Paris, June 1904.

ANON-54 _____. "Hommage au *Penseur." Les Arts de la Vie.* Paris, September 1904.

ANON-55 _____. *"Le Penseur* de Rodin devant le Panthéon." *Les Arts de la Vie.* Paris, December 1904.

ANON-56 _____. *Guide des Plaisirs à Paris.* Paris, 1905.

ANON-57 _____. "Le Rodinophobe." *Le Rire,* no. 104. Paris, January 28, 1905.

ANON-58 _____. "M. Rodin on Whistler." *Pall Mall Gazette.* London, February 3, 1905.

ANON-59 _____. "Le poète Rollinat et le sculpteur Rodin." *L'Illustration.* Paris, September 8, 1906.

ANON-60 _____. "Rodin and Rosso." *The London Observer.* London, February 3 and 17, 1907.

ANON-61 _____. "Twixt Rodin and Rosso." *Pall Mall Gazette.* London, February 21, 1907.

ANON-62 _____. "Rodin and Rosso." *Pall Mall Gazette.* London, March 11, 1907.

ANON-63 _____. "Revues." *Antée.* Paris, June 1, 1907.

ANON-64 _____. "Living Statuary." *The Daily Chronicle.* London, June 26, 1907.

ANON-65 _____. "Mark Twain's Lost Chance." *The Daily Express.* London, June 26, 1907.

ANON-66 _____. Untitled article. *The Oxford Review.* London, June 26, 1907, p. 4.

ANON-67 _____. "Oxford Honours." *The Daily Chronicle.* London, June 27, 1907.

ANON-68 _____. "Living Statuary." *The Daily Telegraph.* London, June 27, 1907.

ANON-69 _____. "Commemoration—The Encaenia." *The Oxford Chronicle.* London, June 28, 1907.

ANON-70 _____. "Rodin Talks of His Work." *The Sun.* London, September 12, 1909.

ANON-71 _____. "L'Empereur d'Allemagne refuse une décoration pour Rodin." *Gil Blas.* Paris, February 2, 1911.

ANON-72 _____. "Die Abgelehnten Kandidaten für den Orden Pour le Mérite." *National Zeitung.* Berlin, February 3, 1911.

ANON-73 _____. "Le Thé littéraire des Unes." *Comoedia.* Paris, June 28, 1911.

ANON-74 _____. "Chaussettes d'azur." *Le Cri de Paris.* Paris, July 2, 1911.

ANON-75 _____. "Rodin and Duchess Quarrel." *The New York Times.* New York, September 16, 1912.

ANON-76 _____. "Calmette's End and the Rodin Museum." *The Literary Digest,* vol. 48. London, April 11, 1914.

ANON-77 _____. "Une Place de secrétaire." *Le Canard Enchaîné,* Paris, November 1, 1916.

ANON-78 _____. "Auguste Rodin." *L'Homme Libre.* Paris, November 16, 1917.

ANON-79 _____. "Künstler Anekdoten." *Kunst und Künstler,* vol. 16. Berlin, 1918, p. 410.

ANON-80 _____. "M. Degas et son modèle." *Le Carnet de la Semaine.* Paris, March 2, 1919.

ANON-81 _____. "Rodin et Séverine." *Comoedia.* Paris, August 18, 1923.

ANON-82 _____. "Rodin and the 'Burghers.' " *The Times.* London, July 7, 1955.

ANON-83 _____. "A Woman, Now 98, Who Was Immortalized by Rodin." *Johannesburg Star,* April 4, 1970.

ANON-84 _____. "Le Salon de Bruxelles." Unidentified clipping from the Bibliothèque Nationale, Cabinet des Estampes, Paris.

ANON-85 _____. Untitled article. *The New York Times,* September 5, 1903.

APOL-1 Apollinaire, Guillaume. *Chroniques d'art 1902–1918.* Paris, 1960.

APOL-2 ————. *Petites merveilles du quotidien*. Montpellier, 1979.

ARMI Armitage, E. "The Royal Academy. Letter to the Editor." *The Times*. London, August 30, 1886.

ASSE Asselin, Henry. "Camille Claudel et les Sirènes de la Sculpture." *La Revue Française*, no. 187. Paris, April 1966, pp. 8–12.

AUDE Audebrand, Philibert. "La Statue d'Honoré de Balzac." *L'Art*, vol. 2. Paris, 1892, pp. 253–57.

AURE-1 Aurel. "Rodin et la Femme." *La Grande Revue*, vol. 86. Paris, June 1914, pp. 206–19.

AURE-2 ————. *Rodin devant la femme: Fragments inédits de Rodin; sa technique par lui-même*. Paris, 1919.

BAC Bac, Ferdinand. *Intimités de la IIIème République. La fin des temps délicieux*. Paris, 1935.

BAHR Bahr, Hermann. *Pariser Notizen*. Leipzig, 1900.

BALD Baldick, Robert. *The Siege of Paris*. London, 1964.

BARB Barbic, Vesna. "Supplément à la monographie d'Ivan Mestrovic." *Annales de l'Institut Français de Zagreb*, 2e série, no. 22–23. Zagreb, 1970–71.

BARB-C Barbier, Carl-Paul. *Correspondance Mallarmé-Whistler. Histoire de leur grande amitié de leurs dernières années*. Paris, 1964.

BARG Barga, Corpus. "Una visita a Rodin." *España*, January 1916.

BARJ Barjanski, Catherine. *Portraits with Backgrounds*. New York, 1947.

BARN Barney, Natalie Clifford. *Souvenirs indiscrets*. Paris, 1960.

BARR Barr, Margaret Scolari. *Medardo Rosso*. New York, 1963.

BARRE Barrès, Maurice. *Mes cahiers*, vol. 4. Paris, 1931.

BART Bartlett, Truman H. "Auguste Rodin, Sculptor." *The American Architect and Building News*, vol. 25, no. 682–703, January 19–June 15, 1889, pp. 27–29, 44–45, 65–66, 99–101, 112–14, 198–200, 223–25, 249–51, 260–63, 283–85.

BASS Basset, Serge. *"La Porte de l'Enfer." Le Matin*. Paris, March 19, 1900.

BAUD-1 Baudelaire, Charles. *Curiosités Esthétiques*. Paris, 1873.

BAUD-2 ————. *Les Fleurs du Mal*, Musée Rodin Edition. Paris, 1983.

BAUDI Baudin, Pierre. "*Le Penseur* et la statuaire de la rue." *Les Arts de la Vie*. Paris, June 1904, pp. 340–42.

BAZI Bazire, Edmond. "Auguste Rodin." *Art et Critique*. Paris, July 6, 1889.

BBC B.B.C. Television Archives, London. *Sir Gerald Kelly Remembers*, May 1956.

BEAC Beach, Sylvia. "A Musée Rodin in Paris." *The International Studio*, vol. 62, July–October 1917.

BECK Beckett, Ernest. "A Visit to Rodin." *Current Literature*. New York, June 1901, pp. 730–31.

BEEC Beecham, Thomas. *Frederick Delius*. New York, 1960.

BENE-1 Bénédite, Léonce. "Une Exposition d'oeuvres de Rodin au Musée du Luxembourg." *Art et Décoration*, vol. 27–28. Paris, 1905, pp. 47–51.

BENE-2 _____. *Rodin. 60 Plates*. London, 1924.

BENE-3 _____. "Musée Rodin," *Beaux-Arts*. Paris, November 1, 1924, pp. 280–81.

BENE-4 _____. *Rodin*. Paris, 1926.

BENJ Benjamin, Walter. *Illuminationen*. Frankfurt, 1955.

BENN-1 Bennett, Arnold. *Books and Persons. Being Comments on a Past Epoch, 1908–1911*. London, 1917.

BENN-2 _____. *The Journals of Arnold Bennett*. New York, 1933.

BERG-1 Bergerat, Emile. "Salon de 1882." *Le Voltaire*. Paris, May 31, 1882.

BERG-2 _____. *Figarismes de Caliban*. Paris, 1888.

BERG-3 _____. "Les débuts d'Auguste Rodin." *Le Figaro*. Paris, March 31, 1906.

BERG-4 _____. *Souvenirs d'un enfant de Paris*, vols. I–III. Paris, 1911–12.

BERG-5 _____. "Auguste Rodin." *Les Annales Politiques et Littéraires*. Paris, June 9, 1915.

BERL Berlin. Staatliche Museen zu Berlin, DDR. *Auguste Rodin, Plastik, Zeichnungen, Graphic*. Berlin, 1979.

BERN Bernier, Rosamond. "Henry Moore parle de Rodin." *L'Oeil*. Paris, November 1967, pp. 26–33.

BERNS Bernstein, Herman. *Celebrities of Our Time*. London, n.d.

BERT Bertaud, Jules. *Paris 1870–1935*. London, 1936.

BESN Besnard, Albert. *Souvenirs. Sous le ciel de Rome*. Paris, 1921.

BIEN Bienne, Claude. "La Sculpture à la Société des Beaux-Arts." *La Revue Hebdomadaire*. Paris, May 14, 1898, pp. 264–71.

BILL Billy, André. *L'Epoque 1900*. Paris, 1951.

BLAN-1 Blanche, Jacques-Emile. *Les Arts Plastiques*. Paris, 1931.

BLAN-2 _____. *Portraits of A Lifetime*. London, 1937.

BLAN-3 _____. *La Pêche aux souvenirs*. Paris, 1949.

BLOO Bloomington, Indiana. Lilly Library, Indiana University, Cladel Papers.

BLOY-1 Bloy, Léon. "A la gloire de Barbey d'Aurevilly." *La Flamme*. Paris, February 20, 1910, pp. 354–58.

BLOY-2 ———. *Le Vieux de la montagne (1907–1910)*. Paris, 1919.

BLOY-3 ———. *Journal de Léon Bloy. I. Le Mendiant ingrat*. Paris, 1956.

BLOY-4 ———. *Journal de Léon Bloy. II. Mon Journal*. Paris, 1956.

BOEL Boelpaepe, Christiane de. *Le Séjour de Rodin en Belgique*. Unpublished dissertation. Brussels, 1958.

BOES Boès, Karl. "Toast à Rodin." *La Plume* (special Rodin issue). Paris, May–August 1900, p. 88.

BOET Boethius, Gerda. *Zorn. Tecknaren, Malaren, Etsaren, Skultören*. Stockholm, 1949.

BOIS-G Bois, Georges. "Le Sculpteur Rodin et les Danseuses Cambodgiennes." *L'Illustration*. Paris, July 28, 1906.

BOIS-J Bois, Jules. "Etudes de sculpteurs. Auguste Rodin." *L'Evènement*. Paris, July 24, 1893.

BONI Boni de Castellane, Comte. *L'Art d'être pauvre*. Paris, 1925.

BOOT Boothby, Robert John Graham. *I Fight to Live*. London, 1947.

BORG Borglum, Gutzon. "Auguste Rodin. A Neglected Genius." *The Lotus Magazine*. New York, 1948, pp. 151–55.

BOST Boston. Library of the Boston Atheneum.

BOUR Bourdelle, Antoine. *La Sculpture et Rodin*. Paris, 1937.

BOURG Bourget, Paul. *Oeuvres complètes. Romans II, Physiologie de l'amour moderne*. Paris, 1901.

BRAN-1 Brandes, Georg. "Bei Auguste Rodin." *Die Kunstwelt*. Berlin, May 1913, pp. 500–508.

BRAN-2 ———. *Correspondance de Georg Brandes*, vol. 3, edited by Paul Krüger. Copenhagen, 1966.

BRIS-1 Brisson, Adolphe. *Portraits intimes, 1ère série*. Paris, 1894.

BRIS-2 ———. *Portraits intimes, 5ème série*. Paris, 1901.

BRIS-3 ———. "Chez le cabaretier d'Auguste Rodin." *Le Temps*. Paris, June 7, 1900.

BROU Brousson, Jean-Jacques. "Le Secret de Geffroy." *Les Nouvelles Littéraires*. Paris, September 21, 1935.

BROW-1 Brownell, W. C. *French Art, Classic and Contemporary, Painting and Sculpture*. New York, 1912.

BROW-2 ———. "Two French Sculptors: Rodin-Dalou." *The Century Magazine*. New York, 1912, pp. 17–32.

BROW-R Browning, Robert. *Learned Lady: Letters from Robert Browning to Mrs. Thomas Fitzgerald*. Cambridge, Mass., 1966.

BRUNH Brunhammer, Yvonne et al. *Art Nouveau Belgium-France*. Houston, 1976.

BRUN-A Brunnemann, A. "Der Bildhauer Auguste Rodin." *Die Gegenwart*, no. 5, February 2, 1901, pp. 72–74.

BRUN-B Brunner-Littmann, Birgit. *Auguste de Niederhäusern-Rodo, 1863–1913*. Zurich, 1968.

BRUS-1 Brussels. Archives Municipales.

BRUS-2 ———. Musées Royaux des Beaux-Arts de Belgique, Archives de l'Art Contemporain.

BUCH Buchanan, Donald W. *James Wilson Morrice*. Toronto, 1936.

BUCK-R Buckle, Richard. *Nijinsky*. Harmondsworth, 1975.

BUCK-J Buckley, Jerome Hamilton. *William Ernest Henley: A Study in the "Counter Decadence" of the Nineties*. Princeton, 1945.

BUFF Buffenoir, Hippolyte, and Haquette, Maurice. *Le Décret de Moscou et la Comédie Française*. Paris, 1902.

BURD Burdett, Osbert, and Goddard, E. H. *Edward Perry Warren. The Biography of a Connoisseur*. London, 1941.

BUTL Butler, Ruth. *Rodin in Perspective*. Englewood Cliffs, New Jersey, 1980.

BYVA Byvanck, W. G. C. *Un Hollandais à Paris en 1891*. Paris, 1892.

CALD Calder-Marshall, Arthur. *The Sage of Sex. A Life of Havelock Ellis*. New York, 1959.

CAMB Cambridge, Massachusetts. Harvard University, Houghton Library, Rothenstein Letters.

CAMP Campagnac, Edmond. "Rodin et Bourdelle." *La Grande Revue*, vol. 131. Paris, November 1929.

CARD-1 Cardiff. National Library of Wales, Manuscript Division, Gwen John Letters.

CARD-2 ———. National Museum of Wales. *Catalogue Gwen John at the National Museum of Wales*. Cardiff, 1976.

CARDI Cardinne-Petit. "En écoutant Louÿs." *Les Nouvelles Littéraires*. Paris, December 1, 1934.

CARR-E Carrière, Eugène. *Ecrits et lettres choisies*. Paris, 1919.

CARR-J Carrière, Jean-René. *De la vie d'Eugène Carrière*. Toulouse, 1966.

CASO Caso, Jacques, and Sanders, Patricia B. *Rodin's Sculpture, a Critical Study of the Spreckles Collection, California Palace of the Legion of Honor*. San Francisco, 1977.

CASS Casson, Stanley. *Some Modern Sculptors*. London, 1928.

CHAI Chaigne, Louis. *Vie de Paul Claudel et Genèse de son oeuvre*. Paris, 1961.

CHAM Champfleury. "La statue de Balzac." *Paris Illustré*. Paris, May 28, 1887, pp. 73–76.

CHAM-B Champigneulle, Bernard. *Rodin*. London, 1967.

CHAM-F Champsaur, Félicien. "Celui qui revient de l'Enfer: Auguste Rodin." Supplement to *Figaro*. Paris, January 16, 1886.

CHAN Chanourdie, Enrique. "Sarmiento y su Estatua," *Revista Tecnica*. Buenos Aires, June 1900.

CHAR Charpentier, Thérèse. "Notes sur le Claude Gellée de Rodin, à Nancy." *Bulletin de la Société de l'Histoire de l'Art Français.* Paris, 1968.

CHART Charteris, Evan. *John Sargent.* New York, 1972.

CHAST Chastel, André. "Edouard Vuillard." *Art News Annual*, vol. 23, November 1953, p. 37.

CHAS Chastenet, Jacques. *La France de M. Fallières.* Paris, 1949.

CHER-1 Chéruy, René. "Rodin's Gate of Hell Comes to America." *New York Herald Tribune*, Sunday magazine supplement, January 20, 1929.

CHER-2 _____. "Un Musée Rodin à Philadelphie." *L'Illustration*, no. 4521. Paris, October 23, 1929, pp. 466–67.

CHIN-1 Chincholle, Charles. "Balzac et Rodin." *Le Figaro*. Paris, November 25, 1894.

CHIN-2 _____. "La vente de la statue de Balzac." *Le Figaro*. Paris, May 12, 1898.

CHIN-3 _____. "M. Chéramy chez Rodin." *Le Figaro*. Paris, May 13, 1898.

CHIT Chitty, Susan. *Gwen John, 1876–1939.* London, 1981.

CHRI Christie's, London. Sale catalogue, October 22, 1980.

CIOL-1 Ciolkowska, Muriel. "Auguste Rodin on Prejudice in Art." *The Englishwoman.* London, April 1910, pp. 263–69.

CIOL-2 _____. *Rodin.* London, 1912.

CLAD-1 Cladel, Judith. "L'Oeuvre de Rodin à l'étranger." *La Dépêche.* Paris, November 1, 1899.

CLAD-2 _____. *Auguste Rodin, pris sur la vie.* Paris, 1903.

CLAD-3 _____. *Auguste Rodin: l'oeuvre et l'homme.* Brussels, 1908.

CLAD-4 _____. "Le plus grand sculpteur français, le maître Rodin, va être mis à la porte de l'Hôtel Biron qu'il contribua à sauver." *Le Matin.* Paris, November 27, 1911.

CLAD-5 _____. *Pour le Musée Rodin.* Tours, 1912.

CLAD-6 _____. *Rodin, the Man and His Art.* New York, 1917.

CLAD-7 _____. *Rodin, sa vie glorieuse, sa vie inconnue.* Paris, 1936.

CLAD-8 _____. "Dans l'intimité de Rodin." *Le Figaro Littéraire.* Paris, May 2, 1936.

CLAD-9 _____. "Rodin." *Le Point*, vol. 2, no. 6. Paris, December 1937, pp. 249–50.

CLAD-10 _____. *Rodin.* London, 1953.

CLAR-1 Claretie, Jules. "La vie à Paris." *Le Temps.* Paris, May 5, 1898.

CLAR-2 _____. "La vie à Paris." *Le Temps.* Paris, February 1, 1907.

CLARI-1 Claris, Edmond. "L'Impressionnisme en sculpture. Auguste Rodin et Medardo Rosso." *La Nouvelle Revue*, vol. 10. Paris, June 1, 1901, pp. 321–36.

CLARI-2	_____. *De l'Impressionnisme en sculpture*. Paris, 1902.
CLARK	Clark, Kenneth. *The Romantic Rebellion*. New York, 1973.
CLAU-1	Claudel, Paul. *Correspondance*. Paris, 1952.
CLAU-2	_____. *Cahiers Paul Claudel. I. "Tête d'or" et les Débuts littéraires*. Paris, 1959.
CLAU-3	_____. *L'Oeuvre de Paul Claudel: Prose*. Paris, 1965.
CLAU-4	_____. *Journal*, vol. 1. Paris, 1968.
CLAU-5	_____. *Journal*, vol. 2. Paris, 1969.
CLAU-6	_____, and Mauriac, François. *Chroniques du Journal de Clichy. Claudel-Fontaine correspondance*. Paris, 1978.
CLEO	Cléon. "La Question Rodin à la Société des Gens de Lettres." *L'Echo de Paris*. Paris, May 12, 1898.
COBU	Coburn, Alvin Langdon. *Photographer, an Autobiography*. New York, 1966.
COCT	Cocteau, Jean. *Portraits-Souvenir, 1900–1914*. Paris, 1935.
CONS	Constant, Benjamin. "Rodin." *Le Figaro*. Paris, May 6, 1898.
COPE	Copenhagen. Det Kongelige Bibliotek, Georg Brandes Papers.
COQU-1	Coquiot, Gustave. "Jules Desbois." *L'Art et les Artistes*, vol. 13. Paris, April–September 1911, pp. 161–68.
COQU-2	_____. *Le Vrai Rodin*. Paris, 1913.
COQU-3	_____. *Rodin, Cinquante-sept statues*. Paris, 1915.
COQU-4	_____. *Rodin à l'Hôtel de Biron et à Meudon*. Paris, 1917.
COX	Cox, Kenyon. "Rodin." *The Architectural Record*, vol. 18, New York, November 1905, pp. 327–46.
CROW-1	Crowley, Aleister. *The Star and the Garter*. London, 1903.
CROW-2	_____. *Rodin in Rime*. London, 1907.
CROW-3	_____. *The Confessions of Aleister Crowley*. New York, 1970.
CROW-4	_____. *Clouds Without Water*. London, 1909.
CROZ	Croze, J. L. "Les Fêtes de Calais." *L'Echo de Paris*. Paris, June 5, 1895.
CUNA	Cunard, Nancy. *Memories of George Moore*. London, 1956.
CURI	Curie, Eve. *Madame Curie. A Biography*. New York, 1939.
DARG	Dargenty, G. "Le Salon National." *L'Art*, vol. 4. Paris, 1883.
DAUD-A	Daudet, Alphonse. *Trente ans à Paris*. Paris, 1888.
DAUD-L-1	Daudet, Léon. *Souvenirs*. Paris, 1920.
DAUD-L-2	_____. *Souvenirs*. Paris, 1926.
DAUD-L-3	_____. *Memoirs of Léon Daudet*. London, 1926.
DAUD-L-4	_____. *Ecrivains et artistes*, vol. 1. Paris, n.d.
DAYO-1	Dayot, Armand. "A la Galerie des Machines." *La Nouvelle Revue*, vol. 112. Paris, May 15, 1898.
DAYO-2	_____. "Le Musée Rodin." *L'Illustration*. Paris, March 7, 1914.
DEBU-1	Debussy, Claude. *Lettres à deux amis*. Paris, 1942.

DEBU-2 ———. *Correspondance de Claude Debussy et Pierre Louÿs.* Paris, 1945.

DEKA De Kay, Charles. *Life and Works of Antoine Louis Barye.* New York, 1889.

DEKO De Koven, Mrs. Reginald. *A Musician and His Wife.* New York and London, 1926.

DELA Delacroix, Eugène. *Selected Letters.* London, 1971.

DELAR Delarue-Mardrus, Lucie. *Mes Mémoires.* Paris, 1938.

DELB Delbée, Anne. *Une Femme.* Paris, 1982.

DELS Delsemme, Paul. *Un théoricien du symbolisme: Charles Morice.* Paris, 1958.

DELT Delteil, Loÿs. *Rude-Barye-Carpeaux-Rodin. Le Peintre-Graveur Illustré, XIXe et XXe siècles,* vol. 6. Paris, 1910.

DEMA Demaison, Louis. "Discours d'ouverture." *Travaux de l'Académie Nationale de Reims.* Reims, July 1914.

DESC Descaves, Lucien. *Souvenirs d'un ours.* Paris, 1946.

DESCH Descharnes, Robert, and Chabrun, Jean-François. *Auguste Rodin.* Lausanne, 1967.

 ———. *Auguste Rodin.* London, 1967.

DESH Deshairs, Léon. *C. Despiau.* Paris, 1930.

DEUT Deutsch, Felix. "Creative Passion of the Artist and Its Synesthetic Aspects." *International Journal of Psychoanalysis,* no. 40. Boston, 1959, pp. 38–51.

DILL Dillens, Juliaan. *Autobiography.* Manuscript in the Bibliothèque Royale de Belgique. Brussels.

DIOL Diolé, Philippe. "Despiau nous parle de Rodin qui fut 'son père spirituel.' " *Beaux-Arts,* no. 45. Paris, November 10, 1933.

 Dircks, Rudolf. *Auguste Rodin.* London, 1904.

DOLE-1 Dolent, Jean. *Monstres.* Paris, 1896.

DOLE-2 ———. *Maître de sa joie.* Paris, 1902.

DONA Donaldson, Alec. "Gallery's Red Faces over Miss Fairfax," *Yorkshire Post,* January 31, 1970.

DORM Dorment, Richard. *Alfred Gilbert.* New Haven, Conn., 1985.

DREY-1 Dreyfous, Maurice. *Ce que je tiens à dire: un demi-siècle de choses vues et entendues, 1862–1872.* Paris, n.d.

DREY-2 ———. *Dalou: sa vie et son oeuvre.* Paris, 1903.

DROU Drouet, Juliette. *Mille et une lettres d'amour à Victor Hugo.* Paris, 1951.

DUCR Ducros, Louis. *French Society in the Eighteenth Century.* London, 1926.

DUHE Duhem, Henri. *Auguste Rodin.* Paris, 1901.

DUJA Dujardin-Beaumetz, Henri. *Entretiens avec Rodin.* Paris, 1913.

DUNC Duncan, Isadora. *My Life.* New York, 1927.

DURH Durham, North Carolina. Duke University Library, Warrington Dawson Papers.

ECKE Eckenrode, H. J., and Edmunds, Pocahontas Wight. *E. H. Harriman, The Little Giant of Wall Street*. New York, 1933.

EDIN Edinburgh. National Library of Scotland, Ottilie McLaren Papers.

ELSE-1 Elsen, Albert E. *Rodin's* Gates of Hell. Minneapolis, 1960.

————. *Auguste Rodin. Readings on His Life and Works*. Englewood Cliffs, New Jersey, 1965.

————. "Rodin's *La Ronde*." *The Burlington Magazine*, vol. 107, London, June 1965, pp. 290–99.

————. "Rodin's *The Walking Man*." *The Massachusetts Review*, vol. 7, no. 747, spring 1966, pp. 289–320.

————. "Rodin's Portrait of Baudelaire." *25: A Tribute to Henry Radford Hope*. Bloomington, Indiana, 1966.

————. *Rodin*, New York, 1967.

————. "Rodin's *Naked Balzac*." *The Burlington Magazine*, vol. 109, no. 776. London, November 1967, pp. 606–22.

ELSE-2 ————. "A New Book on Rodin." *The Burlington Magazine*, vol. 109. London, November 1967, pp. 649–50.

————. *The Partial Figure in Modern Sculpture from Rodin to 1969*. Baltimore Museum of Art, 1969.

————. *In Rodin's Studio*. Oxford, 1980.

————. *The* Gates of Hell *by Auguste Rodin*. Stanford, California, 1985.

————. *Rodin's* Thinker *and the Dilemmas of Modern Public Sculpture*. New Haven, Conn., 1985.

———— et al. *Rodin and Balzac*. Stanford, California, 1973.

———— et al. *Rodin Rediscovered*. National Gallery of Art. Washington, 1981.

ELSE-3 ————, and Varnedoe, Kirk T. *The Drawings of Rodin*. London, 1972.

EMER Emerson, Edwin. *A History of the Nineteenth Century Year by Year*. New York, 1902.

EN E.N. Untitled article on Claude Gellée monument. *La Dépêche Lorraine*, June 12, 1892.

ENCI Encina, Juan de la. "Zuloaga y Rodin." *España*, February 13, 1919.

ENCY *Encyclopaedia Britannica*, eleventh edition. New York, 1910.

EPST Epstein, Jacob. *Let There Be Sculpture*. London, 1942.

EUGE Eugen, Prince of Sweden. *Breven berätta*. Stockholm, 1942.

FAGU-1 Fagus, Félicien. Note in *La Revue des Beaux-Arts et des Lettres*. Paris, January 1, 1899.

FAGU-2 ———. "Ses Collaborateurs." *Revue des Beaux-Arts et des Lettres*. Paris, January 1, 1899, p. 13.

FAUR Faure, Elie. *Eugène Carrière*. Paris, 1908.

FERR Ferry, Gabriel. "La Statue de Balzac." *Le Monde Moderne*, vol. 10, Paris, July–December 1899, pp. 641–54.

FINL-1 Finley, Donald G. Introduction to *John Russell, Australian Impressionist*. Wildenstein and Co. Ltd. Catalogue. London, July–August 1965.

FINL-2 ———. "John Peter Russell: Australia's Link with French Impressionism." *Journal of the Royal Society of Arts*, vol. 115, no. 5215. London, December 1966, pp. 18–36.

FISC Fischel, Oskar. "Auguste Rodin." *Ver Sacrum*, vol. 2, 1899.

FITZ Fitz-Gerald, William G. "A Personal Study of Rodin." *World's Work*, November 1905, pp. 6818–34.

FLAM Flam, Jack D. *Matisse on Art*. London and New York, 1973.

FLAX Flax. "Auguste Rodin." *Les Hommes du jour*. Paris, October 10, 1908.

FONT-A Fontainas, André. "La statue de Balzac." *Mercure de France*, vol. 26. Paris, May 1898, pp. 378–89.

FONT-J Fontanes, Jean de. *La vie et l'oeuvre de James Vibert*. Geneva, 1942.

FOUQ-1 Fouquières, André de. *Cinquante ans de panache*. Paris, 1951.

FOUQ-2 ———. *Mon Paris et ses Parisiens*, vol. 1, Paris, 1953; vol. 5, Paris, 1959.

FOUR-1 Fourcaud, Louis de. "La Sculpture Française." *Revue de l'Exposition Universelle de 1889*, vol. 2. Paris, 1889.

FOUR-2 ———. "Le Salon de 1884." *Gazette des Beaux-Arts*, vol. 2. Paris, 1884, pp. 50–63.

FRAN-1 France, Anatole. *Le Lys Rouge*. Paris, 1894.

FRAN-2 ———. "La Porte de l'Enfer." *Le Figaro*. Paris, June 7, 1900.

FRER Frère, Henri. *Conversations de Maillol*. Geneva, 1956.

FREU Freud, Sigmund. *Collected Papers*, vol. 5. New York, 1959.

FROI Froissart, Jean. *The Chronicle*. London, 1901.

FRY Fry, Roger. *Vision and Design*. London, 1925.

FULL Fuller, Loïe. *Fifteen Years of a Dancer's Life*. London, 1913.

Fusco, Peter, and Janson, H. W. *The Romantics to Rodin*. Los Angeles County Museum of Art, 1980.

FUSS Fuss-Amoré, Gustave. "Mes Souvenirs Parisiens: Auguste Rodin." *La Revue Belge*, July 15, 1929.

GALB Galbally, Ann. *The Art of John Peter Russell*. Melbourne, 1977.

GALL Gallé, Emile. "L'Art expressif et la statue de Claude Gellée par M. Rodin." *Le Progrès de l'Est.* Nancy, August 7, 1892.

GANT Gantner, Joseph. *Rodin und Michelangelo.* Vienna, 1953.

GASQ Gasquet, Joachim. *Cézanne.* Paris, 1926.

GAUG Gauguin, Paul. *Oviri. Ecrits d'un sauvage.* Paris, 1974.

GEFF-1 Geffroy, Gustave. "Chronique: Rodin." *La Justice.* Paris, July 11, 1886.

GEFF-2 ————. "Le Statuaire Rodin." *Les Lettres et les Arts*, vol. 3. Paris, 1889.

GEFF-3 ————. "L'Imaginaire." *Le Figaro.* Paris, August 29, 1893.

GEFF-4 ————. *La Vie artistique*, vol. 2. Paris, 1893.

GEFF-5 ————. *Claude Monet, sa vie, son oeuvre.* Paris, 1980.

GEIS Geissbuhler, Elisabeth Chase. *Rodin. Later Drawings.* London, 1963.

GENE-1 Geneva. Bibliothèque Publique et Universitaire, Mathias Morhardt Papers.

GENE-2 ————. Musée Rath Archives.

GEOR Georges-Michel, Michel. *Peintres et sculpteurs que j'ai connus.* New York, 1942.

GHEU Gheusi, P. B. *Cinquante ans de Paris*, vol. 2. Paris, 1940.

GIDE-1 Gide, André. "Promenade au Salon d'Automne." *Gazette des Beaux-Arts*, vol. 34. Paris, December 1, 1905.

GIDE-2 ————. *The Journal of André Gide, vol. 1, 1889–1913.* London, 1947.

GILL Gille, Philippe. "Balzac et M. Rodin." *Le Figaro.* Paris, May 18, 1898.

GIMP Gimpel, René. *Diary of an Art Dealer.* New York, 1966.

GODE Godet, Henri. "La Sculpture à la Nationale." *L'Action*, April 18, 1905.

GOER Goerg, Charles. "Quelques lettres inédites de Rodin." *Musée de Genève*, no. 23. Geneva, 1962, pp. 5–7.

GOLD-A Gold, Arthur, and Fizdale, Robert. *The Life of Misia Sert.* New York, 1981.

GOLD-1 Goldscheider, Cécile. "Rodin en Belgique." *Médecine de France*, no. 90. Paris, 1950.

GOLD-2 ————. "Rodin: Influence de la gravure anglaise sur le projet primitif de *la Porte de l'Enfer.*" *Bulletin de la Sociéte de l'Histoire de l'Art Français*, 1950.

GOLD-3 ————. "Rodin et le monument de Victor Hugo." *Revue des Arts, 6ème année.* Paris, October 1956.

GONC Goncourt, Edmond, and Goncourt, Jules de. *Journal. Mémoires de la vie littéraire*, vols. 1–22. Monaco, 1956.

GOSS-1 Gosse, Edmund W. "The Salon of 1882." *The Fortnightly Review*, vol. 31. London, June 1, 1882, pp. 735–46.

GOSS-2 _____. "The Place of Sculpture in Daily Life." *The Magazine of Art*. London, November 1895–October 1896, pp. 326–29.

GOUR Gourmont, Rémy de. "Le marbre et la chair." *Le Journal*. Paris, November 1, 1893.

GOZL Gozlan, Léon. *Balzac en pantoufles*. Paris, 1946.

GRAP-1 Grappe, Georges. Preface to *Elégies amoureuses d'Ovide*. Paris, 1935.

GRAP-2 _____. *Le Musée Rodin*. Monaco, 1944.

GRAU-1 Grautoff, Otto. "Aus Gesprächen mit Rodin." *Jugend*, no. 47. Munich, 1907.

GRAU-2 _____. "Bei Auguste Rodin." *Jugend*, no. 47. Munich, 1907.

GRAU-3 _____. *Auguste Rodin*. Leipzig, 1908.

GSEL-1 Gsell, Paul. "Auguste Rodin raconté par lui-même." *La Revue*. Paris, May 1906, pp. 92–100.

GSEL-2 _____. "Chez Rodin." *L'Art et les Artistes*, vol. 4. Paris, February 1907, pp. 393–415.

GSEL-3 _____. "Propos d'Auguste Rodin sur l'art et les artistes." *La Revue*. Paris, November 1, 1907, pp. 95–107.

GSEL-4 _____. "Auguste Rodin." *Revue de Paris*. Paris, January–February 1918, pp. 400–17.

GSEL-5 _____. *Douze aquarelles de Auguste Rodin*. Geneva and Paris, 1920.

GSEL-6 _____. *Anatole France and His Circle*. London, 1922.

GUIL-H Guillemin, Henri. *Hugo et la sexualité*. Paris, 1954.

GUIL-M Guillemot, Maurice. "Au Val-Meudon." *Le Journal*. Paris, August 17, 1898.

 Güse, Ernst-Gerhard, ed. *Auguste Rodin, Zeichnungen und Aquarelle*. Stuttgart, 1984.

HANO Hanotaux, Gabriel. *La France du Nord*. Paris, 1913.

HARD Harden, Maximilian. "Weimar." *Die Zukunft*, December 29, 1906.

HARG Hargrove, June Ellen. *The Life and Work of Albert Carrier-Belleuse*. New York, 1977.

HARRI Harriman Family Archives.

HARR-1 Harris, Frank. "A Masterpiece of Modern Art." *The Saturday Review*, vol. 86, no. 2227. London, July 2, 1898.

HARR-2 _____. *Contemporary Portraits*. New York, 1915.

HARR-3 _____. *Frank Harris, His Life and Adventures, an Autobiography*. London, 1947.

HART Hartrick, A. S. *A Painter's Pilgrimage Through Fifty Years.* Cambridge, 1939.

HAVA Havard, Henry, and Vachon, Marius. *Les Manufactures Nationales.* Paris, 1888.

HENL-1 Henley, William Ernest. "Two Busts of Victor Hugo." *The Magazine of Art*, vol. 7. London, December 1883, pp. 127–32.

HENL-2 ————. "Modern Men." *The Scots Observer*, vol. 3, no. 77. Edinburgh, May 10, 1890, pp. 682–83.

HENL-3 ————. *Views and Reviews. I. Literature.* London, 1890.

HENL-4 ————. *Views and Reviews. II. Art.* London, 1902.

HENL-5 ————. *Poems.* London, 1921.

HERB Herbert, Lady. *A Sketch of the Life of the Very Reverend Peter J. Eymard.* New York, 1907.

HERR Herriot, Edouard. *Rodin.* Lausanne, 1949.

HEVE-1 Hevesi, Ludwig. *Acht Jahren Secession.* Vienna, 1906.

HEVE-2 ————. *Finale und Auftakt: Wien 1898–1914.* Salzburg, 1964.

HILL Hillairet, Jacques. *Dictionnaire historique des rues de Paris*, vol. I. Paris, 1963.

HITS Hitschmann, Eduard. *Zeitschrift für Psychoanalytische Pädagogik*, vol. 3, 1928–29.

HOCH Hoche, Jules. *Confessions d'un homme de lettres.* Paris, 1906.

HOFB Hofbauer, A. "Několik Hodin u Rodina." *Volné Směry.* Prague, 1901, pp. 52–56.

HOFF-1 Hoffman, Malvina. *A Sculptor's Odyssey.* London, 1936.

HOFF-2 ————. *Sculpture Inside and Out.* New York, 1939.

HOFF-3 ————. *Yesterday Is Tomorrow.* New York, 1965.

HONE Hone, Joseph. *The Life of Henry Tonks.* London, 1939.

HOUS Houssaye, Arsène. *Man About Paris: The Confessions of Arsène Houssaye.* New York, 1970.

HOUST Houston, Craig. "Rilke and Rodin." *German Studies* (presented to Professor H. G. Fiedler). Oxford, 1938.

HUGO Hugo, Victor. *Lettres à Juliette Drouet.* Paris, 1964.

HUNE Huneker, James. *Essays by James Huneker.* Selected by H. L. Mencken. New York, 1929.

HUNI Hunisak, John M. *The Sculptor Jules Dalou. Studies in His Style and Imagery.* New York and London, 1977.

HUYS-1 Huysmans, J. K. *Croquis Parisiens.* Paris, 1880.

HUYS-2 ————. *L'Art moderne/Certains.* Paris, 1976.

JAME James, Henry. *Parisian Sketches. Letters to the New York Tribune, 1875–1876.* New York, 1957.

JANI Janin, Clément. "Les Dessins de Rodin." *Les Maîtres Artistes.* Paris, October 15, 1903.

JAVE-1 Javel, Firmin. "M. Roger Marx." *L'Art Français*. Paris, January 17, 1888.

JAVE-2 ———. "A Rodin." *L'Art Français*. Paris, February 1888.

JAVE-3 ———. "Auguste Rodin." *L'Art Français*. Paris, July 6, 1889.

JEAN Jean-Bernard. "Chez le Sculpteur Rodin." *Tribune de Lausanne*, May 27, 1898.

JEANE Jeanès, J. E. S. *D'après nature. Souvenirs et portraits*. Geneva, 1946.

JEANN Jeanniot, Georges. "Le Salon du Champ-de-Mars." *Revue Encyclopédique*, vol. 7, 1897.

JIAN-1 Jianou, Ionel. *Rodin*. Paris, 1979.

JIAN-2 ———, and Goldscheider, Cécile. *Rodin*. Paris, 1967.

JIAN-3 ———, and Noica, Constantin. *Introduction à la sculpture de Brancusi*. Paris, 1976.

JIRA Jiránek, Milos. "Kresby a Rodina." *Volné Směry*. Prague, 1901, pp. 38–46.

JOHA Johannesburg. Johannesburg Art Gallery. Eve Fairfax Papers.

JOHN John, Augustus. *Chiaroscuro. Fragments of Autobiography*. London, 1952.

JOSE-1 Josephson, Matthew. *Zola and His Time*. New York, 1928.

JOSE-2 ———. *Victor Hugo*. New York, 1942.

JOUR Jourdain, Francis. *Rodin*. Lausanne, 1949.

JOURD Jourdain, Frantz. *Au Pays du Souvenir*. Paris, 1922.

JULL-1 Jullian, Philippe. *D'Annunzio*. London, 1972.

JULL-2 ———. *Dreamers of Decadence*. New York, 1974.

JULL-3 ———. *Montmartre*. Oxford, 1977.

KAHN-1 Kahn, Gustave. "Notes sur Rodin." *Mercure de France*, vol. 17. Paris, May–June 1924, pp. 313–25.

KAHN-2 ———. *Silhouettes Littéraires*. Paris, 1925.

KAY Kay, John W. de. *Thoughts*. London, 1911.

KEEN Keene, Donald. "Hanako." *New Japan*, vol. 14, 1962, pp. 125–27.

KEMP Kempt, Robert. *Pencil and Palette*. London, 1881.

KENNA Kennan, George. *E. H. Harriman. A Biography*. Boston and New York, 1922.

KENN-M Kennedy, Michael. *Mahler*. London, 1974.

KENN-L Kennet, Lady. *Self-Portrait of an Artist*. London, 1949.

KESS-1 Kessler, Harry. *Maillol*. Translated from the original German by J. H. Mason, 1928.

KESS-2 ———. *Les Cahiers du Comte Kessler*. Paris, 1972.

KESS-3 ———. *The Diaries of a Cosmopolitan*. London, 1971.

KING King, Graham. *Garden of Zola*. London, 1978.

KLEE Klee, Paul. *The Diaries of Paul Klee*. London, 1965.

KORE Koreska-Hartmann, Linda. *Jugendstil—Stil der Jugend.* Munich, 1969.

KROH-1 Krohg, Christian. "Rodins Balzac." *Verdens Gang*, no. 177. Oslo, July 12, 1898.

KROH-2 ———. "Moto." *Verdens Gang*, no. 288. Oslo, October 28, 1901.

KROH-3 ———. "Moto." *Verdens Gang*, no. 312. Oslo, November 18, 1901.

KROH-4 ———. Manuscript on Frits Thaulow, Oslo University Library.

LACA La Cagoule. "Visions de notre heure." *L'Echo de Paris*. Paris, May 27, 1898.

LAMA Lamartine, Alphonse de. *Balzac et ses Oeuvres*. Paris, 1866.

LAMI Lami, Stanislas. *Dictionnaire des Sculpteurs de l'Ecole Française au Dix-neuvième Siècle*, vol. 3, Paris, 1916; vol. 4, Paris, 1921.

LAND Landowska, Wanda. *Landowska on Music*. Edited by Denise Restout. New York, 1964.

LARC Larchey, Lorédan. *Dictionnaire de l'Argot Parisien*. Paris, 1872.

LARO *Larousse Mensuel Illustré*. Paris, 1907–10.

LARR-1 Larroumet, Gustave. "Rodin." *Le Figaro*. Paris, January 12, 1895.

LARR-2 ———. *Petits portraits et notes d'art*. Paris, 1897.

LAWT-1 Lawton, Frederick. *The Life and Work of Auguste Rodin*. London, 1906.

LAWT-2 ———. *François-Auguste Rodin*. London, 1907.

LAWT-3 ———. *The Third French Republic*. London, 1909.

LAWT-4 ———. *Balzac*. London, 1910.

LEAU Léautaud, Paul. *Journal Littéraire*, vol. 19. Paris, 1966.

LECO Lecomte, Georges. "Rodin tel que je l'ai vu." Preface to *Chefs-d'oeuvre de Rodin*. Photographs by René-Jacques. Paris, 1946.

LECOQ-1 Lecoq de Boisbaudran, Horace. *The Training of the Memory in Art and the Education of the Artist*. London, 1911.

LECOQ-2 ———. *L'Education de la mémoire pittoresque et la formation de l'artiste*. Paris, 1913.

LEFR Lefranc, Jean. "Rome vue par Rodin." *Le Temps*. Paris, February 20, 1912.

LEGE-1 Léger, Charles. "Rodin, son cocher, et Rataplan." *Bulletin de la Société des Amis de Meudon*, no. 8. May 1938, pp. 153–55.

LEGE-2 _____. "Rodin à Bellevue et à Meudon." *Bulletin des amis de Meudon et de Bellevue*, 1940, pp. 352–57.

LEMO-1 Lemonnier, Camille. "Le Salon de Paris. La Sculpture." *L'Europe*. Brussels, June 11, 1880.

LEMO-2 _____. *Anversa*. Published for Universal Exhibition. Antwerp, 1885.

LEMO-3 _____. "Judith Cladel." *L'Art Moderne*, no. 20. Brussels, May 14, 1899, pp. 167–68.

LEMO-4 _____. *Félicien Rops*. Paris, 1908.

LEPR Leprieur, P. "La Sculpture décorative aux Salons." *Art et Décoration*. Paris, May 1898.

LERO-1 Leroi, Paul. "Salon de 1886." *L'Art*, vol. 41. Paris, 1886, pp. 64–68.

LERO-2 _____. "Musées en plein vent." *L'Art*, vol. 59. Paris, 1900.

LERO-3 _____. "La Vérité sur les Salons de 1898 et 1899." *L'Art*, vol. 59. Paris, 1900.

LEROU Le Roux, Hugues. *Portraits de Cire: Rodin*. Paris, 1891.

LESL Leslie, Anita. *Rodin: Immortal Peasant*. London, 1959.

LETH Lethève, Jacques. *Daily Life of French Artists in the Nineteenth Century*. London, 1972.

LICH Lichtwark, Alfred. *Briefe an die Kommission für die Verwaltung der Kunsthalle*, vol. 1. Hamburg, 1924.

LIPC Lipchitz, Jacques, and Arnason, H. H. *My Life in Sculpture*. London, 1972.

LIPS Lipschutz, Léon. Review of *Octave Mirbeau* by Thérèse Gribelin. *Les Cahiers Naturalistes*, no. 34. Paris, 1967.

LIPSC Lipscomb, Jessie. Letters and documents. Private collection. London.

LOLI Loliée, Frédéric. *La Fête Impériale*. Paris, n.d.

LOND-1 London. British Library.

LOND-2 _____. Tate Gallery Archives. Catalogue Information, Chéruy Papers.

LOND-3 _____. Tate Gallery Archives. "M. Rodin's Statue of Victor Hugo." Unidentified clipping, October 1, 1909.

LOND-4 _____. Tate Gallery Archives. "The Gift of Rodin." Unidentified clipping, November 13, 1914.

LOND-5 _____. Tate Gallery Archives. "Death of M. Rodin." Unidentified clipping, November 19, 1917.

LORR-1 Lorrain, Jean. Untitled article on Rodin and Verlaine. *Le Journal*. Paris, August 10, 1901.

LORR-2 _____. *Poussières de Paris*. Paris, 1902.

LORR-3 _____. *La Ville Empoisonnée*. Paris, 1936.

LOUI Louisville, Kentucky. J. B. Speed Art Museum. *Nineteenth Century French Sculpture*. November 2–December 5, 1971.

LOVE Lovett, Robert A. *Forty Years After: An Appreciation of the Genius of Edward H. Harriman.* New York, 1949.

LOW Low, Will. *A Chronicle of Friendships.* London, 1908.

LOWT Lowther, Alice. "A Glimpse of Rodin." *The National Review,* vol. 70. London, 1918, pp. 598–601.

LRM L.R.M. "Inauguration du *Penseur* de Rodin." *Le Figaro.* Paris, April 22, 1906.

LUBE Lübeck. Öffentliche Bücherei der Hansestadt Lübeck. Max Linde Collection.

LUCB Luc-Benoist. *La Sculpture Romantique.* Paris, 1928.

LUCA-1 Lucas, Justin, in the *Revue Encyclopédique,* vol. 1. Paris, 1891, p. 46.

LUCA-2 ———. "Le Salon des Salons." *Revue Encyclopédique,* vol. 8. Paris, 1898.

LUDO-1 Ludovici, A. *An Artist's Life in London and Paris.* London, 1926.

LUDO-2 Ludovici, Anthony M. *Personal Reminiscences of Auguste Rodin.* London, 1926.

LUHA Luhan, Mabel Dodge. *European Experience,* vol. 2. New York, 1935.

MACC MacCameron, Robert. "Auguste Rodin: His Life and Work." *Town and Country.* New York, February 4, 1911.

MACCO-1 MacColl, D. S. "Rodin in London." *The Saturday Review,* May 17, 1902.

MACCO-2 ———. "Alphonse Legros." *The Saturday Review,* December 19, 1911, pp. 761–62.

MACK Mackail, J. W., and Wyndham, Guy. *Life and Letters of George Wyndham,* vol. 2. London, 1925.

MAHL-A-1 Mahler, Alma. "Reminiscences," oral-history tape, private collection. Paris.

MAHL-A-2 ———. *Gustav Mahler, Memories and Letters.* New York, 1946.

MAHL-A-3 ———. *Mémoires et correspondances.* Paris, 1980.

MAHL-G-1 Mahler, Gustav. *Gustav Mahler. Ein Bild Seiner Persönlichkeit in Widmungen.* Munich, 1910.

MAHL-G-2 ———. *Gustav Mahler Briefe.* Berlin, Vienna and Leipzig, 1925.

MAIL Maillard, Léon. *Auguste Rodin, Statuaire.* Paris, 1899.

MAIN Maingon, Charles. *L'Univers artistique de J. K. Huysmans.* Paris, 1977.

MALE Mâle, Emile. "Rodin interprète des Cathédrales de France." *Gazette des Beaux-Arts,* vol. 4. Paris, 1914, pp. 372–78.

MALL Malliet, René. "Chez le sculpteur Rodin." *Le Rappel.* Paris, October 14, 1892.

MARQ Marquet de Vasselot, Anatole. "L'Art Nouveau: la statue de Balzac." *Revue du Monde Catholique*. Musée Rodin Archives, undated clipping.

MART-J Martet, Jean. *Georges Clemenceau*. London, 1930.

MARTI Martigny. *Rodin*, catalogue. Fondation Pierre Gianadda, May 12–October 7, 1984.

MARX-1 Marx, Roger. Untitled article on Rodin. *Nancy-Artiste*. May 22, 1884.

MARX-2 ———. "Le Paria de l'Art." *Le Progrès Artistique*. Paris, November 20, 1885.

MARX-3 ———. "Balzac et Rodin." *Le Voltaire*. Paris, February 23, 1892.

MARX-4 ———. "Les Pointes sèches de Rodin." *Gazette des Beaux-Arts*. Paris, 1902.

MARX-5 ———. *Auguste Rodin, Céramiste*. Paris, 1907.

MATI Matisse, Henri. *Ecrits et propos sur l'art*. Paris, 1972.

MAUC-1 Mauclair, Camille. "La Technique de Rodin." *Revue des Beaux-Arts et des Lettres*. Paris, January 1, 1899, pp. 20–23.

MAUC-2 ———. *Idées vivantes*. Paris, 1904.

MAUC-3 ———. *La Ville Lumière*. Paris, 1904.

MAUC-4 ———. *Auguste Rodin*. London, 1905.

MAUC-5 ———. "Notes sur la technique et le symbolisme de M. Auguste Rodin." *Le Renaissance Latine*, vol. 2, no. 5. Paris, May 15, 1905, pp. 200–20.

MAUC-6 ———. "Madame Bardey." *L'Art et les Artistes*. Paris, June 1913.

MAUC-7 ———. *Auguste Rodin*. Paris, 1918.

MAUC-8 ———. *Servitude et grandeur littéraires*. Paris, n.d.

MAUP Maupassant, Guy de. *Notre Coeur*. Paris, 1902.

MAURE Maurevert, Georges. "La Légion d'Honneur." *Le Crapouillot*. Paris, March 1938.

MAUR-1 Maurois, André. *Olympio*. New York, 1956.

MAUR-2 ———. *The Quest for Proust*. London, 1962.

MAUS Maus, Madeleine Octave. *Trente années de lutte pour l'art*. Brussels, 1926.

MCAL McAllister, Isabel. *Alfred Gilbert*. London, 1929.

MCCA McCarthy, Lillah. *Myself and My Friends*. London, 1933.

McNamara, Mary Jo, and Elsen, Albert E. *Rodin's Burghers of Calais*. New York and Los Angeles, 1977.

MEDA Médard, C. La Chesnay, France. Bastien-Lepage family papers.

MEIE Meier-Graefe, Julius. *Modern Art*, vol. 2. London, 1908.

MERS Merson, Olivier. "Rodin." *Les Arts Français* (special Rodin issue), no. 14. Paris, February 1918, p. 38.

MEST Meštrović, Ivan. "Quelques souvenirs sur Rodin." *Annales de l'Institut Français de Zagreb*, no. 1. Zagreb, April–June 1937.

MEUD Meudon, Pierre. "Octave Mirbeau." *Le Canard Enchaîné*. Paris, February 21, 1917.

MEUN-1 Meunier, Mario. "Les souvenirs de Rodin sur Marseille." *Le Petit Provençal*. Marseille, May 2, 1912.

MEUN-2 ———. "Rodin, dans son art et dans sa vie." *Les Marges*. Paris, April 15, 1914, pp. 247–51.

MEUN-3 ———. "Auguste Rodin." *L'Eventail*. Geneva, 1918, pp. 347–55.

MEYE Meyer, Agnes Ernest. "Some Recollections of Rodin." *Camera Work*, no. 34/35. New York, April–July 1911, pp. 15–19.

MG M.G. "Studio Talk." The International Studio. London, December 1902.

MILA Milano. *Mostra de Medardo Rosso*, Palazzo della Permanente, 1979.

MILL Milles, Karl. *Milles berattar*. Stockholm, 1979.

MIRB-1 Mirbeau, Octave. "L'Exposition Internationale de la rue de Sèze." *Gil Blas*. Paris, May 14, 1887.

MIRB-2 ———. *Le Jardin des Supplices*. Paris, 1899.

MIRB-3 ———. "La Défense de Balzac." *Les Arts Français* (special Rodin issue), no. 14. Paris, February 1918, p. 38.

MIRB-4 ———. *Des Artistes, Première Série*. Paris, 1922.

MIRB-5 ———. *Des Artistes, Deuxième Série*. Paris, 1924.

MODE Modersohn-Becker, Paula. *In Briefen und Tagebüchern*. Frankfurt, 1979.

MOND Mondor, Henri. *Vie de Mallarmé*. Paris, 1941.

MONK Monkhouse, Cosmo. "Auguste Rodin." *The Portfolio*, vol. 18. London, 1887, pp. 7–12.

MOOR-1 Moore, George. *Memoirs of My Dead Life*. London, 1906.

MOOR-2 ———. *Impressions and Opinions*. London, 1914.

MOOR-3 ———. *Letters 1895–1933 to Lady Cunard*. London, 1957.

MORH-1 Morhardt, Mathias. "Mlle Camille Claudel." *Mercure de France*, vol. 25. Paris, March 1898.

MORH-2 ———. "La Bataille du Balzac." *Mercure de France*, vol. 256. Paris, November–December 1934.

MORH-3 ———. "Le Banquet Puvis de Chavannes." *Mercure de France*, vol. 261. Paris, August 1935.

MORI-1 Morice, Charles. *Eugène Carrière*. Paris, 1906.

MORI-2 _____. "Rodin." *Mercure de France*, vol. 124. Paris, December 1917.

MORIS Morisot, Berthe. *The Correspondence of Berthe Morisot*. New York, 1959.

MORT Mortier, Pierre. "Le 'Becque' de Rodin." *Gil Blas*. Paris, April 2, 1908.

MORW Morwitz, Ernst. *Gedichte*. Amsterdam, 1974.

MOTT Mott, Colonel T. Bentley. *Myron T. Herrick, Friend of France*. London, 1930.

MOUR-1 Mourey, Gabriel. "The Work of Auguste Rodin." *The Studio*, vol. 13, no. 62. London, May 1898, pp. 215–23.

MOUR-2 _____. "Aspects et Sensations." *L'Echo de Paris*. Paris, September 8, 1898.

MOUR-3 _____. "Le Monument du Travail." *Revue des Beaux-Arts et des Lettres*. Paris, January 1, 1899, p. 16.

MOUR-4 _____. *Des hommes devant la nature et la vie*. Paris, 1902.

MOUR-5 _____. "Le Penseur de Rodin offert par souscription publique au peuple de Paris." *Les Arts de la Vie*, vol. 1, no. 5. Paris, May 1904, pp. 267–70.

MUCH Mucha, Jiri. *Alphonse Mucha*. London, 1967.

MURR Murray, James A. H., ed. *A New English Dictionary on Historical Principles*. Oxford, 1893.

NANC Nancy. Archives Municipales.

NEWH New Haven. Beinecke Rare Book and Manuscript Library, Yale University, R. L. Stevenson and Agnes Meyer Collections.

NEWT-1 Newton, Joy, and MacDonald, Margaret. "Rodin: The Whistler Monument." *Gazette des Beaux-Arts*. Paris, December 1928, pp. 221–32.

NEWT-2 Newton, Joy, and Fol, Monique. "Zola and Rodin." *Les Cahiers Naturalistes*. Paris, 1976, pp. 177–85.

NEWY-1 New York. Columbia University Library, Pulitzer Collection.

NEWY-2 _____. Curt Valentin Gallery. *Auguste Rodin*. Exhibition catalogue. New York, 1954.

NEWY-3 _____. Museum of Modern Art Library, Manuscript Division. Conversation with Edward Steichen, Peters Sels, July 25, 1962.

NEWY-4 _____. State University College at Brockport. Yerkes Papers.

NICO Nicoladze, Jakov. *God u Rodiena (A Year with Rodin)*. Tbilisi, U.S.S.R., 1977.

NICOL Nicolson, Nigel. *Portrait of a Marriage*. London, 1973.

NORD Nordau, Max. *On Art and Artists*. London, n.d.

NOST-1 Nostitz, Helene von. *Aus dem alten Europa*. Berlin, 1933.

NOST-2 _____. *Auguste Rodin: Briefe an Zwei Deutsche Frauen.* Berlin, 1936.

NOST-3 _____. *Berlin: Erinnerungen und Gegenwart.* Leipzig and Berlin, 1938.

NOST-4 _____. *Rodin in Gesprächen und Briefen.* Dresden, 1955.

NOST-5 Nostitz, Oswalt von. *Vortrag über Helene von Nostitz.* Unpublished lecture, circa 1980.

NOST-6 _____. Family papers.

NOTT-1 *Nottingham French Studies,* "Jelka Rosen Delius: The Correspondence" I, edited by Lionel Carley, vol. 9, no. 1, May 1970.

NOTT-2 *Nottingham French Studies,* "Jelka Rosen Delius: The Correspondence" II, edited by Lionel Carley, vol. 9, no. 2, October 1970.

NOZI Nozière. "L'Echo." *L'Avenir.* Paris, February 6, 1919.

OJET Ojetti, Ugo. *As They Seemed to Me.* London, 1928.

OKEY Okey, Thomas. "Alphonse Legros: Some Personal Reminiscences," unidentified clipping, private collection, London.

ORCU Orcutt, William Dana. *Celebrities off Parade.* Chicago and New York, 1935.

OSLO Oslo University Library. Manuscript Division, Frits Thaulow Collection.

OXFO Oxford. *The Oxford Dictionary of Quotations.* London, 1941.

PANG Pange, Comtesse Jean de. *Comment j'ai vu 1900,* vol. 3. Paris, 1968.

PAOL Paoli, Xavier. *My Royal Clients.* London, 1912.

PARI-1 Paris. Archives de Paris.

PARI-2 _____. Archives Nationales.

PARI-3 _____. Bibliothèque de l'Arsenal, Académie Goncourt Collection.

PARI-4 _____. Bibliothèque de l'Institut, Manuscript Division.

PARI-5 _____. Bibliothèque Littéraire Jacques Doucet, Université de Paris.

PARI-6 _____. Bibliothèque Nationale, Manuscript Division.

PARI-7 _____. Bibliothèque Nationale, Catalogue *J.-K. Huysmans, L'homme et l'oeuvre,* 1948.

PARI-8 _____. Bibliothèque Nationale, Catalogue *Emile Zola,* 1952.

PARI-9 _____. Bibliothèque Nationale, Catalogue *Gustave Geffroy et l'art moderne,* 1957.

PARI-10 _____. Bibliothèque Nationale, Catalogue *Pierre et Marie Curie.* 1967.

PARI-11 _____. Bodin, Th. *Autographs,* sale catalogue, autumn 1978.

PARI-12 _____. Galerie Georges Petit, Catalogue *Claude Monet— A. Rodin,* 1889.

PARI-13 _____. Galerie Georges Petit, *La Collection Antony Roux*, May 19–20, 1914.

_____. Galeries Nationales du Grand Palais. *La Sculpture Française au XIXe siècle*, April 10–July 28, 1986.

PARI-14 _____. Hôtel Drouot, sale catalogue, January 30, 1980.

PARI-15 _____. Mairie du 1er Arrondissement, *Naudin-Audoux-Baffier-Lapaire-Adam, Exposition organisée par le Centre Amical du Berry*, 1980.

PARI-16 _____. Ministère des Relations Extérieures, Archives.

PARI-17 _____. Musée d'Art Moderne, *Gustav Mahler, un homme, une oeuvre, une époque*, January 24–March 31, 1985.

_____. Musée du Louvre, *Rodin inconnu*, December 1962–January 1963.

PARI-18 _____. Musée du Petit Palais, *Catalogue de l'Exposition Baudelaire, 1968–1969*.

PARI-19 _____. Musée Rodin Archives.

PARI-20 _____. Musée Rodin, Catalogue *Balzac et Rodin*, 1950.

PARI-21 _____. Musée Rodin, Catalogue *Rodin, ses collaborateurs et ses amis*, 1957.

_____. Musée Rodin, Catalogue *Rodin collectionneur*, 1967–1968.

PARI-22 _____. Musée Rodin, Catalogue *Rodin et les écrivains de son temps*, 1976.

PARI-23 _____. Musée Rodin, Catalogue *Auguste Rodin. Le Monument des Bourgeois de Calais (1884–1895)*, 1977.

_____. Musée Rodin, Catalogue *Rodin et l'Extrême-Orient*, 1979.

_____. Musée Rodin, Catalogue *Rodin et la sculpture contemporaine*, 1982.

_____. Musée Rodin, Catalogue *Rodin, les mains, les chirurgiens*, 1983–1984.

PARI-24 _____. Musée Rodin, Catalogue *Camille Claudel*, 1984.

PARI-25 _____. Musée Rodin, Catalogue *Correspondance de Rodin*, 1985.

_____. Musée Rodin, Catalogue *Les Photographes de Rodin*, 1986.

_____. Musée Rodin, Cabinet des Dessins, Catalogue *Les Centaures*, 1981–1982.

_____. Musée Rodin, Cabinet des Dessins, Catalogue *Ugolin*, 1982–1983.

 _____. Musée Rodin, Cabinet des Dessins, Catalogue *Dante et Virgile aux Enfers*, 1983–1984.

PARI-26 _____. Saffroy, Autographs, sale catalogue, March 1972.

PARI-27 _____. Morssen, Autographs, sale catalogue, October 1981.

PARIS Paris, Reine-Marie. *Camille Claudel*. Paris, 1984.

PAUL Paul-Margueritte, Eve and Lucie. *Deux frères, deux soeurs*. Paris, 1951.

PEAR-1 Pearson, Hesketh. *Bernard Shaw: His Life and Personality*. London, 1950.

PEAR-2 _____. *The Life of Oscar Wilde*. London, 1960.

PELA Peladan, Joséphin. "Les Intersignes du temps, M. Rodin et son Musée." *La Revue Bleue*. Paris, 1916, pp. 687–89.

PENN-1 Pennell, E. R., and Pennell, Joseph. *The Life of James McNeill Whistler*. London, 1920.

PENN-2 _____. *The Whistler Journal*. Philadelphia, 1921.

PERA Pératé, André. "Rodin." *Le Correspondant*. Paris, December 10, 1917, pp. 874–82.

PHILA Philadelphia Museum of Art. Archives.

PHIL-1 Phillips, Claude. "The Salon." *The Magazine of Art*. London, 1888, vol. 11, p. 345.

PHIL-2 _____. "The Rodin Gift." *The Times*. London, November 12, 1914.

PIER-1 Pierron, Sander. "François Rude et Auguste Rodin à Bruxelles." *La Grande Revue*, vol. 4. Paris, October 1, 1902.

PIER-2 _____. *Histoire illustrée de la forêt de Soignes*. Brussels, 1938.

PIGA Pigache, D. Nichols. *Café Royal Days*. London, 1934.

 Pinet, Hélène. *Rodin sculpteur et les photographes de son temps*. Paris, 1985.

PING Pingeot, Anne. "Le Chef-d'oeuvre de Camille Claudel: L'Age mûr." *La Revue du Louvre et des Musées de France*, no. 4. Paris, 1982, pp. 287–95.

PLAO Plaoutine, N., and Roger, J. *Corpus Vasorum Antiquorum, Musée National Rodin*. Paris, 1945.

PLES Plessier, Ghislaine. *Etude critique de la correspondance de Zuloaga et Rodin de 1903 à 1917*. Paris, 1983.

POUQ Pouquet, Jeanne-Maurice. *Le Salon de Madame Arman de Caillavet*. Paris, 1926.

PREA Préaud, Tamara. *Sèvres Porcelain*, catalogue, Smithsonian Institution. Washington, D.C., 1980.

PRIN Princeton University Library, Manuscript Division, Chéruy Papers.

PROU Proust, Antonin. *Edouard Manet*. Berlin, 1929.

PUGE Puget, Jean. *La Vie extraordinaire de Forain*. Paris, 1957.
PULL Pullar, Philippa. *Frank Harris*. London, 1975.
QUEN-1 Quentin, Charles. "Rodin." *The Art Journal*. London, July
 1898, pp. 193–96.
QUEN-2 _____. "Le Musée Rodin." *The Art Journal*. London, 1900,
 pp. 213–17.
RACO Racowitza, Princess Helene von. *An Autobiography*. London,
 1910.
RAIM Raimond, Michel. "Mirbeau, Octave." *Dictionnaire des Lettres
 Françaises, XIXe Siècle*, vol. 2. Paris, 1972.
RAMB Rambaud, Yveling. "Medardo Rosso." *Le Journal*, June 6,
 1898.
RAME Rameau, Jean. "La victoire de M. Rodin." *Le Gaulois*. Paris,
 May 3, 1898.
RAMS R.A.M.S. "The International Society of Sculptors, Painters
 and Gravers." *The Pall Mall Gazette*. London, May 16,
 1898.
REDO Redon, Odilon. *A soi-même. Journal 1867–1915*. Paris, 1922.
RENA Renard, Jules. *Journal*. Paris, 1935.
RESN Resnevic Signorelli, Olga. *Il Ritratto di Benedetto XV di
 Auguste Rodin*. Staderini, Pomezia, 1981.
REVA Réval, Gabrielle. "Les artistes femmes au Salon de 1903."
 Femina, no. 55. Paris, May 1, 1903, pp. 519–21.
REWA-1 Rewald, John. *Maillol*. Paris, 1939.
REWA-2 _____. *The History of Impressionism*. London, 1980.
REYE Reyer, Georges. "L'Amour fou de deux génies: la soeur de
 Claudel et Rodin le sculpteur." *Marie-Claire*. Paris, Sep-
 tember 1975.
RHEI Rheims, Maurice. *La Sculpture au XIXe siècle*. Paris, 1972.
RICE Rice, Howard C., Jr. "Glimpses of Rodin." *The Princeton
 University Library Chronicle*, vol. 27, no. 1. Princeton,
 autumn 1965, pp. 33–44.
RICK-1 Ricketts, Charles. "Dalou." *The Burlington Magazine*, vol.
 7. London, 1905, pp. 348–54.
RICK-2 _____. *Self-Portrait*. London, 1939.
RILK-1 Rilke, Rainer Maria. *Auguste Rodin*. Berlin, 1903.
RILK-2 _____. *Gesammelte Werke*, vols. 3 and 4. Leipzig, 1927.
RILK-3 _____. *Briefe aus den Jahren 1902 bis 1906*. Leipzig, 1930.
RILK-4 _____. *Lettres à Rodin*. Paris, 1931.
RILK-5 _____. *Briefe aus den Jahren 1907 bis 1914*. Leipzig, 1933.
RILK-6 _____. *Briefe an Sidonie Nádherný von Borutin*, 1973.
RIMB Rimbaud, Arthur. *Oeuvres Complètes*. Paris, 1972.
RIOT-1 Riotor, Léon. "Auguste Rodin." *Revue Populaire des Beaux-
 Arts*, vol. 1, no. 14, April 8, 1899, pp. 219–21.

RIOT-2 ———. *Rodin*. Paris, 1927.

RL R.L. "Ein Gespräch mit Rodin." *Neue Freie Presse*, June 6, 1902.

ROCH-1 Rochefort, Henri. *La Grande Bohème*. Paris, 1867.

ROCH-2 ———. "La Critique du Balzac." *Les Arts Français* (special Rodin issue), no. 14. Paris, February 1918, p. 36.

ROD Rod, Edouard. "L'atelier de M. Rodin." *Gazette des Beaux-Arts*. Paris, January–June 1898, pp. 419–30.

RODE-1 Rodenbach, Georges. "Une Statue." *Le Figaro*. Paris, May 17, 1898.

RODE-2 ———. *L'Elite*. Paris, 1899.

RODI-1 Rodin, Auguste. "Le Leçon de l'Antique." *Le Musée*, vol. 1, no. 1. Paris, January–February 1904.

RODI-2 ———. "La Tête Warren." *Le Musée*, vol. 1, no. 6. Paris, November–December 1904, pp. 298–301.

RODI-3 ———. "Le Parthénon et les Cathédrales." *Le Musée*, vol. 2, no. 1. Paris, January–February 1905, pp. 66–68.

RODI-4 ———. "The Gothic in the Cathedrals and Churches of France." Translated by Frederick Lawton. *The North American Review*, February 1905.

RODI-5 ———. "Mon séjour à Rome." *Excelsior*. Paris, February 18, 1912.

RODI-6 ———. "Vénus—A la Vénus de Milo." *L'Art et les Artistes*, no. 108, March 1914.

RODI-7 ———. *Les Cathédrales de France*. Paris, 1914.

RODI-8 ———. *L'Art. Entretiens réunis par Paul Gsell*. Paris, 1919.

RODI-9 ———. "La Danse de Civa." *Ars Asiatica*. Brussels and Paris, 1921, pp. 9–13.

RODI-10 ———. Manuscript notes on French cathedrals, Hôtel Drouot, Catalogue *Précieux livres et manuscrits autographes*. Paris, June 5, 1962.

———. *Cathedrals of France*, translated by Elisabeth Chase Geissbuhler. Boston, 1965.

———. *Art. Conversations with Paul Gsell*, translated by Jacques de Caso and Patricia B. Sanders. London, 1984.

RODI-H Rodin, Hippolyte. *Les plantes médicinales et usuelles de nos champs, jardins, forêts*. Paris, 1872.

ROGE Roger-Milès, L. "Rodin." *L'Eclair*. Paris, July 24, 1899.

ROLL Rolland, Romain. *Journal des années de guerre, 1914–1919*. Paris, 1952.

ROSN-1 Rosny, J. H. Aîné. *Torches et lumignons. Souvenirs de la vie littéraire*. Paris, 1921.

ROSN-2 ———. *Mémoires de la vie littéraire*. Paris, 1927.

ROSN-3 ———. *Portraits-Souvenirs*. Paris, 1945.

ROTH-J Rothenstein, John. *Modern English Painters: Sickert to Smith.* London, 1952.

ROTH-1 Rothenstein, William. *Men and Memories*, vol. 1. London, 1931.

ROTH-2 ———. *Men and Memories*, vol. 2. London, 1932.

ROTH-3 ———. *Since Fifty.* London, n.d.

ROUA Rouault, Georges. "Trois Artistes." *Mercure de France*, no. 83. Paris, November 16, 1910.

ROUS-1 Rousseau, Jean. "La Nouvelle Bourse." *L'Art Universel*, vol. 1, no. 22. Brussels, January 1, 1874.

ROUS-2 ———. "Revue des Arts." *L'Echo du Parlement Belge.* Brussels, April 11, 1877.

RUSS Russell-Jouve, Jeanne. *Rodin chez nous*, unpublished manuscript, private collection.

RUTT Rutter, Frank. *Since I Was Twenty-Five.* London, 1927.

SACK Sackville, Victoria. Lady Sackville's *Journal.* Nigel Nicolson Collection. Sissinghurst Castle, Kent.

SAIN-V Saint-Point, Valentine de. "La double personnalité d'Auguste Rodin." *La Nouvelle Revue*, vol. 43. Paris, November–December 1906.

SAIN-L Saint-Valéry, Léon de. "Un samedi . . ." *Revue des Beaux-Arts et des Lettres.* Paris, January 1, 1899, pp. 23–24.

SALA Sala, George Augustus. *Paris Herself Again.* London, 1884.

SALM Salmson, Jules. *Entre deux coups de ciseau: Souvenirs d'un sculpteur.* Geneva, 1892.

SART Sartre, Jean-Paul. *Baudelaire.* New York, 1950.

SCHI Schiaffino, Eduardo. "El Monumento de Sarmiento." *La Nación.* Buenos Aires, May 25, 1900.

SCHM-1 Schmoll gen. Eisenwerth, J. A. "Rodins Europäische Wirkung." *Actes du Congrès International d'Histoire de l'Art.* Paris, September 1958.

SCHM-2 ———. "Auguste Rodin: Das Heutige Bild seines Werkes und seiner Wirkung." *Universitas*, vol. 23, no. 4. Stuttgart, 1968.

SCHM-3 ———. *Rodin-Studien.* Munich, 1983.

SCHN Schnack, Ingeborg. *Rainer Maria Rilke—Chronik seines Lebens und seines Werkes.* Frankfurt, 1965.

SCHNE Schneider, Gustave. "L'Exposition privée de Rodin." *Le Petit Bleu.* Paris, July 19, 1899.

SCHO Scholl, Aurélien. "La question Rodin." *L'Echo de Paris.* Paris, August 28, 1896.

SCHOO Schoolfield, George C. "Rilke's Ibsen." *Scandinavian Studies*, vol. 51, no. 4. New Haven, autumn 1979.

SCHOP Schopfer, Jean, and Anet, Claude. "Auguste Rodin." *The Craftsman*, vol. 5. London, March 1904, pp. 525–45.

SCHU Schurr, Gerald. "Continental Dispatch." *The Connoisseur*, vol. 167, no. 672. London, February 1968, p. 110.

SCHW Schwob, Marcel. "Balzac" and "Rodin." *Les Maîtres Artistes* (special Rodin issue). Paris, October 15, 1903, p. 283.

SEAT Seaton-Schmidt, Anna. "Auguste Rodin: Man and Sculptor." *The American Magazine of Art*, vol. 9. New York, February 1918, pp. 129–40.

SEIT Seitz, Don C. *Joseph Pulitzer. His Life and Letters.* New York, 1924.

SEVE-1 Séverine. "Auguste Rodin." *Le Journal.* Paris, November 10, 1894.

SEVE-2 _____. "Les dix mille francs de Rodin." *Le Journal.* Paris, November 27, 1894.

SEVE-3 _____. *Pages mystiques.* Paris, 1895.

SHAW-1 Shaw, George Bernard. "Rodin." *The Nation*, vol. 12, no. 6. London, November 9, 1912.

SHAW-2 _____. "A Memory of Rodin." *The Lantern*. London, January 1918.

SHAW-3 _____. "Rodin." *Annales Politiques et Littéraires*. Paris, December 2, 1932.

SHAW-4 _____. *Collected Letters, 1898–1910*, edited by Dan H. Laurence. New York, 1972.

SIGN-1 Signac, Paul. "Excerpts from the Unpublished Diary of Paul Signac." *Gazette des Beaux-Arts*, vol. 36, nos. 989–991. Paris, July–September 1949, pp. 166–74.

SIGN-2 _____. "Extraits du Journal Inédit de Paul Signac, II," *Gazette des Beaux-Arts*, vol. 39, no. 1001. Paris, April 1952.

SIGO Sigogneau, Albert. *Le Tourment de Rodin.* Bordeaux, 1933.

SIMM Simmel, Georg. *Brücke und Tür.* Stuttgart, 1957.

SIMO-1 Simond, Charles. *Paris de 1800 à 1900*, vol. 2. Paris, 1900.

SIMO-2 _____. *Paris de 1800 à 1900*, vol. 3. Paris, 1901.

SITW Sitwell, Osbert. *The Scarlet Tree.* London, 1947.

SMET Smet, Frédéric de. "Rodin et les Gantois." *Grand Artistique*, April 1922, pp. 45–46.

SMYT Smyth, Ethel. *As Time Went On.* London, 1936.

SOCI-1 Société des Artistes Français pour l'exposition des Beaux-Arts, Salon de 1875.

SOCI-2 Société des Artistes Français pour l'exposition des Beaux-Arts, Salon de 1885.

SOFF Soffici, Ardengo. *Il caso Medardo Rosso.* Florence, 1909.

SOLV Solvay, Lucien. *Une vie de journaliste.* Paris, 1934.

Bibliography

SOTH-1	Sotheby & Co., London. Sale catalogue, April 27, 1971.
SOTH-2	———. Sale catalogue, April 19, 1977.
SPEA	Spear, Richard E. "Acquisitions: 1975–1976," *Allen Memorial Museum Bulletin*, vol. 34. Oberlin, Ohio, 1976.
SPIE	Spielmann, M. H. "Glimpses of Artist-Life." *The Magazine of Art*, 1887, pp. 136–41.
STDE	St. Denis, Ruth. *An Unfinished Life*. New York, 1939.
STEI	Steinberg, Leo. *Other Criteria*. New York, 1972.
STEV-A	Stevens, Alfred. *A Painter's Philosophy*. London, 1904.
STEV-1	Stevenson, Robert Louis. "Rodin and Zola." Letter to the editor, *The Times*. London, September 6, 1886.
STEV-2	———. *Letters and Miscellanies of Robert Louis Stevenson*, edited by Sidney Colvin, vol. 2. New York, 1901.
STEV-3	———. *The Letters of Robert Louis Stevenson, 1880–1887*, vol. 2. London, 1911.
STIE	Stiegler, Gaston. "Rodin and Balzac." *L'Echo de Paris*. Paris, November 12, 1894.
STOC	Stockholm. Prins Eugen Waldemarsudde.
STOK	Stokes, Adrian. *Selected Writings. The Image in Form*, edited by Richard Wollheim. Harmondsworth, 1972.
STRI	Strindberg, Freda. *Marriage with Genius*. London, 1937.
	Sutton, Denys. *Triumphant Satyr: The World of Auguste Rodin*. London, 1966.
SYDN	Sydney. Mitchell Library, Tom Roberts Collection.
SYMO-1	Symons, Arthur. "Rodin." *The Fortnightly Review*, vol. 77. London, 1902, pp. 957–67.
SYMO-2	———. "For Le Penseur de Rodin." *The Saturday Review*. London, December 31, 1904.
SYMO-3	———. *From Toulouse-Lautrec to Rodin*. London, 1929.
SZEP	Szeps, Berta. *My Life and History*. London, 1938.
TACH	Tacha Spear, Athena. *Rodin Sculpture in the Cleveland Museum of Art*. Cleveland, 1967.
TANC	Tancock, John. *The Sculpture of Auguste Rodin*. Philadelphia, 1976.
TARD	Tardieu, Charles. "Le Salon de Paris, 1877: la Sculpture." *L'Art*, vol. 3. Paris, 1877.
TAUB	Taubman, Mary. *Gwen John*. London, 1985.
TELL	Tellegen, Lou. *Women Have Been Kind. The Memoirs of Lou Tellegen*. New York, 1931.
THAU	Thaulow, Alexandra. *Mens Frits Thaulow malte*. Oslo, 1929.
	Thorson, Victoria. *Rodin Graphics*. San Francisco, 1975.
TIRE	Tirel, Marcelle. *Rodin Intime*. Paris, 1923.
TIRR	Tirranen, Hertta. *Suomen Taiteilijoita*. Helsinki, 1950.

TREU Treu, Georg. "Bei Rodin." *Kunst und Künstler*, vol. 3. Berlin, 1905.

TWEE Tweed, Lendal. *John Tweed, Sculptor. A Memoir.* London, 1936.

VAIL Vaillat, Léandre. *En écoutant Forain.* Paris, 1931.

VALE Valéry, Paul. *Degas, Manet, Morisot.* New York, 1960.

VAND Van de Velde, Henry. *Geschichte Meines Lebens.* Munich, 1962.

VANV Van Vorst, John. "Rodin and Bernard Shaw." *Putnam's Monthly*, vol. 3. New York, October 1907–March 1908.

VARE Varenne, Gaston. *Bourdelle par lui-même. Sa pensée et son art.* Paris, 1937.

VARES Varèse, Louise. *Varèse. A Looking-Glass Diary.* New York, 1972.

VAUX Vauxcelles, Louis. "Notes d'art. Au Salon d'Automne: le Sculpteur Medardo Rosso." *Gil Blas.* Paris, October 31, 1904.

VENT Venturi, Lionello. *Les Archives de l'Impressionnisme*, vol. 1. Paris and New York, 1939.

VERH Verhaeren, Emile. "A Marthe Verhaeren." *Mercure de France.* Paris, 1951.

VERO Véron, Pierre. "Courrier de Paris." *Le Monde Illustré.* Paris, May 21, 1898.

VIAL Vial, André. *Guy de Maupassant et l'art du roman.* Paris, 1954.

VIBE Vibert, Paul. "Rapport de M. Thoinot sur la réforme de la loi sur les aliénés." *La République Radicale.* Paris, May 28, 1914.

VICK Vickers, Hugo. *Gladys, Duchess of Marlborough.* New York, 1979.

VIEN Vienna. Austrian State Archives, Gauchez Collection.

VIGE Vigeland, Gustave. *Om Kunst og Kunstnere.* Oslo, 1955.

VINC-1 Vincent, Clare. "In Search of a Likeness: Some European Portrait Sculpture." *The Metropolitan Museum of Art Bulletin*, April 1966, pp. 245–60.

VINC-2 ———. "Rodin at the Metropolitan Museum of Art." *The Metropolitan Museum of Art Bulletin*, spring 1981.

VIRM Virmaître, Charles. *Paris-Médaillé.* Paris, 1890.

VOLA Volavkova-Skorepova, Zdenka. "Auguste Rodin." *Volné Směry.* Prague, 1901.

VOLL-1 Vollard, Ambroise. *La vie et l'oeuvre de Pierre-Auguste Renoir.* Paris, 1919.

VOLL-2 ———. *Renoir. An Intimate Record.* New York, 1930.

VOLL-3 ———. *Recollections of a Picture Dealer.* London, 1936.

WAGN Wagner, Hans. "Die Briefsammlung Gauchez." *Mitteilungen des Oesterreichischen Staatsarchivs*, vol. 9, 1956, pp. 573–88.

Waldmann, Emil. *Auguste Rodin*. Vienna, 1945.

WALK Walker, Mack. *Metternich's Europe, 1813–1848*. New York, 1968.

WARD Ward, Maisie. *The Tragi-Comedy of Pen Browning*. New York, 1972.

WARW Warwick, [Frances] Countess of. *Afterthoughts*. London, 1931.

WASH-1 Washington, D.C. Library of Congress, Manuscript Division.

WASH-2 ———. Library of Congress, Manuscript Division, Bartlett Papers.

WASH-3 ———. Library of Congress, Manuscript Division, Bartlett Papers, "Rodin's Home at Meudon." Unidentified clipping, 1906.

Wasserman, Jeanne L., ed. *Metamorphoses in Nineteenth-Century Sculpture*. Cambridge, Mass., 1975.

WASS ———. *Sculpture by Antoine-Louis Barye*. Cambridge, Mass., 1982.

WEIN-1 Weintraub, Stanley, ed. *Shaw, An Autobiography, 1898–1950*, vol. 2. New York, 1970.

WEIN-2 ———. *Whistler, A Biography*. London, 1974.

WEIS Weisberg, Gabriel P. "Baron Vitta and the Bracquemond-Rodin Hand Mirror." *Bulletin of the Cleveland Museum of Art*, November 1979.

WEST Westheim, Paul. *Wilhelm Lehmbruck*. Potsdam, 1922.

WILDE Wilde, Oscar. *The Letters of Oscar Wilde*. New York, 1962.

WILD Wildenstein, Daniel. *Claude Monet. Biographie et catalogue raisonné, Vol. III, 1887–1898*. Geneva, 1979.

WILL Williams, Roger L. *Henri Rochefort, Prince of the Gutter Press*. New York, 1966.

WILL-K Williamson, Kennedy. *W. E. Henley*. London, 1930.

WILM Wilmès, M. "Paul Claudel et le Rhône." *Panorama*. Paris, July 15, 1943.

WOOL Woolf, Leonard. *Beginning Again*. London, 1964.

YOUN Young, Ella. *Flowering Dusk. Things Remembered*. New York, 1945.

ZIMM Zimmern, Helen. "Auguste Rodin Loquitur." *The Critic*. New York, December 1902, pp. 514–20.

ZOLA-1 Zola, Emile. *Correspondance*. Paris, 1928.

ZOLA-2 ———. *L'Assommoir*. Harmondsworth, 1970.

ZOLA-3 ———. *Correspondance*, vol. 3. Montreal, 1982.

ZUCK Zuckerkandl, Bertha. *Oesterreich Intim*. Frankfurt, 1970.

ZWEI Zweig, Stefan. *The World of Yesterday*. London, 1943.

ACKNOWLEDGMENTS

At the outset I must express my gratitude to the people whose assistance was absolutely essential: Vicomtesse Sarah du Bosq de Beaumont, Mlle Brigitte Vienneaux, Mrs. Svea Gold, Mrs. Ingrid Remak, Prof. Henry H. Remak, Ms. Sarah Fox-Pitt, Ms. Gail Ellis, Ms. Toby Molenaar, Mme Idh von Weissenfluh, Ms. Rachel Fry, Ms. Cecily Taylor, Ms. Harriet Morgan, Mrs. Philippa Fraser, Mr. Ian Fraser, Ms. Dolors Udina, Mrs. Catherine Fuster, Ms. Laura Grunfeld, Mr. Foster V. Grunfeld, Mr. Javier Maza, Ms. Melanie Custer, Mr. B. Scott Custer, Jr., and Kenneth Rickler, M.D.

Mlle Marie-Pierre Deshayes of Metz solved the riddle of the origins of the Cheffer family and M. F. Bibolet of the Bibliothèque Municipale, Troyes, did the research that took the Rodin family tree back to the 1760s; Count Oswalt von Nostitz provided invaluable information about his mother, Helene von Nostitz; Mr. Nigel Nicolson invited me to Sissinghurst Castle to inspect the diaries of his grandmother, Lady Sackville; Mr. R. E. M. Elborne kindly furnished copies of the Rodin letters to his grandmother, Jessie Lipscomb; Mr. Vidar Poulsson, M.A., went to a great deal of trouble to assist me in matters concerning Frits Thaulow and Christian Krohg; Professor John A. Green of Brigham Young University shared his Marcel Schwob expertise with me; Mrs. Helen Bander of Paris, Arkansas, did several oral-history interviews with Rodin's last living model, the centenarian Mrs. Marguerite Pryce-Durkee; Mrs. Mary Taubman told me about her researches into the

life of Gwen John; Dr. Donald J. Finley sent important documents on the Rodin–John Peter Russell relationship; Captain Ian Whitman and his father-in-law, the Count de Valois, provided background material on the Duchesse de Choiseul; M. Robert Lemaire of the Bibliothèque Municipale, Beauvais, unearthed documents concerning Rodin's school days; M. C. Médard of La Chesnay, France, furnished some of the Bastien-Lepage family papers; Mme Emilienne Cruchet wrote to me about her grandfather, one of Rodin's favorite employers; Ms. Macha Khmelevskaja and Ms. Pamela Dempster translated some of the Russian manuscripts, and Mrs. Erika Erdos translated all of the Czech documents for me.

Others who gave generously of their time were Mrs. Doris Asmundsson, Ms. Anita Hart Balter, Ms. Miranda Banks, Mr. Bruce Bernard, Mr. John Bird, Mlle Lucia Blaise, Mme Christiane de Boelpape Donner, Ms. Gunn Brinson, Ms. Miranda Carter, the late Jacques Cassar, Mr. Timothy Clifford, Mlle Sylvie Doutre, Ms. Salina Fellowes, Ms. Amie Frank, Ms. Laure Frapier, M. Pierre Gassier, Mrs. Natascha Giesel, Mr. Peter Giesel, Mr. Rainer von Harnack, Mr. David Harris, Mr. Paul Hogarth, Lord Howard de Walden, Mr. Ernest L. Hufnagel, Mr. Ben Jakober, Mr. Ben John, Ms. Sarah G. John, Prof. John Kelly, Prof. Janet Kennedy, Lord Kennet of the Dene, Mr. Mati Klarwein, Mr. Guy Krohg, Mme Bärbel Kicska-Neumann, Mr. Paul R. Krause, Ms. Hillary Laurie, Mlle Sylvie Lebrun, Mme Martine Legein, Mr. Gershon Legman, Ms. Kate Lewin, Mr. Sandy Lieberson, Ms. Julia Loomis, Mr. Harry Lunn, Mme Florence de Lussy, Mrs. Edith Malkin, Mr. Lawrence Malkin, Mr. Golo Mann, Dr. Amanda C. Martin, Mr. Charles L. Mee, Jr., M. Daniel Paris, M. Jean Paris, Mme Reine-Marie Paris, Ms. Vera Oberlander, Georgia O'Keeffe, Mr. Austin Olney, Ms. Penny Reed, Mme Chantal Rotsaert, Ms. Nina Rudling, Ms. Mary Bayes Ryan, the late John Sackur, Ms. Valerie Saint-Rossy, Mrs. Hella Sieber-Rilke, Mr. Jesse Simons, M. Pierre Skira-Breteau, Mrs. Ursula Stechow, Ms. Ashley Thompson, Mme Marie-José Van der Eecken, Ms. Anne Vanhaeverbeke, Ms. Dominique Vanier, Ms. Jordan Verner, Mme Françoise Viatte, M. Germain Viatte, Ms. Lois Wallace, Ms. Leila Ward and Dr. Dorothea Zucker-Franklin.

I am indebted to the Académie Goncourt for permission to quote from letters in its Geffroy collection at the Bibliothèque de l'Arsenal; to the Archives Nationales, Paris, for innumerable letters and manuscripts; to the Austrian State Archives for letters from the Gauchez collection; to the Beinecke Rare Book and Manuscript Library, Yale University, for letters from the R. L. Stevenson and the Agnes Meyer collections; to the Bibliothèque Nationale for letters from the Robert de Montesquiou and Madame Curie collections, among others; to the Columbia University Library for

letters from the Pulitzer Collection; to the Library of Congress for unpublished manuscripts by Truman H. Bartlett; to Duke University for papers from the Warrington Dawson collection; to the Houghton Library, Harvard University, for letters from the Rothenstein collection; to the Bibliothèque de l'Institut, Paris, for the Anna de Noailles papers and Rodin's curriculum vitae; to the Lilly Library, Indiana University, for documents from the Cladel collection; to the Mitchell Library, Sydney, for letters from the Tom Roberts collection; to the Princeton University Library for letters from the Chéruy collection; to the Musée Rodin for both pictures and documents; to the National Library of Scotland and Mr. Mark Oliver for the Ottilie McLaren letters; to the Tate Gallery for documents from its catalogue information archives; and to the National Library of Wales for letters from the Gwen John collection.

Finally, I should like to thank Ms. Ann Mary O'Sullivan for sustaining me in the Columbia University stacks and, subsequently, for her untiring assistance, understanding, and forbearance. I owe an inestimable debt to Amy Hertz, Ann Bartunek, Cathie Fallin, and Renée Rabb at Henry Holt, and especially to Rob Cowley, my editor, who has proved utterly unflappable and a source of sage counsel throughout the inordinately long time it took me to complete this book.

INDEX